W9-BNA-450

www.wadsworth.com

www.wadsworth.com is the World Wide Web site for Thomson Wadsworth and is your direct source to dozens of online resources.

At www.wadsworth.com you can find out about supplements, demonstration software, and student resources. You can also send e-mail to many of our authors and preview new publications and exciting new technologies.

www.wadsworth.com
Changing the way the world learns®

A History of Roman Art

Fred S. Kleiner

A History of Roman Art

Fred S. Kleiner

THOMSON

WADSWORTH

Australia • Brazil • Canada • Mexico • Singapore • Spain • United Kingdom • United States

THOMSON

★
™

WADSWORTH

A History of Roman Art
Fred S. Kleiner

Publisher: Clark Baxter

Acquisition Editor: John R. Swanson

Development Editor: Sharon Adams-Poore

Assistant Editor: Anne Gittinger

Editorial Assistant: Allison Roper

Technology Project Manager: Dave Lionetti

Marketing Manager: Mark Orr

Marketing Assistant: Alexandra Tran

Marketing Communications Manager: Stacey Purviance

Senior Project Manager, Editorial Production: Kimberly Adams

Creative Director: Rob Hugel

Executive Art Director: Maria Epes

Print Buyer: Barbara Britton

Permissions Editor: Joohee Lee

Production Service: Joan Keyes, Dovetail Publishing Services

Text Designer: Jerry Wilke

Photo Researcher: Sarah Evertson / Image Quest

Copy Editor: Ida May Norton

Illustrator: John Burge

Map Art: Mapping Specialists, Ltd.

Cover Designer: Jerry Wilke

Cover Image: Hadrian's Villa/© Macduff Everton/CORBIS

Cover Printer: Phoenix Color Corp

Compositor: Progressive Information Technologies

Printer: Courier Corporation/Kendallville

Printed in the United States of America
2 3 4 5 6 7 09 08 07

Library of Congress Control Number: 2005931977

ISBN 978-0-534-63846-7
ISBN 0-534-63846-5

Thomson Higher Education
10 Davis Drive
Belmont, CA 94002-3098
USA

For more information about our products, contact us at:
Thomson Learning Academic Resource Center
1-800-423-0563

For permission to use material from this text or product, submit a request online at **http://www.thomsonrights.com**.

Any additional questions about permissions can be submitted by e-mail to **thomsonrights@thomson.com**.

About the Author

Fred S. Kleiner is Professor of Art History and Archaeology and Chairman of the Art History Department of Boston University, where he has taught since 1978. Prior to that he was a member of the faculty of the University of Virginia and a Fellow of the Agora Excavations of the American School of Classical Studies in Athens. He has also excavated at Cosa, Italy, with the American Academy in Rome. From 1985 to 1998, Professor Kleiner served as Editor-in-Chief of the *American Journal of Archaeology*. He is the author of more than a hundred publications on Greek and Roman art, architecture, and numismatics, including *The Arch of Nero in Rome* and scores of articles and reviews in the leading archaeological journals of North America and Europe. His research has been supported by grants from the American Council of Learned Societies, the American Philosophical Society, and the John Simon Guggenheim Memorial Foundation. Professor Kleiner is also the co-author of the 10th, 11th, and 12th editions of *Gardner's Art through the Ages*, which in 2001 won both the Texty and McGuffey Prizes of the Text and Academic Authors Association as the best college textbook in the humanities and social sciences. Long recognized for his passionate teaching and devotion to students, Professor Kleiner has won Boston University's prestigious Metcalf Award for Excellence in Teaching and other teaching prizes as well as the College of Arts and Sciences Prize for Excellence in Advising in the Humanities.

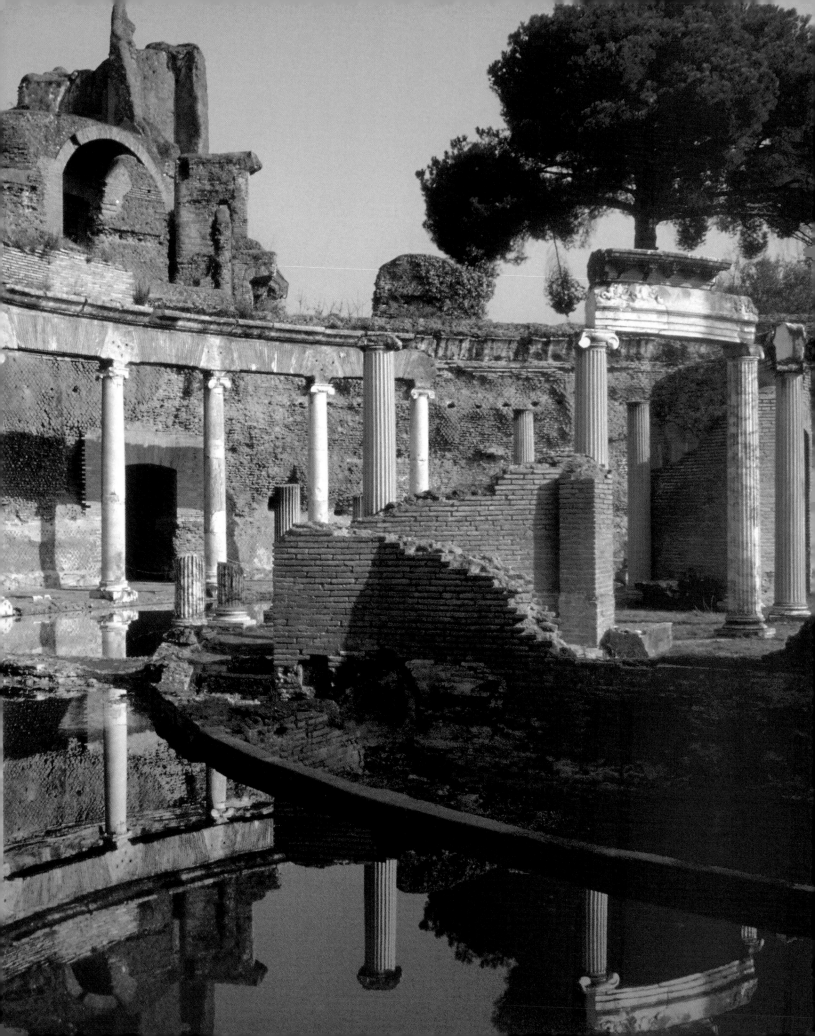

About the Cover Art

Island villa ("Teatro Marittimo"), Hadrian's Villa, Tivoli, ca. 118–125.

Hadrian was emperor of Rome from 117 to 138. A true intellectual and a connoisseur of all the arts, he was also an author and architect. In Rome, he designed a new temple for the joint worship of Venus and the city's own goddess, Roma, and erected it on a prominent site near the Roman Forum, directly across from the Colosseum. Hadrian must also have played a key role in the design of the buildings he constructed at his private villa at Tivoli. Hadrian's villa in many ways epitomizes the multifaceted and eclectic character of Roman art. Numerous copies of famous Greek statues have been found at the villa and several of the buildings were named after places the emperor had visited in the Greek-speaking Eastern provinces of the Empire. But the architect—perhaps Hadrian himself—of buildings like the so-called Teatro Marittimo ("Maritime Theater") transformed traditional Greek architecture into something new and distinctly Roman. Although employing Greek columns, the Teatro Marittimo's plan, centered on a scalloped fountain on an island surrounded by a moat and a concrete annular barrel vault, is remarkable for the almost total suppression of straight lines. Hadrian delighted in the interplay of convex and concave shapes and the mix of concrete walls and vaults and stone columns.

Contents

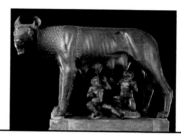

Part One *Monarchy and Republic*

Part Two *The Early Empire*

Part Three The High Empire

Part Four The Late Empire

Preface

I began to think about writing this book in 1996, shortly after the publication of the 10th edition of *Gardner's Art through the Ages,* to which I had contributed the chapter on Roman art, among many others. Colleagues around the country who were familiar with that chapter and reported its enthusiastic reception by their students strongly encouraged me to prepare a full-length introductory textbook for use in undergraduate courses on Roman art and architecture. I was easily convinced. Ancient Rome has been the focus of my scholarly work from undergraduate days and my love of Rome and all things Roman has only grown with the passage of time. In *A History of Roman Art,* I have tried to distill more than three decades of teaching, reading, and thinking about Roman art and architecture into a volume destined for today's college students. The book has obviously benefited enormously also from my experience as co-author of three editions of *Art through the Ages,* the introductory global survey of the history of art from Paleolithic times to the present that in 2001 won both the Texty and McGuffey Prizes of the Text and Academic Authors Association as the best college textbook in the humanities and social sciences. I hope this new book receives the same warm welcome in college classrooms that its much larger and broader predecessor has.

The title—*A History of Roman Art*—was chosen with care. There are many ways to approach Roman art and architecture, and I wanted to underscore that this is *a* history, not *the* history of the art and architecture of Rome and its Empire from the time of Romulus to the mid fourth century CE, a period of roughly 1,100 years. That translates as less than half a page a year for all the remains of Roman civilization on three continents from the British Isles to Morocco to the Middle East. One must obviously be very selective. Although I unapologetically focus on monuments in Rome and Italy and on the official art of the Roman state, I also pay unusual attention, as many of the reviewers of the manuscript noted, to developments in the Western and Eastern provinces; to private art, especially domestic and funerary art and architecture; to the so-called (but very important) minor arts, including coins; and to Early Christian art through the time of Constantine.

Features

A History of Roman Art has four parts. The first, devoted to the Monarchy and Republic, has four chapters. Parts Two, Three, and Four, which treat the Early, High, and Late Empire, have six, five, and five chapters respectively. Each chapter combines a discussion of general issues and individual monuments with a series of boxed essays on architecture, artistic media, religion and mythology, documentary sources, and cultural context in general. Most chapters open with a **Who's Who in the Roman World** box, which contains brief biographies of the historical figures discussed in that chapter, whether Republican senators, consuls, and generals or the emperors and empresses and their families from Augustus to Constantine. These boxes allow students easily to keep track of the key players in the unfolding drama of Roman history.

Architectural Basics boxes provide a sound foundation for understanding Roman architecture. The discussions are concise primers on the major aspects of design and

construction, usually with accompanying drawings and diagrams. Topics discussed include the orders of Classical architecture; arches, vaults, and domes; concrete construction; and Roman aqueducts.

Materials and Techniques essays explain the various media Roman artists employed. Because materials and techniques often influence the character of works of art, these discussions also contain essential information on why many monuments look the way they do. Roman frescoes, illustrated books, mosaics, and encaustic painting are among the subjects treated.

Written Sources boxes present and discuss key historical documents and literary works that shed light on important monuments and sites and provide invaluable background information about Roman culture in general. The translated passages permit voices from the past to speak directly to today's students. Examples include Pliny the Younger's eyewitness account of the eruption of Mount Vesuvius and his panegyric to the emperor Trajan; Augustus's *Res Gestae*; Josephus's account of the triumphal procession of Vespasian and Titus; Petronius's description of the tomb of Trimalchio; and the *Meditations* of Marcus Aurelius.

Religion and Mythology boxes introduce students to the principal deities and religions of the Roman world and to the representation of mythological themes in painting and sculpture. The topics include Roman gods and goddesses; the imperial cult; Greek myths on Roman sarcophagi; polytheism and monotheism at Dura-Europos; and the iconography of Early Christian art.

Art and Society essays treat the historical, social, political, and cultural context of Roman art and architecture. Among the subjects examined are the social structure of the Roman house; spectacles in the Colosseum; *damnatio memoriae*; imperial funerals; Roman baths; and the quality of life in the city during the High Empire.

Illustrating the 20 chapters are almost 500 photographs, plans, and drawings, mostly in color. Each figure has a caption that contains a wealth of information, including the identification of the sculpture, painting, building, site, etc.; the provenance of the object or location of the building (and, if not in Italy, the country as well); the date; the material or materials used; the size; and the name and city of the museum, if the work is in a public collection. I urge students to pay attention to the scales provided on the plans and to the dimensions given in the captions. The buildings and objects illustrated vary enormously in size, from gigantic public amphitheaters and baths and colossal sculptures to intimate houses and coins, gems, and silver cups that one can hold in the hand.

There are also five full-color maps that are indispensable for understanding the geography of the Roman world: Etruscan, Greek, and Roman Republican sites in Italy; the Bay of Naples at the time of the eruption of Mount Vesuvius; Roman sites in Italy, France, and Spain during the first and second centuries CE; the Roman Empire at the death of Trajan; and the Eastern provinces during the second and third centuries. To facilitate placing the ancient sites in a modern context, the names of contemporary nations appear on all maps.

To aid students in mastering the specialized vocabulary of Roman art and of Roman civilization in general, I have italicized and defined all terms and other unfamiliar words at their first occurrence in the text. Definitions of all the italicized words appear once more in the Glossary at the back of the book, where readers will also find a topical Bibliography of books in English as well as a list of illustration credits and an index.

Acknowledgments

It is impossible even to begin to thank the innumerable colleagues, teachers, and students from whom I have learned so much since I was first introduced to the study of Roman art as an undergraduate in the mid 1960s. But I can thank those whom Thomson Wadsworth asked to review various drafts of all or part of this book: William C. Archer, Illinois State University; Derek B. Counts, University of Wisconsin–Milwaukee; John J. Dobbins, University of Virginia; Barbara Tsakirgis, Vanderbilt University; Roger B. Ulrich, Dartmouth College; Eric R. Varner, Emory University; and Rolf Winkes, Brown University; as well as several anonymous reviewers whom I wish I could also thank by name. All read the manuscript with exceptional care and the detailed nature of their comments was invaluable to me. The final, published version of *A History of Roman Art* is a better book because of their willingness to share ideas and information. I am very grateful indeed.

I also happily express my gratitude in the following long list to the extraordinary group of people at Thomson Wadsworth involved with the editing, production, and distribution of *A History of Roman Art*. Some of them I have now worked with on other projects for more than a decade and feel privileged to count among my friends. Whatever success this book may enjoy will be due in no small part to the expertise and unflagging commitment of these dedicated professionals: Sean Wakely, president; Marcus Boggs, vice president and editor-in-chief; Clark Baxter, publisher; John R. Swanson, acquisitions editor; Sharon Adams Poore, senior development editor; Allison Roper, assistant editor; Kathryn M. Stewart, editorial production manager; Kim Adams, senior project manager; and Marie Epes, executive art director. I am also deeply indebted to Joan Keyes of Dovetail Publishing Services; Ida May Norton, my copy editor; Sarah Evertson, my photo researcher; Katherine Hyde, my proofreader; and Jerry Wilke, my designer. John Burge contributed a superb series of new drawings and reconstructions expressly for this volume; I am very much in his debt. I also wish to thank Thomson's peerless marketing and sales executives and their tireless sales representatives for the indispensable work they do in bringing my books into the hands of readers worldwide: Diane Wenckebach, senior executive marketing manager; Margaret Parks, executive director of advertising and marketing communications; Scott Stewart, vice president and managing director of sales; and—certainly not least—Mark Orr, senior marketing manager. Finally, I gratefully acknowledge the support I have received for many years for this and other projects from Ronald Schlosser, president and chief executive officer, Thomson Learning; and Susan Badger, chief executive officer, Thomson Higher Education.

Fred S. Kleiner

A History of Roman Art

Fred S. Kleiner

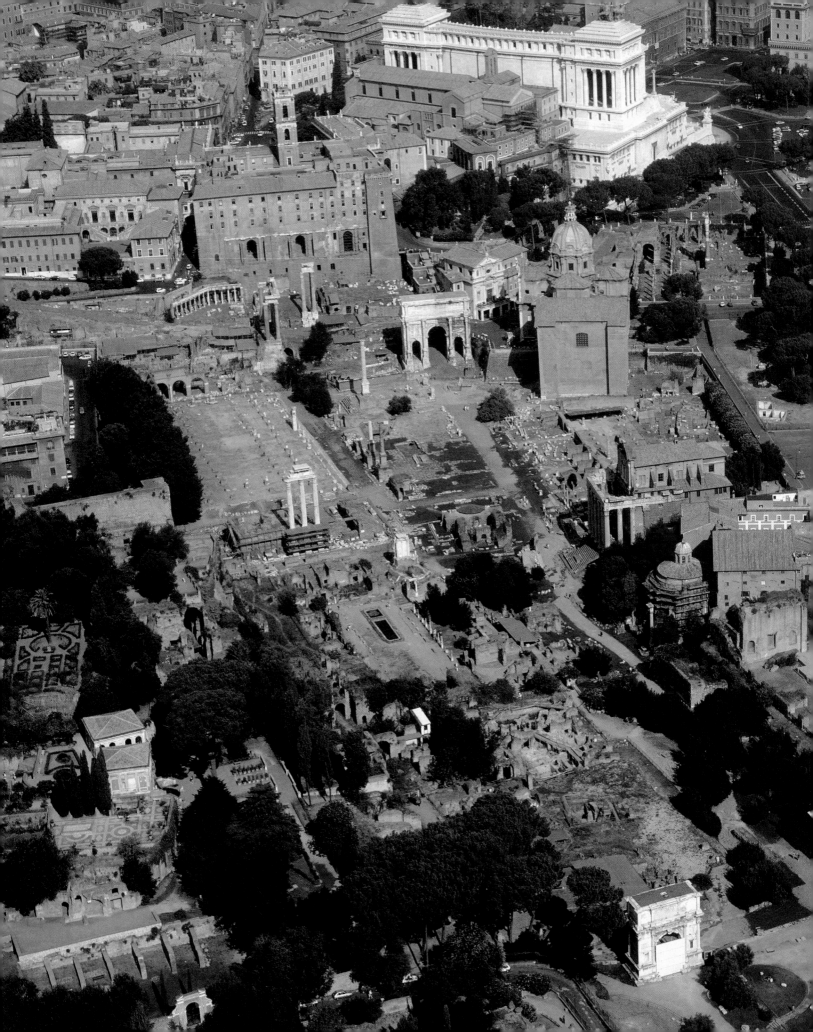

From Village to World Capital

The name "Rome" almost invariably conjures up images of power and grandeur, of mighty armies and fearsome gladiators, of marble cities and far-flung roads. Indeed, at its height in the second century CE, the "eternal city" was the capital of the greatest empire the world had ever seen (see Map 11-1, page 156). Rome's territories extended from the Strait of Gibraltar to the Nile, from the Tigris and Euphrates to the Rhine, Danube, Thames, and beyond. The Romans presided over prosperous cities and frontier outposts on three continents, ruling virtually all of Europe, North Africa, and West Asia. Millions of people of many races, religions, tongues, traditions, and cultures called themselves Romans. Of all the civilizations of antiquity, the Roman most closely approximates today's world in its multicultural character.

The longevity and vast extent of the Roman Empire explain why Roman monuments of art and architecture are more conspicuous and numerous than those of any other ancient civilization. Many are now gated tourist attractions with admission fees, but others are part of the very fabric of modern life. In Rome, Western Europe, Greece, the Middle East, and Africa today, the powerful concrete vaults of Roman theaters and baths form the cores of modern houses, stores, restaurants, and museums. Almost everywhere, Roman temples, basilicas, and even mausoleums have had an afterlife as churches or mosques. Bullfights, sports events, operas, and rock concerts are held in Roman arenas. Roman aqueducts continue to supply water to some modern towns. Ships dock in what were once Roman ports, and Western Europe's highway system still closely follows the ancient routes of Roman roads.

Ancient Rome also lives on in the Western world in concepts of law and government, in languages, in calendars—even in the coins people use daily. Roman art speaks to contemporary Western viewers in a language most people can readily understand. Its diversity and eclecticism foreshadowed the modern world. The Roman use of art, especially portraits and historical relief sculptures, to manipulate public opinion is similar to the carefully crafted imagery of contemporary political campaigns. And the Roman mastery of concrete construction began an architectural revolution still felt today.

Imperial Rome (**Figs. 1-1** and **1-2**) was a wonder to behold, crammed with temples, basilicas, baths, theaters, amphitheaters, and triumphal arches, as well as multistory apartment houses for a huge urban population. The city awed all those who saw it for the first time, whether rich or poor, citizen or foreigner. For example, according to the historian Ammianus Marcellinus, when the emperor Constantius II (r. 337–361 CE) traveled to Rome in 357 from the new fourth-century CE capital at Constantinople (present-day Istanbul, Turkey; see Chapter 20), he entered

1-1 Aerial view of the Forum Romanum, Rome.

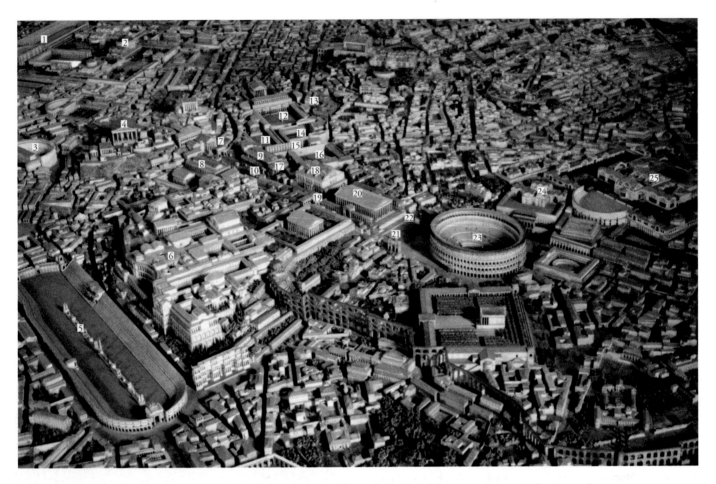

1-2 **Model of the city of Rome in the early fourth century CE. Museo della Civiltà Romana, Rome. 1) Stadium of Domitian, 2) Pantheon, 3) Theater of Marcellus, 4) Temple of Jupiter Capitolinus, 5) Circus Maximus, 6) Palace of Domitian, 7) Arch of Septimius Severus, 8) Basilica Iulia, 9) Basilica Aemilia, 10) Temple of Divus Iulius, 11) Forum Iulium, 12) Forum of Trajan, 13) Markets of Trajan, 14) Forum of Augustus, 15) Forum of Nerva, 16) Templum Pacis, 17) Temple of Antoninus and Faustina, 18) Basilica Nova, 19) Arch of Titus, 20) Temple of Venus and Roma, 21) Arch of Constantine, 22) Colossus of Nero, 23) Colosseum, 24) Baths of Titus, 25) Baths of Trajan.**

the forum (Figs. 1-2, no. 12, and 11-6) the emperor Trajan constructed 250 years earlier and "stopped in his tracks, astonished," and marveled at the complex's opulence and size, "which cannot be described by words and could never again be attempted by mortal men."[1]

ROME UNDER THE KINGS

This history of Roman art and architecture begins, however, more than a millennium before Constantius II's visit, when the Romans possessed little territory beyond one of its famous seven hills. According to legend, the twins Romulus and Remus (see the discussion of Fig. 1-8) founded Rome on April 21, 753 BCE, on the Palatine Hill, a lofty site overlooking what was then uninhabited marshland.

VILLAGE OF ROMULUS Archaeologists exploring the area of the Palatine west of the later imperial palace (Fig. 1-2, no. 6) uncovered a series of cuttings in the bedrock corresponding to the floors and postholes of simple dwellings (**Fig. 1-3**). These can be reconstructed based in part on the appearance of contemporary Italian ash urns in the shape of huts built of wattle and daub over a framework of wooden poles. The foundations on the Palatine Hill indicate that the Roman huts were roughly rectangular in shape with rounded corners. Some had a porch at the front, and all must have had overhanging *thatched* (straw) roofs. The excavations did not reveal the names of any of the village's residents, but they did confirm that a settlement was established on the Palatine at precisely the time the twins are said to have founded Rome. Such was the humble beginning of the greatest city of the ancient world.

LATINS, GREEKS, AND ETRUSCANS In the most common version of the story of Rome's founding, Romulus and Remus quarreled, and Romulus killed his brother and became Rome's

[1] Ammianus Marcellinus, *History of Rome*, 16.10.15–16. Translated by J. J. Pollitt, *The Art of Rome, c. 753 B.C.-A.D. 337: Sources and Documents* (New York: Cambridge University Press, 1983), 170.

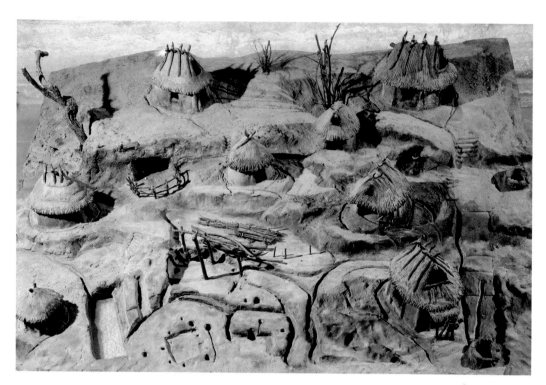

1-3 **Model of the village of Romulus on the Palatine Hill, Rome, eighth century BCE. Museo della Civiltà Romana, Rome.**

first king. During the eighth, seventh, and sixth centuries BCE, a series of Latin kings ruled the city on the Tiber. At that time Rome was still a modest city situated in the midst of other far more developed cultures, especially those of the Greeks and Etruscans (**Map 1-1**). The former had established so many colonies in southern Italy and Sicily (for example, Naples, Paestum, Taranto, Agrigento, and Syracuse) that scholars usually refer to this geographical area and its civilization as *Magna Graecia* (Greater Greece). To the north, the Etruscans held sway from such strongholds as Tarquinia, Cerveteri, Vulci, and Veii. Even today, the Etruscan heartland between the Arno and Tiber rivers of central Italy bears their name—*Tuscany*, the land of the people the Romans called *Tusci*, the region centered on Florence, the great Renaissance city that was an Etruscan (and later, a Roman) city. The origin of the Etruscans is much debated, but the Etruscan people of historical times were very likely the result of a gradual fusion of native and immigrant populations. During the early centuries of the first millennium BCE, the Etruscans emerged as a people with a culture related to but distinct from those of other Italic peoples and from the Greeks of Magna Graecia. The Etruscan cities, however, never united to form a state, so it is improper to speak of an Etruscan "nation" or "kingdom," but rather only of *Etruria*, the territory the Etruscans occupied.

THE TARQUINS AND THE CAPITOLIUM The chronology of Rome's kings is uncertain, but sometime during the sixth century BCE, Tarquinius Priscus, who had emigrated from Corinth in Greece to Tarquinia, became king of Rome. The last Roman king, according to all ancient sources, was Tarquinius Superbus (r. 534–509 BCE), the son or grandson of Priscus. A tyrannical ruler whom the Romans eventually overthrew,

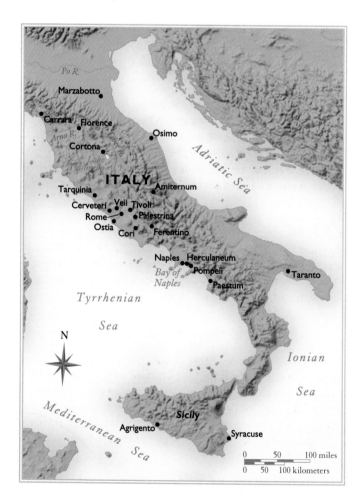

Map 1-1 Etruscan, Greek, and Roman Republican sites in Italy.

Roman Gods and Goddesses

The Romans worshiped a discrete set of deities with Latin names and distinctly Roman characteristics and cult rituals, but the Roman gods and goddesses had close equivalents in the pantheons of ancient Greece and Etruria. The major Roman gods, for example, were commonly equated with the 12 Greek gods and goddesses of Mount Olympus.

These were the most important Roman deities (and their closest Greek and Etruscan counterparts):

Jupiter (Greek **Zeus,** Etruscan **Tinia)** was king of the gods and ruled the sky. His attribute was the thunderbolt. The Roman emperors often claimed to be the earthly counterparts of Jupiter.

Juno (Hera/Uni), the wife and sister of Jupiter, was the goddess of marriage.

Neptune (Poseidon/Nethuns), Jupiter's brother, was lord of the sea. His attribute was the *trident,* a three-pronged pitchfork.

Vesta (Hestia), sister of Jupiter, Neptune, and Juno, was goddess of the hearth. Her priestesses in Rome were the *Vestal Virgins,* who tended her perpetual flame.

Ceres (Demeter/Vei), Jupiter's third sister, was the goddess of grain and agriculture. (Her name is the root of the English word "cereal.")

Mars (Ares/Maris), the god of war, was the son of Jupiter and Juno and, with the Vestal Virgin *Rhea Silvia,* the father of *Romulus* and *Remus,* the twin founders of Rome.

Minerva (Athena/Menerva), miraculously born from the head of Jupiter, was the virgin goddess of wisdom and warfare.

Vulcan (Hephaistos/Sethlans), the son of Jupiter and Juno, was the god of fire and of metalworking. He fashioned the armor of the hero *Aeneas,* who fled Troy to found the Roman race in Italy.

Apollo (Apollo/Apulu), the son of Jupiter with *Leto/Latona,* was the god of light and music and a renowned archer.

Diana (Artemis/Aritimi), the sister of Apollo, was the goddess of the hunt.

Venus (Aphrodite/Turan), the daughter of Jupiter and *Dione* (one of the *nymphs*—the goddesses of springs, caves, and woods), was the goddess of love and beauty. She was the mother of *Aeneas* by *Anchises.*

Mercury (Hermes/Turms), the son of Jupiter and another nymph, was the fleet-footed messenger of the gods. His attributes were a winged cap and sandals and the *caduceus* (herald's rod).

Among the other important Roman gods and goddesses were these three:

Pluto (Hades/Aita), Jupiter's other brother, was god of the dead. He did not reside with the other gods because Jupiter allotted him lordship over the Underworld.

Bacchus (Dionysos/Fufluns), another of Jupiter's sons, was the god of wine.

Cupid (Eros) was the winged child-god of love and the son of Mars and Venus. ■

Superbus ("the Arrogant") was responsible for completing the construction of Rome's greatest temple, the Temple of Jupiter Optimus Maximus (Best and Greatest) on the Capitoline Hill (Fig. 1-2, no. 4), although the formal inauguration of the shrine did not occur until after his death. Several sources say the temple was begun by Priscus, although many scholars attribute the entire project to Superbus. In any case, the *Capitolium,* as it came to be called, was burned and rebuilt several times, but the foundations of the sixth-century temple are preserved in part, permitting its plan (**Fig. I-4**) to be reconstructed with confidence. The temple had three joined *cellae* (inner chambers for *cult statues* of the deity or deities to whom the shrine was dedicated). The central cella was Jupiter's, and the left and right cellae housed statues of his consort, Juno, and his daughter, Minerva (see "Roman Gods and Goddesses," above). In front of the cellas were three rows of six columns and a staircase giving access to the high podium. The columns also extended to the sides, or wings (*alae*), of the temple, but not around the back. The walls were of mud brick, the columns of wood, and the roof was covered with *terracotta* (baked clay) tiles.

ETRUSCAN TEMPLES Excavations at Etruscan sites in Italy and the invaluable account of Etruscan architecture preserved in the Roman architect Vitruvius's late-first-century BCE treatise, *On Architecture,* make it clear that the Jupiter temple on the Capitoline Hill was Etruscan in every respect. In fact, several ancient authors specifically state that the Tarquins imported architects, sculptors, and workmen from Etruria to design, build, and decorate the temple.

The typical Archaic Etruscan temple (**Fig. I-5**) resembled the stone gable-roofed temples of the Greeks (for example, **Fig. I-6**), but, like the Capitolium, it had wooden columns, a tile-covered wooden roof, and walls of sun-dried mud brick. Entrance was possible only via a narrow staircase at the center of the front of the temple, which sat on a high podium, the only part of the building made of stone. Columns also were restricted to the building's front, creating a deep porch that occupied roughly half of the podium, setting off one side of the structure as the main side. This was contrary to Greek practice, in which the temple's front and rear were indistinguishable and steps accompanied the *peripteral* (on all sides)

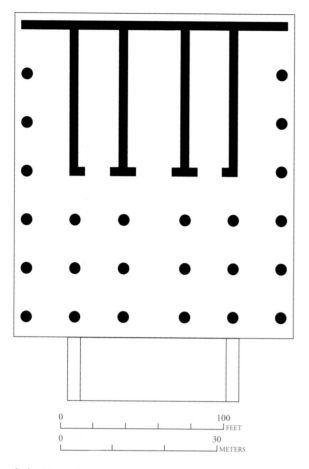

1-4 Plan of the Temple of Jupiter Capitolinus, Rome, dedicated 509 BCE.

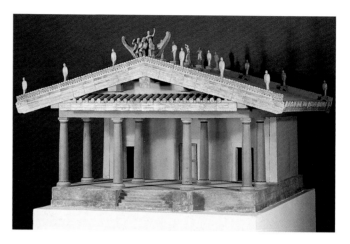

1-5 Model of a typical Etruscan temple of the sixth century BCE, according to Vitruvius. Istituto di Etruscologia e di Antichità Italiche, Università di Roma, Rome.

colonnade. The Greek temple was meant to be seen from all directions, the Etruscan temple only from the front.

Etruscan temples differed in other ways from those of Greece. Etruscan (or *Tuscan*) columns resembled Greek Doric columns (see "Doric, Ionic, and Corinthian," page 6), but they were made of wood instead of stone, were unfluted, and had bases. Because of the lightness of the superstructure they had to support, Etruscan columns were, as a rule, much more widely spaced than Greek columns. And statues were only rarely set into the pediments of Etruscan temples. The Etruscans normally placed narrative statuary—in terracotta instead of stone—on the peaks of the roofs.

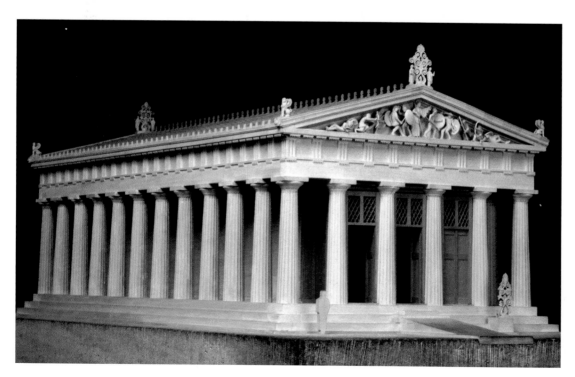

1-6 Model of the Temple of Aphaia, Aegina, Greece, ca. 500–490 BCE. Glyptothek, Munich.

ARCHITECTURAL BASICS

Doric, Ionic, and Corinthian

In Greece, two basic systems, or *orders*, of architecture evolved during the period corresponding to the monarchy in Rome. The names of the orders are derived from the Greek regions where they were most commonly employed. The *Doric* was formulated on the mainland, and the *Ionic* was the order of choice in the Aegean Islands and on the western coast of Asia Minor. The geographical distinctions are, however, not absolute.

The most distinguishing characteristic of each order is the form of the *columns* used. Greek (and Roman) columns have two or three parts, depending on the order: the *shaft*, which is usually marked with vertical channels (*flutes*); the *capital* ("head"); and, in the Ionic order, the *base*. In both orders, the columns rest on the *stylobate*, the uppermost course of the platform. The capital has two elements. The lower part (the *echinus*) varies with the order. In the Doric, it is convex and cushionlike. In the Ionic, it is small and supports a bolster ending in scroll-like spirals (the *volutes*). The capital's upper element, present in both orders, is a flat, square block (the *abacus*) that provides the immediate support for the entablature.

The *entablature* has three parts: the *architrave*, the main weight-bearing and weight-distributing element; the *frieze;* and the *cornice*, a molded horizontal projection that together with two sloping (*raking*) cornices forms a triangle that enframes the *pediment*. In the Doric order, the frieze is subdivided into triple vertical dividers called *triglyphs* and square plaques called *metopes*, whereas in the Ionic, the frieze is left open to provide a continuous field for relief sculpture.

The *Corinthian capital* (Figs. 1-13 and 1-14) is more ornate than either the Doric or Ionic. It consists of a double row of acanthus leaves, from which tendrils and flowers emerge, wrapped around a bell-shaped echinus. Although this capital often is cited as the Corinthian order's distinguishing feature, strictly speaking no Corinthian order exists. This new type of capital was simply substituted for the volute capital in the Ionic order. ■

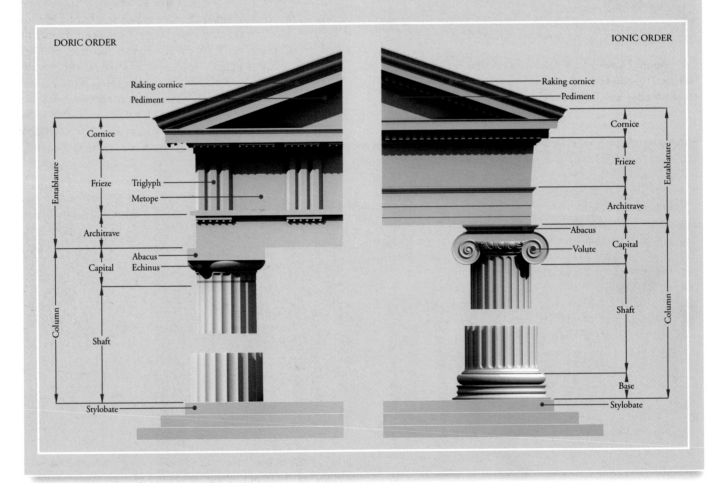

1-7 Apollo (Apulu), from the roof of the Portonaccio temple, Veii, ca. 510–500 BCE. Painted terracotta, approx. 5′ 11″ high. Museo Nazionale di Villa Giulia, Rome.

VULCA OF VEII The finest of these rooftop statues to survive today is the life-size image of Apollo/Apulu (**Fig. 1-7**) from a temple in the Portonaccio sanctuary at Veii. It is but one of a group of at least four painted terracotta figures that adorned the top of the temple's roof. Apollo's vigorous striding motion, gesticulating arms, fanlike calf muscles, rippling drapery, and animated face are distinctly Etruscan. Some scholars have attributed the statue to Vulca of Veii, the most famous Etruscan sculptor of the time. Although the name of the architect of the Temple of Jupiter Capitolinus is not known, several sources report that Tarquinius Superbus hired Vulca to fashion the temple's statues. Pliny the Elder, writing in the first century CE, described Vulca's works as "the finest images of deities of that era . . . more admired than gold."[2] Vulca fashioned the statue of Jupiter that stood in the central cella of the Capitolium as well as the enormous terracotta statuary group of Jupiter in a *quadriga* (four-horse chariot) placed on the temple's roof at the highest point directly over the facade's center. The fame of Vulca's red-faced (painted terracotta) portrayal of

[2] Pliny the Elder, *Natural History,* 35.157.

Jupiter was so great that Roman generals would paint their faces red in emulation of his Jupiter when they paraded in triumph through Rome after a battlefield victory. (Fig. 1-5 gives an approximate idea of the appearance of Vulca's roof statue.)

ROME AND LATIUM UNDER THE REPUBLIC

In 509 BCE, the Romans revolted against Tarquinius Superbus and established a constitutional government called the Republic. In the new state, there were many different magistracies entrusted with overseeing civil, religious, and military affairs, but the two major magistrates, annually elected, were called *consuls*, who assumed most of the roles formerly fulfilled by the monarch. The Republican legislative body was the *senate* (literally, "a council of elders, *senior* citizens"), which a few centuries after the overthrow of the monarchy grew to have about 300 members, almost exclusively wealthy men from old Roman families.

CAPITOLINE WOLF Although various dates have been proposed, many think that one of the first artistic commissions of the new Roman state was the bronze statue known today as the "Capitoline Wolf" (**Fig. 1-8**), one of the most memorable portrayals of an animal in the history of world art. The statue is a somewhat larger-than-life-size hollow-cast bronze portrayal of the she-wolf that, according to ancient legend, nursed Romulus and Remus after they were abandoned as infants. According to the myth, Amulius deposed his older brother, Numitor, as king of Alba Longa, and to guard against a future coup, he made Numitor's daughter, Rhea Silvia, a Vestal Virgin. Vesta's priestesses were prohibited from marrying, but Mars violated Rhea Silvia (Fig. 18-20) and she gave birth to the twins Romulus and Remus. Amulius ordered that the infant boys be thrown into the Tiber River in a basket. They drifted

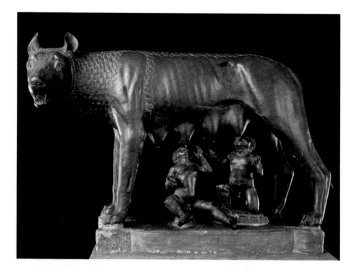

1-8 "Capitoline Wolf," from Rome, ca. 500-480 BCE. Bronze, approx. 2′ 7 1/2″ high. Palazzo dei Conservatori, Rome.

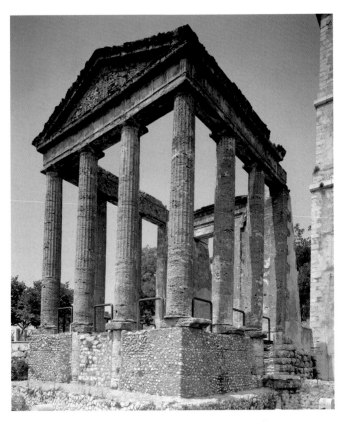

1-9 Temple of Hercules, Cori, ca. 100 BCE.

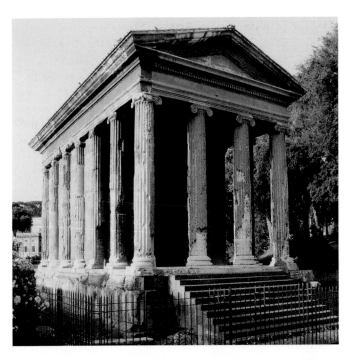

1-10 Temple of Portunus ("Fortuna Virilis"), Rome, ca. 75 BCE.

ashore, however, where they were suckled by the she-wolf until the shepherd Faustulus found them and raised them as his own sons. When the twins grew to adulthood, they killed Amulius, restored Numitor to his kingship, and then founded a city of their own on the Palatine Hill.

The Capitoline Wolf is not, however, a work of Roman art, which had not yet developed a distinct identity. It is the product of an Etruscan workshop. (The suckling infants are additions by the Italian Renaissance sculptor Antonio Pollaiuolo.) The vitality noted in the Etruscan statue of Apollo is here concentrated in the tense, watchful animal body of the she-wolf, with her spare flanks, gaunt ribs, and taut, powerful legs. The lowered neck and head, alert ears, glaring eyes, and ferocious muzzle capture the psychic intensity of the fierce and protective beast as danger approaches. The sculptor balanced this flair for naturalism with a keen appreciation of decorative pattern, seen especially in the curly hair of the animal. The fur unnaturally also covers only part of the body, perhaps because the artist wished to suggest that Rome's wolf had the mane of a lion. The Capitoline Wolf became the emblem of the new Republic and remains the emblem of the city of Rome today.

CONQUEST AND ECLECTICISM In the centuries following the downfall of Tarquinius Superbus, the armies of the Republic conquered Rome's neighbors one by one: the Etruscans to the north, the Samnites (an Italic people that occupied Pompeii and other sites in the general area of Naples; see Chapter 2), and the Greek colonists to the south (Map 1-1). Even the Carthaginians

of North Africa, who under Hannibal's dynamic leadership had annihilated some of Rome's legions and almost brought down the Republic, fell before the Roman onslaught.

Exposure to the Greek cities of southern Italy and Sicily had a profound effect upon the development of Roman art (see Chapter 4, especially "Marcellus, Syracuse, and the Craze for Greek Art," page 49). In architecture, it marked the end of the purely Etruscan style of the Temple of Jupiter Capitolinus and the beginning of a hybrid, eclectic style combining elements of Etruscan and Greek design.

TEMPLE OF HERCULES, CORI A characteristic example of the eclecticism of Republican architecture in Italy is the so-called Temple of Hercules (**Fig. 1-9**) at Cori (ancient Cora), in Latium, the area of central Italy around Rome. The deity to whom the temple was dedicated is not known, but it was built at the end of the second or beginning of the first century BCE by two local magistrates, Marcus Matlius and Lucius Turpilius, who inscribed their names on the architrave. In plan, the Cori temple resembles traditional Etruscan shrines with its deep porch of freestanding columns (four on the facade, two more on each side) on a high podium. The porch is, in fact, larger than the cella behind it. But the widely spaced columns are stone, not wood, and both columns and frieze conform to the Greek Doric order of architecture, complete with fluted column shafts and a frieze of metopes and triglyphs (see "Doric, Ionic, and Corinthian," page 6). The slender proportions of the Cori columns are characteristic of contemporary architecture in Greece, as are the distinctive shafts, where the lower third is unfluted. This hybrid Etrusco-Greek design is unknown in either Etruria or Greece. The eclectic combination is uniquely Roman and the hallmark of Republican temple architecture.

TEMPLE OF PORTUNUS, ROME The Doric order most closely approximates the Tuscan, but during the Republic, Roman architects also embraced the two other, more ornate orders of Greek architecture. The little temple on the east bank of the Tiber popularly known as the Temple of "Fortuna Virilis" (**Fig. 1-10**), actually a temple dedicated to Portunus, the Roman god of harbors, combines an Etruscan plan with Ionic columns and frieze. Excavations beneath the temple have uncovered ceramics that indicate the shrine was erected about 75 BCE. Like Etruscan temples, the Portunus temple has a high podium accessible only at the front, and its freestanding columns are confined to the porch. But, as at Cori, the structure is built of local stone, in this case a combination of travertine (for the freestanding columns) and tufa for most of the rest of the structure. Both stones originally had an overlay of stucco in imitation of the marble temples of the Greeks. Moreover, in an effort to approximate a peripteral Greek temple (Fig. 1-6) while maintaining the basic Etruscan plan, the architect added a series of *engaged* (attached) Ionic half-columns around the cella's sides and back. The result was a *pseudo-*

peripteral temple, a type unknown in Greece but a hallmark of the eclecticism of Roman Republican architecture.

LARGO ARGENTINA TEMPLES In 1926, in the course of demolition work prior to new construction in the Largo Argentina, the remains of four Republican temples (**Fig. 1-11**) were uncovered and work was halted. The identity of the gods honored in the temples is uncertain, and it is customary to refer to them as Temples A–D. They were erected at different times beginning in the early third century BCE and were repeatedly remodeled through the mid-first century BCE and later. The Largo Argentina temples reveal that the frontal orientation of individual Republican temples also characterized groups of temples. All four shrines are aligned in a neat row, each facing east, each with an access stairway only on the front. The simplest is Temple D, whose plan resembles that of the Cori temple (Fig. 1-9). Temple C has columns also in its alae, like the Temple of Jupiter Capitolinus (Fig. 1-4). Temple A (**Fig. 1-12**, *right*) is a rare example of a peripteral Republican temple, but it nonetheless follows the Etruscan pattern in having stairs only at the front.

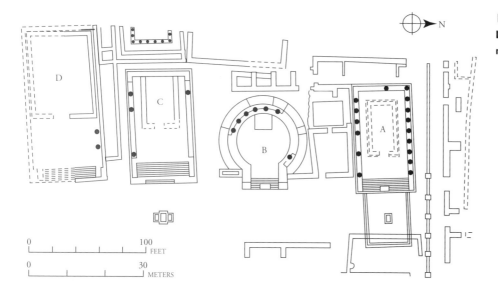

1-11 **Plan of four Republican temples, Largo Argentina, Rome, early third to mid-first century BCE and later.**

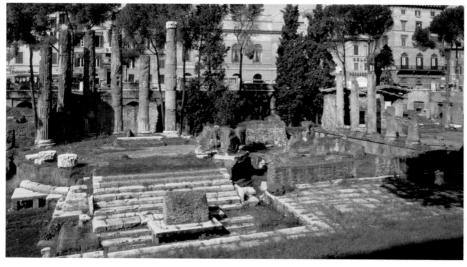

1-12 **Temples B (*left*) and A (*right*), Largo Argentina, Rome, early third to mid-first century BCE and later.**

Of special interest is Temple B (Fig. 1-12, *left*), a *tholos*, or round temple, which has no parallel in Etruria. Although inspired by Greek temples like the fourth-century BCE tholos at Delphi, Temple B, constructed around 100 BCE, is not a copy of any Greek temple. Greek tholoi, like Greek rectangular temples (Fig. 1-6), have not only a peripteral colonnade but also a flight of stairs all around the building. Temple B has a small porch and stairs on the east side that clearly distinguish that side as the front.

TEMPLE OF VESTA, ROME The names of the dedicators of the Largo Argentina temples are also unknown, but it was common during the Republic for victorious generals to build new temples upon their return to Rome using the proceeds of the spoils they acquired in battle, vying with one another to impress the populace with the magnificence of their buildings. One of these generals was Lucius Mummius, who quelled a revolt in Greece in 146 BCE and destroyed Corinth. He built a temple to Hercules Victor in Rome, fulfilling a vow he had made during his campaign. Some scholars identify Mummius's Hercules temple with a round temple (**Fig. 1-13**) built of Greek marble near the Temple of Portunus. The attribution is very tenuous, and most scholars continue to refer to the shrine as a temple of Vesta, because her temples were usually circular in plan. Whatever its identity, the round temple on the Tiber is a rare example of a purely Greek temple in Rome—one not only constructed of costly imported marble but also having a peripteral staircase, unlike Temple B in the Largo Argentina. It is noteworthy, however, that in front of the doorway to the cella, extra steps were added to emphasize the front of the building.

TEMPLE OF VESTA, TIVOLI Both Temple B in the Largo Argentina and the round temple on the Tiber have Corinthian colonnades. So too does the round temple (**Fig. 1-14**) erected in the early first century BCE at Tivoli (ancient Tibur). Usually also called the Temple of Vesta, it stands on a dramatic site overlooking a deep gorge. The travertine frieze is carved with garlands held up by oxen heads, a motif that has many precedents in Greece and refers to the ritual sacrifice of those animals. Like almost all Roman tholoi (the marble temple on the Tiber is a rare exception), the Tivoli temple has a high podium and a single narrow stairway leading to the cella door. Also in contrast with Greek practice, the Roman builders did not construct the cella wall using *masonry* (cut-stone) blocks but a new material of recent invention: concrete (see "Arches, Barrel Vaults, and Concrete," page 12). The podiums of most Republican temples are also made of concrete of the early type called *opus incertum*, because of the irregular shape of the stones used in its fabric, as in the podium of the Hercules temple at Cori (Fig. 1-9) and the curved cella wall of the temple at Tivoli.

PORTICUS AEMILIA, ROME The earliest known use of concrete on a grand scale is in the Porticus Aemilia (**Fig. 1-15**), the huge (533 × 66 yds) warehouse erected by two magistrates, Marcus Aemilius Lepidus and Marcus Aemilius Paullus, both members of a distinguished Republican family. The warehouse was initially constructed in 193 BCE and restored by two other magistrates in 174 BCE. It was situated on the east bank of the Tiber where barges unloaded the cargo brought upriver from Rome's port at Ostia (see Chapter 14). The floor of the building rises in steps to conform to the sloping ground along the river.

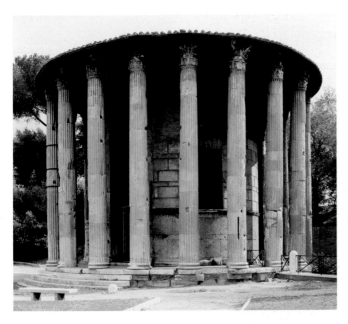

1-13 Temple of Vesta or Hercules Victor(?), Rome, mid-second century BCE and later.

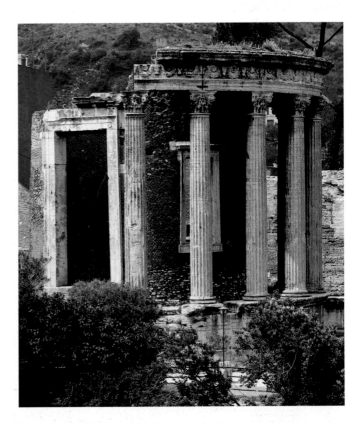

1-14 Temple of Vesta(?), Tivoli, early first century BCE.

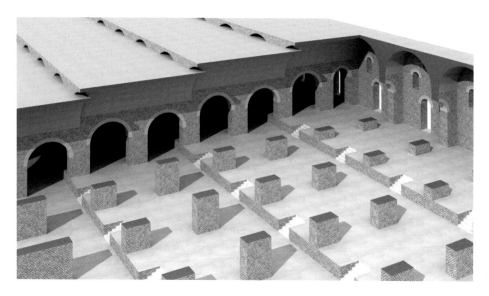

1-15 Restored cutaway view of the Porticus Aemilia, Rome, 193–174 BCE (John Burge).

On each level is a series of opus incertum barrel-vaulted units (about 200 in all) whose long sides are pierced with arcuated openings so that the entire hall becomes a continuous space. Windows in the front and back walls of the warehouse provided some illumination to the structure, but light entered primarily through windows ingeniously placed at the end of each vaulted unit above the roof line of the next vaulted unit on a lower level.

MARKET HALL, FERENTINO Very little survives of the Porticus Aemilia, but Republican market halls constructed of opus incertum barrel vaults springing from masonry piers and arches can be found outside Rome. One of the earliest and best-preserved is at Ferentino, where a series of barrel-vaulted *tabernae* (shops) open onto a long barrel-vaulted central corridor (**Fig. 1-16**). The early, experimental nature of the construction is evident from the heavy reliance on stone supports and the absence of windows. The earlier Porticus Aemilia was a much more sophisticated design.

FORUM ROMANUM The heart of Republican Rome was its *forum*, which in Romulus's day was the marshy valley used as a place of burial for those whose homes were on the Palatine Hill (Fig. 1-3). One of the Romans' first great engineering projects

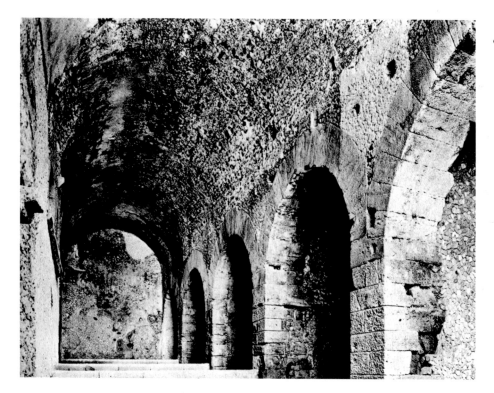

1-16 Market hall, Ferentino, ca. 100 BCE.

Arches, Barrel Vaults, and Concrete

The *arch* has a long history in the ancient world as one of two basic ways to construct a doorway in a wall or a freestanding gateway. The older method is *post-and-lintel* construction, in which a horizontal block (lintel) rests on two vertical pillars (posts). It was the standard means of construction used for Greek, Etruscan, and Roman columnar temples. *Arcuated* portals are formed by a series of trapezoidal stone *voussoirs* held in place by pressing against each other. Arches were built earlier in Greece as well as in Mesopotamia, but in Italy, first under the Etruscans and later under the Romans, arcuated gateways and freestanding ("triumphal") arches became a major architectural type.

The *barrel vault*, also called the *tunnel vault,* is an extension of a simple arch, creating a semicylindrical ceiling over parallel walls. Such vaults were constructed both before and after the Romans using traditional cut-stone masonry, but the Romans pioneered the use of barrel vaults made of concrete. Roman *concrete* was made from a changing recipe of lime mortar, volcanic sand, water, and small stones (*caementa*, from which the English word *cement* is derived). Builders placed the mixture in wooden frames and left it to dry and to bond with a brick or stone facing. When the concrete dried completely, the wooden molds were removed, leaving behind a solid mass of great strength, though rough in appearance. The Romans often covered the rough concrete with stucco or with marble *revetment* (facing). Despite this lengthy procedure, concrete walls were much less costly to construct than masonry walls, especially if the stone had to be brought to the site from faraway quarries in Greece, Turkey, or North Africa.

The advantages of concrete, however, go well beyond cost and the fact that the material offers fire resistance superior to that of traditional wooden-roofed structures. It is possible to fashion concrete shapes that masonry construction cannot achieve, especially huge vaulted and domed rooms without internal supports (for example, Fig. 12-1). Concrete barrel vaults are much more stable than masonry barrel vaults. If any of the blocks of a cut-stone vault come loose, the whole may collapse. Also, masonry barrel vaults can be illuminated only by light entering at either end of the tunnel. In contrast, builders can insert windows at any point in concrete barrel vaults, because once the concrete hardens, it forms a seamless sheet of "artificial stone" in which the openings do not lessen the vault's structural integrity. Concrete enabled Roman builders to think of architecture in radically new ways. ■

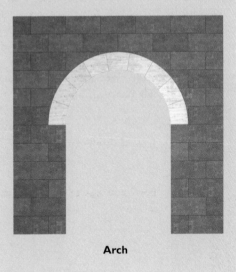

Arch

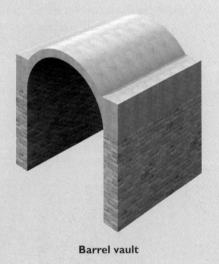

Barrel vault

was to drain the area and raise the ground level to provide a suitable area for commerce and civic administration. The Forum Romanum (Fig. 1-1), as it is called, was significantly remodeled under the emperor Augustus at the end of the first century BCE (Fig. 5-5), but many of its original features were retained throughout its long history, including the Curia, or senate house (Fig. 5-5, no. 9), the Rostra, or speakers' platform

(Fig. 5-5, no. 3), and two *basilicas* (Fig. 5-5, nos. 4 and 8), columnar halls for the administrative and legal proceedings of the state. One of the Forum's basilicas, the Basilica Aemilia, was built in the early second century BCE by members of the same family responsible for the contemporary Porticus Aemilia. (Forum planning and basilican architecture are discussed more fully in Chapter 2.)

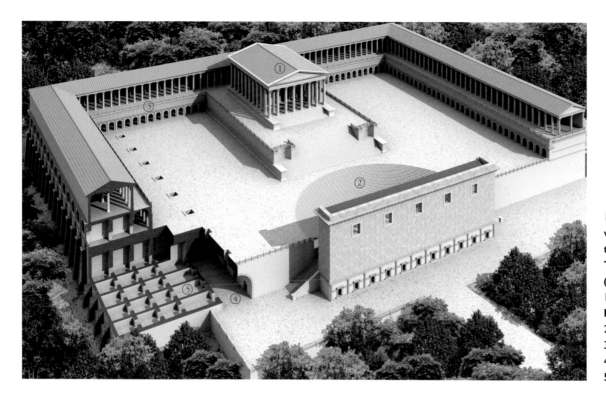

1-17 **Restored view of the Sanctuary of Hercules, Tivoli, ca. 50 BCE (John Burge).** 1) Temple of Hercules, 2) theater, 3) portico, 4) Via Tiburtina, 5) tabernae.

THEATER-TEMPLES The most grandiose Republican building type was the so-called theater-temple, a religious sanctuary whose main feature was a temple situated directly above the semicircular seating area of a theater. In the Greco-Roman world, theatrical performances were not purely secular entertainments, as they generally are today. Plays were performed in connection with religious festivals, and theater-temple complexes usually also included *porticos* (roofed colonnades) containing shops, supplemented in some cases by barrel-vaulted tabernae beneath the spacious terraces supporting the temple and porticos.

The Sanctuary of Hercules (**Fig. 1-17**) at Tivoli, built in the middle of the first century BCE, is one of the most elaborate Republican theater-temples. The complex is set in rocky terrain that Roman engineers regularized by constructing an immense platform of opus incertum concrete. The road from Rome to Tivoli, the Via Tiburtina, brought large crowds to the sanctuary during festivals. A 28-foot-wide barrel-vault-covered extension of the road ran beneath the sanctuary, where it became an underground shopping mall with a series of barrel-vaulted tabernae opening onto the road at right angles, as in the market hall at Ferentino. Rectangular skylights in the floor of the temple platform provided light to the market below.

The portico (**Fig. 1-18**) of the Hercules sanctuary displays the increasing confidence of Roman architects in the use of

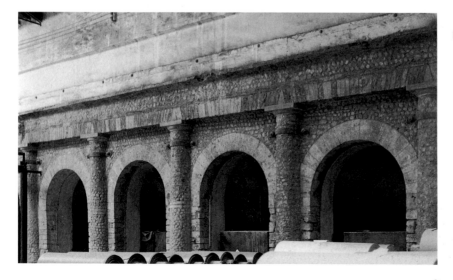

1-18 **Portico arcade of the Sanctuary of Hercules, Tivoli, ca. 50 BCE.**

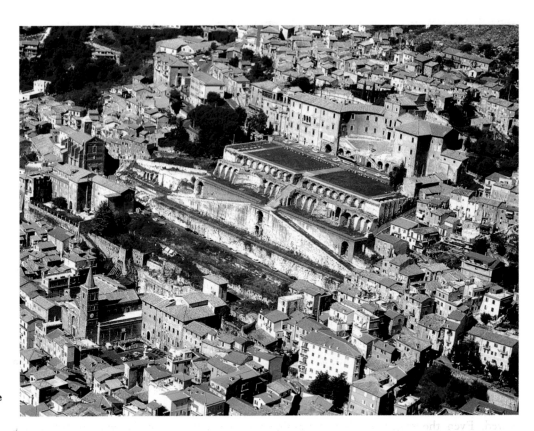

1-19 Aerial view of the Sanctuary of Fortuna, Palestrina, late second century BCE.

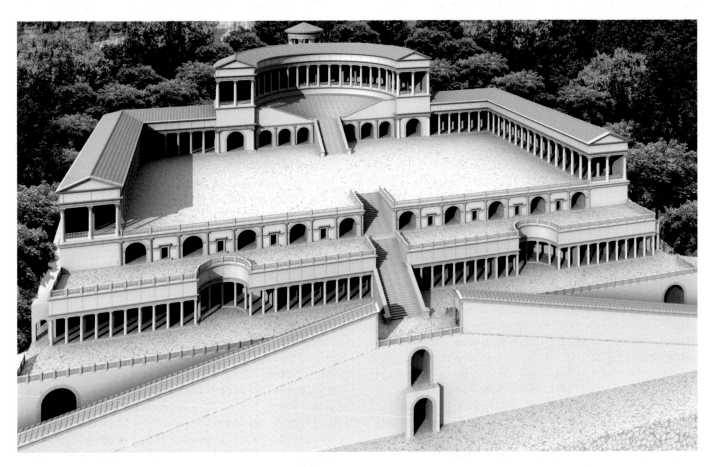

1-20 Restored view of the Sanctuary of Fortuna, Palestrina, late second century BCE (John Burge).

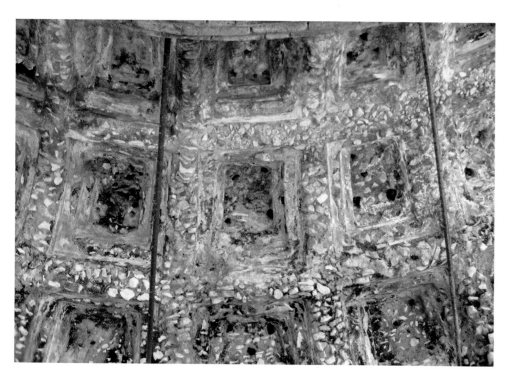

1-21 **Coffered barrel vault of a hemicycle, Sanctuary of Fortuna, Palestrina, late second century BCE.**

the new concrete medium. Stone masonry has all but disappeared. Even the engaged columns framing the arcuated openings were, except for the capitals, fashioned in opus incertum. (As usual, the concrete was once coated with painted stucco to disguise its rough fabric and to imitate marble.)

SANCTUARY OF FORTUNA, PALESTRINA Still more impressive and innovative, although earlier in date, is the Sanctuary of Fortuna (**Figs. 1-19** and **1-20**), the goddess of good fortune, at Palestrina (ancient Praeneste, formerly an Etruscan city). The great complex was constructed in the late second century BCE. Spread out over several terraces leading up the hillside, the complex culminates in a tholos above a theater at the peak of an ascending triangle. The layout reflects the influence of the colossal second-century BCE terraced Greek sanctuaries of the eastern Mediterranean, such as those at Kos and Lindos, with framing porticos on successive levels leading to a traditional rectangular temple at the top. The means of construction, however, as at Tivoli, was distinctly Roman.

The builders used concrete barrel vaults of enormous strength to support the imposing terraces and to cover the great ramps leading to the grand central staircase, as well as to give shape to the shops aligned on two consecutive levels. The lower level of shops has a columnar portico with two recessed hemicycles behind which are *annular* (curving or ring-shaped) barrel vaults (**Fig. 1-21**). The vaults are especially elaborate and covered with *coffers* (quadrangular recesses). Coffered ceilings are common in fine marble architecture in Greece, but at Palestrina the coffers are concrete. They were formed by pouring the concrete into intricately shaped wooden molds. Once dry, the opus incertum fabric received a stucco veneer—at a great cost savings versus carved stone

coffers. An additional advantage was that the same molds could be used for both hemicycles.

The Fortuna sanctuary is a triumph of Roman engineering in which an unknown architect succeeded in subjecting nature itself to human will and rational order. It is emblematic of the power of the ever-expanding empire of the Romans. By the mid-second century BCE, even Greece had become a Roman province, and Romulus's village of huts on the Palatine was but a distant memory, the stuff of legends.

SUMMARY

According to legend, the hero Romulus founded Rome as a village of huts on the Palatine Hill in 753 BCE. For centuries, the new city was overshadowed by other more advanced civilizations in Italy, especially those of the Etruscans and the Greeks. During the sixth century, when Etruscan kings ruled Rome, an Etruscan-style temple was erected on the Capitoline Hill in honor of Jupiter, Juno, and Minerva, but as the Romans expanded their territory to include Magna Graecia and Greece itself, Roman architecture underwent a profound change. Architects began to mix Etruscan and Greek features to produce eclectic—and distinctly Roman—designs such as the pseudoperipteral temple and the tholos with a staircase only at the front. These Republican temples were also built of stone instead of wood and mud brick, the traditional Etruscan materials. In the second century BCE, the Romans also began to construct warehouses, market halls, and terraced sanctuaries using concrete, a new medium that would eventually permit Roman builders to revolutionize the history of architecture.

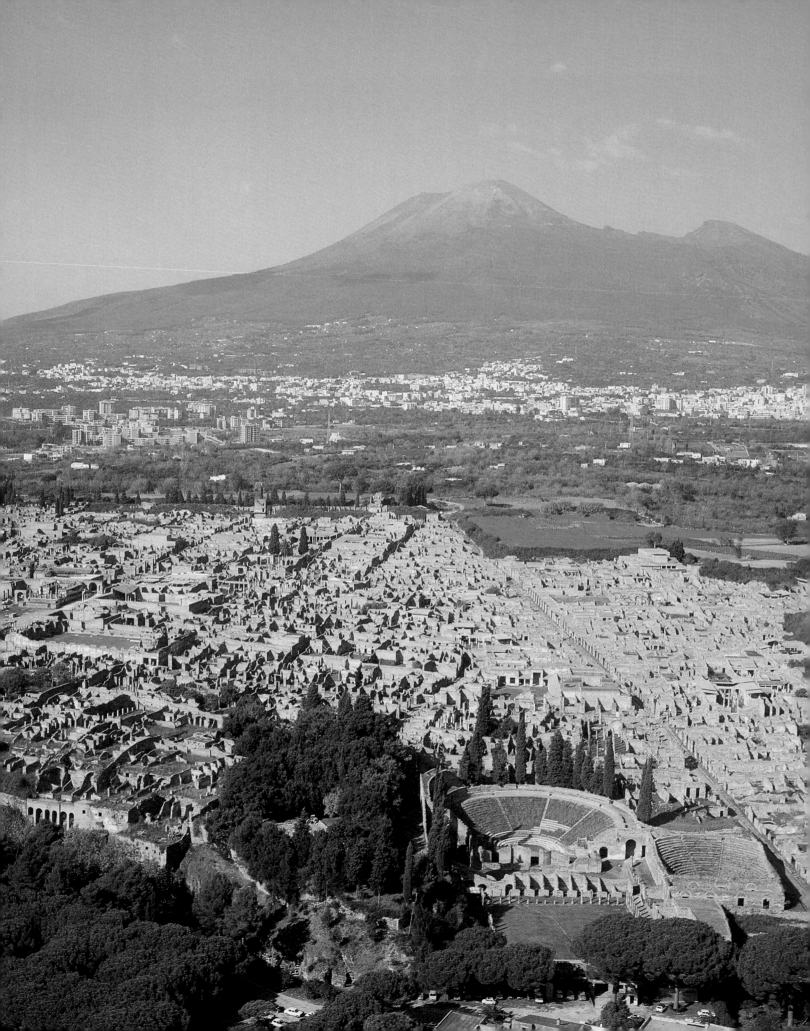

II

Republican Town Planning and Pompeii

The evolution of Rome from a small eighth-century BCE settlement on the Palatine Hill to a Mediterranean-wide empire in the second century BCE that counted Greece itself among its provinces was not without setbacks. The most dramatic occurred in 386 BCE, when the Gauls descended upon Rome from the north and sacked the city. The historian Livy, writing around 25 BCE, described the horrible event and its aftermath, and noted the random way the Romans rebuilt their city after the sack: "In their haste [the Romans] were careless about making straight the streets . . . This is the reason that . . . the appearance of the City is like one where the ground has been appropriated [by settlers] rather than divided [i.e., allocated according to a master plan]."[1]

TOWN PLANNING

Many other ancient authors commented on the narrow and winding streets of Rome, even centuries later. In fact, the hilly terrain of Rome was never suited to systematic urban planning or to a grid of wide thoroughfares. But tightly organized city plans are well documented in the Mediterranean world during the Republic, if not at the time of Rome's founding. The great fourth-century BCE Greek philosopher Aristotle singled out Hippodamos of Miletus as the father of rational city planning.[2] Hippodamos was responsible for supervising the rebuilding of Miletus, his hometown on the west coast of Asia Minor in present-day Turkey (Map 17-1, page 252), after the Persians had reduced the city to ruins in the early fifth century BCE. Hippodamos imposed a strict grid plan on the site's irregular terrain and undulating coastline, making all streets meet at right angles. He also assigned each of the city's constituent parts its proper place in the whole, so that Miletus was logically, as well as regularly, planned.

Architectural historians refer to such layouts as *orthogonal plans*, or *Hippodamian plans*, because Hippodamos became so famous that his name has ever since

2-1 View of the ruins of Pompeii with Mount Vesuvius in the background.

[1] Livy, *History of Rome*, 5.55.5. Translated by B.O. Foster, *Livy*, vol. 3 (Cambridge, Mass.: Harvard University Press, 1960), 187.

[2] Aristotle, *Politics*, 7.10.4.

been synonymous with regularized grid plans for cities. But despite Aristotle's claim that the idea originated in Greece, grid schemes are documented earlier in the Near East and Egypt and, of special relevance for the history of Roman architecture, in Etruscan Italy. At Marzabotto (Map 1-1), near Bologna, archaeologists have uncovered a large portion of the town plan laid out at the beginning of the fifth century BCE, that is, shortly after the founding of the Republic and about a century before the Gallic sack of Rome. Roman authors often noted the highly developed and codified rituals of Etruscan religion, which applied also to the laying out of towns. Strict rules dictated the orientation of temples and the organization of cities into distinct quarters and blocks. At Marzabotto, the blocks are elongated rectangles, and all the streets meet at right angles.

OSTIA To this day Rome retains the irregular web of narrow streets that characterized the ancient city. But when the Romans established their first colony in the late fourth century BCE, they laid out the new city according to a simple and rational scheme. Ostia (**Fig. 2-2**), at the mouth of the Tiber River (discussed in detail in Chapter 14), was a walled settlement, rectangular in plan, with four gates at the cardinal points. Running from gate to gate were the main north-south and east-west streets, the *cardo* and the *decumanus*, respectively. At the intersection of the cardo and decumanus—at the geo-

graphical and figurative center of the colony—was the forum, the civic square. The plan closely resembles the layout of a typical Roman military camp, or *castrum*. Scholars have long debated without resolution whether such Roman city plans were based on castrum plans or vice versa.

TIMGAD Once formulated, this castrum-type plan became the norm for new Roman colonies throughout the Mediterranean world. More than 400 years after the founding of Ostia, in 100 CE, the Roman emperor Trajan (see Chapter 11) planted a new colony at Timgad (ancient Thamugadi; Map 17-1) in Algeria, a hundred miles from the Mediterranean coast in North Africa. An aerial view (**Fig. 2-3**) shows that the original plan followed Ostia's in all major respects. Monumental gates marked the ends of the cardo and decumanus. The forum was located at the point where those two avenues intersected. The quarters were subdivided into square blocks (*insulae*, or "islands"), and the forum and public buildings, such as the theater and baths, occupied areas sized as multiples of those blocks.

The fact that the Romans laid out their colonies in the same manner, regardless of whether they were in Italy, North Africa, Mesopotamia, or England, expresses concretely the unity and centralized power of the Roman Empire at its height. But even the Romans could not regulate human behavior completely. As the population of Timgad grew sevenfold and burst through the

2-2 **Plan of Ostia, founded late fourth century BCE.**

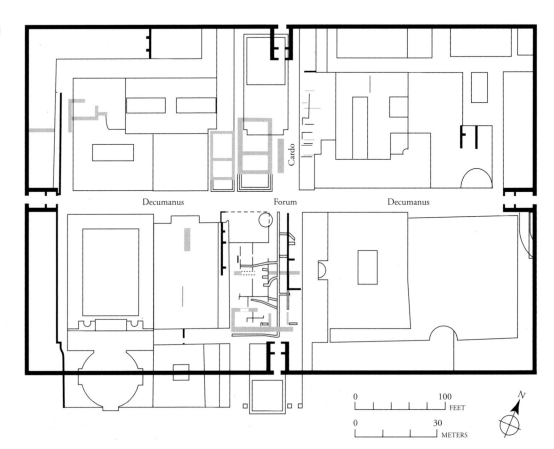

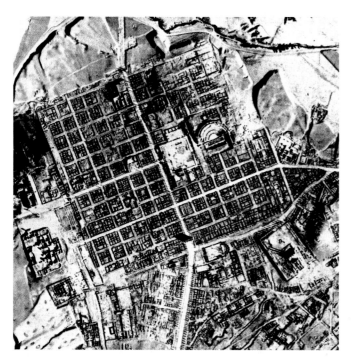

2-3 Aerial view of Timgad (ancient Thamugadi), Algeria, founded 100 CE.

original settlement's boundaries, the streets branched out haphazardly. The new areas of the city were as irregular as those of Rome after the Gallic sack. The contrast underscores the rationality and order of the castrum plan.

POMPEII

For most people today, the most famous Roman city other than Rome itself is Pompeii (**Fig. 2-1**). Ironically, Pompeii was not a Roman foundation, although it was a Roman colony on August 24, 79 CE, when Mount Vesuvius, a long-dormant volcano whose fertile slopes were covered with vineyards during the Late Republic and Early Empire, suddenly erupted (see "An Eyewitness Account of the Eruption of Mount Vesuvius," page 20). This catastrophe for the inhabitants of Pompeii and the other towns around the Bay of Naples (**Map 2-1**), however, has proved a boon for archaeologists and art historians. When researchers first explored the buried cities in the 18th century, the ruins they found had been largely undisturbed for nearly 1,700 years. The Vesuvian sites are still being excavated, but the remains already uncovered permit a reconstruction of the art and life of Roman towns of the Late Republic and Early Empire with a completeness far beyond that possible anywhere else.

OSCANS, SAMNITES, AND ROMANS The Oscans, one of the many Italic tribes that occupied Italy during the time Etruscan kings ruled Rome, were the first to settle at Pompeii. Toward the end of the fifth century BCE, the Samnites, another

Italic people, took over the town. Under the influence of their Greek neighbors, the Samnites greatly expanded the original settlement and, according to most archaeologists, gave monumental shape to the city center. Pompeii fought with other Italian cities on the losing side against Rome in the so-called Social War that ended in 89 BCE, and in 80 BCE the Roman general Sulla (see "Republican Senators, Consuls, and Generals," Chapter 4, page 48) founded a new Roman colony on the site, with Latin as its official language. The colony's population had grown to 10,000 to 20,000 when, in February 62 CE, an earthquake shook the city, causing extensive damage. When Mount Vesuvius erupted 17 years later, repairs were still in progress.

POMPEII TODAY Walking through Pompeii today is an experience that cannot be approximated at any other site other than Herculaneum (Fig. 10-2), another Vesuvian city but one much less completely excavated than Pompeii (see "Excavating Herculaneum," Chapter 10, page 140). The Pompeian streets, with their heavy flagstone pavements and sidewalks, are still there, as are the stepping stones that enabled pedestrians to cross the streets without having to step in puddles. Ingeniously, the civic authorities placed these stones in such a way that vehicle wheels could straddle them, enabling supplies to be brought directly to the shops, taverns, and bakeries. Tourists still can visit the impressive concrete-vaulted rooms of Pompeii's public baths (Fig. 2-12), sit in the seats of its theater and amphitheater (Figs. 2-13 and 2-15), and even walk among the tombs (Fig. 2-18) outside the city's walls. The sights include private homes with magnificently

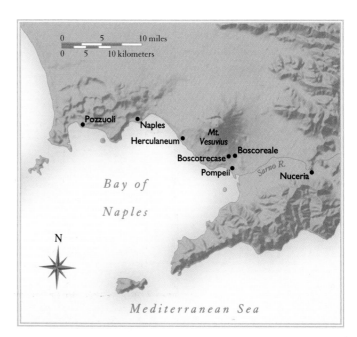

Map 2-1 The Bay of Naples at the time of the eruption of Mount Vesuvius.

An Eyewitness Account of the Eruption of Mount Vesuvius

Pliny the Elder, author of an encyclopedic *Natural History*, was among those who tried to rescue others from danger when Mount Vesuvius erupted. He was overcome by fumes the volcano spewed forth, and died. His nephew, Pliny the Younger, a government official in the early second century CE (see "Pliny the Younger's Panegyric to Trajan," Chapter 11, page 155), left an account of the eruption and his uncle's demise:

> [The volcanic cloud's] general appearance can best be ex-pressed as being like a pine . . . for it rose to a great height on a sort of trunk and then split off into branches. . . . Sometimes it looked white, sometimes blotched and dirty, according to the amount of soil and ashes it carried with it. . . . The buildings

were now shaking with violent shocks, and seemed to be swaying to and fro as if they were torn from their foundations. Outside, on the other hand, there was the danger of falling pumice-stones, even though these were light and porous. . . . Elsewhere there was daylight, [but around Vesuvius, people] were still in darkness, blacker and denser than any night that ever was. . . . When daylight returned on the 26th—two days after the last day [my uncle] had been seen—his body was found intact and uninjured, still fully clothed and looking more like sleep than death.* ∎

* Translated by Betty Radice, *Pliny the Younger: Letters and Panegyricus*, vol. 1 (Cambridge, Mass.: Harvard University Press, 1969), 427–33.

painted walls and pleasant gardens (see Chapter 3), bakeries, *thermopolia* (hot-food stands), even a brothel with mural paintings depicting the activities that took place there. Pompeii has been called the living city of the dead for good reason.

Because most, if not all, of the ancient city has been uncovered (note, however, the large patches of unexcavated areas at the top of the aerial view in **Fig. 2-4**), it is clear that Pompeii (whose foundation, like Rome's, predates Ostia's by centuries) was not laid out in conformity with the later

castrum plan. Although there is a semblance of a grid plan, many of the streets bend, and the city blocks are often trapezoidal in shape. This is true in both the newest parts of the city (the eastern sections of the town) as well as in the oldest areas, around the forum.

FORUM AND CAPITOLIUM Pompeii's forum (**Figs. 2-5** and **2-6**) lies in the southwest corner of the expanded Roman city (Fig. 2-4, no. 1) but at the heart of the original town where the cardo and decumanus met. The forum, however, generally

2-4 **Aerial view of Pompeii, destroyed 79 CE. 1) Forum, 2) Forum Baths, 3) theater and odeum, 4) amphitheater.**

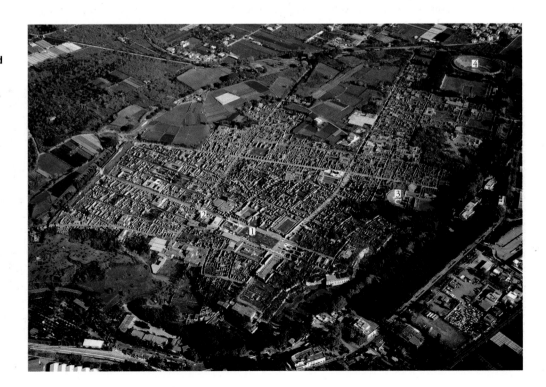

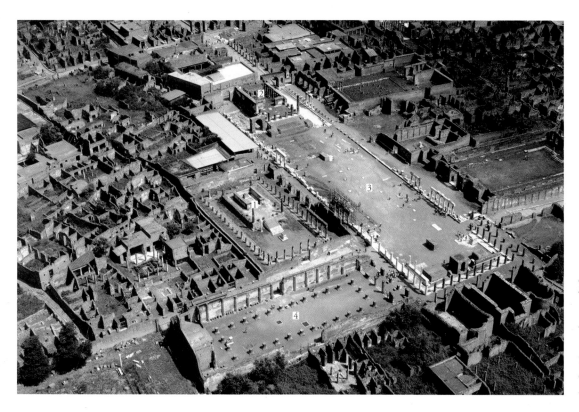

2-5 Aerial view of the forum and the Temple of Apollo, Pompeii, second century BCE and later. 1) Temple of Apollo, 2) Temple of Jupiter (Capitolium), 3) forum, 4) basilica.

was closed to all but pedestrian traffic. Most scholars believe that the open area took on monumental form in the second century BCE when the Samnites erected two-story colonnades on three sides of the long and narrow plaza. Recent investigations in the forum, however, have cast a degree of doubt on this chronology, and some archaeologists now believe that the erection of columnar porticos did not occur until after 80 BCE, when Pompeii became a Roman colony. Further excavation may settle this controversy. The Samnites, however, were very likely responsible for erecting the original Temple of Jupiter (Figs. 2-5, no. 2, and 2-6) at the north end of the forum, although that chronology is being re-examined as well. In any case, the area within the porticos was empty, except for statues, some of whose pedestals are preserved. The statues probably portrayed local dignitaries and, later, Roman emperors. Outside the colonnade were a variety of civic, religious, and commercial structures, including a Temple of Apollo (Fig. 2-8) and a basilica (Figs. 2-9 and 2-10), discussed later.

According to the most widely accepted chronology, when Pompeii became a Roman town, the Romans converted the

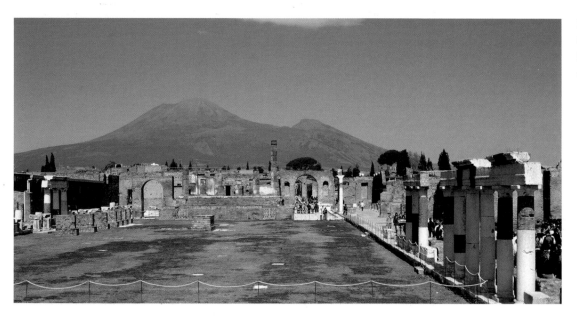

2-6 Forum and Capitolium, Pompeii, looking north, second century BCE and later.

2-7 **Capitolium, Pompeii, during the earthquake of 62 CE, relief from the lararium of the House of L. Caecilius Iucundus, Pompeii, ca. 62–70 CE. Marble, 7″ high. Museo Archeologico Nazionale, Naples.**

Samnite Jupiter temple into a Capitolium in emulation of the triple shrine of Jupiter, Juno, and Minerva on the Capitoline Hill in Rome (Fig. 1-4). A relief (**Fig. 2-7**) from the *lararium* (shrine to the *lares*, or household gods) in the House of Lucius Caecilius Iucundus at Pompeii shows the Capitolium during the earthquake of 62 CE. The sculptor represented the shaking ground by tilting the temple to one side. Also teetering are the gateway to the forum on the west side of the temple and two equestrian statues on high pedestals at the front of the building. The horsemen are probably Castor and Pollux, the twin sons of Jupiter who were especially venerated by soldiers. Army veterans made up a large percentage of the new Roman colonists who settled in Pompeii after 80 BCE.

Based on its remains today and the representation on the lararium relief, Pompeii's Capitolium was of standard Republican type, constructed of tufa covered with fine white stucco and combining an Etruscan plan with Corinthian columns. It is unusual only in having a very elongated plan. Its porch, for example, is four columns deep but only six columns wide, and the cella is even deeper than the porch. The temple faces into the civic square, dominating the area, and its back wall cannot be seen at all from the forum. This is very different from the siting of Greek temples (for example, Fig. 1-6), which usually stood in isolation and could be approached and viewed from all sides, like colossal statues on giant stepped pedestals. The Roman forum, like the Etrusco-Roman temple, had a chief side, a focus of attention.

TEMPLE OF APOLLO Considerably older than the cult of the Capitoline triad at Pompeii was the cult of Apollo, which may date as far back as the sixth century BCE. The remains of the present temple (Fig. 2-5, no. 1), however, are no earlier than the second century BCE. Like the Jupiter temple, the Apollo temple displays an eclectic mix of Greek and Etruscan elements. Especially noteworthy is the peripteral colonnade, although the cella could be reached only from a narrow flight of stairs at the front of the shrine. The temple stands in a precinct with a portico (**Fig. 2-8**) on all four sides. The columns of both the temple and its portico are stucco-covered dark tufa. Those of the temple are Corinthian, whereas the portico columns are Ionic. The temple's entablature is not preserved, but the Ionic portico has a Doric frieze of triglyphs and metopes (see "Doric, Ionic, and Corinthian," Chapter 1,

page 6). Such mixing of the Doric and Ionic orders, although not the norm, is widely documented in Greece at the same time and is symptomatic of the breaking down of the traditional rules of Classical Greek architecture.

BASILICA The Temple of Apollo was entered from the western branch of the city's decumanus leading into the forum, but all the other structures bordering the forum, whether secular or religious, opened onto its east, west, or south portico. The oldest and most noteworthy of these is the basilica (**Fig. 2-9**) at the southwest corner of the forum (Fig. 2-5, no. 4). Although earlier basilicas were built in the Forum Romanum (see Chapter 1) and elsewhere, Pompeii's is the oldest well-preserved example. Constructed during the late second century BCE (or, as some scholars now argue, around 80 BCE), the basilica was a place of shelter from the

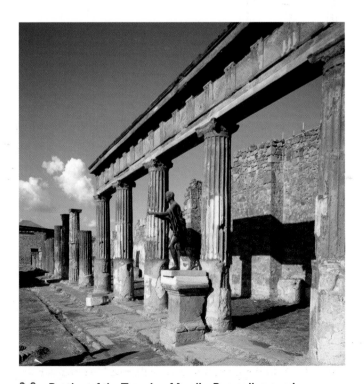

2-8 **Portico of the Temple of Apollo, Pompeii, second century BCE.**

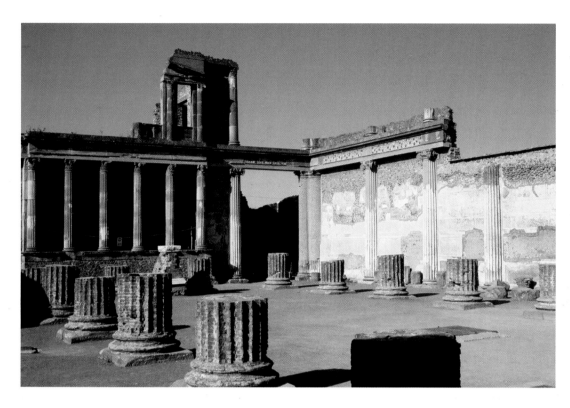

2-9 Interior of the basilica, Pompeii, ca. 130–120 BCE.

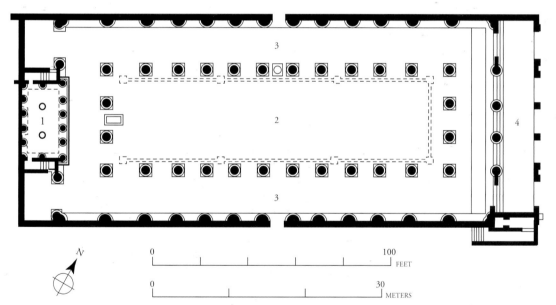

2-10 Plan of the basilica, Pompeii, ca. 130–120 BCE. 1) tribunal, 2) nave, 3) aisle, 4) chalcidicum.

rain and sun for the conduct of private and public business that previously might have taken place in the forum. The Pompeii basilica also housed the city's law court.

In plan (**Fig. 2-10**), the basilica resembles the Pompeian forum itself: long and narrow, with two stories of internal columns dividing the space into a central *nave* and flanking *aisles*. Those who had business to conduct entered the basilica through a vestibule, the *chalcidicum*, at the east end and then proceeded into the nave. The nave columns have shafts built up of layers of wedge-shaped kiln-fired tiles sheathed with stucco fluting. No capitals are preserved. Engaged columns decorate the two-story aisle walls. Those of the main level are Ionic, those of the second floor Corinthian. At the end of the nave is the two-story *tribunal*, the elevated platform on which judges and other magistrates conducted the city's official business. The basilica, therefore, like the forum, was designed to focus attention on one short end of the building. Light entered the basilica through second-story windows in the tribunal and aisles. The tile roof rested on timber beams.

FORUM BATHS The basilica would have been crowded during the morning, but in the afternoon Pompeians preferred to

An Afternoon at the Baths

In the Roman world, the public baths were so important a feature of urban life that in the fourth century CE, there were 856 small baths, or *balnea*, in Rome, in addition to the 11 major baths, or *thermae*, constructed by the emperors over several centuries (and constantly refurbished). The imperial thermae (Figs. 1-2, nos. 24 and 25, 11-18, 16-20 to 16–24, and 19-10 to 19-12)—vast, luxuriously appointed complexes with marble-clad walls, mosaic floors, and fine statuary—were far more than places to bathe. They were complete social centers, much as are modern health clubs and community centers, and they housed libraries, lecture halls, and gardens, as well as at least one exercise court (*palaestra*), swimming pool (*natatio*), and sweating room (*laconicum*) alongside the actual bathing facilities. At the baths, Romans could enjoy the camaraderie of friends or negotiate business deals. The baths provided a pleasant setting for good conversation, physical exercise, and intellectual stimulation to supplement the refreshing spring water brought in from Rome's celebrated network of aqueducts (see "Roman Aqueducts," Chapter 7, page 91).

Admission to the public baths was open to virtually everyone for a small fee, and on any given day a bather would encounter both commoners and aristocrats, even the emperor and his entourage, using the facilities. Men and women bathed separately, however. Usually, separation of the sexes was achieved by assigning different times of day for male and female bathers. Sometimes, men and women had separate bathing facilities in the same building, although they might share a common exercise area and central heating system (Fig. 2-11). The men's baths were, as a rule, larger and better appointed than the women's.

The Roman workday was a short one and ended at lunchtime. Most people, therefore, went to the baths in the afternoon. The wealthy were accompanied by their slaves, who carried the bathing and exercise garments, fresh towels, perfumed oils, and other supplies. Upon arrival, the bather would undress in the *apodyterium*, or changing room, and then do light exercises in the palaestra, perhaps followed by a massage or swim. Bathing proper began with submersion in a pool or basin of warm water in the *tepidarium*, then a hot bath in the *caldarium*, and concluded with a plunge in cold water in the *frigidarium*. After changing back into street clothes in the apodyterium, the Roman bather could complete a perfect day by going to a fine dinner with friends or business clients. ■

go to one of the several public baths located throughout the city (see "An Afternoon at the Baths," above). The earliest were constructed by the Samnites during the second century BCE, but the best preserved are the baths just north of the Capitolium, which were built immediately after the founding of the Roman colony in 80 BCE. The Forum Baths (Figs. 2-4, no. 2, and **2-11**), as they are called today, occupied an entire insula, although much of the block was given over to shops opening onto the street. The baths had separate entrances and bathing facilities for men and women, but both sexes shared a common exercise yard. The plan is typical of Republican bath complexes, with the bathing suite to one side of the palaestra and consisting of a series of adjoining rectangular barrel-vaulted rooms housing tubs or small pools of cold, warm, or hot water. Heating was provided by a central furnace strategically situated between the men's and women's caldaria.

The photograph of the men's caldarium (**Fig. 2-12**) shows the stucco-covered opus incertum walls, the rectangular windows in the barrel vault, the tub of hot water at the curved end, or *apse*, of the room, and the circular window in the apse's half dome, which may have had a shutter in order to control the temperature of the steam-filled caldarium. The floor is raised on brick stilts so that hot air could flow into the room (a *hypocaust* system).

THEATER AND ODEUM The Samnite period at Pompeii also saw the construction of the city's first great entertainment center, the theater (Figs. 2-4, no. 3, and **2-13**, *left*) built southeast of the forum on the sloping terrain leading down to the Sarno River where it flowed into the sea. The theater may have been used on occasion as a place of assembly and voting, but its main purpose was to provide a locale for the staging of plays (and, before the construction of the city's amphitheater, perhaps also for gladiatorial shows). The plan resembles that of Greek theaters, for example, the fourth-century BCE theater at Epidauros (**Fig. 2-14**), where the seating area (*cavea*) takes up a bit more than a semicircle, and the stage is separated from the cavea by entranceways for spectators. Pompeii's theater does have a portico behind the stage, as Vitruvius recommended,[3] for the use of the audience during intermissions or rain interruptions, as well as for the storing and assembling of stage sets.

The Pompeian theater that tourists visit today is the result of a major remodeling at the end of the first century BCE, a gift to the city from its most prominent citizen, Marcus Holconius Rufus, who had a reserved inscribed marble seat in the sixth row. His renovation included the addition of

[3] Vitruvius, *On Architecture*, 5.9.

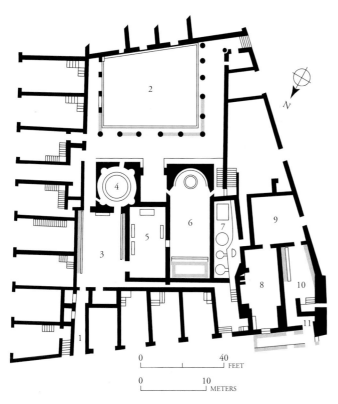

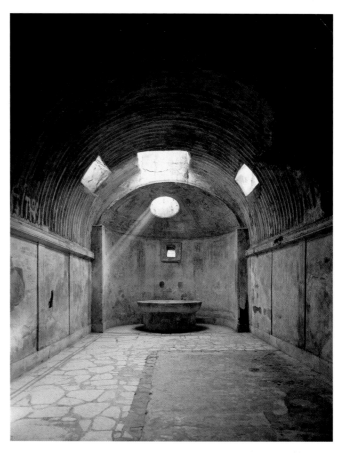

2-11 Plan of the Forum Baths, Pompeii, ca. 80–70 BCE.
1) men's entrance, 2) palaestra, 3) men's apodyterium,
4) men's frigidarium, 5) men's tepidarium, 6) men's caldarium,
7) furnaces, 8) women's caldarium, 9) women's tepidarium,
10) women's apodyterium and frigidarium, 11) women's
entrance.

2-12 Men's caldarium, Forum Baths, Pompeii, ca. 80–70 BCE.

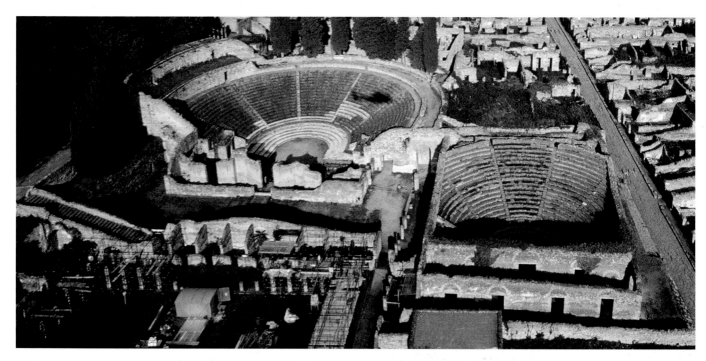

2-13 Aerial view of the theater (*left*), begun second century BCE, and odeum (*right*), ca. 80–70 BCE, Pompeii.

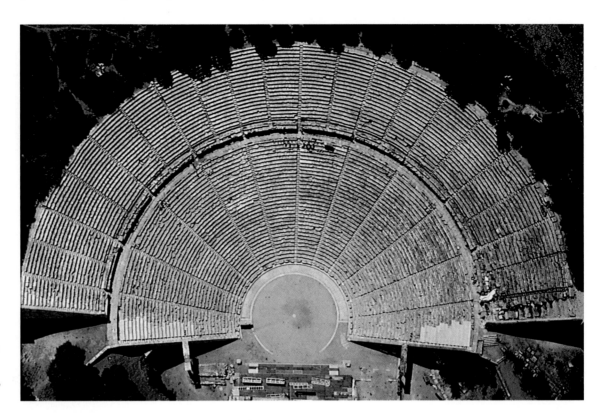

2-14 **Aerial view of the theater, Epidauros, Greece, ca. 350 BCE.**

concrete barrel-vaulted entrance passageways between the cavea and the stage as well as another level of seats at the top of the cavea. Further repair and remodeling, again using concrete, followed the earthquake of 62 CE. The second-century BCE structure was essentially Greek, however, both in its design and in the use of stone.

Next to the theater is a building that most architectural historians call an *odeum* (Fig. 2-13, *right*), or concert hall, but the official name for the structure at Pompeii was the *theatrum tectum* (roofed theater). Some scholars think it functioned as an assembly hall as well as, or instead of, a concert hall. The theatrum tectum is smaller in size than the open-air theater and, as its name indicates, was once covered by a timber roof without interior supports, an engineering triumph. Construction of the odeum was one of the first projects the Roman colonists initiated. Two magistrates, Quinctius Valgus and Marcus Porcius, oversaw the construction of the building. Concrete was used from the outset, and the odeum is in every way a Roman building. In contrast to the Greek theater, the cavea is semicircular, and both the seating area and the stage are enclosed within a rectangle of opus incertum walls. As in the remodeled theater, the audience (about 1,500 could be accommodated at one time) reached their seats through vaulted passageways.

AMPHITHEATER Quinctius Valgus and Marcus Porcius also were responsible for building Pompeii's amphitheater (Figs. 2-4, no. 4, **2-15**, and **2-16**), in this case, according to the dedicatory inscription, using their own funds. The Pompeian amphitheater is the earliest such structure known. Dwarfing the odeum and even the open-air theater in size, the amphitheater could seat some 20,000 spectators—more than the entire population of Pompeii on the eve of the Vesuvian eruption, a century and a half after the amphitheater was built. The donors would have had choice reserved seats in the new entertainment center, as Holconius Rufus later did in the theater he renovated. In fact, seating was assigned by rank, both civic and military, so that the Roman social hierarchy was on display at every event.

The word *amphitheater* means "double theater," and Roman amphitheaters do resemble two Greek theaters put together, although the Greeks never built amphitheaters. Greek theaters, like those at Pompeii and Epidauros (Fig. 2-14), were situated on natural hillsides, but supporting an amphitheater's continuous elliptical cavea required building an artificial mountain. Only concrete was capable of such a job. In the Pompeii amphitheater, a series of shallow concrete barrel vaults forms a giant retaining wall that supports the earthen mound and stone seats. Extended barrel vaults running all the way through the mountain of earth form the tunnels leading to the *arena*, the open central area where the bloody gladiatorial combats and wild animal hunts were staged. (*Arena* is Latin for "sand," which soaked up the blood of the wounded and killed.) The Roman amphitheater stands in sharp contrast, both architecturally and functionally, to the theater and odeum.

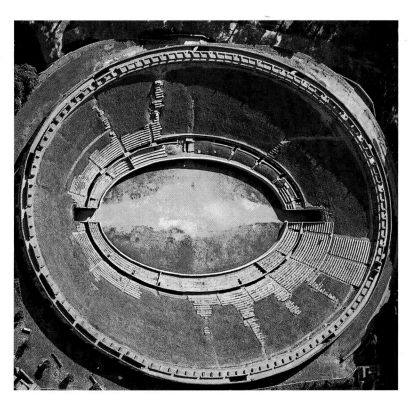

2-15 **Aerial view of the amphitheater, Pompeii, ca. 80–70** BCE.

A painting (**Fig. 2-17**) on the wall of a Pompeian house records an unfortunate incident that occurred in the amphitheater. A brawl broke out between the Pompeians and their neighbors, the Nucerians, during a gladiatorial contest in 59 CE. The fighting left many seriously wounded and led to the closing of the amphitheater for a decade. The painting shows the cloth awning (*velarium*) that could be rolled down from the top of the cavea to shield spectators from either sun or rain. (Such awnings were used in theaters too.) The fresco painter also recorded the amphitheater's distinctive external double staircases (Fig. 2-16) that enabled large numbers of people to enter and exit the building in an orderly fashion. To do so, however, they had to climb to the top of the cavea and then descend to their seats, and leave the amphitheater by going up and then down again. It is one of many signs that Pompeii's amphitheater was an early, experimental design. The architects of later amphitheaters would find a better solution to the problem (see Chapter 9).

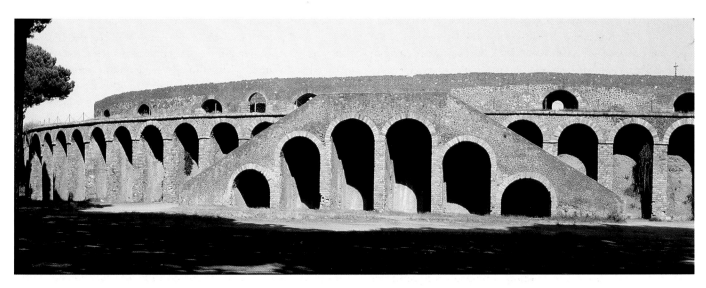

2-16 **Facade of the amphitheater with double stairway, Pompeii, ca. 80–70** BCE.

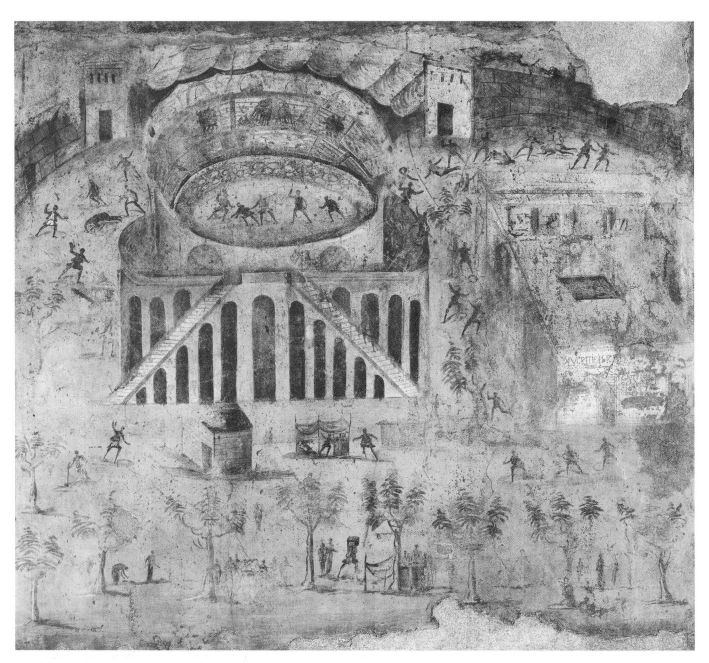

2-17 **Brawl in the Pompeii amphitheater, from House I,3,23, Pompeii, ca. 60–79 CE. Fresco, approx. 5′ 7″ × 6′ 1″. Museo Archeologico Nazionale, Naples.**

OUTSIDE THE WALLS The Nucerians who attended the gladiatorial games at Pompeii on that unfortunate day in 59 CE would have entered the city through a gate in the wall circuit not far from the amphitheater. The road from Nuceria ran directly up to that gate. Immediately outside the gate, on both sides of the road, the Pompeians erected monumental tombs (**Fig. 2-18**) in honor of deceased members of their families. Many other tombs line the road outside Pompeii's Herculaneum gate, and such tomb complexes are typical of Roman cities. The Romans, like many other ancient peoples, carefully separated the city of the dead (*necropolis*) from the

city of the living. Roman law dictated that burials had to take place outside a city's walls.

The tombs on the Via Nucera, like those on the Via dei Sepolcri (Street of the Tombs) outside the Herculaneum gate, assume a wide variety of forms. Roman tombs are the most personalized and diverse of all ancient building types because their design was not constrained by functional considerations, as were basilicas, theaters, baths, and all other structures that served the living. A tomb can take virtually any form, and the Roman repertory is extraordinarily diverse. All tombs, however, had a common purpose—to memorialize the dead and

2-18 **Necropolis outside the Nuceria gate, Pompeii.**

compete for the attention of passersby. To that end, some families placed benches in front of the tombs for their own use on anniversaries of a loved one's death and in the hope that travelers would sit for a while and take note of the achievements of the person buried nearby. No examination of the art and architecture of the Roman world would be complete without a journey to the cities of the dead outside the walls of Roman cities (see Chapters 6 and 14).

SUMMARY

When the Romans founded their first colony in the late fourth century BCE at Ostia, they laid out the new town using the kind of grid plan that had been used earlier for Etruscan and Greek cities alike. The canonical Roman city plan, however, was even more sharply defined than those of other ancient civilizations. The city center, or forum, was located at the intersection of the main north-south and east-west avenues. Also usually in or adjoining the forum were the city's main temple, the Capitolium, and its chief administrative and legal hall, the basilica. These buildings as well as baths, a theater, and an amphitheater (the oldest known) are all found at Pompeii, which was buried in the Vesuvian eruption of 79 CE. Excavation of Pompeii's ruins has provided the best evidence for all aspects of public and private life in an ancient Roman city. This chapter focused on the public buildings of Pompeii. The city's houses and their paintings and mosaics are examined in Chapter 3.

Republican Domestic Architecture and Mural Painting

On the Bay of Naples in Roman times, as in cities and towns around the world today, private homes occupied most of the area outside the civic center. The evidence from Pompeii and other Vesuvian sites regarding Roman domestic architecture is unparalleled and is the most precious by-product of the catastrophic volcanic eruption of 79 CE (see "An Eyewitness Account of the Eruption of Mount Vesuvius," Chapter 2, page 20). Visitors to the houses of Pompeii and nearby Herculaneum enjoy an unforgettable experience in which the past comes to life again as they walk through dining rooms, bedrooms, and bath suites decorated with mural paintings and paved with mosaics; relax by fountains in gardens framed by columns and filled with marble statues; or, on certain days, watch the rain fall through an open roof and collect in a catch basin in the heart of the house, just as it did 2,000 years ago.

DOMESTIC ARCHITECTURE

DOMUS ITALICA Although in the eighth century BCE Romulus, the Romans' first king, dwelled in a simple hut on the Palatine Hill (Fig. 1-3), during the mid-Republic wealthy Romans resided in much more comfortable and pretentious homes. The typical single-family house of this period, the *domus italica* (**Fig. 3-2**), was a well-appointed structure with many rooms of clearly defined function (see "The Social Structure of the Roman House," page 32). Like the townhouses of densely populated modern cities, the Roman domus was connected to other houses on the same city block, and unless the house was situated at the corner of the insula, the only exposed exterior wall was the facade, which provided access to the interior from the sidewalk.

Visitors would enter through a narrow foyer, or *fauces* (the "jaws" of the house; Fig. 3-2, no. 1), which led to a large central reception area, the *atrium* (Fig. 3-2, no. 2). The rooms flanking the fauces could open inward onto the atrium or outward, as in Fig. 3-2, and serve as one-room shops (*tabernae*) operated by the owner or rented out to others. The roof over the atrium sloped inward and had a central opening (*compluvium*) that not only admitted much-needed light to the house but also channeled rainwater into a basin (*impluvium*; Fig. 3-2,

3-1 Detail of the Second Style mural paintings in cubiculum M (Fig. 3-22), Villa of Publius Fannius Synistor, Boscoreale, ca. 50–40 BCE. Metropolitan Museum of Art, New York.

The Social Structure of the Roman House

The Roman house was more than just a place to live. It played an important role in Roman societal rituals. In the Roman world, individuals were frequently bound to others in a patron-client relationship whereby a wealthier, better-educated, and more powerful *patronus* protected the interests of a *cliens,* sometimes large numbers of them. The standing of a man in Roman society often was measured by clientele size. To be seen in public accompanied by a crowd of clients was a badge of honor. In this system, a *plebeian* (a member of the social class that included small farmers, merchants, and freed slaves) might be bound to a *patrician* (a freeborn landowner, usually from an old and influential family), a freed slave to a former owner, or even one patrician to another. Regardless of rank, all clients were obligated to support their patron in political campaigns and to perform specific services on request, and to call on and salute the patron at the patron's home.

Although many ancient authors condemn the *luxuria* of Roman private homes as prime examples of wasteful spending on useless ostentation, social pressures dictated that a Roman house reflect the owner's standing in the community. In the Roman world, one's house was not a place of refuge from the public eye but rather, as one scholar has aptly described it, "a stage deliberately designed for the performance of social rituals."* Indeed, the standard plan of Roman houses reflects the rituals of the patron-client relationship, especially the central axis leading from the doorway to the atrium (filled with portraits of distinguished ancestors in aristocratic residences; see "Ancestor Portraits," Chapter 4, page 54) to the tablinum, where the patronus, dressed in his formal *toga*, would receive the *salutatio* of his clients. The distinction between home and office that characterizes most contemporary societies was blurred in ancient Rome. The Romans regularly conducted business in their houses.

Even the normally less accessible areas of a private home, such as the dining room(s) and garden(s), were often the setting for important social interactions with friends and clients. This helps to explain the lavish expenditure on marble basins and statuary in peristyles (Fig. 3-7) and the introduction of columns into dining rooms (Figs. 3-12 and 3-13)—often complemented by mural paintings evoking palaces and sacred precincts (Figs. 3-1, 3-21, and 3-22) that lent prestige to the setting and to the host. Ancient texts clearly indicate that business could be conducted in virtually every room in a Roman house, even the bedrooms. Guests would learn very quickly how high they stood in the esteem of the host by which rooms in the "private" house they would be invited to enter. ■

*Andrew Wallace-Hadrill, *Houses and Society in Pompeii and Herculaneum* (Princeton, N.J.: Princeton University Press, 1994), 60.

no. 3) below. The water thus collected could be stored in cisterns for household use. Opening onto each side of the atrium were two or three bedrooms called *cubicula* (sleeping cubicles; Fig. 3-2, no. 4) as well as a pair of recesses or wings (*alae*; Fig. 3-2, no. 5) that created a T-shaped central space. At the back, directly on axis with the fauces, was the *tablinum* (Fig. 3-2, no. 6), or "home office," of the head of the household (the *paterfamilias*), and, on either side, a *triclinium* (dining room; Fig. 3-2, no. 7)—named for the three couches, or *klinai*, set against three walls—and a kitchen. Behind the tablinum at the rear of the house, there was often a small garden (*hortus*; Fig. 3-2, no. 8) in which the city dweller could enjoy a small piece of nature.

Endless variations of the same basic plan exist, dictated by an owner's personal tastes and means, the nature of the plot of land, and so forth, but all Roman houses of this type were inward-looking in nature. The design shut out the street's noise and dust. It also separated the public wing of the house, centered on the brightly illuminated atrium, from the more intimate and private garden at the rear, which most guests would never be invited to enter.

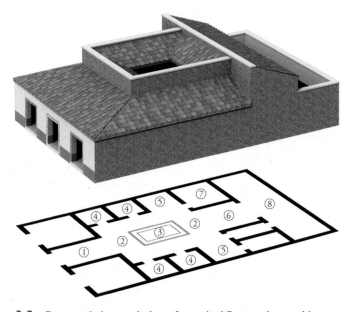

3-2 **Restored view and plan of a typical Roman house (*domus italica*) of the third century BCE (John Burge). 1) fauces, 2) atrium, 3) impluvium, 4) cubiculum, 5) ala, 6) tablinum, 7) triclinium, 8) hortus.**

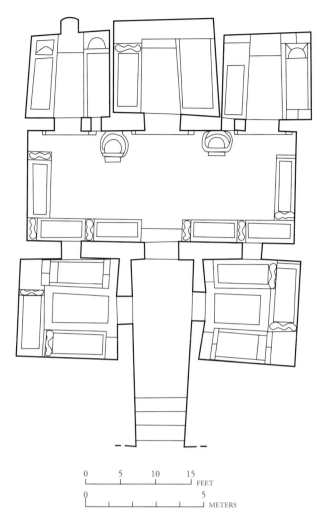

0 5 10 15
FEET

0 5
METERS

3-3 **Plan of the Tomb of the Shields and Chairs, Banditaccia necropolis, Cerveteri, second half of the sixth century** BCE.

ETRUSCAN HOUSES The domus italica plan closely resembles the plans of many underground tombs in the Banditaccia necropolis of Cerveteri, for example the sixth-century BCE Tomb of the Shields and Chairs (**Fig. 3-3**). The rooms and furniture of these "houses of the dead" were carved out of the bedrock in imitation of the houses of the living in ancient Etruria, of which, unfortunately, only foundations of the actual houses remain because they were constructed largely of mud brick and wood. Both Vitruvius, whose treatise on architecture was published in the late first century BCE, and Varro, who wrote a history of the Latin language during the 40s BCE, trace the origin of the Republican domus to the Etruscan house, and the archaeological evidence confirms the literary testimony.[1] As with temple architecture (see Chapter 1), Republican domestic architecture grew out of the Etruscan tradition.

HOUSE OF SALLUST One early Pompeian house that conforms fairly closely to the domus italica plan is the so-called House of Sallust (**Fig. 3-4**), an erroneous attribution based on painted inscriptions on the facade of a neighboring residence. Originally built in the third century BCE, in its last phase the domus was converted into an inn, no doubt in large part because of its strategic location on the first street inside the city gate marking the end of the road from Herculaneum to Pompeii. Despite this later transformation, the House of Sallust still exhibits all of the features of the Republican domus italica. Fig. 3-4 shows the atrium looking toward the tablinum and beyond into the hortus at the back of the house. Also visible are the doorways opening into two cubicula on the left side of the atrium. In the left rear corner is one of the alae, and in the center of the atrium is the impluvium. The water collected in that basin was piped beneath the floor to a cistern in the hortus.

[1] Vitruvius, *On Architecture*, 6.3; Varro, *On the Latin Language*, 5.161.

3-4 **Atrium of the House of Sallust looking toward the hortus, Pompeii, third century** BCE.

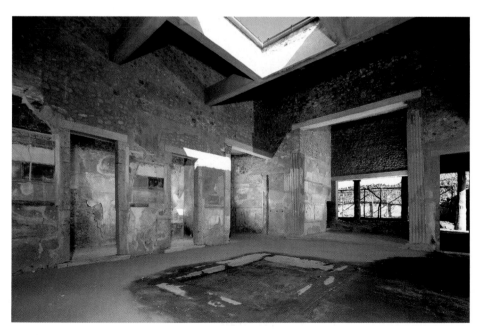

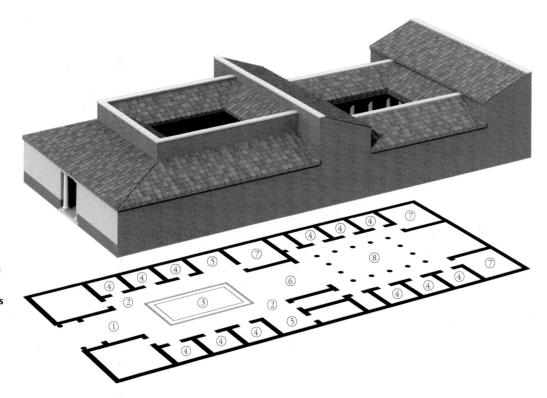

3-5 Restored view and plan of a typical Roman house of the second and first centuries BCE (John Burge). 1) fauces, 2) atrium, 3) impluvium, 4) cubiculum, 5) ala, 6) tablinum, 7) triclinium, 8) peristyle.

THE HELLENIZED DOMUS During the second century BCE, when Roman architects were beginning to construct stone temples with Doric, Ionic, and Corinthian columns (see Chapter 1), the Roman domus also took on Greek airs (**Fig. 3-5**). Builders added a column-framed garden (*peristyle*; Fig. 3-5, no. 8) behind the Etruscan-style house, replacing the modest hortus (Fig. 3-2, no. 8) of the domus italica with an expanded, pretentious setting for private discourse with selected guests, as well as an additional venue for dining, especially in the summer months. These peristyle gardens often boasted a fountain or pool, marble statuary, mural paintings, and mosaic floors. Not surprisingly, the statues displayed in these Hellenized homes were often copies of or variations on Greek masterpieces (usually in marble instead of the original bronze) and the paintings and mosaics often depicted subjects from Greek mythology (for example, Fig. 3-23; see also Chapter 10). Although larger and far more luxurious than the domus italica, the Hellenized Roman house retained the essential features of the earlier type, including its inward-looking nature and its axiality. Upon entering the fauces of a Roman peristyle house, visitors were still greeted by a vista through the atrium and tablinum into a garden at the rear.

HOUSE OF THE VETTII One of the best-preserved houses of this later type at Pompeii, partially rebuilt, is the House of the Vettii, a second-century BCE residence remodeled during the third quarter of the first century CE. **Fig. 3-6** shows the view from the fauces, with the impluvium in the center of the atrium, the compluvium in the roof above, and, in the

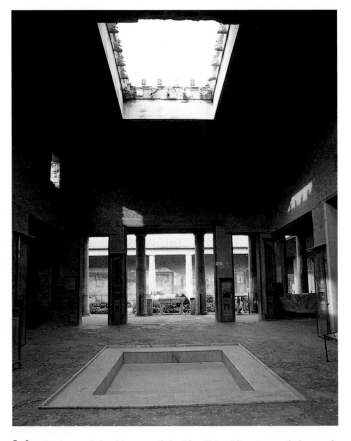

3-6 Atrium of the House of the Vettii looking toward the peristyle, Pompeii, second century BCE, rebuilt third quarter of first century CE.

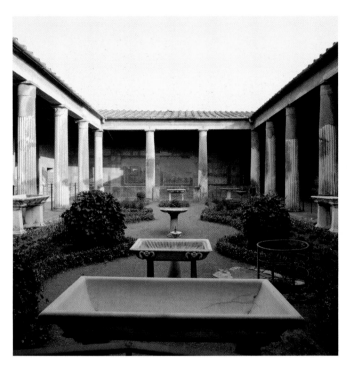

3-7 Peristyle of the House of the Vettii, Pompeii, second century BCE, rebuilt third quarter of first century CE.

background, the peristyle garden (**Fig. 3-7**) with its marble tables and splendid mural paintings (compare Figs. 10-15 and 10-16) dating to the last years of the Vesuvian city, when the house was redecorated following the earthquake of 62 CE.

At that time, two brothers, Aulus Vettius Restitutus and Aulus Vettius Conviva, freedmen who had made their fortune as merchants, owned the house. It was probably during their remodeling of the old domus that the tablinum was removed. Freedmen did not have the same need for an office in which to receive clients that the previous owners did. (Vitruvius noted that tablina were not necessary for freedmen "because they perform[ed] their duties by making the rounds visiting others, rather than having others make the rounds visiting them.)[2] The Vettii were nonetheless influential men at Pompeii. Conviva was an *augustalis*, the highest civic office that a freedman could hold in the Roman world. Such honors were reserved for those who had donated large sums of money for public works projects. In short, Conviva bought his status—and the kind of fashionable townhouse that in an earlier era only patricians could have acquired. For someone who had spent the better part of his life in servitude, there were no greater marks of success than possessing such a lavish townhouse and having been awarded the title of augustalis.

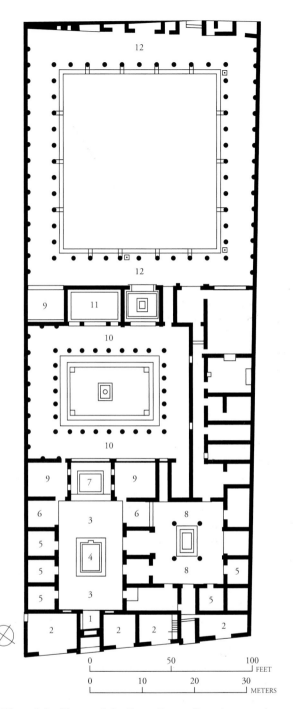

3-8 Plan of the House of the Faun, Pompeii, early second century BCE. 1) fauces, 2) taberna, 3) Tuscan atrium, 4) impluvium, 5) cubiculum, 6) ala, 7) tablinum, 8) tetrastyle atrium, 9) triclinium, 10) first peristyle, 11) exedra with Alexander Mosaic, 12) second peristyle.

HOUSE OF THE FAUN The home of the Vettius brothers paled in comparison, however, with the largest mansion at Pompeii, the so-called House of the Faun (**Fig. 3-8**). Built during the first half of the second century BCE and enlarged at the end of that century to encompass the entire insula, the

[2] Vitruvius 6.5.1. Translated by Ingrid D. Rowland, *Vitruvius. Ten Books on Architecture* (New York: Cambridge University Press, 1999), 80.

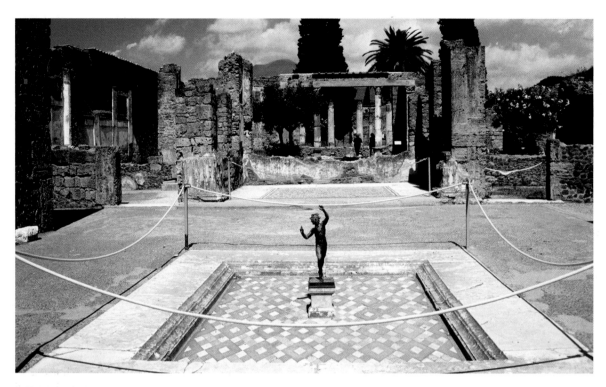

3-9 Tuscan atrium of the House of the Faun, Pompeii, looking toward the tablinum and first peristyle, early second century BCE.

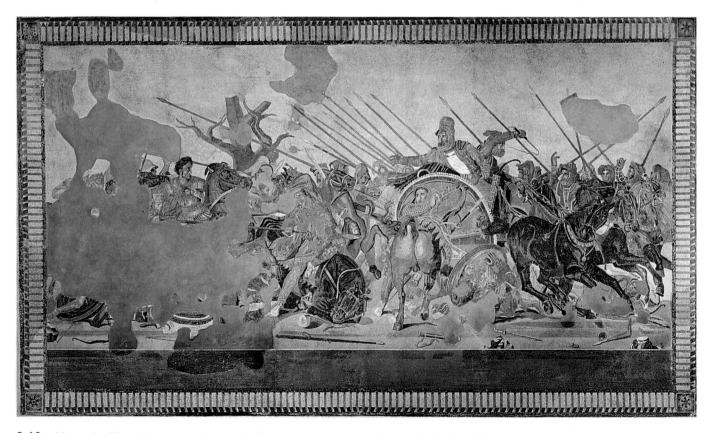

3-10 Alexander Mosaic, late second- or early first-century BCE copy of a panel painting of the *Battle of Issos* by Philoxenos of Eretria, late fourth century BCE. Mosaic, approx. 8′ 10″ × 16′ 9″. Museo Archeologico Nazionale, Naples.

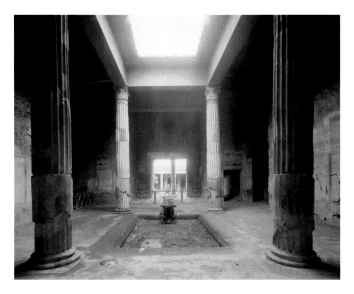

3-11 Tetrastyle atrium of the House of the Silver Wedding, Pompeii, mid-second century BCE.

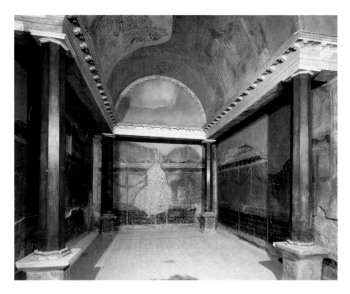

3-12 Tetrastyle oecus of the House of the Silver Wedding, Pompeii, mid-first century BCE.

house takes its name from the Hellenistic-style bronze statuette that stood in one of its two atria. The house also had two successive peristyles, with the larger one situated at the rear of the residence and constituting the culmination of the long axis beginning at the entrance portal and continuing through the atrium and tablinum. The main atrium (Fig. 3-8, no. 3, and **3-9**) is of the traditional *Tuscan* (that is, Etruscan-derived) *atrium* type with no supports for the roof other than timber beams projecting out of the walls. The Tuscan atrium was the setting for the public rituals of the house. The second atrium (Fig. 3-8, no. 8) was for the private use of the family. Although smaller, it was more elaborate. There, Corinthian columns at the corners of the impluvium supported the roof. This more luxurious kind of atrium, the *tetrastyle* (four-column) *atrium*, is another sign of the fascination Roman patrons and builders had with the trappings of Greek architecture.

Many of the floors of the House of the Faun were paved with figural *mosaics* composed of thousands of tiny *tesserae* (cubes; see "Roman Mosaics," Chapter 14, page 207). The most spectacular mosaic (**Fig. 3-10**) covered the floor of an *exedra* (recessed area or room off a larger space; Fig. 3-8, no. 11) situated between the two peristyles (Fig. 3-8, nos. 10 and 12). Corinthian columns framed the entrance to the room. The mosaic represents the *Battle of Issos* between Alexander the Great and the Persian king Darius III. Most scholars believe the Alexander Mosaic, as it is commonly referred to, is a copy of a lost late-fourth-century BCE Greek panel painting by Philoxenos of Eretria. To capture all of the subtleties of the original painting—the facial expressions, the play of light across *foreshortened* (depicted from an angle) human and animal bodies, even the reflection of a fallen Persian's face in a polished Macedonian shield—the artist employed an estimated million and a half tesserae in the roughly 9 × 17-foot

mosaic. Pliny the Elder claimed that Philoxenos's painting was "inferior to none."[3] The copy in the House of the Faun lent prestige to its owner—through both the fame of the painting and the nature of its subject—as well as provided a visual feast for the family and guests.

HOUSE OF THE SILVER WEDDING In the House of the Faun, the tetrastyle atrium was a smaller, secondary area of the home, but in the House of the Silver Wedding at Pompeii (excavated in 1893, the 25th anniversary of the king and queen of Italy), there is a tetrastyle atrium (**Fig. 3-11**) of grandiose size, the largest in the city. At the time of the eruption, Lucius Albucius Celsus, the scion of an old patrician family, owned the house. The domus dates originally to the second century BCE. Fig. 3-11 shows the atrium seen from the fauces. The peristyle is clearly visible through the four stucco-covered tufa Corinthian columns framing the unusually large compluvium and impluvium.

Opening onto the peristyle at the left rear corner of the house is one of the most distinctive dining rooms in Pompeii, a *tetrastyle oecus* (**Fig. 3-12**), a banquet hall with four red stucco octagonal columns beneath a barrel vault. The stuccoed ceiling, painted walls, and mosaic floor complemented what must have been elegant dining couches and fine silver tableware and utensils (compare Figs. 8-4 and 8-5, from a Vesuvian villa) to form a luxurious setting for genial conversation. As in the theater and amphitheater, seating in Roman dining rooms was hierarchical, with the host and the most distinguished guest sharing the couch that had the best view out to the peristyle garden.

[3] Pliny the Elder, *Natural History,* 35.110.

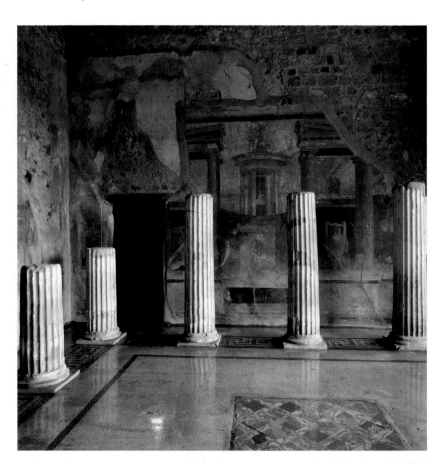

3-13 **Corinthian oecus of the House of the Labyrinth, Pompeii, mid-first century BCE.**

HOUSE OF THE LABYRINTH An even more spectacular setting for formal meals at Pompeii and elsewhere was the *Corinthian oecus*, a dining room in which a continuous colonnade lines all the walls, forming a kind of peristyle around the host and guests. An unusually well-preserved example (**Fig. 3-13**) is in the House of the Labyrinth at Pompeii, a large private residence that takes its modern nickname from a floor mosaic depicting the Greek hero Theseus battling the monstrous *minotaur* (man-bull) in the labyrinth of the palace of King Minos of Knossos on Crete. The House of the Labyrinth is another example of an old house that was re-modeled several times over the course of a few centuries. The domus was initially constructed in the late second century BCE. The Corinthian atrium dates to the mid-first century BCE. The house was lavishly decorated throughout with mural paintings and mosaic pavements, and in 79 CE it boasted a tetrastyle atrium as well as a Tuscan one, a peristyle garden, and a private bath suite in addition to the Corinthian oecus. The last owner of the house was Publius Sextilius Rufus, a patrician descended from one of the first magistrates of the new Roman colony of 80 BCE.

SUBURBAN VILLAS As luxurious as the finest residences of Pompeii were, they were nonetheless, with the notable exception of the House of the Faun, still attached townhouses crowded together inside the city walls. Not even the quieter side streets were free of traffic or noise. Peristyle gardens might

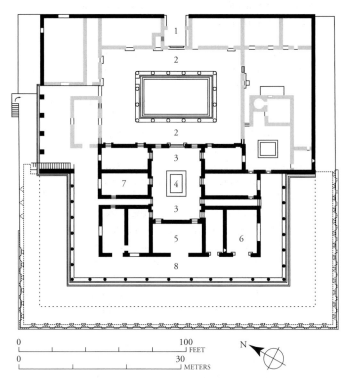

3-14 **Plan of the Villa of the Mysteries, Pompeii, early second century BCE. 1) fauces, 2) peristyle, 3) atrium, 4) impluvium, 5) tablinum, 6) room with Dionysiac mysteries murals, 7) cubiculum 16, 8) terrace.**

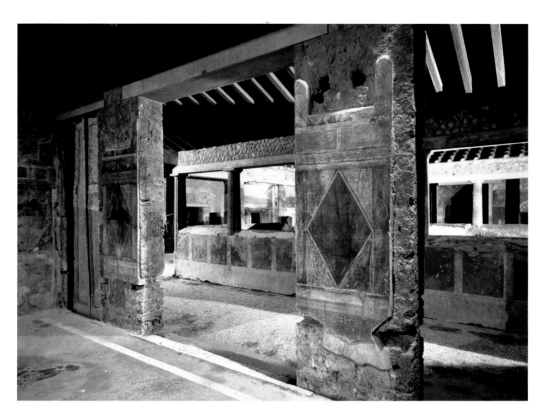

3-15 Peristyle seen from the atrium, Villa of the Mysteries, Pompeii, early second century BCE with later remodeling.

be verdant refuges from the hustle and bustle of the city, but no Pompeian townhouse, even the House of the Faun, could provide its owner with direct access to the Campanian countryside or distance from neighbors.

During the second century BCE, when columnar peristyles and atria were rapidly becoming standard features of the homes of wealthy city dwellers, there was also a building boom in *villae suburbanae*—private homes with expansive grounds located in the immediate vicinity of towns like Pompeii. These suburban villas provided their owners with enhanced privacy but also afforded them easy access to the political, cultural, and social life of the urban centers.

Vitruvius described these villas in the same section in which he commented on the importance of "spacious atria and peristyles" and "lush gardens and broad walkways" as essential elements in the homes of "the most prominent citizens, those who carry out their duties to the citizenry by holding honorific titles and magistracies." He further noted that the principles of urban domus design also applied to homes in the countryside, except that "in the city the atria are customarily next to the entrance, whereas in the countryside . . . the peristyle comes first, then afterward the atria."[4]

VILLA OF THE MYSTERIES Vitruvius's description of the typical suburban villa applies perfectly to the most famous villa at Pompeii, the Villa of the Mysteries (**Fig. 3-14**), located a mere thousand feet outside the city's Herculaneum gate. Built during the early second century BCE and extensively remodeled and repainted in the mid-first century BCE after the establishment of the Roman colony at Pompeii, the villa commanded an uninterrupted view of the sea from its western terrace, which rested on opus incertum concrete barrel vaults. Entrance to the villa was from the opposite end (Fig. 3-14, no. 1). Visitors first encountered the peristyle (Figs. 3-14, no. 2, and **3-15**), then the atrium (Fig. 3-14, no. 3), and finally the tablinum (Fig. 3-14, no. 5), which opened directly onto the terrace (Fig. 3-14, no. 8) overlooking the sea. The numerous other rooms included well-appointed bedrooms for the residents and their guests; much more modest quarters for the servants; multiple dining rooms and sitting rooms, some with sea views; and a facility for producing wine.

MURAL PAINTING

The Villa of the Mysteries takes its name from the most distinctive of its many painted rooms. In fact, the houses and villas around Mount Vesuvius are as valuable for the history of Roman painting (see "Roman Mural Painting," page 41) as they are for the history of domestic architecture. The sheer quantity of mural paintings from the buried Vesuvian towns tells a great deal about both the prosperity and the tastes of the times. How many homes today, even of the very wealthy, have custom-painted murals in nearly every room?

In the early years of exploration at Pompeii, Herculaneum, and other Vesuvian sites, excavators focused almost

[4] Vitruvius 6.5.2–3. Translated by Rowland, 81.

exclusively on the figural panels that formed part of the overall mural designs, especially those depicting Greek heroes and famous myths. These were cut out of the walls and transferred to the Naples Archaeological Museum. (The painting of the brawl in the amphitheater, Fig. 2-17, suffered this fate.) In time, more enlightened archaeologists put an end to the practice of cutting pieces out of the walls and gave serious attention finally to the mural designs as a whole. Toward the end of the 19th century, August Mau, a German art historian, divided the various mural painting schemes into four so-called Pompeian Styles, numbered in the order they were introduced. Mau's classification system, although later refined and modified in detail, still serves as the basis for the study of Roman painting. The two Republican styles are discussed in this chapter.

THE FIRST STYLE AND GREECE The *First Style* also has been called the Masonry Style because the decorator's aim was to imitate costly marble panels using painted stucco relief. (For walls faced with real marble slabs, see, for example, Fig. 12-1.) In the fauces (**Fig. 3-16**) of the Samnite House at Herculaneum, one of the city's older townhouses, an unknown painter created a stunning illusion of walls constructed, or at least faced, with marbles imported from quarries all over the Mediterranean. Similar walls may be found at Pompeii, including in the atrium, tablinum, and alae of the House of Sallust (Fig. 3-4) and throughout the House of the Faun. This approach to wall decoration is comparable to the modern practice, employed in private libraries and corporate meeting rooms alike, of using cheaper manufactured materials to approximate the look and shape of genuine wood paneling. The practice is not, however, uniquely Campanian or Roman. First Style walls are well documented in the Greek world from the late fourth century BCE on. The use of the First Style in Republican houses is yet another example of the Hellenization of Roman domestic architecture during the late second and early first centuries BCE.

SECOND STYLE ILLUSIONISM The First Style never fell completely out of fashion, but after 80 BCE a new approach to mural design became more popular. The *Second Style* is in most respects the antithesis of the First Style. Some scholars have argued that the Second Style also has precedents in Greece, but most believe it is a Roman invention. Certainly, the Second Style evolved in Italy and was popular until around 15 BCE, when Roman painters introduced the Third Style (see Chapter 5). Second Style painters aimed not to create the illusion of an elegant marble wall, as First Style painters sought to do. Rather, they wanted to dissolve a room's confining walls and replace them with the illusion of an imaginary three-dimensional world. They achieved this effect pictorially. The First Style's modeled stucco panels gave way to the Second Style's flat wall surfaces.

HOUSE OF THE GRIFFINS Several of the earliest examples of the Second Style were found, not coincidentally, in a house

3-16 **First Style mural painting, fauces, Samnite House, Herculaneum, late second century BCE.**

in the most elite residential neighborhood in the Roman world, the Palatine Hill in Rome. The so-called House of the Griffins was discovered when excavators explored the substructures of the palace (Fig. 9-15) the emperor Domitian built at the end of the first century CE. Several of the painted rooms in the old Republican domus survived relatively intact underneath the vast imperial residence. The house owes its name to the painted stucco relief griffins in one of the rooms. Illustrated here is a different room, room 2 (**Fig. 3-17**), which has been reconstructed in the Palatine Antiquarium.

In this early example of the Second Style, datable around 80 BCE, the painter maintained the First Style goal of creating

Roman Mural Painting

Roman wall paintings were true frescoes. *Fresco* (Italian for "fresh") has a long history in the Mediterranean, where the Minoans, a pre-Greek people of the Aegean Islands, regularly used it as early as the mid-second millennium BCE. Fresco means that the colors were applied while the plaster was still damp. Because the pigments are absorbed into the wall's surface as the plaster dries, fresco is among the most durable painting techniques.

Roman mural painting was a painstaking process. First, the painter had to prepare the wall by applying several layers of plaster to ensure a smooth surface. In the finest examples, six or seven coats of lime plaster were applied—mixed with water and sand or gravel for the undercoats and marble dust for the top three coats. Only then could painting begin.

Each wall often required weeks to complete. The first step was to draw the composition in red ochre or to incise outlines into the plaster surface. Then the colors were applied with a brush using a variety of pigments produced from different minerals. Many Roman murals have visible seams between sections of the wall. These sections are the areas the painters set out to complete in a single session (called a *giornata di lavoro*; Italian for "work day"). Any area of plaster the painter could not cover in a giornata had to be cut away so that fresh plaster could be applied for the next session. Generally, apprentices were assigned less important areas of the wall to paint; the master of the workshop painted the figures or landscapes. Finally, when the surface dried, the wall was polished to achieve a marblelike finish. ■

the appearance of marble-revetted walls but did so using only brush and pigment. Although there are no relief panels, the illusionism is actually heightened, because the painter depicted a series of columns on projecting pedestals all around the room. The Second Style muralist transformed the room into a luxurious oecus like those with real columns in the House of the Silver Wedding (Fig. 3-12) and the House of the Labyrinth (Fig. 3-13) at Pompeii. Vitruvius described exactly

this kind of progression in painting styles when he reported that "the ancients who established the beginnings of painting plaster first imitated the varieties and placement of marble veneers . . . [Later] they imitated . . . the projection into space of columns and pediments."[5]

[5] Vitruvius 5.5.1–2. Translated by Rowland, 91.

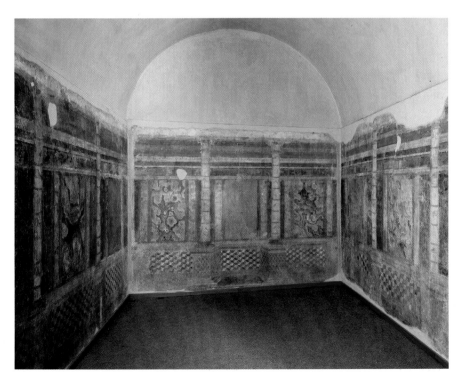

3-17 Second Style mural paintings, room 2, House of the Griffins, Palatine Hill, Rome, ca. 100–80 BCE. Antiquario Palatino, Rome.

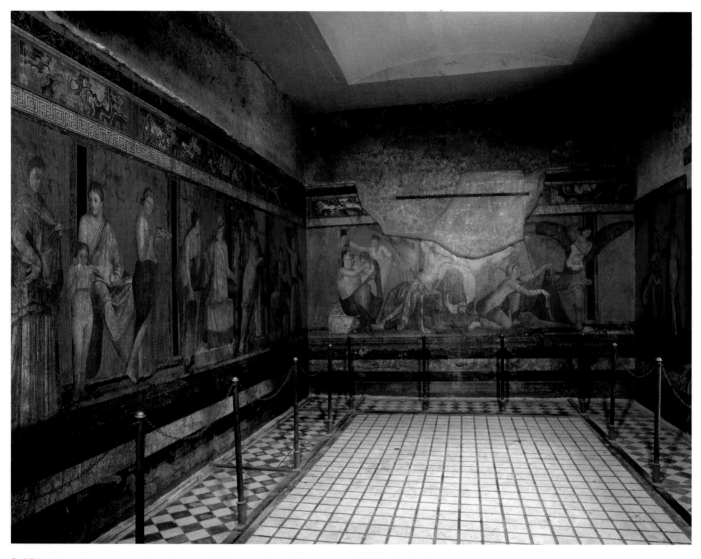

3-18 Dionysiac mystery rites, Second Style mural paintings, room 5, Villa of the Mysteries, Pompeii, ca. 60–50 BCE.

3-19 Flagellation of the bride, detail of the Second Style mural paintings, room 5, Villa of the Mysteries, Pompeii, ca. 60–50 BCE.

3-20 Bride, attendant, and erotes, detail of the Second Style mural paintings, room 5, Villa of the Mysteries, Pompeii, ca. 60–50 BCE.

DIONYSIAC MYSTERIES A somewhat later example of Second Style painting is the room (**Fig. 3-18**) that gives its name to the Villa of the Mysteries. Many scholars believe that this chamber (Fig. 3-14, no. 6) was used to celebrate, in private, the rites of the Greek god Dionysos (Roman Bacchus). Dionysos was the focus of an unofficial mystery religion popular in Italy at this time among women. The precise nature of the Dionysiac rites is unknown, but the figural cycle in the Villa of the Mysteries, illustrating mortals (all women save for one boy) interacting with mythological figures, probably

provides some evidence for the cult's initiation rites. In these ceremonies young women, emulating the Greek heroine Ariadne, were united in marriage with Dionysos.

The backdrop for the nearly life-size figures is a series of large painted marble-revetment panels, in front of which the painter created the illusion of a shallow ledge on which the human and divine actors move around the room. Especially striking is the way some of the figures interact across the corners of the room. For example, a seminude winged woman at the far right of the rear (east) wall (**Fig. 3-19**) lashes out with her whip across the space of the room at a kneeling woman with a bare back (whom most scholars identify as the initiate and bride-to-be of Dionysos) on the left end of the right (south) wall. At the southwest corner of the room (**Fig. 3-20**), the bride appears again looking at her reflection in a mirror that a small cupid (*eros,* pl. *erotes*) holds up. A second eros gazes at the seated bride from the adjacent wall. All the figures reveal the painter's mastery of modeling flesh and cloth using hatching, shading, and color modulation—techniques the Greeks pioneered in the fifth century BCE.

There is no agreement regarding the precise meaning of the details of the figure cycle, whether the Pompeian frieze is a copy or near-copy of a Greek original, or even whether the narrative unfolds from left to right around the room. Nevertheless, it is incontestable that the painter took into consideration the space of this specific room in planning the placement of the figures. Despite the presence of Dionysos, satyrs, and other figures from Greek mythology, this is a Roman Second Style design.

PERSPECTIVE PAINTING In the House of the Griffins and the Dionysiac mystery room, the spatial illusionism is confined to the painted colonnade or the shallow platform that projects into the room. But in mature Second Style designs, like that of cubiculum 16 (Figs. 3-14, no. 7, and **3-21**) of the

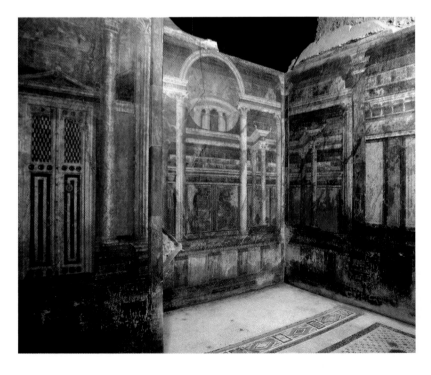

3-21 Second Style mural paintings, cubiculum 16, Villa of the Mysteries, Pompeii, ca. 60–50 BCE.

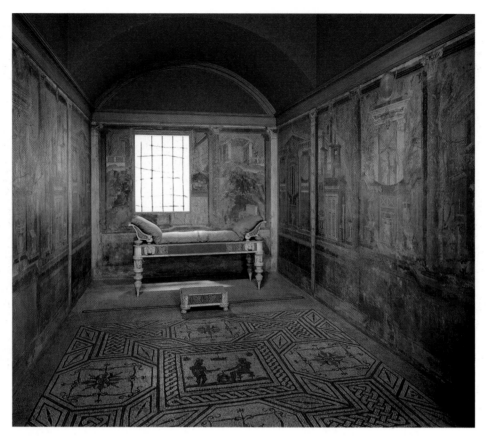

3-22 **Second Style mural paintings, cubiculum M, Villa of Publius Fannius Synistor, Boscoreale, ca. 50–40 BCE. Metropolitan Museum of Art, New York.**

Villa of the Mysteries, the viewer also gets a glimpse beyond the walls. In cubiculum 16, the marble-paneled wall behind the projecting columns is lower than that in the House of the Griffins, revealing a tholos temple "behind" the cubiculum wall. The painter also suggested that there is a way to enter the sacred precinct: Painted double doors invite the viewer to walk through the wall into the illusionistic space beyond it.

In a cubiculum (**Fig. 3-22**) from the Villa of Publius Fannius Synistor at Boscoreale, near Pompeii, decorated between 50 and 40 BCE, the mural painter opened up the walls even farther. All around the room vistas of Italian towns, marble temples, and colonnaded courtyards greet the viewer. The suggestion of a three-dimensional world beyond the confines of the room is so successful because the Boscoreale painter, like the painter of cubiculum 16 in the Villa of the Mysteries, had a knowledge of *linear (single vanishing-point) perspective*, although both artists were inconsistent in applying it. In this kind of perspective (often incorrectly said to be an innovation of Italian Renaissance artists), all the receding lines in a composition converge on a single point along the painting's central axis to create the illusion of distance. Ancient writers noted that Greek painters of the fifth century BCE first used linear perspective for the design of Athenian stage sets (hence its Greek name, *skenographia* or scene painting). In the Boscoreale cubiculum, the device is most successfully employed in

the far corners, where a low gate leads to a peristyle framing a tholos temple (**Fig. 3-1**). Linear perspective was a favored tool of Second Style painters seeking to transform the usually windowless walls of Roman houses into "picture-window" vistas that expanded the apparent space of the rooms.

An almost identical scheme was used in the Corinthian *oecus* of the House of the Labyrinth (Fig. 3-13). There, the actual columns of the room often line up with the painted columns, enhancing the illusion of depth and blurring the distinction between the real and the painted.

ODYSSEY LANDSCAPES The similarities among the Villa of the Mysteries, Boscoreale, and House of the Labyrinth designs suggest that the painting workshops around the Bay of Naples shared a common repertory of motifs, probably recorded in the form of pattern books, and adjusted them as necessary to conform to the shape and dimensions of each room they were called upon to decorate. Even some schemes that are unique today may have been common in antiquity. A case in point is the series of fragmentary paintings of the adventures of the Homeric hero Odysseus that were excavated in a house on the Esquiline Hill in Rome. The one reproduced here (**Fig. 3-23**) represents Odysseus in the Underworld. The hero and his companions (labeled in Greek) are seen through Corinthian pillars. The missing lower portion

3-23 **Odysseus in the Underworld, detail of the Second Style mural paintings in a house on the Esquiline Hill, Rome, ca. 50–40 BCE. Biblioteca Apostolica Vaticana, Rome.**

of the wall would have resembled the murals in the tetrastyle oecus of the House of the Silver Wedding (Fig. 3-12). Vitruvius listed "the wanderings of Ulysses [Odysseus] through various landscapes"[6] as a standard subject for Republican mural painting, but the Esquiline landscapes are the only ones that survive.

The Esquiline landscapes depicting episodes in the *Odyssey* are almost certainly copies or variations of Greek panel paintings or illustrations in books (see "Roman Illustrated Books," Chapter 10, page 151). But, as in the Dionysiac frieze of the Villa of the Mysteries, Roman painters transformed the originals by setting the figural scenes in a Second Style architectural frame. In that respect, the *Odyssey* landscapes epitomize Republican art in their simultaneous dependence on and independence from Greek prototypes.

[6] Vitruvius 7.5.2. Translated by Rowland, 91.

SUMMARY

The houses and villas buried during the eruption of Mount Vesuvius in 79 CE have given historians of art and architecture a rich body of material with which to trace the development of domestic architecture and mural painting during the closing centuries of the Roman Republic. The oldest houses at Pompeii are of the domus italica type and conform closely to Etruscan prototypes, whereas later examples reveal the desire of Roman patrons to imitate the column-filled homes of the Greeks. The evolution of the Republican house therefore paralleled that of the Republican temple (see Chapter 1).

Because Roman houses were also places where important business was conducted and guests were frequently entertained, owners with sufficient means decorated them with statues, mosaics, and mural paintings. The earliest mural painters, working in the so-called First Style, followed the Greek practice of using painted stucco relief to make walls appear as if they were revetted with marble. Second Style painters pursued a very different goal: to cover the walls with illusionistic paintings of figures, architecture, and landscapes that made the walls seem to disappear.

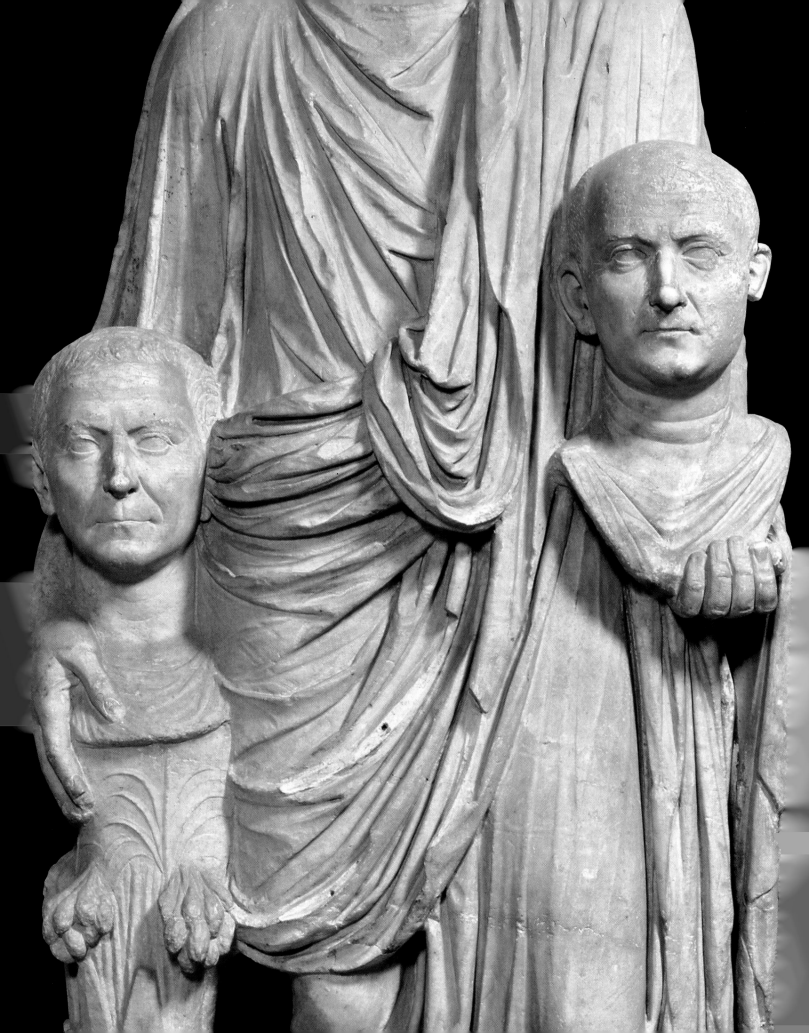

From Marcellus to Caesar

When the owners of private homes, like the proprietor of the House of the Faun at Pompeii, decided to decorate their atria and peristyles with Greek-style statues of bronze and marble (Figs. 3-9, 10-12, and 10-13) and to place mosaics on their floors (Fig. 3-10) and frescoes on their walls recalling masterpieces of Greek panel painting (Figs. 10-15 to 10-17), they were following a practice that began in 211 BCE. In that year, Marcellus (see "Republican Senators, Consuls, and Generals," page 48), conqueror of the fabulously wealthy Sicilian Greek city of Syracuse (Map 1-1), broke with precedent and brought back to Rome not only the usual spoils of war—captured arms and armor, gold and silver coins, and the like—but also the city's artistic patrimony. Thus began, in the words of the historian Livy, "the craze for works of Greek art" (see "Marcellus, Syracuse, and the Craze for Greek Art," page 49).[1] According to the biographer Plutarch, the Romans, "who had hitherto been accustomed only to fighting or farming," now began "affecting urbane opinions about the arts and about artists, even to the point of wasting the better part of a day on such things."[2] Ships filled with plundered Greek statues and paintings became a frequent sight in the harbor of Ostia at the mouth of the Tiber River (see Chapter 14).

ROMAN GENERALS AND GREEK ART

Exposure to Greek sculpture and painting as well as the splendid marble temples of the Greek gods (see Chapter 1) increased as the Romans expanded their conquests beyond Italy. Greece became a Roman province in 146 BCE, and in 133 BCE, the last ruler of Pergamum (see Map 17-1, page 252), the most powerful kingdom in western Asia Minor, willed his realm to Rome.

FLAMININUS Roman generals also left their mark on the Greek landscape by erecting victory monuments and, in one notable instance, minting their own coins for use in Greece. Titus Quinctius Flamininus became a hero in Greece when he liberated the old city-states from Macedonian rule in 197 BCE. After his

4-1 Detail of a statue (Fig. 4-7) of a man holding portrait busts of his ancestors, from Rome, late first century BCE. Musei Capitolini–Centrale Montemartini, Rome.

[1] Livy, *History of Rome*, 35.40.1–3.

[2] Plutarch, *Life of Marcellus*, 21. Translated by J. J. Pollitt, *The Art of Rome, c. 753 B.C.–A.D. 337: Sources and Documents* (New York: Cambridge University Press, 1983), 32.

Republican Senators, Consuls, and Generals

The Republic was founded in 509 BCE when the Romans overthrew Tarquinius Superbus, the last Etruscan king of Rome. It ended in 27 BCE when the Senate bestowed the title of Augustus on Octavian after more than a decade of civil war. Following are some of the major Republican personalities:

Marcellus (Marcus Claudius Marcellus, 268–208 BCE) commanded Roman armies in Gaul and against Hannibal. He besieged and captured the Greek city of Syracuse in 211 BCE.

Fabius Maximus (Quintus Fabius Maximus, 260–203 BCE) also fought against Hannibal in the First Punic War. He gained fame for capturing Tarentum (Taranto) from the Greeks in 209 BCE.

Cato (Marcus Porcius Cato, 234–149 BCE) was a senator and consul who celebrated a triumph in 194 BCE. He is remembered above all as the greatest orator of his day and as the defender of traditional Roman values.

Flamininus (Titus Quinctius Flamininus, 229–174 BCE) defeated King Philip V at the battle of Cynoscephalae in 197 BCE and freed the cities of Greece from Macedonian domination.

Aemilius Paullus (Lucius Aemilius Paullus, 229–160 BCE) successfully concluded the Third Macedonian War by defeating King Perseus at the battle of Pydna in 168 BCE.

Mummius (Lucius Mummius, dates unknown) was consul in 146 BCE when he put down the revolt of the Achaean Confederacy in Greece and destroyed Corinth.

Marius (Gaius Marius, 157–86 BCE), a *novus homo* ("new man") in the Roman Senate, celebrated a triumph in 104 BCE over Jugurtha, King of Numidia in North Africa.

Sulla (Lucius Cornelius Sulla, 138–79 BCE) was general in the Social War, which led to the establishment of a Roman colony at Pompeii. He sacked Athens in 86 BCE during the war against King Mithradates of Pontus.

Pompey (Gnaeus Pompeius Magnus, 106–48 BCE) was a renowned general who celebrated triumphs for his successful campaigns in Africa and Asia but whom Caesar decisively defeated in 48 BCE at the battle of Pharsalus in Greece.

Julius Caesar (Gaius Iulius Caesar, 100–44 BCE), whose family claimed descent from Venus, was conqueror of Gaul. In 44 BCE he became *dictator perpetuo* (dictator for life) and was assassinated on the Ides of March.

Mark Antony (Marcus Antonius, 83–30 BCE) was co-consul with Caesar in 44 BCE. He allied himself with Queen Cleopatra of Egypt in the civil war following Caesar's death. Defeated at Actium in 31 BCE, he committed suicide in 30 BCE.

Octavian (Gaius Octavius, 63 BCE–14 CE) was the grand-nephew and adopted son of Caesar and victor in the civil war after Caesar's assassination. He became Rome's first emperor in 27 BCE. ■

defeat of Philip V of Macedon, Flamininus issued gold *staters* bearing his portrait head on the obverse (**Fig. 4-2**) and the personification of Victory crowning his name on the reverse. Such coins could never have been produced at home, where the Romans prohibited the portrayal of living persons on their currency (as the U.S. government does today). Roman coins of that era bore images solely of deities, personifications, and heroes, but in the Greek world, ruler portraits frequently appeared on coin obverses.

Flamininus's portrait is stylistically in the *Hellenistic* tradition as well (the period of Greek art between the death of Alexander the Great in 323 BCE and the Roman conquest of Egypt in 31 BCE). He wears a beard, the norm for mature Greek men but rare among Romans. His tousled hair spilling over his forehead and worn long behind his ears and neck is also characteristic of contemporary Greek numismatic portraiture.

4-2 **Stater of Titus Quinctius Flamininus, struck in Greece, 197–196 BCE. Gold, approx. $\frac{3}{4}''$ diameter. British Museum, London.**

Marcellus, Syracuse, and the Craze for Greek Art

According to both Livy and Plutarch, Marcus Claudius Marcellus's *triumph* (Latin *triumphus;* the celebratory procession through Rome that the Senate awarded to victorious generals) in 211 BCE after his victory over Syracuse marked the beginning of the influx of Greek statues and paintings into Rome and of the Romans' fascination with Greek art. Livy acknowledged that Marcellus acted legally, but observed that his action was unprecedented.

> The statues and paintings, of which Syracuse had a great abundance . . . were no doubt the spoils of the enemy and were property taken by the right of war; all the same it was from these that one can trace the beginning of the craze for works of Greek art.*

Plutarch described Marcellus's motivation for removing the artworks from Syracuse and the controversy that resulted from his decision:

> Marcellus . . . returned bringing with him many of the most beautiful public monuments in Syracuse, realizing that they would both make a visual impression of his triumph and also be an ornament for the city. Prior to this Rome neither had nor even knew of these exquisite and refined things . . . For this reason Marcellus was even more respected by the populace—he had decorated the city with sights which both provided pleasure and possessed Hellenic charm . . . while Fabius Maximus was more respected by the older Romans. For

Fabius neither disturbed nor carried any such things from Tarentum when he took it, but rather, although he carried off the money and other valuables of the city, he allowed the statues to remain, adding this widely remembered remark: "Let us leave," he said, "these aggravated gods to the Tarentines." The elders blamed Marcellus . . . because he filled the Roman people . . . with a taste for leisure and idle talk . . . [But Marcellus] proclaimed proudly . . . that he had taught the Romans, who had previously understood nothing, to respect and marvel at the beautiful and wondrous works of Greece.†

The conservative reaction to Marcellus's triumph is best summed up in the speech that Livy attributed to the renowned orator and senator Cato:

> I fear that these things will make prisoners of us rather than we of them. They are dangers, believe me, those statues which have been brought into the city from Syracuse. For now I hear far too many people praising and marveling at the ornaments of Corinth and Athens and laughing at our terracotta [statues] of the Roman gods [that is, statues like Vulca's for the Temple of Jupiter Capitolinus; see Chapter 1].‡ ■

* Livy, *Roman History*, 25.40.1–2. Translated by J. J. Pollitt, *The Art of Rome, c. 753 B.C.–A.D. 337: Sources and Documents* (New York: Cambridge University Press, 1983), 33.

† Plutarch, *Life of Marcellus*, 21. Translated by Pollitt, 32–33.

‡ Livy, *Roman History*, 34.4.3–4. Translated by Pollitt, 33.

AEMILIUS PAULLUS Three decades later, Rome won another victory over Macedon when Lucius Aemilius Paullus defeated King Perseus at Pydna in 168 BCE. To commemorate his success, Paullus converted to his own glorification a monument Perseus had erected in the important Panhellenic sanctuary of Apollo at Delphi (Map 17-1), thereby humiliating the king a second time. Perseus's monument took the form of a tall pillar capped by a bronze equestrian portrait. Paullus replaced the portrait with one of himself and added a frieze around the top of the pillar depicting the battle of Pydna.

The frieze (**Fig. 4-3**) is the work of a Greek artist in Roman employ and, like Flamininus's portrait, is fully Hellenistic in

4-3 **Battle of Pydna, detail of the frieze of the Victory Monument of Aemilius Paullus, Delphi, Greece, 168 BCE. Marble, 1′ ¼″ high. Archaeological Museum, Delphi.**

style. The sculptor displays a typically Greek interest in depicting warfare as a series of heroic duels and in showing the combatants and their horses in a variety of postures. Noteworthy are the horse collapsing to the ground and especially the riderless horse with a twisted, foreshortened head and neck seen at an angle from the rear. The riderless horse also establishes that the frieze represents the battle of Pydna specifically. A prophecy foretold that the side that initiated the battle would lose it, and thus the fighting did not begin until a horse broke free from the Roman ranks. When the Macedonians saw the horse approaching, they thought the Romans had attacked, and they launched their own counter-attack. Unwittingly, Perseus's army had attacked first—and lost. The inclusion of this detail seems to reflect a Roman desire for explicit historical narrative in contrast to the Greek preference for generic representations of heroic combat.

When Aemilius Paullus returned to Rome, he celebrated a triumph in which he exhibited the treasures he had confiscated from Perseus. Plutarch reported that the spoils of war were so extensive that "the triumph was spread out over three days. The first day was just barely sufficient for seeing the statues which had been seized, and the paintings and the colossal images, all carried along on 250 wagons."[3]

PASITELES The triumphs that brought vast quantities of Greek statues to Rome created an almost insatiable demand for Greek masterpieces among wealthy Romans. The supply of originals was limited, and soon workshops sprang up in Italy to churn out copies of statues by renowned Greek sculptors, usually in marble, a much less expensive medium than the bronze that most Greek masters preferred. The artists who produced these copies were themselves primarily Greeks, either slaves or freedmen who welcomed the abundant commissions for sculpture available in Italy. To facilitate copying, which became a veritable industry at this time, sculptors employed a *pointing machine,* a device for reproducing sculpture consisting of a framework of metal arms used to measure and transfer a series of points on a plaster model to a block of stone in order to ensure that the copy is of the exact dimensions of the model.

More adventurous artists produced variations on the Greek originals, often combining elements of statues by different artists from different periods. The most famous of these sculptors was a Greek artist from southern Italy named Pasiteles, who established an influential workshop in Rome during the first half of the first century BCE.

An unsigned work believed to have been carved by one of his followers is the so-called San Ildefonso group (**Fig. 4-4**), now in Madrid but found in the Gardens of Sallust on the slopes of the Pincian and Quirinal hills in Rome. The subject is unknown. Two nude youths stand beside a small statue of a

4-4 **School of Pasiteles: San Ildefonso group, from the Gardens of Sallust, Rome, ca. 50–25 BCE. Marble, 5′ 3 $\frac{3}{8}$″ high. Prado, Madrid.**

caryatid (a female figure used in place of a column in the Ionic order). One lights a small altar with a torch held in his right hand. His companion, who leans against him for support, is a near-copy of the *Apollo Sauroktonos* (Lizard-Slayer) by Praxiteles, a mid-fourth-century BCE work. (The head, a portrait of Antinous, is a later replacement and dates to the Hadrianic era; compare Fig. 12-6.) The torch-bearer is a near-copy of Polykleitos's mid-fifth-century BCE statue of Kyniskos, a Greek athlete. The head, however, is a copy of another work by the same master, the *Doryphoros* (Spear-Bearer, Fig. 10-12). The caryatid is an *Archaistic* work—that is, a revival of the style of the Archaic Greek period of the sixth century BCE, but not a copy of any specific work. In contrast to the two Classical Greek-inspired statues, the caryatid stands in a stiff posture with her head rigidly frontal and both feet planted firmly

[3] Plutarch, *Life of Aemilius Paullus,* 32. Translated by Pollitt, 44.

4-5 **Wedding procession of Neptune and Amphitrite, two details of the frieze of the "Altar of Domitius Ahenobarbus," from Rome, late second or early first century BCE. Marble, 2′ 8″ high. Glyptothek, Munich.**

on the ground, key features of Archaic statuary, as are the patterned, pressed folds of her garment. Such eclecticism is not surprising, given that the Romans were exposed to 500 years of Greek sculptural tradition all at once. Nonetheless, eclecticism—in architecture as well as in sculpture and painting—remained a central feature of Roman art throughout its long history.

"ALTAR OF DOMITIUS AHENOBARBUS" Another example of eclecticism in sculpture is the so-called Altar of Domitius Ahenobarbus, a work that is neither an altar nor associated with Domitius Ahenobarbus. The old name persists, although many art historians now refer to the monument by the more neutral title "Paris/Munich Reliefs" because its reliefs are divided today between the Louvre in Paris and the Glyptothek in Munich. The reliefs probably decorated a statuary

base in or near the Temple of Neptune in Rome. The date is controversial, but most scholars believe the reliefs were carved sometime during the late second or early first century BCE.

Three sides of the base were covered with reliefs depicting the wedding procession (**Fig. 4-5**) of the sea god Neptune and his bride Amphitrite, accompanied by *nereids* and *tritons* (female and male sea creatures respectively) and flying erotes. At the center are the groom and bride in a chariot pulled by music-making tritons (Fig. 4-5, *top*). The frieze features animated movement, swirling cloaks, diaphanous garments, and many foreshortened figures (some of which are seen from the rear, Fig. 4-5, *bottom*, as is the riderless horse on the Aemilius Paullus frieze, Fig. 4-3). Almost certainly the work of a Greek sculptor, the reliefs document the importation of Hellenistic style and mythological subject matter into the repertory of Roman Republican art in Italy.

4-6 **Census, sacrifice to Mars, and enrollment of troops, detail of the frieze of the "Altar of Domitius Ahenobarbus," from Rome, late second or early first century** BCE. **Marble, 2′ 8″ high. Louvre, Paris.**

The fourth side (**Fig. 4-6**) of the "altar" offers a sharp contrast in both style and subject. Largely static vertical figures acting out a contemporary Roman ritual replace the Greek style and theme of the rest of the frieze. At the left, Roman officials solemnly take the census, which determined, among other things, who was eligible for military service. In the center, a priest, wearing a toga with a veil drawn over his head, offers sacrifice at an altar to the war god Mars, who is portrayed as an unseen general standing to the left of the altar. Attendants (*victimarii*) slowly lead in the three animals—a pig (*sus*), a sheep (*ovis*), and a bull (*taurus*)—to be sacrificed to Mars in the ritual called the *suovetaurilia*. At the right, newly enlisted soldiers prepare to depart with their units.

The dichotomy of style and subject matter is so pronounced between the Munich and Paris reliefs that until it was established that both sections came from the same source, scholars thought they decorated different monuments. In fact, it has recently been argued that the Hellenistic-style reliefs did once decorate an older Greek monument and that they were trimmed for reuse on the Roman base. But whether the wedding procession reliefs were created in Italy for a new monument or were imported from abroad, the resulting clash of styles is the same. This combination of different artistic modes was a recurring phenomenon in Roman relief sculpture (compare Figs. 13-17 and 13-18), as in statuary.

PORTRAITURE

Whoever commissioned the "Altar of Domitius Ahenobarbus" was probably a Roman official from an old and distinguished family, like the victorious generals Marcellus, Aemilius Paullus, and Fabius Maximus who used the spoils of war to finance public works. These aristocratic patricians were fiercely proud of their lineage. They kept wax likenesses (*imagines*) of their ancestors in wooden cupboards in their homes and paraded them at the funerals of prominent relatives (see "Ancestor Portraits," page 54).

Ancestor portraits separated the old patrician families not only from the plebeian middle and lower classes of working citizens and former slaves but also from the newly wealthy and powerful of more modest origins. Around 40 BCE, Sallust described the speech Marius gave as consul in 107 BCE in which he felt compelled to defend himself as a self-made *novus homo* ("new man") in the Senate who did not have a home filled with portraits of his illustrious patrician ancestors: "I am not able to inspire confidence by parading the masks or triumphs or consulships of my ancestors, but . . . I can show spears and standards presented for valour . . . and besides the scars on the front of my body. These are my masks, these my 'nobility'."[4]

MAN WITH ANCESTOR BUSTS Pride in genealogy was unquestionably the motivation for a unique Roman portrait statue (**Fig. 4-7**) datable to the early years of the Roman Empire in which a man wearing a toga, the badge of Roman citizenship, holds in each hand a bust of one of his male forebears. The head of the *togatus* is ancient but does not belong to the statue, and it is uncertain how he was portrayed, but the two heads he holds (**Fig. 4-1**)—probably likenesses of his father and grandfather—are characteristic examples of Republican portraiture of the first century BCE. The heads may be reproductions of wax or terracotta portraits; marble or bronze heads would have been too heavy to carry. They are not, however, wax *imagines*, because they are sculptures in the round, not masks. The statue nonetheless would have had the same effect on the observer as the spectacle of parading ancestors at a patrician funeral.

[4] Sallust, *Jugurthine War*, 85.29–30. Translated by Harriet I. Fowler, *Ancestor Masks and Aristocratic Power in Roman Culture* (Oxford: Clarendon Press, 1996), 312.

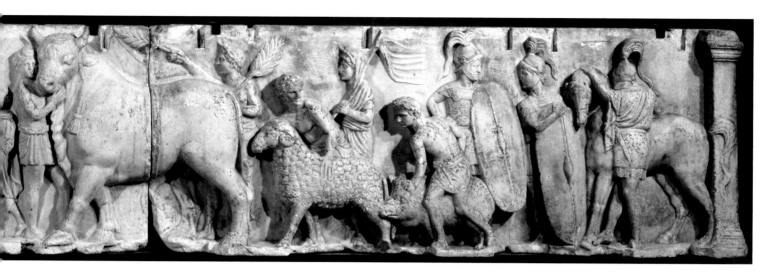

4-7 Man with portrait busts of his ancestors, from Rome, late first century BCE. Marble, 5′ 5″ high. Musei Capitolini–Centrale Montemartini, Rome.

REPUBLICAN VERISM These and other surviving portraits of the Late Republic, like the *imagines* upon which they appear to be modeled, give the impression—whether true or not—of being literal reproductions of individual faces, without any hint of an attempt on the part of the sculptor to beautify the appearance of those portrayed. The subjects of these so-called *veristic* (superrealistic) portraits were almost exclusively men (and to a lesser extent women) of advanced age, for generally only elders held power in the Republic. A head (**Fig. 4-8**) of an unidentified patrician from Osimo, south of

4-8 Head of an old man, from Osimo, mid-first century BCE. Marble, life size. Palazzo del Municipio, Osimo.

Ancestor Portraits

Many ancient authors make reference to the wax masks of distinguished ancestors that were displayed in the atria of patrician homes and formed the backdrop for the *salutatio* of a client fulfilling his duty to call upon his patron each morning (see "The Social Structure of the Roman House," Chapter 3, page 32).

Pliny, for example, writing in the 70s CE, lamented the decline of realistic portraiture in his day, remarking that it was

> different in the *atria* of the ancestors where portraits offered a spectacle to behold, not the statues by foreign artists either of bronze or marble; but faces rendered in wax were arranged in separate cupboards . . . *imagines* to accompany funerals in the extended family. And whenever someone died the whole crowd of his family members who had ever lived was present.*

Polybius, who wrote a history of Rome in the middle of the second century BCE, painted a vivid picture of the funerals Pliny mentioned:

> For whenever one of the leading men amongst them dies . . . the body is brought . . . [to] the Forum where it is usually propped up for all to see . . . [A son or another relative] delivers a speech about the virtues of the dead man and his achievements during his lifetime . . . After that they bury the body and perform the customary rites. Then they place a likeness of the dead man in the most public part of the house, keeping it in a small wooden shrine. The likeness is a mask especially made for a close resemblance both as regards the shape of the face and its colouring . . . And whenever a leading member of the family dies, they introduce them [the masks] into the funeral procession, putting them on men who seem most like them in height and as regards the rest of their general appearance. These men assume their costume in addition [for example, the gold embroidered toga of a man who had celebrated a triumph] . . . It is not easy for an ambitious and high minded young man to see a finer spectacle than this. For who would not be won over at the sight of all the masks together of those men who had been extolled for virtue as if they were alive and breathing?† ■

* Pliny, *Natural History*, 35.6. Translated by Harriet I. Fowler, *Ancestor Masks and Aristocratic Power in Roman Culture* (Oxford: Clarendon Press, 1996), 304.

† Polybius, *History of Rome*, 6.5.1–10. Translated by Fowler, 309.

Ancona, near Italy's Adriatic coast (see Map 1-1, page 2), is one of the most striking surviving Republican portraits. The sculptor painstakingly recorded the receding hairline, sunken cheeks, thin lips, and each rise and fall, each bulge and fold, of the facial surface, all in the manner of a mapmaker who did not want to miss the slightest detail of surface change. Scholars debate whether portraits such as this one were truly blunt records of actual features or exaggerated types designed to make a statement about personality: serious, experienced, determined, loyal to family and state—virtues that were much admired during the Republic. It was widely believed in the ancient world that physiognomy revealed character. The veristic Republican portraits were designed to convey those elements of character that the patrician class valued most highly.

AULUS METELLUS Almost all preserved Republican portraits were carved in marble. A rare exception is the life-size bronze statue (**Fig. 4-9**) discovered in 1566 in Cortona near Lake Trasimeno in the heart of Etruria. The portrait of Aulus Metellus is a supremely self-confident image of a magistrate with close-cropped hair and the first signs of aging in his lined face. He raises his arm to address an assembly—hence his modern name, "Arringatore" (Orator). The Arringatore was most likely produced at about the time that Roman hegemony over the Etruscans became total. The so-called Social War of the early first century BCE, during which many Italian cities, Pompeii among them, revolted against Rome's hegemony, ended in 89 BCE with the conferring of Roman citizenship on all of Italy's inhabitants. In fact, Aulus Metellus—his Etruscan name, Aule Metele, and his father's and mother's names are inscribed on his garment's hem—wears the short toga and high-laced boots of a Roman magistrate. This orator is Etruscan in name only. The statue is therefore an invaluable document of the demise of the Etruscans as well as a masterpiece of Republican portraiture.

"PSEUDO-ATHLETE" The tradition of displaying wax masks of ancestors in atrium cupboards and the practice of carving portraits that terminate at the neck or shoulders (Figs. 4-1, 4-7, and 4-8) reflect the Roman belief that the head alone was enough to constitute a portrait. The Greeks, in contrast, believed that head and body were inseparable parts of an integral whole, so their portraits were always full length. In fact, in Republican portraiture, veristic heads were often, although incongruently, placed on bodies to which they could not possibly belong.

4-9 **Aulus Metellus ("Arringatore"), from Cortona, ca. 90–70 BCE. Bronze, approx. 5′ 7″ high. Museo Archeologico Nazionale, Florence.**

4-10 **"Pseudo-Athlete," from the House of the Diadoumenos, Delos, Greece, early first century BCE. Marble, 7′ 5″ high. National Archaeological Museum, Athens.**

That is the case in the curious and discordant over-life-size portrait (**Fig. 4-10**) of a nude man that was found in the house of a Roman businessman on the Greek island of Delos. The French excavators dubbed his residence the House of the Diadoumenos because it also contained a marble copy of a mid-fifth-century BCE bronze statue by Polykleitos depicting a nude Greek athlete tying a fillet around his head. The Polykleitan *Diadoumenos* no doubt inspired the Roman portrait, which the French nicknamed the "Pseudo-Athlete" because of the signs of advanced age in the head. The portrait incorporates all the trappings of Greek statuary, including the *contrapposto*, or weight shift, of the Polykleitan original and the sharp turn of the head upward and to one side that was a common trait of

Hellenistic statuary. But the head, with its bald pate, lined forehead, prominent ears, and heavy jowls, is unmistakably Republican, as is the distinctive combination of veristic head and idealized body. Each has an independent message for the viewer. The nude body announces the Greek taste and heroic pretensions of the house's owner. The realistic head proclaims that he is a man of experience and, presumably, wisdom. In Greek portraiture, young bodies always have youthful heads; old bodies always have aged faces. In the Roman Pseudo-Athlete, the body is a prop for the head, not part of a unified image. Nudity is here a kind of costume. The businessman would never have appeared nude in public or in front of his guests at home. Nudity is the "garment" he has donned only for this portrait.

4-11 **Statue of a general, from the Sanctuary of Hercules, Tivoli, ca. 75–50 BCE. Marble, approx. 6′ 2″ high. Museo Nazionale Romano–Palazzo Massimo alle Terme, Rome.**

TIVOLI GENERAL The Pseudo-Athlete is not unique. Quite the contrary. Several similar portraits exist, and all exhibit the same eclectic combination of idealized Greek body and veristic Roman head. An example of the type from Italy is the portrait (**Fig. 4-11**) of a general found in the Sanctuary of Hercules at Tivoli (Fig. 1-17). The *cuirass* (leather breastplate) at the man's side, which serves as a prop for the heavy marble statue, is also the emblem of his rank, comparable to the toga and high boots Aulus Metellus (Fig. 4-9) wears. But the general does not appear as he would in life. Although he has a typically stern and lined Republican face, the head sits atop a powerful, youthful, almost nude body. As in the Pseudo-Athlete, the reference to Greek statuary in the Tivoli portrait evokes the notion of patrician cultural superiority, while imbuing the person portrayed with a heroic aura. In the Tivoli statue, however, the patron's modesty dictated that a mantle shield the genitals.

POMPEY AND CAESAR

No portraits can be confidently associated with any of the great historical figures of the third and second centuries BCE, but in the early first century BCE, Roman magistrates began to issue coins bearing portraits of one or more of their illustrious ancestors. The new practice was a parallel phenomenon to the display of ancestor portraits in atria and at funerals, but in an even more public arena. Those who issued portrait coins basked in the reflected glory of the fame and achievements of generations past.

POMPEY THE GREAT One leading Roman of the first century BCE portrayed on the coins of the Late Republic was Pompey the Great. A marble head (**Fig. 4-12**) in Copenhagen has been definitively identified as Pompey because of its similarity to his numismatic likenesses. The portrait of Julius Caesar's one-time ally and later enemy came from a tomb belonging to Pompey's descendants on the Via Salaria in Rome and is a mid-first-century CE copy of a century-earlier original. Consistent with the norms of Republican verism, the sculptor carefully recorded the famous general's round face, deeply lined forehead, small eyes, and fleshy nose. But unlike other first-century BCE portraits, Pompey has a full head of hair that is combed to form an arc over the center of his forehead, a feature borrowed from the portraiture of Alexander the Great, the legendary general to whom Pompey often compared himself. In this

4-12 **Head of Pompey the Great, mid-first-century CE copy from Via Salaria, Rome, of a portrait of ca. 55–50 BCE. Marble, 9¾″ high. Ny Carlsberg Glyptotek, Copenhagen.**

portrait, the generic reference to Greek heroes seen in the Pseudo-Athlete and the Tivoli general has become specific. Portraiture here served to underscore visually the connection Pompey sought to make with Alexander in his actions and words.

THEATER OF POMPEY After being awarded a triumph in 61 BCE for his successful campaigns in the eastern Mediterranean, Pompey began work on a grandiose theater in the Campus Martius, the "Field of Mars" outside the city walls of Rome on the east bank of the Tiber River (Fig. 18-22). Today, the remains of the Theater of Pompey form the foundations and some of the rooms of later buildings whose outer walls conform to the curve of the theater's cavea. Excavations now in progress are shedding new light on the ancient building, but the primary evidence for its plan still comes from an early-third-century CE marble plan (**Fig. 4-13**) of the theater and its portico (see "The *Forma Urbis Romae*," Chapter 16, page 237), which has permitted a reliable reconstruction (**Fig. 4-14**) of the theater's appearance. Dedicated in 55 BCE, Pompey's theater was still considered the finest in the city in the fourth century CE—an extraordinary distinction considering that it was also the first permanent theater erected in the capital. Although stone theaters had long been common features of Greek and Italian cities, such entertainment centers had been blocked in Rome by the same conservative forces that opposed the importation of Greek statues and paintings. Instead, plays were staged in Rome in temporary structures, although they were frequently lavishly decorated.

Pompey's theater was richly embellished too. The peristyle behind the stage, for example, was the setting for a garden filled with trees, fountains, statues, and paintings. The theater proper was constructed of stone and concrete and employed radially disposed concrete barrel vaults holding up the cavea, in contrast to the earlier theater (Fig. 2-13) at Pompeii, which, like theaters in Greece, was built on a natural slope. At the top of

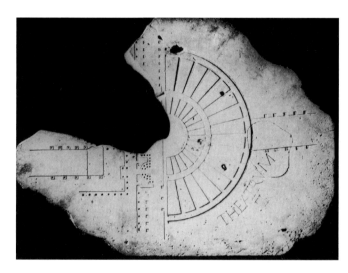

4-13 Theater of Pompey, Rome, dedicated 55 BCE, as represented on the *Forma Urbis Romae,* early third century CE.

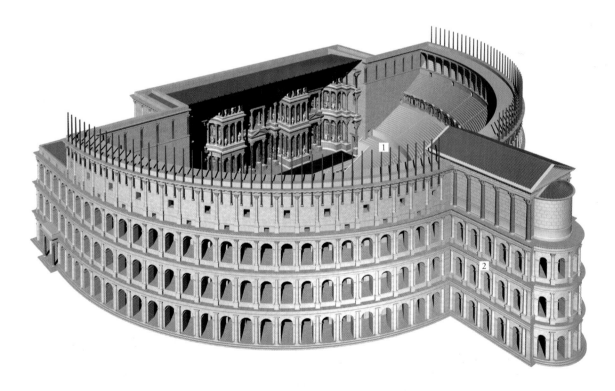

4-14 Restored view of the Theater of Pompey, Rome, dedicated 55 BCE (James E. Packer, John Burge, Richard Beacham, and King's Visualization Lab, Kings's College London). 1) Theater, 2) Temple of Venus Victrix.

the cavea, Pompey erected several shrines, including a temple (Fig. 4-14, no. 2) dedicated to his favorite goddess, Venus Victrix, who he believed brought him victory on the battlefield. The temple served a double function, for it also enabled Pompey to mollify his critics. When he dedicated the theater, he presented it to the people as a temple in front of which he had provided stairs for spectators of shows. In this respect, Pompey was also bringing a well-established architectural type from the countryside into the capital, namely the Republican theater-temple (Figs. 1-17 and 1-20).

JULIUS CAESAR Copies also survive of contemporary portraits of Julius Caesar. The best is a green basalt bust (**Fig. 4-15**) from Egypt. Many believe it is an abbreviated version of the portrait that Queen Cleopatra set up at Alexandria in a temple dedicated to the worship of the man whom the Senate had just declared a *divus* (deified mortal). The lined forehead, pinched cheeks, large nose and ears, and jutting jaw appear to be true to life, but Caesar's new status as a god may have led the sculptor to portray him with close-cropped hair instead of as nearly bald, as the great second-century CE biographer Suetonius described him.

Less flattering portraits of Caesar appear on coins struck in the opening months of 44 BCE. The example illustrated here (**Fig. 4-16**) is a *denarius* (see "The Roman Imperial

4-16 Denarius with obverse portrait of Julius Caesar as *dictator perpetuo*, 44 BCE. Silver, approx. $\frac{3}{4}$″ diameter. American Numismatic Society, New York.

Coinage," Chapter 5, page 63) labeled with Caesar's name and the title he bore at the time of his death: *dictator perpetuo* (dictator for life). In this portrait, Caesar has a receding hairline, aging face, and deeply lined neck in the Republican veristic tradition. The portrait is less remarkable for its character than for its choice as a coin type. Caesar was the first to place the likeness of any living person on a Roman coin—in violation of the norms of Republican propriety. That action was one of many that led a faction in the Senate to suspect that Caesar was attempting to reestablish the monarchy in Rome with himself as king. His assassination on the Ides of March 44 BCE was their answer to that perceived threat.

FORUM IULIUM Before his death, Caesar began work on a new forum, the Forum Iulium (Julian Forum), or Forum of Caesar (**Figs. 4-17** and **4-18**), adjacent to the old Republican Forum Romanum (see Chapter 1; the ruins of Caesar's forum are at the upper right of Fig. 1-1; compare Fig. 1-2, no. 11). Unlike the earlier forum, which developed gradually over the centuries without any master plan, Caesar's forum has the symmetry and regularity of Republican fora outside the capital. As in Pompeii's forum (Figs. 2-5 and 2-6), columnar porticos (Fig. 4-18, no. 2) frame a rectangular plaza with a temple (Fig. 4-18, no. 1) at one end. Designed to provide additional space for public business, the Forum Iulium was also intended to glorify the dictator and remind the populace of his divine lineage. The Julii traced their ancestry to Aeneas, the Trojan hero who founded the Roman race in Italy, and to Aeneas's mother, the goddess Venus. The temple in Caesar's forum was dedicated to Venus Genetrix, that is, to Venus in her role as founding mother of the Julian line. The Forum Iulium therefore reveals the same arrogance and penchant for self-glorification as do Caesar's coins. The *dictator perpetuo* paved the way for all the Roman emperors to follow in his calculated use of art and architecture as instruments of personal propaganda.

4-15 Detail of bust of Julius Caesar, from Egypt, ca. 44 BCE. Green basalt, 1′ 10″. Staatliche Museen, Berlin.

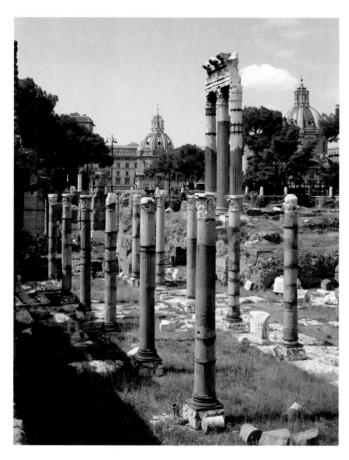

4-17 Temple of Venus Genetrix and portico of the Forum of Caesar (Forum Iulium), Rome, begun ca. 54 BCE, dedicated by Augustus in 29 BCE.

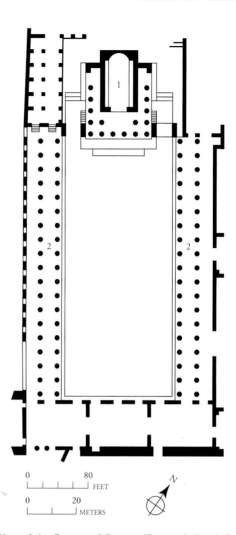

4-18 Plan of the Forum of Caesar (Forum Iulium), Rome, begun ca. 54 BCE, dedicated by Augustus in 29 BCE. 1) Temple of Venus Genetrix, 2) portico.

CIVIL WAR Julius Caesar was murdered at the feet of a statue of Pompey in a hall adjoining the Theater of Pompey where the Senate was meeting on that fateful day in March 44 BCE. His death plunged the Roman world into a bloody civil war that lasted 13 years and ended only when Octavian, Caesar's grandnephew and adopted son (see Chapter 5), crushed the naval forces of Mark Antony and Cleopatra at Actium in northwestern Greece. Antony and Cleopatra fled Actium for Egypt and committed suicide there in 30 BCE. What was once the ancient world's wealthiest and most powerful kingdom then became another province in the ever-expanding empire of Rome.

SUMMARY

The year 211 BCE was a turning point in the history of Roman art. In that year, the general Marcellus paraded through the streets of Rome the spoils of his victory over Syracuse, including the Greek city's most precious statues and paintings. Marcellus's triumph unleashed a "craze for Greek art" and gave rise to a new industry of manufacturing copies of Greek masterpieces.

The Romans, however, had their own sculptural traditions, of which the most significant was the carving of veristic portraits that celebrated the virtuous character of the patrician class. This tradition was connected to the practice of displaying masks of ancestors in homes and at funerals. Often the realistic heads were placed on young nude bodies in emulation of idealized Classical and Hellenistic statuary. These eclectic portraits can be seen as parallels to the distinctively Roman pseudoperipteral temple (see Chapter 1).

In the closing years of the Republic, two powerful men from old Roman families vied with each other in battle and in the erection of public buildings in Rome. Pompey, who likened himself to Alexander the Great in his portraits, built a grandiose theater that was the city's first permanent entertainment center. Julius Caesar, the first to place his own portrait on the state coinage, built a forum celebrating his descent from Venus. His assassination on the Ides of March 44 BCE launched the civil war that brought the Republic to an end.

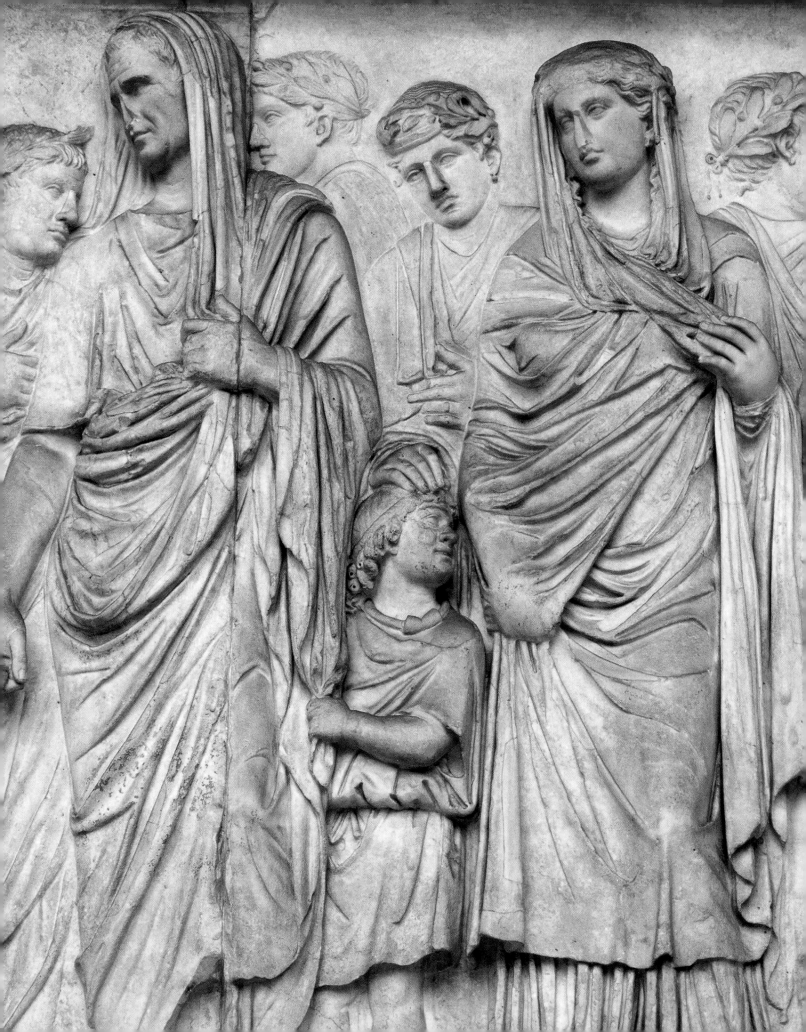

The Augustan Principate

When Octavian inherited Caesar's name and Caesar's fortune in 44 BCE, he was not yet 19 years old. Before he had turned 33, he had vanquished the forces of Antony and Cleopatra at Actium and annexed Egypt to become undisputed master of the Mediterranean world. The rule by a council of elders (the Senate) that had characterized the Roman Republic for nearly half a millennium finally came to an end. The senators formally recognized that their world had changed when they conferred the majestic title of Augustus (see "The Family of Augustus," page 62) on Octavian in 27 BCE. Historians mark the passage from the Republic to the Empire on the day Augustus received his new name.

CAESAR'S HEIR

SON OF A GOD More than a decade before he became Augustus, Octavian had assumed a different title. The Senate had proclaimed his father Julius Caesar a *divus* (deified mortal) in 42 BCE, and the young man who now bore his name began to refer to himself as the son of a god (*divi filius*)—although he was always careful not to claim in Rome, where it would have been unacceptable, to be a god himself (see "The Imperial Cult," Chapter 7, page 97).

A remarkable *sestertius* (**Figs. 5-2** and **5-3**), struck sometime between 37 and 31 BCE, documents how Octavian presented himself to the public during the years leading up to the final battle with Mark Antony. On the obverse of the coin (see "The Roman Imperial Coinage," page 63), Octavian (by then called Caesar) is portrayed as a young man with a short beard (a sign that he is in mourning). The accompanying inscription gives his name as Caesar divi filius. The reverse depicts the divus referred to on the obverse: the deified Julius, who, befitting his new stature as a god, has shed all the signs of age present in his lifetime numismatic portraits (Fig. 4-16). The sestertius is an early example of how the Roman emperors, following the example Caesar himself set in 44 BCE, used the coinage as a powerful tool of pictorial and verbal propaganda. In this case, Octavian, not yet the emperor Augustus, was using the coinage to communicate his right to rule in words and pictures. Antony, of course, did the same, issuing, for example, coins with his portrait on one side and Cleopatra's on the other, emphasizing his ties to Egypt, whereas Octavian featured his Roman genealogy. The coinage was a key weapon in the battlefield of public opinion—an area in which Octavian also was victorious.

5-1 Procession of the imperial family, detail of the south frieze of the Ara Pacis Augustae (Altar of Augustan Peace, Fig. 5-15), Rome, 13–9 BCE. Marble, figural frieze 5′ 3″ high.

WHO'S WHO IN THE ROMAN WORLD

The Family of Augustus

Augustus (Gaius Iulius Caesar Octavianus, r. 27 BCE–14 CE), first emperor of Rome, was the grandnephew and adopted son of Julius Caesar, whose name he took until the Senate awarded him the honorific title of Augustus.

Livia divorced Tiberius Claudius Nero to marry Octavian in 39 BCE after having given birth to the future emperor Tiberius with her first husband.

Octavia was the sister of Augustus and wife of Gaius Claudius Marcellus (d. 40 BCE) and then of Mark Antony until he divorced her in 32 BCE.

Julia was the daughter of Augustus and his first wife, Scribonia. Augustus arranged marriages for Julia to Marcellus, Agrippa, and Tiberius in turn.

Marcellus (Marcus Claudius Marcellus) was the son of Octavia and her first husband. In 25 BCE he married Julia, an indication that he was Augustus's first choice as successor, but he died in 23 BCE.

Agrippa (Marcus Vipsanius Agrippa) was the lifelong friend of Augustus and naval commander at the battle of Actium. After the death of Marcellus, Agrippa was Augustus's preferred successor. He married Julia in 21 BCE and died in 12 BCE.

Gaius Caesar (Gaius Iulius Caesar), the first son of Agrippa and Julia, was adopted by Augustus in 17 BCE. He died in 4 CE of wounds incurred during a military campaign in the East.

Lucius Caesar (Lucius Iulius Caesar) was the second son of Agrippa and Julia. Augustus also adopted him in 17 BCE. He died in Gaul in 2 CE.

Tiberius (Tiberius Iulius Caesar Augustus), Livia's son, married Julia after Agrippa's death. Augustus adopted him in 4 CE after the death of Gaius Caesar. Tiberius became emperor in 14 CE (see "The Julio-Claudians," Chapter 8, page 104.) ■

APOTHEOSIS OF CAESAR Sometime after 12 BCE, long after he was secure in power, Augustus still found it useful to refer to Caesar's deification in his program of pictorial propaganda. On one side of the "Belvedere Altar" (**Fig. 5-4**), so called because at one time it was exhibited in the Belvedere gallery of the Vatican Museums, a now-headless figure dressed in a toga drives a four-horse chariot that is about to lift off the ground and carry him heavenward. He rides toward Caelus, the sky god, represented here as a bust-length nude male figure whose billowing mantle symbolizes the arc of the firmament. At the upper left is the chariot of the sun god, Sol, or of Apollo, who was closely associated with the sun and was the god who ensured Octavian's victory at Actium. Scholars have suggested different identifications for the figure in the quadriga, but the most likely is that he is Julius Caesar and that the scene represents his *apotheosis* (ascent to Heaven of a new god). There are four witnesses to the event. At the left is Augustus himself. At the right, waving farewell to the new divus, is a woman who is either Augustus's wife Livia or, more likely, his daughter Julia, because the boys with her must be the emperor's grandsons Gaius and Lucius Caesar. The altar simultaneously presents to the public both

5-2 **Sestertius with obverse portrait of Octavian,** ca. 37–31 BCE. Bronze, approx. $1\frac{1}{4}''$ diameter. British Museum, London.

5-3 **Sestertius with reverse portrait of Divus Julius,** ca. 37–31 BCE. Bronze, approx. $1\frac{1}{4}''$ diameter. British Museum, London.

The Roman Imperial Coinage

When Julius Caesar placed his own portrait on a Roman coin (Fig. 4-16) in 44 BCE, he broke with centuries of Republican tradition, but he also set a pattern that all the Roman emperors would follow. Beginning with Augustus, the official coinage of Rome, struck at mints throughout the empire, became a powerful instrument for the molding of public opinion. The obverses of the coins usually bore the portrait of the current emperor (Figs. 8-20, 9-2, 16-2, 19-2, and 20-2 to 20-4) or a member of his family, permitting the emperor to distribute his chosen self-image (in the case of Augustus, the image of an eternally youthful son of a god) to all of Rome's vast territories. The reverses (and sometimes the obverses also) often bore the images of his deified predecessor (Fig. 5-3), his biological or adopted son(s) and designated successor(s), his wife and daughter(s), or sometimes full family portraits (Fig. 16-3). The reverses also were used to advertise the emperor's achievements—victories on the battlefield, distributions of money to the populace, buildings erected (for example, Fig. 5-6; see "Buildings

on Coins," Chapter 11, page 160), and so forth—as well as the emperor's virtues—piety, clemency, and the like—or those of the empress—for example, beauty or fecundity. The importance of the Roman coinage for spreading imperial propaganda cannot be overstated. Whereas only a small percentage of the citizens of the Empire might ever see the reliefs carved on a triumphal arch or the portrait statues exhibited in a forum in the capital, everyone was exposed to the pictorial and verbal messages of the coins.

Roman coins were issued in three major metals—gold, silver, and bronze—and in many denominations. These were the most common Roman coins:

Aureus: the standard gold coin, which under Augustus weighed 1/40 of a pound.
Denarius: the standard silver coin, from which the word *penny* ultimately derives, worth 1/25 of an aureus.
Sestertius: the standard bronze coin, worth 1/4 of a denarius and 1/100 of an aureus. ■

Augustus's divine lineage and his hopes for the future, namely the two boys whom he adopted and wished to succeed him until their premature deaths in 2 and 4 CE. The Belvedere

5-4 Apotheosis of Caesar, "Belvedere Altar," ca. 12–2 BCE. Marble, 3′ 1⅜″ high. Musei Vaticani, Rome.

Altar is an early example of what would become two important recurrent themes in imperial art: the honoring of an emperor's divine predecessor and the presentation of his prospective successor(s). In fact, Augustan artists established almost all of the patterns of pictorial propaganda that would endure for centuries in official Roman art.

FORUM ROMANUM Augustus paid homage to his adoptive father in other ways too. He completed the architectural projects Caesar had begun, including the Forum Iulium (**Figs. 5-5**, no. 10, 4-17, and 4-18) and the adjoining Curia Iulia (Fig. 5-5, no. 9) in the Republican Forum Romanum (Fig. 1-1). More significantly, he erected a temple for the worship of Divus Iulius (Fig. 5-5, no. 7) at the eastern end of the Forum Romanum. The new temple, together with other Augustan projects, among them the rebuilding of the Basilica Iulia (Fig. 5-5, no. 4) and the Temple of Castor (Fig. 5-5, no. 5), gave new shape to the venerable center of Roman public life. Unlike Caesar's forum, the Republican forum had no framing porticos and no focus of attention. By situating the Temple of Divus Iulius at one end of the open plaza, framed by the two great basilicas to the north and south, Augustus made his father's shrine the centerpiece of the symbolic heart of the city—and of the Empire. The new temple, begun in 42 BCE and completed in 29 BCE, dominated the Forum Romanum in the same way the Temple of Venus Genetrix (Fig. 4-18, no. 1) dominated Caesar's forum.

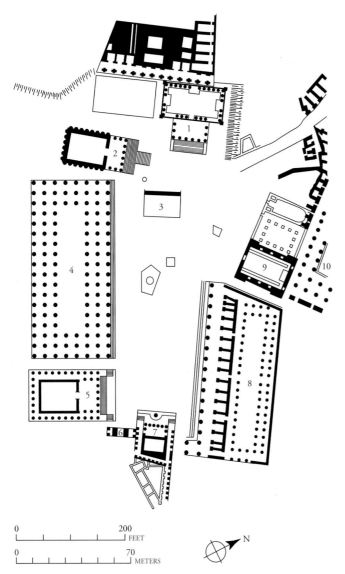

5-6 **Parthian Arch of Augustus, Rome, 19 BCE, represented on the reverse of a denarius of Augustus, 16 BCE. Silver, approx. $\frac{3}{4}''$ diameter. American Numismatic Society, New York.**

Stertinius in 196 BCE in three different locations in Rome, paid for with the booty he brought back from his campaigns in Spain. These and the other known Republican arches seem to have been simple single-passageway gates crowned by statues (usually of gilded bronze) representing Roman deities.

Augustus's arch, which he proudly reproduced on his coinage (**Fig. 5-6**; see "Buildings on Coins," Chapter 11, page 160), was more elaborate than any erected during the Republic. It had a central *arcuated bay* (arch-shaped passageway) plus two additional (non-arcuated) passageways, each topped with a statue of a captured Parthian. Above the *attic* of the central bay was a gilded bronze group of Augustus in his triumphal quadriga. Those entering the Forum Romanum from the east after 19 BCE passed through the Parthian gateway and emerged in the plaza beside the temple to Augustus's deified father. The proximity of the two structures was, of course, intentional. Augustus wished to present himself to the populace as the worthy successor of Caesar, as demonstrated by his Parthian triumph.

FORUM AUGUSTUM Augustus placed the standards recovered from the Parthians in the Temple of Mars Ultor (Mars the Avenger; **Figs. 5-7** and **5-8**, no. 1) that the emperor had vowed to build in 42 BCE when he sought the war god's aid in pursuing Caesar's assassins. Work did not commence until 28 BCE, after Actium. Pliny the Elder rated the Mars temple and the forum of which it was the centerpiece as one of the three most beautiful buildings in the world,[1] primarily owing to the lavish use of imported colored marbles in the plaza and porticos of the forum.

The Mars temple itself, however, had Corinthian columns and a facing for its podium and walls of gleaming white

5-5 **Plan of the Forum Romanum (Fig. 1-1), Rome, after the Augustan building program, ca. 10 CE. 1) Temple of Concord, 2) Temple of Saturn, 3) Rostra, 4) Basilica Iulia, 5) Temple of Castor, 6) Parthian Arch of Augustus, 7) Temple of Divus Iulius, 8) Basilica Aemilia, 9) Curia Iulia, 10) Forum Iulium.**

PARTHIAN ARCH In 19 BCE, Augustus added another monument to the reorganized Forum Romanum, the arch (Fig. 5-5, no. 6) celebrating his victory over the Parthians, a powerful Near Eastern kingdom that, for centuries to come, would repeatedly challenge the Romans on their eastern frontier. (Augustus's Parthian "victory" was, in reality, no more than a negotiated return of the military standards that the Parthians had captured from the Republican general Crassus in 53 BCE. The incident humiliated the Romans, and Augustus restored Roman honor with their recovery.) Honorary arches, or so-called *triumphal arches*, had been erected in Rome by victorious generals as early as the late third century BCE. The first recorded examples were set up by Lucius

[1] Pliny the Elder, *Natural History*, 36.102.

5-7 Temple of Mars Ultor, Forum of Augustus, Rome, dedicated 2 BCE.

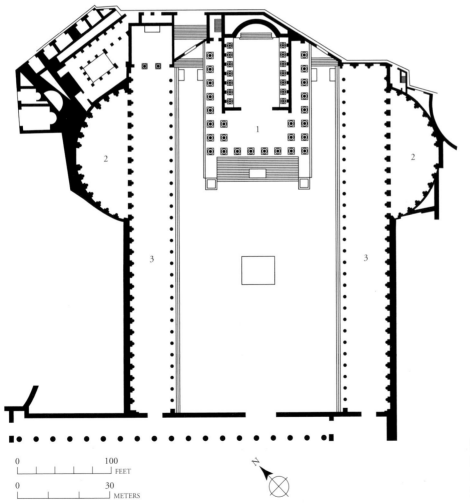

5-8 Plan of the Forum of Augustus, Rome, begun ca. 27 BCE, dedicated 2 BCE. 1) Temple of Mars Ultor, 2) exedra, 3) portico.

0 100 FEET

0 30 METERS

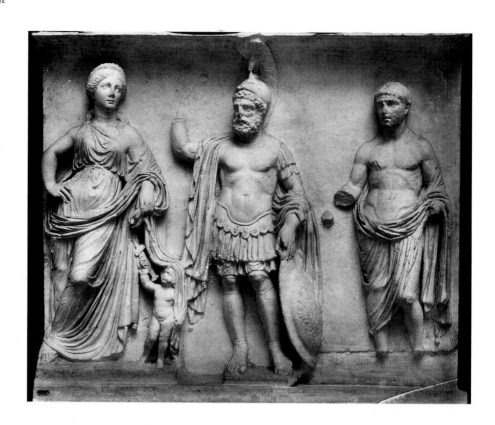

5-9 **Venus and Cupid, Mars, and Divus Iulius, early first century CE. Marble. Musée Nationale d'Antiquités, Algiers.**

marble from Luna, modern Carrara, in northwestern Italy (see Map 1-1, page 2). The recently opened quarries at Luna made possible Augustus's famous boast, recorded by Suetonius, that the emperor had "found Rome a city of brick and left it a city of marble."[2] Prior to Augustus, Italian builders had to ship marble blocks at great expense from Athens or the Greek islands, and it was used sparingly. (The round temple on the Tiber, Fig. 1-13, is a notable exception.) The sharply reduced freight costs made Italian marble much less expensive, and Augustus employed large quantities of Luna marble in his building program. The emperor desired his new marble capital to rival Athens during its Golden Age under Pericles in the mid-fifth century BCE.

Inside the Temple of Mars Ultor, Augustus set up a group of three statues representing Mars Ultor, Venus Genetrix (the founder of the Julian line, shown with her son Cupid), and the deified Caesar. If a relief (**Fig. 5-9**) in Algiers reproduces these statues, as most scholars believe, Caesar, then an immortal deity, was represented as a young man. His eternal youthfulness was consistent with the central conceit of Augustus's own portraits (discussed later). Mars and Venus also appeared in the temple's pediment (Fig. 8-16) along with statues of Romulus, Fortuna, and the goddess Roma (Rome personified), as well as personifications of the Palatine Hill and the Tiber River.

The Mars Ultor temple stood at the north end of the new Forum Augustum (Figs. 1-2, no. 14, and 5-8), which the emperor built contiguous with and perpendicular to the Forum Iulium (Figs. 1-2, no. 11, and 4-18). The plan is similar to that of the earlier forum, but with the addition of two great semicircular exedras (Fig. 5-8, no. 2) opening onto the two porticos (Fig. 5-8, no. 3) at the east and west. (Recent excavations indicate that there may originally have been one more exedra on each side, later torn down.) In the attic story of the porticos, above the Luna marble Corinthian columns, were half-size marble copies of the caryatids of the late-fifth-century BCE temple on the Athenian Acropolis called the Erechtheion. The caryatid statues reinforced the link Augustus sought to make between his building campaign in Rome and that of Pericles in Athens.

In the porticos and exedras, however, Augustus did not compare himself to any Greek statesmen or heroes but instead presented himself as the latest in a long line of Roman *summi viri* (great men), including Aeneas, Romulus, and a host of senators and consuls of the Republic in general and of the Julian family in particular, which traced its origins to Aeneas. Augustus's forum became, in a sense, an atrium filled with ancestor portraits, which served to underscore the emperor's distinguished family tree and divine descent.

PORTRAITURE

ETERNAL YOUTH Augustus's own portraits (**Fig. 5-10**), however, broke radically from Republican verism. This was due in part to the fact that the new emperor, unlike his father Caesar and all of the summi viri of the Republic, was a young man when he assumed power. Suddenly, Roman portrait sculptors were called on to record the likenesses of a *youthful* head of state. But Augustus lived to be an old man, dying at

[2] Suetonius, *Augustus*, 28.

5-10 **Bust of Augustus wearing the corona civica, early first century CE. Marble, 1′ 5″ high. Glyptothek, Munich.**

age 76, and his portraits never showed any signs of age. That is because his portraits were not intended to be *likenesses*. Rather, they were carefully crafted *images*—not of Augustus the man but of Augustus the divi filius. His portraits were designed to present the image of a godlike leader, a superior being who, miraculously, was eternally youthful. Such a notion may seem ridiculous today, when television, the Internet, magazines, and newspapers portray world leaders as they truly appear, but in antiquity few people ever saw the emperor. Because most people knew only his official image, it could be manipulated at will.

AUGUSTAN ROLE-PLAYING The Empire was ostensibly a continuation of the Republic, with the same constitutional offices, but in fact Augustus, who was recognized as *princeps* (first citizen), occupied all the key positions (see "The *Res Gestae* of the Deified Augustus," at right). In the *principate* he created, Augustus was consul and *imperator* (commander in chief; root of the word "emperor") and even, after 12 BCE, *pontifex*

WRITTEN SOURCES

The *Res Gestae* of the Deified Augustus

Shortly before he died in 14 CE, the emperor Augustus reflected on his achievements during his 76 years and summarized them for posterity in a lengthy document inscribed on two bronze columns set up in front of his mausoleum (Fig. 6-2) in the Campus Martius in Rome. The *Res Gestae Divi Augusti* (Achievements of Divus Augustus) recounts his successes in all of the many arenas in which he made his mark—political, military, religious, economic, social, and artistic.

The *Res Gestae* opens with Augustus's claim to have restored liberty to the Republic by freeing the Roman people from the tyranny of Mark Antony. Then follows Augustus's lengthy enumeration of the wars he fought and the territories he added to the Empire; the triumphs he celebrated and the numerous other honors the Senate awarded him, including those he chose to decline; the many occasions on which he distributed gifts of cash or grain to the people; and the extensive building program he undertook, including the construction or restoration of the Curia Iulia, Basilica Iulia, and the Temple of Divus Iulius in the Forum Romanum; the Temple of Jupiter Capitolinus; the Temple of Mars Ultor and the Forum Augustum; the Ara Pacis; the Theaters of Pompey and Marcellus; and roads, aqueducts, and bridges throughout Italy.

Here are some selections:

> [W]hen I had extinguished the flames of civil war, after receiving by universal consent the absolute control of affairs, I transferred the republic from my own control to the will of the senate and the Roman people. For this service I was given the title of Augustus by decree of the senate . . . After that time I took precedence of all in rank [*princeps*], but of power I possessed no more than those who were my colleagues in any magistracy. [6.34]

> I rebuilt in the city eighty-two temples of the gods, omitting none which at that time stood in need of repair. [4.20]

> The Parthians I compelled to restore to me the spoils and standards of three Roman armies . . . These standards I deposited in the inner shrine of the Temple of Mars Ultor. . . . Phrates, son of Orodes, king of the Parthians, sent all his sons and grandsons to me in Italy, not because he had been conquered in war, but rather seeking our friendship by means of his own children as pledges. [5.29, 32]

> When I returned from Spain and Gaul . . . the senate voted in honour of my return the consecration of an altar to Pax Augusta in the Campus Martius. [2.12]* ∎

* All passages translated by Frederick W. Shipley, *Res gestae divi Augusti*, rev. ed. (Cambridge, Mass.: Harvard University Press, 1979), 365, 379, 393–401.

5-11 **Augustus as imperator, from the Villa of Livia, Primaporta, early-first-century CE copy of a bronze original of ca. 20 BCE. Marble, 6′ 8″ high. Musei Vaticani, Rome.**

5-12 **Augustus as pontifex maximus, from Via Labicana, Rome, after 12 BCE. Marble, 6′ 10″ high. Museo Nazionale Romano–Palazzo Massimo alle Terme, Rome.**

maximus (chief priest of the state religion). These offices gave Augustus control of all aspects of Roman public life.

In his official portraits, Augustus appears in all of his numerous roles. The Munich bust (Fig. 5-10), for example, represents him wearing the *corona civica* (civic crown) of oak leaves awarded to a Roman who had saved the life of another Roman in battle. Augustus had saved the lives of thousands by bringing peace to the Mediterranean after 13 years of civil warfare.

AUGUSTUS AS IMPERATOR One of the best surviving full-length portraits (**Fig. 5-11**) of Augustus depicts him as commander in chief of Rome's armies. The statue was found at the villa the empress Livia owned at Primaporta, a short distance north of Rome. Most scholars believe it is a posthumous copy (Augustus has the bare feet of a god instead of military

boots) of a bronze original of about 20 BCE. The Cupid riding a dolphin was an addition of the copyist. It served to remind viewers of Augustus's descent from Venus (compare Fig. 5-9). The elaborate ornament of the emperor's cuirass may not have been part of the bronze original, although it depicts the Parthians' return of the captured Roman military standards in a cosmic setting, with the sky god Caelus at the top and the earth goddess Tellus at the bottom holding a *cornucopia* (horn of plenty), imagery that is certainly consistent with an Augustan date.

In the Primaporta portrait, Augustus is shown addressing his troops with his right arm extended in the manner of Aulus Metellus (Fig. 4-9), but the model the sculptor used was a Classical Greek statue—the *Doryphoros* of Polykleitos. The overall shape of the head, the sharp ridges of the eyebrows, and the tight cap of layered hair also emulate the

5-13 Bust of Livia, from Arsinoe, Egypt, early first century CE. Marble, 1′ 1½″ high. Ny Carlsberg Glyptotek, Copenhagen.

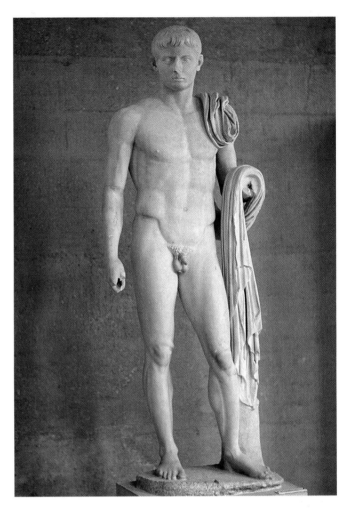

5-14 Heroic statue of Gaius Caesar, from the Julian Basilica, Corinth, Greece, early first century CE. Marble, 6′ 8¼″ high. Archaeological Museum, Corinth.

Polykleitan style (Fig. 10-12), but the head is unmistakably Augustus's and not that of a nameless athlete. The artists the state employed adhered closely to the official, immediately recognizable image for all portraits of the emperor set up in all corners of the Empire. For example, the distinctive and seemingly casual pattern of the locks of hair falling over Augustus's forehead is the same as in the Munich bust.

AUGUSTUS AS PONTIFEX MAXIMUS The identical coiffure appears in a portrait (**Fig. 5-12**) of Augustus wearing a toga, part of which is drawn over his head as a veil. The statue was found in the Via Labicana in Rome and represents Augustus in his role as pontifex maximus, the sacred office he assumed in 12 BCE. The emperor once held a *patera* (offering plate) in his right hand and was pictured in the act of offering a sacrifice at an altar, like the priest on the "Altar of Domitius Ahenobarbus" (Fig. 4-6). The Via Labicana statue is an instructive example of Roman workshop practice. The body was carved from a large block of Luna marble, probably by an apprentice. The portrait head, of higher quality and made of costlier imported Greek marble, was almost certainly the work of the master of the workshop.

LIVIA A marble portrait (**Fig. 5-13**) of Livia, now in Copenhagen, shows that the imperial women of the Augustan age shared the emperor's eternal youthfulness. Although she

sports the latest Roman coiffure, with the hair rolled over the forehead to form a *nodus* and knotted at the nape of the neck, Livia's blemish-free skin and sharply defined youthful features derive from images of Classical Greek goddesses. Livia outlived Augustus by 15 years, dying in 29 CE at age 87. In her portraits, the coiffure changed with the introduction of each new fashion, but her face remained ever young, as befitted her exalted position in the Roman state.

DYNASTIC PORTRAITURE Livia's Copenhagen portrait was found in Arsinoe in Egypt with portraits of Augustus and of her son Tiberius (Fig. 8-2), whom Augustus had adopted in 4 CE and who succeeded Augustus as emperor. Dynastic group portraits (Fig. 8-14) were familiar sights in Roman towns throughout the Empire. Another Augustan group, exhibited in the Julian Basilica at Corinth, Greece, portrayed the emperor as pontifex maximus flanked by statues of his grandsons Gaius and Lucius Caesar, both depicted in heroic nudity. Illustrated here (**Fig. 5-14**) is the better-preserved portrait, which probably represents Gaius Caesar,

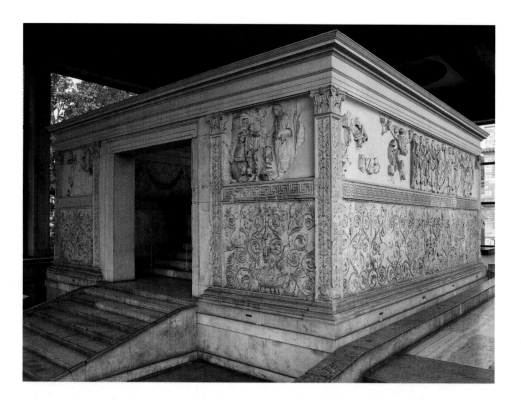

5-15 Ara Pacis Augustae (Altar of Augustan Peace), Rome, 13–9 BCE (view from the southwest).

although the two brothers are often difficult to distinguish. Both were presented as younger versions of the emperor himself, and the close similarity of the three official types was intentional. The sons of Augustus were supposed to look like their adoptive father, whether they did or not. (The boys may have resembled their father Agrippa much more than their grandfather.) All Augustan portraits are essentially pictorial fictions. Their purpose was not to present individual likenesses of the members of the imperial family but to create the impression of a ruling family that was descended from the gods and that shared the ageless beauty of the gods.

THE PAX AUGUSTA

ARA PACIS On Livia's birthday in 9 BCE, Augustus dedicated the Ara Pacis Augustae (Altar of Augustan Peace), the monument celebrating what most Romans regarded as his most important achievement, the establishment of peace (*Pax*). The altar (**Fig. 5-15**), erected on the Via Flaminia (today the Via del Corso), was reconstructed and moved to its present location next to the emperor's tomb (Fig. 6-2) on the Tiber River during the Fascist era in Italy in connection with the 2,000th anniversary of Augustus's birth, when Mussolini was seeking to build a modern Roman Empire. Figural reliefs and acanthus tendrils adorn the altar's marble precinct walls. Four panels on the east and west ends depict carefully selected mythological subjects, including (at the right in Fig. 5-15) a relief (**Fig. 5-16**) of Aeneas (or, according to a recent suggestion, Numa Pompilius, Rome's second king) making a sacrifice. The former identification is likely because the con-

nection between the emperor and Aeneas was a key element of Augustus's political ideology for his new Golden Age. It is no coincidence that the *Aeneid* was written during the principate of Augustus. Vergil's epic poem glorified the young emperor by celebrating the founder of the Julian line. On the Ara Pacis, Aeneas is shown as a priest with veiled head and with a patera in his extended right hand. Augustus appears in a comparable posture in his role as pontifex maximus immediately around the corner on the south frieze of the altar.

A second panel (**Fig. 5-17**), on the other (east) end of the altar enclosure, depicts a seated matron with two animated babies on her lap. (The two infant boys may be references to Gaius and Lucius Caesar, Augustus's heirs apparent in 9 BCE, and to the promise of a bountiful future under their rule.) The identity of the mother is uncertain. She is usually called Tellus, although some have named her Pax (Peace), Ceres (goddess of grain), or even Venus. Whoever she is, she epitomizes the fruits of the Pax Augusta. All around her the earth is in bloom, and animals of different species live peacefully side by side. Personifications of refreshing breezes (note their windblown drapery) flank her. One rides a bird, the other a sea creature. Earth, sky, and water are all elements of this picture of peace and fertility in the Augustan cosmos.

Processions of the imperial family and other important dignitaries (**Figs. 5-1** and **5-18**) appear on the long north and south sides of the Ara Pacis. These parallel friezes were clearly inspired to some degree by the Ionic frieze of the Parthenon on the Athenian Acropolis, which depicted the procession of Athenian citizens during the quadrennial Panathenaic Festival. The Ara Pacis frieze is another Augustan allusion to Periclean Athens, as were the contemporary

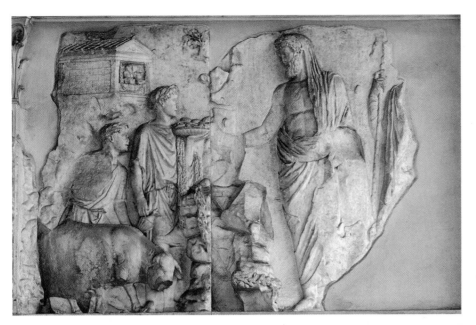

5-16 Aeneas sacrificing, panel on the west facade of the Ara Pacis Augustae (Altar of Augustan Peace), Rome, 13–9 BCE. Marble, 5′ 3″ high.

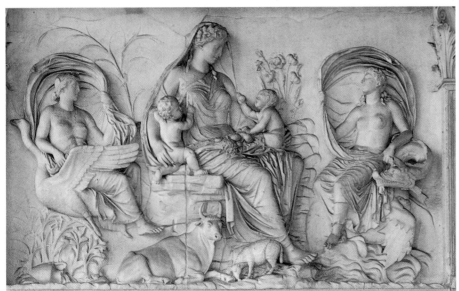

5-17 Tellus(?), panel on the east facade of the Ara Pacis Augustae (Altar of Augustan Peace), Rome, 13–9 BCE. Marble, 5′ 3″ high.

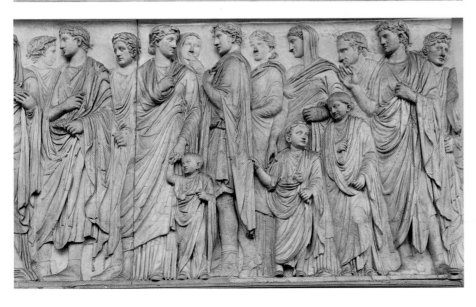

5-18 Procession of the imperial family, detail of the south frieze of the Ara Pacis Augustae (Altar of Augustan Peace), Rome, 13–9 BCE. Marble, figural frieze 5′ 3″ high.

Forum Augustum caryatids. In Augustus's new marble capital, the emulation of Classical models made a political statement as well as an artistic one.

Even so, the Roman procession is very different in character from the Greek. On the Parthenon, anonymous figures act out an event that recurred every four years. The frieze stands for *all* Panathenaic Festival processions. The Ara Pacis depicts a specific event—probably the inaugural ceremony of 13 BCE when work on the altar began—and recognizable figures of the time. Among those portrayed are Augustus, Livia, and Agrippa and several children, who restlessly tug on their elders' garments and talk to one another when they should be quiet on a solemn occasion—in short, children who act like children, not like miniature adults as they frequently do in the history of art. Their presence lends a great deal of charm to the procession, but that is not why children were included on the Ara Pacis when they had never before appeared on any Greek or Roman state monument. Augustus was concerned about a decline in the birthrate among the Roman nobility, and he enacted a series of laws designed to promote marriage, marital fidelity, and raising children. The portrayal of men with their families on the Altar of Peace was intended as a moral exemplar. Once again, the emperor used art to further his political and social agendas.

Two of the children, including the one in Fig. 5-1 tugging on the toga of Agrippa, are of special interest because they wear necklaces and tunics instead of togas. Considerable controversy exists regarding their identification. Many scholars think they are Gaius and Lucius Caesar, Agrippa's sons whom Augustus adopted before the Ara Pacis was completed, dressed in Trojan garb (Aeneas's birthplace was Troy). Others identify them as barbarian princes—like the sons and grandsons of Phrates mentioned in the *Res Gestae* (see "The

Res Gestae of the Deified Augustus," page 67)—who resided in Rome as a pledge of friendship. Their presence would be consistent with a monument celebrating the Pax Augusta.

THEATER OF MARCELLUS The Ara Pacis was constructed of Luna marble, but not all new architectural projects in Augustan Rome were designed to emulate Classical Greek buildings. Eclecticism was a persistent trait of Roman art and architecture, and some Augustan buildings carried on the Republican tradition of vaulted concrete construction rather than the Greek tradition of marble columnar architecture. The Theater of Marcellus (**Fig. 5-19**), dedicated in 13 or 11 BCE in honor of Augustus's nephew and son-in-law who had died a decade earlier, may have been planned by Caesar to rival the Theater of Pompey (Figs. 4-13 and 4-14), but construction did not begin until after Actium. As in Pompey's theater, the cavea of the Augustan theater was supported by a series of radially disposed concrete barrel vaults, but the Theater of Marcellus also incorporated an ingenious network of concrete ramps that permitted efficient entrance to and exit from the seating area for an estimated 11,000 spectators.

The design of the travertine facade of Marcellus's theater was also innovative and very influential, both in antiquity and in the Renaissance. As in the Republican sanctuaries at Tivoli (Fig. 1-18) and Palestrina (Fig. 1-20), engaged Greek columns frame arcuated openings on the first and second stories. The architect varied the orders from level to level, employing the statelier and heavier Doric on the ground floor and the more elegant and lighter Ionic above it. The third story probably had Corinthian pilasters and no arches, as on the Colosseum's facade (Fig. 9-12), which was modeled on that of Marcellus's theater.

5-19 **Theater of Marcellus, Rome, dedicated 13 or 11 BCE.**

MURAL PAINTING

HOUSE OF AUGUSTUS About the time that Pompey dedicated his theater in the Campus Martius, theatrical stage designs became popular motifs in Second Style mural painting and remained so under Augustus. Perhaps the finest of all theatrical mural paintings was discovered in 1961 when Italian excavators uncovered the remains of what most archaeologists identify as the House of Augustus on the Palatine Hill. The site of the domus—strategically located near the huts of Romulus (Fig. 1-3) and the Temple of Apollo, which Augustus dedicated in 28 BCE in honor of the god who delivered his victory at Actium and was rumored to have been his true father—matches the ancient literary testimony. Each wall of the so-called Room of the Masks (**Fig. 5-20**) in Augustus's house resembles the tripartite stage set (*scaenae frons*) of a Roman theater. The pair of masks on each wall underscores the connection.

In the Room of the Masks, the painter opened up the center of each wall to reveal a view of a rustic sanctuary—a *sacro-idyllic landscape*—beyond the confines of the cubicu-lum. The intentional blurring of the forms and general haziness of the landscape are characteristics of *atmospheric perspective*, a technique Second Style painters began to use in order to suggest distance. Forms farther away appear less sharp than those closer to the viewer, just as they appear smaller (the principle underlying linear perspective; see Chapter 3). The Room of the Masks is also one of the most successful examples of single-vanishing-point linear perspective in the ancient world. In this room, the shadows the projecting columns cast greatly enhance the three-dimensional illusion. The theoretical source of light that produced these painted shadows appears to be at the opposite (northwest) corner of the room—the precise location of the actual doorway.

VILLA OF LIVIA, PRIMAPORTA The ultimate examples of Second Style illusionism are found on the walls of a vaulted, partly underground room in the Villa of Livia at Primaporta, the *findspot* (place found, or provenance) of the portrait of Augustus as imperator (Fig. 5-11). In this room, an imperial painter surrounded the viewer with the illusion of a lush gardenscape

5-20 Second Style mural paintings, east and south walls of the Room of the Masks (room 5), House of Augustus, Palatine Hill, Rome, ca. 30–25 BCE.

5-21 **Gardenscape, Second Style mural paintings, from the Villa of Livia, Primaporta, ca. 30–20 BCE. Museo Nazionale Romano–Palazzo Massimo alle Terme, Rome.**

(**Fig. 5-21**) in which the only remaining architectural element is the flimsy fence of the garden itself. The use of atmospheric perspective is especially impressive here. The fence, trees, and birds in the foreground are precisely painted, whereas the details of the dense foliage in the background are indistinct. Rarely did any other ancient painter equal the Primaporta master in creating such a successful illusion of a world filled with air and light just a few steps away from where the viewer stands.

HOUSE OF LIVIA, ROME Another residence traditionally attributed to Livia, on the Palatine Hill in Rome, is actually a Republican *domus* of ca. 75–50 BCE that Augustus may have acquired after Caesar's death to become part of his official residence. The walls of the so-called House of Livia are decorated with Second Style paintings of ca. 30–25 BCE. The scheme in room 3 (**Fig. 5-22**) represents a further stage in the development of the Second Style in which solid walls begin to take up a greater part of the design again. In the center of each wall, the painter inserted a view into a landscape peopled with mythological figures. In the detail shown here, Argos guards the maiden Io while Hermes approaches from the left. To either side of the Io and Argos scene are projecting columns and a reproduction of an actual painting, complete with shutters to protect it from sunlight. In fact, in the House of Livia it is uncertain whether the painter wished the viewer to think that Io, Argos, and Hermes are standing in a landscape seen *through* the wall or whether the artist intended to represent a mythological panel painted *on* the wall.

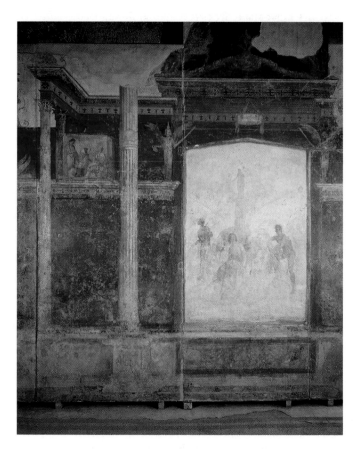

5-22 **Second Style mural painting, detail of southwest wall, room 3, House of Livia, Palatine Hill, Rome, ca. 30–25 BCE.**

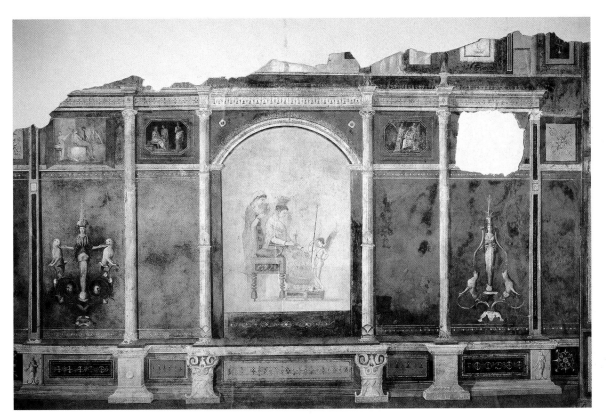

5-23 Second Style mural painting, left wall of cubiculum B, Villa Farnesina, Rome, ca. 20 BCE. Museo Nazionale Romano–Palazzo Massimo alle Terme, Rome.

VILLA FARNESINA, ROME That ambiguity disappears in cubiculum B (**Fig. 5-23**) of a villa discovered in 1879 on the west bank of the Tiber near the bridge Agrippa constructed to connect present-day Trastevere with the Campus Martius. The Villa Farnesina, as it is called, may have belonged to Agrippa himself. In this late Second Style design, the painter returned to the shallow illusionism of the early Second Style, as in the House of the Griffins (Fig. 3-17), but included reproductions of paintings with shutters high on the wall, as in the House of Livia, as well as a large central panel depicting Aphrodite/Venus enthroned between Cupid and a female attendant. The blue sky and rocky landscape of the Io and Argos panel have given way to a pure white background. The white ground and the elegant linear style of figure painting have close parallels in Athenian painting of the fifth century BCE. The Farnesina panels are another example of the conscious evocation of the Golden Age of Athens in Augustan Rome.

THE THIRD STYLE The frescoes in cubiculum B of the Villa Farnesina document a change in taste in Augustan Rome. This movement away from the picture-window-wall approach of the third quarter of the first century BCE culminated shortly before 10 BCE with the introduction of the *Third Style*. In the Third Style, artists no longer attempted to replace the walls of a room with three-dimensional worlds of their own creation. Nor did they seek to imitate the appearance of luxurious marble-clad walls, as they did in the First Style. Instead, they decorated walls with delicate linear fantasies sketched on predominantly *monochromatic* (one-color) backgrounds.

VILLA AT BOSCOTRECASE Some of the earliest examples of the new style appear on the walls of another villa believed to have been the property of Agrippa, and he may have been instrumental in making the Third Style popular. The Villa of Agrippa Postumus (the villa became the property of his posthumously born son when Agrippa died in 12 BCE) at Boscotrecase, near Pompeii, was also buried by the eruption of Mount Vesuvius (Map 2-1). The villa was probably painted just before 10 BCE. Its murals are now divided between the Naples Archaeological Museum and the Metropolitan Museum of Art in New York.

A comparison between the so-called Red Room (**Fig. 5-24**) of the Boscotrecase villa and the Room of the Masks (Fig. 5-20) in the House of Augustus brings to the fore the differences between the Second and Third Styles. Both mural schemes feature a central sacro-idyllic landscape. Indeed, some of the details of the rustic sanctuary, such as the column topped by a large urn, are nearly identical in both rooms. But the Second Style landscape fills the entire central opening in the illusionistically rendered scaenae frons, and it appears as if the viewer can step through the stage's projecting columns and walk under its roof and enter that landscape. At Boscotrecase, in contrast, nowhere does the artist use illusionistic painting to penetrate the wall. In place of the stately columns of the Second Style are insubstantial and impossibly thin *colonnettes* supporting a featherweight entablature. In the center of this delicate and elegant architectural frame is a small landscape floating on a white ground. No one could mistake this painted landscape panel for a window or doorway through which can be glimpsed a world beyond the room.

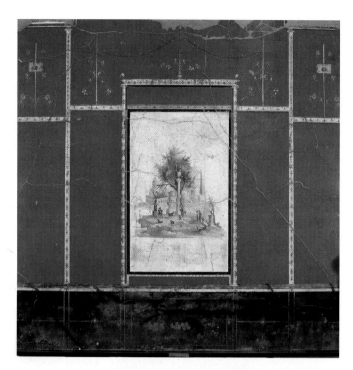

5-24 Detail of a Third Style mural painting, from the north wall of the Red Room (cubiculum 16), Villa of Agrippa Postumus, Boscotrecase, ca. 10 BCE. Museo Archeologico Nazionale, Naples.

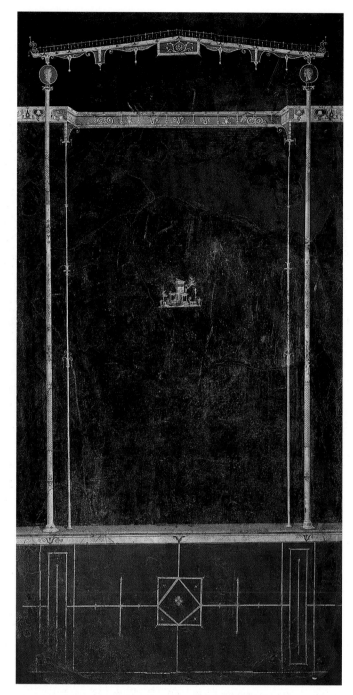

5-25 Detail of a Third Style mural painting, from the Black Room (cubiculum 15), Villa of Agrippa Postumus, Boscotrecase, ca. 10 BCE. Metropolitan Museum of Art, New York.

An even more radical departure from the illusionism and single-vanishing-point perspective of the Second Style can be found in the Black Room (**Fig. 5-25**) at Boscotrecase. As in the Red Room, the architectural elements are attenuated and insubstantial—and unbelievable. The crowning form, which is barely reminiscent of a pediment, sits on flower petals resting on painted medallions that picture profile heads atop impossibly thin Ionic colonnettes. In the center of the wall is a tiny floating landscape painted directly on the jet-black ground. It is hard to imagine a sharper contrast between this landscape painting and the Second Style gardenscape (Fig. 5-21) of Livia's Primaporta villa.

The new style was not to everyone's taste, however. Vitruvius, for example, who wrote his architectural treatise at about the time that the Third Style was introduced, complained about contemporary

depraved taste. For monsters are now painted in frescoes rather than reliable images of definite things. Reeds are set up in place of columns, as pediments, little scrolls, striped with curly leaves and volutes, candelabra hold up the figures of aediculae, and above the pediments of these, several tender shoots, sprouting in coils from roots, have little statues nestled in them for no reason, or shoots split in half, some holding little statues with human heads, some with the heads of beasts. No these things do not exist nor can they exist nor have they ever existed, and thus

this new fashion has brought things to such a pass that bad judges have condemned the right practice of the arts [that is, Second Style painting] as lack of skill.[3]

[3] Vitruvius, *On Architecture,* 7.5.3–4. Translated by Ingrid D. Rowland, *Vitruvius: Ten Books on Architecture* (New York: Cambridge University Press, 1999), 91.

5-26 Perseus and Andromeda, detail of a Third Style mural painting, from the east wall of the Mythological Room (cubiculum 19), Villa of Agrippa Postumus, Boscotrecase, ca. 10 BCE. Metropolitan Museum of Art, New York.

A third room in the Boscotrecase villa has a mythological panel at the center of each wall. The detail reproduced here (**Fig. 5-26**) depicts the story of Perseus rescuing Andromeda. Perseus flies in from the left to free Andromeda, who is chained to a cliff and guarded by a monstrous sea creature whose huge head bursts from the sea at the lower left. At the right, Perseus appears a second time, meeting with Andromeda's father Cepheus at his palace, in a sequel to the main story. (Perseus had been promised Andromeda in marriage if he rescued her.) Many art historians consider this an early instance of *continuous narration* (the depiction of the same figure in the same setting at different moments in an unfolding story), but although Perseus is shown twice in the same frame, the location has changed. In any case, the Boscotrecase mythological panel is different in kind from the Io and Argos panel (Fig. 5-22) in the House of Livia. They represent the two poles of Roman mythological painting. The Boscotrecase composition, which is unprecedented, seems to be a Roman invention, whereas the Palatine mural, with its monumental figures filling the mythological panel (compare Fig. 10-17), follows in the tradition of Greek painting. The latter is the far more common mode even in the Roman world, and similar mythological paintings appear frequently on later Third and Fourth Style walls at Pompeii (see Chapter 10).

SUMMARY

With the establishment of the Augustan principate, Roman art entered a new era in which the state's vast resources were marshaled to promote the political ideology and artistic tastes of a single all-powerful ruler. Augustus's portraits, for example, depict him as an eternally youthful quasi-divine being, consistent with his self-identification as the son of a god. Modeled on the statuary of Classical Greece, the portraits of Augustus and his family share the idealizing style of their prototypes.

Augustus was also a great builder who, by his own account, transformed Rome into a marble city on a par with Athens during the Golden Age of Pericles. He remodeled the Forum Romanum and provided it with a new focus—the temple in honor of his deified father, Julius Caesar—and erected a new gateway to the civic center that celebrated his Parthian victory. He also constructed a new forum in his own name in which he presented himself as the avenger of Caesar's murder and the latest and greatest in a line of *summi viri* beginning with Romulus and Aeneas. In the Campus Martius he erected an altar commemorating the Pax Augusta and a new theater honoring his nephew Marcellus.

The Augustan age also saw the passage from the Second to the Third Style in mural painting. Some of the finest examples of both styles in Rome, Primaporta, and Boscotrecase were commissions of the imperial family itself.

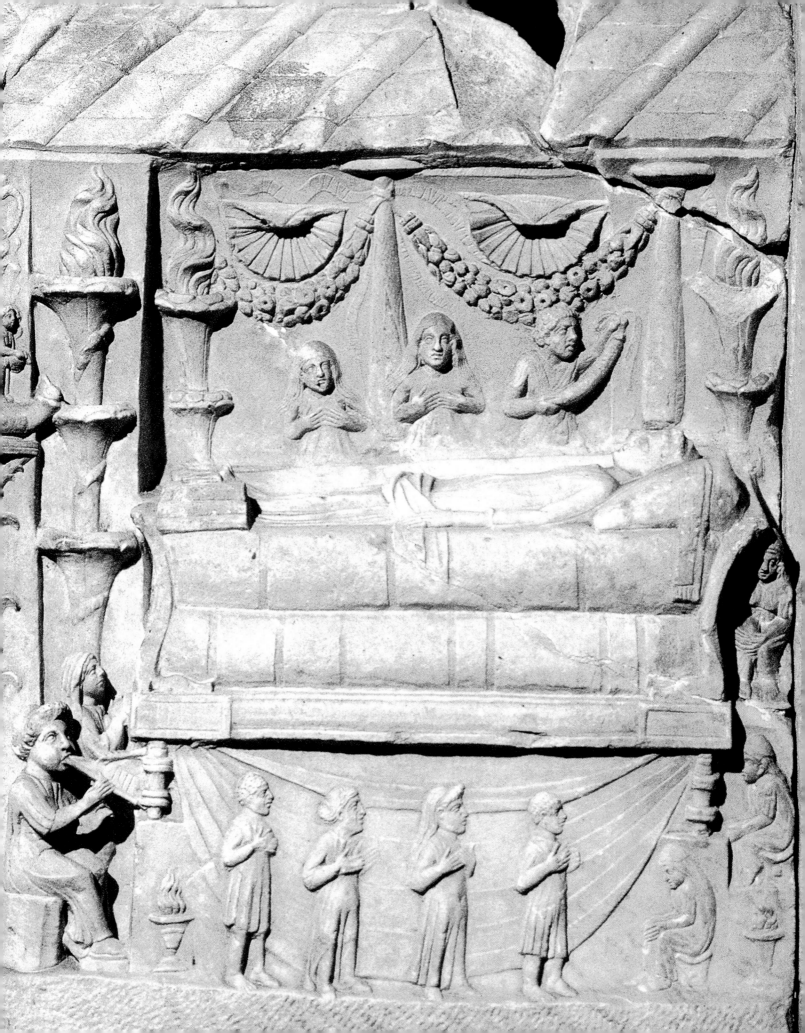

VI

Preparing for the Afterlife during the Early Empire

When Augustus returned to Rome after defeating Mark Antony and Cleopatra at Actium, he set immediately to work to transform the look of the capital by erecting temples in honor of the ancient gods and of the newest Roman god, his deified father, Julius Caesar (see Chapter 5). Those buildings were faced with Luna marble in imitation of the marble temples of the Greeks. But Augustus also began no later than 28 BCE to construct a huge monument of a very different kind—his own tomb.

FUNERARY ARCHITECTURE

MAUSOLEUM OF AUGUSTUS Some scholars think that Augustus may have begun construction of his tomb even before Actium, but it is certain that work began before the Senate named him Augustus in 27 BCE. Octavian, still in his early 30s, could not know that he would live another four decades, but preparing for the afterlife was probably not his motivation for erecting his tomb so early in his principate. Rather, he may have wanted to leave no doubt about his intention to be buried in Rome—in contrast to Mark Antony, whose will stipulated that he wished to be laid to rest in Alexandria in Egypt, even if he died in Rome. When Octavian revealed the contents of Antony's will during their struggle for power, he achieved a great public-relations coup.

Contemporaries called the tomb Augustus built for himself the *Mausoleum* (**Fig. 6-2**), a reference to the grandiose mid-fourth-century BCE tomb of Mausolos of Halikarnassos in Asia Minor, one of the Seven Wonders of the ancient world. But Augustus's tomb on the east bank of the Tiber in the Campus Martius (Fig. 18-22) looked nothing like Mausolos's tomb, which had a gigantic masonry base, square in plan, and featured a host of marble statues between columns, as well as a colossal chariot group at the summit. The geographer Strabo, writing shortly after the completion of Augustus's Mausoleum in 23 BCE, described the tomb:

> [In the Campus Martius, the Romans erected] the tombs of their most illustrious men and women. The most noteworthy is what is called the Mausoleum, a great mound near

6-1 Deceased woman lying in state, detail of a relief (Fig. 6-12) from the Tomb of the Haterii, Via Labicana, Rome, late first century CE. Musei Vaticani, Rome.

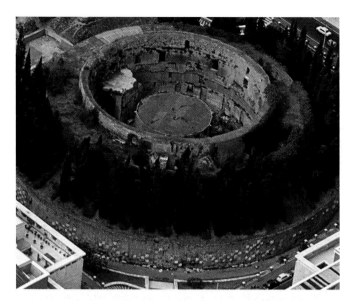

6-2 **Aerial view of the Mausoleum of Augustus, Via Flaminia, Rome, begun ca. 28 BCE.**

6-3 **Etruscan tumuli, Banditaccia necropolis, Cerveteri, sixth century BCE and later.**

the river on a lofty foundation . . . thickly covered with evergreen trees to the very summit. Now on top is a bronze image of Augustus Caesar.[1]

The remains of the Mausoleum of Augustus today give a good idea of the mammoth size of the structure, but not of its original appearance. It seems likely, however, that the preserved concentric concrete rings once supported the huge earthen *tumulus* that Strabo described, a burial mound planted with trees and topped by a colossal statue of the emperor. Augustus's tomb, therefore, was radically different in both material and form from the *Classicizing* (imitating the Greek Classical style) temples, basilicas, and porticos that the emperor erected throughout his new marble city, and different even from the travertine-and-concrete Theater of Marcellus (Fig. 5-19) with its facade of engaged Greek columns. Instead, the Mausoleum most closely resembled the monumental tumuli (**Fig. 6-3**) the Etruscans erected in the Banditaccia necropolis at Cerveteri. Augustus may have chosen to build his tomb in the form of a tumulus in order to conjure an image of great antiquity and to associate himself with the Republic's most ancient traditions. Romans of his day may have believed that Aeneas was buried beneath such an earthen mound. The Mausoleum would therefore have been a fitting memorial to Augustus, the descendant of Aeneas, who figures prominently in the sculptural program of the Forum of Augustus (Fig. 5-8) and the Ara Pacis (Fig. 5-16).

PYRAMID OF CESTIUS Tombs are unlike any other architectural genre. Because only a simple grave is needed to dispose of the dead (or, in the case of cremation, the common

practice during the Early Empire, only a small urn), the tomb marker can take any size or shape. The type chosen can reveal a great deal about the patron. Whereas Augustus elected to be buried in a tumulus in order to dissociate himself from Antony, Cleopatra, and Egypt, Caius Cestius, who died around 15 BCE, built his tomb (**Fig. 6-4**) on the Via Ostiensis (Fig. 18-22), which ran from Rome to Ostia, in the shape of an Egyptian pyramid, precisely in order to make an unmistakable visual connection to the tombs of the ancient pharaohs. After 30 BCE, when Egypt became a Roman province, a kind of Egyptomania swept Rome. Egyptian motifs are common, for example, in Augustan mural painting, although, curiously, not in the burial chamber of Cestius's tomb. Those murals are nonetheless of special interest because they are the earliest securely dated examples of the Third Style of Roman painting. It may not be coincidental that one of Cestius's heirs was Marcus Agrippa, who is closely associated with the transition from the Second to the Third Style (see Chapter 5). In any case, the murals in Cestius's pyramid must have been painted before Agrippa died in 12 BCE.

TOMB OF EURYSACES As the tombs of Augustus and Cestius demonstrate so clearly, tomb design was a very personal matter (see "The Tomb of Trimalchio," page 85), and in the Roman world the diversity of tomb types is perhaps greater than in any other culture, ancient or modern. Only individual taste and background can explain, for example, the unique tomb (**Fig. 6-5**) that the baker Marcus Vergilius Eurysaces built at the junction of the Via Labicana and the Via

[1] Strabo, *Geography*, 5.3.9. Translated by Horace Leonard Jones, *The Geography of Strabo*, vol. 2 (Cambridge, Mass.: Harvard University Press, 1960), 409.

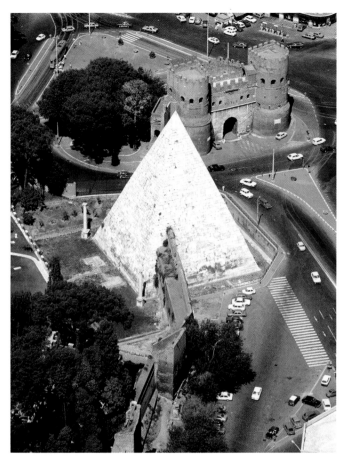

6-4 Aerial view of the Tomb of Caius Cestius, Via Ostiensis, Rome, ca. 15 BCE.

6-5 Tomb of Marcus Vergilius Eurysaces, between Via Labicana and Via Praenestina, Rome, late first century BCE.

Praenestina just outside the city limits of Rome (Fig. 18-22). This choice piece of real estate provided Eurysaces the opportunity to impress travelers entering Rome from two directions on two major highways. In contrast to Augustus and Cestius, scions of aristocratic families who enjoyed inherited wealth, Eurysaces was a former slave, a *libertus* (freedman) who made his fortune as a *pistor* (baker) and *redemptor* (contractor). The tomb he built in his own honor—but initially to house the cinerary urn (in the shape of a bread basket) of his wife Atistia—is unlike any other built during the Roman Republic or Empire. Made of travertine over a concrete core, it is trapezoidal in plan (to fit on the irregular plot of land between the converging roads) and is decorated with what most scholars believe are either cylindrical grain measures used in baking bread or, as recently suggested, the stone machines used to knead the dough before forming the loaves.

The frieze (**Fig. 6-6**) that runs around the top of the tomb has no parallel in the art of the imperial family or of other elite

6-6 The baking of bread, detail of the frieze of the Tomb of Marcus Vergilius Eurysaces, Rome, late first century BCE.

patrons. It depicts the various bread-making stages, from the grinding of grain to the formation and baking of individual loaves to the weighing of the final product under the watchful eyes of a Roman magistrate. The frieze is Eurysaces' pictorial version of the emperor's *Res Gestae* (see "The *Res Gestae* of the Deified Augustus," Chapter 5, page 67). The style of the relief also forms a vivid contrast with the Classicizing style Augustus favored. Plebeian patrons like Eurysaces preferred a less pretentious narrative style without visual references to Greek art. The baking frieze, for example, features shorter, stockier figures than those on the Ara Pacis (Figs. 5-1 and 5-18), and the figures rarely overlap each other. In Augustan Rome, artistic style and social class were intimately linked.

FUNERARY SCULPTURE

On the front of his tomb (severely damaged today; the tomb stands in front of the Porta Maggiore, Fig. 8-18), Eurysaces placed a tall marble relief of himself and his wife. Portraits of married couples were common on the tombs of freedmen during the Augustan period, and similar reliefs survive from the Late Republic.

VIA STATILIA RELIEF One especially well-preserved Late Republican example is the double portrait (**Fig. 6-7**) of a man and woman, a husband and wife, that once decorated a tomb on the Via Statilia in Rome. As in the Augustan portrait relief of Eurysaces and Atistia, the man wears the toga of a Roman citizen. The husband and wife in the Via Statilia relief were probably also former slaves. Slavery was common in the Roman world, and it is estimated that Italy at the end of the Republic had some two million slaves, or roughly one slave for every three citizens. The very rich might own hundreds of slaves, but slaves could be found in all but the poorest households. The practice was so much a part of Roman society that even slaves often became slave owners when their former masters freed them. Some gained freedom in return for meritorious service. Others were freed only in their masters' wills. Most slaves died as slaves in service to their original or new owners. As slaves, couples had no legal standing; they were the property of their owners. After they were freed, however, in the eyes of the law the former slaves became people. This explains the desire of freedmen and freedwomen to portray themselves as married couples on their tombs. The celebration of marriage was also a celebration of the newly acquired freedom of the former slaves who commissioned these portraits. Significantly, the husbands always are portrayed wearing the toga, the badge of Roman citizenship—and of freedom.

Usually, either the husband or wife was still alive when the portrait relief was set into the tomb facade, as was the case with the baker's tomb. Therefore, the reliefs projected another important message as well, namely that the bonds of marriage are not broken at death. Eurysaces expected to be buried in the tomb he had built for Atistia and to join her in the afterlife.

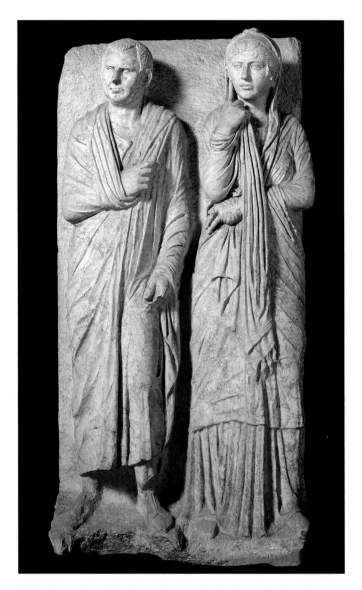

6-7 Portrait relief of a husband and wife, from Via Statilia, Rome, ca. 75–50 BCE. Marble, 5′ $10\frac{7}{8}$″ high. Musei Capitolini–Centrale Montemartini, Rome.

RELIEF OF THE SERVILII The importance of personhood, citizenship, and family among newly enfranchised slaves is especially clear on those funerary reliefs where inscriptions are preserved naming those portrayed. The fragmentary portrait relief (**Fig. 6-8**) of the Servilii depicts three members of the same freedman family. (There may originally have been others portrayed as well.) The upper part of a *pilaster* (a flat version of an engaged column) between two of the portraits indicates that the relief once decorated the upper part of a tomb facade of the Corinthian order. The father (*pater* in the epitaph) was the libertus of Quintus Servilius (*Q.L.*) and took his patron's name upon *manumission* (gaining freedom). His wife (*uxor*) was formerly a slave of a woman named Sempronia. She too assumed her patron's name and has *L.* (*liberta*)

following her name. Their son, however, who was born after they had been freed, is Publius Servilius, *filius* of Quintus (*Q.F.*). He wears, in addition to the citizen's toga, the circular pendant called a *bulla* on a cord around his neck. The bulla was the emblem freeborn boys wore until they reached adulthood. The relief commemorates the progress of the Servilius family from slave to freedman to freeborn citizen, which opened up avenues for advancement for young Publius that were denied to his father (for example, serving in the Roman army and holding higher civic offices). These stern frontal portraits were the freedman's equivalent of the household *imagines* of Rome's old families (see "Ancestor Portraits," Chapter 4, page 54).

RELIEF OF THE GESSII Sometimes the relationship among the figures portrayed is ambiguous, because all freedmen took

the name of their master or mistress when manumitted. On a relief (**Fig. 6-9**) now in Boston, three people, all named Gessius, are portrayed. At the left is Gessia Fausta, and at the right, Gessius Primus. Both are the freed slaves of the much older Publius Gessius, the freeborn citizen in the center shown wearing a soldier's cuirass and portrayed in the standard Republican veristic fashion. Whether the two freed slaves were sister and brother, wife and husband, or unrelated is unclear. Their names reveal only that both Fausta and Primus were formerly the property of Publius Gessius. The relief's inscriptions, however, provide other valuable information. They state that the monument was paid for with funds provided by the will of Gessius Primus and that the work was directed by Gessia Fausta, the only survivor of the three. The relief thus depicts the living and the dead side by side, as on the portrait relief of Eurysaces and Atistia.

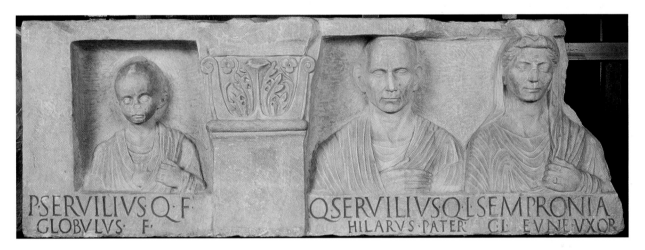

6-8 Funerary relief with portraits of the Servilii, from Rome, late first century BCE. Marble, 2′ × 5′ 9″. Musei Vaticani, Rome.

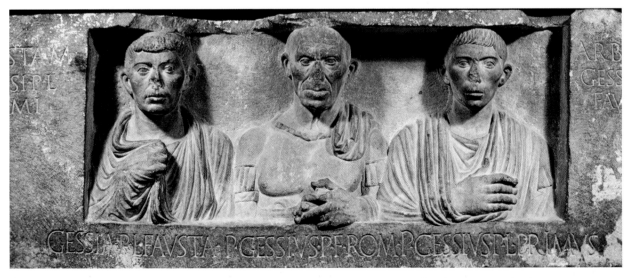

6-9 Funerary relief with portraits of the Gessii, from Rome(?), ca. 30–13 BCE. Marble, approx. 2′ 1½″ high. **Museum of Fine Arts, Boston.**

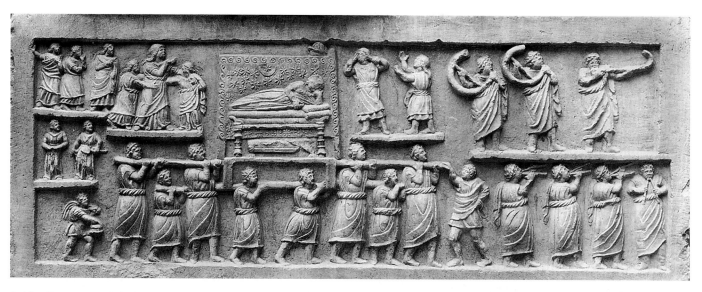

6-10 **Funerary relief with cortege of the deceased, from Amiternum, second half of first century BCE.** Limestone, approx. 2′ 2″ high. Museo Nazionale d'Abruzzo, L'Aquila.

RELIEF FROM AMITERNUM More rarely, freed slaves commissioned tomb reliefs that were narrative in character, like the frieze (Fig. 6-5) of Eurysaces' tomb. A relief (**Fig. 6-10**) from Amiternum depicts the cortege in honor of the deceased, complete with musicians, professional female mourners who pull their hair in a display of feigned grief, and the deceased's wife and children. The deceased is laid out on a bier with a canopy as a backdrop. He surprisingly props himself up as if still alive, surveying his own funeral. This may be an effigy, like the reclining figures on the lids of Etruscan sarcophagi (Fig. 15-2), rather than the dead man himself.

The composition of the relief is unexpected. Mourners and musicians stand on floating ground lines, as if on "magic carpets." They are not to be viewed as suspended in space, however, but as situated behind the front row of pallbearers and musicians. This sculptor, in striking contrast to the (usually Greek) artists the patrician aristocracy employed, had little regard for the rules of Classical art. The Amiternum artist studiously avoided overlapping and placed the figures wherever they fit, so long as they were clearly visible. This approach to making pictures was characteristic of pre-Classical art, but it had been out of favor for several centuries. No similar compositions appear in the art commissioned by Republican consuls and senators or the emperor. The linkage between social standing and artistic taste, already noted in the discussion of the baking frieze (Fig. 6-6) on the tomb of Eurysaces, is seen again at Amiternum. This dichotomy in both subject and style between elite and plebeian art during the Late Republic and Early Empire is another example of the eclecticism that characterizes Roman art and architecture throughout its long history.

TOMB OF LUSIUS STORAX Around 45 CE, a freedman named Lusius Storax, who held the position of *sevir* (a local magistrate charged with overseeing the cult of Roma and Divus Augustus) at Teate (modern Chieti), constructed a tomb for himself decorated with relief sculptures of a type that must have been quite common at the time (see "The Tomb of Trimalchio," page 85). Storax, accompanied by other magistrates and musicians, was depicted in the facade's pediment (**Fig. 6-11**) seated on a dais presiding over the gladiatorial games he had financed. The gladiators appeared in the frieze below his feet. The sevir is the central figure and larger than all the rest. He is even taller seated than the standing magistrates to his left and right. This equation of size and rank—what art historians call *hierarchy of scale*—is familiar in the sculpture and painting of many cultures in different places and times, but it is antithetical to the Classical style Augustus, his successors, and other elite patrons favored during the Early Empire.

Also different from imperial art is the way the sculptor represented the other toga-clad magistrates behind Storax. If interpreted literally, these figures would be eight feet tall, but that was not the artist's intent. Instead of depicting the background figures almost hidden behind the foreground figures, as in the imperial procession (Fig. 5-18) on the Ara Pacis, the sculptor elevated them, both to show them more clearly and to fill every available inch of the relief surface, a characteristic also of the Amiternum relief (Fig. 6-10). During the Late Republic and Early Empire, the funerary art of freedmen constituted a distinctive, independent, and important pictorial tradition—one ignored until relatively recently by art historians focused exclusively on the official art of the Roman emperors.

The Tomb of Trimalchio

Petronius Arbiter was the author of a famous parody of the life of nouveau-riche freedmen during the mid-first century CE. A vocal critic of the excesses of the emperor Nero (see Chapter 8), he was forced to commit suicide. In his *Satyricon*, Petronius recounted a lavish dinner party given by the freedman Gaius Pompeius Trimalchio, who described himself as a self-made multimillionaire who began life penniless and had the good sense "never to have listened to a philosopher." At one point in the raucous dinner conversation, Trimalchio told his guests about the plans he had made for his tomb. The description rings true—one key feature of Trimalchio's tomb is a prominent part of the contemporary tomb of Lusius Storax (Fig. 6-11) at Chieti.

Tell me, [Habinnas, my] old friend, are you building my tomb just as I told you to? Please be sure that you put my lap-dog at the foot of my statue along with plenty of wreaths and jars of perfume, and all the fights of Petraites [a renowned gladiator of the time] so that, thanks to you, I may live on after my death . . . It makes no sense to decorate the house you live in now but not the one where you'll spend so much longer . . . [And on the front please] put me high on a ceremonial dais wearing my purple-striped toga and five golden rings as I pour money out of a sack in front of the whole town! —For you know, I once put on a public banquet that cost two [denarii] a head—and if it's all right with you, put some banqueting tables up there and show the whole town having a good time . . . And put a sundial in the middle so whoever checks the time will read my name, like it or not!*

*Petronius, *Satyricon*, 71. Translated by R. Bracht Branham and Daniel Kinney, *Satyrica* (Berkeley: University of California Press, 1996), 65–66.

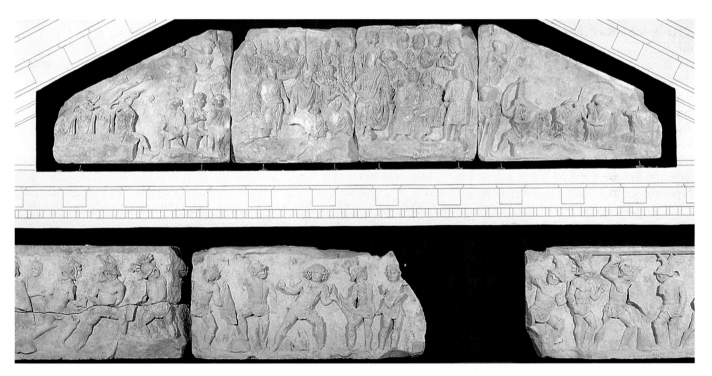

6-11 **Magistrates viewing gladiatorial games, relief in pediment of the Tomb of Lusius Storax, Chieti, ca. 45 CE. Limestone, 2′ × 3′ 8¾″. Museo Nazionale, Chieti.**

TOMB OF THE HATERII A tomb that far surpassed Storax's in the richness of its sculptural decoration was erected by the Haterius family at the end of the first century CE a few miles from Eurysaces' tomb on the Via Labicana outside Rome. The tomb was discovered and excavated in 1848; additional finds were uncovered in 1969 and 1970. Numerous marble inscriptions, altars, busts of Quintus Haterius and his wife and of several Underworld deities, and reliefs depicting contemporary buildings in Rome, a monumental tomb, and other subjects are today in the Vatican Museums.

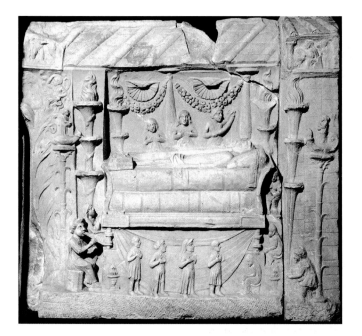

6-12 **Deceased woman lying in state, from the Tomb of the Haterii, Via Labicana, Rome, late first century CE. Marble, 2′ 5¾″ × 3′ 1″ high. Musei Vaticani, Rome.**

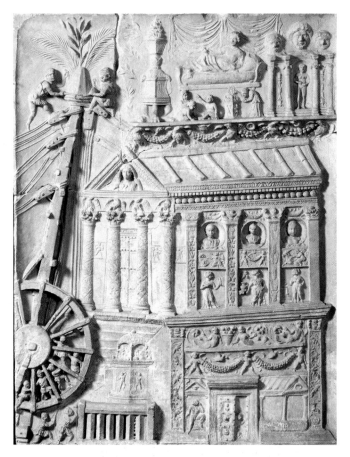

6-13 **Construction of a mausoleum, from the Tomb of the Haterii, Via Labicana, Rome, late first century CE. Marble, 4′ 4″ × 3′ 5″. Musei Vaticani, Rome.**

One of the reliefs (**Figs. 6-1** and **6-12**) represents a deceased woman on her funerary bed in what seems to be the atrium of a private house. The room is decorated with garlands and candelabra, and mourners have gathered around the dead woman's couch. The figures are tiny in comparison with the deceased—another example of hierarchy of scale. Behind the bed are two girls, probably the woman's daughters, who are beating their chests in grief. The other figures present include a flute player and household slaves, one of whom is placing a garland on the deceased's body. Some of the slaves wear conical caps, indicating that they have just been freed by the terms of the woman's will. A small inset panel at the top right appears to depict the woman writing that will, with a witness present to make it legal. The discrepancies in scale, the simultaneous representation of the interior and exterior of the house, and the depiction of the woman in two different locations, alive and dead, have no parallels in the art of the Early Empire outside the realm of plebeian funerary art.

A second relief (**Fig. 6-13**) from the Tomb of the Haterii is stylistically similar. Depicted is a grandiose tomb in the form of a temple of characteristic Roman type with freestanding columns and stairs only at the front. The building crane at the left suggests that the tomb is still under construction, although the crowning feature may soon be set in place. The portrait in the pediment indicates that this is the tomb of the woman in the mourning scene in Fig. 6-12. Bust-length portraits of three of her children are depicted on the side of the tomb. The same two boys and a girl may be represented a second time in the scene above the roof, where they play beside their mother's bed, and a third time in the form of three heads above a shrine in which the woman is represented beneath an arch as a Venus-like figure in full nudity. She, like the emperors and empresses of Rome, has achieved immortality after death. The ambiguous spatial relationship of the tomb, the shrine, and the woman on her bed (indoors, with a curtain for a backdrop) is another distinctive feature of freedmen reliefs that cannot be found in contemporary elite art.

CLASSICISM IN PLEBEIAN ART Not all the sculptures from the Tomb of the Haterii are of this kind, however. The lintel (**Fig. 6-14**) above the doorway to the tomb—the symbolic border between the worlds of the living and of the dead—was decorated with four busts of Roman deities: from left to right, Mercury, the god responsible for guiding the dead to the Underworld; Proserpina, the daughter of Ceres and Jupiter; Pluto, lord of the Underworld; and Ceres, Pluto's wife. Although these busts lack the polish and perfect proportions of their Classicizing Roman models (compare, for example, the roughly contemporary reliefs, Figs. 9-22 and 9-23,

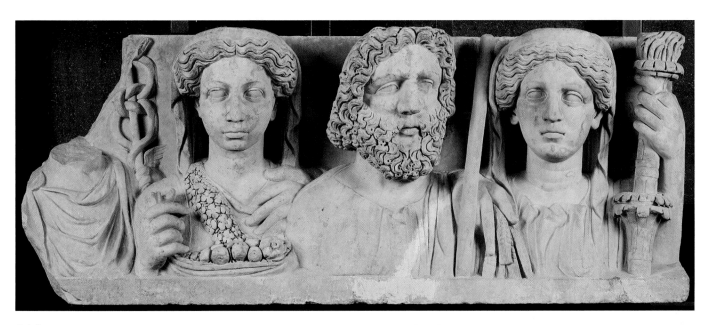

6-14 **Underworld deities, from the Tomb of the Haterii, Via Labicana, Rome, late first century CE.**
Marble, 2′ 1½″ × 5′ 4½″. Musei Vaticani, Rome.

from the Palazzo della Cancelleria in Rome), they nonetheless share the same stylistic traits. The Tomb of the Haterii is a reminder that Roman monuments—plebeian as well as elite—often display different styles (compare Figs. 4-5 and 4-6) and that eclecticism is a core characteristic of Roman art from beginning to end.

SUMMARY

Many Romans devoted careful attention and expended a great deal of money on their tombs, convinced, like the fictional Trimalchio of Petronius's *Satyricon*, that they would spend much more time in their tombs after their death than in their homes while still alive. Personal taste usually dictated the form these tombs took, especially in the case of monuments of unusual or unique design, such as the Mausoleum of Augustus, the Pyramid of Cestius, and the tomb of the baker Eurysaces.

Freed slaves often used their tombs to advertise their new status in society, both through inscriptions describing themselves as *liberti* and by dressing in the toga that only free citizens could wear. Most of these freedmen would never have commissioned portraits of themselves at any other time. The family portraits on their tombs, however, presented the deceased (and often their living relatives too) to posterity in a way reminiscent of the parade of ancestor masks at the funerals of old aristocratic families.

The narrative reliefs on the tombs of freedmen usually also are distinct in character from contemporary elite art and show little interest in the Classicizing style Augustus and his immediate successors favored. In ancient Rome, artistic style and one's position in the social hierarchy were often closely linked.

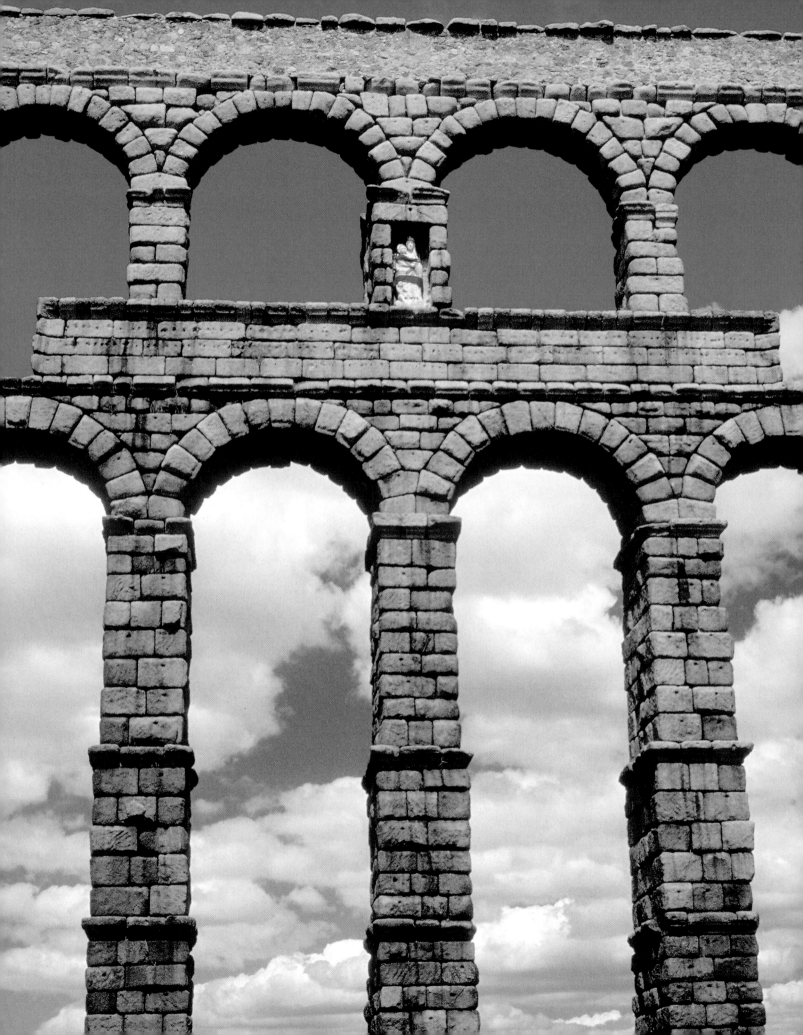

The Pax Augusta in the West

In the *Aeneid,* Vergil's great national epic written while Augustus was emperor, Anchises reveals to his son Aeneas that the destiny of the Roman people will be to pacify and rule the world:

> Roman, remember by your strength to rule
> Earth's peoples—for your arts are to be these:
> To pacify, to impose the rule of law,
> To spare the conquered, battle down the proud.[1]

The Pax Augusta that Anchises foresaw brought unprecedented prosperity along with Roman laws to every corner of Augustus's empire. As Pliny the Younger observed a little more than a century after Vergil's death, the Romans had "opened roads, built harbours, created routes overland, let the sea into the shore and moved the shore out to sea, and linked far distant peoples by trade so that natural products in any place now seem to belong to all."[2]

There were, of course, negative consequences of Roman rule—loss of independence, suppression of local traditions in favor of a homogenized *Romanitas,* and so forth—but almost every new Roman citizen in the provinces enjoyed a higher standard of living in exchange. In the western provinces, especially Gaul and Spain (**Map 7-1**, page 90), the exceptionally well-preserved monuments of the Early Empire bear witness today to the enormous investment in infrastructure (roads, bridges, and aqueducts) and entertainment structures (theaters and amphitheaters) that Augustus and his successors made—at the same time that they were building temples to the Roman gods and the imperial family itself.

AQUEDUCTS

PONT-DU-GARD, NÎMES One of the grandest and most frequently photographed Roman monuments in the world is the Augustan aqueduct bridge in southern France known as the Pont-du-Gard (**Fig. 7-2**), which provided about 100 gallons of water a day for each inhabitant of Nîmes (ancient Nemausus). Nîmes, an old Celtic town with trading links to the Greek colony of Marseilles (ancient

7-1 **Detail of the aqueduct (Fig. 7-3), Segovia, Spain, early to mid-first century CE.**

[1] Vergil, *Aeneid,* 6.1151–1154. Translated by Robert Fitzgerald, *The Aeneid* (New York: Vintage Books, 1990), 190.

[2] Pliny the Younger, *Panegyricus,* 29.2. Translated by Betty Radice, *Pliny: Letters and Panegyricus,* vol. 2 (Cambridge, Mass.: Harvard University Press, 1975), 385, 387.

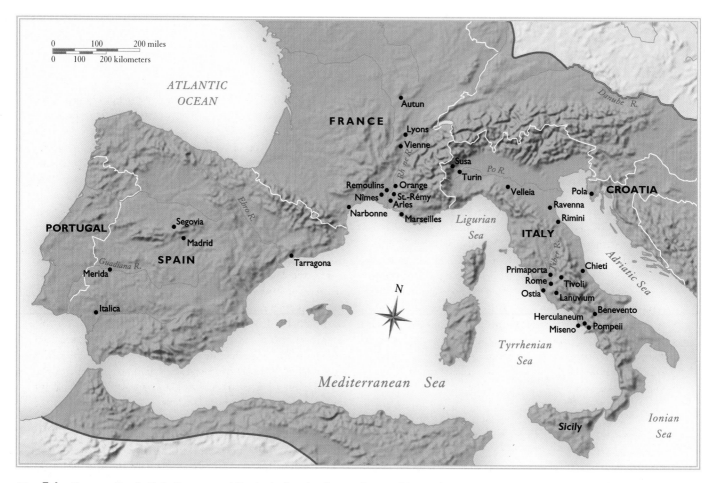

Map 7-1 **Roman sites in Italy, France, and Spain during the first and second centuries CE.**

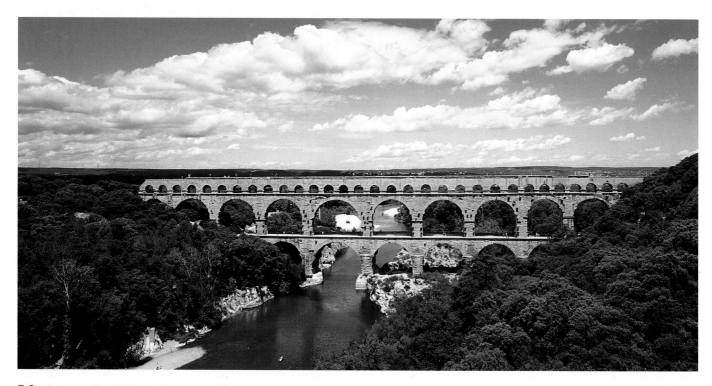

7-2 **Pont-du-Gard, Nîmes, France, ca. 16 BCE.**

ARCHITECTURAL BASICS

Roman Aqueducts

The amenities of urban life, especially the Romans' beloved baths (see "An Afternoon at the Baths," Chapter 2, page 24) but also the health of the populace, necessitated the provision of a dependable supply of clean water to the capital and to cities throughout the Empire. The emperors met that demand by constructing and maintaining a network of aqueducts that brought water from mountain springs and rivers to population centers often dozens of miles away.

Rome itself had 11 aqueducts. The first, the Aqua Appia, was constructed in 312 BCE by Appius Claudius Caecus, who was also responsible for one of Italy's most important roads, the Via Appia, laid out at the same time. Three more aqueducts followed during the third and second centuries BCE. Between 33 and 2 BCE, Augustus built three new aqueducts to serve Rome's rapidly growing population. The Julio-Claudian emperors and Trajan constructed three additional aqueducts between 38 and 103 CE. The emperor Severus Alexander built Rome's last aqueduct in 226 CE, primarily to carry water to his new bath complex in the Campus Martius.

Rome's aqueducts were marvels of ancient engineering. Sextus Iulius Frontinus, a senator who was appointed water commissioner of Rome in 97 CE and whose treatise *On the Aqueducts of Rome* is the primary source of information about the Roman water distribution system, considered Rome's aqueducts to be "indispensable" and far superior to "the idle Pyramids [of the Egyptians] or the useless, though famous, works of the Greeks."*

The genius of the Roman water system was its simplicity. Rome's aqueducts operated by gravitational forces alone for most of their length. The goal of the engineers charged with constructing a new aqueduct was to lay out a continuous course from the water source to the city so that the cement-lined water channel maintained a steady declining slope from beginning to end. The average gradient was between 0.15 percent and 0.30 percent, that is, a drop of 15 to 30 centimeters every 100 meters. Sand, rocks, and other impurities were removed at periodic settling tanks along the line.

Most aqueduct channels were underground and about one meter wide and two meters tall so that they could be entered for repairs and to permit circulation of air, which helped preserve the quality of the water. Only when the conduit had to cross a river, as at Nîmes (Fig. 7-2), or a valley or depression, as at Segovia (Fig. 7-3), was it necessary to erect a bridge or viaduct to maintain the gradient of the aqueduct. When the drop exceeded about 50 meters, an inverted siphoning system was employed instead. Airtight lead pipes carried the water to the valley floor. The water was forced up the opposite hill by the pressure of the descending water. The pressurized piped water then entered another free-flow channel where gravity took over again and the water resumed its steady descent toward the city. ∎

* Frontinus, *On the Aqueducts of Rome,* 1.16. Translated by Charles E. Bennett, *Frontinus: The Strategems and the Aqueducts of Rome* (Cambridge, Mass.: Harvard University Press, 1925), 357, 359.

Massalia), was strategically located on the Via Domitia, the main east-west Roman highway in the province of Gallia Narbonensis, named after the city of Narbonne (ancient Narbo). Augustus settled many of his veterans at Nîmes after his victory at Actium in 31 BCE, and the city's population expanded rapidly during the first century of the Empire, peaking around 30,000. Before Augustus, the populace drew water from a local spring, but that source could not supply enough water for the growing population. Imperial Nîmes depended on water that came from a mountain spring about 30 miles away (see "Roman Aqueducts," above).

The Pont-du-Gard is the three-story, 49-meter-high bridge that Marcus Agrippa erected to carry the water channel across the Gard River near Remoulins at a point about 12 miles from the Roman colony. Each large arch spans some 25 meters and is constructed of yellow limestone blocks from a nearby quarry that weigh up to two tons each. No mortar was used; the weight of the blocks held them in place. The bridge's uppermost level consists of a row of smaller arches,

three above each of the large openings below. At the top is the water channel, still intact today, which has a very slight slope so that the water could flow freely toward Nîmes by the force of gravity alone. The harmonious proportional relationship between the larger and smaller arches reveals that the Roman engineer had a keen aesthetic, as well as practical, sense.

AQUEDUCT, SEGOVIA The construction of aqueduct bridges was an expensive enterprise, and any damage they sustained threatened the water supply of an entire city. The Romans preferred to place their conduits underground. Only where the local topography required the building of a bridge to maintain the gradient of the water channel did the Romans choose to incur the expense and risk of these engineering projects. At Segovia, north of Madrid, Spain, the natural depression in the land required that kind of investment. The 823-meter stretch of slender granite arches (**Fig. 7-1**)—constructed, as at Nîmes, of stones laid without mortar—perfectly illustrates the fundamental principle of aqueduct design. Preserving a consistent

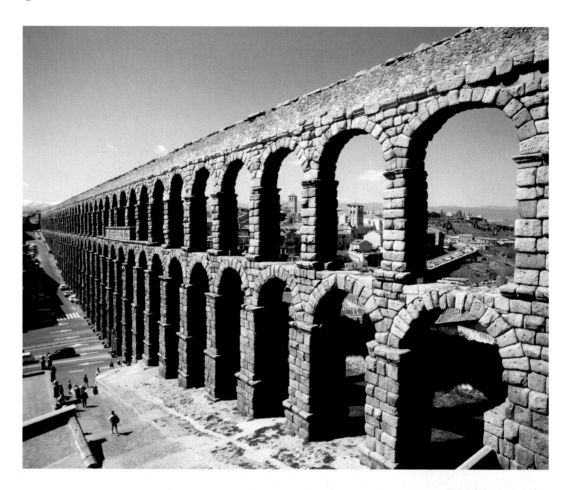

7-3 **Aqueduct, Segovia, Spain, early to mid-first century CE.**

gradient in the aqueduct channel was paramount. The Segovia viaduct is just a series of stilts supporting that channel. The aqueduct varies in height and in the number of stories with the contour of the land (**Fig. 7-3**). The aqueduct bridge turns a corner at the left edge of the photograph and then disappears shortly thereafter when the water channel enters the ground once again.

ARCHES AND GATES

In 27 BCE, as he noted with pride at the end of his life, Augustus "constructed the Via Flaminia from the city [Rome] to Ariminum [modern Rimini in northeastern Italy, south of Venice], and all the bridges except the Mulvian and the Minucian."[3] To commemorate the completion of the Via Flaminia project, Augustus erected one arch at the beginning of the road, at the Mulvian Bridge in Rome, and one at its end, at Rimini. Both underscore that although architectural historians use the conventional term "triumphal arch" to describe almost any freestanding commemorative arch, most Roman arches had nothing to do with warfare or the subsequent triumphal

7-4 **Arch of Augustus, Rimini, 27 BCE.**

[3] *Res Gestae,* 4.20. Translated by Frederick W. Shipley, *Res gestae divi Augusti,* rev. ed. (Cambridge, Mass.: Harvard University Press, 1979), 379.

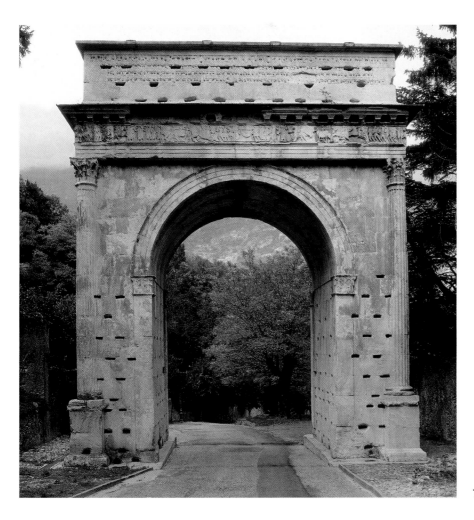

7-5 **Arch of Augustus, Susa, 9 BCE.**

processions of the victorious generals. Often, as was the case with Augustus's two Via Flaminia arches, they were erected to celebrate engineering feats and other public works projects.

ARCH OF AUGUSTUS, RIMINI The Mulvian Bridge arch does not survive, but the Augustan arch at Rimini (**Fig. 7-4**) still stands as part of the city's wall circuit. It marked the point where the Via Flaminia highway became the decumanus of ancient Ariminum. The arch formed the city's east gate.

The Rimini arch is typical of Augustan arches in its elegance and severity. Engaged half-columns and a pediment frame the single passageway. A similar framing system was used a decade later for the lateral passageways of Augustus's Parthian arch (Fig. 5-6) in the Forum Romanum. There are, however, no Victories in the *spandrels* (the roughly triangular area around the arch proper between the columns and the architrave) of the Rimini arch, as there were on the Parthian arch. Instead, four small *tondi* or *roundels* (reliefs or paintings with circular frames) with busts of Jupiter, Neptune, Apollo, and Roma were inserted near the Corinthian capitals. Before Augustus, most Roman arches had statues of Roman deities above their attics, and the Rimini tondi reflect this tradition. Imperial arches, in contrast, usually had crowning statues of the emperor, often in a triumphal quadriga, as on the Parthian arch.

ARCH OF AUGUSTUS, SUSA In 9 BCE, on the opposite side of Italy at Susa (ancient Segusio), south of Turin, on the road leading to the Alpine crossing to Gaul, Augustus erected an arch (**Fig. 7-5**) celebrating the peace treaty he had signed with Marcus Iulius Cottius. Cottius was the son and successor of the king of 14 tribes in the so-called Cottian Alps. The terms of the treaty called for Cottius to renounce his kingship and become a Roman citizen with the name Iulius and a local magistrate with authority over the people he formerly ruled. The "triumphal" arch at Susa commemorates the bloodless establishment of the Pax Augusta in this northwestern corner of Italy, an event that Augustus also boasted about in the *Res Gestae*:

> The provinces of the Gauls, the Spains, and Germany, bounded by the ocean from Gades to the mouth of the Elbe, I reduced to a state of peace. The Alps, from the region which lies nearest to the Adriatic as far as the Tuscan Sea, I brought to a state of peace without waging on any tribe an unjust war.[4]

The arch at Susa is the best preserved of all Augustan arches in Italy and in many respects is also the finest, epitomizing the austerity and classical proportions of Augustan architectural

[4] *Res Gestae,* 5.26. Translated by Shipley, 387, 389.

94

7-6 Treaty signing (*top*) and suove-taurilia (*bottom*), details of the frieze of the Arch of Augustus, Susa, 9 BCE.

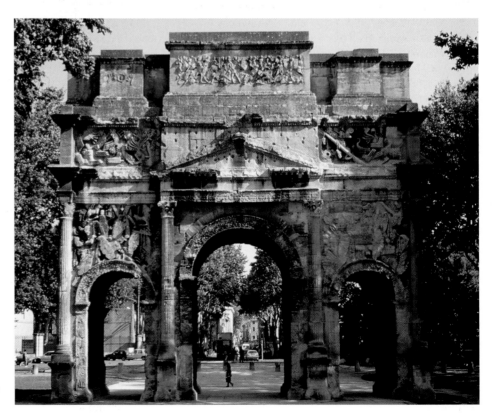

7-7 Arch of Tiberius, Orange, France, ca. 25 CE.

design. The arch's spare decoration and single bay recall the general format of the Rimini arch, but the Susa arch has no pediment and no sculpture of any kind in the spandrels. A sculptured frieze (**Fig. 7-6**), however, extends to all four sides of the arch. It depicts the treaty signing and suovetaurilia and related ceremonies that accompanied it. Augustus is shown at the center (Fig. 7-6, *top*), recognizable not only by his privileged position but also by his distinctive hairstyle. The style of the togate figures to either side of the emperor contrasts sharply with that of imperially commissioned reliefs like the processional friezes (Fig. 5-18) of the contemporaneous Ara Pacis in Rome. On the Susa arch, the postures are repetitive, the proportions awkward, and the carvings shallow. Each of the animals in the suovetaurilia (Fig. 7-6, *bottom*), for example, is unnaturally depicted as tall as the height of the frieze, regardless of its true size. Differences in skill and training no doubt explain in large part the dichotomy in quality between Augustan court art and this provincial frieze, but taste was also an important factor, as in the funerary art of Roman freedmen (see Chapter 6). The Classical style that Augustus championed as a symbol of his new golden age was not to everyone's taste.

ARCH OF TIBERIUS, ORANGE Not all Early Imperial arches were as austerely decorated as those at Rimini and Susa. In Augustan Gaul, sculptors regularly decorated the piers of triumphal arches with reliefs depicting conquered enemies in chains and piles of captured arms and armor. The most elaborate of the preserved Gallic arches was probably erected around 25 CE as the north gate (**Fig. 7-7**) of Orange (ancient Arausio) under Augustus's successor, Tiberius. The date is controversial, and some scholars have placed it as late as the third century CE. If the bronze letters of the dedicatory inscription were preserved, the precise date would be known. Still, stylistic comparisons with other Early Imperial arches and reliefs in Gaul make a Tiberian date very likely.

The Orange arch has three arcuated bays and two attics and must once have been crowned by a huge statuary group. The upper attic has a narrative relief at the center of each side depicting a battle between Romans and Gauls. The lower attic has a central pediment and flanking reliefs (**Fig. 7-8**) depicting ships' prows and other naval motifs. Below, above the two lateral passageways, are representations of captured Gallic shields, spears, swords, cuirasses, and military standards. The short ends of the arch are also richly decorated with chained Gauls and sea monsters. Overall, the arch celebrates not only the Roman victory over the Gauls but the universality of Roman power on both land and sea. The density of the sculptural ornament is without parallel elsewhere in the Empire at this time. The Gallic arches are a distinct regional phenomenon and highlight the complexity and diversity of Roman art throughout its long history. It is often impossible, for example, to apply dating criteria developed from monuments erected in the capital to provincial monuments built by craftsmen trained in a very different artistic milieu.

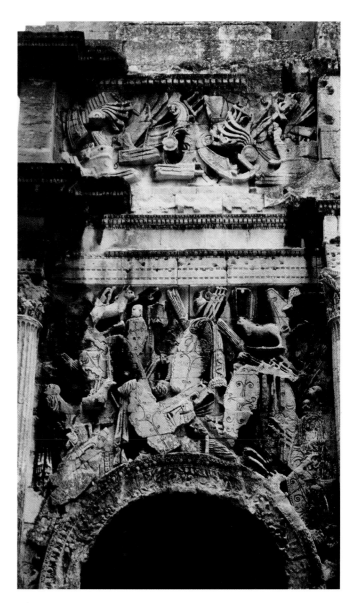

7-8 **Detail of the facade reliefs, Arch of Tiberius, Orange, France, ca. 25 CE.**

PORTA PALATINA, TURIN Many freestanding arches, such as the Orange arch, doubled as commemorative monuments and city gates, but more commonly the entrances to Roman provincial towns bore no sculptural decoration, had multiple portals for wheeled and pedestrian traffic, and could provide for defense even though the Pax Augusta made attack unlikely. An exceptionally well-preserved city gate of the Augustan period is the Porta Palatina at Turin (ancient Augusta Taurinorum), a Roman colony that Augustus founded in 25 BCE. The town was laid out according to the traditional castrum plan (Fig. 2-2) with a rectangular grid, a fortified wall circuit, and gates at each end of both the cardo and decumanus.

7-9 Porta Palatina, Turin, early first century CE.

The Porta Palatina (**Fig. 7-9**), built mostly of brick rather than stone, has two large central arcuated bays sufficiently wide and tall to accommodate horse-drawn vehicles with their drivers and cargo, and two smaller lateral bays for pedestrians. Tall 16-sided watchtowers frame the passageways and two upper stories of *fenestrated* (with windows) galleries for patrolling guards. No longer standing is the walled courtyard behind the gate, also three stories high, which permitted local officials to regulate traffic entering or leaving the colony. Similar gateways are preserved on the other side of the Alps at Nîmes, Arles, Autun, and other Gallo-Roman sites. They served to announce the presence of Roman rule and Roman arms in the provinces.

TEMPLES, THEATERS, AND AMPHITHEATERS

The heart of every provincial Roman city was its forum, and that is where Roman power was usually conspicuously on display in the form of imperial portrait statues and often by the presence of a temple dedicated to the official worship of the emperor or the goddess Roma or both (see "The Imperial Cult," page 97).

TEMPLE OF AUGUSTUS, VIENNE Vienne (ancient Vienna) was an important Gallic outpost at a strategic bend in the Rhône River. Conquered by Rome in 121 BCE, Vienne became a colony under Julius Caesar in 52 BCE. Under Augustus, a new temple (**Fig. 7-10**) was constructed in the forum of Vienne. Dedicated to Augustus and Roma during the emperor's lifetime, it was rededicated in the mid-first century CE to Divus Augustus and the newly deified Livia. The Vienne temple is an example of the Roman type with alae, like the

Temple of Jupiter Capitolinus (Fig. 1-4), but it is smaller and narrower than the Capitoline temple and has a facade of six Corinthian columns. The Classicizing style of the building was itself a symbol of Roman hegemony in Gaul.

7-10 Temple of Roma and Augustus, Vienne, France, late first century BCE or early first century CE.

The Imperial Cult

The elevation of rulers to divine status was commonplace in the Hellenistic world. When the Romans arrived in the Greek-speaking Mediterranean as conquerors or liberators, it was only natural that new cults were established for the worship of charismatic figures. The first Roman to have a permanent cult in Greece was Titus Quinctius Flamininus (Fig. 4-2), liberator of the Greek cities from Macedonian domination. Flamininus was hailed as *soter* (Greek, "savior") in Chalcis, Corinth, Argos, and elsewhere in Greece as early as 191 BCE.

Julius Caesar was the first Roman to be voted a *divus* by the Senate. Considerable evidence exists that Caesar was awarded divine honors in early 44 BCE. Those honors signaled to the Senate his intention to rule Rome as a divine monarch on the Hellenistic model and precipitated the assassination plot against him (see Chapter 4). But it was only after Caesar's death that Octavian established the cult in honor of his adoptive father and constructed a temple in the Forum Romanum (Fig. 5-5, no. 7) for the worship of Divus Iulius on the spot where he had been cremated.

As princeps, Augustus never permitted open worship of himself in the capital, although he promoted himself as the son of the god Iulius (Fig. 5-2), the descendant of Venus, and even as the son of Apollo. Outside Rome, however, in Italy and the provinces, where there was no conservative senatorial opposition to the notion of a divine ruler, the cult of Augustus spread rapidly during his lifetime—even though there was no prior tradition of ruler worship in the West as there was in the East. In the West, the earliest known altar for the worship of Augustus was set up in Lyons (ancient Lugdunum) in 12 BCE, the same year Augustus became pontifex maximus. The first priest of Augustus in Gaul was Gaius Iulius Vercondaridubnus, who came from an elite Gallic family whose members had become Roman citizens under Caesar and taken the Julian name. The Lyons altar was formally dedicated not to Augustus alone but to Roma and Augustus. The joint worship of the state and the ruler became the norm in the Western provinces, as at Vienne (Fig. 7-10). ■

Maison Carrée Another example of the importation of the Augustan Neoclassical style is the equally well-preserved temple at Nîmes long known as the Maison Carrée (**Fig. 7-11**). Once thought to be contemporary to the Pont-du-Gard, this Corinthian pseudoperipteral temple is now believed to have been erected in the first decade CE and patterned on the Temple of Mars Ultor (Fig. 5-7) in the Forum of Augustus. In fact, many scholars believe that the Corinthian capitals and other details of the two buildings are so similar that some of the artisans who worked on the Roman temple traveled

7-11 **Maison Carrée, Nîmes, France,** ca. 1–10 CE.

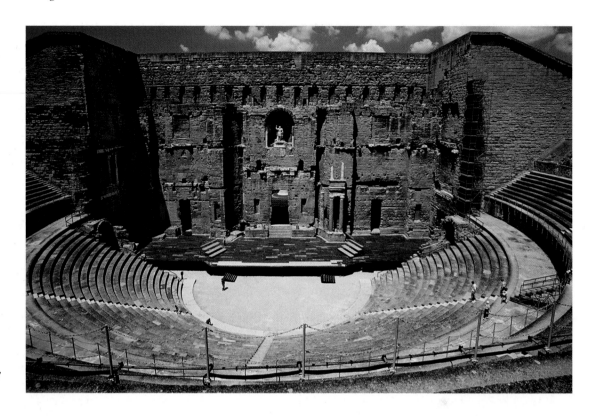

7-12 Theater, Orange, France, early first century CE.

immediately afterward to Nîmes to work on the Maison Carrée. The temple was the centerpiece of the Nemausus forum and seems to have been dedicated to the recently deceased adopted sons of Augustus, Gaius and Lucius Caesar. The temples at Vienne and Nîmes are enduring monuments to the obligatory worship of the imperial family in Augustan Gaul.

THEATER AT ORANGE The population of the Roman colonies of Early Imperial Gaul and Spain consisted of large

numbers of army veterans as well as local families who were new Roman citizens. Both groups demanded Roman forms of entertainment, and under Augustus theaters and amphitheaters were constructed in many of the most important cities.

At Orange, the colony that Augustus founded around 35 BCE for veterans of the Second Gallic Legion, a new theater (**Fig. 7-12**) was constructed in the early first century CE with its cavea resting on a steep natural hillside. It could seat 7,000 spectators, all having good views of the scaenae frons, which

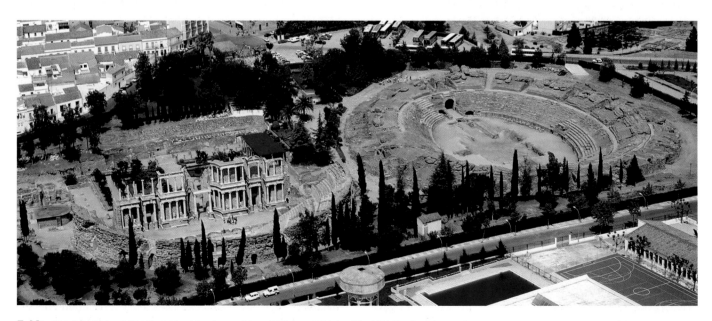

7-13 **Aerial view of the theater, 16 BCE, and amphitheater, 8 BCE, Merida, Spain.**

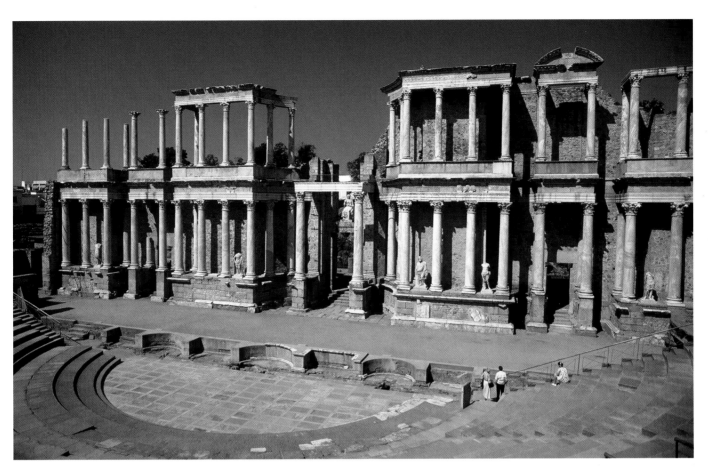

7-14 Scaenae frons, theater, Merida, Spain, 16 BCE.

still stands to a height of 37 meters. Most of its three stories of columns and statues are long gone, but the stage building is still one of the most impressive in the Roman world and an excellent illustration of the Roman penchant for dramatic multistory stage fronts (compare Figs. 4-14 and 17-14). The central niche contained a twice-life-size statue of Augustus. Other niches probably housed statues of other members of the Augustan family and Roman gods and goddesses.

AUGUSTA EMERITA Orange did not have an amphitheater, although nearby Arles (ancient Arelate), which became a Roman colony in 46 BCE, had both a theater and an amphitheater. The Augustan theater could seat 11,000, and the late-first-century CE amphitheater at least 20,000. In Merida (ancient Augusta Emerita), however, an important Roman colony founded in 25 BCE in southwestern Spain near the border with Portugal at the confluence of two Spanish rivers, both a theater and an amphitheater (**Fig. 7-13**) were constructed in quick succession between 16 and 8 BCE. The great entertainment complex was complemented by a circus for chariot racing, not visible in the aerial photograph. Unlike the Orange cavea, the Merida seating area rested on substructures of concrete and granite. The two-tier marble colonnade of the scaenae frons (**Fig. 7-14**) has been ably reconstructed and gives visitors an idea of what the stages of other Early Imperial theaters looked like. (The tourists

at the lower right of Fig. 7-14 also provide an accurate sense of the scale of the Merida theater.) Several of the statues displayed between the columns of the scaenae frons have been preserved. The elliptical Merida amphitheater was also built of granite and concrete. Sixteen entrances permitted up to 15,000 spectators to enter and exit the building in orderly fashion.

FUNERARY MONUMENTS

Of private architecture in the western provinces, the most interesting remains are the many tombs and other funerary monuments erected to perpetuate the memory of deceased members of wealthy and influential local families—and of the living heirs who paid for the memorials and often placed their names on them alongside those of the dead. Two examples suffice to demonstrate the great variety of architectural forms employed during the Early Empire.

ARCH OF THE SERGII During the second decade CE, at Pola in northwestern Croatia, not far from the border of modern Italy, Salvia Postuma Sergia erected an arch *de sua pecunia* (with her own money) in honor of several deceased family members. The attic bears her dedicatory inscription and the names of those whose statues stood on top of the arch above

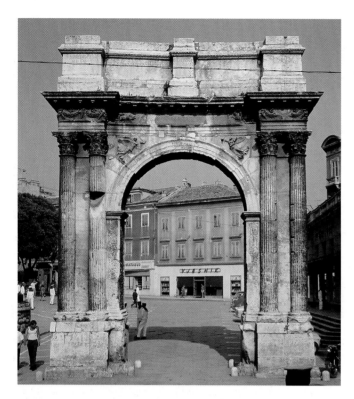

7-15 **Arch of the Sergii, Pola, Croatia, ca. 10–20 CE.**

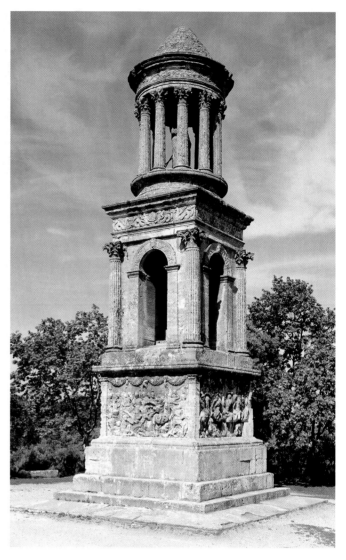

7-16 **Mausoleum of the Julii, Saint-Rémy-de-Provence, France, ca. 30–20 BCE.**

each of three projecting bases. A statue of Salvia was added after her death.

The Arch of the Sergii (**Fig. 7-15**) is therefore in no way a "triumphal arch," but the form of the monument intentionally conveys the notion that the Sergii have triumphed over death by achieving a happy afterlife. The arch's extensive relief decoration conveys a similar message, again borrowing from the repertory of triumphal art. Victories, for example, fill the spandrels, and the frieze includes erotes and bulls' skulls, racing chariots, and arms and armor, motifs common in both triumphal and funerary art. At the apex of the vaulted bay, in a lozenge-shaped panel, is an eagle carrying a serpent skyward—a clear reference to the ascent of the Sergii to heaven.

MAUSOLEUM OF THE JULII A generation before the Sergii erected their arch at Pola, three brothers of a Gallic family that had been granted Roman citizenship by Julius Caesar—and, as so many others in Gaul, took his name—built the so-called Mausoleum of the Julii (**Fig. 7-16**) at Saint-Rémy-de-Provence (ancient Glanum), south of Orange between Marseilles and Nîmes. The Julian *cenotaph* (a funerary monument without a burial chamber) was built in honor of the brothers' father and grandfather. The three-story tower is similar in its general form to several Italian tombs also datable to the Early Empire, but the specific form of the Mausoleum of the Julii is unique. At the top is a small tholos temple containing two portrait statues, unfortunately headless, of the father and grandfather, both dressed in togas,

emblems of their Roman citizenship. The intermediate story is a *quadrifrons* (a freestanding arch with four sides of equal width and an arcuated opening on each side). The lowest story resembles a giant sarcophagus, complete with battle and hunting scenes framed by garlands and pilasters. The cenotaph is an eclectic combination of funerary, triumphal, and sacred architectural forms. It stood beside the road leading into Glanum and proclaimed to all those entering or leaving the town that the Julii—who may have died in battle or hunting—had triumphed over death and been enshrined like gods in a temple.

The reliefs of the cenotaph also draw on diverse sources. The one illustrated here (**Fig. 7-17**) depicts a boar hunt in which several of the motifs were borrowed from representations of the Greek hero Meleager hunting the Calydonian boar. The three rearing, foreshortened horses and the boar emerging at an angle from behind a tree are motifs that

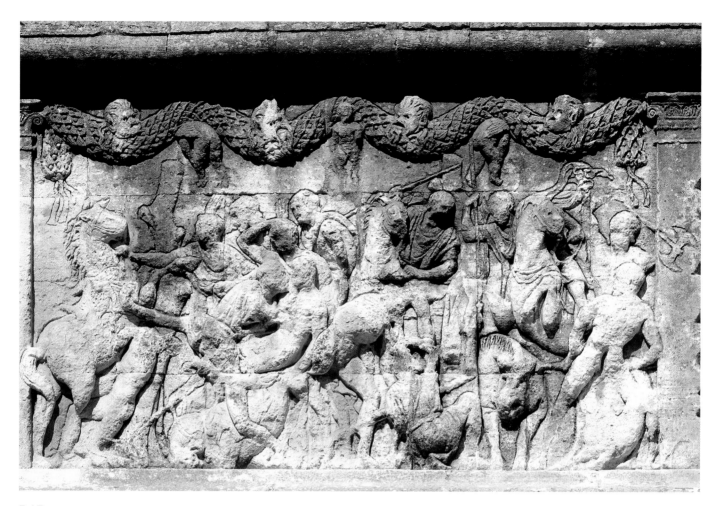

7-17 Boar hunt, relief on the Mausoleum of the Julii, Saint-Rémy-de-Provence, France, ca. 30–20 BCE.

Greek painters employed regularly (compare Fig. 3-10). Hellenistic paintings probably lie behind all of the relief panels of the Mausoleum of the Julii, although in one relief a Roman family (the Julii?) and Roman soldiers are included in a scene of Greeks fighting Amazons. The Gallic cenotaph is a prime example of the eclecticism and mixing of styles that are hallmarks of Roman art, whether public or private, elite or plebeian, in Rome or in the provinces.

SUMMARY

Under Augustus, the Romanization of the Western provinces of the Empire accelerated rapidly. Both the state and the local municipalities invested heavily in improvements in infrastructure and built aqueducts, gates, temples, fora, theaters, and amphitheaters to serve the needs of a growing population of veterans and businessmen.

In France and Spain especially, many of the Early Imperial monuments are among the best preserved in the Roman world, including the aqueduct bridge at Nîmes called the Pont-du-Gard and the theaters at Orange and Merida. At the same time, the Romans also built new temples dedicated to the worship of the imperial family, which served as constant reminders of the source of the benefactions the citizens of the provinces enjoyed.

Private monuments, especially tombs, were also erected in great numbers. As in contemporary Italy (see Chapter 6), the provincial funerary monuments took a wide variety of forms, including "triumphal arches" and multistory tower tombs such as those the Sergii and the Julii constructed at Pola and Saint-Rémy.

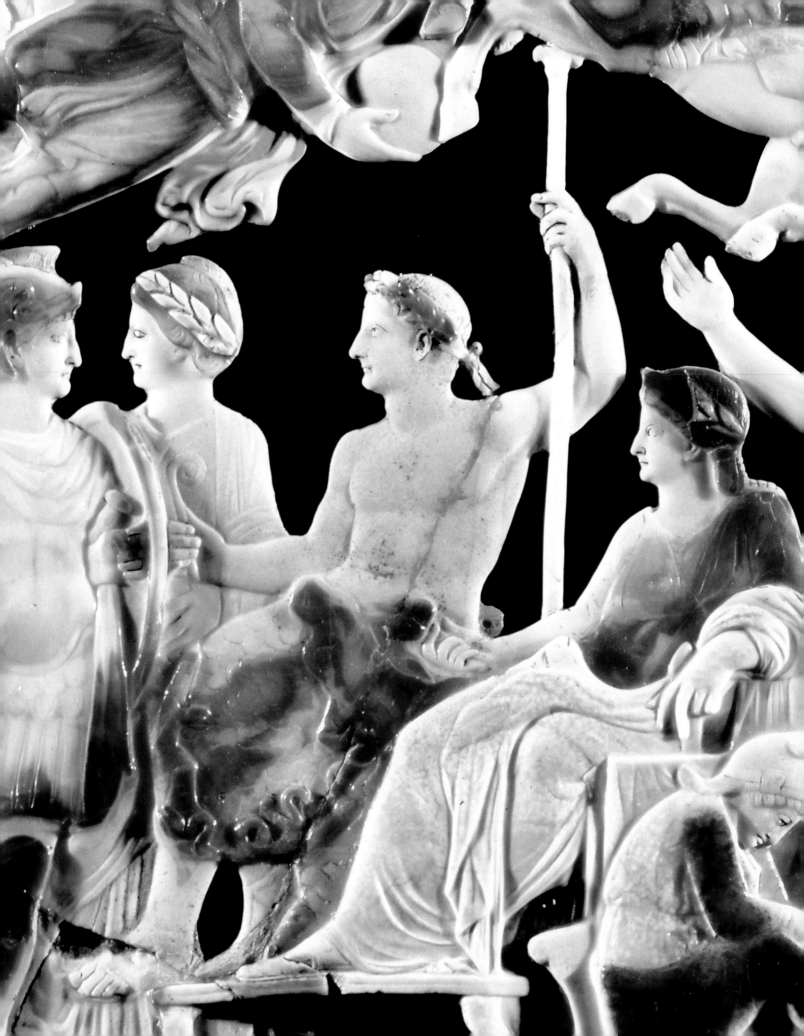

The Julio-Claudian Dynasty

In 4 CE, Augustus placed the ashes of his grandson and adopted son Gaius Caesar in the Mausoleum (Fig. 6-2) the emperor had built for himself three decades earlier. Gaius's cinerary urn joined those of other intended successors of Augustus dating back to Marcellus in 23 BCE. All had been married to or were the sons of Augustus's daughter Julia (see "The Family of Augustus," Chapter 5, page 62). Thus, no one was surprised when, following Gaius's tragic and premature death, Augustus adopted his stepson Tiberius, the son of the empress Livia and her first husband, Tiberius Claudius Nero. Sixteen years before, when Marcus Agrippa died, Augustus had forced Tiberius to divorce Agrippa's daughter and to marry Julia. At the time he became Augustus's latest adopted son, Tiberius was 46 years old. He succeeded Augustus as the second emperor of Rome in 14 CE. Historians refer to Tiberius and his three immediate successors, Caligula, Claudius, and Nero—all descendants of the families of Julius Caesar and Augustus or of Livia—as the Julio-Claudian dynasty (see "The Julio-Claudians," page 104).

TIBERIUS

Tiberius immediately had his adoptive father deified and began to build a temple for the worship of the new god, Divus Augustus, although the temple was still incomplete at the time of Tiberius's death. Coins struck early in Tiberius's principate portray the first emperor as Divus Augustus Pater and refer to the new emperor as *divi filius* (compare Fig. 5-2). Tiberius also carried on Augustus's policies in domestic and foreign matters and continued to promote the Classicizing style of sculpture and architecture that his divine father had favored.

TIBERIUS'S PORTRAITS The portraits of Tiberius were closely modeled on those of Augustus. Some of them, like the marble head (**Fig. 8-2**) found in the Roman amphitheater at Arsinoe, Egypt, with portraits of Augustus and Livia (Fig. 5-13), were carved while Augustus was still alive and reflect the first emperor's preferences, but Tiberius's later portraits follow the same pattern. Tiberius was 56 in 14 CE and 78 at the time of his death in 37 CE, but, like Augustus, who lived almost as long, the second emperor never matured into an old man in his portraits, which instead maintain the fiction of eternal youth that characterized all of the portraits of the Augustan family. The new emperor also emulated Augustus's coiffure, although the specific pattern of locks of hair

8-1 Tiberius and Livia, detail of the Grand Camée de France (Fig. 8-7), ca. 26–29 CE or ca. 45 CE. Bibliothèque Nationale, Paris.

WHO'S WHO IN THE ROMAN WORLD

The Julio-Claudians

Tiberius (Tiberius Iulius Caesar Augustus, r. 14–37 CE), the son of Livia, was the adopted son of Augustus (see "The Family of Augustus," Chapter 5, page 62) and second emperor of Rome.

Germanicus (Nero Claudius Drusus Germanicus), a renowned general, was the nephew and adopted son of Tiberius, and father and brother respectively of the future emperors Caligula and Claudius.

Agrippina the Elder was the daughter of Marcus Agrippa and Julia, the daughter of Augustus; the wife of Germanicus; and the mother of Caligula.

Caligula (Gaius Iulius Caesar Germanicus, r. 37–41 CE), third emperor of Rome, was the son of Germanicus and Agrippina the Elder.

Claudius (Tiberius Claudius Nero Germanicus, r. 41–54 CE), fourth emperor of Rome, was the brother of Germanicus; uncle of Caligula; and grandson of Augustus's sister Octavia.

Messalina was the third wife of Claudius.

Britannicus was the son of Claudius and Messalina.

Octavia, the daughter of Claudius and Messalina, was Nero's first wife.

Agrippina the Younger was the daughter of Germanicus and Agrippina the Elder; sister of Caligula; niece and fourth wife of Claudius; and mother of Nero with her first husband.

Nero (Nero Claudius Caesar, r. 54–68 CE), adopted son of Claudius, was the fifth emperor of Rome. ▪

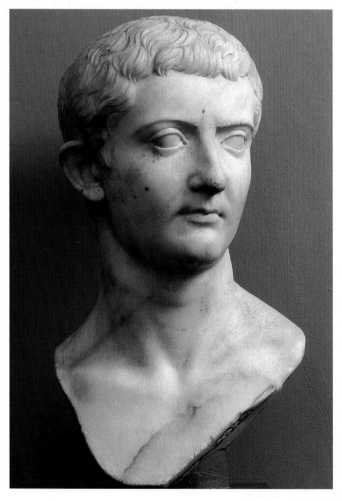

8-2 Head of Tiberius, from Arsinoe, Egypt, early first century CE. Marble, 1′ 6½″ high. Ny Carlsberg Glyptotek, Copenhagen.

over the forehead differs. The shapes of Tiberius's cranium, eyes, nose, and mouth also more closely resemble those of the portraits of his mother Livia, and these distinctions permitted the new emperor's likenesses to be differentiated from those of his adoptive father. The resemblance to Augustus is closer in the portraits of his biological grandsons (Fig. 5-14), but Tiberius's portraits unmistakably depict a member of the same imperial family, as they were intended to do.

DOUBLE SUOVETAURILIA Tiberian relief sculpture also carried on the Augustan style. Two fragments of a marble frieze in the Louvre depict a double suovetaurilia at two altars. **Fig. 8-3**, the larger fragment, shows a dozen toga-clad men; an officiating priest with veiled head; a bull, sheep, and pig; an altar and laurel tree; and part of a second altar and tree. Enough remains of the second section to establish that the right half of the relief was nearly a mirror image of the left half, no doubt with a second priest to the right of the second altar. The style of the relief is similar to that of the imperial procession of the Ara Pacis (Fig. 5-18), and although certainty is impossible because the head of the preserved priest is restored and the other priest is missing, most scholars have concluded that Augustus and Tiberius were the priests performing the double suovetaurilia and that it took place in 14 CE when they were co-censors. (The laurel trees are probably the two that grew next to Augustus's house on the Palatine Hill.) Tiberius apparently decided to commemorate this event because it was one of the rare occasions when Augustus and his heir apparent appeared in public as equal in stature.

BOSCOREALE CUPS Another retrospective depiction of the new emperor at a key moment during his early career appears on a silver *scyphus* (two-handled drinking cup), one of a unique pair depicting historical and pseudo-historical events

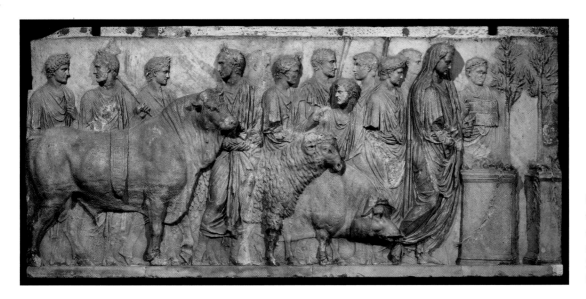

8-3 **Double suove-taurilia relief (left section), from Rome, ca. 14 CE. Marble, 2′ 10¼″ high. Louvre, Paris.**

featuring Tiberius and Augustus. The cups were discovered in a villa at Boscoreale, and although some scholars have argued that they are Augustan in date, the *iconography* (pictorial content) of one of the scenes depicting Augustus suggests that they were more likely manufactured after his death. Most scholars agree that the four compositions on the two cups are derived from imperial reliefs or paintings, but they disagree as to whether the cup reliefs are based on a single lost monument or on two or more sources, perhaps of different date. The latter is probably the case.

The Tiberius cup shows on one side the emperor-to-be riding in a triumphal quadriga holding a laurel branch and an eagle-tipped scepter (**Fig. 8-4**). Behind him is a state slave who places a wreath on Tiberius's head. The slave's job was

also to whisper an admonition in the victorious general's ear as he paraded through Rome in glory as a Jupiter-like figure: "Remember, you are only mortal!" The other side of the cup shows Tiberius sacrificing in front of a temple of Jupiter, perhaps the god's Capitoline temple, the end point of all triumphal processions. Tiberius celebrated a triumph after his defeat of the Germans in 7 BCE and a second after his Illyrian victory in 12 CE, and the cup (and the monument on which it was based) must represent one of those occasions.

The second Boscoreale cup depicts Augustus on one of his military campaigns, seated and surrounded by his *lictors* (imperial bodyguards who carry bundles of rods called *fasces*) and lieutenants as he grants clemency to suppliant barbarians. The other side shows the emperor in very different

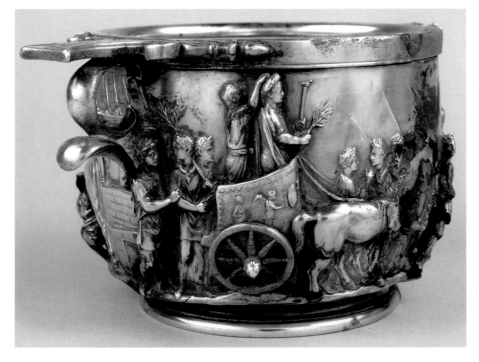

8-4 **Triumph of Tiberius, scyphus from Boscoreale, ca. 15–20 CE. Silver, approx. 4″ high. Louvre, Paris.**

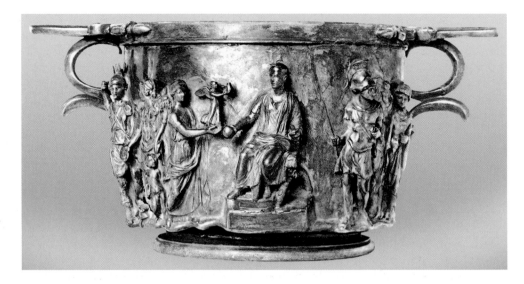

8-5 **Augustus seated among gods and personifications, scyphus from Boscoreale, ca. 15–20 CE. Silver, approx. 4″ high. Louvre, Paris.**

company (**Fig. 8-5**). At the left are the Amazon-like figure that in Roman art is the personification of *Virtus* (manly valor) and the seminude male personification of *Honos* (honor), who holds a patera and cornucopia. Also at the left are Venus and Cupid, reminders of Augustus's divine descent. Venus presents the emperor with a statuette of Victory on a globe, the symbol of world domination. At the right, Mars ushers in personifications of four conquered provinces to pay homage to Augustus.

The depiction of Augustus among gods and personifications is inconsistent with lifetime portrayals of the emperor, for example on the Ara Pacis (Fig. 5-15), where Aeneas and

Tellus (Figs. 5-16 and 5-17) and other legendary and divine figures were carefully separated from Augustus and his entourage (Fig. 5-18). The Boscoreale cups therefore are more likely early Tiberian in date and juxtapose historical representations of the new emperor and divi filius with depictions of his deified father.

GEMMA AUGUSTEA Also thought by some to be late Augustan, but more likely datable to the early years of Tiberius's principate, is the gem known as the Gemma Augustea (**Fig. 8-6**), one of the largest—and in the opinion of many, the finest—sardonyx cameos known. *Cameos* are reliefs carved

8-6 **Gemma Augustea, ca. 15 CE. Sardonyx cameo, approx. $7\frac{1}{2}″ \times 9″$. Kunsthistorisches Museum, Vienna.**

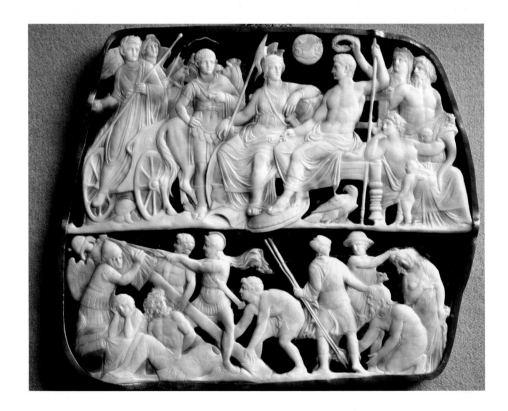

from rare stones with layers of different colors. As the artist cuts deeper into the stone, different colors are revealed. The gem cutter must therefore possess great skill, because if too much stone is cut away, what was meant to be, for example, a white arm on the Gemma Augustea will become part of the dark blue background instead. Cameo carvers rated high esteem in Rome, as indicated by the fact that one of the Early Empire's only artists known by name was Dioscurides, Augustus's personal gem cutter. Cameos were often produced as special imperial gifts to favored Roman officials and foreign dignitaries. They frequently bear imperial portraits (Fig. 8-15), but sometimes feature complex narrative scenes, as on the Gemma Augustea.

The Gemma Augustea, in fact, has two distinct narrative zones. Below, four Roman soldiers set up a *trophy* (a tree trunk adorned with the enemy's captured arms and armor), while two of their comrades drag in a barbarian man and woman by their hair. Another captive couple is seated at the left. The shield affixed to the trophy is decorated with a scorpion, the birth sign of Tiberius, so this cameo must celebrate one of his victories. Above, Tiberius steps down from a chariot driven by Victory herself. His gaze is directed toward the seminude

Augustus, who appears in the guise of Jupiter seated next to Roma beneath Augustus's own birth sign (capricorn). Augustus holds a scepter, and Jupiter's eagle stands at his feet. *Oikoumene,* the personification of the civilized world, places a wreath on Augustus's head, while Oceanus (Ocean) and Tellus (with two children, as on the Ara Pacis, Fig. 5-17) look on. As on the Boscoreale cup depicting Augustus with Mars and Venus (Fig. 8-5), the Gemma Augustea must represent Divus Augustus and not the emperor during his lifetime. It is another case of Tiberius playing the role of divi filius after Augustus's death.

GRAND CAMÉE DE FRANCE Divus Augustus appears again on an even larger and more elaborate three-zone sardonyx cameo in Paris known as the Grand Camée de France (**Fig. 8-7**). Here, the bottom zone is also filled with enemy prisoners, but the two prominent seated figures in the central zone (Fig. 8-1) are the bare-chested Tiberius, who has assumed Augustus's Jupiter-like role, and his mother Livia, who was still alive during most of her son's rule. In the upper zone, the heavenly realm, Divus Augustus, with veiled head, crown, and scepter, rides on the back of a flying figure who

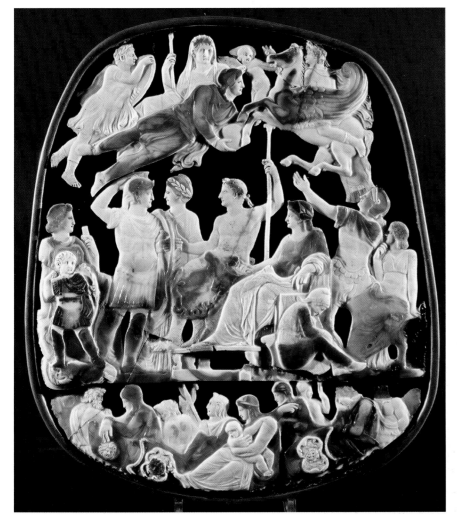

8-7 Grand Camée de France, ca. 26–29 CE or ca. 45 CE. Sardonyx cameo, 1' $\frac{1}{4}''$ × 10". Bibliothèque Nationale, Paris.

has never been satisfactorily identified. Nor is there any consensus about the identities of most of the other figures on the Grand Camée, but the central message of the composition is clear: Tiberius has now taken on the role formerly played by his deified father, and a younger general—of uncertain identity but unquestionably a member of the next generation of the Julio-Claudian dynasty—presents himself before the current princeps. If this interpretation is correct, the Grand Camée de France, like the Augustan Belvedere Altar (Fig. 5-4), features the present (in the person of the current emperor), the past (the emperor's deified father and immediate predecessor), and the future of Rome's first family.

A strong case has been made, however, that the Grand Camée postdates Tiberius's death and was carved under Claudius, which would explain, among other things, the depiction of Tiberius in the guise of Jupiter. But whatever the answer to the dating controversy, the essential messages of apotheosis and dynastic succession are unmistakable.

CALIGULA

When Tiberius died, half his estate went to his great-nephew Gaius, better known by the nickname he acquired as a boy—Caligula ("little boot"). Caligula's father, Germanicus, was a popular general who dressed his young son in a military uniform—complete with boy-sized boots—when he walked among the soldiers. The boy immediately won the affection of the army, which enthusiastically endorsed him as emperor in 37 CE. He was 25 at the time.

Caligula was the first "colorful" Roman emperor, and the historical sources are uniformly hostile to him. According to those sources, Caligula soon abandoned the moderation that characterized the rule of Augustus and became an autocratic despot who demanded to be recognized not merely as princeps but as a god. Caligula was accused of cruelty, depravity, and even of committing incest with his three sisters, and he was said to have ordered the murder of his perceived enemies and potential rivals. Within four years he was assassinated.

CALIGULA'S PORTRAITS Few portraits of Caligula survive, in part because of the brevity of his rule, in part because many of them were destroyed after his assassination (see "Rewriting History," Chapter 9, page 136). All portraits, of course, represent him as a young man—he died at 29—and none gives a hint of his reputed mental instability. Caligula's portraits, for example, a marble head (**Fig. 8-8**) now in Worcester, Massachusetts, depict a handsome, blemish-free, aloof youth in the Augustan-Tiberian Classicizing mold. But the hair is fuller, looser, and more deeply cut, and it adheres less strictly to the shape of the skull. The treatment of the hair is all the more remarkable because according to the second-century CE biographer Suetonius, the young emperor lost much of his hair prematurely. If true, Caligula's portraits are almost as much fictional images as the "likenesses" of his ever-young predecessors.

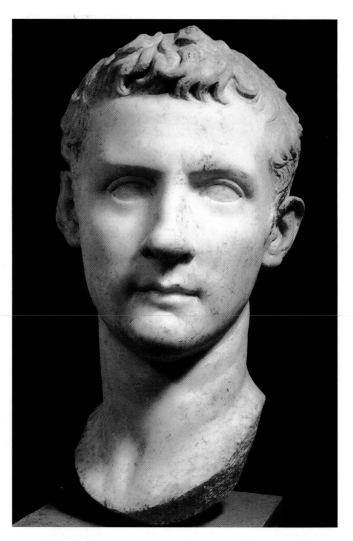

8-8 Head of Caligula, from Marino, 37–41 CE. Marble, 1′ 7⅛″ high. Worcester Art Museum, Worcester.

AGRIPPINA THE ELDER Portraits of the women of the Julio-Claudian dynasty display a similar treatment of the hair and an increased sensitivity for the recording of different textures. These stylistic changes were well suited to reproducing the much more elaborate coiffures fashionable in the mid-first century CE. A posthumous bust (**Fig. 8-9**) of Agrippina the Elder, Caligula's mother, is a characteristic example, although the quality of carving and state of preservation place the portrait in a class almost by itself. Agrippina's portrait can be contrasted with the earlier portrait (Fig. 5-13) of Livia with its more austere Augustan hairstyle. In the Julio-Claudian portrait, a mass of curls—accentuated by drilled holes—covers the sides of the head. The hair is worn long behind the neck and cascades over both shoulders. Agrippina has a perfectly proportioned girlish face, even though she lived to a much older age. If the original paint had been preserved, the textural contrasts between hair and flesh and fabric would be even sharper.

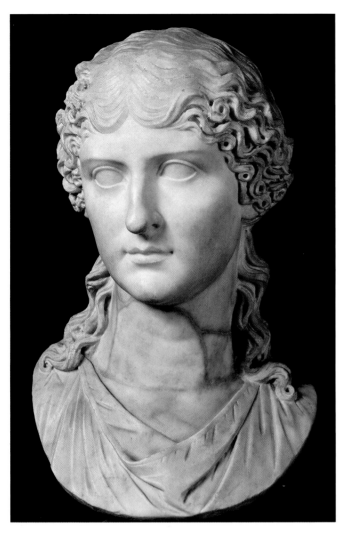

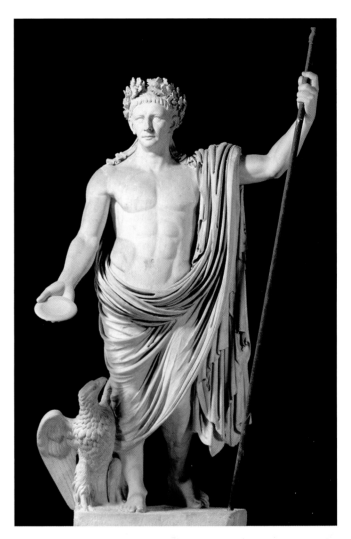

8-9 Bust of Agrippina the Elder, ca. 40–45 CE. Marble, 1′ ¼″ high. Museo Capitolino, Rome.

8-10 Claudius in the guise of Jupiter, from Lanuvium, 42–43 CE. Marble, 8′ 4″ high. Musei Vaticani, Rome.

CLAUDIUS

Caligula's behavior as emperor was said to be so outrageous that the Senate favored restoring the Republic after his murder. Indeed, his relatives feared for their lives. But when the *praetorian guard* (the imperial police force in the capital) located Caligula's uncle Claudius cowering behind a curtain, they saluted him as emperor—and the Senate was powerless to protest. Claudius was then already 51 years old. He ruled for 13 years, until his death in 54 CE. Some ancient historians accused his fourth wife (and niece), Agrippina the Younger, of poisoning Claudius so that her son Nero could become emperor in his place, but modern historians generally do not believe that Claudius was murdered.

CLAUDIUS AS JUPITER Claudius's earliest portraits, both on coins and in the round, depict him as a youth in what might be called the "default mode" of early imperial portraiture. But the new emperor soon put his own stamp on official art, and the majority of his portraits show Claudius as a man in his 50s. One of his best portraits is the over-life-size marble statue (**Fig. 8-10**) from Lanuvium in which Claudius is portrayed in the guise of Jupiter with the god's eagle by his feet. The patera in his right hand is an incorrect modern restoration. The emperor may have originally held a thunderbolt. The representation of emperors during their lifetimes with the trappings of Jupiter seems to have begun under Caligula. The purpose of such statues was not merely to flatter the emperor but to suggest that he ruled the earth as Jupiter ruled the sky, a recurrent theme in Latin literature as well as in Roman art.

In this and many other portraits of Claudius, the emperor has a broad cranium, lines in his forehead and face, and bags under his eyes, but he has a full head of hair and it is combed in a manner that recalls the coiffures of Augustus and Tiberius. Consequently, despite the frank portrayal of his age in contrast to his predecessors, Claudian portraits can never be confused with Republican portraits, where the

realism is also more pronounced. One Republican trait has nonetheless been resuscitated, namely the dichotomy between the heroically nude young body and the old head (compare Figs. 4-10 and 4-11). The Senate probably greeted with approval the revival of Republican values in Claudius's portraits, for it signaled the new emperor's rejection of Caligula's despotism.

DYNASTIC GROUP PORTRAITURE Like Augustus, Tiberius, and Caligula, Claudius appeared in a wide variety of roles in his portrait statues. The second example illustrated here (**Fig. 8-11**) portrays the emperor as pontifex maximus. It comes from the basilica at Velleia and is of special interest because Claudius's portrait was found with statues of 12 other members of the Julio-Claudian dynasty. The display of portraits of one's extended family had its roots in the Republic (see "Ancestor

Portraits," Chapter 4, page 54), but under Augustus it became common practice to create dynastic statuary groups in which individuals were as likely to be linked by adoption as by blood. The groups of Augustus and Gaius and Lucius Caesar from Corinth (Fig. 5-14) and of Augustus, Livia, and Tiberius from Arsinoe (Figs. 5-13 and 8-2) have already been discussed, as have dynastic groups on coins (Figs. 5-2 and 5-3). The Velleia group follows in this well-established tradition.

AGRIPPINA THE YOUNGER AND NERO Among the other figures in the Velleia basilica were the empress Agrippina the Younger (**Fig. 8-12**) and her son Nero. At the time of his succession, Claudius was married to Messalina (his third wife), who had given birth to two children—Britannicus, destined to succeed his father as emperor, and Octavia. When Messalina died in 48 CE, Claudius married the ambitious and scheming

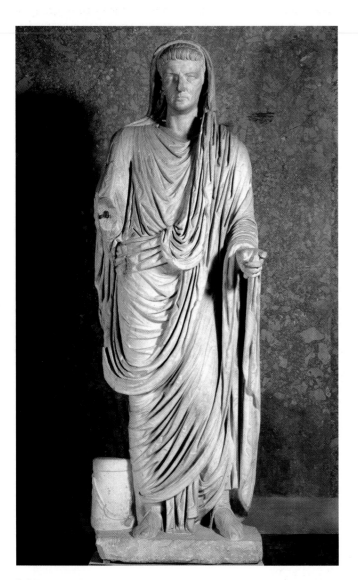

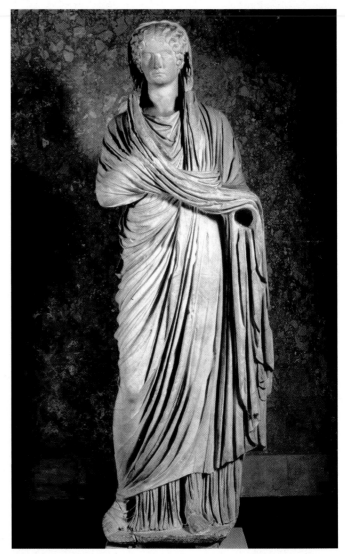

8-11 **Claudius as pontifex maximus, from the basilica, Velleia, ca. 45 CE. Marble, 7′ 2⅝″ high. Museo Archeologico Nazionale, Parma.**

8-12 **Agrippina the Younger, from the basilica, Velleia, ca. 48–51 CE. Marble, 6′ 8″ high. Museo Archeologico Nazionale, Parma.**

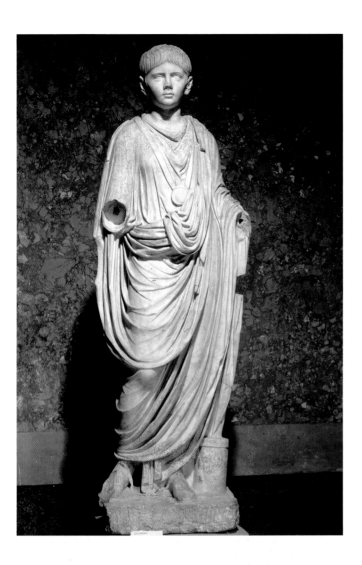

8-13 Nero, from the basilica, Velleia, ca. 48–51 CE. Marble, 4′ 8¾″ high. Museo Archeologico Nazionale, Parma.

Agrippina the Younger, who convinced the emperor to adopt Nero as his son and to permit him to marry Octavia, giving Nero precedence in the line of succession even over Britannicus.

Agrippina's Velleia portrait depicts her as a young woman with an elaborate coiffure of curls, and Nero's (**Fig. 8-13**) represents him as a boy still wearing the youthful bulla (compare Fig. 6-8). He did not reach adulthood until 51 CE, so his portrait and that of his mother must have been set up between 48 and 51, probably as additions to a smaller group of Claudius and others. Nero is portrayed as a prince and emperor-in-waiting, with a round face and long locks of hair combed down over his forehead and parted in the middle.

JULIO-CLAUDIANS AT RAVENNA In the Corinth group of Augustus and his adopted sons, the emperor was portrayed as pontifex maximus and Gaius and Lucius Caesar were depicted in heroic nudity (Fig. 5-14). Roman dynastic groups were not like modern group photos of members of athletic teams or the nine justices of the U.S. Supreme Court, all similarly garbed, or a group portrait of the U.S. president and vice president and their families attired in suits and dresses. Each Roman statue represented the person in his or her most appropriate role and corresponding costume, and portraits of the dead were joined with those of the living.

One lost group depicting members of the Julio-Claudian dynasty, past and present, was reproduced on a relief (**Fig. 8-14**) found at Ravenna. The relief is fragmentary, and more figures were represented both to the left and right. Seated and

8-14 Julio-Claudian dynastic group, from Ravenna, ca. 45–50 CE. Marble, 4′ 7⅛″ high. Museo Nazionale, Ravenna.

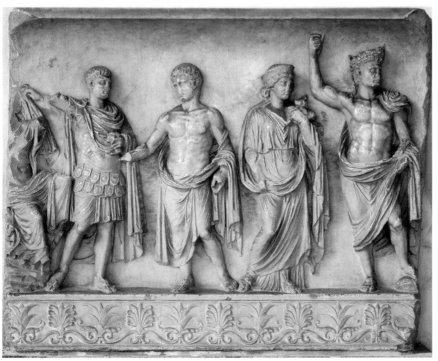

standing portraits are combined, as are clothed and seminude figures and even one figure dressed in armor. The identifications of the left three figures are disputed, but the figure at the far right, appropriately the tallest, is Divus Augustus. A gilded bronze star once adorned his forehead, signaling his divinity. Next to Augustus is Livia (whom Claudius deified) in the guise of Venus Genetrix holding Cupid. Claudius must have been portrayed in the missing right section.

Imperial dynastic groups are also significant for whom they do not portray. The Velleia group does not include Caligula; the Ravenna group must have omitted him as well. Murdered out-of-favor emperors were excluded from "family portraits" (see "Rewriting History," Chapter 9, page 136).

GEMMA CLAUDIA Dynastic portrait groups also appear on Julio-Claudian cameos, for example the so-called Gemma Claudia (**Fig. 8-15**). The cameo depicts Claudius and Agrippina the Younger at the left. Claudius's head emerges from one end of a double cornucopia symbolizing the prosperity the imperial family has brought to the Roman people. Jupiter's eagle turns its head to gaze up at the emperor, the god's counterpart on earth. Facing Claudius at the opposite end of the cornucopia is another, younger man—or at least he is so represented. Many have identified him as Tiberius, paired with Livia (sporting an updated Claudian coiffure). But the juxtaposition of this pair with Claudius and his wife suggests that the second couple ought also to be married. A more likely identification of the

pair is Germanicus, Claudius's brother, and his wife Agrippina the Elder, the empress's mother. Given, however, the intentional physiognomic similarity of all portraits of the Julio-Claudians—Claudius is the notable exception—scholars will continue to propose different identifications for many portraits.

ARA PIETATIS Shortly after his accession, Claudius erected a monumental altar in Rome celebrating one of the most revered Roman virtues, *pietas*, or piety toward the gods, Rome, and family. The Ara Pietatis Augustae had been vowed by Tiberius but was never built. Claudius's fulfillment of Tiberius's vow was in itself a demonstration of the new emperor's piety. A series of marble reliefs has long been associated with this altar, although the attribution has been contested. All scholars agree, however, that the reliefs must have decorated a monumental altar similar to the Ara Pacis Augustae. Among the preserved fragments are sections of a procession of togati comparable to the north and south friezes (Figs. 5-1 and 5-18) of the Ara Pacis and scenes of sacrifice before three Augustan temples in Rome, further underscoring Claudius's piety.

One of the sacrifices (**Fig. 8-16**) takes place in front of the Temple of Mars Ultor (Fig. 5-7). The representation of the temple is so detailed that all of the pedimental statues can be named. Mars is in the center; Venus with Cupid, Romulus seated, and the personified Palatine Hill, respectively, are at the left; and Fortuna, Roma seated, and the reclining Tiber

8-15 **Gemma Claudia**, ca. **49** CE. **Sardonyx cameo, approx. $4\frac{3}{4}''\times6''$. Kunsthistorisches Museum, Vienna.**

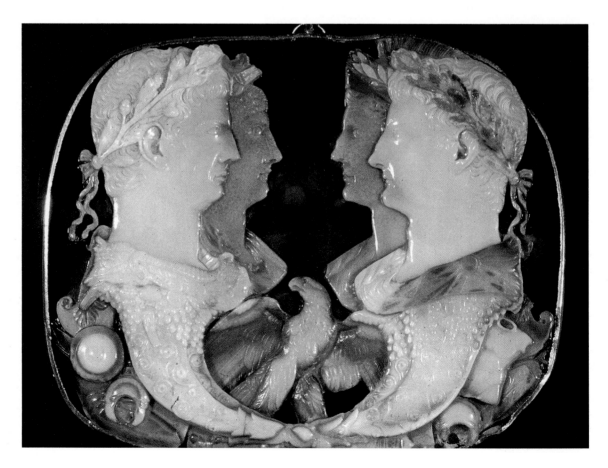

8-16 Sacrifice at Temple of Mars Ultor, from the Ara Pietatis Augustae (Altar of Augustan Piety), Rome, ca. 43 CE. Marble, 3′ 9″ high. Villa Medici, Rome (plaster cast, Museo della Civiltà Romana, Rome).

are at the right. The Claudian relief can be compared to Aeneas's sacrifice on the Ara Pacis (Fig. 5-16). The shrine in the earlier relief is smaller and in the background, whereas the Ara Pietatis temples are all large and in the foreground. The probable reason for the stylistic shift is that easy identification of the buildings as temples Augustus built was a prerequisite for communicating Claudius's piety to the viewer.

SEBASTEION AT APHRODISIAS Under Claudius, monuments celebrating the Julio-Claudian family were also erected throughout the provinces. Of those that are known today, the one most richly decorated with narrative relief sculptures was the Sebasteion at Aphrodisias in modern Turkey. *Sebastos* is the Greek equivalent of *Augustus,* and the Sebasteion was a sanctuary dedicated to the worship of the Julio-Claudian dynasty (see "The Imperial Cult," Chapter 7, page 97). Construction of the Sebasteion probably began under Tiberius and was most likely completed under Nero. The reliefs included representations of Divus Augustus as ruler of earth and sea; of Claudius and Agrippina with clasped right hands (*dextrarum iunctio*), commemorating their recent marriage; and of Claudius, heroically nude, vanquishing the personification of Britannia (**Fig. 8-17**), which he

8-17 Claudius vanquishing Britannia, from the Sebasteion, Aphrodisias, Turkey, ca. 42–45 CE. Marble, approx. 5′ high. Archaeological Museum, Aphrodisias.

8-18 **Country façade of the Porta Maggiore, Rome, ca. 50 CE, with the Tomb of Marcus Vergilius Eurysaces (Fig. 6-5) in the foreground.**

conquered in 43 CE. As in official portraits produced in Rome, Augustus appears at Aphrodisias as an eternally youthful figure, whereas the portrayal of Claudius combines the head of a man in his 50s with the body of a man in his 20s.

PORTA MAGGIORE Claudius continued the work Augustus began to improve and expand the aqueduct system that brought vital water to the capital (see "Roman Aqueducts," Chapter 7, page 91). Around 50 CE, he constructed a grandiose double gateway known as the Porta Maggiore (**Fig. 8-18**) at the point where the Via Labicana and the Via Praenestina converged (Fig. 18-22). (Fig. 8-18 also shows Eurysaces' tomb, Fig. 6-5, in the foreground, between the two roads.) The huge attic of the Porta Maggiore bears a lengthy dedicatory inscription that conceals the conduits, one above the other, of the two aqueducts that entered the city at this point.

The Porta Maggiore is the outstanding example of Roman *rustication* (rustic, or rough, unfinished masonry). Instead of using the precisely shaped (*dressed*) stone blocks Augustan architects favored, the designer of the Claudian gate combined smooth and rusticated surfaces in a deliberately eccentric manner, juxtaposing, for example, crisply carved pediments with engaged columns composed of irregular, unfinished drums (**Fig. 8-19**). This rusticated style is unique to Claudian architecture and may reflect the personal preference of the emperor, who had many antiquarian interests and wrote, among many other works, a history of the Etruscans. Claudian rustication can be seen as a rejection of the Classicizing style of earlier imperial buildings, just as Claudius abandoned Augustan idealism in portraiture in favor of a more realistic (rougher) look.

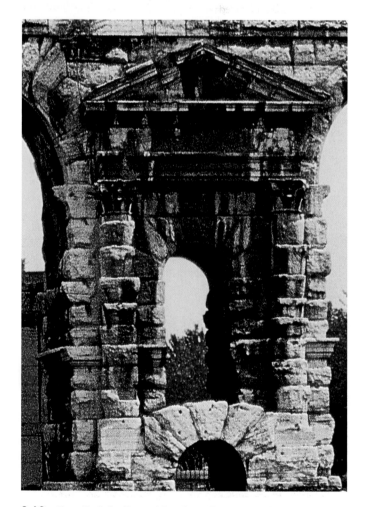

8-19 **Detail of the Porta Maggiore, Rome, ca. 50 CE.**

NERO

Although Claudius broke from the Augustan style of art and architecture, he adhered to Augustus's policy of moderation in governing. Nero, in contrast, followed the model Caligula established. The identical hostile sources that condemned Caligula characterized Nero as displaying the same self-indulgent extravagance and megalomania that were the hallmarks of Caligula's short-lived tenure as emperor. Nero lasted 14 years, but he too met an unhappy end. In 68 CE, the Senate declared him an enemy of the state, and he committed suicide. Even according to his critics, however, at the outset Nero's true character was held in check by his mother Agrippina the Younger, Claudius's powerful widow, who was the de facto ruler of the Empire when Nero succeeded his adoptive father at age 17. But the young emperor soon exerted his independence. Within five years, Agrippina, Britannicus, and Octavia were all dead. Agrippina and Octavia were executed for alleged treason; Britannicus may have been murdered under Nero's orders. In any case, Nero was now free to pursue a life devoted to art and music, luxury, and, according to Suetonius, no fan of Nero's, every conceivable vice.

NERO'S PORTRAITS The changing appearance of the new emperor can be followed in his portraits. As was the case with Caligula, not many portraits survived the wholesale destruction of Nero's images after his death in 68 CE, but a continuous series is preserved on the coins issued during his 14-year rule. The earliest tellingly portray him with his mother. On some coins, Agrippina's portrait actually overlaps Nero's, but a second series (**Fig. 8-20**) portrays the emperor and his mother in seemingly equal facing images. The surrounding inscription, however, names only Agrippina. The numismatic portraits are stylistically comparable to the heads of Agrippina and Nero's Velleia statues (Figs. 8-12 and 8-13).

A later head (**Fig. 8-21**) of the emperor, found on the Palatine Hill and datable between 59 and 64 CE, presents a very different picture of Nero. His flesh is softer and puffier, and his neck is thicker. The hair is also rendered in higher relief, as in Caligula's portraits (Fig. 8-8), but Nero's hair is much fuller and more deeply cut, creating shadows across the forehead. The latest numismatic portraits show an obese 31-year-old man with even more facial hair than in the Palatine portrait. These late portraits reflect Nero's self-indulgent life of monarchical luxury, a royal image he may have wanted to project. Whatever the motivation for the new imagery, the surviving portraits possess a sensuality and realistic sense of texture absent from the portraits of Nero's predecessors.

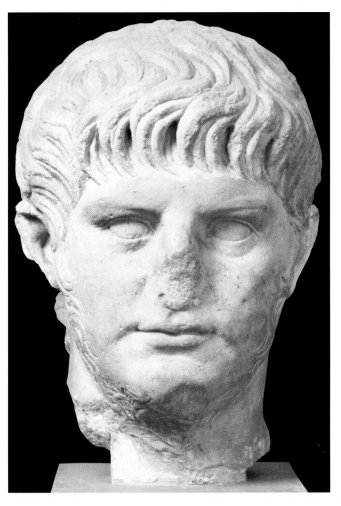

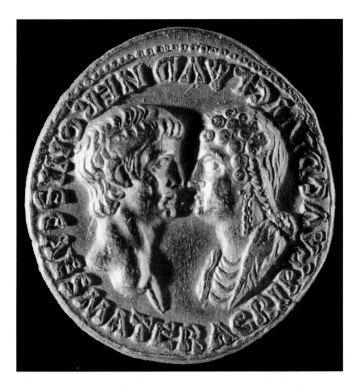

8-20 Aureus with obverse portraits of Nero and Agrippina the Younger, 54 CE. Gold, approx. $\frac{3}{4}$″ diameter. British Museum, London.

8-21 Head of Nero, from the Palatine Hill, Rome, ca. 59–64 CE. Marble, 1′ $\frac{1}{4}$″ high. Museo Nazionale Romano—Palazzo Massimo alle Terme, Rome.

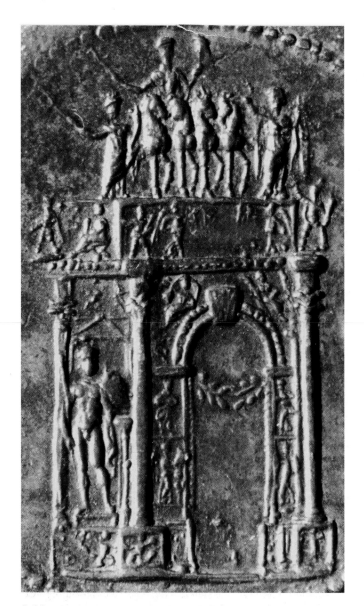

8-22 **Arch of Nero, Capitoline Hill, Rome, 62 CE. Reverse of a sestertius of Nero, 64 CE. Bronze, approx. 1¼″ diameter. Private collection.**

colossal gilded-bronze attic statuary group of Nero in his triumphal quadriga accompanied by Peace and Victory. A colossal statue of Mars stood in a niche on at least one end of the arch. (The coin engraver chose a three-quarter view of the monument in order to record this unprecedented feature; see "Buildings on Coins," Chapter 11, page 160.)

Earlier arches also had undecorated piers and attics (Figs. 7-4 and 7-5), save for the arches of Roman Gaul (Figs. 7-7 and 7-8), but according to the coins, Nero's arch had framed panel reliefs on each side of the passageway and also flanking the attic inscription. Many later imperial arches (for example, Fig. 11-19) would follow the model set here. Nero's Parthian arch stood at the head of a long line of arches that functioned like modern roadside billboards, bearing narrative relief panels delivering the messages the emperor wanted the public to read.

DOMUS AUREA Other revolutionary changes in architectural design also occurred under Nero. In 64 CE, a great fire destroyed large sections of Rome. Afterward, Nero won praise even from his harshest critics for the way in which his builders reconstructed many of the residential areas of the city with new

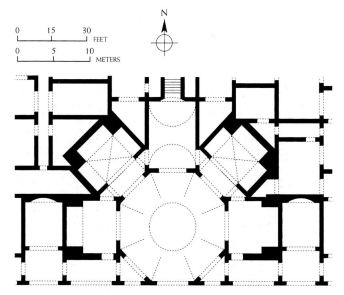

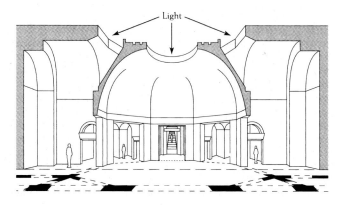

8-23 **Severus and Celer, plan and section of the octagonal hall, Domus Aurea (Golden House), Rome, 64–68 CE.**

PARTHIAN ARCH Nero was a lover of architecture, and many of the reverses of his coins commemorated his various building projects. Sestertii (**Fig. 8-22**) struck beginning in 64 CE depict the lost arch he erected in 62 on the Capitoline Hill in Rome to celebrate his victory over the Parthians. The defeat of those old enemies of the Romans permitted Nero to draw a parallel between himself and Augustus, whose own Parthian arch (Fig. 5-6) stood in the Forum Romanum below. Nero's arch, however, had a revolutionary new design. It had freestanding columns instead of the engaged columns of all earlier triumphal arches, and the columns had richly carved projecting pedestals (compare Fig. 16-15) and supported statues on the projecting entablature above (compare Fig. 20-8). This marked the first known time either feature appeared on a Roman arch. Dominating the entire monument was a

WRITTEN SOURCES

The Golden House of Nero

Nero's Golden House was a vast and notoriously extravagant country-style villa a short walk from the civic center of Rome. Suetonius described it vividly in his biography of the emperor:

> [Nero's] wastefulness showed most of all in [his] architectural projects. He built a palace . . . [called] 'The Golden House' . . . The entrance-hall was large enough to contain a huge statue [of Nero in the guise of Sol, the sun god; Fig. 1-2, no. 22], 120 feet high; and the pillared arcade ran for a whole mile. An enormous pool, like a sea, was surrounded by buildings made to resemble cities, and by a landscape garden consisting of ploughed fields, vineyards, pastures, and woodlands where every variety of domestic and wild animal roamed about. Parts of the house were overlaid with gold [hence the name, Golden House] and studded with precious stones and mother-of-pearl. All the dining-rooms had ceilings of fretted ivory, the panels of which could slide back and let a rain of flowers, or of perfume from hidden sprinklers, shower upon [Nero's] guests. The main dining-room was circular, and its roof revolved, day and night, in time with the sky. Sea water, or sulphur water, was always on tap in the baths. When the palace had been decorated throughout in this lavish style, Nero dedicated it, and condescended to remark: "Good, now I can at last begin to live like a human being!"*

Suetonius's description is a welcome reminder that even the most impressive Roman ruins are just that—fragmentary and bare shells of what were once lavishly decorated, complete structures. Only in rare instances, such as the Pantheon with its marble-faced walls and floors (Fig. 12-1), can visitors experience anything approaching the architects' intended effects. And even in the Pantheon, much of the marble paneling is of later date, and the gilded bronze is missing from the dome. ■

*Suetonius, *Nero*, 31. Translated by Robert Graves, *Suetonius: The Twelve Caesars* (New York: Penguin, 1957; illustrated edition, 1980), 197–198.

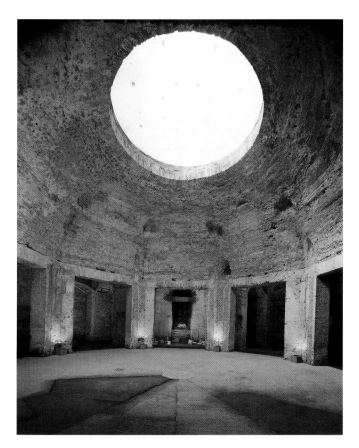

8-24 **Severus and Celer, octagonal hall, Domus Aurea (Golden House), Rome, 64–68 CE.**

fire-resistant concrete structures and wider, rationally planned networks of streets. But he outraged the Senate and the citizenry when he asked Severus and Celer, two brilliant architect-engineers, to build a luxurious new palace—the Domus Aurea, or Golden House—on a huge confiscated plot of fire-ravaged land near the Forum Romanum (see "The Golden House of Nero," above). Nero's predecessors owned many magnificent villas, but they were all country or seaside retreats, outside the capital and unseen by the public. Nero's private but highly visible pleasure palace gobbled up large tracts of prime real estate in the heart of Rome.

The residential wing of the Domus Aurea (Fig. 11-18, no. 3) was a sprawling complex of vaulted concrete halls and chambers laid out on the Esquiline Hill facing the urban villa's artificial lake. Unlike traditional villas, Nero's Golden House did not have an axial sequence of rooms, and it was much wider than it was long. Structurally, most of the rooms were unremarkable, except for the materials employed and the artifices they incorporated. One octagonal hall (**Figs. 8-23** and **8-24**), however, stands apart from the rest and testifies to the entirely new approach Severus and Celer took to architectural design.

Superficially, the hall resembles the atrium of a traditional domus with a compluvium in the roof and cubicula and alae opening onto the central space (compare Fig. 3-6), but the plan and spatial relationships among the parts are dramatically different. The ceiling of the octagonal room is a *dome* (see "The Dome," page 118), probably once covered with mosaics, that modulates from an eight-sided to a hemispherical form as it rises toward the oculus, which admitted

The Dome

The largest domed space in the ancient world before the Romans was the beehive-shaped burial chamber of the so-called Treasury of Atreus, a 13th-century BCE tomb at Mycenae, Greece, in which the dome was constructed by piling up stones in *courses* (horizontal rows) of smaller and smaller diameter until they met at the apex of the dome. This kind of masonry construction is called *corbeling*. The principle is similar to that of an arch (see "Arches, Barrel Vaults, and Concrete," Chapter 1, page 12).

The Romans were able to surpass the Mycenaeans by using concrete to build hemispherical domes, which usually rested on concrete cylindrical *drums*, although in the Domus Aurea of Nero, the dome rests on an octagonal base (Figs. 8-23 and 8-24). If a barrel vault is described as a round arch extended in a line, then a hemispherical dome may be described as a round arch rotated around the full circumference of a circle. Masonry domes, like masonry vaults, cannot accommodate windows without threatening the stability of the dome itself. Concrete domes can be opened up even at their apex with a circular *oculus* ("eye"), as in Nero's Golden House and the Pantheon (Figs. 12-1, 12-17, 12-19, and 12-20), allowing much-needed light to reach the often vast spaces beneath. ∎

Treasury of Atreus, Mycenae

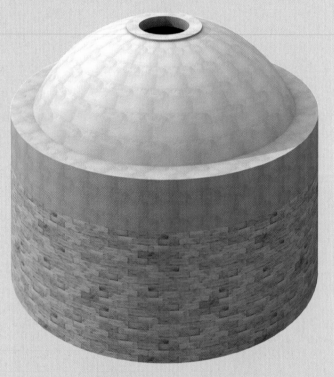

Hemispherical dome with oculus

light to the room. Radiating outward from the five inner sides (the other three, directly or indirectly, faced the outside) are smaller, rectangular rooms, three covered by concrete barrel vaults, two others (marked by a broken-line **X** on the plan) by the earliest known examples of concrete *groin vaults* (see "The Groin Vault," Chapter 11, page 164). Decorative recesses enlivened these satellite rooms; the middle one contained a waterfall. Severus and Celer ingeniously lit the rooms by leaving spaces between their vaulted ceilings and the dome's exterior. But the most significant aspect of the design is that here, for the first time, the architects appear to have thought of the walls and vaults not as limiting space but as shaping it.

Today, the octagonal hall is deprived of its marble, stucco, and mosaic decoration, and the concrete shell stands bare, focusing attention on the design's spatial complexity. The central domed octagon is defined not by walls but by eight angled piers. The wide square openings between the piers are so large that the rooms beyond look like extensions of the central hall. The grouping of spatial units of different sizes and proportions under a variety of vaults creates a dynamic three-dimensional composition that is both complex and unified. Nero's architects were not only inventive but also progressive in their recognition of the malleable nature of concrete, a material not limited to the rectilinear forms of traditional architecture.

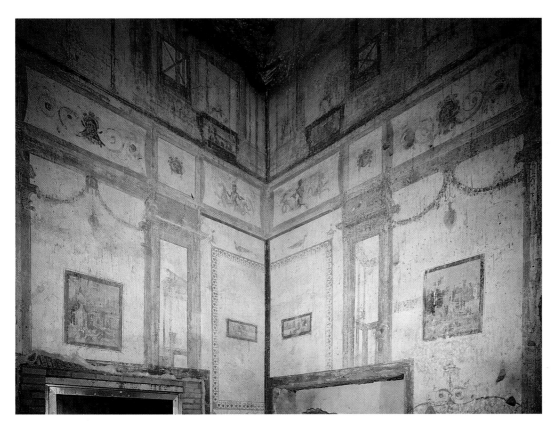

8-25 Fourth Style mural paintings, room 78, Domus Aurea (Golden House), Rome, 64–68 CE.

THE FOURTH STYLE The Domus Aurea also boasts some of the finest examples of the *Fourth Style* of Roman painting, which seems to have been introduced in the 50s CE (see Chapter 10). In this genre too, therefore, Neronian artists appear to have been pioneers. The chief painter of the Golden House, who directed the covering of hundreds of thousands of square feet of concrete walls and vaults with frescoes, was Famulus, an eccentric figure known for painting while wearing a toga. Many of the Domus Aurea frescoes, for example, those in room 78 (**Fig. 8-25**), although not among the oldest examples of the Fourth Style, still display a kinship with the Third Style but reveal a renewed taste for illusionism. The background is an austere creamy white. In some areas the artist painted sea creatures, birds, and other motifs directly on the monochromatic wall, much like the landscapes in the Black Room (Fig. 5-25) of the Boscotrecase villa. Landscapes appear in Nero's palace also—as framed paintings in the center of each large white subdivision of the wall. But views through the wall are also part of the design, although the Fourth Style architectural vistas are irrational fantasies. Nero and his guests did not look out on cityscapes or round temples set in peristyles as in the Second Style (Figs. 3-1, 3-13, 3-21, and 3-22) but at fragments of buildings—columns supporting half-pediments, double stories of columns supporting nothing at all—painted on the same white ground as the rest of the wall. In the Fourth Style, architecture became just another motif in the Roman painter's ornamental repertoire.

Few paintings in the Domus Aurea can be dated after the death of Nero in 68 CE. Fortunately, the latest stages of the Fourth Style can be seen in the houses of Pompeii and Herculanuem built or remodeled in the decade leading up to the eruption of Mount Vesuvius in 79. They are discussed in Chapter 10.

SUMMARY

Augustus, the founder of the Roman Empire and its revered ruler for almost half a century, was succeeded in turn by four emperors who were all related to him or to his wife Livia. The first Julio-Claudian emperor, Tiberius, adhered closely to the Augustan style in art and architecture, but during the three decades following his death, important changes took place. In portraiture, for example, Claudius rejected Augustan idealism and allowed himself to be depicted as an older man. Nero's latest portraits are noteworthy for their sensuousness and the realistic depiction of the textures of flesh and hair. Under Nero, the Fourth Style was also introduced in mural painting.

The most important innovations, however, occurred in architecture. Under Claudius, Augustan Classicism gave way to a preference for rusticated masonry, and the Neronian age marked the beginning of a revolution in architectural design made possible by the increasingly sophisticated use of concrete for vaults and domes. The key surviving monument is Nero's Golden House, in which concrete groin vaults were used for the first time and where the architects Severus and Celer invented an ingenious lighting system employing barrel vaults and a dome with a central oculus, innovations that paved the way for buildings like the Pantheon (see Chapter 12) a half century later.

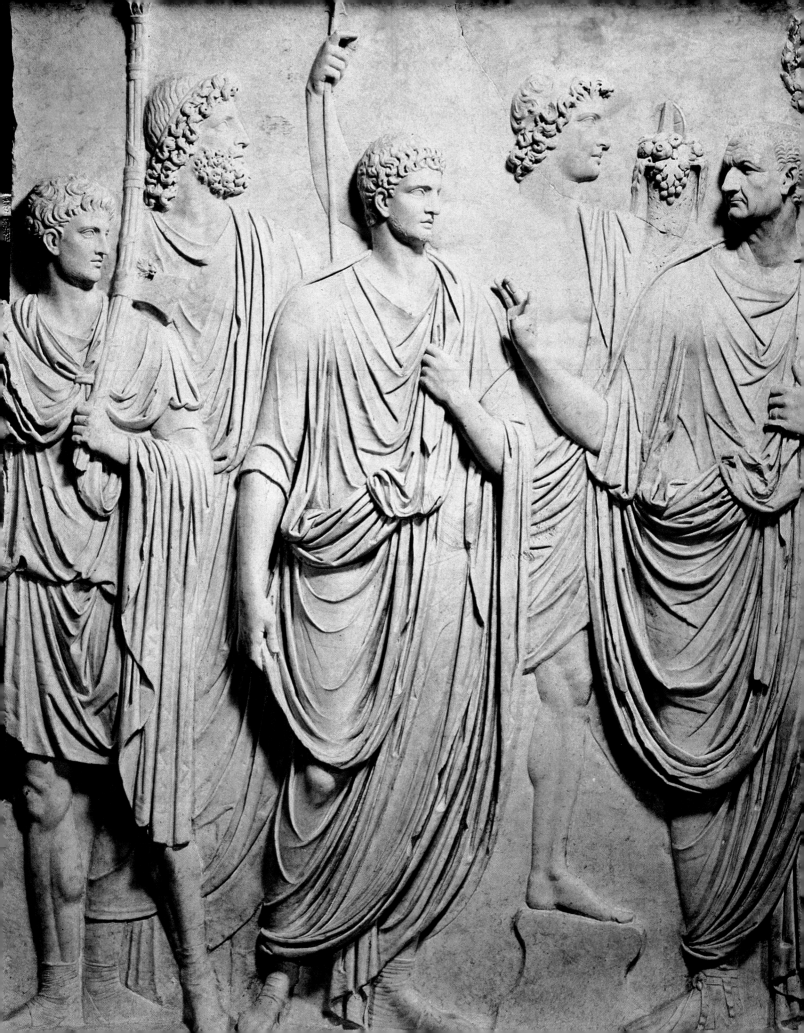

Civil War, the Flavians, and Nerva

Nero's suicide on June 9, 68,* came in reaction to a revolt that began in Gaul and unleashed a civil war that, although bloody, mercifully ended in a year—but not before the Roman people saw three new emperors come and go in quick succession until a fourth succeeded in securing lasting power and reestablishing peace. Augustus had ruled for nearly half a century, Tiberius for 23 years, Caligula for 4, Claudius for 13, and Nero for 14. In the brief span 68–69, Rome had five emperors (including Nero).

The first to challenge Nero was Galba (see "Civil War, the Flavians, and Nerva," page 122), who was serving as governor of Spain when he decided to march on Rome and wrest power from the last of the Julio-Claudians. When the praetorian guard threw its support behind Galba, Nero killed himself. Galba, who should have learned a lesson from the role the praetorians played in the downfall of Nero, soon alienated the praetorians, and they murdered him, proclaiming Otho, the governor of Lusitania and a friend of Nero's, as emperor in Galba's place. But another governor, Vitellius, whose troops had hailed him as emperor even before Galba's death, defeated Otho's army in northern Italy. Otho committed suicide, and Vitellius entered Rome unchallenged in July 69.

Meanwhile, the eastern armies had proclaimed Vespasian, the general in charge of quelling a rebellion in Judaea, as emperor. Vespasian's forces reached Rome on December 20, defeated the Vitellians, dragged the emperor through the city, and killed him. The civil war was concluded when Vespasian, now unopposed, received the Senate's formal recognition as emperor. He ruled for a decade and succeeded in establishing a new dynasty, the Flavian (Vespasian's family name was Flavius), passing on power to his two sons, Titus and Domitian, who were emperors in succession from 79 until 96.

9-1 Domitian and Vespasian, detail of the adventus of Vespasian (Fig. 9-22), frieze from the Palazzo della Cancelleria, Rome, ca. 93–95. Musei Vaticani, Rome.

PORTRAITURE

It is revealing that Galba, Otho, and Vitellius, all of whom held power for mere months, issued large numbers of coins in different denominations. The coinage had become

* From this point on, all dates are CE unless otherwise stated.

Civil War, the Flavians, and Nerva

Galba (Servius Sulpicius Galba, r. 68–69) was governor of Spain when he joined the revolt against Nero. He won the emperorship in 68 but lost favor with the praetorian guard. Praetorians murdered him on January 15, 69.

Otho (Marcus Salvius Otho, r. 69) was governor of Lusitania when the praetorians hailed him as emperor after Galba's murder. He committed suicide on April 16, 69, when Vitellius humiliated his army on the battlefield.

Vitellius (Aulus Vitellius, r. 69) was governor of Lower Germany when his troops proclaimed him emperor on January 2, 69. After crushing Otho's troops, he entered Rome in July. Vespasian's forces murdered Vitellius on December 20.

Vespasian (Titus Flavius Vespasianus, r. 69–79) was commander of the Roman legions in Judaea in July 69 when he was hailed as emperor by the armies of Egypt, Judaea, and Syria. The Senate recognized him as emperor after the death of Vitellius.

Domitilla the Elder was the wife of Vespasian and mother of Titus and Domitian.

Titus (Titus Flavius Vespasianus, r. 79–81) was the elder son of Vespasian. He captured Jerusalem in 70 and became the second emperor of the Flavian dynasty upon the death of his father.

Domitian (Titus Flavius Domitianus, r. 81–96), the third and last Flavian emperor, was the younger son of Vespasian. He was murdered in 96. The Senate immediately damned his memory.

Domitia, the wife of Domitian, was suspected of participating in the assassination plot against her husband.

Nerva (Marcus Cocceius Nerva, r. 96–98), a respected senator who had served twice as consul, was the Senate's choice to succeed Domitian. Old and in poor health, he died 16 months after becoming emperor. ∎

an indispensable tool of propaganda, and those claiming to be emperor took full advantage of it, using the reverses to proclaim slogans such as "Liberty Restored" and "Victory of the Roman People" (over the tyrant Nero). It was also essential that the competing emperors paid their troops with money bearing their image and imperial titles and not those of a rival.

GALBA Galba was more than 70 years old in 68, and his coin portraits (**Fig. 9-2**) depict him as an older man, although not bald as Suetonius described him. If Suetonius's report is accurate, Galba's official image is not a realistic likeness, although it appears to be. The frank rendition of his aging features nonetheless shows that he had no interest in being represented as artificially youthful. His tough, determined look invoked the values of the Roman Republic and was especially well suited for an emperor who wished to present himself as the people's champion in a fight for liberty from tyranny.

VITELLIUS According to Suetonius, Vitellius was a huge man, tall as well as obese, and those qualities were captured in a colossal marble head (**Fig. 9-3**) in Copenhagen. The portrait combines the close-cropped military-style coiffure of Galba with the heavy rolls of flesh present in Nero's latest portraits—further exaggerated in the Copenhagen head—but the texture of the skin is that of an older man. Nothing remains of the body into which the separately worked head was set. The statue most likely depicted Vitellius in his role as cuirassed commander of

the army, perhaps even with a trim, well-toned body, echoing the dichotomy between portrait head and body type so common in Roman sculpture (compare Figs. 4-10, 4-11, and 8-10).

9-2 **Sestertius with obverse portrait of Galba, 68. Bronze, approx. $1\frac{1}{4}''$ diameter. Private collection.**

9-3 Head of Vitellius, 69. Marble, approx. 1′ 8⅝″ high. Ny Carlsberg Glyptotek, Copenhagen.

VESPASIAN Many more portraits exist of Vespasian than of his immediate predecessors because of his longer tenure as emperor and because he was deified after his death and his sons continued to commission portraits of their father during their principates. Vespasian was 60 when he assumed power and 70 when he died. All of the emperor's portraits, like those of Galba, present him as an older, serious, and unpretentious man who was in every respect the anti-Nero: a career military officer concerned not for his own pleasure but for the welfare of the Roman people, the security of the Empire, and the solvency of the treasury.

One of the best likenesses of Vespasian is a marble head (**Fig. 9-4**) in Copenhagen that shows him with a deeply reced-

9-4 Head of Vespasian, ca. 75–79. Marble, approx. 1′ 4″ high. Ny Carlsberg Glyptotek, Copenhagen.

ing hairline, leathery skin, etched lines in his face and neck, and thin lips disguising the apparent loss of some of his teeth. It could be mistaken for a Republican portrait, underscoring the emperor's traditional values.

TITUS Titus's two-year rule was marked by tragedy, most notably the eruption of Mount Vesuvius in 79 and a fire and plague in the capital in 80. The emperor devoted a large portion of his time to providing relief to victims and repairing damaged buildings. The former war hero, who brought a successful end to Vespasian's campaign in Judaea, seems to have acquitted himself well in his new role. When he died, Titus too became a divus.

Portraits of Titus began to be produced in large numbers under Vespasian—in relief on coins as well as in the round—in order to present the Roman people with the likeness of the heir apparent. Groups of statues depicting Vespasian and his two sons served to promote the notion that stability had

9-5 Togate statue of Titus, from Rome, ca. 79–81. Marble, 6′ 5⅛″ high. Musei Vaticani, Rome.

9-6 Bust of Domitian, from Rome, ca. 88. Marble, 1′ 8⅝″ high. Musei Capitolini–Centrale Montemartini, Rome.

returned to the Roman world, because an orderly succession, not civil war, was in store when the elderly Vespasian passed away.

A togate statue (**Fig. 9-5**) with a separately worked head of Titus inserted in the neck cavity depicts a man around 40 years old who, although heavier, closely resembles his father—a similarity Titus would have wanted to emphasize. Baldness was a Flavian family trait, and Titus's hair is already thinning and receding in this portrait. His heavy toga is more deeply carved than Augustan togas (compare Fig. 5-12, which also has

a separately carved head), and the folds create a rich pattern of light and shadow across the surface.

DOMITIAN Whereas Titus continued the moderate policies of his father, Domitian, who became emperor at 30, was a self-indulgent megalomaniacal emperor in the Neronian mold, who also built a lavish new residence (Fig. 9-17) for himself in Rome. He drained the treasury, demanded that his subjects address him as *dominus et deus* (lord and god), and quickly incurred the hatred of the Senate. In 96 he was murdered at the instigation of a group said to include even his wife Domitia, and his memory was officially damned (see "Rewriting History: *Damnatio Memoriae*," page 136).

Portraits of Domitian as a young prince show him with a full head of hair, but the likenesses of him as emperor faithfully record his receding hairline. A heroically nude bust (**Fig. 9-6**), carved when Domitian was about 40, is a characteristic example of these later portraits and also of the Flavian

9-7 Bust of a Flavian woman, from Rome, ca. 90. Marble, 2′ 1⅜″ high (without modern bust). Museo Capitolino, Rome.

9-8 Rear view of the bust of a Flavian woman in Fig. 9-7.

type of bust portrait. The Roman bust form had evolved from an abbreviated portrait that included little more than the head and collarbone during the Republic and Early Empire to a true bust portrait that, by the late first century, extended below the chest. In this portrait, the physiognomic resemblance between Domitian and his brother and father is unmistakable. In spite of his pretension to be a god on earth, Flavian verism, not Augustan idealism, is the key ingredient of Domitian's portraits.

FLAVIAN WOMEN Flavian portraits of women differ sharply from those of men. The women of the imperial household did not share the emperors' interest in realism and the implied embrace of Republican values. They preferred to be represented as young and beautiful—and sporting the latest hairstyles, which had become extremely elaborate by the end

of the first century. The most famous, and probably the best, female portrait of the era is a marble bust (**Figs. 9-7** and **9-8**) in the Capitoline Museum in Rome that has never been convincingly identified, but must depict either a member of the Flavian dynasty or a very wealthy nonimperial woman because a replica of it also survives. The portrait is notable for its elegance and delicacy and for the virtuoso way the sculptor rendered the differing textures of hair and flesh. The coiffure, which is even larger than the woman's face, consists of corkscrew curls punched out by skilled hands using a drill in addition to the standard chisel. This technique created a dense mass of light and shadow set off boldly from the softly modeled and highly polished skin of the face and swanlike neck. The paint that would once have been applied to the hair, eyebrows, eyes, and lips would have further enhanced the sensuality and immediacy of the image.

A FLAVIAN VENUS Another late Flavian portrait (**Fig. 9-9**) depicting an anonymous woman with a high crown of curls framing her forehead is, like the figures in the Pasitelean groups (Fig. 4-4) of the Late Republic and Early Empire, a creative pastiche based on various Greek statuary types. It presents the woman in the guise of Venus, with only the lower

9-9 Statue of a Flavian woman in the guise of Venus, from Porta San Sebastiano, Rome, late first century. Marble, 6′ ½″ high. Museo Capitolino, Rome.

part of her body draped. Being portrayed as the goddess of love was a popular conceit of Roman female portraiture of every period. Sometimes the woman posing as Venus has an older head and a perfect youthful body, as in male portraiture. In Fig. 9-9, however, the woman is young, so the picture is believable. Elite women did not, of course, appear undressed in public, nor did their male counterparts. Nude portraits were neither intended nor perceived as literal representations. The body type was merely a prop, an attribute that conveyed a message, namely that the woman depicted was as noble and beautiful as Venus herself.

ARCHITECTURE

Vespasian inherited a bankrupt treasury from Nero, but through prudent fiscal administration, he managed to replenish it during his decade as emperor while also undertaking an ambitious architectural program in Rome. Many of his construction projects were also astute politically—for example, his decision to complete the Temple of Divus Claudius, which Nero had abandoned in favor of more personally gratifying projects like the Domus Aurea.

TEMPLUM PACIS One of Vespasian's first initiatives was to construct a Temple of Peace (Figs. 1-2, no. 16, **9-10**, and 11-5,

9-10 Restored view of the Templum Pacis (Temple of Peace), Rome, 71–79 (John Burge).

no. 3) to the east of the Forum Augustum. Vespasian, like Augustus, had gained supreme power after a war pitting Roman against Roman, and he too wanted to hammer home the message that he had restored peace to Italy. The plan of the new temple precinct was simple and resembled that of a traditional Roman forum. It consisted of a rectangular courtyard with colonnades on three sides and a temple at the center of one short end, but the temple porch barely projected beyond the colonnade, and behind it was an unusual wider cella.

The courtyard itself also broke with tradition. It was planted with trees so that it resembled a park more than a forum or temple precinct. The complex doubled as a public art museum, housing many of the finest paintings and statues that the Romans had looted from Greek cities. The greatest spoils from the war in Judaea, including the *menorah* (seven-branched candlestick) from the Jewish temple in Jerusalem (see "The Triumph of Vespasian and Titus," page 131), were also put on display in the Templum Pacis.

COLOSSEUM Almost nothing of the Templum Pacis is visible today, but another Flavian building, the Colosseum (Figs. 1-2, no. 23, **9-11**, and **9-12**), has been one of Rome's landmarks since the day it was dedicated. Vespasian's decision to build the Flavian Amphitheater, as it was known at the time, was very shrewd. The site chosen was the artificial lake on the grounds of Nero's Domus Aurea, which was drained for the purpose. By building the new amphitheater there, Vespasian reclaimed for the public the land Nero had confiscated for his private pleasure and provided the masses with the largest arena for gladiatorial combats and other lavish spectacles that had ever been constructed. The Colosseum takes its name, however, not from its size—it could hold more than 50,000 spectators—but from its location beside the Colossus of Nero (Fig. 1-2, no. 22), the huge statue of the emperor portrayed as the sun god, at the entrance to his urban villa.

Vespasian did not live to see the Colosseum completed. Titus formally dedicated the amphitheater in 80. To mark the opening, games were held for 100 days (see "Spectacles in the Colosseum," page 128). Later emperors would compete to see who could mount the most elaborate spectacles, and over the

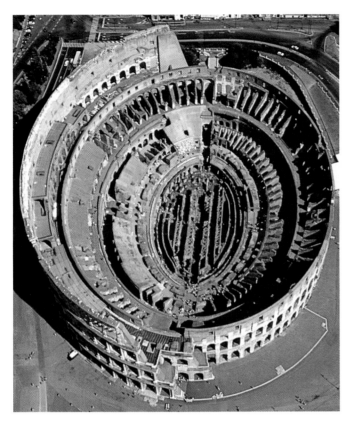

9-11 Aerial view of the Colosseum (Flavian Amphitheater), Rome, ca. 70–80.

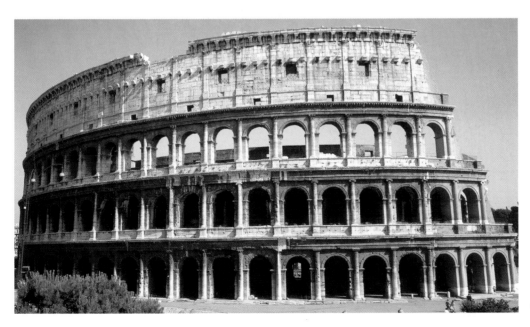

9-12 Facade of the Colosseum (Flavian Amphitheater), Rome, ca. 70–80.

Spectacles in the Colosseum

Romans flocked to amphitheaters all over the Empire to see two main kinds of spectacles: gladiatorial combats and animal hunts.

Gladiators were professional fighters, usually slaves who had been purchased to train in gladiatorial schools as hand-to-hand combatants. Their owners, seeking to turn a profit, rented them out for performances. Beginning with Domitian, however, all gladiators who competed in the Colosseum were state-owned to ensure that they could not be used as a private army to overthrow the government. Although every gladiator faced death every time he entered the arena, some had long careers and achieved considerable fame. Others, for example, criminals or captured enemies, were sent into the amphitheater without any training and without defensive weapons. Those "games" were a form of capital punishment coupled with entertainment for the masses.

Wild animal hunts (*venationes*) were also immensely popular. Many of the hunters were also professionals, but often the hunts, like the gladiatorial games, were thinly disguised executions involving helpless prisoners who were easy prey for the animals. Sometimes no one would enter the arena with the animals; instead, skilled archers shot the beasts with arrows from positions in the stands. Other times animals would be pitted against other animals—bears versus bulls, lions versus elephants, and such—to the delight of the crowds.

The Colosseum was the largest and most important amphitheater in the world, and the kinds of spectacles staged there were costlier and more impressive than those held anywhere else. There are even accounts of the Colosseum being flooded so that naval battles could be staged before an audience of tens of thousands, although some scholars have doubted that the arena could be made watertight or that ships could maneuver in the space available.

The historian Dio Cassius, writing in the early third century, described the ceremonies that Titus sponsored at the inauguration of the Colosseum in 80.

There was a battle between cranes and also between four elephants; animals both tame and wild were slain to the number of nine thousand; and women . . . took part in despatching them. As for the men, several fought in single combat and several groups contended together both in infantry and naval battles. For Titus suddenly filled [the arena] with water and brought in horses and bulls and some other domesticated animals that had been taught to behave in the liquid element just as on land. He also brought in people on ships, who engaged in a sea-fight there . . . On the first day there was a gladiatorial exhibition and wild-beast hunt . . . On the second day there was a horse-race, and on the third day a naval battle between three thousand men, followed by an infantry battle . . . These were the spectacles that were offered, and they continued for a hundred days.*

Titus's opening spectacles in the Colosseum were never equaled in duration or expense, but the appetite of the Roman people for lavish, imperially funded combats and hunts ensured that they were not the last. Two centuries later, in 281, the emperor Probus celebrated his military successes by staging spectacles that also involved hundreds of animals and gladiators.

Probus produced in the Amphitheatre one hundred male lions at a single performance; their roaring brought on a thunderstorm . . . Then he displayed one hundred leopards from Libya; then one hundred from Syria; then one hundred lionesses together with three hundred bears . . . He further displayed three hundred pairs of gladiators, among whom were many . . . who had been prisoners in his triumph.† ∎

* Dio Cassius, *Roman History,* 66.25. Translated by Earnest Cary, *Dio's Roman History,* vol. 8 (Cambridge, Mass.: Harvard University Press, 1925), 311, 313.

† *Historia Augusta, Vita Probi,* 19. Translated by Donald R. Dudley, *Urbs Roma* (Aberdeen: Phaidon, 1967), 142–143.

years many thousands of lives were lost in the gladiatorial and animal combats staged there.

The Colosseum, like the much earlier amphitheater at Pompeii (Figs. 2-15 and 2-16), could not have been built without concrete. In fact, the builders began construction of the Flavian Amphitheater by laying an enormous elliptical ring of concrete, about 170 feet wide and 40 feet deep, to serve as the building's foundation. Above, travertine piers, tufa walls, and a complex system of annular-vaulted corridors and barrel-vaulted ramps (as well as groin vaults in the upper level) hold up the gigantic cavea. Anyone entering the

amphitheater today immediately sees its inner concrete "skeleton." In the centuries following the fall of Rome, the Colosseum served as a convenient quarry for ready-made building materials. Almost all its marble seats were hauled away, exposing the network of vaults below. Also hidden in antiquity but visible today are the arena substructures, which in their present form date from the third century. They housed waiting rooms for the gladiators, animal cages, and machinery for raising and lowering stage sets as well as animals and humans. Cleverly designed lifting devices brought beasts from their dark dens into the arena's bright light.

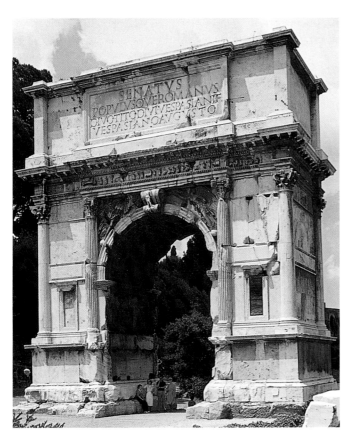

9-13 Arch of Titus, Via Sacra, Rome, ca. 81.

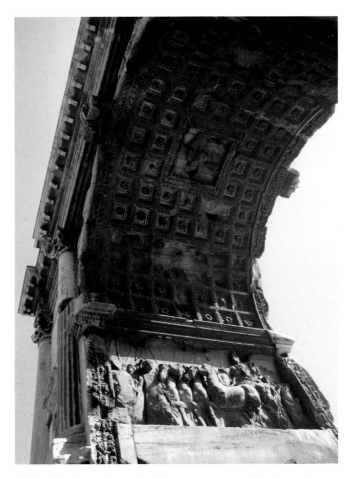

9-14 View into the vault of the passageway with the apotheosis of Titus, Arch of Titus, Via Sacra, Rome, ca. 81.

Above the seats a great velarium, as at Pompeii (Fig. 2-17), once shielded the spectators. Poles affixed to the Colosseum's facade held up the giant awning.

The exterior travertine shell is approximately 160 feet high, the height of a modern 16-story building. Numbered entrances, 76 in all, led to the cavea, where the spectators sat according to their place in the social hierarchy. The relationship of the gateways to the tiers of seats within was carefully considered and resembled that seen in modern sports stadiums. The exterior's decor, however, had nothing to do with function. The facade is divided into four bands, with large arched openings piercing the lower three. Ornamental Greek orders frame the arches: Tuscan Doric, Ionic, and then Corinthian from the ground up, progressing from heaviest and most severe to lightest and most ornate, as in the Theater of Marcellus (Fig. 5-19), which must have served as the model. The uppermost story is circled with Corinthian pilasters (and between them the brackets for the wooden poles that held up the velarium).

ARCH OF TITUS Shortly after Titus died in 81, Domitian erected an arch (Figs. 1-2, no. 19, and **9-13**) in Titus's honor on the Via Sacra (Sacred Way) leading into the Forum Romanum, not far from the Colosseum and the entrance to Nero's former villa. The large attic dedicatory inscription states that the arch was set up to honor the god Titus, son of

the god Vespasian. Therefore, although the arch is always referred to as the Arch *of* Titus, it is really an arch *for* Titus, and the posthumous nature of the dedication is crucial for the interpretation of the arch's sculptured decoration.

Architecturally, the Arch of Titus is similar to the sparsely decorated arches of the Augustan period, for example that at Susa (Fig. 7-5), which also has a sculptured frieze and engaged columns. The Flavian arch's columns, however, have *Composite capitals,* an ornate combination of Ionic volutes and Corinthian acanthus leaves that became popular at about this time. Victories fill the spandrels, as on Augustus's Parthian arch (Fig. 5-6) in Rome and the Arch of the Sergii (Fig. 7-15) at Pola. They carry a double meaning on Titus's arch, referring both to the deceased emperor's victory in Judaea and his more recent triumph over death through apotheosis.

Titus's apotheosis is, in fact, depicted on the arch — in the small relief panel set into the center of the vault over the arch's single passageway (**Fig. 9-14**). Titus is shown riding to heaven on the wings of an eagle. The representation of Titus's apotheosis is more explicit than the comparable panel in the vault of the Pola arch where an eagle carries a serpent, but the general meaning is the same.

SPOILS OF JERUSALEM Inside the passageway of the Arch of Titus are two great relief panels. They represent the triumphal parade of Titus down the Via Sacra after his return in 70 from the conquest of Judaea. One of the reliefs (**Fig. 9-15**) depicts Roman soldiers carrying the Jewish spoils, including the sacred menorah from the temple in Jerusalem. Despite considerable damage to the relief, the illusion of figures moving through space is convincing. The parade proceeds forward from the left background into the center foreground and disappears through the obliquely placed arch in the right background. The energy and swing of the column of soldiers suggest a rapid march. Domitian's sculptor rejected the Classicizing low relief of the Augustan and Julio-

Claudian eras in favor of extremely deep carving, which produces a greater sense of depth and creates strong shadows—a contrast already noted in connection with the treatment of drapery in Flavian freestanding statuary (Fig. 9-5). The heads of the forward figures have broken off because they stood free from the block. Their high relief emphasized their different placement in space from the heads in low relief, which are intact. The play of light and shadow across the protruding foreground and receding background figures quickens the sense of movement.

The representation of the triumph conforms closely to the eyewitness account of Josephus (see "The Triumph of Vespasian and Titus," page 131), with one notable exception.

9-15 Spoils of Jerusalem, panel in the passageway, Arch of Titus, Via Sacra, Rome, ca. 81. Marble, 6′ 7″ high.

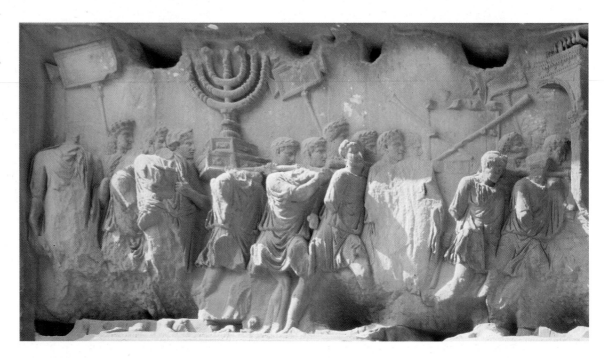

9-16 Triumph of Titus, panel in the passageway, Arch of Titus, Via Sacra, Rome, ca. 81. Marble, 6′ 7″ high.

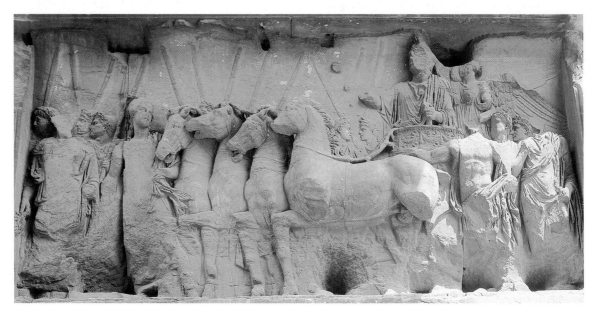

The Triumph of Vespasian and Titus

Flavius Josephus was a Jewish priest and influential figure in Jerusalem before the Roman siege of the city in 70. His history of the war in Judaea, written originally in Aramaic and then published in Greek between 75 and 79, contains an invaluable eyewitness account of the triumph of Vespasian and Titus following the defeat of the Jews.

[Vespasian and Titus] having donned their triumphal robes and sacrificed to the gods whose statues stood beside the [Porta Triumphalis, the gate through which all triumphal processions entered Rome], sent the pageant on its way, driving off through the theatres [of Pompey and Marcellus, Fig. 1-2, no. 3, in the Campus Martius, and the Circus Maximus, at the foot of the Palatine Hill, Fig. 1-2, no. 5; compare Fig. 18-22], in order to give the crowds an easier view. It is impossible adequately to describe the multitude of those spectacles and their magnificence under every conceivable aspect, whether in works of art or diversity of riches or natural rarities . . . Silver and gold and ivory in masses, wrought into all manner of forms . . . tapestries borne along, some of the rarest purple . . . transparent gems, some set in golden crowns . . . images of [Roman] gods, of marvelous size and no mean craftsmanship, and of these not one but was of some rich material. . . . But nothing in the procession excited so much astonishment as the structure of the moving stages; indeed, their massiveness afforded ground for alarm and misgiving as to their stability, many of them being three or four stories high . . . many were enveloped in tapestries interwoven with gold, and all had

a framework of gold and wrought ivory. The war was shown by numerous representations, in separate sections, affording a very vivid picture of its episodes . . . [T]he art and magnificent workmanship of these structures now portrayed the incidents to those who had not witnessed them, as though they were happening before their eyes The spoils in general were borne in promiscuous heaps; but conspicuous above all stood out those captured in the temple at Jerusalem. These consisted of a golden table, many talents in weight, and a lampstand, likewise made of gold . . . Affixed to a pedestal was a central shaft, from which there extended slender branches, arranged trident-fashion, a wrought lamp being attached to the extremity of each branch; of these there were seven, indicating the honour paid to that number among the Jews. After these, and last of all the spoils, was carried a copy of the Jewish Law. Then followed a large party carrying images of [V]ictory, all made of ivory and gold. Behind them drove Vespasian, followed by Titus; while Domitian rode beside them, in magnificent apparel and mounted on a steed that was itself a sight. The triumphal procession ended at the temple of Jupiter Capitolinus [Fig. 1-1, no. 4] . . . [where] the princes began the sacrifices . . . The triumphal ceremonies being concluded and the empire of the Romans established on the firmest foundation, Vespasian decided to erect a temple of Peace [Fig. 9-10].* ▪

* Josephus, *Jewish War*, 7.131–158. Translated by H. St.J. Thackeray, *Josephus*, vol. 3 (Cambridge, Mass.: Harvard University Press, 1928), 543–551.

The arch through which the procession passes could not have been standing then, because the statuary group on its attic represents the same procession. Vespasian and Titus are shown driving twin chariots with Domitian riding on horseback between them, exactly as Josephus reported. The anachronistic representation is probably to be explained by Domitian's desire to remind the public that he too had taken part in the events of that glorious day.

TITUS IN TRIUMPH The panel (**Fig. 9-16**) on the other side of the passageway shows Titus in his triumphal chariot, but not Vespasian, because the arch honors the son, not the father. Moreover, whereas the spoils panel was a seemingly accurate portrayal of the procession, the triumph panel is overtly allegorical. In the triumph of Tiberius (Fig. 8-4) on the silver cup from Boscoreale, a state slave rode with the victorious general in his chariot. Here, Victory accompanies Titus in the quadriga and places a wreath on his head. Below her is a bare-chested youth who is probably a personification of Honos (compare Fig. 8-5), although some identify him as the personification of

the Roman people. A female personification of Virtus (thought by some to be Roma) leads the horses. These allegorical figures transform the relief from a record of Titus's battlefield success into a celebration of imperial virtues. Such an intermingling of divine and human figures occurred earlier in the private sphere (Figs. 8-5 to 8-7), but the Arch of Titus panel is the first known instance of divine beings interacting with a mortal in a narrative relief on a public monument purporting to represent an event that took place during the person's lifetime. (On the Ara Pacis, Fig. 5-15, Aeneas and "Tellus," Figs. 5-16 and 5-17, appear in separate framed panels and were carefully segregated from the procession of living Romans.) The break with tradition probably would have offended no one, because the Arch of Titus was erected after the emperor's death and its reliefs were carved when Titus was already a god. Soon afterward, however, this kind of interaction between mortals and immortals became a staple of Roman narrative relief sculpture—beginning, not surprisingly, with Domitian, who paid for Titus's arch and who openly claimed to be a divine ruler (dominus et deus).

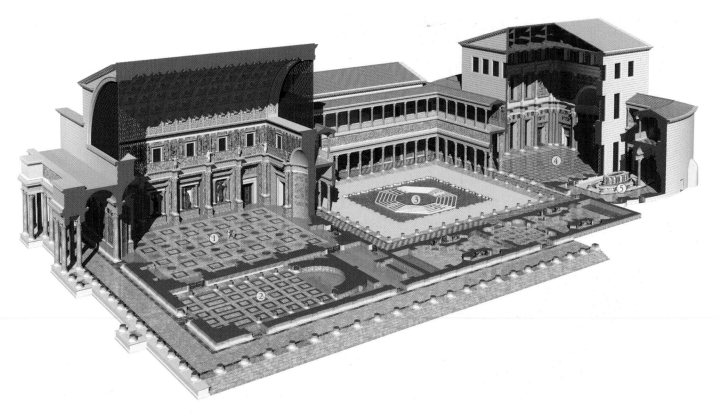

9-17 **Rabirius, restored view of the Palace of Domitian, Palatine Hill, Rome, 92 (John Burge).**
1) aula regia, 2) basilica, 3) peristyle, 4) triclinium, 5) nymphaeum.

PALACE OF DOMITIAN When the Flavians assumed power in Rome in 69, the official imperial residence was then Nero's Golden House, but Vespasian's plan to restore all of the land Nero had confiscated meant that their occupation of the palace was destined to be temporary. After the dedication of the Colosseum (Fig. 1-2, no. 23) in 80 and the opening of the neighboring Baths of Titus (Figs. 1-2, no. 24, and 11-18, no. 2) the same year, the Domus Aurea residence was also effectively cut off from the Forum Romanum. Domitian therefore decided to construct a new imperial palace (Fig. 1-2, no. 6) on the Palatine Hill, not far from the House of Augustus (Fig. 5-20) in the old residential district that included the Republican House of the Griffins (Fig. 3-17), which was buried beneath the terrace of the new palace.

The architect of Domitian's palace was Rabirius, who designed a huge three-part complex (**Fig. 9-17**) to provide separate wings for the conduct of official business and for the private residence of the emperor. The public wing, conventionally called the Domus Flavia, had three vaulted halls on the north side, facing the Forum Romanum. Two of them—an *aula regia,* or audience hall, and a basilica (Fig. 9-17, nos. 1 and 2)—had an apse at the south end so that the emperor could look down on visitors from an elevated position in a vaulted niche. Similar apses had been a feature of some earlier temples in Rome, including the Temples of Venus Genetrix and

of Mars Ultor in the Fora of Caesar and Augustus (Figs. 4-18, no. 1, and 5-7, no. 1). The decoration of both rooms was opulent and included imported colored marbles and, in the aula regia, colossal green marble statues of gods and heroes.

The aula regia corresponded to the atrium and tablinum of a traditional domus. Beyond the audience hall was a colonnaded peristyle (Fig. 9-17, no. 3) and then a gigantic triclinium (Fig. 9-17, no. 5) for state dinners, paved with marbles of many colors and ending in another apse, from which Domitian could preside over his guests. Opening onto the triclinium on each side was a *nymphaeum* (Figs. 9-17, no. 4, and **9-18**), or monumental fountain, in which Rabirius's genius for exploiting the interplay of convex and concave forms is evident. A similar taste for curvilinear forms and complex patterns can be seen throughout the palace, for example, in the plans and vaults of some of the rooms in the residential wing, the Domus Augustana, which featured three peristyle gardens, one with an elaborate fountain (**Fig. 9-19**). The third wing, set at a lower level than the two main wings, was an immense peristyle with a curved end, called the *stadium* (Fig. 9-17, no. 6) because its shape resembled that of a Roman racetrack. At the south end of this sunken garden was the imperial box from which the emperor and privileged guests could look down upon the chariot races in the Circus Maximus (Fig. 1-2, no. 5).

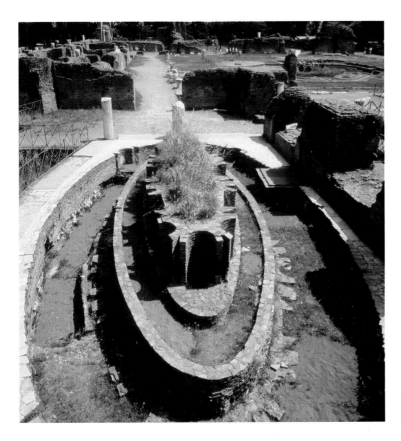

9-18 Rabirius, nymphaeum off the triclinium, Domus Flavia, Palace of Domitian, Palatine Hill, Rome, 92.

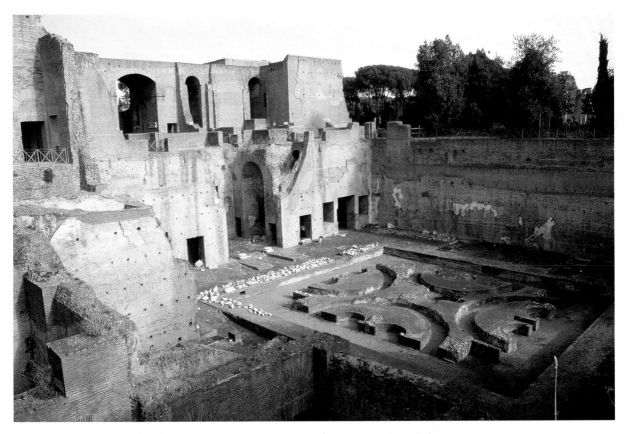

9-19 Rabirius, southern peristyle garden, Domus Augustana, Palace of Domitian, Palatine Hill, Rome, 92.

9-20 Aerial view of Piazza Navona, formerly Stadium of Domitian, Rome, ca. 86.

9-21 "Le Colonnacce," colonnade of the Forum Transitorium, Rome, begun by Domitian, dedicated by Nerva, 97.

STADIUM OF DOMITIAN Domitian also built a real stadium (Fig. 1-2, no. 1) in the Campus Martius, which survives today as Piazza Navona (**Fig. 9-20**), one of Rome's most breathtaking public spaces. The open area of the piazza (with one curved end) corresponds to the ancient racetrack proper; Bernini's magnificent 17th-century Four Rivers Fountain is its centerpiece. The buildings fronting on the piazza—restaurants, bars, and houses today, in addition to Borromini and Rainaldi's 17th-century church of Sant'Agnese in Agone—rest on the concrete substructures of the ancient seating area. Some of those substructures are still visible. The facade of the stadium had two stories and resembled the facade of the Colosseum (Fig. 9-12).

DAMNATIO MEMORIAE AND NERVA

When Domitian died and the Senate officially condemned his memory, one consequence was that all buildings erected in his honor were rededicated if they were not torn down, because the decree of *damnatio memoriae* required the erasing of the condemned person's name from all inscriptions (see "Rewriting History: *Damnatio Memoriae,*" page 136).

FORUM TRANSITORIUM One of the renamed buildings was the Forum Transitorium (Figs. 1-2, no. 15, and 11-5, no. 4), which became the Forum of Nerva, the respected senator and former consul whom the Senate appointed emperor to succeed Domitian. The Forum Transitorium derives its name from being constructed on the Argiletum, the narrow thoroughfare leading to the Forum Romanum between the Fora of Caesar and Augustus (Fig. 11-5, nos. 1 and 2) and Vespasian's Templum Pacis (Fig. 11-5, no. 3). The plot of land was too narrow for traditional columnar porticos on the long sides, so the unknown architect designed pseudo-colonnades of projecting Corinthian columns connected to the forum wall by a bracketed entablature—like the columns on Nero's Parthian arch (Fig. 8-22). The temple in the Forum Transitorium was dedicated to Minerva, Domitian's patron deity, who was also honored in the forum's sculptural program. Minerva appears in the framed panel between the only two preserved columns, the so-called Colonnacce (**Fig. 9-21**), and the remaining section of the frieze depicts the Greek myth of Minerva and Arachne.

CANCELLERIA RELIEFS Two fragmentary reliefs (**Figs. 9-22** and **9-23**) found in nearly pristine condition in excavations under the Palazzo della Cancelleria in Rome are the only surviving examples of commemorative reliefs depicting Domitian. They were preserved only because they had been discarded instead of destroyed. Their style is Classicizing and closer to that of the processions of the Ara Pacis (Fig. 5-18) than to the panels (Figs. 9-15 and 9-16) of the Domitianic Arch of Titus, illustrating once again the coexistence of different styles in Roman art.

The first relief (Fig. 9-22) depicts the *adventus* (entry into Rome) of Vespasian in 70 to receive the recognition of the Senate as emperor after the defeat of Vitellius. Human and divine actors (of similar size) mix freely in the frieze. At the far left, the enthroned Roma awaits the new emperor's arrival. The

bearded, toga-clad personification of the Senate and the semi-nude cornucopia-carrying personification of the Roman People (*Populus Romanus*) have gone out to meet him with the young Domitian (**Fig. 9-1**). This was the only occasion before he became emperor that Domitian was the most important man in Rome, because Titus was still fighting in Judaea at the time, and that must be why the subject was selected for depiction more than 20 years later.

The second relief (Fig. 9-23) represents an event of 92, Domitian's *profectio* (departure from Rome) to wage war against the Sarmatians. Victory (only one wing is preserved) leads the way, as do Mars and Minerva. Roma literally pushes the emperor out of the city as the Senate and Roman People bid him farewell.

9-22 **Adventus of Vespasian, frieze from the Palazzo della Cancelleria, Rome, ca. 93–95. Marble, 6′ 9½″ high. Musei Vaticani, Rome.**

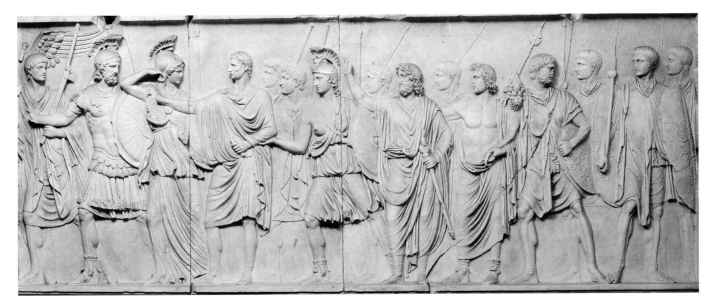

9-23 **Profectio of Domitian, frieze from the Palazzo della Cancelleria, Rome, ca. 93–95. Marble, 6′ 9½″ high. Musei Vaticani, Rome.**

Rewriting History: *Damnatio Memoriae*

Around 405, Saint Jerome could state matter-of-factly that "when a tyrant [that is, an unpopular Roman emperor] is destroyed, his portraits and statues are also deposed. The face is exchanged or the head removed, and the likeness of he who has conquered is superimposed. Only the body remains and another head is exchanged for those that have been decapitated."*

Jerome was describing one of the most visible consequences of *damnatio memoriae*—the official condemnation of a person's memory—by the Roman Senate, a practice that dated to the Republic and involved, among other penalties, the erasing of a person's name from inscriptions and other public documents and the recalling of coins bearing the person's portrait. Damnatio also resulted in the recutting of portrait heads (Fig. 9-23) or the removal of entire figures (Figs. 13-21, 16-18, and 16-19) from stone reliefs and the destruction of painted portraits (Fig. 16-4). Damnatio memoriae was a tool for rewriting history, in both words and pictures. Men who once ruled the world suddenly never even lived.

The first emperor to suffer this fate, although he was never officially damned, was Caligula. Many scholars believe, for example, that the head of Claudius (Fig. 8-11) as pontifex maximus in the Velleia basilica group is a replacement for one of Caligula. Portraits of Nero that were not mutilated or destroyed were frequently refashioned as likenesses of Vespasian. Heads of Domitian were regularly transformed into portraits of Nerva (Figs. 9-23 and 9-25). Other imperial figures whose portraits were destroyed or recut were Galba, Otho, and Vitellius; Commodus (see Chapter 13); and Caracalla's brother Geta and wife Plautilla (see Chapter 16); as well as many of the short-lived "soldier emperors" of the third century (see Chapter 18). ∎

*Jerome, *Book of Habakkuk*, 2.3.14–16.984–988. Translated by Eric R. Varner, *Mutilation and Transformation:* Damnatio Memoriae *and Roman Imperial Portraiture* (Leiden: Brill, 2004), 1.

9-24 **Head of Nerva, from Tivoli, 97–98. Marble, 1′ 6 $\frac{1}{8}$″ high. Museo Nazionale Romano—Palazzo Massimo alle Terme, Rome.**

Consistent with the Classicizing style of the reliefs, all the figures in both friezes have perfect proportions—except for Domitian in the profectio relief, whose head is too small for his body. That is because Domitian's features were chiseled away after his damnatio and his head recut as a portrait of Nerva (compare **Fig. 9-24**) but with Domitian's hair left almost intact. Domitian's head was not removed, however, from the other relief. The following is the most likely explanation: The Cancelleria friezes were probably intended for a monument in Rome that was not yet complete when Domitian was murdered and his memory damned. Sometime during the short 16-month principate of Nerva, the decision was made to rework the reliefs and dedicate the monument to Nerva. One head was recut, but then Nerva, an old and infirm man, died, the project was suspended, and the reliefs, now useless, were unceremoniously dumped in a Republican cemetery, where they were found in 1937 and 1939.

DOMITIAN ON HORSEBACK Another example of a portrait of Domitian refashioned as Nerva is the magnificent bronze equestrian statue (**Fig. 9-25**) from the temple dedicated to the imperial cult at Miseno (ancient Misenum), in which the cuirassed emperor was depicted thrusting a spear into a now-lost enemy. In this case, the front half of Domitian's head was sawed off and replaced with Nerva's face. The portrait is very similar to the marble head (Fig. 9-24) from Tivoli, where Nerva also has a Julio-Claudian hairstyle, large ears, and a hooked nose. (The marble head may also have originally portrayed Domitian.)

The frequency with which the Romans mutilated, or, in the case of the Cancelleria reliefs, threw away, artworks of the highest quality seems peculiar and unappreciative today, but the concept of producing and conserving "art for art's sake" is a notion inconsistent with the political purpose of official Roman art.

9-25 **Equestrian statue of Nerva (formerly Domitian), from the Sanctuary of the Augustales, Miseno, 97. Bronze. Museo Archeologico dei Campi Flegrei, Bacoli.**

SUMMARY

In the aftermath of Nero's suicide, the Roman world was once again plunged into a civil war, almost exactly a century after Octavian brought an end to the last such conflict when he defeated Antony and Cleopatra at Actium. The victor, Vespasian, founded a new dynasty, and the Flavians ruled the Roman Empire for a quarter century.

Vespasian, a shrewd politician as well as an accomplished general, used art and architecture to present himself as the anti-Nero, a man of traditional values who had the people's interests at heart. His portraits revived the veristic imagery of the Republic, depicting him as an older man with deep lines and a balding head. Dynastic groups portraying him with his sons Titus and Domitian prepared the public for their uncontested succession.

Vespasian also initiated a major building program in Rome that began the process of reclaiming the land of Nero's Domus Aurea for the people. On the grounds of that villa and in the adjoining area near the Forum Romanum and the Fora of Caesar and Augustus, the Flavians built the Colosseum, the Baths of Titus, the Temple of Peace, the Arch of Titus, and the Forum Transitorium. On the Palatine Hill, Domitian erected a magnificent new imperial palace.

Domitian, however, abandoned his father's moderation in favor of a life of monarchical luxury and demanded to be addressed as dominus et deus. During his principate, the emperor began to appear in narrative art intermingling with the gods. He was assassinated, his memory was damned, and many of his buildings, reliefs, and portraits were refashioned to honor Nerva.

Pompeii and Herculaneum in the First Century CE

Of the cities and towns buried by the Vesuvian eruption of 79, Pompeii is by far the best known and most completely excavated (see Chapters 2 and 3), but Herculaneum (**Fig. 10-2**) is the best conserved, owing to the way it was destroyed. The superheated mud and other debris that covered Herculaneum eventually hardened to the consistency of stone and trapped poisonous gases beneath it, making excavation slow, costly, and perilous (see "Excavating Herculaneum," page 140). Because of the difficulty and danger involved in digging out the city, only about a quarter of Herculaneum (named after its legendary founder, Hercules) has been exposed, but parts of the second stories of buildings are often preserved, as are the carbonized remains of wooden doors and the best collection of Roman household furniture from any site.

DOMESTIC ARCHITECTURE

Most of the civic center of Herculaneum has yet to be explored, but several blocks on the southwestern side of the city facing the sea have been uncovered, including mansions of the Republican period, such as the Samnite House with its First Style fauces (Fig. 3-16), as well as houses datable to the last decades of the city's life.

HOUSE OF THE MOSAIC ATRIUM One of the most spacious houses at Herculaneum is the House of the Mosaic Atrium (**Fig. 10-3**), which takes its name from the mosaic floor (**Fig. 10-4**) of black and white rectangles in the atrium (Fig. 10-3, no. 2).

10-1 Detail of a Fourth Style mural painting, Ixion Room (triclinium P, Fig.10-16), House of the Vettii, Pompeii, ca. 62–79.

The floor and the impluvium owe their buckled form to the crushing weight of the fiery volcanic material that flowed into the house and seems also to have washed away all of its statues and furnishings. Entrance to the domus was from a side street, and the first section of the house a visitor would have seen was very traditional—a fauces (Fig. 10-3, no. 1) leading into an atrium with a

Excavating Herculaneum

Herculaneum suffered the same general fate as Pompeii from the Vesuvian eruption, but the destruction took a different form. The initial explosion had produced a huge cloud of ash, pumice, and gases (see "An Eyewitness Account of the Eruption of Mount Vesuvius," Chapter 2, page 20), and the wind carried the volcanic material to Pompeii, where the pumice stones and ash gradually buried the city to a depth of about 17 feet. In contrast, Herculaneum at first escaped the rain of debris because of its location upwind. But around midnight Vesuvius began to spew forth more devastation. Six successive waves of a fiery hot mix of mud, ash, pumice, and limestone rocks flowed down the volcano's slope and buried Herculaneum, which was located less than five miles from the peak, to a depth of more than 65 feet. After the material cooled, it hardened into an extremely dense mass, as solid as the local tufa. Consequently, excavating Herculaneum has been a virtual mining operation. Those exploring the site since the 18th century have been in constant risk of collapsing tunnel shafts and asphyxiation from trapped gases. It is no surprise that a much smaller percentage of Herculaneum has been uncovered than of Pompeii.

The dangers of excavating Herculaneum were vividly recounted in a letter Karl Weber, the Swiss engineer in charge of exploring the Villa of the Papyri, wrote in 1752:

> I have shunned no fatigue or labor in order to procure numerous finds, singular and rare, and, on reflection, things for which the academies of Europe would pay a fortune . . . I have been seeking to procure [these precious objects] for the space of two years, with clear danger to my life, not only on a single occasion but daily, even twice a day, as a result . . . of my being attached to a rope and lowered into a well [88 feet] deep, where I have been exposed . . . to many unfortunate accidents . . . [for example, when] the sleeve of thick iron on the wheel [of the winch] broke . . . and by a miracle I had enough time to be lifted from the well, and the supervisor and others congratulated me for having been reborn then.*

In the 18th century, archaeology was little more than treasure hunting, and it is no coincidence that in the same letter Weber enumerated the hoard of "singular and rare" objects worth "a fortune" that he had recovered from the Villa of the Papyri (Figs. 10-11 to 10-13) as justification for a promotion and higher salary (neither of which he received). Weber, however, also was a pioneer in the scientific documentation of archaeological sites. For example, he annotated his plan of the Villa of the Papyri to show the precise findspot of every artifact—a practice unheard of at the time. ∎

* Letter to Giovanni Fogliani d'Aragona, April 1752. Translated by Christopher Charles Parslow, *Rediscovering Antiquity: Karl Weber and the Excavation of Herculaneum, Pompeii, and Stabiae* (New York: Cambridge University Press, 1995), 90–91.

10-2 **Aerial view of Herculaneum, looking north.**

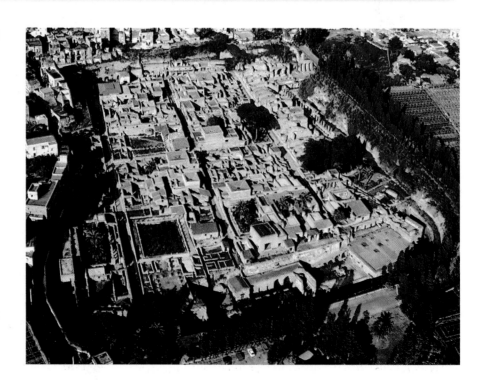

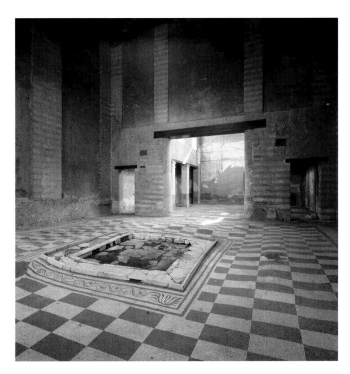

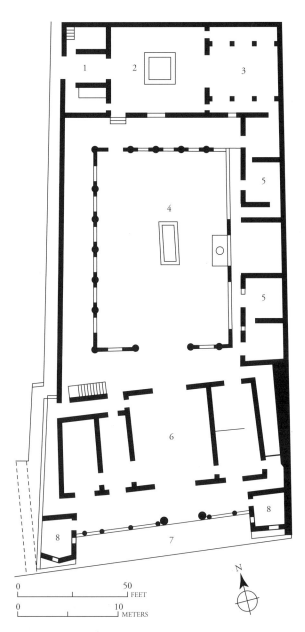

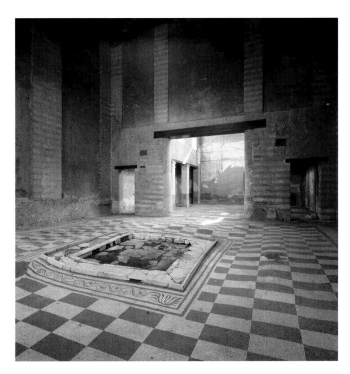

10-4 Atrium and Egyptian oecus, House of the Mosaic Atrium, Herculaneum, ca. 70–79.

garden (Fig. 10-3, no. 4) leading to an unusually spacious summer triclinium (Fig. 10-3, no. 6) opening onto a terrace (Figs. 10-3, no. 7, and **10-5**) with a splendid view of the sea. Such unorthodox bent-axis plans became increasingly common as urban populations grew and all space within the walls

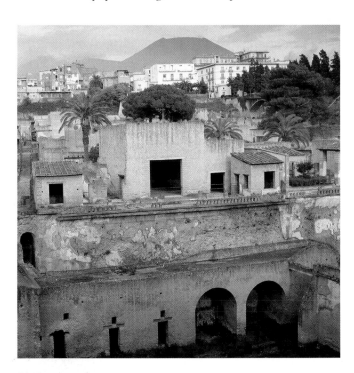

10-5 South terrace, House of the Mosaic Atrium, Herculaneum (with Mount Vesuvius in the background), ca. 70–79.

10-3 Plan of the House of the Mosaic Atrium, Herculaneum, ca. 70–79. 1) fauces, 2) atrium, 3) tablinum (Egyptian oecus), 4) peristyle garden, 5) cubiculum, 6) triclinium, 7) panoramic terrace, 8) sitting room.

tablinum behind it. The tablinum (Figs. 10-3, no. 3, and 10-4, *rear*) was no longer an office at the time of the eruption but a winter triclinium of a rare design that Vitruvius called an *Egyptian oecus,* a banquet hall in the form of a miniature basilica. The Egyptian oecus of the House of the Mosaic Atrium has piers separating the "nave" from the "aisles" and a *clerestory* (second story with windows) to provide direct illumination to the dining area. The banquet hall provided the host with a stately setting with overtones of a law court for entertaining and impressing his friends and clients.

The rest of the house extended at a right angle to the entrance axis, permitting the owner to construct a large peristyle

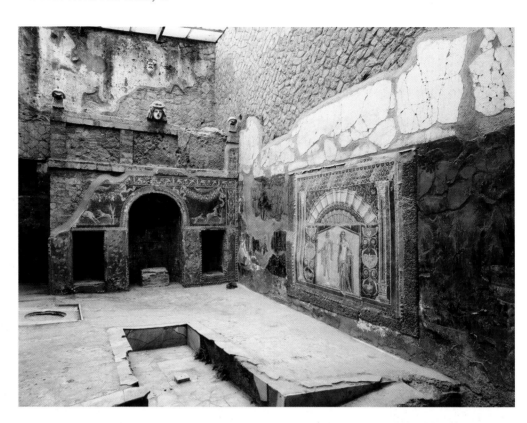

10-6 **Nymphaeum, House of Neptune and Amphitrite, Herculaneum, ca. 62–79.**

had been developed. In fact, the terrace of the House of the Mosaic Atrium was built on top of Herculaneum's Republican fortification wall, which the Pax Romana had rendered superfluous. Flanking the terrace were sitting rooms (*cubicula diurna;* Fig. 10-3, no. 8) where guests could look out onto the Bay of Naples while shielded from the heat of the sun in summer. On a cold winter day, they could still enjoy a walk in the garden because the spaces between the columns were filled in with fenestrated brick walls. Brick would soon become an important building material in Rome and central Italy (see Chapter 14). The use of brick in the latest houses of Herculaneum is evidence of the emerging popularity of that material during the third quarter of the first century.

HOUSE OF NEPTUNE AND AMPHITRITE The owner of the so-called House of Neptune and Amphitrite had at his disposal a much smaller plot of land wedged between two other houses; consequently, he had to dispense with a peristyle entirely. But the architect was able to provide an impressive setting for meals by transforming the triclinium behind the tablinum into a nymphaeum (**Fig. 10-6**) with mosaics of glass tesserae, landscape paintings, and marble theatrical masks on the walls. The main figural panel (**Fig. 10-7**), visible from the fauces through a window in the tablinum, depicts the sea god Neptune and his wife Amphitrite, who fittingly oversaw the waterworks show in the nymphaeum. The figures are based on Classical statues of gods and goddesses. (Compare, for example, Neptune with the statue of Claudius as Jupiter, Fig. 8-10, and Amphitrite with the statue of a Flavian woman in the guise of Venus, Fig. 9-9.)

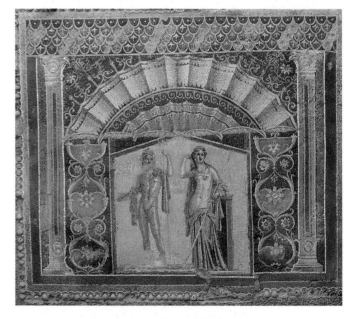

10-7 **Neptune and Amphitrite mosaic, nymphaeum, House of Neptune and Amphitrite, Herculaneum, ca. 62–79.**

HOUSE OF THE LARGE FOUNTAIN Another mosaic fountain (**Fig. 10-8**) was installed in an older house at Pompeii at about the same time. The fountain in the appropriately named House of the Large Fountain has a mosaic-clad niche and basin with decorative bronze and marble sculptures, some of which doubled as water spouts. The fountain is the

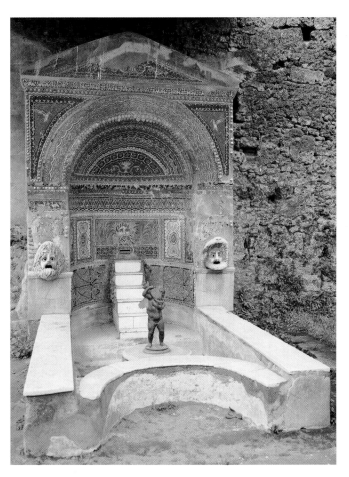

10-8 Fountain, House of the Large Fountain, Pompeii, ca. 70–79.

most ostentatious one in the city, besting even the mosaic-covered fountain in the house next door, the House of the Small Fountain, which was also refurbished after the earthquake of 62. The two fountains may attest to a friendly competition between neighbors, but both houses and the House of Neptune and Amphitrite at Herculaneum document a new trend in domestic architecture during the third quarter of the first century. Wall mosaics were the norm during the Byzantine Empire, but in the ancient world, mosaics were primarily floor coverings (see "Roman Mosaics," Chapter 14, page 207). Even in the Republican House of the Faun at Pompeii, where there were mosaics throughout the house, including the famous Alexander Mosaic (Fig. 3-10), there were no mosaics on any of the walls, only frescoes. During the last years of Pompeii and Herculaneum, mosaics began to appear with increasing frequency on vertical as well as horizontal surfaces.

HOUSE OF D. OCTAVIUS QUARTIO The sound of cascading water and the beauty of mosaics must have been gratifying to the owners of the House of Neptune and Amphitrite at Herculaneum and the Houses of the Large and Small Fountain at Pompeii, but they had to sacrifice some of the precious space available in urban residences of modest size to have these amenities. The fountains may have been the centerpieces of these houses, but they took up only a fraction of the total square footage. In contrast, when D. Octavius Quartio purchased a plot of land near the Pompeii amphitheater extending the entire length of a city block (**Fig. 10-9**), he decided to allocate almost all of the space to a large garden

10-9 Restored view of the House of D. Octavius Quartio, Pompeii, ca. 62–79 (John Burge).

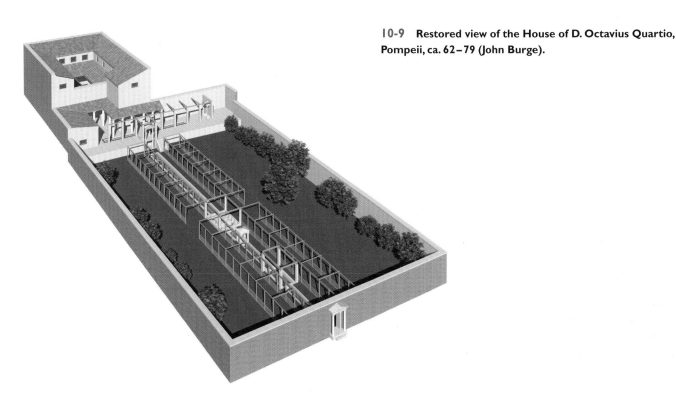

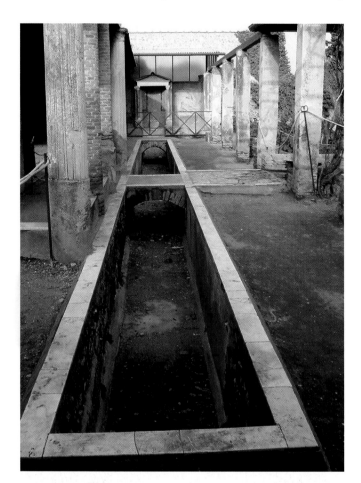

10-10 **Canal in the garden, House of D. Octavius Quartio, Pompeii, ca. 62–79.**

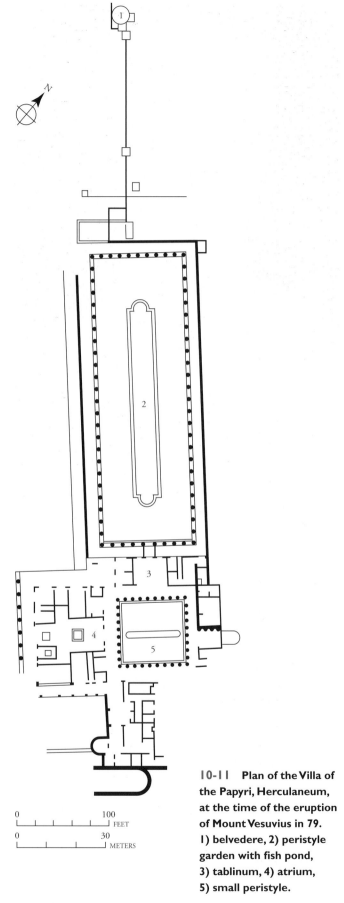

10-11 **Plan of the Villa of the Papyri, Herculaneum, at the time of the eruption of Mount Vesuvius in 79. 1) belvedere, 2) peristyle garden with fish pond, 3) tablinum, 4) atrium, 5) small peristyle.**

(**Fig. 10-10**) filled with fountains and canals, manmade versions of natural streams and waterfalls. In this respect, he was emulating Nero who, having much more land and much more money at his disposal, constructed an artificial lake in his Domus Aurea, but Octavius Quartio's intent was the same—to imitate a suburban villa in the heart of a city.

Octavius Quartio's house was also stocked with dozens of marble sculptures, most displayed in the garden and encompassing a wide range of subjects, from Egyptian themes to Greek muses. There were also mural paintings throughout the domus proper. On the wall at the end of the small canal that runs along the rear wall of the house, a fresco shows the hero Narcissus admiring his reflection in the water (not visible in Fig. 10-10). Visitors would be forgiven for believing Narcissus was in fact gazing into the water beneath the mural, for that was no doubt the owner's wish.

VILLA OF THE PAPYRI Octavius Quartio did not have to look to the Domus Aurea for inspiration in designing his pseudo-villa in the city. All around the Bay of Naples, wealthy Romans had constructed expansive country homes since Republican times. The most extraordinary Campanian villa ever discovered is the so-called Villa of the Papyri (**Fig. 10-11**)

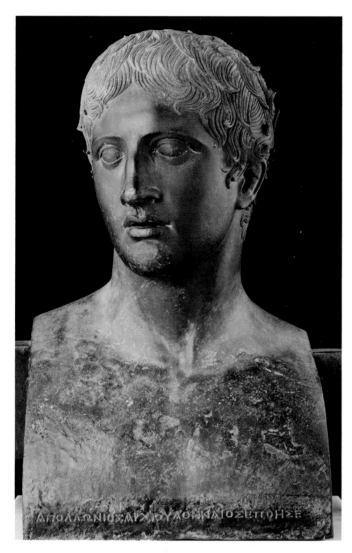

10-12 Apollonios of Athens, first-century CE copy in the form of a herm of the head of the *Doryphoros* (Spear-Bearer) of Polykleitos, ca. 450–440 BCE, from the Villa of the Papyri, Herculaneum. Bronze, 1′ 9¼″ high. Museo Archeologico Nazionale, Naples.

books in Piso's library. At or near the entrance to the villa was a circular *belvedere* (Fig. 10-11, no. 1), a pavilion with a luxurious marble pavement and a fabulous view out over the Bay of Naples. The belvedere marked the beginning of a long promenade overlooking the water, which led to a vast peristyle (Fig. 10-11, no. 2) with a fish pond in the center and then to a tablinum (Fig. 10-11, no. 3) and a second, smaller peristyle (Fig. 10-11, no. 5) with an atrium (Fig. 10-11, no. 4) to one side. The sequence of rooms is typical of villa architecture (compare Fig. 3-14) and the reverse of the canonical layout of an urban domus.

Among the spectacular finds in the Villa of the Papyri was a copy (**Fig. 10-12**) in the form of a *herm* (a bust on a quadrangular pillar) of the head of Polykleitos's *Doryphoros,* found in the small peristyle. The herm bears the name of the sculptor, Apollonios of Athens. The patron and cultured guests who viewed the herm at the villa did not require a label stating that Apollonios was reproducing a work by one of Classical Greece's most renowned artists.

The same courtyard in which the *Doryphoros* herm was found also housed other herms and busts, including a collection of portraits of Greek philosophers displayed between columns. One of the finest portraits is a bronze bust (**Fig. 10-13**) of a bearded man thought by some to be Aristotle, although the identification cannot be confirmed. The gallery of philosophers

at Herculaneum, named for the library of papyrus scrolls found in the villa in the 18th century. The villa still lies beneath more than 65 feet of petrified volcanic matter. Because of the difficulty and risk of excavating it (see "Excavating Herculaneum," page 140), the Villa of the Papyri has never been fully explored, although excavations resumed in the early 1990s. The limited early digging nonetheless yielded scores of bronze and marble sculptures now housed in the National Archaeological Museum in Naples. Copies of many of the statues are in the J. Paul Getty Museum in Malibu, California, which was modeled on the Herculaneum villa.

The original owner of the villa was probably Lucius Calpurnius Piso Caesoninus, the father-in-law of Julius Caesar and the friend and patron of the Epicurean philosopher Philodemus, whose works made up a large percentage of the

10-13 Bust of a philosopher, from the Villa of the Papyri, Herculaneum, mid-first century CE. Bronze, head 10⅝″ high on modern bust. Museo Archeologico Nazionale, Naples.

is not surprising given the collection of philosophical treatises in the villa's library, but the sculptures found in the Villa of the Papyri represented many other subjects, for example, Greek gods and goddesses, drunken satyrs, and a pair of deer. The eclecticism of this ensemble and of that in the House of D. Octavius Quartio was typical of villa decoration and of Roman taste in general.

MURAL PAINTING

Roman aristocrats like Piso took every opportunity to escape from Rome to their villas around the Bay of Naples. The pastoral poetry of Vergil (more famous as the author of the *Aeneid*) and of Horace, another Augustan poet, is filled with expressions of love for the countryside, where life is said to be beautiful, simple, and natural, in contrast to the filth, noise, and narrow streets of the city (see "Life in the City during the High Empire," Chapter 14, page 210). A similar sentiment accounts for the enduring popularity of gardens and landscapes in Roman painting, even though the introduction of the Third Style during the Augustan period represented a repudiation of the illusionistic, wall-dissolving, picture-window approach to mural decoration that was the key ingredient of the Second Style (see Chapter 3).

HOUSE OF THE FRUIT ORCHARD A decade or two before the earthquake rocked Pompeii in 62, the owner of the so-called House of the Fruit Orchard had one of his dining rooms (**Fig. 10-14**) decorated with a gardenscape that is a Third Style version of the murals (Fig. 5-21) in Livia's villa at Primaporta. Unlike Livia's Second Style gardenscape, the walls in the Orchard house are divided into three distinct zones. The lowest is a standard Third Style design (compare Fig. 5-25) with delicate linear ornament painted on a monochromatic background. The second zone, which most closely resembles Livia's paintings, could in fact easily be mistaken for a Second Style mural. A fence opens into a garden beneath a blue sky, but the entrance to the painted world is now set well above the floor, so it is hard to imagine stepping from the room into the garden. More important, the illusionism of the second zone is negated in the third, where trees and shrubs grow out of nowhere and are eerily and artificially illuminated against a black background. The second and third zones are therefore independent motifs painted on the wall and not vistas beyond the wall. This is, of course, precisely the feature that distinguishes the Third Style from the Second.

The Third Style remained in fashion in the Vesuvian cities until about the middle of the century. About a decade before the earthquake of 62, the first Fourth Style designs began to appear on Pompeian walls. Most Fourth Style murals, however, date to the 17-year-period between the earthquake and the volcanic eruption, a time when the Pompeians were busy repairing the damage to their homes and civic buildings.

HOUSE OF THE VETTII One of the houses remodeled and repainted between 62 and 79 was the second-century BCE

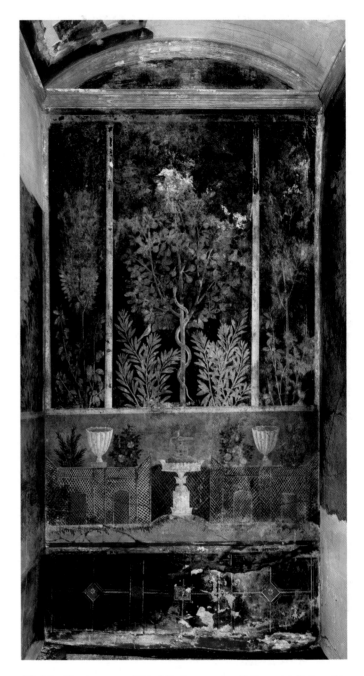

10-14 **Gardenscape, Third Style mural paintings, triclinium 11, House of the Fruit Orchard, Pompeii, ca. 40–50.**

townhouse (Figs. 3-6 and 3-7) that became the residence of the Vettius brothers during the last years of Pompeii's existence. The Pentheus Room (**Fig. 10-15**) represents what most scholars consider to be a later stage of the Fourth Style than room 78 (Fig. 8-25) in Nero's Golden House, although no firm evidence exists to establish a precise chronology for the Fourth Style. The rooms in the House of the Vettii, for example, would not all have been repainted at the same time, but it is not certain whether the most complex designs are, in fact, the latest. The Pentheus Room was a triclinium opening directly onto the peristyle garden and takes its name from the

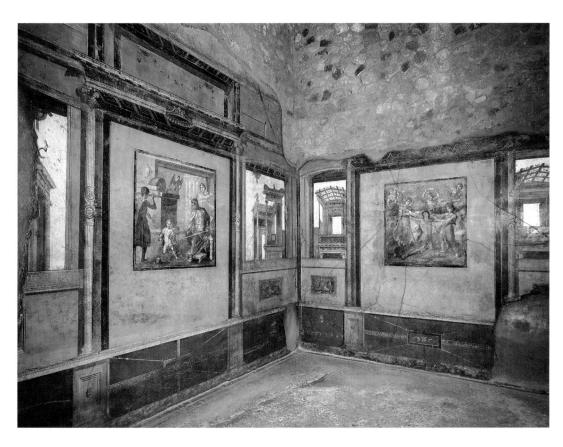

10-15 Fourth Style mural paintings, Pentheus Room (triclinium N), House of the Vettii, Pompeii, ca. 62–79.

mythological panel in the center of its north wall depicting the death of the Greek hero Pentheus. Mythological paintings are the centerpiece of the east and west walls also, representing the infant Hercules strangling serpents and the story of Dirce and the bull, respectively. The heritage of the Third Style is apparent in the design of the lowest zone and in the large expanses of solid orange in the central and upper zones. But to the left and right of each mythological panel, the painter "punctured" the wall to reveal architectural forms beyond it. As in Nero's room 78, the viewer does not look out on complete buildings or believable cityscapes but at fragments of buildings, the product of the painter's fertile imagination. Fragmentary architectural vistas are common motifs on Fourth Style walls.

The Ixion Room (**Fig. 10-16**), a second triclinium facing the peristyle in the same house, also features a mythological panel at the center of each of its three walls, but it is a prime example of the most complex Fourth Style designs at Pompeii, characterized by more crowded and confused compositions and sometimes garish color combinations. The decor of the Ixion Room is a kind of résumé of all the previous styles—another instance of the eclecticism of Roman art. The lowest zone, for example, is one of the most successful imitations anywhere of costly multicolored imported marbles, despite the fact the illusion was created without recourse to relief, as in the First Style (Fig. 3-16). The large white panels in the corners of the room, with

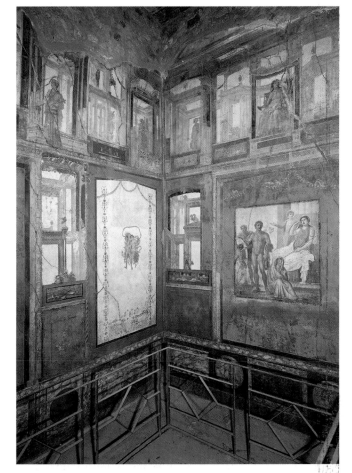

10-16 Fourth Style mural paintings, Ixion Room (triclinium P), House of the Vettii, Pompeii, ca. 62–79.

their delicate floral frames and floating central motifs, would fit naturally into the most elegant Third Style design. Unmistakably Fourth Style, however, are the fragmented architectural views (**Fig. 10-1**) of the central and upper zones of the Ixion Room walls. They are unrelated to one another, do not constitute a unified cityscape beyond the wall, and are peopled with figures that would tumble into the room if they took a single step forward.

The Ixion Room was named after the panel painting at the center of its rear wall. Ixion had attempted to seduce Hera, and Zeus punished him by binding him to a perpetually spinning wheel. The panels on the two side walls also have Greek myths as subjects, as in the Pentheus Room. The two triclinia in the House of the Vettii may be likened to a small private art gallery with paintings decorating the walls, as in many modern homes. Scholars long have believed that these and the many other mythological paintings on Third and Fourth Style walls were based on lost Greek panels. Whether the selection of paintings in each room was dictated by common underlying themes (for example, amorous affairs

between mortals and deities), by the fame of specific Greek paintings, or by a combination of those and other factors is uncertain and no doubt varied from patron to patron.

PERSEUS AND ANDROMEDA Among the Pompeian paintings suggested as a possible copy of a lost Greek masterpiece is the panel (**Fig. 10-17**) from the House of the Dioscuri depicting Perseus freeing Andromeda from the rock to which she is chained. This representation of the myth departs markedly from the depiction of the same story (Fig. 5-26) in the Villa of Agrippa Postumus at Boscotrecase. In the Dioscuri panel, the statuesque figures of Perseus and Andromeda fill almost the entire frame. The posture of Perseus, with bent knee and right foot resting on a boulder, in fact echoes a well-known statuary type of the third quarter of the fourth century BCE. Because Pliny the Elder mentioned a famous painting of the same date by the Greek artist Nikias, many scholars have postulated that the Dioscuri composition is a copy of his painting. By extension, the similar rendition of the Io and Argos myth (Fig. 5-22) in the House of Livia in

10-17 Perseus and Andromeda, mural painting from the House of the Dioscuri, Pompeii, ca. 62–79. Fresco, 4′ high. Museo Archeologico Nazionale, Naples.

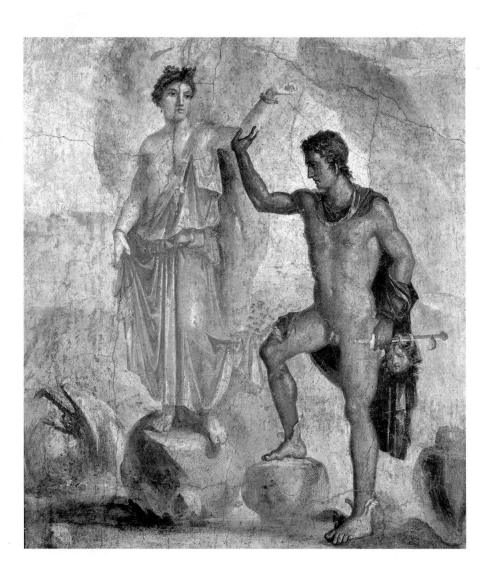

paid scrupulous attention to shadows and highlights as well as to the fruit and the glass jar. The fruit, the stem and leaves, and the carafe were set out on shelves to give the illusion of the casual, almost accidental, relationship of objects in a cupboard. Art historians have not found evidence of anything like these Roman studies of food and other common objects until the Dutch still lifes of the 17th and 18th centuries. The Roman murals are not as exact in drawing, perspective, or rendering of light and shade as the Dutch canvases, but Pompeian painters understood that the appearance of objects is a function of light. The goal was to paint light as an artist would strive to paint the touchable object that reflects and absorbs it.

PRIVATE PORTRAITS Given the Roman custom of keeping *imagines* of illustrious ancestors in atriums, it is not surprising that painted portraits also appear in Pompeian houses. The portrait of a husband and wife illustrated here (**Fig. 10-19**) originally formed part of a Fourth Style wall of an exedra opening onto the atrium of a Pompeian house. The man holds a scroll and the woman a stylus and a wax writing tablet, standard attributes in Roman marriage portraits. These objects suggest the fine education of those depicted—even if, as was sometimes true, the individuals were uneducated or even illiterate. Such portraits were thus the Roman equivalent of modern wedding photographs of the bride and

10-18 **Still life with peaches, detail of a Fourth Style mural painting, from Herculaneum, ca. 62–79. Fresco, approx. 1′ 2″ × 1′ 1½″. Museo Archeologico Nazionale, Naples.**

Rome has led some to attribute that composition to Nikias as well. But several other similar Roman paintings of both myths are known, and none is exactly like any other. Often, for example, the number of figures is different, and in some cases the postures and placement of the protagonists are reversed. The Roman murals may therefore have common Greek prototypes, but none is likely to be a true copy of a Greek painting—even in terms of its composition, and certainly not with regard to the detailed modeling and coloring of the figures. Nonetheless, the mythological paintings on Pompeian walls testify to the Romans' continuing admiration for Greek artworks three centuries after Marcellus brought the treasures of Syracuse to Rome.

STILL-LIFE PAINTING The subjects chosen for Roman wall paintings (and mosaics) were diverse. Although mythological themes were immensely popular, Roman patrons commissioned a vast range of other subjects. As noted, landscape paintings frequently appear on Second, Third, and Fourth Style walls. Paintings and mosaics depicting scenes from history include the *Battle of Issus* mosaic (Fig. 3-10) in the House of the Faun and the mural painting of the brawl in the Pompeii amphitheater (Fig. 2-17). Also very popular were *still life* paintings (depictions of inanimate objects). A still life with peaches and a carafe (**Fig. 10-18**), a detail of a Fourth Style wall from Herculaneum, is typical of this genre of painting in which everyday objects are arranged in artful compositions. To record the appearance of the objects faithfully, the artist

10-19 **Husband and wife, mural painting from house VII, 2, 6, Pompeii, ca. 70–79. Fresco, approx. 1′ 11″ × 1′ 8½″. Museo Archeologico Nazionale, Naples.**

10-20 **Menander, detail of a Fourth Style mural painting, exedra 23, House of the Menander, Pompeii, ca. 62–79.**

groom posing in rented formal garments never worn by them before or afterward. (The satirist Juvenal wryly noted around 120 CE that "there are many parts of Italy . . . in which no man puts on a toga until he is dead.")[1] In contrast, the heads are not standard types but sensitive studies of the individual faces. This is another instance of a realistic portrait placed on a conventional figure type, a recurring phenomenon in Roman portraiture from the Republic (Figs. 4-10 and 4-11) on.

MENANDER Rarely, portraits of historical figures also appear on Pompeian walls. The most famous is the painting (**Fig. 10-20**) on the right wall of an exedra facing the peristyle in the House of the Menander, which was named for this depiction of the seated Greek author. On the open scroll he holds in his left hand is a label identifying Menander as "the first to write New Comedy." Without that inscription, no one could have recognized Menander because his features do not match those of the many known sculptured portraits of him. This therefore is a generic portrait of a learned man, book in

hand (compare Figs. 18-18 and 18-19)—the genuine man of letters that the unknown Roman in Fig. 10-19 was pretending to be. On the opposite wall, poorly preserved, is a second generic portrait of a bearded man with theatrical masks—possibly Euripides but definitely a tragedian as a pendant to the writer of comic plays across from him.

VATICAN VERGIL Not all Roman paintings were on walls or large wooden panels. Books such as the one Menander holds often had painted illustrations, but unfortunately no illustrated books survive from the Early Empire (see "The Roman Illustrated Book," page 151). The oldest preserved painted manuscript, itself very incomplete, is the "Vatican Vergil," which dates from the early fifth century. It originally contained more than 200 pictures illustrating all of Vergil's works. Only 50 painted pages remain. They illustrate passages in Vergil's epic saga, the *Aeneid,* and his pastoral poems, the *Georgics.*

The page reproduced here (**Fig. 10-21**) includes a section of text from the *Georgics* at the top and a framed illustration below. Vergil recounts his visit to a modest farm near Tarentum (Taranto, in southern Italy) belonging to an old man from Corycus in Asia Minor. In the illustration, the old farmer is seated at the left. His rustic farmhouse is in the background, rendered in a three-quarter view (compare Fig. 5-16). The farmer speaks about the pleasures of the simple life in the country and on his methods of gardening. His audience

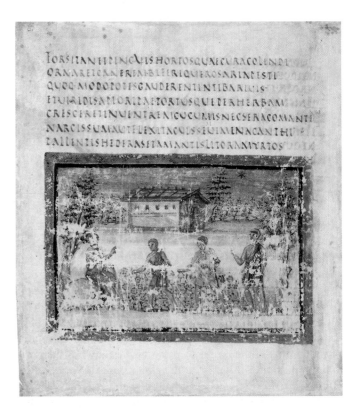

10-21 **The old farmer of Corycus, folio 7 verso of the "Vatican Vergil," ca. 400–420. Tempera on parchment, approx. $1'\frac{1}{2}'' \times 1'$. Biblioteca Apostolica Vaticana, Rome.**

[1] Juvenal, *Satires,* 3.171. Translated by G. G. Ramsay, *Juvenal and Persius* (Cambridge, Mass.: Harvard University Press, 1918), 45.

MATERIALS AND TECHNIQUES

The Roman Illustrated Book

The hundreds of paintings uncovered in the cities Mount Vesuvius buried give the false impression that the history of Roman painting is well documented and that art historians can trace its development decade by decade. But Pompeii, Herculaneum, and the other towns around the Bay of Naples have yielded only frescoes. No Roman paintings on wooden panels have been discovered, save for the special case of Roman Egypt (Figs. 15-16 to 15-19 and 16-4). Nor has anyone found any of the grand tableaus of battles and besieged cities that were exhibited in Roman triumphal processions and then displayed in public buildings to perpetuate the memory of a general's great achievements on the state's behalf (see "The Triumph of Vespasian and Titus," Chapter 9, page 131).

Also lost are virtually all illustrated Roman books (excavation of the Villa of the Papyri at Herculaneum produced none), although art historians know they once existed in great numbers. The manufacture of illustrated books began in Egypt centuries before the founding of Rome, even before Aeneas landed in Italy after fleeing Troy. Egyptian, Greek, Etruscan, and many Roman books took the form of a long scroll (*rotulus*), usually of *papyrus,* a plant native to Egypt that could be made into a paperlike material well suited for ink text and painted illustrations. Some preserved Egyptian scrolls are 70 feet long. The Roman man in Fig. 10-19, the Etruscan magistrate Lars Pulena (Fig. 15-2), the emperor Titus (Fig. 9-5), various Roman philosophers (Fig. 18-18), and even Christ in his role as teacher (Fig. 20-1) all hold rotuli in their hands.

During the Early Empire, however, a new form of book was invented. The *codex* was much like a modern book, composed of separate leaves (*folios*) enclosed within a cover and bound together at one side. The codex gradually displaced the rotulus as the preferred form of book in the ancient world. Much more durable *vellum* (calfskin) and *parchment* (lambskin), which provided better surfaces for painting, also replaced the comparatively brittle papyrus.

Ancient books—in fact, all books before the introduction of the printing press—were handmade and costly to produce. Numerous artisans performed very specialized tasks, beginning with the preparation and cutting (and sometimes the dyeing) of the papyrus or animal skin, followed by the sketching of lines to guide the scribe and to set aside spaces for illustration, the lettering of the text, the addition of paintings, and finally, in the case of the codex, the binding of the pages and attachment of covers, buckles, and clasps. Illustrated books were treasured possessions, very different in kind from contemporary mass-produced disposable books and magazines. ■

is two laborers and, at the far right, Vergil himself in the guise of a farmhand. The style is reminiscent of Pompeian landscapes, with quick touches that suggest space and atmosphere. In fact, the heavy, dark frame has close parallels in Third and Fourth Style mural paintings. Compare, for example, the framed landscapes in room 78 (Fig. 8-25) of Nero's Domus Aurea.

The Vatican Vergil is another reminder of how fragmentary the record of ancient art is and of how likely it is that modern histories of Roman art and architecture such as this one would have to be revised if everything were preserved.

SUMMARY

During the last decades of the life of Pompeii and Herculaneum, much building activity took place, prompted in large part, at least at Pompeii, by the necessity of repairing and repainting both civic and private buildings after the earthquake of 62.

The latest houses were often lavishly embellished. The owner of the House of the Mosaic Atrium at Herculaneum, for example, installed a basilica-like Egyptian oecus in his home and built a terrace over the city walls to gain an unobstructed view of the sea. Other owners added mosaic-clad fountains to their residences. The House of D. Octavius Quartio at Pompeii had a sculpture-filled garden that was larger than the house proper, in imitation of suburban villas such as Herculaneum's Villa of the Papyri, which has produced a treasure trove of bronze and marble sculptures as well as a library of papyrus manuscripts.

Many houses and villas also received new Third and Fourth Style mural paintings, sometimes featuring picture galleries that may have been modeled on lost Greek panel paintings. Landscapes, still lifes, and portraits, as well as fragmentary architectural vistas, were popular subjects.

The enormous diversity in plan and decoration in the houses and villas of Pompeii and Herculaneum is a reflection of the personal taste of their owners and of the intrinsic multifaceted nature of Roman art and architecture.

Trajan, Optimus Princeps

Nerva was elderly and in poor health when the Senate appointed him emperor in 96. Childless and lacking the crucial backing of the praetorian guard, which supported Domitian and demanded the execution of his assassins, Nerva averted a mutiny and another civil war by adopting Trajan in 97 and naming him co-ruler. Trajan was a respected and popular military commander who had put down a revolt against Domitian in 89. Born in Italica, Spain, and governor of Upper Germany at the time of his adoption, Trajan was the first non-Italian to rule Rome (see "The Family of Trajan," page 154). During his two-decade principate, imperial armies brought Roman rule to ever more distant areas, and the imperial government took on ever greater responsibility for its people's welfare by instituting a number of farsighted social programs. Trajan was so popular he was granted the title *Optimus* (the Best), an epithet he shared with Jupiter, who was said to have instructed Nerva to choose Trajan as his successor (see "Pliny the Younger's Panegyric to Trajan," page 155). In late antiquity, Augustus, the founder of the Roman Empire, and Trajan became the yardsticks for success. Whenever the Senate hailed a new emperor, protocol required senators to wish that he be *felicior Augusto, melior Traiano* (even luckier than Augustus, even better than Trajan).

PORTRAITURE

In addition to the title *optimus princeps,* which was regularly stamped on Trajan's coins, the emperor received other epithets in recognition of his many military successes on the frontiers of the Empire, including *Dacicus* (victor over the Dacians, who inhabited the territory roughly corresponding to modern Romania) and *Parthicus* (victor over Rome's old enemy, the Parthians). Like his predecessors, Trajan held several important offices simultaneously and assumed a variety of roles in his portraits, but he was most frequently depicted as imperator.

TRAJAN AS IMPERATOR One of the best portraits of Trajan is a full-length statue (**Fig. 11-2**) from Ostia in which he wears armor and boots and originally held a spear in his raised right hand. The relief decoration of Trajan's cuirass consists of mirror images of a Victory pressing one knee into the back of a bull while she cuts the throat of the animal. The composition originated in fifth-century Athens and conflates two separate motifs: Victory crowning the victor, in this case the emperor, and the emperor slaying a bull in thanksgiving for his military

11-1 Detail of bands 9 to 11 of the spiral frieze of the Column of Trajan (Fig. 11-9), Forum of Trajan, Rome, dedicated 112.

success. The bull-slaying Victory was a fitting choice for cuirasses, but the motif was employed widely in Trajanic art, including architectural friezes. It symbolized the might of the Roman army at a time when Rome ruled virtually all of Europe, the Middle East, and North Africa (**Map 11-1**, page 156).

TRAJAN AS HERO In a bust-length portrait (**Fig. 11-3**) carved around 108 to celebrate his 10th anniversary as emperor, Trajan also wears an officer's *paludamentum* (military cloak) draped over his left shoulder, and he has a sword sheath across his chest, but the emperor is portrayed as he

11-2 **Trajan as imperator, from Ostia, ca. 108–117. Marble, 6′ 4¾″ high. Museo Ostiense, Ostia.**

11-3 **Bust of Trajan, ca. 108. Marble, 1′ 10⅝″ high (without base). Museo Capitolino, Rome.**

Pliny the Younger's Panegyric to Trajan

A tradition going back to Augustus dictated that one of the consuls deliver a *panegyric* (speech of thanks and praise) to each new emperor on behalf of the Senate. Pliny the Younger was called upon to give the panegyric to Trajan in 100. Although Pliny claimed that his lengthy speech was "no more than a faithful record of the truth" (56.2), the Trajanic panegyric provides invaluable insights regarding the excessive flattery the Roman emperors received (and expected), even an emperor like Trajan, known for his modesty and moderation, especially in contrast to Domitian (see Chapter 9).

Some excerpts:

[We should not flatter Trajan] as a divinity and a god; we are talking of a fellow-citizen, not a tyrant, one who is our father not our over-lord (2.3).

Our emperor . . . was divinely chosen for his task . . . [by] Jupiter himself . . . Nerva was no more than [Jupiter's] minister, no less obedient as adopter than you who were adopted (1.5; 8.2).

In adopting you, [Nerva] gave you his own name, to which the Senate added that of *Optimus* . . . [Jupiter] is worshipped under the title *Optimus* followed by *Maximus* . . . [In] the eyes of all [you] are equally Highest and Best (88.5, 88.8).

[Jupiter is now] free to devote himself to heaven's concerns, since he has given you to us to fill his role with regard to the entire human race (80.5).* ■

*All passages translated by Betty Radice, *Pliny: Letters and Panegyricus,* vol. 2 (Cambridge, Mass.: Harvard University Press, 1975), 323, 325, 341, 451, 511, 531.

never would have appeared in life—heroically nude. Full-length nude portraits of Trajan are also preserved. The bust portrait, however, permits a closer look at the emperor's face. Trajan was 45 when he succeeded Nerva, and his portraits always showed him as a man in his 40s, even those made shortly before his death at age 64. Augustus posed as a never-aging youth because his portraits began to appear in public—in the round and on coins—when he was 30. Trajan's official portraiture did not begin until he was 15 years older, but he too froze his age at the moment he walked onto the world stage. Although there are several variant portrait types, Trajan's hair is always combed straight forward over his forehead, and the only lines in his face are around his mouth.

PLOTINA The portraits of Plotina (**Fig. 11-4**) were conceived as pendant images to those of her husband. She too was depicted as a mature woman, and she also did not age in her portraits. In his panegyric to the emperor, Pliny described Plotina as the perfect model of the ancient virtues and modest in her attire as well as the number of her attendants.[1] Her coiffure is appropriately much less ornate than those popular under Domitian (Figs. 9-7 to 9-9). An arc of short comma-shaped locks of hair frames her forehead. Above, the hair fans out like a crown and is pulled into a knot at the back. Because Plotina and Trajan were deified, posthumous portraits of both the emperor and empress were widely distributed. Those that survive differ from the lifetime portraits in style and technique, but not in their essential character.

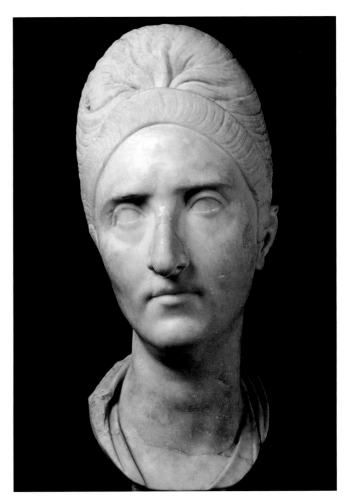

11-4 **Head of Plotina, ca. 112. Marble, 2′ 3″ high. Museo Capitolino, Rome.**

[1]Pliny the Younger, *Panegyricus,* 83.5–8.

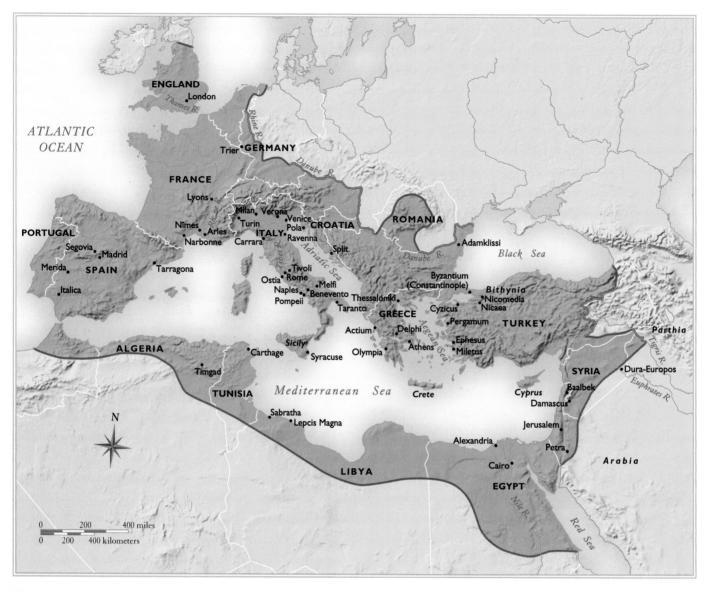

Map 11-1 **The Roman Empire at the death of Trajan.**

ARCHITECTURE AND RELIEF SCULPTURE

Trajan was a builder on a vast scale, in the provinces as well as in the capital. In North Africa, for example, he founded the colony of Thamugadi (Timgad, Algeria), whose textbook city plan (Fig. 2-3) was discussed in Chapter 2. At the opposite end of the Empire, Trajan constructed a giant trophy at Adamklissi, Romania, to mark his victory over the Dacians. His most famous buildings, however, were in Rome itself.

FORUM OF TRAJAN Of all Trajan's architectural projects in the capital, the grandest was his new forum (**Figs. 11-5**, no. 5, and **11-6**), roughly twice the size of the forum (Fig. 11-5, no. 2) Augustus built a century before—even excluding the enormous market complex (Fig. 11-5, no. 6) next to the Trajanic forum. The Forum of Trajan glorified the emperor's success in two wars

against the Dacians and was paid for with the spoils of those campaigns. The architect was Apollodorus of Damascus, Trajan's chief military engineer during the Dacian Wars, who had constructed a world-famous bridge across the Danube River. Apollodorus's plan emulated that of the Forum Augustum (Fig. 5-8) with its large semicircular exedras opening onto the forum porticos, but in the Trajanic forum a grandiose basilica—the Basilica Ulpia (Ulpius was Trajan's family name)—not a temple, dominated the open square. The temple (completed after the emperor's death and dedicated to the newest god in the Roman pantheon, Trajan himself) was set instead behind the basilica. It stood at the rear of the forum in its own courtyard, with two libraries and a giant commemorative column, the Column of Trajan (Fig. 11-9). Scholars still debate whether the temple was part of the original forum plan and, if so, to whom it was dedicated, because Trajan—in contrast to Domitian, the self-proclaimed

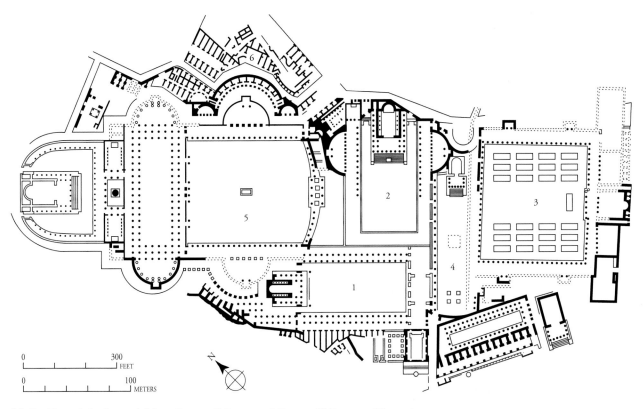

11-5 Plan of the imperial fora, Rome. 1) Forum of Caesar, 2) Forum of Augustus,
3) Templum Pacis, 4) Forum Transitorium, 5) Forum of Trajan, 6) Markets of Trajan.

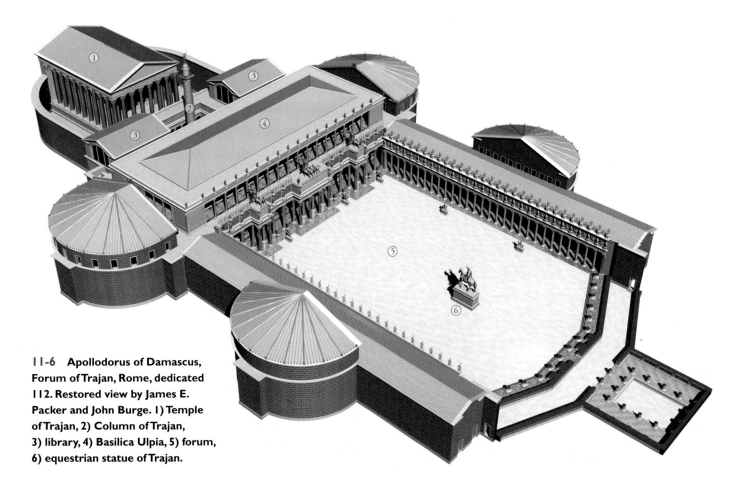

11-6 Apollodorus of Damascus,
Forum of Trajan, Rome, dedicated
112. Restored view by James E.
Packer and John Burge. 1) Temple
of Trajan, 2) Column of Trajan,
3) library, 4) Basilica Ulpia, 5) forum,
6) equestrian statue of Trajan.

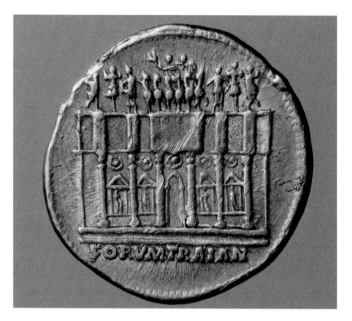

11-7 Apollodorus of Damascus, gateway to the Forum of Trajan, Rome, dedicated 112, represented on the reverse of an aureus of Trajan, 112. Gold, approx. $\frac{3}{4}''$ diameter. Museo Nazionale Romano, Rome.

dominus et deus (see Chapter 9)—would not have erected a temple for his own worship in Rome during his lifetime (see "The Imperial Cult," Chapter 7, page 97).

Entry to Trajan's forum was through an impressive gateway that the emperor commemorated on his coins (**Fig. 11-7**; see "Buildings on Coins," page 160). The gate resembled a triumphal arch, complete with an attic statuary group of Trajan driving a six-horse chariot flanked by statues of Dacians chained to trophies. As on the Arch of Titus (Fig. 9-16), Victory rode in the chariot with the emperor and placed a crown on his head. Inside the forum were other reminders of Trajan's Dacian triumph. Statues of captive Dacians (some of which were reused two centuries later on the Arch of Constantine, Fig. 20-8) stood above the columns of the forum porticos, just as caryatids adorned the comparable area of the Augustan forum. A larger-than-life-size gilded-bronze equestrian statue (Fig. 11-6, no. 6) of the emperor stood at the center of the great court in front of the basilica. The portrait, like the entrance gate, is lost, but it also was reproduced on Trajanic coins. The statue depicted Trajan trampling a helpless Dacian foe. The portrait must have resembled the bronze statue (Fig. 9-25) of Domitian/Nerva on horseback from Miseno. When the emperor Constantius visited Rome in 357, he was awestruck by the Forum of Trajan and, according to the historian Ammianus Marcellinus, commissioned a replica of Trajan's equestrian portrait, although he despaired of ever being able to construct "the stable" in which the horse roamed.[2]

BASILICA ULPIA The Basilica Ulpia (Figs. 11-6, no. 4, and 11-8) was said to be one of the most beautiful buildings in the Roman world, owing to the extensive use of white and colored marbles. The Trajanic basilica was a much larger and far more ornate version of the basilica in the forum of Pompeii (Figs. 2-9 and 2-10). Two aisles flanked the nave on each side, and there was an apse at each end of the building. In contrast to the Pompeian basilica, the entrances were on the

[2]Ammianus Marcellinus, *History of Rome,* 16.10.16

11-8 Apollodorus of Damascus, interior of the Basilica Ulpia, Forum of Trajan, Rome, dedicated 112. Restored view by James E. Packer and Gilbert Gorski.

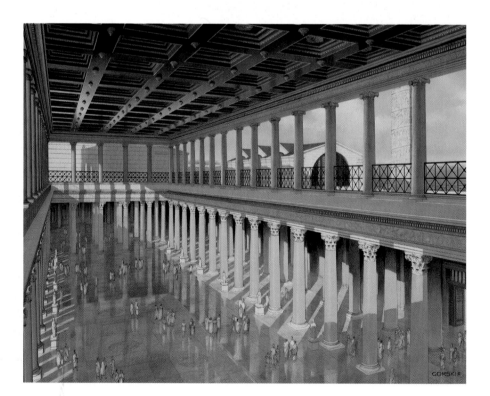

long side facing the forum. The building was vast: about 400 feet long (without the apses) and 200 feet wide. Light entered through a clerestory, made possible by elevating the timber-roofed nave above the aisles, as in the Egyptian oecus of the House of the Mosaic Atrium at Herculaneum (Fig. 10-4). In the Republican basilica at Pompeii, light reached the nave only indirectly through aisle windows. The clerestory (used millennia before in the columnar halls of Egyptian temples) was a much better solution and would have made easily visible the sculptured interior frieze of the basilica featuring bull-slaying Victories.

COLUMN OF TRAJAN The Column of Trajan (**Fig. 11-9**) was probably also the brainchild of Apollodorus of Damascus. The idea of covering the shaft of a colossal freestanding column with a continuous spiral narrative frieze seems to have been invented here, but it was often copied in antiquity, the Middle Ages, and later. In the early 19th century, a column inspired by the Column of Trajan was erected in the Place Vendôme in Paris in commemoration of the victories of Napoleon.

Trajan's Column is 128 feet high. Coins indicate that it was once topped by a heroically nude statue of the emperor. Trajan's portrait was lost in the Middle Ages, and in 1588 a statue of Saint Peter replaced it. The square pedestal (**Fig. 11-10**), decorated with captured Dacian arms and armor, served as Trajan's tomb. His ashes and those of Plotina were placed inside it in golden urns.

The 625-foot relief frieze that winds around the column has been likened to an illustrated scroll of the type housed in the neighboring libraries (see "The Roman Illustrated Book," Chapter 10, page 151). The reliefs depict Trajan's two successful campaigns against the Dacians. The story is told in more

11-9 Column of Trajan, Forum of Trajan, Rome, dedicated 112.

11-10 Pedestal of the Column of Trajan, Forum of Trajan, Rome, dedicated 112.

ARCHITECTURAL BASICS

Buildings on Coins

The Forum of Trajan was the largest and most lavish of all the imperial fora, and Trajan celebrated the great building project with a series of coins illustrating its main features. One reverse type pictured the forum's entrance gate (Fig. 11-7), another the emperor's over-life-size equestrian statue in the center of the forum proper, a third the facade of the Basilica Ulpia, and a fourth the Column of Trajan. A fifth series had reverses reproducing an *octastyle* (eight-column-facade) temple in a portico. The basilica and gateway coins are clearly labeled, but the temple coins are not, and it therefore is not certain if the temple is the one at the rear of Trajan's forum or another building project. If it is the forum temple, that would settle the question of whether Apollodorus included a temple in his original plan for the complex or whether the temple was an addition by Hadrian, Trajan's successor. Excavation may one day provide the answer.

The representations of buildings on Roman coins are invaluable for architectural historians, especially when the structures illustrated are lost, as is Nero's triumphal arch (Fig. 8-22) on the Capitoline Hill. The numismatic evidence must be weighed with care, however, because the coin engravers sometimes intentionally altered details of the buildings for the sake of clarity. Often, for example, the artists widened the space between the two central columns of a temple's facade in order to provide a view of the deity's statue within the cella. Or, as in the case of the denarius (Fig. 5-6) reproducing Augustus's Parthian arch in the Forum Romanum, the coin designer exaggerated the size of the statues above the three passageways so that they could be readily identified. Nonetheless, in other cases, like the Neronian arch (Fig. 8-22) and the Trajanic gateway (Fig. 11-7), the artists appear to have faithfully recorded the buildings, in the former instance even representing the arch in a three-quarter view to reveal the statue of Mars in a niche on the side of the structure. The numismatic evidence takes on additional importance in instances when the coins are the *only* record that the buildings existed. ■

than 150 episodes in which some 2,500 figures appear. As the band winds around 23 times to the top of the column, it increases in width in order to make the upper portions easier to read. Throughout, the relief is very low so as not to distort the contours of the shaft. In antiquity, paint enhanced the legibility of the frieze, but it still would have been very difficult for viewers to follow the narrative from beginning to end from any position on the ground. Many details would have been more clearly discerned from the balconies of the flanking libraries or the steps of the deified Trajan's temple, but only one side of the column would have been visible at a time.

Scholars have long debated the origin of this first-ever spiral narrative frieze, but Apollodorus most likely drew on diverse pictorial traditions, including (in addition to illustrated scrolls) stone relief sculpture and the painted panels depicting military campaigns that were regularly carried in triumphal processions. In his description of the triumph following the conclusion of the Jewish War in 70 (see "The Triumph of Vespasian and Titus," Chapter 9, page 131), Josephus listed the subjects of the Flavian paintings:

> Here was to be seen a prosperous country devastated, there whole battalions of the enemy slaughtered; here a party in flight, there others led into captivity; walls of surpassing compass demolished by engines, strong fortresses overpowered, cities with well-manned defences completely mastered and an army pouring within the ramparts, an area all deluged with blood, the hands of those incapable of resistance raised in

supplication, temples set on fire, houses pulled down over their owners' heads.[3]

Josephus's description could also apply to the scenes (**Figs. 11-1 and 11-11 to 11-13**) on the Column of Trajan. In band 11 (Fig. 11-1, *top left;* the bands are numbered from bottom to top), a group of Roman soldiers storms a Dacian fortress with their shields raised and joined to form a turtle-shell umbrella to protect them. To the right, the battle won, Trajan, flanked by two lieutenants, views the severed Dacian heads that his soldiers have brought to him as evidence of the successful completion of their mission. Farther to the right, another battle begins. In another scene (Fig. 11-11, *top*) remarkable for its frankness, Roman soldiers are depicted caring for their wounded—an admission that although the Romans defeated the enemy, the Dacians waged a fierce battle. The heroism of the Dacians is epitomized near the top of the column in the scene (Fig. 11-13) in which Decebalus, the Dacian king, is shown taking his own life to avoid capture by the Romans and the inevitable humiliation of being paraded down the Via Sacra in chains in Trajan's triumph.

All is not battle and gore, however, in the spiral frieze. In fact, most of the narrative is devoted to scenes of preparation

[3]Josephus, *Jewish War,* 7.142–144. Translated by H. St.J. Thackeray, *Josephus,* vol. 3 (Cambridge, Mass.: Harvard University Press, 1928), 547.

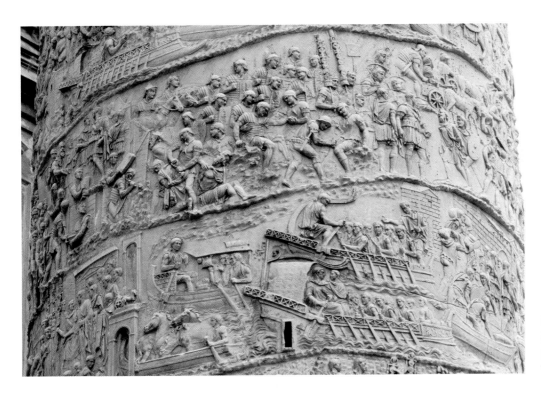

11-11 Detail of bands 5 and 6 of the spiral frieze of the Column of Trajan, Forum of Trajan, Rome, dedicated 112.

for battle, the construction of forts (Fig. 11-1, *center*) and roads, the transportation of men and supplies on land and water (Figs. 11-1, *bottom,* and 11-12, *top*), and generic scenes of Trajan addressing his troops (Fig. 11-12, *bottom*), receiving suppliant Dacians (Fig. 11-1, *bottom,* and 11-11, *top*), and sacrificing to the gods. Although the inclusion of topographical details, such as amphitheaters, bridges, and triumphal arches complete with their attic statuary (Fig. 11-12, *top left*), gives

the impression of a documentary film, the frieze of the Column of Trajan is not a reliable chronological account of the Dacian Wars, as was once thought, but a stringing together of the same kinds of readily recognizable compositions found on coin reverses and stone reliefs and in triumphal paintings.

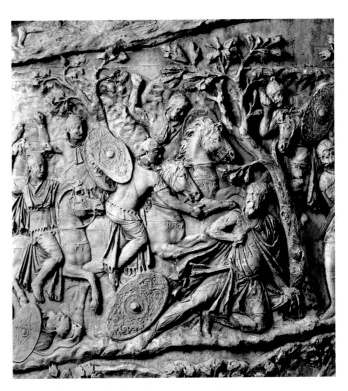

11-12 Detail of bands 4 and 5 of the spiral frieze of the Column of Trajan, Forum of Trajan, Rome, dedicated 112.

11-13 Suicide of Decebalus, detail of the spiral frieze of the Column of Trajan, Forum of Trajan, Rome, dedicated 112.

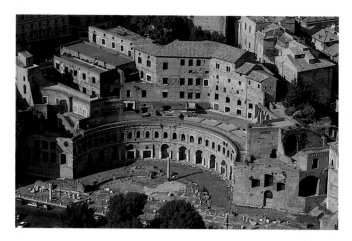

11-14 **Apollodorus of Damascus, aerial view of the Markets of Trajan, Quirinal Hill, Rome, ca. 100–112.**

11-15 **Apollodorus of Damascus, Via Biberatica, Markets of Trajan, Quirinal Hill, Rome, ca. 100–112.**

From every vantage point, Trajan could be seen directing the operation. His involvement in every aspect of the Dacian campaigns was one of the central messages of the Column of Trajan—and it comes through clearly despite the problem of the legibility of the details of the spiral frieze seen from the ground.

MARKETS OF TRAJAN On the Quirinal Hill overlooking the forum, Apollodorus built the Markets of Trajan (Figs. 1-2, no. 13, and **11-14**) to house both shops and administrative offices. The transformation of a natural slope into a multilevel complex was possible here, as earlier at Palestrina (Figs. 1-19 and 1-20), only by using concrete. Trajan's architect was a master of this modern medium as well as of the conservative stone-and-timber post-and-lintel architecture of the forum below.

The basic unit was the traditional single-room taberna with a concrete barrel vault. Each taberna had a wide doorway, usually with a window above it that allowed light to enter a wooden inner attic used for storage. The shops were on several levels. They opened either onto a hemispherical facade winding around one of the great exedras of Trajan's forum, onto a paved street farther up the hill, or onto a great indoor market hall at an even higher level. Walking along what is today called the Via Biberatica (**Fig. 11-15**) above the hemicycle facade is perhaps the only way now to get a sense of walking through the streets of Rome during the High Empire. The "look" of second-century Rome is, however, approximated at the port city of Ostia (see Chapter 14, especially Figs. 14-8 and 14-9).

The hemicycle facade is of special interest because it is an early example of the use of exposed brick, which was beginning to be appreciated as an attractive building material in its own right and not just as a cost-effective way to build walls that would then be concealed by stucco painted to imitate marble. In Trajan's markets, brick was also used for applied

architectural orders, as in the pilasters and pediments that frame the arcuated openings on the second story of the hemicycle facade. The pediments took three forms: triangular, *segmental* (rounded), and *broken* (that is, half-pediments). The varied shapes, arranged in groups of four to form a pleasing decorative pattern, have no structural function whatsoever. This is another example of the Roman use of the Greek architectural vocabulary while ignoring the rules of Classical architectural design.

The indoor market hall (at the upper left in Fig. 11-14) resembled a modern shopping mall. The hall housed two floors of shops, with the upper shops set back on each side and lit by skylights (**Figs. 11-16** and **11-17**). Light from the same sources reached the ground-floor shops through arches beneath the great umbrellalike *groin vaults* covering the hall (see "The Groin Vault," page 164). Groin vaults had been used earlier in the Domus Aurea, the uppermost story of the Colosseum, and the Baths of Titus, but never before had they been constructed with such sophistication. Groin vaulting transformed the character of Roman interiors by admitting natural light to rooms and halls that were formerly lit only by lamps and torches, as in the Republican market hall at Ferentino (Fig. 1-16).

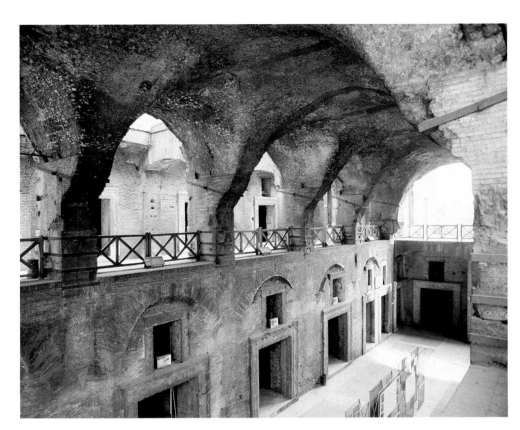

11-16 Apollodorus of Damascus, interior of the great hall, Markets of Trajan, Quirinal Hill, Rome, ca. 100–112.

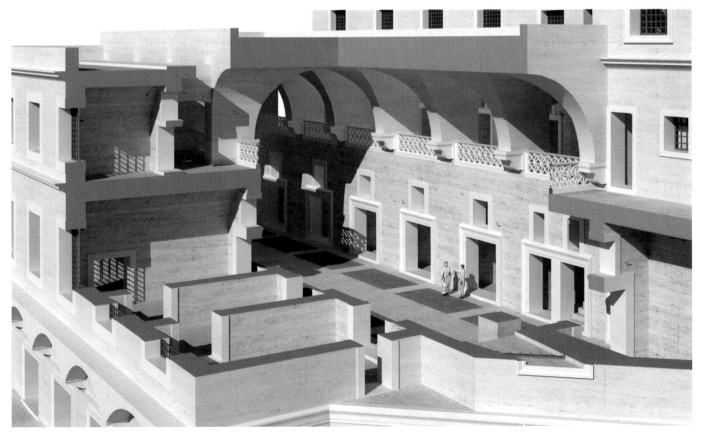

11-17 Apollodorus of Damascus, axonometric view of the great hall, Markets of Trajan, Quirinal Hill, Rome, ca. 100–112 (John Burge).

The Groin Vault

Groin, or *cross,* vaults are formed by the intersection at right angles of two barrel vaults (see "Arches, Barrel Vaults, and Concrete," Chapter 1, page 12) of equal size. Besides appearing lighter than the barrel vault, the groin vault needs less *buttressing.* The barrel vault's *thrust* is concentrated along the entire length of the supporting wall. The groin vault's thrust, however, is concentrated along the groins, and buttressing is needed only at the points where the groins meet the vault's vertical supports. The system leaves the covered area open, permitting light to enter. Groin vaults, like barrel vaults, can be built with stone blocks—

but with the same structural limitations when compared to concrete vaulting.

When a series of groin vaults covers an interior hall, as in the drawing below and in Figs. 11-16, 11-17, 16-22, 19-12, and 20-13, the open lateral arches of the vaults form the equivalent of a clerestory of a traditional timber-roofed structure (for example, Figs. 11-8 and 20-16c). Such a *fenestrated* (with openings or windows) sequence of groin vaults has a major advantage over wooden clerestories. Concrete vaults are relatively fireproof, always an important consideration given that fires were common occurrences in the ancient world. ∎

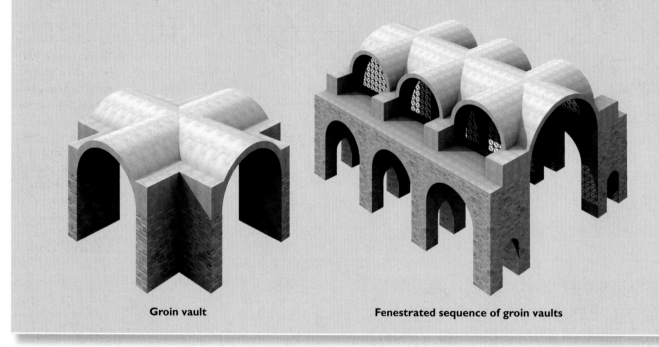

Groin vault **Fenestrated sequence of groin vaults**

BATHS OF TRAJAN Apollodorus also used concrete groin vaults in the new bath complex (Figs. 1-2, no. 25, and **11-18,** no. 1) that he built for Trajan on the grounds of Nero's Golden House. Almost three decades earlier, Titus had built his own thermae (Figs. 1-2, no. 24, and 11-18, no. 2) right next to the Neronian palace (Fig. 11-18, no. 3). At that time, the Domus Aurea may still have been the official imperial residence, because Domitian had not yet built his palace (Fig. 9-17) on the Palatine Hill. By the time Trajan became emperor, the Golden House had long been abandoned, and Trajan buried the building beneath the terrace of his new baths, thereby completing the eradication of Nero's villa that Vespasian had begun.

The Baths of Trajan dwarfed the earlier imperial thermae of Nero and Titus in size, but followed the same general plan, with the bathing rooms proper (frigidarium, tepidarium, caldarium; see "An Afternoon at the Baths," Chapter 2,

page 24) and the swimming pool (natatio) on the central axis and twin exercise yards (palaestrae) to either side. Innovative was the development of the precinct itself to include gardens, lecture halls, and other rooms for social interaction. These amenities would become the norm for imperial bathing complexes from this time forward.

ARCH OF TRAJAN, BENEVENTO The same year the Baths of Trajan were dedicated in Rome, Trajan opened a new road, the Via Traiana, in southern Italy. Several years later a great arch (**Fig. 11-19**) honoring Trajan was built at the point where the road entered Benevento (ancient Beneventum). Architecturally, the Arch of Trajan at Benevento is almost identical to Titus's arch (Fig. 9-13) on the Via Sacra in Rome, but relief panels (separated by bull-slaying Victories) cover both facades of the Trajanic arch, giving it a billboardlike appearance similar

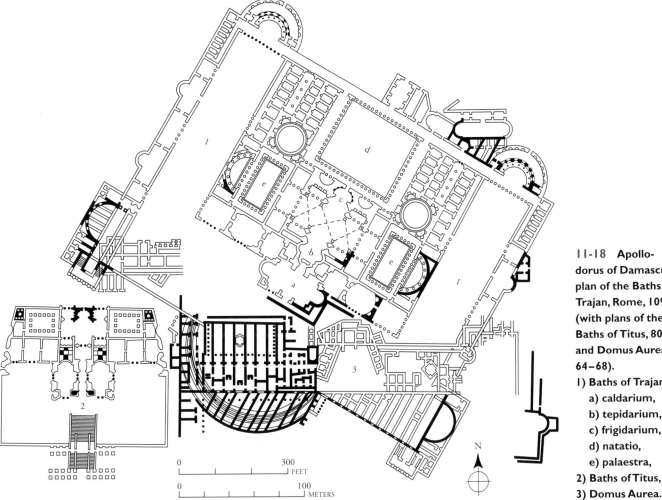

11-18 Apollodorus of Damascus, plan of the Baths of Trajan, Rome, 109 (with plans of the Baths of Titus, 80, and Domus Aurea, 64–68).

1) Baths of Trajan
 a) caldarium,
 b) tepidarium,
 c) frigidarium,
 d) natatio,
 e) palaestra,
2) Baths of Titus,
3) Domus Aurea.

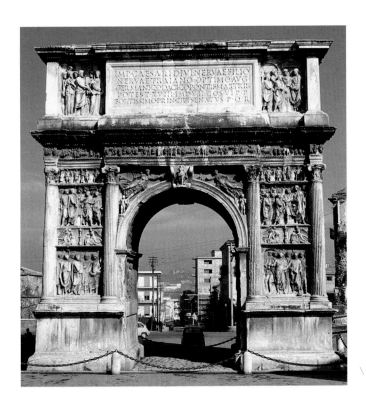

to the earlier Arch of Nero (Fig. 8-22). Indeed, this was no triumphal arch but rather a vehicle for advertising Trajan's achievements in every arena. Although Trajan is shown entering Rome after a successful military campaign and is pictured with a kneeling personification of a newly conquered province, he is also presented as the builder of a new port at Ostia, as pontifex maximus offering a solemn sacrifice, as the distributor of money to needy citizens, and more. The reliefs portray Trajan as the guarantor of peace and security in the Roman Empire, the patron of soldiers and merchants alike, and the benefactor of the poor. In short, the emperor is all things to all people. The arch at Benevento, or perhaps one like it in the capital, set the pattern for many later imperial arches.

The reliefs in the spandrels of the Benevento arch are expanded versions of those on the Arch of Titus (Fig. 9-13). On the facade facing the city (Fig. 11-19), Victories fill the spandrels, but on the country facade there are reclining river gods instead. On each facade there are also two *putti* (cupid-like cherubic young boys), variously dressed or undressed and with different attributes. They are personifications of the four seasons. The spandrels of Titus's arch celebrated the Judaean

11-19 **City facade of the Arch of Trajan, Benevento, ca. 114–118.**

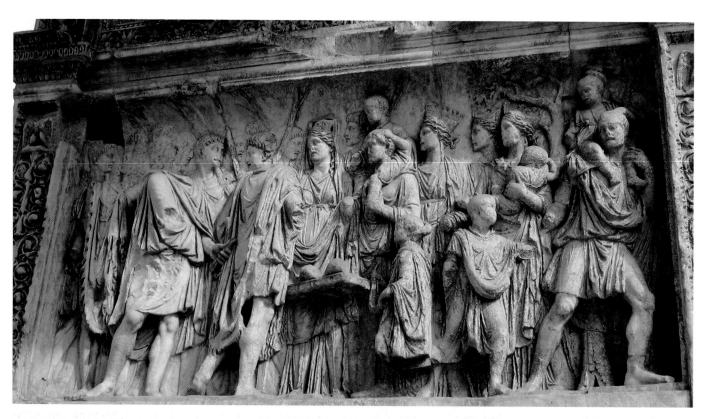

11-20 **Alimentary program of Trajan, passageway relief, Arch of Trajan, Benevento, ca. 114–118. Marble, 7′ 10″ high.**

victory (and perhaps also the emperor's victory over death), but the Trajanic spandrels delivered a more general message: Rome is victorious in every corner of the world and at every season of the year.

Three reliefs decorate the passageway of the Benevento arch, following the model of the Arch of Titus (Fig. 9-14). In the vault, Victory crowns Trajan. The two horizontal panels represent the sacrifice at the inauguration of the Via Traiana and Trajan's innovative alimentary program (**Fig. 11-20**), in which the state lent money in the form of mortgages on land and allocated the interest collected from those loans to feeding the poor children of Italy. On the Arch of Trajan, the emperor is depicted distributing funds to the children in the presence of female personifications of Italian cities wearing turreted crowns. One father carries his son on his shoulders—a common occurrence on these occasions according to Pliny the Younger.[4] The representation is remarkable for being the first known instance of the representation of the lower classes on an official Roman monument.

The attic reliefs of the Benevento arch present a problem for the precise dating of the monument. Those on the city facade

constitute a pair (**Figs. 11-21** and **11-22**) in which Trajan is shown arriving at the gate to Rome at the right while Jupiter and other deities await his entrance at the left. Jupiter extends his thunderbolt to the emperor, entrusting him with power over the earth so that the king of gods can concern himself with the heavens, exactly as Pliny described in his panegyric (see "Pliny the Younger's Panegyric to Trajan," page 155). In the adventus relief at the right and in one of the reliefs on the country attic as well, a bearded man is present who never appears in any other Trajanic relief or on any Trajanic coin. He is Hadrian (compare Fig. 12-2), whom Trajan did not formally adopt until the day he died (if ever; see Chapter 12). Most scholars therefore believe that the arch was begun, not completed, in 114, the date given in the dedicatory inscription, and that the attic reliefs must have been inserted when Hadrian became emperor. The new ruler took advantage of the incomplete state of the Benevento arch to write himself retrospectively into the pictorial record of Trajan's principate.

GREAT TRAJANIC FRIEZE The most problematic reliefs depicting Trajan are the surviving slabs of what once would have been a 10-foot-tall and 100-foot-long sculptured frieze known, because of its huge dimensions, as the Great Trajanic Frieze (**Fig. 11-23**). Several of the slabs were reused in the early fourth century on the Arch of Constantine (Fig. 20-7),

[4]Pliny the Younger, *Panegyricus*, 26.1.

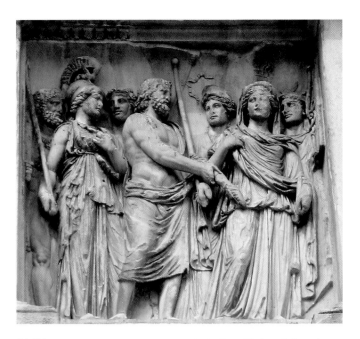

11-21 Jupiter extending his thunderbolt to Trajan, left attic relief, city facade, Arch of Trajan, Benevento, ca. 114–118. Marble, 8′ 10″ high.

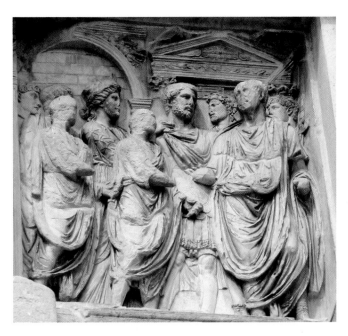

11-22 Trajan entering Rome, right attic relief, city facade, Arch of Trajan, Benevento, ca. 114–118. Marble, 8′ 10″ high.

11-23 Trajan battling Dacians, section of the Great Trajanic Frieze, ca. 117–120, reused as Liberator Urbis panel in the central passageway of the Arch of Constantine, Rome, 312–315. Marble, 9′ 10″ high.

11-24 Victory crowning Trajan, section of the Great Trajanic Frieze, ca. 117–120, reused as Fundator Quietis panel in the central passageway of the Arch of Constantine, Rome, 312–315. Marble, 9′ 10″ high.

but their original provenance is unknown. Some evidence, however, suggests that the frieze was part of the decoration of the Forum of Trajan. One suggestion that has won a good deal of support is that the Great Trajanic Frieze adorned the unexcavated Temple of Divus Traianus, in which case the reliefs would be early Hadrianic in date—but Hadrian does not appear in any of the preserved sections.

The subject of the Great Trajanic Frieze is the same as that of the spiral frieze of Trajan's Column—the Dacian Wars—but the style and composition are very different, even though some of the motifs reprise ones used elsewhere in the Forum of Trajan, for example, Trajan trampling a Dacian (Fig. 11-23), as in his colossal equestrian statue. The figures on the Great Trajanic Frieze are in very high relief, and Trajan takes part in the fighting himself, whereas on the Column of Trajan, the emperor directs the military campaign but does not participate in the battles. Moreover, the action in the Great Trajanic Frieze moves in opposite directions. In **Fig. 11-24**, for example, Trajan is shown stepping from right to left as Victory places a wreath on his head, but immediately to the right the Roman cavalry is

pursuing Dacians from left to right. These discrepancies in style and composition between the Column of Trajan and the Great Trajanic Frieze cannot be explained by a Hadrianic dating of the latter, because there are no comparable compositions in Hadrianic art either (see Chapter 12). As puzzling as these reliefs are, different styles appearing at the same date in Roman art—even in the same building project—should surprise no one.

CIRCUS MAXIMUS One of Trajan's many benefactions to the Roman people was the restoration of the Circus Maximus (Fig. 1-2, no. 5), where the world's best horse teams competed in chariot races. A relief (**Fig. 11-25**) that once decorated a circus official's tomb gives a partial view of the refurbished racecourse. The style of the relief differs sharply from those of the Column of Trajan, the Great Trajanic Frieze, and the Arch of Trajan at Benevento, underscoring again the stylistic diversity of Roman art, especially when, as is the case here, the patrons came from Rome's huge working population instead of from the ruling class.

11-25 Funerary relief of a circus official, from Ostia, ca. 110–130. Marble, approx. 1′ 8″ high. Musei Vaticani, Rome.

The relief shows the Circus Maximus in distorted perspective. Only one team of horses races around the central island, but the charioteer is shown twice, once driving the horses and a second time holding the palm branch of victory. This, unlike the painting of Perseus and Andromeda (Fig. 5-26) from Boscotrecase, is a clear case of continuous narration, in which the same figure appears more than once in the same space at different stages of a story. Trajan's many appearances in different settings in the Column of Trajan's frieze and on the Great Trajanic Frieze are not examples of continuous narration.

In fact, the charioteer may appear a third time within the same relief, for he may be, later in life, the toga-clad official who appears at the panel's left end. There, the recently deceased official and his wife clasp hands, the standard gesture in Roman art signifying a man and a woman are married. She is of smaller stature—and less important than her husband in this context, for it is his career in the circus commemorated on his tomb—and she is shown standing on a base. The base indicates that she is not a living person but a statue. The handshake between man and statue is the artist's shorthand way of saying the wife predeceased her husband, that her death had not broken their marriage bond, and that because the husband has now died, the two will be reunited in the afterlife. The rules of Classical design were ignored here, as in the funerary relief from Amiternum (Fig. 6-10), also made for a nonelite patron. But the composition of the Great Trajanic Frieze suggests that even artists in the employ of the state were beginning to break away from the traditional forms of narration too. By the end of the second century, Roman imperial art would be dramatically transformed stylistically.

SUMMARY

Trajan, the first non-Italian to rule the Roman Empire, early on received the honorary title optimus princeps. Under this "best emperor," the territory of the Romans reached its greatest extent. A brilliant general as well as skilled administrator, Trajan waged successful campaigns on several frontiers, including Parthia in the East and Dacia in the North. He also instituted a number of innovative social policies.

The spoils from the Dacian Wars funded a massive building program in the capital under the direction of Apollodorus of Damascus. Trajan's forum was the largest ever erected in Rome, and his markets on the Quirinal Hill and public baths near the Colosseum used the latest concrete technology to provide the Roman people with new shopping, administrative, and recreational facilities unequaled anywhere in the ancient world.

The development of new forms of commemorative sculpture also marked Trajan's principate. The relief-clad column he erected in his forum became one of the most influential commemorative monuments in the history of art, copied frequently in antiquity (Fig. 13-23), the Middle Ages, and modern times. The facades of triumphal arches became veritable advertising billboards used to project an image of the emperor as the source of all good things in the Empire, military, economic, and social alike.

When Trajan died in 117, he was immediately deified, and his successor, Hadrian (see Chapter 12), constructed a temple for the worship of Divus Traianus behind the Column of Trajan, which became his tomb.

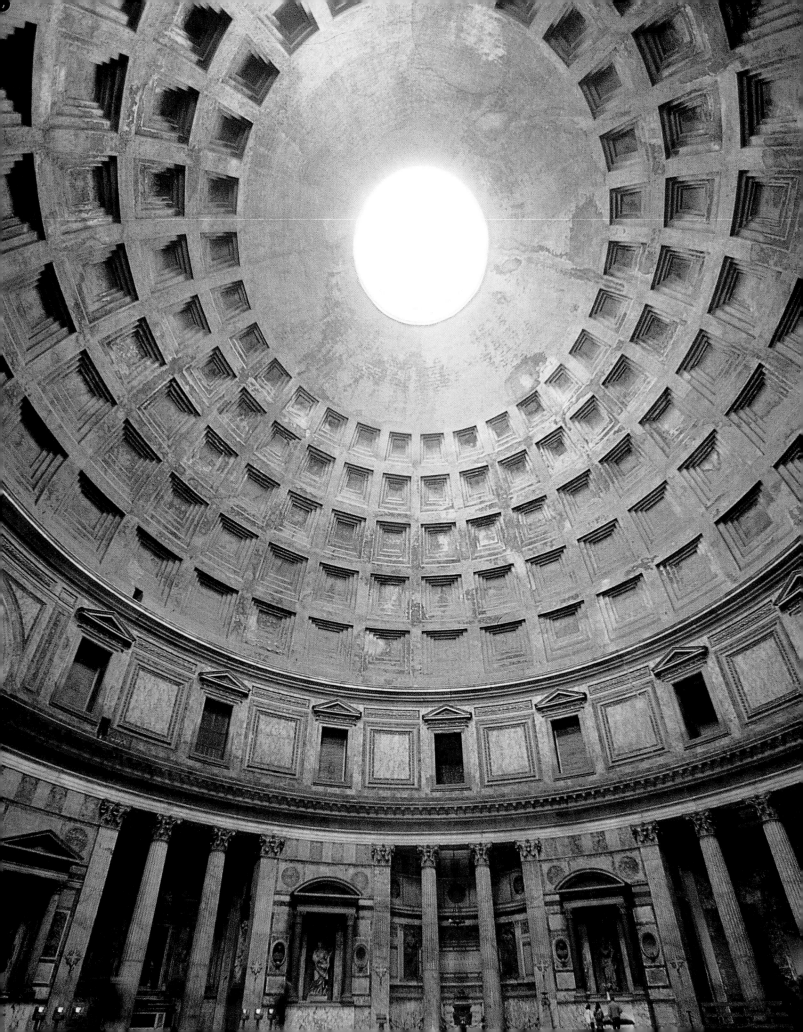

Hadrian, the Philhellene

Hadrian was born in Spain, probably in Italica, the hometown also of Trajan. His grandfather was married to Trajan's aunt, and when Hadrian's father died before his son was 10, Trajan became Hadrian's guardian (see "Hadrian, Sabina, and Antinous," page 172). Shortly after Trajan became emperor, Hadrian married Trajan's niece, Sabina, an early sign that the optimus princeps wanted Hadrian to succeed him. Yet, although Hadrian was Plotina's favorite, Trajan seems never to have formally adopted him. Trajan died on August 8, 117. Hadrian's adoption was announced August 9, but the news of Trajan's death was delayed until August 11 to make it appear that Hadrian was adopted while the emperor was still alive. Despite the suspicious circumstances, few doubted the legitimacy of Hadrian's accession.

Hadrian was a true intellectual, a connoisseur and lover of all the arts as well as an author and architect. He greatly admired Greek culture and was nicknamed *Graeculus* ("Greekling"). As the most philhellenic (Greek-loving) of all emperors, he traveled widely in the Greek East but also to many other parts of the vast Empire (Map 11-1, page 156) he inherited from Trajan. He did not, however, wish to extend Rome's territory any farther, preferring to concentrate on maintaining peace and prosperity in the provinces Rome already ruled. He devoted much of his time to touring those provinces, and everywhere Hadrian went, statues and arches were set up in his honor. More portraits of Hadrian exist today than of any other emperor except Augustus.

PORTRAITURE

THE BEARDED EMPEROR Hadrian was 41 at the time of Trajan's death, and although he ruled Rome for more than two decades, he, like Trajan, never aged in his portraits, which all represent him as a man in his early 40s. Hadrian's portraits (**Fig. 12-2**) differ from those of all previous emperors, because he wore a full beard. Some said he did so to disguise a poor complexion (see "The Biography of Hadrian," page 173), but Hadrian's beard should probably be seen as a Greek affectation. In Greece, unlike in Rome, mature men had always worn beards. Hadrian's court sculptors turned to portraits of Greek statesmen and philosophers (Fig. 10-13) as models for the philhellenic emperor's official images. As in Classical statuary, Hadrian's features are idealized. His handsome face is unlined and reveals no indication of the blemishes that supposedly prompted his decision to grow a beard. Because of Hadrian, beards quickly became fashionable in Italy and the western provinces. For the next two centuries, every subsequent Roman emperor (who was old enough) also grew a beard.

12-1 Interior of the Pantheon (Fig. 12-17), Rome, 118–125.

Hadrian, Sabina, and Antinous

Hadrian (Publius Aelius Hadrianus, r. 117–138) was born in Spain and was a relative of Trajan's. Hadrian became the future emperor's ward when his father died. He was not formally adopted, however, until Trajan's death.

Sabina, daughter of Matidia, Trajan's niece (see "The Family of Trajan," Chapter 11, page 154), married Hadrian in 100. She was awarded the title Augusta in 128 and was deified at her death in 136.

Antinous of Bithynia met Hadrian during his travels in the East and became his lover. After Antinous's death in Egypt in 130, Hadrian deified him and established a cult for his worship. ■

HADRIAN AS IMPERATOR Perhaps the most impressive of all surviving portraits of Hadrian is the over-life-size marble statue (**Fig. 12-3**) from Hierapytna (Crete, Greece) in which the emperor appears in the role of imperator wearing cuirass, paludamentum, boots, and an elaborate wreath on his head. The relief decoration of the cuirass is unique to Hadrian's portraits. Two Victories crown the goddess Minerva/Athena, who stands on the back of the she-wolf that is nursing Romulus and Remus (compare Fig. 1-8). The imagery proclaims the triumph of Greece and Rome, that is, of the united Roman Empire, over the barbarian world, here symbolized by the

12-2 **Fragmentary bust of Hadrian, from Rome, ca. 117–120. Marble, 1′ 4¾″ high. Museo Nazionale Romano—Palazzo Massimo alle Terme, Rome.**

12-3 **Hadrian as imperator, from Hierapytna, Greece, ca. 120–125. Marble, greater than life-size. Archaeological Museum, Istanbul.**

The Biography of Hadrian

The best-known biographer of the Roman emperors was Suetonius, who wrote his lives of the so-called 12 Caesars (Caesar through Domitian) during the early second century. Other authors recorded the biographies of the emperors of the second and third centuries. One series of later biographies, 30 in all, known conventionally as the *Historia Augusta,* was written at the end of the third and beginning of the fourth century. Composed long after their subjects lived, these biographies cannot be relied upon as historically accurate, but they remain invaluable in the absence of contemporaneous accounts. The *vitae* (lives) of the *Historia Augusta* are the work of at least six different authors. Hadrian's biography is attributed to Aelius Spartianus. Several passages in his *Vita Hadriani* are of special interest in connection with the portraits, reliefs, and buildings discussed in this chapter.

[Hadrian] was tall of stature and elegant in appearance; his hair was curled on a comb, and he wore a full beard to cover up the natural blemishes on his face; and he was very strongly built. He rode and walked a great deal and always kept himself in training by the use of arms and the javelin. He also hunted, and he used often to kill a lion with his own hand. . . . [T]hese hunts of his he always shared with his friends (26.1–3).

His villa at Tibur was marvelously constructed, and he actually gave to parts of it the names of provinces and places of the greatest renown, calling them, for instance, Lyceum, Academia, Prytaneum, Canopus, Poecile [Poikile], and Tempe (26.5).

He built public buildings in all places and without number, but he inscribed his own name on none of them except the temple of his father Trajan (19.9).

With the aid of the architect Decrianus he raised the Colossus and, keeping it in an upright position, moved it away from the place in which the Temple of Rome is now, though its weight was so vast that he had to furnish for the work as many as twenty-four elephants. This statue he then consecrated to the Sun, after removing the features of Nero (19.112–13).*∎

*All passages from the *Vita Hadriani* translated by David Magie, *The Scriptores Historiae Augustae,* vol. 1 (Cambridge, Mass.: Harvard University Press, 1921), 59, 61, 79.

12-4 Sabina in the guise of Venus, from Ostia, ca. 117. Marble, 5′ 10⅞″ high. Museo Ostiense, Ostia.

diminutive enemy beneath the emperor's left foot. The motif of the emperor stepping on a foe may have been introduced in Trajanic portraiture. It is a variation of the type of the equestrian emperor trampling a barbarian, perhaps already used in Flavian art (Fig. 9-25) but certainly a staple of Trajanic portraiture, as seen on coins and in the colossal statue in the center of Trajan's Forum in Rome (Fig. 11-6, no. 6).

SABINA Many portraits also survive of Hadrian's wife Sabina. Like the emperor, she appeared in a number of different guises. A marble statue (**Fig. 12-4**) from Ostia depicts Sabina as Venus and is modeled on a famous late-fifth-century BCE statue of

12-5 Veiled bust of Sabina, from Rome, ca. 136–138. Marble, 1′ 2″ high. Museo Nazionale Romano—Palazzo Massimo alle Terme, Rome.

Aphrodite with clinging drapery and an exposed left shoulder. Sabina's features are youthful and idealized in contrast to those of Matidia, Plotina (Fig. 11-4), and Marciana. Sabina is always the imperial princess in her portraits, even after she became empress. Her portrayal as the beautiful and eternally young goddess of love is consistent with that role.

In the Ostia portrait, Sabina's long hair is braided and wrapped repeatedly around her head, forming a perfect arc over the forehead. Most portraits of the empress show her sporting a simpler coiffure, with wavy hair parted in the center, as in many statues of Greek goddesses. Some scholars think the Ostia statue does not depict Sabina but a look-alike private citizen. Others count it among Sabina's earliest portraits as marking a transition from the more elaborate hairstyles popular in Flavian and Trajanic times to her later Greek-inspired coiffure.

Perhaps the best example of Sabina's later hairstyle is a fragmentary bust (**Fig. 12-5**)—or possibly the upper part of a full-length statue—of the empress wearing a veil. Found near the imperial fora in 1887 during construction of the monument to King Victor Emmanuel II, the bust has retained some paint. Sabina's hair was black, her eyes brown, and her garment purple. The portrait is most comparable to the empress's posthumous numismatic likenesses and probably dates to the last years of Hadrian's rule. Noteworthy is

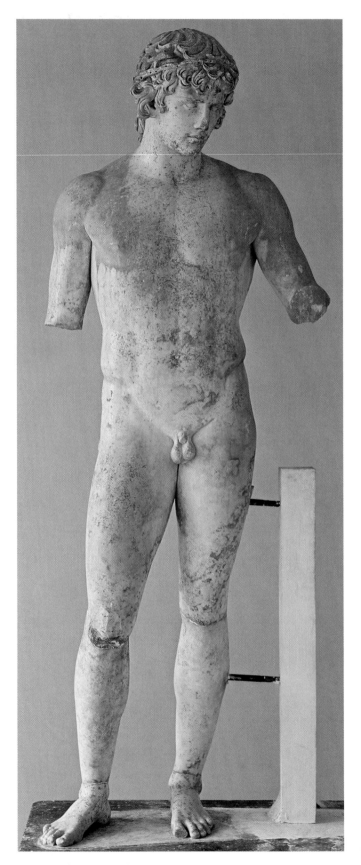

12-6 Antinous in the guise of Apollo, from Delphi, Greece, ca. 130–138. Marble, 5′ 10¾″ high. Archaeological Museum, Delphi.

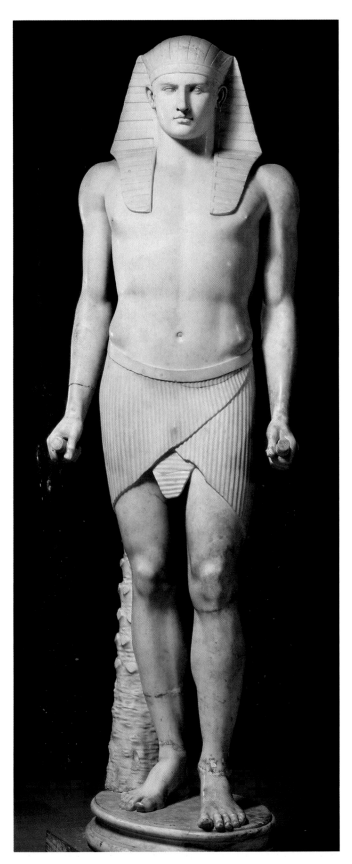

12-7 Antinous in the guise of an Egyptian pharaoh, from the Poikile, Hadrian's Villa, Tivoli, ca. 130–138. Marble, 7′ 10⅞″ high (with plinth). Musei Vaticani, Rome.

that the sculptor used a drill to accentuate the pupils of the eyes. This late Hadrianic innovation soon became standard practice.

ANTINOUS The many known likenesses of Antinous of Bithynia, Hadrian's lover and constant companion, depict the beautiful Greek youth in diverse roles. Most of the portraits date to the brief period between Antinous's death and deification and Hadrian's death eight years later. One of the finest surviving statues (**Fig. 12-6**) of Antinous was set up in the Sanctuary of Apollo at Delphi and depicts the new god as the youthful Apollo. The posture of the body conforms to a statuary type of Apollo created in the mid-fifth century BCE and sometimes attributed to Pheidias, the director of the Parthenon's sculptural program. Antinous's perfect face is framed by cascading locks of hair that were sculpted in part with a drill, a tool used earlier for Flavian portraits of women (Figs. 9-7 and 9-9). The drill was employed in the second century also for male portraits when men began to wear their hair longer and beards became the norm.

Antinous died in Egypt, and some of his posthumous portraits, including one (**Fig. 12-7**) displayed at Hadrian's villa at Tivoli, depict him in the guise of an Egyptian pharaoh. As in Egyptian statuary, Antinous stands stiffly with both arms held at his side and his head looking straight forward, although the bent left knee and the slight shift of weight at the hips reveal the influence of Greek statuary as well. The linen headdress hides Antinous's curly hair, but his features are unmistakable. The sculptor of this portrait, like the sculptor of the contemporary veiled head of Sabina (Fig. 12-5), used a drill to form the pupils of the eyes.

RELIEF SCULPTURE

Fewer Hadrianic than Trajanic reliefs are preserved, and the only ones still in their original context are the attic reliefs (Figs. 11-21 and 11-22) of the Arch of Trajan at Benevento, where Hadrian made his only (albeit retrospective) appearance in Trajanic art.

ANAGLYPHA HADRIANI Two early Hadrianic reliefs, formerly thought to be of Trajanic date and consequently named the "Anaglypha Traiani," are now generally called the "Anaglypha Hadriani" (Figs. 12-8 and 12-9). Each is carved of Greek marble and has a representation of the sacrificial animals of the suovetaurilia on one side and a depiction of a historical event set in the Forum Romanum on the other side. The reliefs were found in that forum and may have served as a balustrade on the Rostra. Dating the reliefs precisely is difficult because the portrait heads were damaged when the slabs were reused in a medieval tower.

One of the reliefs (**Fig. 12-8**) shows an emperor, accompanied by lictors, standing on the Rostra (so called because of the projecting ship's prows on the front of the speakers' platform). The emperor addresses a crowd of togate senators and

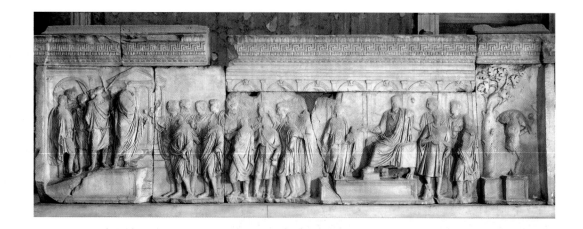

12-8 Adlocutio, Anaglypha Hadriani, ca. 117–120. Marble, 5′ 6″ high. Curia, Forum Romanum, Rome.

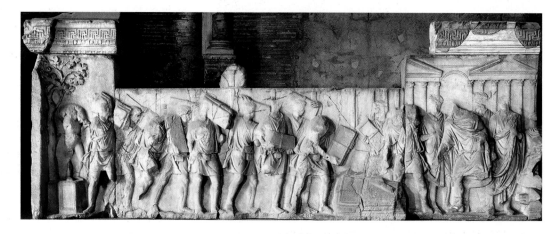

12-9 Burning of debt records, Anaglypha Hadriani, ca. 117–120. Marble, 5′ 6″ high. Curia, Forum Romanum, Rome.

less elegantly garbed common people. The arches, temples, and basilicas of the Forum Romanum serve as a backdrop. At the right, also on a platform but seated, is a second emperor who must be Trajan in the act of distributing largesse to the personified Italia and her child. Most scholars believe that Trajan and Italia are not living participants in the *adlocutio* (address) scene but rather are a statuary group. Trajan might be speaking in front of a monument commemorating his alimentary program (Fig. 11-20), but a more likely identification is that the emperor at the left is Hadrian and that the relief celebrates Hadrian's extension of Trajan's social policies. New emperors frequently associated themselves with the popular programs of their predecessors (for example, Tiberius and Augustus; see Chapter 8), and therefore such a representation would not be surprising if the Anaglypha are early Hadrianic.

The subject of the pendant relief (**Fig. 12-9**) supports a date in the Hadrianic era for both reliefs. It depicts the burning of debt records, a popular decree of Hadrian in 118, one of a series of measures designed to win the favor of the citizenry early in his principate. At the left of the relief, Roman soldiers march into the Forum Romanum carrying the official records of debt owed to the treasury. A lictor then sets them afire under the watchful eyes of the emperor (only partially preserved) seated at the far right on the Rostra. Since Hadrian was the first Roman emperor to cancel the debts of

the Roman people, the relief cannot be Trajanic, but the representation is still problematic: Hadrian's burning of the debt records took place in the Forum of Trajan, not the Forum Romanum.

ARCO DI PORTOGALLO In contrast to the Anaglypha reliefs, the dating of the panel reliefs from the so-called Arco di Portogallo in Rome is certain. The arch was erected in the fifth century and incorporated material from earlier monuments. It stood on the Via Flaminia in Rome (today the Via del Corso) near the Portuguese embassy, hence its name. Pope Alexander VII tore it down in 1662 because it was blocking the racecourse the street had become, but the reliefs from the arch were respectfully preserved.

One of the reliefs (**Fig. 12-10**) depicts the apotheosis of Sabina, and the monument it once decorated must have been erected between her death in 136 and Hadrian's death in 138. The original monument may have resembled the Arch of Trajan at Benevento (Fig. 11-19), with vertically oriented panel reliefs on the facade, but an altar is also a possibility. Whatever form the Hadrianic monument took, it probably was located not far from the later Arco di Portogallo because that section of the Campus Martius was home to several monuments honoring newly deified members of the Hadrianic and Antonine families, including the Temple of Hadrian (Fig. 12-21).

In the apotheosis panel (Fig. 12-10), Sabina flies to heaven on the back of the torch-bearing personification of *Aeternitas* (eternity). Earlier imperial arches (Fig. 9-14) and altars (Fig. 5-4) depicted the apotheosis of men, but this panel is the first known sculptural representation of the apotheosis of an empress. Sabina rises from her *ustrinum* (funerary pyre; see "Imperial Funerals," Chapter 13, page 195) in the Campus Martius (personified by a reclining seminude youth). Hadrian, seated at the right, raises his right hand (incorrectly restored) in a gesture of farewell (compare the seated Roma in Fig. 13-17). Sabina's veiled head in this relief closely resembles her contemporary portraits in the round (Fig. 12-5).

HUNTING TONDI Also securely dated and reused in a later arch are the eight tondi depicting hunting scenes that since the early fourth century have adorned the north and south facades of the Arch of Constantine (Fig. 20-7) in Rome. At the time, Hadrian's portraits were recut with the features of Constantine, just as Trajan's portraits in the Great Trajanic Frieze (Figs. 11-23 and 11-24) also became likenesses of Constantine. The Hadrianic tondi represent the preparation for hunting; the hunt for boar, bears, and lions; and sacrifices to Diana, Apollo, and other divinities after the successful completion of the hunt. **Fig. 12-11** shows the boar hunt and sacrifice to Apollo.

Hunting was one of Hadrian's favorite pastimes (see "The Biography of Hadrian," page 173). In many ancient societies, prowess in hunting was equated with military success, and the motif of Hadrian on horseback attacking the boar with his spear is virtually identical to representations of equestrian Roman emperors assailing enemies (Fig. 11-23).

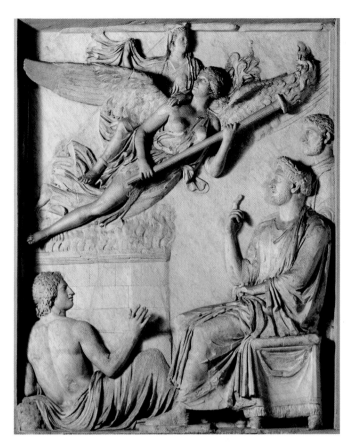

12-10 **Apotheosis of Sabina, from the "Arco di Portogallo," Rome, 136–138. Marble, 8′ 9½″ high. Palazzo dei Conservatori, Rome.**

12-11 **Boar hunt and sacrifice to Apollo, tondi from a lost monument in Rome, ca. 130–138, reused on the Arch of Constantine (Fig. 20-7), Rome, 312–315. Marble, 6′ 6″ diameter. (Below: frieze with Constantine addressing the people from the Rostra.)**

Behind Hadrian/Constantine is a curly-haired youth who can only be Antinous. Some scholars have speculated that the reliefs originally decorated a monument built in honor of Hadrian's lover after his death in 130. In any case, the tondi must date from that period.

ARCHITECTURE

As an architect—and, it seems, one who had a taste for innovative approaches to design and construction—Hadrian involved himself directly in several of the most important architectural projects of his day. During his principate, many older building complexes were restored, including the Forum of Augustus and the Baths of Agrippa, and major new projects were launched, among them a new Temple of Venus and Roma on the Via Sacra, which Hadrian designed himself; a new mausoleum on the Tiber; and the replacement of Agrippa's Pantheon with a revolutionary new temple that many consider to be the greatest building in the ancient world. Outside Rome, Hadrian was busy with the conception and construction of his villa at Tivoli, and he played a seminal role in the urban development of Ostia (see Chapter 14).

HADRIAN'S VILLA The emperor's sprawling private villa (**Fig. 12-12**) at Tivoli was the site of continuous building activity during his principate. Had Hadrian lived longer, many more buildings undoubtedly would have been constructed. The villa was Hadrian's hobby as well as his country home, and according to the *Historia Augusta* (see "The Biography of Hadrian," page 173), the emperor liked to name buildings after famous places he had visited—even though the buildings rarely resembled their namesakes. The Stoa Poikile (Painted Stoa) in Athens, for example, was a covered colonnade that housed panel paintings by some of Classical Greece's most renowned artists. The corresponding building at Tivoli was a huge peristyle garden (Fig. 12-12, no. 1) with a pool. Men of lesser means and imagination might bring home souvenirs of their travels; Hadrian constructed buildings as remembrances.

12-12 **Aerial view of Hadrian's Villa, Tivoli, ca. 118–138. 1) Poikile, 2) Teatro Marittimo, 3) Canopus, 4) Serapeum.**

12-13 Island villa (Teatro Marittimo), Hadrian's Villa, Tivoli, ca. 118–125.

TEATRO MARITTIMO Perhaps the most imaginative design at the Tivoli villa is the so-called Teatro Marittimo (Maritime Theater; Figs. 12-12, no. 2, and **12-13**), a kind of villa within the villa next to the so-called Poikile. The complex was set apart from the rest of the property by a concrete precinct wall that doubled as the back wall of an inner circular colonnade with an annular barrel vault. The miniature villa, which was separated from the colonnade by a moat, is usually referred to as Hadrian's "island villa." Its plan, centered on a scalloped fountain, is remarkable for the almost total suppression of straight lines. Hadrian, who must have discussed the plan with his architect if he was not the designer himself, delighted in the interplay of convex and concave shapes and the mix of concrete walls and vaults and stone columns.

CANOPUS AND SERAPEUM Pools and canals, often named after mighty rivers such as the Nile, were traditional conceits of Republican and Early Imperial villa design, as seen in the House of D. Octavius Quartio (Figs. 10-9 and 10-10) at Pompeii and the Villa of the Papyri (Fig. 10-11) at Herculaneum. Hadrian's Tivoli villa had a *Canopus* (Figs. 12-12, no. 3, and **12-14**) and a *Serapeum* (Figs. 12-12, no. 4, and **12-15**), recalling the Canopus canal in Egypt that led to a temple of Serapis, an Egyptian deity. Nothing about the Tivoli design, however, derives from Egyptian architecture. The Canopus is a pool framed by Corinthian columns and replicas of famous Classical Greek statues, including copies of the caryatids of the Erechtheion on the Athenian Acropolis, and personifications of the Tiber and Nile rivers. The colonnade itself is nonetheless distinctly Roman, with the lintels between the columns alternately horizontal and arcuated, in violation of one of the most basic rules of rectilinear Greek architecture. The so-called Serapeum is not a temple at all but an artificial grotto (another popular conceit of Roman villa design) constructed of concrete and featuring an unusual pumpkin-shaped dome that Hadrian probably designed himself (see

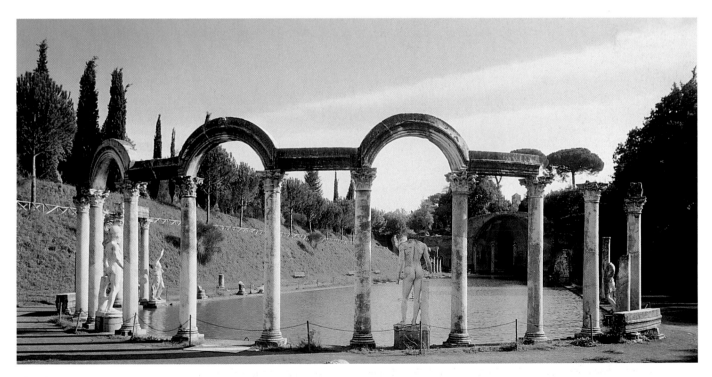

12-14 Canopus, Hadrian's Villa, Tivoli, ca. 125–128.

WRITTEN SOURCES

Hadrian and Apollodorus of Damascus

Dio Cassius, a third-century senator who wrote a history of Rome from its foundation to 229, recounted a revealing anecdote about Hadrian and Apollodorus of Damascus, Trajan's chief architect:

> Hadrian first drove into exile and then put to death the architect Apollodorus who had carried out several of Trajan's building projects. . . . When Trajan was at one time consulting with Apollodorus about a certain problem connected with his buildings, the architect said to Hadrian, who had interrupted them with some advice, "Go away and draw your pumpkins. You know nothing about these problems." For it so happened that Hadrian was at that time priding himself on some sort of drawing. When he became emperor he remembered this insult and refused to put up with Apollodorus's outspokenness. He sent him [his own] plan for the temple of Venus and Roma [Fig. 12-16], in order to demonstrate that it was possible for a great work to be conceived without his [Apollodorus's] help, and asked him if he thought the

building was well designed. Apollodorus sent a [very critical] reply. . . . [The emperor did not] attempt to restrain his anger or hide his pain; on the contrary, he had the man slain.*

The story says a great deal both about the absolute power Roman emperors wielded and about how seriously Hadrian took his architectural designs. But perhaps the most interesting detail is the description of Hadrian's drawings of "pumpkins." These must have been drawings of concrete domes like the one in the Serapeum (Fig. 12-15) at Hadrian's Tivoli villa. Such vaults were too adventurous for Apollodorus, or at least for a public building in Trajanic Rome, and Hadrian had to experiment with them later at his country home at his own expense. ■

*Dio Cassius, *Roman History,* 69.4.1–5. Translated by J. J. Pollitt, *The Art of Rome, c. 753 B.C.–A.D. 337: Sources and Documents* (New York: Cambridge University Press, 1983), 175–176.

"Hadrian and Apollodorus of Damascus," above). It served as a summer triclinium that provided the philhellenic emperor and his guests with a splendid view of the Canopus pool and its copies of Greek statues.

TEMPLE OF VENUS AND ROMA Hadrian was certainly the architect of the Temple of Venus and Roma (Figs. 1-2, no. 20, and 12-16) on the Via Sacra in Rome. To make room for the

new temple, he had to move the *Colossus* of Nero (Fig. 1-2, no. 22) closer to the Flavian Amphitheater (Fig. 1-2, no. 23), which eventually came to be called the Colosseum as a result. In the process of relocating the 120-foot-tall statue, Hadrian also replaced Nero's portrait head with the head of Sol (see "The Biography of Hadrian," page 173), thereby eradicating the last reminder of Nero's urban villa (see "Rewriting History: *Damnatio Memoriae,*" Chapter 9, page 136).

12-15 Serapeum, Hadrian's Villa, Tivoli, ca. 125–128.

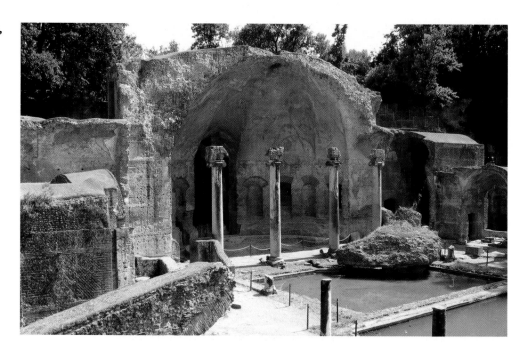

12-16 Hadrian, Temple of Venus and Roma, Rome, dedicated 135.

Hadrian's philhellenic leanings are evident in his design of the temple. In contrast to almost all Roman temples, the Temple of Venus and Roma had a peripteral colonnade and stood on a low podium with a staircase on every side. Its ten-column facade seems to be the first example of its kind in Rome, but *decastyle* temples are known much earlier in Asia Minor, and Hadrian probably looked there for models. Even the blue-veined marble columns were imported from Greece. The fact that the temple was not elevated on a high podium to

compete for visibility with the Colosseum was one of several—quite valid but unwise—criticisms that Apollodorus voiced when Hadrian asked him for his opinion (see "Hadrian and Apollodorus of Damascus," page 180).

PANTHEON If Apollodorus found it easy to criticize Hadrian's Temple of Venus and Roma, he would have been hard pressed to find fault with the unknown designer of the Pantheon (Figs. 1-2, no. 2, 12-1, and **12-17**), Rome's temple to all the gods.

12-17 Pantheon, Rome, 118–125.

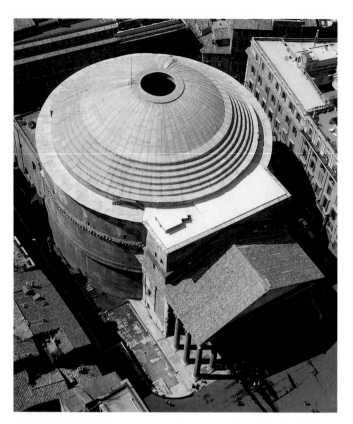

12-18 Aerial view of the Pantheon, Rome, 118–125.

The Hadrianic structure (**Fig. 12-18**) was a replacement for Agrippa's Pantheon, which had been rebuilt by Domitian after a fire in 80, but the Flavian temple was destroyed in 110. Work began on the third Pantheon soon after Hadrian became emperor and was probably completed by 125. Hadrian nonetheless declined to affix his own name to the building, preferring to honor Agrippa by retaining the temple's original dedication on the facade (Fig. 12-17): M.AGRIPPA.L.F.COS.TERTIVM.FECIT (Marcus Agrippa, son of Lucius, consul for the third time, built it). The Pantheon is not only one of the best-preserved buildings of antiquity but also one of the most influential designs in architectural history. It reveals the full potential of concrete, both as a building material and as a means for shaping architectural space.

The temple originally was approached from a columnar courtyard (**Fig. 12-19a**), and, like a temple in a Roman forum, stood at one narrow end of the enclosure. Its facade (Fig. 12-17) of eight Corinthian columns—almost all that could be seen from ground level in antiquity—was a bow to tradition. Everything else about the Pantheon was revolutionary. Behind the columnar porch is an immense concrete cylinder (Figs. 12-18 to **12-19b**) covered by a huge hemispherical dome (see "The Dome," Chapter 8, page 118) 142 feet in diameter. The dome's top is also 142 feet from the floor. The design is thus based on the intersection of two circles (one horizontal, the other vertical) so that the interior space could be imagined

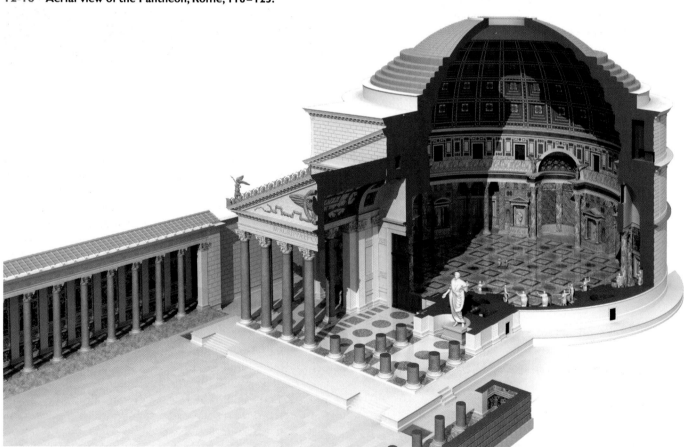

12-19a Axonometric view of the Pantheon, Rome, 118–125 (John Burge).

as the orb of the earth and the dome as the vault of the heavens (Fig. 12-19b).

If the Pantheon's design is simplicity itself, executing that design required every bit of ingenuity Hadrian's engineers could muster. The cylindrical drum and dome were built up level by level using concrete of varied composition. Extremely hard and durable basalt was employed in the mix for the foundations. The recipe was gradually modified until, at the top of the dome, featherweight pumice replaced stones to lighten the load. The dome's thickness also decreases as it nears the 30-foot-diameter oculus, the only light source for the interior (**Figs. 12-1** and **12-20**). The dome's weight was lessened, without weakening its structure, through the use of coffers, which had been employed long before, if more modestly, in the barrel vaults (Fig. 1-21) of the Sanctuary of Fortuna at Palestrina. The coffers further reduced the dome's mass and provided a handsome pattern of squares within the vast circle. Renaissance drawings suggest that each coffer once had a glistening gilded-bronze rosette at its center, enhancing the dome's symbolism as the starry heavens.

Below the dome, much of the original marble veneer of the walls, niches, and floor has survived (Fig. 12-1). Visitors to the Pantheon can get a sense, as almost nowhere else, of how magnificent the interiors of Roman concrete buildings could be. But despite the luxurious skin of the Pantheon's interior, the sense experienced on first entering the structure is not the weight of the enclosing walls but the space they enclose. In pre-Roman architecture, the form of the enclosed space was determined by the placement of the solids, which did not so much shape space as interrupt it. Roman architects were the first to conceive of architecture in terms of units of space that could be shaped by the enclosures. The Pantheon's interior is a single unified, self-sufficient whole, uninterrupted by supporting

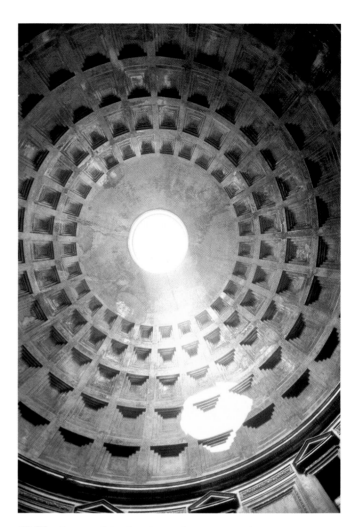

12-20 **Dome of the Pantheon, Rome, 118–125.**

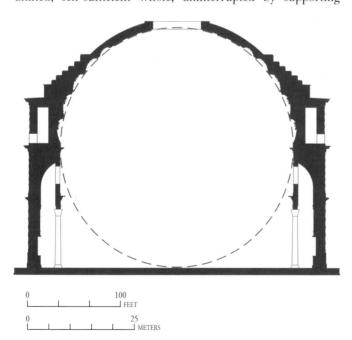

```
0          100
|___|___|___| FEET

0              25
|__|__|__|__|__| METERS
```

12-19b **Lateral section of the Pantheon, Rome, 118–125 (John Burge).**

solids. It encloses visitors without imprisoning them, opening through the oculus to the drifting clouds, the blue sky, the sun, and the gods. In this space, the architect used light not merely to illuminate the darkness but to create drama and underscore the interior shape's symbolism. On a sunny day, the light that passes through the oculus forms a circular beam, a disk of light that moves across the coffered dome in the course of the day as the sun moves across the sky itself (Fig. 12-20). Escaping from the noise and torrid heat of a Roman summer day into the Pantheon's cool, calm, and mystical immensity is an experience almost impossible to describe and one that should not be missed.

HADRIANEUM When Hadrian died in 138, the Senate immediately declared him a *divus,* and a temple was erected for his worship in the Campus Martius west of the Via Flaminia close to the Pantheon—and probably in the vicinity of the lost monument celebrating Sabina's apotheosis (Fig. 12-10). Today, the Hadrianeum, the Temple of Hadrian (**Fig. 12-21**), is the seat of the Rome stock exchange—one of countless examples of how ancient buildings still play a role in the daily life of Romans today. The modern building incorporates in one wall

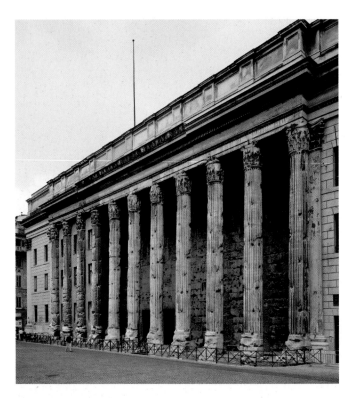

12-21 **Temple of Hadrian, Rome, dedicated 145.**

11 of the original marble Corinthian columns of the ancient temple. The Hadrianeum is noteworthy as one of the very few preserved temples to a deified emperor in the city, but it is unremarkable architecturally, except the cella has a barrel vault, a very unusual feature in a temple of traditional plan.

The sculptural decoration of the Hadrianeum is of considerable interest. A series of reliefs (**Fig. 12-22**) depicting personifications of provinces and piles of arms and armor, today dispersed among several museums, all came from the temple. Although the reliefs are Antonine in date, the theme is Hadrianic. Many of the reverses of Hadrian's coins were stamped with labeled images of the personified provinces of the Roman Empire. Increased attention to the administration of the provinces was a major element of imperial policy under Hadrian, and the depiction of the assembled provinces was a fitting tribute to the new divus. No consensus has ever been reached on where these reliefs were exhibited, and there is not even agreement regarding whether they decorated the interior or the exterior of the temple. They may, in fact, have adorned the portico of the Hadrianeum precinct rather than the temple itself.

MAUSOLEUM OF HADRIAN Although Hadrian did not erect the temple for his own worship, he did build his own mausoleum (**Fig. 12-23**), as Augustus had done a century and a half before. Augustus's mausoleum (Fig. 6-2) had become the official imperial tomb beginning with Tiberius, and the remains of almost all of Augustus's successors through and including Nerva had been deposited in it. Trajan's and Plotina's ashes were installed in the base of the Column of Trajan. Hadrian therefore had to seek another home for his remains and decided to build a new imperial mausoleum for himself and his successors on the west bank of the Tiber, within view of and modeled on Augustus's tomb on the opposite bank (Fig. 18-22). Hadrian's mausoleum became a papal fortress in the Middle Ages, the Castel Sant'Angelo, but it still

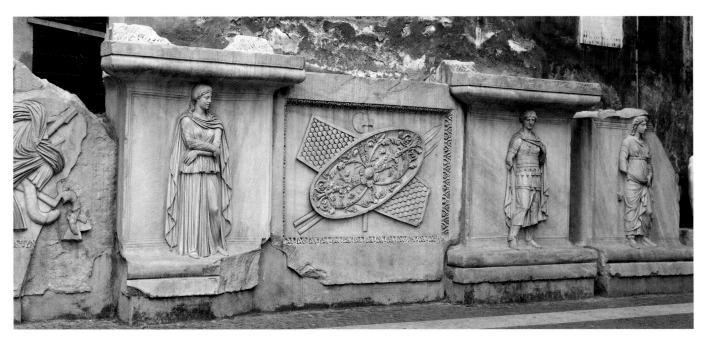

12-22 **Provinces and arms, from the Temple of Hadrian, Rome, dedicated 145. Marble, 6' 10" high (province reliefs). Palazzo dei Conservatori, Rome.**

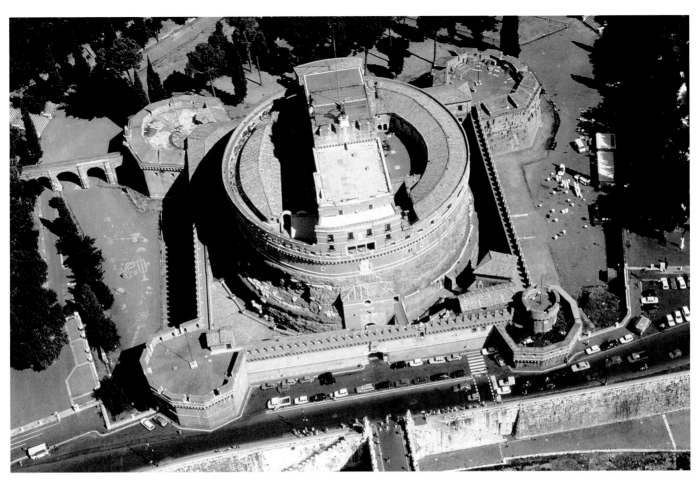

12-23 Aerial view of the Mausoleum of Hadrian, Rome, begun ca. 125, completed 140.

retains its basic Hadrianic form—a circular drum 69 feet in diameter on a 33-foot-tall square marble-faced podium. Like Augustus's mausoleum, Hadrian's was originally planted at the summit with cypress trees. A colossal statue of the emperor was again the crowning feature. The similarity and proximity of the two imperial mausoleums were, of course, intentional. Hadrian wished to present himself as the worthy successor of the founder of the Pax Romana. His tomb effectively delivered that message.

SUMMARY

The Hadrianic period was a time of consolidation of the Roman Empire after Trajan's wars of conquest and territorial expansion, and in many respects, it was also a time of artistic conservatism. A passionate admirer of Greek art and culture, Hadrian embraced the Classical style in sculpture and even adopted the Greek fashion of wearing a beard. He decorated his villa at Tivoli with copies of Classical Greek statues and designed the shrine of Venus and Roma in the capital as a peripteral temple *à la grecque*. The later portraits of his wife Sabina were modeled on statues of Greek goddesses; those of his lover Antinous were also often based on Greek types.

Yet in other ways Hadrianic art, especially Hadrianic architecture, was forward-looking. In the Teatro Marittimo of the emperor's villa at Tivoli, Greek colonnades took on complex curved plans, and in the Canopus, arches replaced horizontal lintels. Unusual pumpkin-shaped vaults were used in the Serapeum. The designer of the Pantheon broke with tradition and introduced a revolutionary domed cylindrical cella behind the temple's traditional columnar facade. Countless Pantheons throughout the Western world today provide eloquent testimony to Hadrian's lasting influence on the history of architecture.

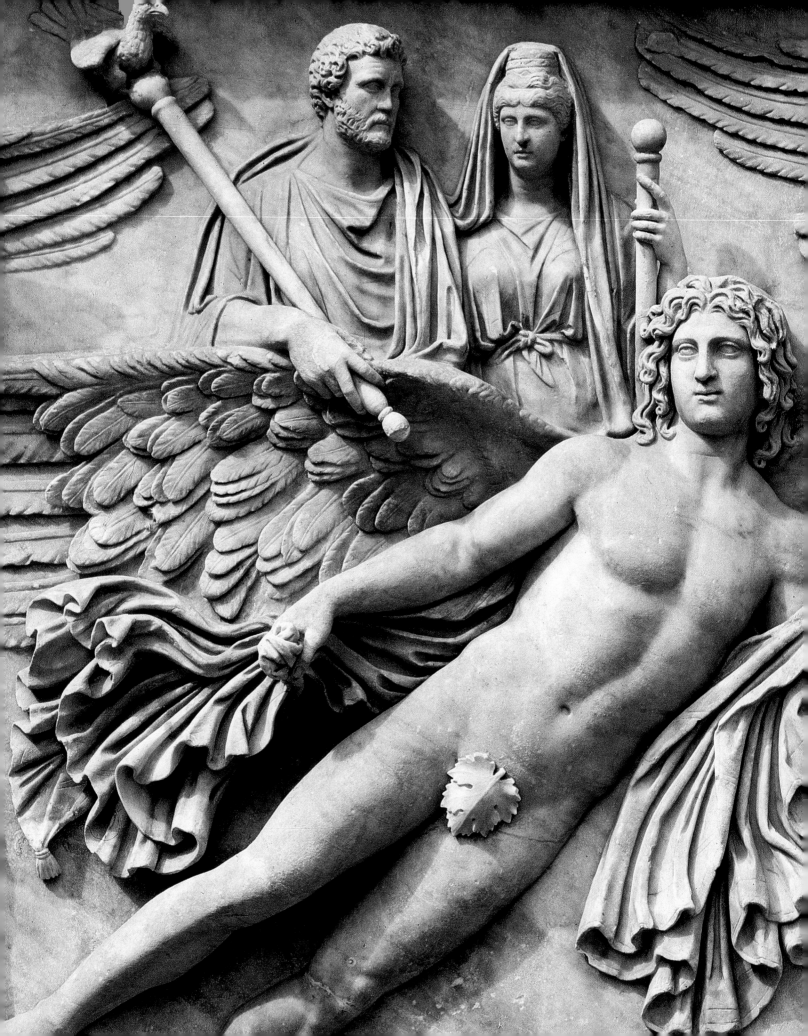

The Antonines

The awkward circumstances of Hadrian's succession, which involved delaying the announcement of Trajan's death in order to spread the news of the posthumous adoption of Hadrian, undoubtedly motivated the new emperor to plan for a smooth and controversy-free succession. Because Hadrian, like Trajan, had no sons, he adopted Lucius Aelius Caesar in 136, but when Aelius died in 138, Hadrian quickly chose Antoninus Pius as his son and successor (see "The Antonines," page 188). The emperor also insisted that Antoninus simultaneously adopt Lucius Verus, Aelius's son, and Marcus Aurelius, the nephew of Antoninus's wife Faustina the Elder. Lucius was only 7 at the time, Marcus 17. Hadrian thus determined the imperial succession for two generations. In striking contrast to Augustus's frustrated plans for succession (see Chapter 5), events unfolded exactly as Hadrian wished. Antoninus became emperor in 138, and Marcus and Lucius succeeded their adoptive father as co-emperors in 161.

The importance of the triple adoption of 138 for the long-term legitimacy of what came to be called the Antonine dynasty is underscored by its depiction two decades later on the Great Antonine Altar at Ephesus, Turkey. The altar was a grandiose U-shaped monument similar in general form to the second-century BCE Great Altar of Zeus at Pergamum and also featured a sculptured marble frieze with life-size figures. The reliefs depicted the major events of the life of Lucius Verus, from his adoption in 138 to his victory over the Parthians in 166 to his apotheosis in 169. The adoption panel (**Fig. 13-2**), in contrast to the representations of tumultuous combat elsewhere on the frieze, shows the newly created Antonine family standing quietly and facing the viewer directly. The Classicizing style and general mood, if not the frontality of the figures, recall the frieze of the Augustan Ara Pacis (Figs. 5-1 and 5-18), but it is not a narrative. In that respect, the Ephesus slab is closer to the Claudian relief from Ravenna reproducing a dynastic statuary group (Fig. 8-14).

At the left of the Ephesus panel is the 17-year-old beardless and curly-haired Marcus Aurelius. Overlapping his new son and taking pride of place is the veiled Antoninus Pius, a mature bearded man whose portraits were modeled on those of his adoptive father, Hadrian. Antoninus puts his arm around his other new son, the boy Lucius Verus. At the right are Hadrian, also veiled, and, barely visible behind his left shoulder, a young woman who must be Faustina the Younger, daughter of Antoninus Pius and the future wife of Marcus Aurelius.

13-1 Detail of the apotheosis of Antoninus Pius and Faustina the Elder (Fig. 13-17), pedestal of the Column of Antoninus Pius, Rome, ca. 161. Musei Vaticani, Rome.

PORTRAITURE

Hadrian not only determined the identity of his Antonine successors; he also set the model for their official portraits. Over the next five decades, the bearded Hadrianic "look" would dominate imperial portraiture, although the length of hair and beard would grow, the drill would be used more extensively in marble sculpture, and under Marcus

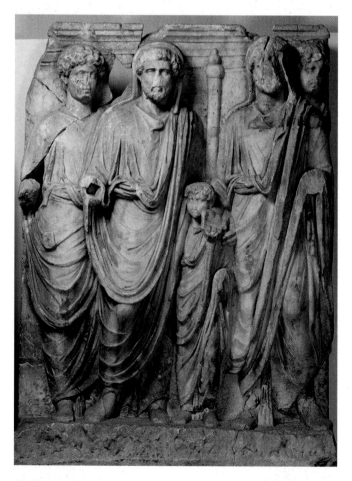

13-2 Hadrian and the Antonine emperors, from the Great Antonine Altar, Ephesus, Turkey, ca. 169. Marble, 6′ 9″ high. Kunsthistorisches Museum, Vienna.

Aurelius, sculptors would begin to record in stone the emperor's psyche as well as his physiognomy.

ANTONINUS PIUS The Antonine family also appeared as a group in portraits in the round. In 1701, several marble portrait busts of the highest quality were discovered in a villa at Lanuvium that apparently belonged to the imperial family. (Lanuvium was Antoninus's birthplace.) The bust (**Fig. 13-3**) of Antoninus, carved around 140, depicts the new emperor wearing a cuirass and paludamentum. Antoninus wears a short beard and turns his head slightly to the left. His hair is curly and some of the locks were accentuated with a drill. The sculptor also employed the drill to delineate the pupils of the eyes, as in late Hadrianic portraits (Figs. 12-5 and 12-7). Antoninus's mature features are blemishless, following in the tradition of the likenesses of Trajan and Hadrian. He too never aged in his portraits.

FAUSTINA THE ELDER Also from the Lanuvium villa is the best portrait (**Fig. 13-4**) of Antoninus's wife Faustina the Elder. Her head is turned to the right, and it is likely that the two busts were displayed as a pair, with the emperor and empress gazing toward each other. Faustina is depicted as a mature, yet ageless, woman with a perfect complexion and unlined face. Her large eyelids—which make her eyes seem half closed, almost sleepy—are characteristic also of some other members of the Antonine family. Her wavy hair is parted at the center and brushed behind the ears, then braided and piled in a bun at the top of her head. In general conception, Faustina's portraits are similar to those of the women of the Trajanic household (Fig. 11-4) rather than to the more youthful, Greek-goddess-like images of Sabina (Figs. 12-4 and 12-5),

13-3 **Bust of Antoninus Pius, from Lanuvium, ca. 138–140. Marble, 2′ 2$\frac{3}{8}$″ high (without base). Museo Capitolino, Rome.**

13-4 **Bust of Faustina the Elder, from Lanuvium, 138–141. Marble, 1′ 1$\frac{1}{4}$″ (without modern restorations). Museo Capitolino, Rome.**

who remained young in her portraits even at the end of her life. Faustina's portraits, in contrast, project a maternal image, as was appropriate for the mother of the woman (Faustina the Younger) married to one of the heirs apparent (Marcus Aurelius) of the Roman Empire.

MARCUS AURELIUS AS PRINCE Not from Lanuvium, but contemporary to the busts of his adoptive parents, is the portrait bust (**Fig. 13-5**) of Marcus Aurelius carved shortly after the accession of Antoninus Pius. The portraits of Marcus Aurelius, although very different in physiognomy and style, are similar to the portraits of the sons of Vespasian (see Chapter 9) in that Marcus aged gradually, from a young prince to an adolescent and finally to an adult emperor. In the case of Marcus Aurelius, however, unlike Trajan, Hadrian, and Antoninus Pius, the aging process was not arrested upon his accession in 161. He continued to grow steadily older in his official portraits until his death at 59.

The earliest official portraits of Marcus Aurelius depict the prince and emperor-to-be in his late teens, both on coins and in the round. The Museo Capitolino bust (Fig. 13-5) depicts a handsome young man with a mass of curly hair, heavy eyelids, and an aloof sensuality. The contrasting textures of hair, flesh, and cloth would have been enhanced originally by paint, as in all Roman marble sculpture.

13-5 **Bust of Marcus Aurelius, ca. 140. Marble, 2′ 1$\frac{1}{4}$″ high. Museo Capitolino, Rome.**

13-6 Head of Marcus Aurelius, from the Forum Romanum, Rome, ca. 147. Marble, 1′ 3″ high. Antiquario Palatino, Rome.

13-7 Bust of Faustina the Younger, from Hadrian's Villa, Tivoli, ca. 147–148. Marble, 2′ high (without base). Museo Capitolino, Rome.

A somewhat later portrait head (**Fig. 13-6**), found in the Forum Romanum, represents Marcus in his mid-20s. His hairstyle is similar, but his face is no longer that of a boy, and he sports a close-cropped beard. Consistent with the later date, the pupils of the eyes are more deeply drilled, and the drillwork is also more clearly evident in the coiffure.

FAUSTINA THE YOUNGER Marcus's Forum Romanum portrait was carved shortly after he married Faustina the Younger in 145, the date that also marks the beginning of a long series of official portraits of the daughter of the emperor and wife of the heir apparent. After Faustina gave birth in 146 to the first of 13 children, her importance in the Antonine dynasty was enhanced, and she received the honorary title Augusta. (Not surprisingly, she was frequently portrayed as Venus and *Fecunditas,* the personification of fertility, in her statues.) The finest early portrait (**Fig. 13-7**) of Faustina, carved soon after she became a mother for the first time, was found at Hadrian's Villa at Tivoli. Faustina, still a teenager, has girlish features. Her hair is perfectly coiffed, parted in the center and layered in overlapping waves across her forehead and over her

ears. At the back of the head, the hair is gathered into a bun. The hairstyle is closer to that of Sabina's later portraits (Fig. 12-5) than to those of Faustina's mother (Fig. 13-4). The beautiful and sensual Tivoli bust is a fitting match for the portraits of Faustina's young husband.

The large number of surviving portraits of Faustina and her husband is not coincidental. Antoninus Pius widely advertised that the imperial succession was secure, that Marcus (and Lucius) were being groomed for the principate, and that Faustina's fertility promised a peaceful transfer of power to still another generation. Never again, it seemed, would Rome suffer events like those of 68–69, the year of Nero, Galba, Otho, Vitellius, and Vespasian (see Chapter 9).

MARCUS AURELIUS AS EMPEROR Marcus succeeded Antoninus Pius when he was 40, and the portraits of him as emperor record his changing appearance over the next two decades. The representations of him in his 50s, like the bust portrait (**Fig. 13-8**) of him attired in cuirass and paludamentum in the Museo Capitolino, show that he retained throughout his life the same basic coiffure he wore as a youth, but he

13-8 Bust of Marcus Aurelius, ca. 170–180. Marble, 2′ 8¾″ high (without base). Museo Capitolino, Rome.

13-9 Equestrian statue of Marcus Aurelius, from Rome, ca. 175. Bronze, approx. 11′ 6″ high. Palazzo dei Conservatori, Rome.

wore his beard longer than Hadrian or Antoninus Pius. The hair beneath the chin hangs down in long strands. Pockets of shadow, produced with a drill, appear throughout the hair and beard.

The most impressive surviving portrait of Marcus Aurelius and by far the most famous is the larger-than-life-size gilded-bronze equestrian statue (**Fig. 13-9**) of the emperor that Pope Paul III selected in the 16th century as the centerpiece for Michelangelo's new design for the Capitoline Hill in Rome. The statue inspired many Renaissance sculptors to portray their patrons on horseback. Recently removed from its Renaissance site and painstakingly restored, the portrait owed its preservation throughout the Middle Ages to the fact it was mistakenly thought to portray Constantine, the first Christian emperor of Rome (see Chapter 20). Most ancient bronze statues—which were generally regarded as impious images from the pagan world—were melted down for their metal value. Even today, after centuries of new finds, only a very few bronze equestrian statues are known, almost all of them fragmentary, such as the statue of Domitian/Nerva (Fig. 9-25) from Miseno.

In the Capitoline statue, the emperor possesses a superhuman grandeur that is due both to the absolute size of the statue and to Marcus's exaggerated size relative to his horse: He is considerably larger than any normal human rider would be. The emperor stretches out his right arm in a gesture that is both a greeting and an offer of clemency. As in the equestrian statue in the Forum of Trajan, an enemy once cowered beneath the horse's raised right foreleg. But instead of slaying his foe, as Trajan did, Marcus's gesture indicates that he will spare him. It is noteworthy that Marcus does not wear battle armor. The victory has been won, and the theme of this statue is imperial *clementia* (clemency). More than any other Roman portrait known today, the equestrian statue of Marcus Aurelius conveys the awesome power of the Roman emperor as benevolent ruler of the world.

The detail (**Fig. 13-10**) of Marcus's head shows the remains of the gilding that once covered the entire statue, both horse and rider—and, no doubt, the barbarian suppliant as well. It is useful to compare the bronze head to contemporaneous marble portraits (Fig. 13-8) of the emperor. The bronze sculptor attempted to capture the coloristic effect of

13-10 Detail of the head of Marcus Aurelius in Fig. 13-9.

the drillwork possible in marble sculpture, but in bronze the emperor's hair does not have the shadows or the texture (or the natural coloration) that it has in painted marble.

LUCIUS VERUS The portraits of Lucius Verus as emperor, for example a marble bust (**Fig. 13-11**) of him dressed in cuirass and paludamentum, from Lanuvium, are comparable in format and style to the contemporaneous marble likenesses of Marcus Aurelius (compare Fig. 13-8), although Lucius was younger than his co-emperor and was so depicted. Lucius's hair is fuller than Marcus's and covers more of his forehead, and his mustache is thinner and more detached from his beard, but the drillwork is equally pronounced. The similarity in portrait types if not in physiognomy was no doubt intended to convey the equality of the two rulers, even though the elder Marcus was "first among equals" and responsible for elevating Lucius to equal rank.

A silver portrait (**Fig. 13-12**) depicting Lucius during his brief tenure as emperor also survives. Imperial portraits in gold and silver were not uncommon in antiquity, but they are far rarer today even than bronze portraits. Most marble imperial portraits were less expensive replicas of originals cast in precious metals, but with the introduction of the drill as a major sculptural tool, the portraits in metal, as noted in the discussion of Marcus's equestrian portrait, lack some of the

13-11 Cuirassed bust of Lucius Verus, from Lanuvium, 161–169. Marble, 2′ 5¾″ high (without base). Museo Capitolino, Rome.

13-12 Cuirassed bust of Lucius Verus, from Marengo, 161–169. Silver, approx. 1′ 8″ high. Museo Archeologico, Turin.

13-13 **Bust of Commodus, from Lanuvium, ca. 175–177. Marble, 1′ 10¼″ high (without base). Museo Capitolino, Rome.**

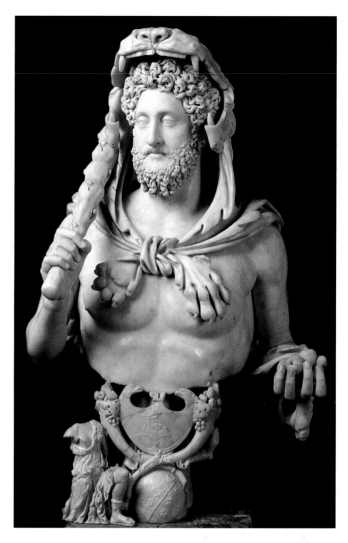

13-14 **Bust of Commodus in the guise of Hercules, from the Esquiline Hill, Rome, ca. 190–192. Marble, 4′ 4⅜″ high. Palazzo dei Conservatori, Rome.**

qualities of the portraits in stone. In the second century, the most innovative sculptural work appears to have been carried out in marble instead of gold, silver, or bronze. Still, nothing can match the visual impact of a gold or silver bust or of an over-life-size gilded-bronze statue. Since few people could afford such portraits, the materials themselves made an important statement about the status of the person portrayed.

COMMODUS AS PRINCE One of Marcus's and Faustina's many children was Commodus, who was groomed from boyhood to succeed his father as emperor. Just as Marcus was introduced to the public on coins and in statues and busts as the heir apparent of Antoninus Pius, so too was the young Commodus's image stamped on coins and reproduced in portrait busts and full-length statues. The marble bust (**Fig. 13-13**) of Commodus from Lanuvium, where he was born, presents the emperor-to-be in the identical manner as his father was depicted in his princely portraits (Fig. 13-5). The facial resemblance is probably true to life because of the blood relationship. Commodus is portrayed as the new young Marcus, complete with curly hair, sleepy eyes, and aloof expression. But because Commodus was 40 years younger than his father, portraits of him at the same age feature the same extensive use of the drill as seen in the portraits of Marcus Aurelius and Lucius Verus as adults.

COMMODUS AS HERCULES Antoninus Pius was, according to the *Historia Augusta,* "in temperament kindly . . . calm in nature . . . conspicuously thrifty . . . gentle, generous, and mindful of others' rights. He possessed all these qualities, moreover, in the proper mean and without ostentation."[1] Marcus Aurelius and Lucius Verus sought to emulate his example, and the emperors from Trajan through Marcus and Lucius are collectively remembered as "the five good emperors"—especially in contrast to Commodus, who is described as follows in the *Historia Augusta*: "Even from his earliest years he was base and dishonorable, and cruel and lewd, defiled of mouth, moreover, and debauched."[2] Commodus was a tyrannical ruler in the mode of Caligula, Nero, and Domitian (see Chapters 8 and 9), and he met with a similarly unhappy end as the victim of an

[1]Julius Capitolinus, *Vita Antonini,* 2.1–2. Translated by David Magie, *The Scriptores Historiae Augustae,* vol. 1 (Cambridge, Mass.: Harvard University Press, 1921), 103.

[2]Aelius Lampridius, *Vita Commodi,* 1.7–8. Translated by Magie, 265, 267.

assassination plot. His memory was damned in 192, but the decree was annulled shortly thereafter by Septimius Severus (see Chapter 16), which explains why so many of Commodus's portraits were preserved.

At the end of his life, Commodus considered himself to be Hercules and had an obliging Senate officially give him the name Hercules Romanus, declare him a god, and rename Rome the Colonia Commodiana. Commodus was also depicted as Hercules on coins and in statuary. An extraordinary half-length portrait (**Fig. 13-14**) of the emperor as Hercules survives in almost perfect condition, save for the disappearance of the paint. The resemblance of Commodus's face, hair, and beard to his father's portraits of the 170s (Figs. 13-8 and 13-10) is unmistakable, but everything else about the bust is unique to Commodus. He holds Hercules' club in his right hand and wears the hero's lion-skin as a headdress, with the paws knotted in front of his chest. In Commodus's left hand are the apples of the Hesperides, which Hercules had to obtain as the last of his 12 labors—for which the gods granted him immortality. Supporting the portrait bust are two kneeling Amazons (one is lost), an Amazonian shield, a globe, and crossed cornucopias. Overall, the portrait presents the emperor as the source of plenty in the Empire, conqueror of the barbarian world, and a god on earth. Although the conceit may seem almost comical to modern eyes, the underlying themes expressed in Commodus's portrayal as Hercules had been staples of imperial iconography since Augustus.

ARCHITECTURE AND ARCHITECTURAL SCULPTURE

The Flavians, Trajan, and Hadrian all carried out major building programs in the capital, transforming the heart of Rome by constructing new forums, temples, baths, and the world's largest amphitheater—and obliterating Nero's urban villa in the process. Under the Antonines, the center of architectural attention shifted to the provinces (see Chapter 17). Building activity in Rome was limited and conservative in nature, confined largely to the erection of triumphal arches and of monuments to the deified members of the Antonine family.

TEMPLE OF ANTONINUS AND FAUSTINA Antoninus Pius was devoted to Faustina the Elder, and when she died he erected a temple (Figs. 1-2, no. 17, and **13-15**) for her worship on a prime piece of real estate on the Via Sacra next to the Basilica Aemilia and close to the Temple of Julius Caesar (Fig. 1-2, no. 10). In the Middle Ages, Faustina's temple was converted into the church of San Lorenzo, and in 1602 it received a new Baroque facade. At that time the ground level had risen so much that it buried the temple podium, stairs, and almost half the height of its columns, which explains why the doorway to the 17th-century church is so high above the ancient entrance. The Antonine temple, with its six Corinthian columns on the facade and simple unadorned cella walls, was traditional in every way, save for the emperor's decision to build a monumen-

13-15 **Temple of Faustina the Elder, Rome, begun 141; rededicated in 161 as the Temple of Antoninus and Faustina.**

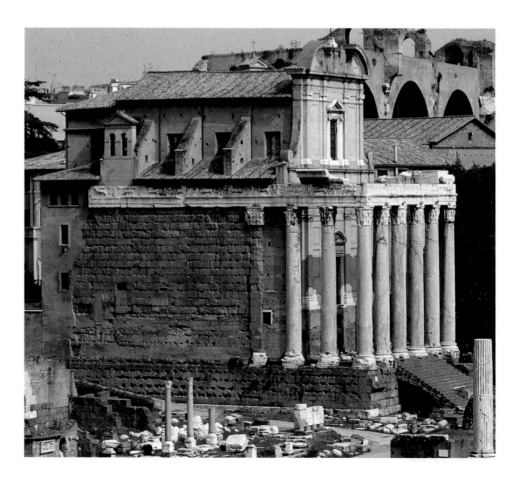

Imperial Funerals

Roman emperors received lavish funerals at state expense, and during the second century, if not before, their corpses were set afire in multistory pyres erected in the Campus Martius. The reliefs of the Column of Antoninus Pius (Figs. 13-17 and 13-18) depict two key aspects of the elaborate ceremony: the decursio in honor of the deceased and the release of an eagle from the funerary pyre, signifying the ascent of the soul to Heaven. Roman coins reproduce Antoninus's pyre (Fig. 13-16) as well as those of some of his successors. This pictorial record is confirmed and amplified by the historian Herodian's account of the funeral of the emperor Septimius Severus, whose two sons succeeded him as co-emperors (see Chapter 16).

It is the normal Roman practice to deify emperors who die leaving behind them children as their successors. The name they give to this ceremony is apotheosis.... They make a wax model exactly like the dead man and lay it on an enormous ivory couch... For seven days... the doctors come and go... and pretend to examine the patient and make an announcement that his condition is deteriorating. Then, when it appears he is dead... [they carry the couch] along the Sacred Way to the [Rostra in the Forum Romanum, where hymns are sung.] ... Next, the bier is carried out of the city to the Campus Martius, where there has been set up... [a square building] of vast wooden beams... completely filled with brushwood, and outside it is decorated with gold-embroidered drapery, ivory carvings and a variety of paintings. On top of this structure there is another one of the same shape and with the same decoration, but smaller with open windows and doors. On top of this are a third and a fourth tier, each smaller than the last, until finally comes the smallest of all.... The bier is taken up and placed on the second [story]... [Then] there is a cavalry procession around the pyre... Chariots, too, circle round... In the chariots are figures wearing masks of all the famous Roman generals and emperors. After this part of the ceremony the heir to the principate takes a torch and puts it to the built-up pyre... Then from the highest [story]... an eagle is released... and soars up into the sky with the flames, taking the soul of the emperor from earth to heaven... After that he is worshipped with the rest of the gods.* ■

*Herodian, *History* [of Rome from 180 to 238], 4.2. Translated by C.R. Whittaker, *Herodian*, vol. 1 (Cambridge, Mass.: Harvard University Press, 1969), 375–383.

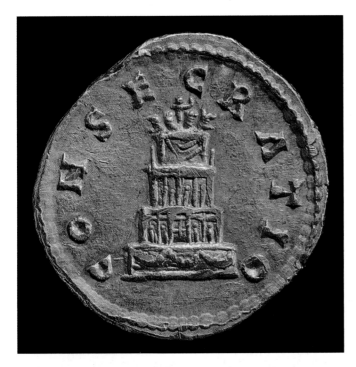

13-16 **Funerary pyre of Antoninus Pius, reverse of an aureus of Marcus Aurelius, 161. Gold, approx. $\frac{3}{4}''$ diameter. British Museum, London.**

tal shrine in honor of a woman in such a prominent location. When Antoninus died in 161, his sons rededicated the 20-year-old temple to the joint worship of Divus Antoninus and Diva Faustina.

COLUMN OF ANTONINUS PIUS In 161, Antoninus's sons and successors also erected a memorial column in his honor in the Campus Martius. Like Trajan's Column (Fig. 11-9), Antoninus's stood on a sculptured pedestal and had a statue of the emperor on the top, but the column shaft was not decorated with reliefs. Only the pedestal is preserved, on one side of which is a dedicatory inscription, and on the opposite side, a relief illustrating the apotheosis of Antoninus Pius and Faustina the Elder. On the adjacent sides are two identical representations of the *decursio,* or ritual circling of the imperial funerary pyre (**Fig. 3-16**; see "Imperial Funerals," above).

The two figural compositions are very different. The apotheosis relief (**Fig. 13-17**) remains firmly in the Classical tradition with its elegant, well-proportioned figures, personifications, and single ground line corresponding to the panel's lower edge. As in the panel from the Arco di Portogallo representing the apotheosis of Sabina (Fig. 12-10), the personified Campus Martius, here holding the Egyptian obelisk that was an important local landmark, reclines at the lower left corner. In place of Hadrian, Roma is seated at the lower right,

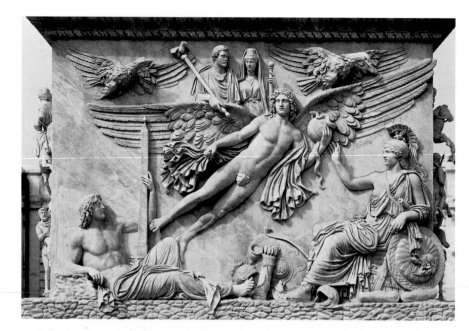

13-17 Apotheosis of Antoninus Pius and Faustina the Elder, pedestal of the Column of Antoninus Pius, Rome, ca. 161. Marble, approx. 8′ 1½″ high. Musei Vaticani, Rome.

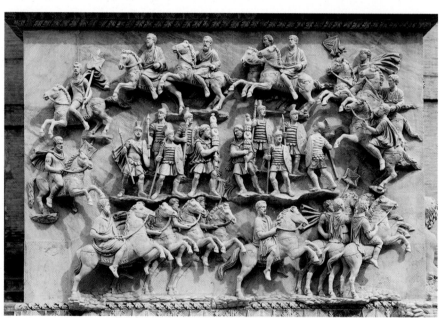

13-18 Decursio, pedestal of the Column of Antoninus Pius, Rome, ca. 161. Marble, approx. 8′ 1½″ high. Musei Vaticani, Rome.

leaning on a shield decorated with the she-wolf suckling Romulus and Remus (compare Fig. 1-8). Roma bids farewell to the couple being lifted into the realm of the gods on the wings of a personification of uncertain identity. In composition and style, the representation is as academically Classical and formulaic as the Temple of Antoninus and Faustina. New to the imperial repertoire, however, is the fusion of time represented by the joint apotheosis of Antoninus and Faustina. By depicting the two as ascending together (**Fig. 13-1**), even though Faustina had entered Heaven 20 years before, the artist wished to suggest that Antoninus, who by all accounts had been absolutely faithful to his wife before and after her death, would now be reunited with her in the afterlife as he was with her in their joint temple. The depiction of marital reunion after death had been a feature of many funerary reliefs (Fig. 11-25) of freed

slaves and the middle class prior to the Antonine period, but the motif had never appeared before in an elite context.

The decursio reliefs (**Fig. 13-18**)—one in honor of Antoninus, one in honor of Faustina, identical and seemingly simultaneous events, not 20 years apart—break even more strongly with Classical convention. The figures are much stockier than those in the apotheosis relief, and the composition was not conceived as a window onto the world. The ground is the whole surface of the panel, and marching soldiers and galloping horses alike are shown on floating patches of earth. This, too, had not occurred before in imperial art, only in the art of freedmen and other members of the middle and lower rungs of Roman society (Fig. 6-10). In the Antonine period, elite Roman artists and patrons seem finally to have become dissatisfied with the rules of Classical design. In seeking

a new artistic direction, Antonine artists adopted some of the non-Classical conventions of the art of the nonelite. Yet, although the hegemony of the Classical style began to wane in the second half of the second century, it never lost its prestige and remained an important element of imperial art until the fall of Rome itself in the fifth century.

ARCHES OF MARCUS AURELIUS Traditional narrative compositions were used exclusively for the 11 surviving panel reliefs from two lost arches Marcus Aurelius erected in Rome during the last five years of his principate. Eight of the reliefs, probably all from the same arch, were reused on the Arch of Constantine (Figs. 20-7 and 20-8), where all the portraits of Marcus Aurelius were replaced with heads of Constantine. Three other reliefs (Figs. 13-19 to 13-21), probably from a second arch, are now in the Palazzo dei Conservatori on the Capitoline Hill. The portraits of the emperor in the Conservatori reliefs are intact. Both sets of reliefs—and the other panels that are not preserved—must have decorated arches similar in format to the Arch of Trajan at Benevento (Fig. 11-19).

The themes of the Antonine panels are also similar to those of the Trajanic arch in that they honor a wide range of imperial achievements on and off the battlefield. The reliefs on the Arch of Constantine represent Marcus distributing largesse to the poor, as well as an adventus, profectio, and adlocutio and scenes of the emperor receiving barbarian suppliants and reviewing prisoners. The Conservatori reliefs show Marcus Aurelius granting clemency to barbarians, sacrificing to Jupiter, and riding in a triumphal quadriga.

The clemency panel (**Fig. 13-19**) is an expanded narrative version of the contemporaneous equestrian portrait (Fig. 13-9) of Marcus Aurelius. The emperor, surrounded by soldiers and dressed in cuirass and paludamentum, as in his bust portrait (Fig. 13-8) in the Museo Capitolino (but not in his equestrian statue), extends his right arm in mercy to two kneeling barbarians. The relief is very high, with some arms and legs carved fully in the round. The sculptor made extensive use of the drill in rendering the hair and beards of the emperor and the supplicating enemies.

In the sacrifice panel (**Fig. 13-20**), Marcus performs the rites in honor of Jupiter after the conclusion of a successful

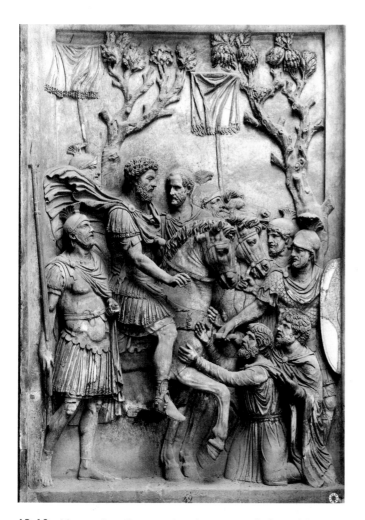

13-19 **Marcus Aurelius granting clemency, relief panel from a lost arch of Marcus Aurelius, Rome, ca. 176–180. Marble, approx. 10′ 6″ high. Palazzo dei Conservatori, Rome.**

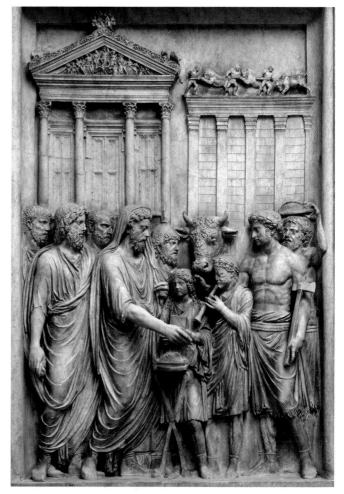

13-20 **Marcus Aurelius sacrificing, relief panel from a lost arch of Marcus Aurelius, Rome, ca. 176–180. Marble, approx. 10′ 6″ high. Palazzo dei Conservatori, Rome.**

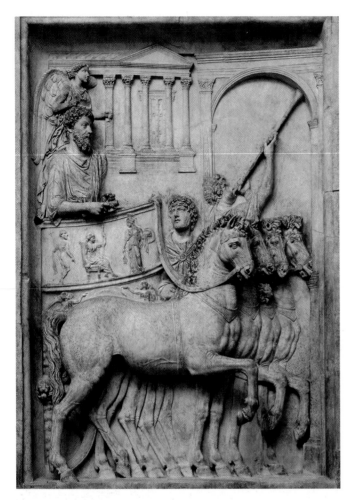

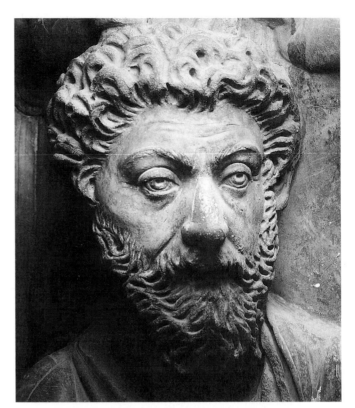

13-22 Detail of the head of Marcus Aurelius in Fig. 13-21.

13-21 Triumph of Marcus Aurelius, relief panel from a lost arch of Marcus Aurelius, Rome, ca. 176–180. Marble, approx. 10′ 6″ high. Palazzo dei Conservatori, Rome.

military campaign in front of the god's chief temple on the Capitoline Hill in Rome — recognizable by the three doors to the three cellas of Jupiter, Juno, and Minerva (Fig. 1-4). Various attendants and the personification of the Senate accompany the emperor. As in the clemency panel, the figures occupy only the lower two-thirds of the relief. The upper portion of the panel was reserved for the depiction of the setting of the action — a generic forest on the northern frontier in the first case, and the buildings of the Capitoline Hill, complete with their sculptural decoration, in the second.

The triumph panel (**Fig. 13-21**) is compositionally somewhat different, because the figures extend to the very top of the relief. The representation is a variation on the triumph (Fig. 9-16) and spoils of Jerusalem (Fig. 9-15) panels on the Arch of Titus, but with a vertical orientation. Marcus is shown steering his four-horse chariot through an arch at the right edge of the relief. As in the Flavian triumph, Victory places a wreath on the emperor's head. In the triumphal parade of 176, Commodus rode in the quadriga with his father, and he too was originally depicted in this panel. After his

damnatio memoriae in 192, the figure of Commodus was chiseled out of the relief, and Marcus's left arm and shoulder and the steps of the temple in the background were (awkwardly) filled in where Commodus's body once was.

Together the 11 reliefs present a now-familiar picture of the omnipotent, benevolent, and pious Roman emperor in his diverse roles as military, civic, and religious leader of the Roman state. The pictorial message of supreme power and confidence is not, however, conveyed by the imperial portraits in these reliefs. **Fig. 13-22** is a detail of the head of Marcus Aurelius in the triumph panel. It is one of the latest known portraits of the emperor and shows him as older than in the other portraits illustrated here. Portraits of aged emperors had been made before (for example, Vespasian, Fig. 9-4), but the latest portraits of Marcus Aurelius, in the round as well as in the Conservatori reliefs, are the first in which a Roman emperor appears weary, saddened, and even worried. For the first time, the strain of constant warfare on the frontiers and the burden of ruling a worldwide empire show in the emperor's face. The Antonine sculptor ventured even beyond Republican verism (Figs. 4-1 and 4-8). The ruler's character, his thoughts, and his soul were now exposed for all to see, as Marcus revealed them himself in his *Meditations,* a deeply moving philosophical treatise setting forth the emperor's personal worldview (see "The *Meditations* of Marcus Aurelius," page 201). This new psychological characterization of Marcus Aurelius as a frail human was a radical departure from all previous imperial portraiture.

COLUMN OF MARCUS AURELIUS After Marcus's death, Commodus deposited his remains in the Mausoleum of Hadrian (Fig. 12-23) and erected a temple for the worship of his father in the Campus Martius near the Temple of Hadrian (Fig. 12-21) and the Column of Antoninus Pius. In front of Marcus's temple, Commodus set up a commemorative column (**Fig. 13-23**) modeled on the Column of Trajan (Fig. 11-9), which was similarly situated in front of the emperor's temple (Fig. 11-6, no. 1). The bronze statue atop Marcus's Column today is a Renaissance portrait of Saint Paul, a pendant for the statue of Saint Peter at the apex of Trajan's Column. Originally there was a statue of Marcus Aurelius above his Column, again in emulation of Trajan's (and Antoninus Pius's) Columns.

The subject of the spiral frieze of the Antonine Column is Marcus Aurelius's campaigns in the North against the Germans and Sarmatians. Many of the scenes are near-duplicates of the corresponding scenes on Trajan's Column, but the Antonine sculptors learned several lessons from the legibility problems of the Trajanic frieze. The Column of Marcus Aurelius has fewer spiral bands peopled with fewer figures carved in higher relief (**Fig. 13-24**). Nonetheless, it is still almost impossible to read all the scenes in sequence from the ground. But, as in Trajan's Column, a faithful chronological narrative was not the purpose. From any side of either Column, the emperor can be seen carrying out all his important duties—receiving barbarian prisoners, sacrificing to the gods, addressing his troops, and so on.

The character of the narrative on Marcus's Column, however, is markedly different from that of the frieze of Trajan's Column. There are far fewer scenes of fort and road building and of the transportation of troops and supplies—the mundane activities of warfare. Moreover, the tone and composition of the battle and ceremonial scenes are of a new character. On Trajan's Column, the enemy is depicted as a noble and capable foe. The Romans win because of their superior technology and organization. On Marcus's Column, even though the Romans in reality met with much fiercer resistance, the barbarians are killed effortlessly, often after being lined up for summary execution (Figs. 13-24, *center,*

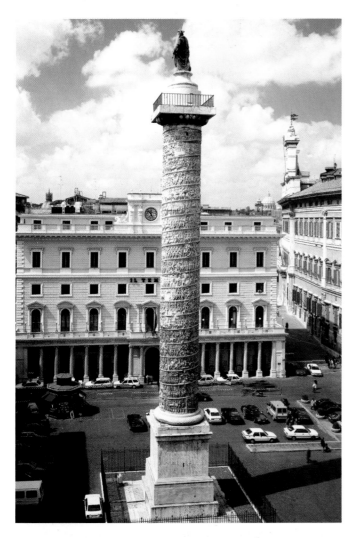

13-23 Column of Marcus Aurelius, Rome, ca. 180–185.

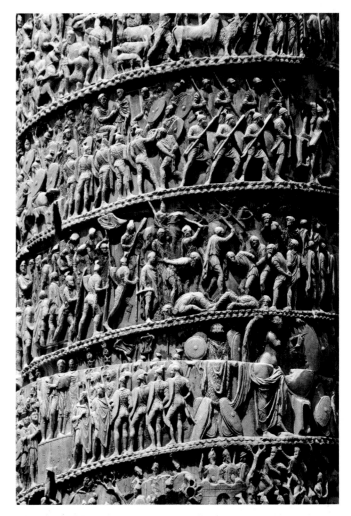

13-24 Detail of the spiral frieze of the Column of Marcus Aurelius, Rome, ca. 180–185.

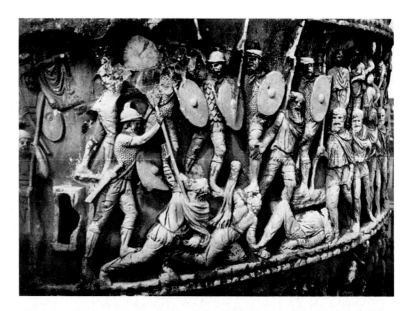

13-25 Romans battling Germans, detail of the spiral frieze of the Column of Marcus Aurelius, Rome, ca. 180–185.

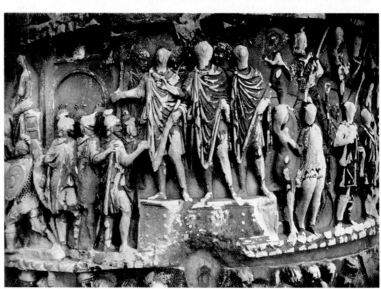

13-26 Adlocutio, detail of the spiral frieze of the Column of Marcus Aurelius, Rome, ca. 180–185.

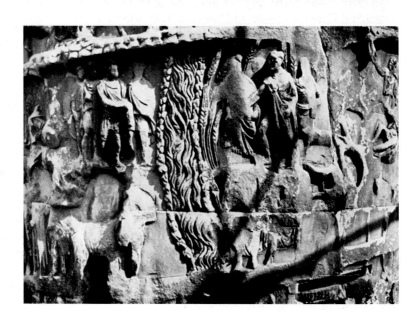

13-27 Conference between Marcus Aurelius and Germans, detail of the spiral frieze of the Column of Marcus Aurelius, Rome, ca. 180–185.

WRITTEN SOURCES

The *Meditations* of Marcus Aurelius

The portraits fashioned of Marcus Aurelius as he was nearing death depict him as a weary and concerned old man (Fig. 13-22). These first-ever portraits of a troubled emperor with the weight of the world on his shoulders invite comparison with Marcus's own melancholic philosophical musings about fame, death, and the afterlife, written on the Danube frontier and published under the title *To Himself,* but popularly known as the *Meditations.*

> Death . . . is among the things that Nature wills. . . . [L]ike the advent of teeth, beard and grey hairs . . . so is our dissolution (9.3).
>
> All things fade into the storied past, and in a little while are shrouded in oblivion. Even to men whose lives were a blaze of glory this comes to pass (4.33).

In the life of a man, his time is but a moment, his being an incessant flux, his senses a dim [candle], his body a prey of worms, his soul an unquiet eddy, his fortune dark, and his fame doubtful. In short, all that is of the body is as coursing waters, all that is of the soul as dreams and vapors; like a warfare, a brief sojourning in an alien land; and after repute, oblivion (2.17).

Souls transferred to the air exist for a while before undergoing a change and a diffusion, and are then transmuted into fire and taken back into the creative principle of the universe. . . . Such will be the answer of any believer in the survival of souls (4.21).* ■

* All passages translated by Maxwell Staniforth, *Marcus Aurelius: Meditations* (New York: Penguin, 1964), 51, 68, 71, 138.

and **13-25**). They react with terror and despair, sometimes crying out helplessly at their plight, their facial expressions revealing their pain and fear. In most scenes the figures are set at different levels (Fig. 13-24, *top*), with those in the upper zone standing on floating patches of earth, as on the decursio relief (Fig. 13-18) of the Column of Antoninus Pius.

When the emperor appears, as in the adlocutio scene in **Fig. 13-26**, he is usually the central, frontal figure of a triad (compare Trajan's adlocutio, Fig. 11-12, *bottom*). Marcus does not address the troops, which are placed to each side, often in two tiers, like the horsemen at the right in the detail illustrated here. Instead, the emperor looks out at the viewer. He is detached from his context and has become an almost iconic figure. This conception of the emperor and these hieratic, frontal triads (compare Fig. 13-2) would soon become the norm in imperial sculpture.

Anti-Classical compositional schemes also were employed in many parts of the Antonine spiral frieze. In one especially noteworthy scene (**Fig. 13-27**), Marcus and his lieutenants stand on one side of a river negotiating with German representatives on the other side. The figures are once again set on successive tiers, but, as before, they are seen head-on. The river, however, is depicted in an aerial view. The representation of the water as a vertical band effectively emphasizes the natural barrier separating the two armies, but the shift in viewpoints within the same scene violates all the rules of Classical perspective. The new compositional devices seen on Marcus's Column and on the Column of Antoninus Pius (Fig. 13-18), coming at the same time that the Classical style was being challenged in portraiture (Fig. 13-22), mark the beginning of the end of Classical art's domination in the Roman world.

SUMMARY

The Antonine age was a time of significant political, economic, and artistic transition in the Roman Empire. Antoninus Pius ruled at the height of the Pax Romana, a period of unequaled prosperity and enormous military might. By the time of Commodus's death a half century later, the frontiers were no longer secure, the imperial treasury was strained, and assassination and civil war had made the imperial succession uncertain.

Throughout history, art has usually reflected changing political, social, and economic conditions. That was certainly true of Antonine art. The idealized portraits of Hadrian and Sabina, for example, were modeled on Classical Greek prototypes. In contrast, the late portraits of Marcus Aurelius depict an aged and worried man. The Column of Trajan projected the image of an invincible Roman army, whereas the Column of Marcus Aurelius reveals the horrors of war.

New compositional patterns also emerged in Antonine relief sculpture as imperial artists became increasingly disinterested in the Classical style. The contrast is most vividly seen on the pedestal of the Column of Antoninus Pius, where the apotheosis relief is fully in the Classical tradition but the decursio reliefs have squat figures spread across the relief ground on floating patches of earth. On the Column of Marcus Aurelius, the rules of Classical perspective are often ignored. The emperor also regularly appears as the frontal, central figure of a triad, an early instance of a compositional formula that would come to characterize the art of the Severans and the Late Empire (see Part Four).

Ostia, Port and Mirror of Rome

Ostia was Rome's first colony, founded around 300 BCE (see Chapter 2). Throughout the Republic and the Early Empire, it was the gateway to Rome at the mouth of the Tiber River—and Rome's gateway to the world, the launching point for its merchant ships destined for ports all over the Mediterranean. In the early first century BCE, Sulla formalized the already expanded boundaries of the city by building a new circuit wall (**Fig. 14-2**, no. 10) around the colony, except along the seacoast. The Sullan city was many times the size of the original castrum (Fig. 2-2), but the Imperial city burst through the Late Republican walls in places. Archaeologists have by now uncovered most of Ostia (Fig. 14-2), but large parts of the areas outside the city center remain unexplored.

Because of Ostia's strategic location, the city was always important to Rome, but not until Claudius built an artificial harbor at its port did Ostia begin to enjoy a significant increase in the number of ships docking there. Trajan's engineers constructed an even larger harbor in the early second century, and under Hadrian and the Antonine emperors, Ostia experienced an economic boom period. At its peak, the population of Ostia was probably about 60,000, a small fraction of Rome's million-plus inhabitants, but Ostia was much closer in character to the capital than were the Vesuvian towns examined in Chapters 2, 3, and 10. In contrast to the towns on the Bay of Naples, Ostia was a densely populated metropolis with high-rise apartment buildings housing merchants from Gaul to Africa in addition to working-class Italians. In many ways, Ostia is a mirror of Rome during the High Empire. The colony's preserved buildings help fill in the gap in the archaeological record of the capital.

PUBLIC ARCHITECTURE

Surprisingly, the Republican colony apparently had no architecturally developed forum, although the area at the junction of the cardo and decumanus (Fig. 2-2) must have been the civic nucleus of Ostia from the beginning and may have had a temple at its north end during the Republic. Under Tiberius, a Luna-marble temple (Fig. 14-2, no. 5) was erected for the worship of Roma and Augustus at the south end of the open area. Definitive development of the civic center of Ostia, however, had to await the injection of economic stimulus that Trajan's new port brought.

14-1 Entrance portal of the Horrea Epagathiana (Fig. 14-8), Ostia, ca. 145–150.

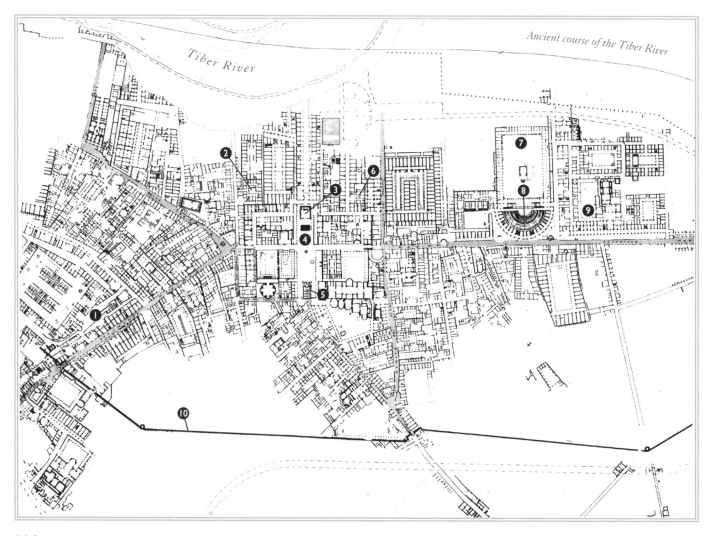

14-2 **Plan of the excavations of Ostia. 1) Insula of the Painted Vaults, 2) Horrea Epagathiana,
3) Capitolium, 4) forum, 5) Temple of Roma and Augustus, 6) Insula of Diana, 7) Piazzale delle
Corporazioni, 8) theater, 9) Baths of Neptune, 10) Sullan walls.**

CAPITOLIUM Under Hadrian, the forum (Fig. 14-2, no. 4) took final shape when a Capitolium (Figs. 14-2, no. 3, and **14-3**) was constructed at the north end of the long and narrow civic center. The Hadrianic temple may have been a replacement for a much earlier shrine that faced the Temple of Roma and Augustus to the south. Framed by a columnar portico on both east and west, the new Capitolium stood on an exceptionally tall brick-faced concrete podium intended to elevate the colony's chief temple above the neighboring multistory apartment buildings. Stripped of its lavish marble revetment paneling and all but part of one of its six freestanding columns at the top of the long entrance staircase, the Capitolium no longer glistens as it once did. In the second century, it stood out like a white beacon amid the surrounding brick-faced commercial and domestic buildings. Even the cella had a marble floor with a geometric pattern created using colored marbles from different quarries around the Mediterranean.

THEATER Ostia did not have its own amphitheater, but long before the peak of its prosperity, it had its own theater (Figs. 14-2, no. 8, and **14-4**). Around 20 BCE or shortly thereafter, Agrippa built a tufa theater with seats for 3,000 spectators on the eastern decumanus of the city. When Commodus restored the building around 190, he expanded the seating capacity to 4,000. Like the large theater (Fig. 2-13) at Pompeii, Agrippa's theater had a rectangular courtyard (Fig 14-2, no. 7) behind the stage. Under Domitian, a small temple was erected at the center of the enclosed area, and under Hadrian, a double portico of outer Doric and inner Ionic columns was added. At that time, and probably from the beginning, the area behind the stage doubled as an integral part of the theater and as an independent marketplace. When Commodus restored the theater, he also remodeled the portico by erecting walls in the colonnade that subdivided it into 61 small rooms paved with mosaics. Italian archaeologists have dubbed the remodeled complex the

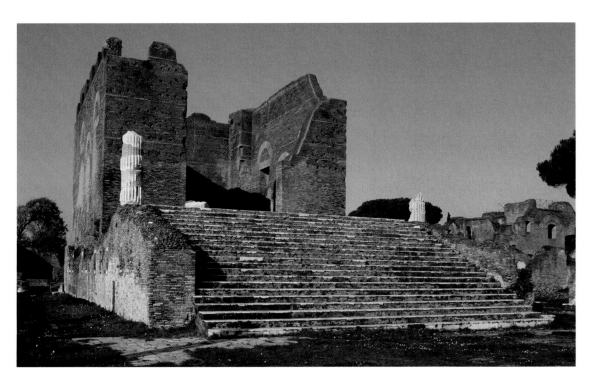

14-3 Capitolium, Ostia, ca. 120–130.

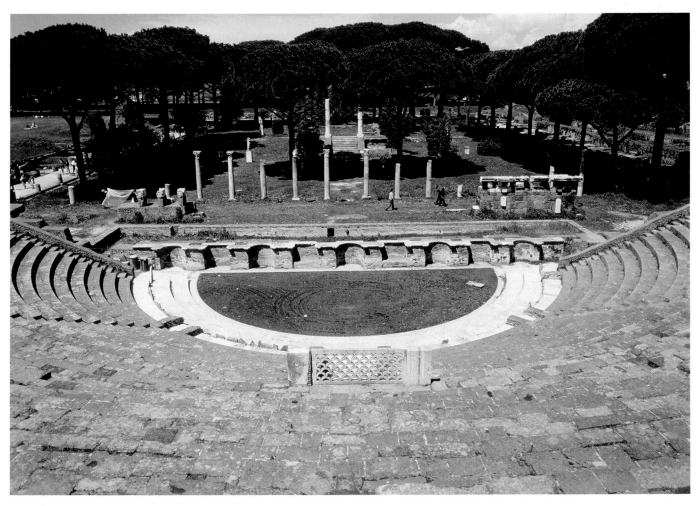

14-4 Theater and Piazzale delle Corporazioni, Ostia, begun ca. 20–12 BCE, remodeled ca. 190.

14-5 **Mosaic floors in the portico, Piazzale delle Corporazioni, Ostia, ca. 190.**

Piazzale delle Corporazioni (Forum of the Corporations) because the portico housed the offices (*stationes*) of local merchants and shipping agents from as far away as Gaul and North Africa. Sea creatures like dolphins are common motifs in the mosaics of the portico (**Fig. 14-5**). Some of the mosaics give the proprietors' names and represent landmarks in their hometowns—a lighthouse or a bridge, for example. One *statio* (**Fig. 14-6**) has a mosaic floor representing an elephant. Above the exotic beast is written STAT.SABRATENSIVM, that is, the business office of the representatives of Sabratha in present-day Libya. The

Romans imported ivory from North Africa and also live elephants for spectacles in the Colosseum and other amphitheaters (see "Spectacles in the Colosseum," Chapter 9, page 128).

BATHS OF NEPTUNE Hadrian also built one of Ostia's largest and finest *thermae*. Two inscriptions establish that funding for the Baths of Neptune (Figs. 14-2, no. 9, and **14-7**) came directly from the imperial treasury. The first announced to those entering the baths that Hadrian had allocated two million *sestertii* for their construction. The second related that Antoninus Pius provided additional financing to complete the project in 139. The Ostian baths, like almost all such complexes outside the capital, followed the pattern established during the Republic. Like Pompeii's Forum Baths (Fig. 2-11), all of the bathing chambers were aligned on one side of a large palaestra, in contrast to the bilateral symmetry of the Baths of Titus and Trajan (Fig. 11-18) in Rome.

Neptune's baths take their name from the large mosaic floor in room 8 (Fig. 14-7), the first room encountered after the vestibule. The sea god was a popular subject in all contexts where water played an important role (compare Figs. 10-6 and 10-7). Here, Neptune is shown racing across the sea pulled by a team of seahorses. He requires no chariot (compare Fig. 4-5) and floats over the waves, accompanied by nereids, tritons, dolphins, and other denizens of the sea. Although the mosaic is of unusually high quality, it is typical of the second- and third-century mosaics of Ostia in being restricted only to black and white tesserae (see "Roman Mosaics," page 207). Black-and-white mosaics were also used in the offices of the Piazzale delle Corporazioni (Figs. 14-5 and 14-6). In these mosaics, the artists rendered the interior details of the anatomy and garments of the twisting and foreshortened figures by inserting white lines in

14-6 **Mosaic floor, statio of the merchants of Sabratha, Piazzale delle Corporazioni, Ostia, ca. 190.**

14-7 **Neptune and creatures of the sea, floor mosaic, room 8, Baths of Neptune, Ostia, ca. 139.**

MATERIALS AND TECHNIQUES

Roman Mosaics

As an art form, *mosaic* had a rather simple and utilitarian beginning, seemingly invented primarily to provide an inexpensive and durable flooring. Originally, small beach pebbles were set, unaltered from their natural form and color, into a thick coat of cement. Artisans soon discovered, however, that the stones could be arranged in decorative patterns. At first, these *pebble mosaics* were uncomplicated and were confined to geometric shapes. Generally, the artists used only black and white stones. Examples of this type, dating to the eighth century BCE, have been found at Gordion in Turkey. Eventually, artists arranged the stones to form more complex pictorial designs, and by the fourth century BCE, the technique had developed to a high level of sophistication. Mosaicists depicted elaborate figural scenes using a broad range of colors—yellow, brown, and red in addition to black, white, and gray—and shaded the figures, clothing, and setting to suggest volume. Thin strips of lead provided linear definition.

By the middle of the third century BCE, artists had invented a new kind of mosaic that permitted the best mosaicists to create designs that more closely approximated true paintings. The new technique employed *tesserae* (Latin for "cubes" or "dice"). These tiny cut stones gave the artist much greater flexibility because their size and shape could be adjusted at will, eliminating the need for lead strips to indicate contours and interior details. Much more gradual gradations of color also became possible, and mosaicists finally could aspire to rival the achievements of panel painters, even use tesserae to copy complex paintings (Fig. 3-10).

In the late first century CE, Roman mosaicists began to reject the illusionism of Greek figural mosaics and experimented with limiting the color scheme to only black and white (Figs. 14-5 to 14-7). In larger rooms, where the mosaics would be seen from several vantage points, the mosaicists usually created compositions that would be intelligible regardless of the viewer's position. These multiple-viewpoint mosaics, like the Neptune mosaic (Fig. 14-7) in the Baths of Neptune at Ostia, soon supplanted in popularity, although never completely replaced, the single-viewpoint mosaics the Greeks favored. Roman black-and-white mosaics were surface decorations, not windows onto the world. ■

the black silhouettes, much the way black-figure vase painters in Archaic Greece used incisions through black glaze to draw details of musculature and costumes. The restricted palette was more than a money-saving device compared with the cost of polychrome mosaics. The resulting flatter look of the mosaic was also better suited as a pavement decoration than the more illusionistic compositions that were achieved with many colors and shading (Fig. 3-10). The Neptune mosaic and many like it at Ostia were also designed to be seen from different angles. Like the royal figures on modern playing cards, some figures in the mosaic were always right side up no matter where the viewer was in the room.

HORREA EPAGATHIANA The major commodity that ships brought to the port of Ostia was grain, the first half of the "bread and circuses" slogan for what the emperors needed to provide to keep the populace happy. After the ships docked at Trajan's new port, longshoremen unloaded the grain and transferred it to barges with shallow hulls for transport up the Tiber to Rome or loaded the grain onto wagons shuttling back

and forth on the Via Ostiensis, which ran from Ostia past the Pyramid of Cestius (Fig. 6-4) and into the city (Fig. 18-22). The barges unloaded their cargo at the Republican Porticus Aemilia (Fig. 1-15) and other warehouses on the Tiber. Ostia itself also had numerous warehouses, called *horrea,* for the storage of grain and other commodities like oil and wine, which in most cases would be resold to retailers in the city.

14-8 **Facade of the Horrea Epagathiana, Ostia, ca. 145–150.**

From an architectural standpoint, the most distinguished Ostian warehouse was the Horrea Epagathiana et Epaphroditiana (Figs. 14-2, no. 2, and **14-8**), as it is called in the inscription over its portal. Epagathius and Epaphroditus were, judging by their Greek names, wealthy freedmen. They constructed their warehouse around 145–150. In plan, the building has small rooms on the ground floor opening onto a central courtyard. On the west, to the left and right of the entrance, several tabernae faced the sidewalk. Entry to the warehouse required passing through two successive locked doors. The stairways leading to the upper floors also had doors, clear indications that the proprietors considered the goods stored there to be valuable.

The entrance portal (**Fig. 14-1**) of the Horrea Epagathiana is one of the finest examples anywhere of the Romans' new taste for exposed brick. The brick aesthetic began to emerge in the Flavian period and is best seen in early-second-century Rome in the hemicycle facade of the Markets of Trajan (Fig. 11-14). The builders of the Horrea Epagathiana employed molded bricks for the ornate pediment, Composite capitals, and column bases of the portal, sometimes adding a color contrast with a thin coat of white plaster. The continued respect for the Greek architectural vocabulary is apparent in the Ostian portal, but so too is the transformation of Greek stone post-and-lintel construction into a new and distinctly Roman style.

DOMESTIC ARCHITECTURE

As in Pompeii (Figs. 2-1 and 2-4), most of the space in second-century Ostia was taken up by houses, but archaeologists have estimated that more than 90 percent of the inhabitants of Ostia and Rome lived in multistory apartment blocks called *insulae*.

(Unfortunately, the Romans used the identical term for city blocks, but in ancient texts the two types of insulae are usually easy to distinguish.) Land was very expensive in Rome and Ostia, and only the privileged few could afford to live in a single-family domus. The apartment houses of the Republic and Early Empire were notorious firetraps, but after the disastrous fire of 64, Nero instituted new building codes (see Chapter 8), and thereafter insulae were built of brick-faced concrete.

INSULA OF DIANA One of the best-preserved insulae at Ostia is the so-called Insula of Diana (Figs. 14-2, no. 6, and **14-9**), which owes its modern name to a terracotta plaque representing the goddess that was on display in its courtyard. Only two stories of the insula are still standing, but a model (**Fig. 14-10**) in the Museum of Roman Civilization in Rome gives an excellent idea of the appearance of it and similar Ostian (and Roman) apartment blocks. Imperial insulae were usually three to five stories tall, with ground-floor shops of the standard one-room concrete-vaulted taberna type opening onto the sidewalk. The plans of the individual floors varied greatly, but as a general rule the higher the floor, the smaller the apartment unit (the Latin term is *cenaculum*). In an era long before elevators, the view from an upper floor was an insignificant bonus compared to the inconvenience of climbing several flights of stairs.

The residents of the Insula of Diana enjoyed a prime location in Ostia just down the street from the Capitolium (Fig. 14-2, nos. 3 and 6). The building's handsome facade (Fig. 14-9) is distinguished by exposed brickwork and false balconies, which Ostian firefighters may have used as platforms from which to extinguish fires. Tabernae line the sidewalks on

14-9 **Insula of Diana (view from the southwest), Ostia, ca. 150.**

the south and west sides of the insula facing the streets called today the Via di Diana and the Via dei Balconi respectively. Two of the tabernae had small back rooms in which the shopkeepers lived. Access to the apartments was through a door on the Via dei Balconi. Immediately inside was the tiny cenaculum of the building's porter and a communal latrine. At the end of the fauces was the insula's courtyard, open to the sky and the sole source of light and air for all apartments that did not also have external windows. In the courtyard was a fountain and cistern from which the residents drew their water. Not all Ostian (or Roman) insulae had either a latrine or a cistern. The Insula of Diana was a relatively upscale high-rise, as its choice location near the forum also suggests.

Some apartments—the best ones—in the Insula of Diana were also located on the first floor, but most of the cenacula in the building were reached by one of three staircases. The second floor, like the first, had a combination of two- and three-room apartments. The upper floors would have had smaller cenacula, many consisting of only a single room; moreover, these units were a few flights of stairs from the only latrine and fountain. On every floor, cooking was done in the common corridor. Odors and noise were unavoidable. The quality of life for a city dweller in second-century Ostia or Rome did not remotely approach that of the owner of a domus in first-century Pompeii or Herculaneum (see "Life in the City during the High Empire," page 210).

14-10 **Model of an insula, Ostia, second century. Museo della Civiltà Romana, Rome.**

Life in the City during the High Empire

Second-century Rome and Ostia were crowded, noisy, and dirty—yet expensive—places to live. The highborn and very wealthy might own private townhouses on the Palatine Hill and have slaves to carry them from place to place in litters (when the owners did not escape the city for their country villas), but the rest of the people, especially the working poor, had to live in cramped fire-prone quarters in upper-floor walk-up apartments with leaking roofs. Residents of these insulae rarely had bathing facilities or latrines and regularly threw their garbage into the streets.

The satirist Juvenal, writing around 120, colorfully summed up his attitude toward life in the capital:

What can I do at Rome? I cannot lie; if a book is bad, I cannot praise it . . . Who at cool Praeneste, or at Volsinii and its leafy hills, was ever afraid of his house tumbling down? Who in modest Gabii, or on the sloping heights of Tivoli? But here we inhabit a city supported for the most part by slender props; for

that is how the bailiff patches up the cracks in the old wall, bidding the inmates sleep at ease under a roof ready to tumble about their ears. No, no, I must live where there are no fires, no nightly alarms . . . If you can tear yourself away from the games of the Circus, you can buy an excellent house at Sora, at Fabrateria or Frusino, for what you now pay in Rome to rent a dark garret for one year. And you will there have a little garden . . . Most sick people here in Rome perish for want of sleep . . . For what sleep is possible in a lodging? Who but the wealthy get sleep in Rome? . . . See what a height it is to that towering roof from which a potsherd comes crack upon my head every time that some broken or leaky vessel is pitched out of the window! . . . You may well be deemed a fool . . . if you go out to dinner without having made your will.* ■

* Juvenal, *Satires*, 3.41–42, 190–198, 223–227, 232–235, 268–275. Translated by G. G. Ramsay, *Juvenal and Persius* (Cambridge, Mass.: Harvard University Press, 1918), 35, 47, 49, 51, 53.

INSULA OF THE PAINTED VAULTS Although the decoration of Ostian insulae was, as a rule, much more modest than that of private country houses, the finer apartments had mosaic floors and painted walls and ceilings. The frescoed groin vaults of Ostia are of special interest, because few painted ceilings are preserved in the cities buried by the eruption of Mount Vesuvius, and they are rarely of the vaulted type. Room 4 (**Fig. 14-11**) in the aptly named Insula of the Painted Vaults (Fig. 14-2, no. 1) at Ostia is typical of painted ceiling design of the second and third centuries. The painter treated

the groin vault as if it were a pumpkin-shaped dome (compare Fig. 12-15) with eight wedge-shaped segments resembling wheel spokes radiating out of a central oculus-like medallion. In each segment is a white *lunette* (crescent or semicircle) with delicate paintings of birds and flowers, motifs common on Pompeian walls. This kind of ceiling composition would be used later in the underground catacombs (Fig. 20-17) of Early Christian Rome.

FUNERARY ARCHITECTURE

During the High Empire, Romans continued to erect tombs of a dazzling variety of types, but on the roads leading out of Rome and Ostia, a standard type emerged that was aesthetically consistent with the taste for exposed brickwork seen in the houses (Fig. 14-9), markets (Figs. 11-14 and 11-15), and warehouses (Figs. 14-1 and 14-8) of the living. Most of the surviving tombs of this period are concentrated in the so-called Isola Sacra (Sacred Island, a modern name) necropolis near the port of Ostia, where more than a hundred tombs, usually attached to each other like townhouses in a city, are aligned along the road. They normally took the form of a single concrete barrel-vaulted room containing the remains of working-class families. Often a relatively well-off freedman would erect the tomb and place an inscription over the doorway giving his name and specifying that this would be the burial place also for his immediate family and their descendants as well as for his freedmen and freedwomen and their descendants. Sometimes families pooled funds for a shared tomb. It was also possible to pay to

14-11 **Ceiling and mural paintings, room 4, Insula of the Painted Vaults, Ostia, early third century.**

14-12 Tomb of Tiberius Claudius Eutychus (tomb 78), Isola Sacra necropolis, Ostia, ca. 110–115.

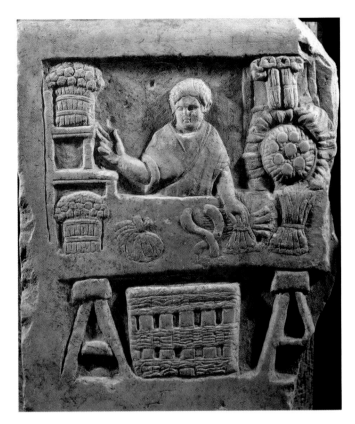

14-13 Funerary relief of a vegetable vendor, from Isola Sacra necropolis, Ostia, second half of second century. Terracotta, 1′ 5″ high. Museo Ostiense, Ostia.

have one's remains placed in a niche of a wealthier family's tomb. None of the inscriptions at Isola Sacra refer to aristocrats or important magistrates, all of whom must have been interred in a more elite cemetery with freestanding tombs on larger plots, but that necropolis has yet to be located.

TOMB OF CLAUDIUS EUTYCHUS The tomb (**Fig. 14-12**) that Tiberius Claudius Eutychus built for himself, his family, and his freedmen toward the end of Trajan's principate is typical of those at Isola Sacra. A rectangular brick facade with a pediment, dedicatory inscription, and terracotta figural reliefs above the travertine doorway concealed the barrel-vaulted burial chamber. The architectural vocabulary is similar to that of contemporary Ostian houses of the living, a familiar conceit in funerary architecture of all times and places. The reliefs suggest that Eutychus derived his income, as did so many of his fellow freedmen, from the grain trade. One of the terracotta reliefs depicts a ship, and the other a grain mill. Eutychus's tomb is thus the second-century counterpart of the baker Eurysaces' tomb (Figs. 6-5 and 6-6) in Rome.

GROCER AND MIDWIFE Similar small painted terracotta plaques adorned the facades of many of the Isola Sacra tombs. They immortalized the activities of a wide range of middle-class merchants and professional people and provide a vivid picture of daily life in Ostia during the High Empire. One of the most interesting plaques (**Fig. 14-13**), of uncertain provenance, depicts a vegetable seller behind a counter (which has been tilted forward so that the produce can be seen clearly). Another (**Fig. 14-14**) shows a midwife delivering a baby. Because she looks out at the viewer rather than at what she is doing, and because most of these reliefs focus on the livelihoods of the deceased, the relief probably commemorates the

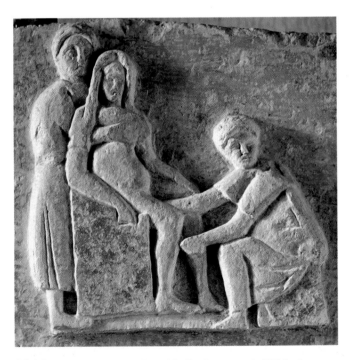

14-14 Funerary relief of a midwife, from tomb 100, Isola Sacra necropolis, Ostia, mid-second century. Terracotta, 11″ high. Museo Ostiense, Ostia.

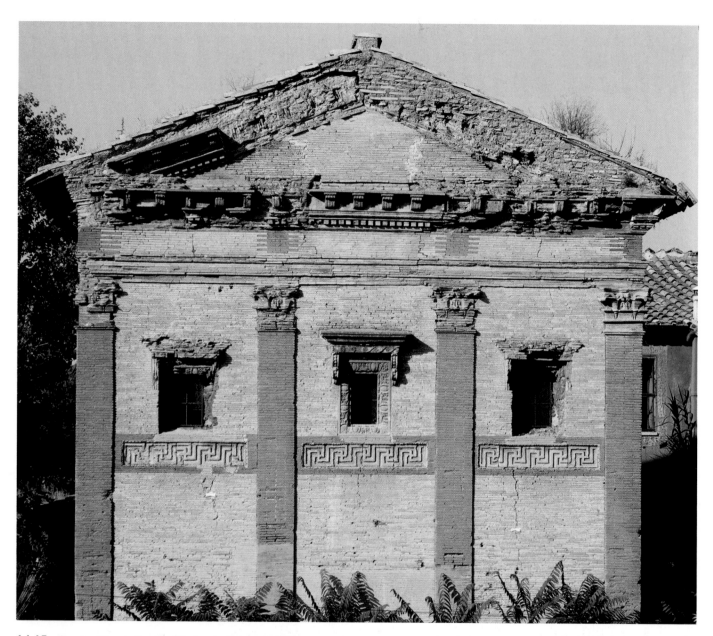

14-15 Tomb of Annia Regilla, Via Appia, Rome, ca. 161.

midwife rather than the mother. The product of artists of modest talent, these Ostian terracotta plaques are also very different in style from the art of the elite classes of Roman society during the second century—although, as discussed in Chapter 13, by the time of Marcus Aurelius and Commodus, the tilted perspective of the Ostian grocer's relief began to be used even in imperial commissions.

TOMB OF ANNIA REGILLA During the Antonine period, more elaborate and more lavishly decorated versions of the Isola Sacra tombs were erected on the roads outside Rome's gates. The finest in terms of the sophistication of the brickwork is, not surprisingly, the tomb (**Fig. 14-15**) on the Via Appia of a very wealthy woman—Annia Regilla. Annia was the wife of

Herodes Atticus, the Athenian teacher of Marcus Aurelius and Lucius Verus and benefactor who built, among other things, the odeum on the south slope of the Athenian Acropolis. The tomb is actually a cenotaph; Annia Regilla was buried in Athens. The columnar porch, which gave the cenotaph the appearance of a small temple, no longer stands, but the gabled roof and side and rear walls of the building are largely intact. Using bricks of different colors from pale yellow to rich red-orange, the builders fashioned moldings, window frames, pilasters, and Corinthian capitals of exceptional quality. White and dark red plaster was used for select details and for the joints between the bricks.

SAINT SEBASTIAN TOMBS At about the same time as Herodes erected the cenotaph in honor of his wife on the

Via Appia, less-well-to-do families were building tombs in crowded cemeteries along all the roads leading out of the city. The Catacomb of Saint Sebastian, also on the Via Appia, incorporates several tombs (**Fig. 14-16**) similar to those of Isola Sacra. Set up in rows and having brick facades, often with pediments over the doorways, the Saint Sebastian tombs are typical of second-century Rome.

TOMB OF THE CAETENNII The interiors of these tombs were usually far more elaborate than their exteriors. The Tomb of the Caetennii (**Fig. 14-17**) is one of several mid-second-century brick buildings in the cemetery that today lies beneath the great Renaissance/Baroque church of Saint Peter's in the Vatican, originally built by Constantine in the early fourth century (see Chapter 20). The interior of the Caetennius family tomb is relatively well preserved. It is characteristic of the Antonine period when the Romans were beginning to bury their dead in marble sarcophagi (see Chapter 15) instead of placing the cremated remains of their family and former slaves in small ash urns. The Tomb of the Caetennii accommodated both cinerary urns in wall niches and sarcophagi in floor-level arcuated recesses called *arcosolia*. The walls feature a complex interplay of projecting columns and recessed rectangular and arcuated niches crowned by full, broken, and segmental pediments. Much of the paint survives, as does a small section of the stuccoed groin vault.

14-16 Roman tombs, Catacomb of Saint Sebastian, Via Appia, Rome, second quarter of second century.

14-17 Interior of the Tomb of the Caetennii, Vatican cemetery, Rome, ca. 150–160.

14-18 Burial chamber of the Tomb of the Pancratii, Via Latina, Rome, ca. 160–170.

TOMB OF THE PANCRATII The vault of the Tomb of the Caetennii must have resembled the almost perfectly preserved painted stucco vault of the subterranean burial chamber of the slightly later Tomb of the Pancratii (**Fig. 14-18**), one of several tombs on the Via Latina that also had one or two upper stories for funerary cult and family reunions. Today a huge undecorated sarcophagus of later date sits on top of the second-century black-and-white mosaic floor. The stucco vault above is compositionally similar to many Third Style walls and presents an eclectic array of subjects from painted still lifes and rustic landscapes to reliefs of seahorses, lions, erotes, and mythological narratives such as the Judgment of Paris and King Priam of Troy recovering his son Hector's body from Achilles. Some of the scenes make an unmistakable reference to death and the afterlife, for example, Her-

cules entering Mount Olympus after the completion of his 12 labors, but others seem purely decorative.

MARS AND VENUS Some Ostian and Roman tombs of the Antonine era contained marble statues in addition to sculptured sarcophagi and painted stuccoes. One statue (**Fig. 14-19**) from Isola Sacra is particularly noteworthy. Like the portrait of Sabina in the guise of Venus (Fig. 12-4) and countless similar representations from Republican times on, the man and woman depicted in the Ostian statue chose to masquerade as Roman deities, in this case Mars and Venus. The body types are based on famous Greek statues of Ares and Aphrodite, but the Greek model for the Venus statue depicted the goddess with bare breasts. The heads of the Isola Sacra "deities" are contemporary portraits. The woman so closely resembles

14-19 Man and woman in the guise of Mars and Venus, from Isola Sacra necropolis, Ostia, ca. 145–150. Marble, 6′ 1$\frac{5}{8}$″ high. Museo Capitolino, Rome.

Faustina the Younger (Fig. 13-7) that some scholars think the group is actually an imperial portrait, but Mars does not look like Faustina's husband Marcus Aurelius. This couple must be a private husband and wife who could afford such an expensive item of "tomb furniture," but they were not members of the imperial family, whose portraits would have been unlikely to be displayed at Isola Sacra. The exact findspot of the Mars-and-Venus group is unknown, but if it came from a tomb with terracotta reliefs of freedmen at work on the facade, it would be still another example of the persistent eclecticism and stylistic diversity of Roman art.

SUMMARY

Rome has been continuously occupied since antiquity, and nearly 2,000 years of later construction have obscured the character of the ancient city, with the notable exception of the archaeological zone between the Capitoline Hill and the Colosseum. Even there, only the Via Biberatica of Trajan's markets gives a sense of Rome's appearance in the second century CE. Fortunately, the excavations of Ostia, Rome's port city and first colony, have furnished a vivid picture of urban life during the High Empire.

Most of the buildings of Ostia—apartment houses, warehouses, baths, and tombs—were built of brick-faced concrete, as were the Markets of Trajan in the capital, and they attest to the new appreciation that began to emerge in the late first century CE of brick as an attractive material in its own right. Brick pediments, engaged columns, and false balconies often enlivened the otherwise austere facades of these buildings. Inside, black-and-white mosaics commonly covered the floors. The walls and vaults frequently were adorned with frescoes or painted stucco reliefs.

The second-century tombs of Ostia and Rome are of additional interest because they were erected at a time of transition in Roman burial customs and their interiors had both wall niches for ash urns and floor-level arcosolia for sarcophagi. By the end of the century, sarcophagi would supplant cinerary urns as the preferred containers for the remains of dead Romans (see Chapter 15).

XV

Burying the Dead during the High Empire

The second century was a time of profound change in Roman society as well as in Roman art. Beginning under Trajan and Hadrian and especially during the rule of the Antonines, Romans began to favor *inhumation* (burial of bodies) over the traditional means of disposing of the dead by *cremation* (burning of bodies). The reasons for this reversal of funerary practices remain unclear, but the growing popularity of inhumation may reflect the influence of Christianity and other Eastern religions, whose adherents believed in an afterlife for the human body. All that is certain is that the imperial family did not initiate the new trend. The emperors and empresses and their relatives continued to practice cremation even after much of the rest of the population had shifted to inhumation.

Burial meant that the newly deceased required larger containers for their remains than the ash urns that were the norm during the Early Empire. This in turn led to a sudden demand for *sarcophagi* (literally "flesh-eaters"), which were more similar to modern coffins than any other ancient type of funerary container. Although sarcophagi are rare in Rome before the second century CE, they had a long history in the eastern Mediterranean and even in Etruscan Italy.

A characteristic Etruscan example dating to the second century BCE is the sarcophagus of Lars Pulena (**Fig. 15-2**) from Tarquinia, the leading production center for stone coffins at that time. The deceased is shown in a reclining position on his funerary bed. He wears a wreath around his neck and proudly displays a partially unfurled scroll inscribed with the record of his life's accomplishments. His head is a generic rather than a specific portrait, and the somber expression on his face is typical of this era when Etruria was in political and economic decline. Etruscan stone sarcophagi also usually have narrative scenes on the front of the coffin proper. Lars Pulena's shows him at the center between two *Charuns* (Etruscan death demons) swinging hammers. The scene indicates that he has successfully made the journey to the Underworld.

15-1 **Detail of a sarcophagus with battle between Romans and barbarians (Fig. 15-15), from Via Tiburtina, Portonaccio, ca. 180–190. Museo Nazionale Romano—Palazzo Massimo alle Terme, Rome.**

MYTHOLOGICAL SARCOPHAGI

Marble sarcophagi were expensive items, heavy to transport (see "Roman Regional Sarcophagus Production," page 218) and requiring skilled sculptors for their

Roman Regional Sarcophagus Production

Ships docking at the port of Ostia (see Chapter 14) unloaded a wide array of goods for transport up the Tiber to Rome. In addition to commodities such as grain, wine, and oil, ships brought items ranging from small, inexpensive terracotta lamps to costly over-life-size bronze statues. Some of the heaviest products were marble coffins imported from the eastern Mediterranean. To protect the relief carving on these sarcophagi, the coffins were commonly shipped with the decoration only roughly blocked out. The sculptors either traveled with the cargo or had permanent workshops in Italy where they completed the carving after the sarcophagi arrived in port.

During the second and third centuries, there were three main centers for the manufacture of marble sarcophagi: Rome itself; Attica, the region of Greece that includes Athens; and Asia Minor in present-day Turkey. Each center produced a distinctive type of sarcophagus, although occasionally a workshop would copy a type from another region, either to satisfy an individual customer's wishes or simply to have in stock less expensive alternatives to imported pieces.

Roman (or Western) sarcophagi (Figs. 15-3 to 15-7 and 15-11 to 15-15) were carved only on the front and sides, usually with higher relief reserved for the figures on the front. Western sarcophagi were designed to be set against a tomb wall or slid into an arcosolium in the burial chamber, as in the Tomb of the Caetennii (Fig. 14-17) in the Vatican cemetery in Rome. The lids of Western sarcophagi are either flat or slope slightly down toward the back. They usually have a decorated front taller than the rest of the lid, with a mask at each end (Figs. 15-3 to 15-5, 15-11, 15-12, and 15-15).

Attic sarcophagi (Fig. 15-8), and Eastern sarcophagi in general, were carved on all four sides in equally high relief, because they were set up either outdoors or in the center of tomb chambers and could be seen from all sides. This distinction between Eastern and Western sarcophagus types exactly parallels the different design of Greek and Roman temples—the former with freestanding columns and access stairs on all four sides, the latter meant to be seen primarily from the front with the rear of the temple set against the precinct wall of a forum or sanctuary. The lids of Eastern sarcophagi usually take the form of a gabled roof, giving the coffins the appearance of miniature freestanding templelike tombs. Attic sarcophagi were decorated with a continuous frieze running around all four sides of the rectangular coffin.

Asiatic sarcophagi (Figs. 15-9 and 15-10) are similar in form in all respects to Attic sarcophagi except that instead of the decoration taking the form of a continuous frieze, the carved figures are set in columnar frames, like statues in niches.

Both Eastern (Figs. 15-9 and 15-10) and Western (Fig. 18-13) sarcophagi sometimes had more elaborate lids in the form of a *kline,* or funerary couch, on which the deceased (or the deceased and his or her spouse) reclined. Kline portraits were a common feature of Etruscan sarcophagi (Fig. 15-2). This most expensive type of lid provided the opportunity for the deceased to be represented in a life-size full-length portrait, which was seen every time the family visited the tomb or travelers passed the sarcophagus placed in the open air beside a road. ∎

decoration. Only relatively well off patrons could afford them. For Romans who had the means to purchase a sarcophagus, the new type of burial container provided prestige as well as an opportunity to craft a pictorial message for posterity. Unlike modern coffins, which are almost always buried and never seen again, Roman sarcophagi remained on view, either in the open air or placed in tombs. This made burial in a sarcophagus an especially attractive option, and it is likely that many Romans chose inhumation over cremation in part because they wished to be laid to rest in a sarcophagus. Roman custom dictated that the deceased's family and friends visit his or her tomb regularly. The family normally returned to the tomb nine days after the funeral and at least once a year thereafter, when they

15-2 **Sarcophagus of Lars Pulena, from Tarquinia, early second century BCE. Tufa, approx. 6′ 6″ long. Museo Archeologico Nazionale, Tarquinia.**

15-3 **Sarcophagus with massacre of the Niobids, from a tomb outside the Porta Viminalis, Rome,** ca. 134–140. Marble, $3' \frac{5}{8}'' \times 6' 11''$. **Musei Vaticani, Rome.**

would participate in feasts in honor of the dead and view his or her sarcophagus. In many cases, the Romans left funds in their wills to pay for both the funerary meals and the sarcophagi in which they were buried.

NIOBID SARCOPHAGI One of the earliest securely datable second-century sarcophagi is the sarcophagus (**Fig. 15-3**) found in a tomb erected in 134 or shortly thereafter outside the Porta Viminalis in Rome. The sarcophagus is of the standard Western type with a sloping lid and reliefs on the front and sides but not on the back. The subject was drawn from Greek mythology (see "Greek Myths on Roman Sarcophagi," page 221) and represents the bloody tale of divine retribution against Niobe, who had boasted that she was better than Leto, mother of Apollo and Artemis, because she had produced more children. On the lid, Apollo and Artemis aim their arrows at the children below. At the right, Niobe tries to protect two of her children, while at the left her husband Amphion raises his shield, but the gods' arrows are not meant for him. On the right short end of the sarcophagus (**Fig. 15-4**), Niobe and Amphion mourn at the garland-draped tomb of their slain children.

ORESTES SARCOPHAGI The Porta Viminalis tomb also contained a sarcophagus of identical format produced at the same time in the same Roman workshop but depicting the myth of Orestes. Both subjects enjoyed wide popularity during the Antonine period, and many replicas are known, proving that the sarcophagus sculptors relied upon standard pattern books as guides in representing the various myths on their customers' coffins. A replica of the Porta Viminalis Orestes sarcophagus is the slightly later sarcophagus (**Fig. 15-5**) that is

15-4 **Amphion and Niobe, right side of the Niobid sarcophagus in Fig. 15-3.**

15-5 Sarcophagus with myth of Orestes, ca. 140–150. Marble, 2′ 7½″ high. Cleveland Museum of Art, Cleveland.

today in the Cleveland Museum of Art. In contrast to surviving sarcophagi depicting the massacre of the Niobids, Orestes appears more than once on the front in both the Porta Viminalis and the Cleveland sarcophagi. On the example in Rome, the hero appears three times: visiting the grave of his father Agamemnon, slaying his mother Clytaemnestra and her lover Aegisthus, and defending himself against the Erinyes. Only the second and third scenes appear on the front of the Cleveland sarcophagus.

HERCULES SARCOPHAGI The choice of the Niobid and Orestes myths is difficult to explain. To be sure, they represent scenes of death, but who would want to be associated with a mother who caused the death of her children or a son

who killed his mother? Perhaps what counted most was that Niobe was an exemplar of female fecundity—the same virtue admired in Faustina the Younger (see Chapter 13)—and that Orestes was a pious son who avenged the death of his father. The popularity of other myths, however, is easy to understand, for example, the 12 labors of Hercules, which led to the hero's being granted immortality.

The Hercules sarcophagus (**Fig. 15-6**) in Mantua is of the Western Roman type. On Western sarcophagi, the front of the coffin shows the first 10 of the 12 labors. The 11th and 12th (Cerberus, the three-headed canine guardian of the Underworld, and the apples of the Hesperides) are depicted on the short sides; the back is blank. The sculptor represented Hercules aging as he progresses from one impossible task to

15-6 Sarcophagus with 12 labors of Hercules, ca. 170. Marble, 2′ 3″ × 7′ 4½″. Palazzo Ducale, Mantua.

Greek Myths on Roman Sarcophagi

Greek myths were among the most popular subjects for the relief decoration of Roman sarcophagi of the second and third centuries. The stories often focused on death (or triumph over death). They recounted the adventures of heroes and heroines, a class of mortals intermediate between humans and the immortal gods who were often the sons and daughters of a deity and a mortal. Some of the myths most frequently represented were the following:

Massacre of the Niobids (Figs. 15-3 and 15-4). Niobe, wife of Amphion, the mortal son of Zeus who founded and built the famous walled city of Thebes, was the mother of many children. Different authors give different numbers, but the total is never less than 10. Homer, the oldest source, said Niobe had six boys and six girls; Ovid said seven of each. Niobe boasted that because of her extraordinary fertility, she was superior to the goddess Leto, who had only two children, Apollo and Artemis. For this act of *hubris* (arrogant pride), Niobe was severely punished. Leto instructed Apollo and Artemis to teach Niobe—and all others who might delude themselves into believing they were on a par with or better than the gods—a bitter lesson. With their arrows, Leto's two divine children shot and killed all of Niobe's offspring (the Niobids) to render her childless—and therefore inferior to Leto, even by Niobe's own standard of measurement.

Orestes (Fig. 15-5). Orestes was the son of Agamemnon, king of Mycenae and commander of the Greek forces in the Trojan War, and his wife Clytaemnestra, the sister of the beautiful Helen of Troy. Clytaemnestra became the lover of Aegisthus, and together they murdered Agamemnon. Eight years after his father's death, Orestes, at Apollo's instruction, returned home from Athens and killed Aegisthus and Clytaemnestra. For this act of matricide, the Erinyes (Furies), divine agents of retribution, hunted down Orestes, but Apollo provided the hero with a bow and arrows to defend himself. Orestes was brought to trial in Athens and was acquitted when Athena cast the deciding vote in his favor.

Labors of Hercules (Fig. 15-6). Hercules (Heracles) was the greatest of all the Greek heroes. He was born in Thebes and was the son of Zeus and Alcmene, a mortal woman. Zeus's jealous wife Hera hated Heracles and sent two serpents to attack him in his cradle, but the infant strangled them (Fig. 16-8). Later, Hera caused Heracles to go mad and to kill his wife and children. As punishment, the hero was condemned to perform 12 great labors. In the first, he defeated the ferocious lion of Nemea and ever after wore its pelt as a headdress. The lion's skin and his weapon, a club, are Heracles' distinctive attributes (Figs. 13-14 and 16-24). The order of the labors was not fixed, but in several accounts the last task was to obtain the golden apples given to Hera at her marriage. They grew from a tree, guarded by a dragon or a serpent, in the garden of the Hesperides at the western edge of the ocean. After completion of the 12 seemingly impossible assignments, Heracles was awarded immortality and was admitted to Mount Olympus, where he resided thereafter with the gods.

Meleager and the Calydonian Boar (Figs. 15-7 and 15-8). Meleager was the son of Oeneus, king of Calydon, who forgot to sacrifice to Artemis. The goddess sent a monstrous boar to ravage Calydon, and Meleager organized a hunting party to track down and kill the beast. The first to wound the boar was the virgin huntress Atalanta, who shot an arrow into it, but it was Meleager who killed the Calydonian boar with his spear. In the course of the hunt, Meleager fell in love with Atalanta and presented the animal's hide to her.

Greeks and Amazons (Fig. 15-11). The Amazons were a race of powerful female warriors whose name seems to mean "breastless." The Amazons figure in several Greek myths, including one of the labors of Heracles. The hero had to fetch the belt of the Amazon queen Hippolyte (Fig. 15-6, *center*), which had been given to her by Ares and which she did not yield without a fight. Another famous duel occurred between Achilles and the Amazon queen Penthesilea (Fig. 18-21), when the Amazons fought on the Trojan side in the Greek war against Troy. According to the myth, at the moment Achilles drove his sword into Penthesilea, they fell in love. Any battle between Greeks and Amazons is generically called an Amazonomachy. ■

another, beginning with the killing of the Nemean lion at the left, when the hero is still a young man. In the third labor he wears the lion's skin as a headdress for the first time. By the fifth labor, Hercules has grown a beard. The sarcophagus does not show the hero on Mount Olympus, but every viewer knew the reward Hercules received at the end of his labors. That Hercules achieved immortality—in essence defeated death—by virtue of his courage, strength, and determination made him an ideal figure to which a Roman man might compare himself on his sarcophagus.

MELEAGER SARCOPHAGI Another Greek hero who was a model of valor in the face of danger was Meleager, who hunted and killed the wild boar of Calydon. On a Western sarcophagus (**Fig. 15-7**) datable about 180 and now in the Doria Pamphili Gallery in Rome, Meleager, wearing only a cloak on his shoulders, is at the center of the front of the coffin, thrusting his spear into the Calydonian boar's head. Behind him is Atalanta with her bow and arrow. Other hunters hurl rocks at the beast, and hounds attack it. The lid continues the Meleager saga and represents the hero's dead body being carried to his grave.

An Attic version (**Fig. 15-8**) of this Western Meleager sarcophagus is today in the Archaeological Museum of Eleusis, west of Athens. It has the standard gable-roofed lid of sarcophagi carved in Eastern workshops (see "Roman Regional Sarcophagus Production," page 218) and has relief figures on all four sides of the coffin proper. Many of the motifs are similar to those on the Doria Pamphili sarcophagus, but Meleager and his comrades attack the boar from the right and the animal charges at them from the left.

Hadrian had made hunting fashionable (Fig. 12-11), and the popularity of Meleager sarcophagi during the Antonine period was no doubt due in part to Hadrian's example. But although it is tempting to speculate that Roman hunters were the sole or even the primary customers for these sarcophagi, that probably was not the case. Rather, the Greek heroes were *exempla virtutis,* models of virtue and valor, qualities univer-

15-7 **Sarcophagus with Meleager and the Calydonian boar, from Rome, ca. 180. Marble, 3′ 1″ × 8′ 1$\frac{1}{4}$″. Galleria Doria Pamphili, Rome.**

15-8 **Sarcophagus with Meleager and the Calydonian boar, from Eleusis, Greece, ca. 200. Marble. Archaeological Museum, Eleusis.**

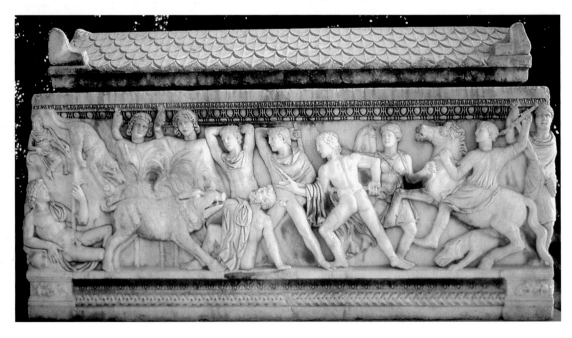

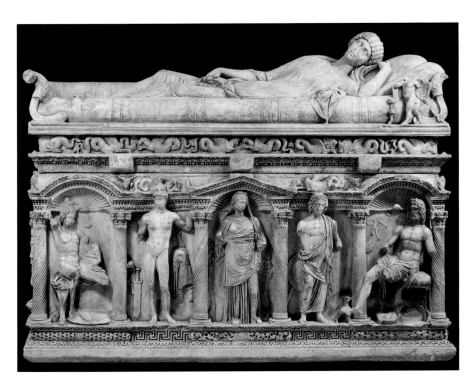

15-9 **Sarcophagus with kline portrait of a woman, from Rapolla, near Melfi, ca. 165–170. Marble, 5′ 7″ high. Museo Nazionale Archeologico del Melfese, Melfi.**

sally admired in the Roman world. Ordinary Romans did not equate themselves with the legendary heroes of the past, but they did wish to present themselves to posterity as sharing some of the same qualities the heroes displayed through their great deeds. Viewers were asked to draw analogies between the lives of the Greek heroes and those of the deceased, not to identify the dead men or women with the heroes or heroines.

The sarcophagus reliefs should be considered narrative versions of the same conceit seen so often in freestanding statuary. A Roman woman might possess the beauty of Venus (Figs. 9-9 and 14-19), but she is not Venus herself. An emperor might be the earthly counterpart of Jupiter (Fig. 8-10), but he is not himself the king of the gods. There are exceptions, however. Commodus, for example, did identify himself with Hercules (Fig. 13-14) and had the Senate officially declare him to be Hercules Romanus. But these were rare exceptions—and in the case of Commodus and other egomaniacal emperors, such pretenses led to their assassination or forced suicide.

VENUS SARCOPHAGI Women were also laid to rest in costly sarcophagi during the Antonine period, and they too sought to present themselves to their relatives and to posterity as embodying admired qualities, especially the female virtues of beauty and fertility. An example of the highest quality is the sarcophagus (**Figs. 15-9** and **15-10**) found at Rapolla near Melfi in southern Italy which, despite its findspot, is one of the earliest examples of the Asiatic type of sarcophagus with statuesque figures in columnar frames on all four sides of the coffin. The sarcophagus must have been shipped across the Mediterranean to Italy and transported overland to Melfi at great expense. The figures on the body of the coffin are a cross-section of major Greek gods and goddesses, heroes and heroines, including Aphrodite and

Apollo, and Helen of Troy and Odysseus. The deceased is shown reclining on a kline on the lid. With her are her faithful little dog (only its forepaws remain at the left end of the lid) and Cupid (at the right). The winged infant-god mournfully holds a down-turned torch, a reference to the death of a woman whose beauty rivaled that of his mother, Venus (who appears on the back of the sarcophagus). The seahorses and dolphins of the small frieze beneath the kline refer to the journey of the dead woman over the sea to a blissful afterlife.

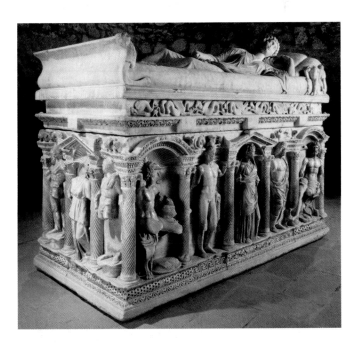

15-10 **Oblique view of the kline sarcophagus in Fig. 15-9.**

BATTLE AND BIOGRAPHICAL SARCOPHAGI

The unending military campaigns of the second century on the northern and eastern frontiers of the Empire help explain the popularity of battle scenes—whether mythological, historical, or contemporary—on Antonine sarcophagi, but again, the general notion of displaying the manly virtue of valor was more likely the primary motivation for the choice of such themes.

AMAZON SARCOPHAGI No Roman, for example, ever fought against the Amazons, but Amazon sarcophagi, such as the one (**Fig. 15-11**) found on the Via Collatina in Rome and datable to the time of Antoninus Pius, were commonly placed in Roman tombs. The Via Collatina sarcophagus shows the raging battle between Greeks and Amazons on the body of the coffin and dejected Amazon captives on the lid. The Amazons figured prominently in Greek art and were often treated as allegories for historical events, especially the war against the Persians in the early years of the fifth century BCE. The Amazonomachy was represented, for example, both on the metopes of the Parthenon and on the shield of the statue of Athena Parthenos inside the temple. All Greeks knew that those depictions of the battle of Greeks and Amazons were an allusion to the clash between Greeks and Persians earlier in the century. On the Via Collatina sarcophagus, the connection between the Greek mythological battle and Antonine warfare is evident in the two figures of Victory at the left and right of the sarcophagus front. One holds a garland, the other a trophy with second-century CE armor—not the distinctive scalloped shields (*peltas*) of the Amazons (compare Fig. 13-14).

GAUL SARCOPHAGI Legendary historical battles were also popular choices for Roman sarcophagi, most notably the victory of the Hellenistic Greeks of Pergamum in Asia Minor over the Gauls. The Gaul sarcophagus (**Fig. 15-12**) found in the Vigna Amendola on the Via Appia and now in the Capitoline Museum is an outstanding example. Its lid reprises the theme of seated captives of the earlier Amazon sarcophagus from the Via Collatina (Fig. 15-11), but the captured enemies are now Gauls. Below, the Gauls (who are said to have gone into battle wearing only necklaces and are so represented) fight the heavily armed Greeks, some of whom are mounted on horses and attack the Gauls from above. Victory for the better-equipped Greeks is therefore inevitable, and trophies with bound Gallic captives frame the scene at left and right. Similar trophies regularly adorned the triumphal arches of Roman Gaul. In fact, the battle scene on the Capitoline Gaul sarcophagus is very similar to and incorporates some of the identical motifs of the attic reliefs of the Tiberian arch (Fig. 7-7) at Orange. No one, however, believes that the Antonine sarcophagus sculptor traveled to Gaul and based his work on monuments seen there. Rather, the Antonine sculptor had access to the same kinds of pattern books as the sculptors in Gaul had. Most scholars believe that the original source of the composition was a painting or relief in Pergamum itself.

SARCOPHAGI OF ROMAN GENERALS Other Antonine sarcophagi depict scenes of contemporary warfare, but they too cannot be interpreted literally; rather, they should be regarded only as representations of noble qualities that the deceased wished viewers to attribute to him. On a sarcophagus (**Fig. 15-13**) in the Vatican, a seated Roman general receives captured northern barbarians, one of whom kneels as he begs for mercy. A female captive and her tearful daughter, probably

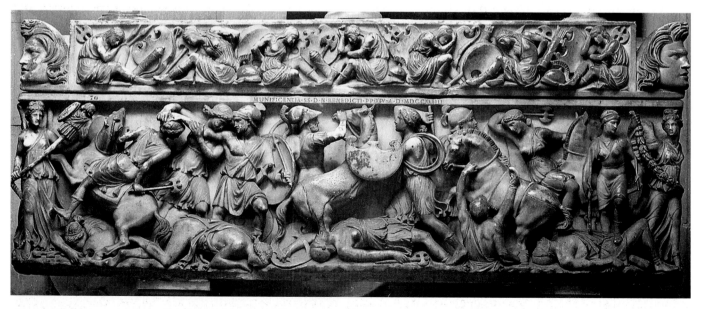

15-11 Sarcophagus with battle between Greeks and Amazons, from Via Collatina, Rome, ca. 150. Marble, 2′ 1⅝″ × 8′ 2″. Museo Capitolino, Rome.

15-12 Sarcophagus with battle between Greeks and Gauls, from Via Appia, Rome, ca. 160–170. Marble, 4′ 1¼″ × 6′ 11″.
Museo Capitolino, Rome.

the supplicant's wife and child, are also present. Trophies frame the scene at left and right. Victory, seminude and holding a palm branch in her left hand, crowns the general with a wreath, as he grants clemency to his enemy with a gesture of his right hand. The general's head seems to be a specific likeness of the deceased, but may be a generic portrait of a bearded Antonine man of about 170. Although the deceased may have served under Marcus Aurelius, perhaps even as a high-ranking officer, he need not have even been a soldier to purchase a sarcophagus in which he played the role of victorious emperor granting clementia. His family and friends would have known the deceased's true role, if any, in the northern campaigns, but he wished to present himself to posterity as a man who embodied the same virtues as the emperor.

A contemporaneous sarcophagus (**Fig. 15-14**) in Mantua depicts a variation of the Vatican clemency scene in the larger context of the deceased's life. At the left, the bearded general,

accompanied by both Victory and Virtus, grants clementia to a barbarian, his wife, and their young son. The father has his hands bound, but the woman and the boy reach out for mercy. In the center is a sacrifice of a bull in front of a temple of Jupiter, probably the god's Capitoline temple, where Roman generals offered prayers before leaving for battle and after their return (compare Fig. 13-20). At the right, the deceased and his wife join hands in a *dextrarum iunctio* (compare Fig. 11-25) at their wedding ceremony. Between the groom and bride are *Concordia* (concord, in this case marital harmony), personified as a robed woman, who unites the two, and Hymenaeus, the torch-bearing boy who is present at marriages. Sarcophagi like this one are usually called biographical sarcophagi, but pseudo-biographical is a more accurate adjective. The deceased would never, for example, have sacrificed at the Temple of Jupiter Capitolinus and probably was never in a position to grant clementia to enemies. Rather,

15-13 Sarcophagus with Roman general granting clemency, ca. 170. Marble, 2′ 6¾″ × 7′ 10⅞″. Musei Vaticani, Rome.

15-14 Sarcophagus with episodes from the life of a Roman general, ca. 170. Marble, 2′ 9½″ high. Palazzo Ducale, Mantua.

the Mantua sarcophagus—and the many others like it with identical scenes—are generic types that celebrate three essential characteristics of a virtuous Roman man, namely success in warfare coupled with clemency toward defeated foes, piety to the gods, and marital fidelity.

That sarcophagi with such scenes should not be interpreted literally is proved not only by their pattern-book compositions, repeatedly replicated, but by the existence of sarcophagi in which the portrait features of the deceased were never added. These sarcophagi, including exceptionally large

and masterfully carved examples such as the battle sarcophagus (**Fig. 15-15**) from Portonaccio, must have been produced in workshops and made available for purchase to any customer who could afford the price. A discount may have been offered for buying the sarcophagus in its unfinished state, or else an additional fee was charged for carving the portrait(s). In either case, the sarcophagi were not custom pieces for specific clients with individual life histories.

On the Portonaccio sarcophagus, the central figure is a faceless general (**Fig. 15-1**) who rides fearlessly into the chaotic

15-15 Sarcophagus with battle between Romans and barbarians, from Via Tiburtina, Portonaccio, ca. 180–190. Marble, 3′ 8⅞″ × 7′ 10⅛″. Museo Nazionale Romano—Palazzo Massimo alle Terme, Rome.

heart of the conflict and strikes down all barbarians in his path. The motif is similar to that of Trajan charging against Dacians on the Great Trajanic Frieze (Fig. 11-23), but the composition, with its tiers of figures spread over the full height of the relief surface, is closer to those of the battle scenes on the contemporary Column of Marcus Aurelius (Figs. 13-24 and 13-25). Trophies and captives appear to the left and right of the clashing armies. On the lid are other events from the life of the deceased—the birth of a child at the left; a marriage scene at the center, as on the Mantua sarcophagus (Fig. 15-14); and a scene of clemency similar to that on the Vatican sarcophagus (Fig. 15-13). The heads of the general and his wife on the lid are also blank. The pseudo-biographical sarcophagi, like the mythological sarcophagi so popular under the Antonines, are allegories, not documentaries. They represent the qualities the deceased wished to have remembered, not the actual events of his life.

EGYPTIAN MUMMIES

With the shift from cremation to inhumation in the second century, sarcophagi began to appear all over the Roman Empire, but in Egypt, where burial had been practiced for millennia, marble coffins did not displace the ancient tradition of burying the dead in mummy cases. In 1996, the number of preserved Egyptian mummies of the Roman period was greatly expanded by the discovery of a cemetery at Bahariya Oasis in the desert southwest of Cairo. The site—at least four square miles in size—has come to be called the Valley of the Golden Mummies. The largest tomb found to date contained 32 mummies, but another had 43, some stacked on top of others because the tomb was used for generations and space ran out. The excavators believe the cemetery was still in use as late as the fourth or fifth century.

MUMMY PORTRAITS The Roman mummies differ from those of pharaonic times in having painted portraits on wood panels inserted into the cases in place of the traditional stylized masks of the deceased. Most preserved mummy portraits, usually painted in encaustic (see "Iaia of Cyzicus and the Art of Encaustic Painting," page 228), came from the cemeteries of the Faiyum district on the west bank of the Nile. These portraits, which date mostly to the second and third centuries, were probably painted while the subjects were still alive and then cut down to fit into the mummy cases. They depict a wide range of people, young and old, male and female, merchants and priests.

The mummy (**Fig. 15-16**) of Artemidorus from Hawara is fully preserved. The painted red stucco case is decorated with several bands of traditional Egyptian funerary motifs in gold leaf. The largest scene, just below the portrait, represents Anubis, the jackal-headed god of mummification, preparing Artemidorus's mummy while two goddesses look on. They are probably Isis and Nephthys, who collected the severed body parts of Osiris, one of the chief deities of Egypt, and brought him back to life. Osiris himself is represented below, rising from his bier. This theme of resurrection had an obvious

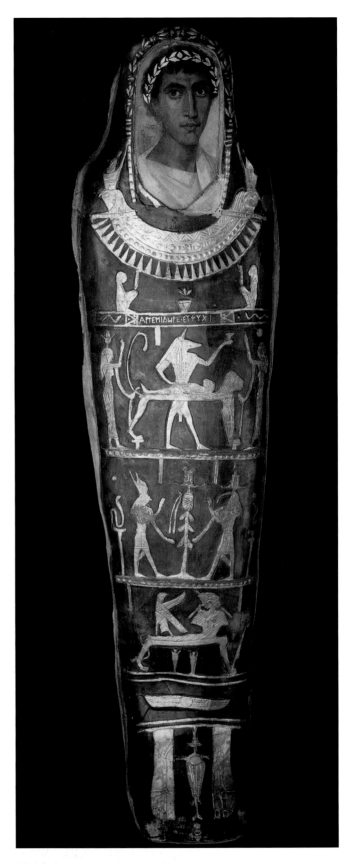

15-16 **Mummy of Artemidorus, from Hawara, Egypt, ca. 100–120. Mummy case, stucco with gold leaf, approx. 5′ 7$\frac{1}{4}$″ high; portrait, encaustic on wood. British Museum, London.**

Iaia of Cyzicus and the Art of Encaustic Painting

The names of very few Roman artists are known. Those that are tend to be names of artists and architects who directed major imperial building projects (Severus and Celer, Domus Aurea; Apollodorus of Damascus, Forum of Trajan), worked on a gigantic scale (Zenodorus, Colossus of Nero), or made precious objects for famous patrons (Dioscurides, gem cutter for Augustus).

An interesting exception to this rule is Iaia of Cyzicus. Pliny the Elder reported the following about this renowned painter from Asia Minor who worked in Italy during the Republic:

> Iaia of Cyzicus, who remained a virgin all her life, painted at Rome during the time when M. Varro [116–27 BCE] was a youth, both with a brush and with a cestrum on ivory, specializing mainly in portraits of women; she also painted a large panel in Naples representing an old woman and a portrait of herself done with a mirror. Her hand was quicker than that of any other painter, and her artistry was of such high quality that she commanded much higher prices than the most celebrated painters of the same period.*

The *cestrum* Pliny mentions is a small spatula used in *encaustic* painting, a technique of mixing colors with hot wax and then applying them to the surface. Pliny knew of encaustic paintings of considerable antiquity, including those of Polygnotos of Thasos, a famous fifth-century BCE Greek painter. The best evidence for the technique, however, comes from Roman Egypt, where mummies were routinely furnished with portraits painted with encaustic on wooden panels (Figs. 15-16 to 15-19).

Artists applied encaustic to marble as well as to wood. According to Pliny, when Praxiteles was asked which of his statues he preferred, the fourth-century BCE Greek artist, perhaps the ancient world's greatest marble sculptor, replied: "Those that Nikias [see Chapter 10] painted."† This anecdote underscores the importance of coloration in ancient sculpture, unfortunately missing from almost all surviving Greek and Roman marble statues and reliefs. ■

* Pliny the Elder, *Natural History,* 35.147–148. Translated by J. J. Pollitt, *The Art of Rome, c. 753 B.C.–A.D. 337: Sources and Documents* (New York: Cambridge University Press, 1983), 87.

† Pliny the Elder, *Natural History,* 35.133.

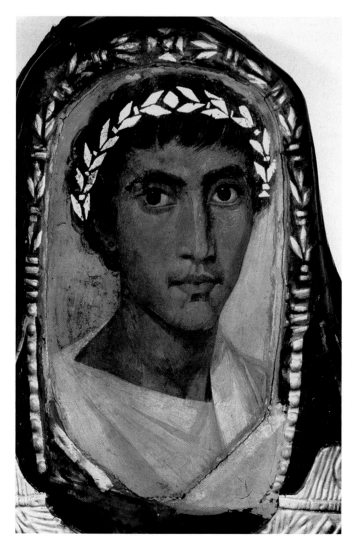

15-17 Portrait of Artemidorus, detail of the mummy in Fig. 15-16.

Also from Hawara is the encaustic portrait (**Fig. 15-18**) of a young woman datable about 110–120 based on the coiffure, which is a variation of Sabina's early hairstyle (Fig. 12-4). The excavator who discovered the portrait dubbed the deceased the "Jewelry Girl" because of her lavish adornment. Her hair, which is gathered into a bun at the top of her head, is held in place by a pin of pearls and garnets and a gold chain with a central medallion. Her trident-shaped earrings have four pearls each, and she wears four necklaces, one of which matches her hairpin.

A portrait (**Fig. 15-19**) of an Antonine man is representative of painting at Hawara of the mid-second century. The length of the man's hair and beard suggests a date between 140 and 160, but although the Egyptians followed the coiffure fashions of the capital, this man's hairstyle is distinctive. The three curly locks of hair that fall down over his forehead indicate that he is an adherent of the cult of Serapis and perhaps a priest of that god. In this portrait, as in the portrait (Fig. 15-18) of the young woman, the painter rendered the drapery in a more summary fashion than the face. The contrast

appeal to Artemidorus, whose portrait (**Fig. 15-17**) suggests that he died at a young age. He wears a wreath on his head and combs his hair in the manner popular during the principate of Trajan (Fig. 11-3).

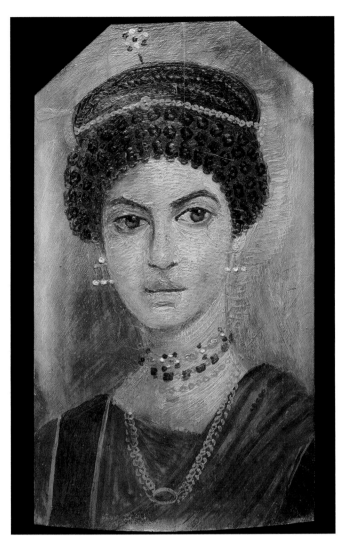

15-18 Mummy portrait of a young woman, from Hawara, Egypt, ca. 110–120. Encaustic on wood, 1′ 5 ¼″ × 1′ 1 ⅜″. **Royal Museum of Scotland, Edinburgh.**

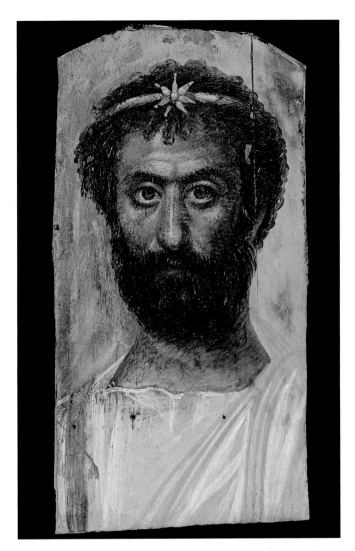

15-19 Mummy portrait of a priest of Serapis, from Hawara, Egypt, ca. 140–160. Encaustic on wood, 1′ 4 ¾″ × 8 ¾″. **British Museum, London.**

between the dark black hair and the highlights on the man's forehead, nose, and cheeks is especially effective. The Faiyum portraits carry on the tradition of portrait painting (Fig. 10-19) seen on the walls of Pompeii and help modern viewers to visualize the original appearance of Roman portraits in stone.

SUMMARY

The change in burial customs from cremation to inhumation that occurred in the Roman world during the second century gave rise to an important new sculptural type, the marble sarcophagus. The demand for sarcophagi was Empire-wide, and regional centers of sarcophagus manufacture were quickly established in Rome, Greece, and Asia Minor. Each center produced a distinctive type of coffin. Western sarcophagi were carved on only the front and sides. Those produced in the East had reliefs on all four sides, either in the form of continuous friezes (Attica, in Greece) or statuesque figures between columns (Asia Minor).

The subjects depicted on Roman sarcophagi were diverse. Themes from Greek mythology were very popular because they gave the deceased the opportunity to compare himself or herself to famous heroes and heroines who embodied admired qualities such as courage, piety, and beauty. Also popular were "pseudo-biographical" sarcophagi in which the deceased played the role of a general fighting the enemies of Rome or the emperor sacrificing in front of the Temple of Jupiter Optimus Maximus. Like the mythological sarcophagi, the coffins with contemporary scenes invited the viewer to reflect on the deceased's virtues—piety and courage again, and also marital fidelity.

In Roman Egypt, the dead were buried in mummy cases with inserted portraits painted in encaustic on wooden panels. The Egyptian mummies provide the best evidence for the evolution of portrait painting in antiquity.

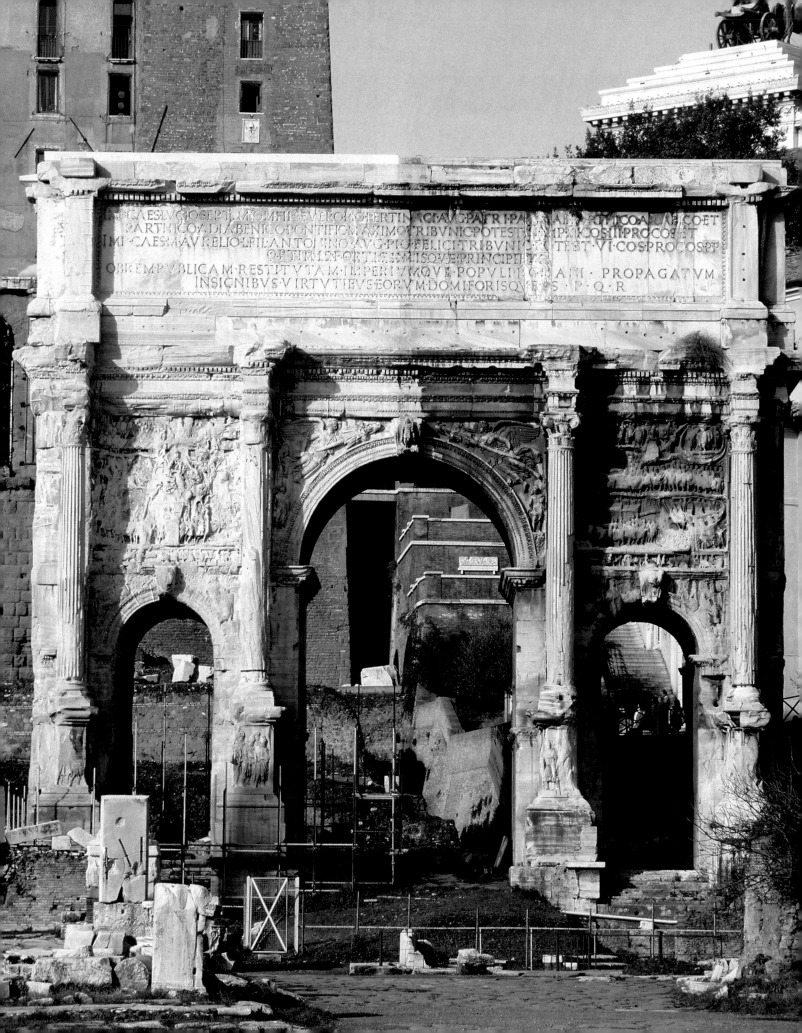

The Severan Dynasty

The assassination of an emperor always brings with it the potential for chaos. When Commodus was murdered on the night of December 31, 192, the Senate, in order to avert a civil war, met before the next day had dawned to proclaim Publius Helvius Pertinax (see "Pertinax and the Severan Dynasty," page 232), the *praetorian prefect* (commander of the praetorian guard) of Rome, as his successor. Pertinax, the son of a freedman, had risen from obscurity to the highest rungs of power during his long career. Originally a teacher, he enrolled as a military officer in Syria when he was in his mid-30s and advanced quickly through the ranks. Marcus Aurelius made him successively a senator, consul, and governor of three provinces. Pertinax served as consul a second time under Commodus before becoming praetorian prefect in his mid-60s and eventually party to the assassination plot. But Rome enjoyed only a brief interlude of stability. By early 193, the praetorian guard had turned against Pertinax. When praetorians murdered him in March, a new civil war became unavoidable.

Within 12 days, Lucius Septimius Severus, the governor of Pannonia Superior, had been proclaimed emperor with a mandate to avenge the death of Pertinax. Severus, who was born in Lepcis Magna (in present-day Libya; see Chapter 17), and who had become a senator under Marcus Aurelius, quickly obtained the backing of all 16 legions stationed on the Rhine and Danube. After taking Pertinax's name as his own, Severus marched on Rome. As he neared the city, the Senate threw its support to him. When the new emperor entered the city on June 9, 193, he purged the praetorian guard—which had just assassinated two emperors within a few months—and filled its ranks with loyal soldiers from the Danube region. A few years later, Severus appointed Gaius Fulvius Plautianus, a kinsman of his from Lepcis Magna, as the new prefect, cementing his control over the praetorians.

Severus's arrival in Rome did not, however, put an end to the ambitions of Pescennius Niger, the governor of Syria, whose troops had proclaimed him emperor in April 193. Severus's forces did not defeat, capture, and kill Niger until the following year. As soon as Severus established uncontested power, he set out to battle Rome's old nemesis, the Parthians, who had backed Niger. The resounding defeat of the Parthians led to Rome's annexation of Mesopotamia. The emperor finally returned to the capital in triumph in 202.

16-1 Arch of Septimius Severus, Forum Romanum, Rome, 203.

Pertinax and the Severan Dynasty

Pertinax (Publius Helvius Pertinax, r. 192–193) was prefect of Rome when Commodus was assassinated. The Senate elevated him to emperor that night, but he antagonized the praetorian guard. Praetorians murdered him three months later.

Septimius Severus (Lucius Septimius Severus, r. 193–211), born in Africa into a distinguished senatorial family, was governor of Pannonia Superior when his troops hailed him as emperor 12 days after the assassination of Pertinax.

Julia Domna, wife of Septimius Severus, was the daughter of the high priest of the Syrian sun god Ba'al. She married Severus in 187 and gave birth to two sons in the following two years.

Caracalla (Marcus Aurelius Antoninus Caracalla, r. 211–217) was the elder son of Septimius Severus and Julia Domna. He and his brother Geta succeeded their father as co-emperors, but Caracalla had Geta killed 10 months later.

Geta (Publius Septimius Geta, r. 211) was the younger son of Septimius Severus and Julia Domna and co-emperor with Caracalla from February to December 211. Caracalla had Geta's memory damned after ordering his murder.

Plautianus (Gaius Fulvius Plautianus) was the powerful praetorian prefect under Septimius Severus whose daughter Plautilla married the emperor's son Caracalla. Caracalla had him murdered in 205.

Plautilla, daughter of Plautianus, married Caracalla in 202. When her father was killed, she was banished from Rome. She was put to death under orders from her estranged husband in 212.

Macrinus (Marcus Opellius Macrinus, r. 217–218) was praetorian prefect under Caracalla and led the assassination plot against him. The next year, the supporters of Elagabalus defeated and killed Macrinus at Antioch.

Elagabalus (Marcus Aurelius Antoninus Elagabalus, r. 218–222) was the great-nephew of Julia Domna. His family promoted him as the rightful heir to power in opposition to Macrinus by claiming that his real father was Caracalla.

Julia Mamaea was the daughter of Julia Domna's sister Julia Maesa and the mother of Severus Alexander.

Severus Alexander (Marcus Aurelius Severus Alexander, r. 222–235) was the cousin and adoptive son of Elagabalus, whom he succeeded when Elagabalus was murdered. ∎

PORTRAITURE

In 195, Septimius Severus took the unprecedented step of creating a new ancestry—and legitimacy—for himself and his family by declaring himself the son of the deified Marcus Aurelius and the brother of Commodus, whom he deified and whose damnatio memoriae he canceled. To underscore that the Septimii had now become Antonines, Severus renamed Caracalla, his elder son, Marcus Aurelius Antoninus.

THE SEVERAN FAMILY Portraits in the round of the new generation of Antonines were created in great numbers and distributed to every corner of the Empire, but the primary vehicle for introducing the Severan family to the people was the imperial coinage. The coins bore the likenesses of the emperor, the empress, and their two sons, sometimes singly, sometimes in pairs, and occasionally as a foursome. The entire family appears on an aureus (**Figs. 16-2** and **16-3**) minted in Rome in 202, the year Severus returned to the capital from his campaigns in the East. Also that year, he arranged the marriage of Caracalla to Plautianus's daughter Plautilla, hoping the union would ensure the loyalty of the praetorian guard and pave the way for two more generations of Severan emperors.

16-2 Portrait of Septimius Severus, obverse of aureus, mint of Rome, 202. Gold, approx. $\frac{3}{4}''$ diameter. American Numismatic Society, New York.

A profile portrait of Septimius Severus wearing a laurel wreath on his head appears alone on the aureus obverse (Fig. 16-2). The emperor's features are distinctive, but the portrait type conforms closely to the later portraits of his "father" Marcus Aurelius (Figs. 13-8 and 13-10), with curly hair and beard separated into long strands beneath the chin. The imagery was fitting for the newest member of the Antonine dynasty.

The aureus reverse (Fig. 16-3) depicts Julia Domna between her two sons. The composition recalls the tripartite groups on the Column of Marcus Aurelius in which the emperor is the central frontal figure (Fig. 13-26). Such triads are common in Severan art (Figs. 16-16, 16-18, and 16-19), but this one is remarkable because very few ancient (or modern) coins have frontal heads for practical rather than aesthetic reasons. As coins pass from hand to hand, the highest parts of the reliefs begin to rub away. Profile heads may lose an ear or part of a cheek, but the facial features have a long life. In frontal portraits like Julia Domna's, the nose is the first detail to disappear, disfiguring the face, as in Fig. 16-3. The selection of a frontal head for a coin means that the aesthetic appeal of such a representation has taken precedence over practical considerations.

Julia Domna is represented with neck-length hair parted in the middle and combed in waves over her ears, a coiffure that is a more elaborate version of Faustina the Younger's (Fig. 13-7). Julia's sons, especially Caracalla to her right, are portrayed as Antonine-style princes. The inscription does not name any of the three, but it sums up the purpose of the family portrait: *felicitas saeculi,* or, loosely translated, "happy days are here again." The reason for the happy times is that the promise of a peaceful succession has brought stability to the Roman world after the civil conflicts following the murders of Commodus and Pertinax.

PAINTED PORTRAITS Painted imperial portraits must have been very common in ancient Rome, but because of their perishable nature, only one survives, a tondo portrait (**Fig. 16-4**) from Egypt depicting the Severan family, all posed frontally. The artist used *tempera* (pigments in egg yolk) on wood, a technique common also for second- and third-century mummy portraits (see Chapter 15), to which this imperial portrait is closely related.

The Severan family portrait is of special interest for two reasons beyond its mere survival. The emperor's hair is tinged with gray, suggesting that his marble portraits—which, like all marble sculptures in antiquity, were painted—also may have revealed his advancing age in this way. (The same was very likely true of the marble likenesses of the old and tired Marcus Aurelius.) The group portrait is also notable because Geta's face was erased after Caracalla had his brother murdered and his memory damned. The painted tondo from Egypt is an eloquent testimony to the far reach of damnatio memoriae decrees (see "Rewriting History: *Damnatio Memoriae,*" Chapter 9, page 136).

16-3 Portraits of Julia Domna (*center*), Caracalla (*left*), and Geta (*right*), reverse of aureus, mint of Rome, 202. Gold, approx. $\frac{3}{4}''$ diameter. American Numismatic Society, New York.

16-4 Group portrait of Septimius Severus (*top right*), Julia Domna (*top left*), Caracalla (*bottom right*), and Geta (*bottom left;* erased), from Egypt, ca. 200. Tempera on wood, approx. 1′ 2″ diameter. Staatliche Museen, Antikensammlung, Berlin.

16-5 **Heroic statue of Septimius Severus, from Nicosia, Cyprus, ca. 197. Bronze, 6′ 9″ high. Cyprus Museum, Nicosia.**

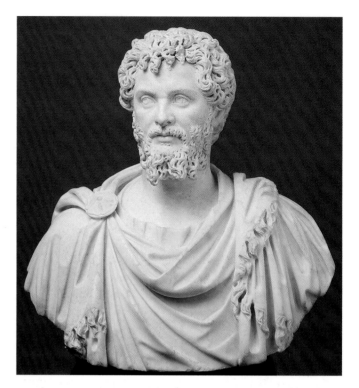

16-6 **Bust of Septimius Severus, ca. 200–211. Marble, 2′ 6¼″ high. Indiana University Art Museum, Bloomington.**

SEPTIMIUS SEVERUS All known portraits in the round of Septimius Severus date to the time of his accession or later and depict him as a mature bearded man in the Antonine tradition, as on his coins and in the Egyptian tondo portrait. He most frequently presented himself as imperator, but he played other roles as well, as, for example, in the over-life-size bronze statue (**Fig. 16-5**) from Cyprus of the emperor fully nude. The position of the hands suggests that he once held a spear and shield or perhaps a small trophy. If the latter, the emperor appeared in the guise of Mars Victor. In either case, the model for the portrait was a Greek statue of a god or athlete of the mid-fifth century BCE similar to Polykleitos's *Doryphoros,* which served as the model for Augustus's Primaporta statue (Fig. 5-11).

A second type of portrait of the emperor began to circulate around 200. An exceptionally well-preserved example is the marble bust (**Fig. 16-6**) in the Indiana University Art Museum. The Antonine "look"—complete with extensive drillwork in the hair, eyes, and beard—remains, but Septimius Severus now has four corkscrew locks of hair hanging vertically over his forehead. This is the canonical coiffure of the Egyptian god Serapis (compare Fig. 15-19), whose shrine at Memphis the imperial family had visited in 199. The "Serapis type," which is the most common type of Severan portrait today, underscores the emperor's North African roots.

JULIA DOMNA The Indiana portrait of Septimius Severus was found with a matching bust-length portrait (**Fig. 16-7**) of Julia Domna, which is also of outstanding quality and in nearly perfect condition, save for the empress's broken nose. Julia was a very important figure in Severan Rome and probably the most powerful empress since Livia. Her prestige, like Faustina the Younger's (see Chapter 13), derived in part from her having given birth to potential heirs. In the Indiana bust, she has the

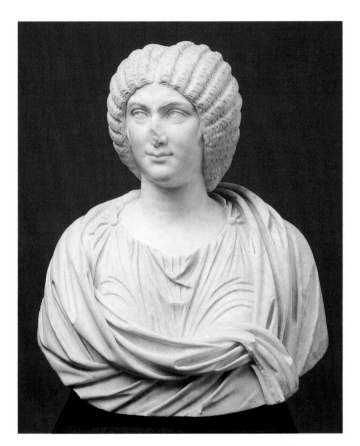

16-7 Bust of Julia Domna, ca. 200–211. Marble, 2' 4½" high. Indiana University Art Museum, Bloomington.

16-8 Caracalla in the guise of the infant Hercules strangling serpents, ca. 193–200. Marble, 2' 1¼" high. Museo Capitolino, Rome.

same coiffure as in her numismatic and painted portraits (Figs. 16-3 and 16-4), but the hair is clearly a wig, which many Roman women frequently wore. Two curls of real hair can be seen on her cheeks, emerging from beneath the helmetlike wig.

CARACALLA AS PRINCE Caracalla, like his namesake and fictive grandfather Marcus Aurelius, was a boy when he became the heir apparent to the emperorship, and he appears as such on coins (Fig. 16-3), in paintings (Fig. 16-4), and in portraits in the round. The most interesting of the sculptured portraits— although some scholars question the identification—is the statue (**Fig. 16-8**) of him in the guise of the infant Hercules strangling serpents (see "Greek Myths on Roman Sarcophagi," Chapter 15, page 221). The portrait is a retrospective one datable to the mid-to-late 190s and portrays the imperial prince as a pudgy child, with a round face and long tousled hair, choking one snake in each hand. A similar portrait representing Commodus or another Antonine prince as the infant Hercules is in the Museum of Fine Arts in Boston. The portraits of both Septimius Severus and his son therefore adhered closely to established Antonine imperial prototypes.

CARACALLA AS EMPEROR In contrast, the portraits of Caracalla as emperor break sharply with the Antonine tradition. A bust (**Fig. 16-9**) in Berlin, in which Caracalla appears

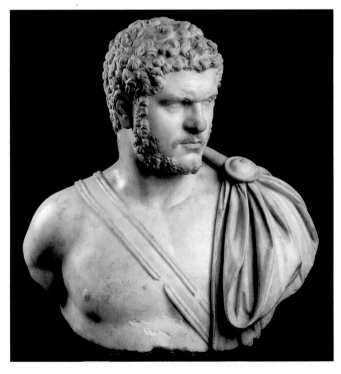

16-9 Bust of Caracalla, ca. 211–217. Marble, approx. 1' 10¾" high. Staatliche Museen, Antikensammlung, Berlin.

16-10 Head of Caracalla, ca. 211–217. Marble, approx. 1′ 2″ high. Metropolitan Museum of Art, New York.

16-11 Head of Elagabalus, ca. 220–222. Marble, 1′ $\frac{5}{8}$″ high. Museo Capitolino, Rome.

in heroic nudity save for a mantle over one shoulder and a sword sheath across his chest, and a head (**Fig. 16-10**) in the Metropolitan Museum of Art in New York are characteristic examples. The portraits brilliantly capture the ruthless personality of the man who arranged the murders of his brother, wife, and father-in-law. By this time, Caracalla was wearing his hair and beard short—so short, in fact, that the sculptor of the New York head chose to reproduce the close-cropped beard using incisions (negative carving) in the marble instead of rendering the strands of hair in relief (positive carving), as did the sculptor of the Berlin portrait. More remarkable, however, is the moving characterization of Caracalla's suspicious nature in both portraits. Their highly charged emotionalism is a further development from the groundbreaking introspection of the portraits of Marcus Aurelius (Fig. 13-22). Caracalla's brow is knotted—the V of his forehead forms an X with the lines running from his nostrils to the corners of his mouth—and he abruptly turns his head over his left shoulder, as if he suspects danger from behind. The emperor had reason to be fearful. He was felled by an assassin's dagger in the sixth year of his rule.

MACRINUS AND ELAGABALUS With the exception of Septimius Severus, all of Marcus Aurelius's immediate successors—Commodus, Pertinax, Geta, and Caracalla—met death by assassination, a pattern that continued through most of the third century. Macrinus, for example, the praetorian prefect who engineered Caracalla's murder and succeeded him as emperor,

was himself murdered by the followers of Elagabalus, the great-nephew of Julia Domna who claimed that Caracalla was his father. Elagabalus was saluted emperor in Syria when he was barely 15 years old. Four years later, he too was dead.

A marble head (**Fig. 16-11**) of Elagabalus in the Capitoline Museum depicts the teenage emperor with the shorter hair that his supposed father Caracalla made fashionable and long sideburns that merge with his incipient beard. He has a thin mustache and heavy eyebrows. The deeply drilled pupils of the eyes give the appearance that the young emperor is deep in thought.

SEVERUS ALEXANDER Shortly before his death, Elagabalus adopted his cousin Severus Alexander as his son in an attempt no doubt to foster renewed stability in the Empire. Because this adoption, like all previous adoptions, was a political act, it did not matter that the adopted son was only six years younger than his new father and that both father and son were teenagers. Alexander's mother, Julia Mamaea (Fig. 18-11), wielded enormous power during her son's 13-year reign. She accompanied him in 134 to Germany where he was planning to launch an attack on the Alamanni, a confederacy of Germanic tribes (the name means "all men"). Outside Mainz, she and her son were murdered in an uprising led by Maximinus Thrax (see Chapter 18).

Because of his relatively long tenure as emperor, more portraits survive of Severus Alexander than of the other rulers of the second quarter of the third century. Perhaps the best is a

16-12 Togate bust of Severus Alexander, ca. 222–235. Marble, 1′ 1⅝″ high (without base). Museo Capitolino, Rome.

togate bust (**Fig. 16-12**) in the Capitoline Museum that depicts Alexander when he was still in his teens. He wears the style of toga that was to become the norm in the third century, the toga with *contabulatio,* the flat band that runs from the left shoulder across the chest and under the right armpit. The portrait and its many now-lost replicas set the pattern for much of the portraiture of the rest of the century. Alexander's hair is cut so short that its contours follow the shape of the emperor's skull exactly. The sculptor delineated the strands of hair through incision, emulating the negative carving technique used for Caracalla's beard in the New York head (Fig. 16-10). Most telling, the emperor turns his head to the right and looks away from the viewer, seemingly unable to meet the onlooker's gaze. The portrait is far removed from the pompous and self-confident imagery of the Early and High Empire, but it was the way of the future.

ARCHITECTURE AND RELIEF SCULPTURE

The Severan emperors were the most ambitious builders in Rome for a century. Their work encompassed both restoration and new construction. In the former category, Severus renovated Vespasian's Templum Pacis (Fig. 9-10) and in the process provided a treasure trove of information about Roman topography for future archaeologists (see "The *Forma Urbis Romae,"* below). Among the new building projects the Severans undertook were the Septizodium, a monumental nymphaeum on the Palatine Hill resembling a theatrical scaenae frons; several bathing complexes including the Baths of Caracalla; a triumphal arch in the Forum Romanum; and various temples for the worship of Eastern deities (see "Oriental Gods in Severan Rome," page 244).

ARCHITECTURAL BASICS

The *Forma Urbis Romae*

One of the halls to the right of the temple proper in the Flavian Templum Pacis (Fig. 9-10) was, by the early third century at the latest, probably the office of the urban prefect of Rome. There, under Septimius Severus, a huge marble plan of the entire city of Rome was displayed on a wall. The plan—known today as the *Forma Urbis Romae*—first came to light by chance in May 1562 and immediately attracted the attention of Renaissance scholars. In its original form, the Severan plan was incised on 151 marble slabs. Only a small portion has been recovered, and the slabs that do survive are broken into hundreds of pieces. Researchers therefore have been confronted with a giant and incomplete jigsaw puzzle, but they have been able to determine the plans of many buildings that have

never been excavated, including miscellaneous insulae, horrea, and streets, as well as those of famous temples, basilicas, and theaters, including the Templum Pacis itself and the Theater of Pompey (Fig. 4-14), whose plan was engraved on one of the largest and best preserved fragments (Fig. 4-13). The Severan *Forma Urbis* does not provide a precisely accurate rendition of the individual buildings, but it must have served its purpose as a sketch map of the city for administrators who needed to consult it in the third century. Despite its inaccuracies and its fragmentary state, the *Forma Urbis* has been a bonanza for archaeologists and architectural historians. The model of imperial Rome illustrated in Fig. 1-2 is based in large part on the Severan marble plan of the city. ■

16-13 Septimius Severus introducing Caracalla and Geta, from Rome, ca. 205. Marble, 7′ 8″ × 5′ 2″. high. Palazzo Sacchetti, Rome.

PALAZZO SACCHETTI RELIEF The Severan buildings in Rome were richly adorned with sculpture, both freestanding and in relief. A marble panel (**Fig. 16-13**) in the Palazzo Sacchetti in Rome that once decorated an unknown Severan civic structure is of interest because it is a narrative version of the dynastic imagery of contemporary coins and paintings (Figs. 16-2 to 16-4). The composition recalls those of the Anaglypha Hadriani adlocutio relief (Fig. 12-8). At the right, Septimius Severus sits on an elevated platform. Opposite him is a triumphal arch with Victories in the spandrels. A group of toga-clad senators has passed through the gateway to attend the ceremony in which the emperor formally presented his two sons to the Senate. Caracalla, easily recognizable by his long hair and youthful face, is the tallest person on the dais. Geta, whose head (like his father's) is missing, is at the far right. The most likely date of the relief is 205, the year Caracalla and Geta served as co-consuls, taking office January 1. But even if this is not the specific occasion depicted, the general message of peaceful dynastic succession is clear.

ARCH OF SEPTIMIUS SEVERUS Severus's auto-adoption into the Antonine family notwithstanding, the new emperor could not disguise that he had seized power in a civil war—as had Augustus and Vespasian before him. And, like those emperors, Severus sought a foreign victory to legitimize his rule. For Augustus, it was a negotiated settlement with the Parthians (see Chapter 5); Vespasian achieved his in his son Titus's triumph in Judaea (see Chapter 9). For Septimius Severus, it was his successful siege of Ctesiphon in 198, which brought the latest war against the Parthians to an end.

Shortly after his return to Rome from the East in 202 and his triumphal parade through the city, Severus began construction of a triumphal arch to commemorate his Parthian victory. The arch (Figs. 1-2, no. 7, **16-1**, and **16-14**) was erected in 203 in the Forum Romanum diagonally across the open plaza from

Augustus's 200-year-old Parthian arch (Figs. 5-5, no. 6, and 5-6) and on the triumphal route that ran down the Via Sacra and then up past the Parthian arch of Nero (Fig. 8-22) to the Temple of Jupiter Capitolinus (Fig. 1-2, no. 4). (The ancient road is clearly visible in Fig. 16-14.) The choice of location was ideal, because it connected the Severan dynasty with the founder of the Roman Empire and gave Severus an opportunity to introduce his sons and successors to the Roman people in a prestigious setting amid some of the city's most venerable buildings. The lengthy inscription on the attic of the arch names both Caracalla and Geta. (Caracalla later had Geta's name erased.) Contemporaneous coins depict the arch and show the colossal gilded-bronze statuary group that once crowned the monument. Severus was portrayed driving his quadriga in the triumphal procession of 202, and his two sons rode on horseback to his left and right.

The Severan arch emulated Augustus's Parthian arch (Fig. 5-6) in having three passageways, but the third-century arch followed the pattern of the Tiberian arch (Fig. 7-7) at Orange and other arches of the Early and High Empire in incorporating three arcuated bays in a single architectural unit. The spandrels of the central bay on each side of the arch have trophy-carrying Victories and personifications of the Four Seasons, as on the city facade of the Arch of Trajan at Benevento (Fig. 11-19). The lateral bays feature reclining river gods in the spandrels, as on the country facade of the Benevento arch. The message was the same: The Parthian victory was just one example of Rome's omnipotence. Rome's armies will always be victorious everywhere and in every season. The Severan architect borrowed other elements of the design from the Neronian arch (Fig. 8-22) on the Capitoline Hill, most notably the freestanding columns on projecting pedestals with relief decoration. On the Severan arch, the pedestal reliefs (**Fig. 16-15**) depict Roman soldiers escorting Parthian captives whom every Roman would have recognized immediately because of their distinctive garb, most notably their soft caps and trousers.

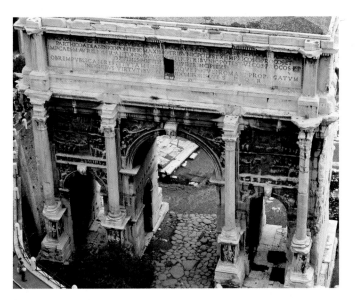

16-14 Arch of Septimius Severus (seen from above), Forum Romanum, Rome, 203.

16-15 Roman soldier and Parthian prisoner, detail of column pedestal, Arch of Septimius Severus, Forum Romanum, Rome, 203.

In all these respects, therefore, the Arch of Septimius Severus was firmly in the tradition of imperially commissioned triumphal arches, but one aspect of the Forum Romanum arch separates it from all the others. The relief panels over the lateral passageways differ sharply from the vertically oriented panels depicting a small number of large figures standing on a common ground line that adorned the facades of the arches of Nero, Trajan, and Marcus Aurelius (Figs. 13-19 to 13-21). Instead, the Severan panels (**Fig. 16-16**) look like excerpts from the spiral frieze of the Column of Trajan (Figs. 11-1, 11-11, and 11-12) and especially that of the Column of Marcus Aurelius (Figs. 13-24 to 13-27). The Severan panels

depict episodes from the emperor's Parthian campaigns and borrow many motifs directly from the Aurelian frieze, for example, the emperor as the central figure of a frontal triad. Each of the four reliefs documents the events that took place in a specific locale. The one illustrated here may represent (reading from bottom to top as on the Columns of Trajan and

16-16 War against the Parthians, northeastern panel, Arch of Septimius Severus, Forum Romanum, Rome, 203.

Marcus Aurelius) the siege of Edessa by means of a gigantic battering ram, the subsequent submission of the Parthian soldiers to the emperor, and (at the upper left and right respectively) an adlocutio and a war council in a military camp whose walls are seen from above, a scene rendered with the same kind of dual perspective as employed in the Aurelian frieze (Fig. 13-27). This style of narrative format, which may ultimately be based on the paintings carried in triumphal processions (see Josephus's description of the Flavian paintings in the triumph of Vespasian and Titus, Chapter 11, page 160), was arguably much better suited to panel reliefs than to spiral friezes, because the entire narrative could be read from a single vantage point.

ARCH OF THE ARGENTARII The unusual nature of the panels on the Severan arch in the Forum Romanum is underscored when that arch is compared to the much smaller arch (**Fig. 16-17**) that the bankers (*argentarii*) and cattle dealers of Rome erected a year later in honor of the imperial family. The Arch of the Argentarii is actually a *porta*, or gate with a flat-roofed passageway, that marked the entrance to the Forum Boarium, Rome's meat market near the Tiber. Plautilla and her father Plautianus were cited in the dedicatory inscription along with Septimius Severus, Julia Domna, Caracalla, and Geta. Whether the merchants were motivated by favors already granted or by the hope of receiving future favors is unknown. What is certain is that the freedmen who paid for the arch looked to imperial models as guides for the content and composition of the arch's reliefs.

The pilasters that frame the reliefs are decorated either with acanthus scrolls or military standards that incorporate portraits of Septimius Severus and his sons. Below the large vertical panels are smaller horizontal panels depicting the sacrifice of bulls—a rite that had special significance for the businessmen who provided the animals that were slain. The vertical relief on the only exposed short end of the arch—the opposite end is built into the church of San Giorgio in Velabro—represents Roman soldiers escorting Parthian captives, just as on the pedestal reliefs (Fig. 16-15) of the Severan arch in the Forum Romanum.

16-17 Arch of the Argentarii, Forum Boarium, Rome, 204.

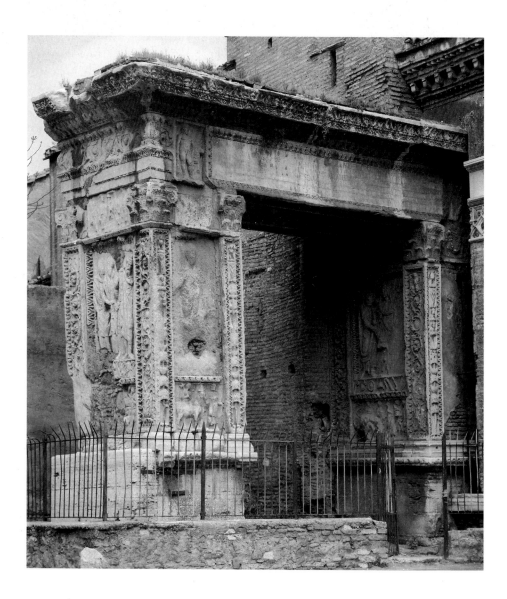

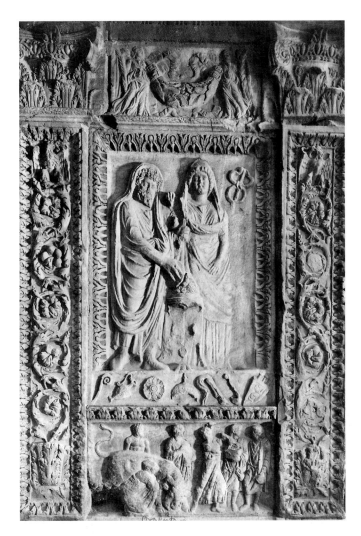

16-18 Septimius Severus, Julia Domna, and Geta (erased) sacrificing, relief panel in passageway, Arch of the Argentarii, Rome, 204.

16-19 Caracalla, Plautilla (erased), and Plautianus (erased) sacrificing, relief panel in passageway, Arch of the Argentarii, Rome, 204.

More interesting, both stylistically and politically, are the two vertical panels in the gate's passageway. They are in a sorry state today—and already were in 212—but originally represented Septimius Severus sacrificing as Julia Domna and Geta look on in one relief (**Fig. 16-18**) and, in the other panel (**Fig. 16-19**), Caracalla sacrificing in the presence of Plautianus and Plautilla. Although the chief figure in each relief stands to one side of the altar, the compositions otherwise adhere to the newly popular pattern of a frontal central figure flanked by two subsidiary figures, usually in three-quarter views facing the central figure.

In the first relief, Severus is dressed as pontifex maximus. His coiffure is the Serapis type of his later portraits (Fig. 16-6). The empress wears a tiara and once held a *caduceus* (the serpent-entwined staff that was the attribute of Mercury, the patron god of businessmen) in her left hand. Today the caduceus floats in space in the upper right corner of the panel, because after Geta's murder and damnatio memoriae in 211,

his portrait was chiseled away (see "Rewriting History: *Damnatio Memoriae,*" Chapter 9, page 136). The artist then added Julia's left arm, formerly hidden by Geta's body, not realizing that she should have been represented holding the caduceus.

The relief on the opposite side of the passageway shows the young Caracalla (compare the contemporary portrait on the Palazzo Sacchetti relief, Fig. 16-13) pouring the contents of his patera onto the tripod altar at the center of the composition. Missing are Plautianus and Plautilla, whose portraits were removed in 205 and 212 respectively. The reactions of the Forum Boarium patrons to the senatorial damnation edicts must have been immediate on each occasion. This means that only one year after the argentarii proudly dedicated their new arch, someone was sent to obliterate Plautianus's name from the attic inscription and cut away his portrait from the Caracalla relief, leaving the prince and his recent bride facing each other across the central void where the praetorian prefect once stood. Six years later, another sculptor had to chisel away Geta's name and portrait—leaving behind the floating caduceus. Finally, in 212, Plautilla's name and portrait were erased. There could be no better example of how political considerations took precedence over artistic integrity in imperial Rome.

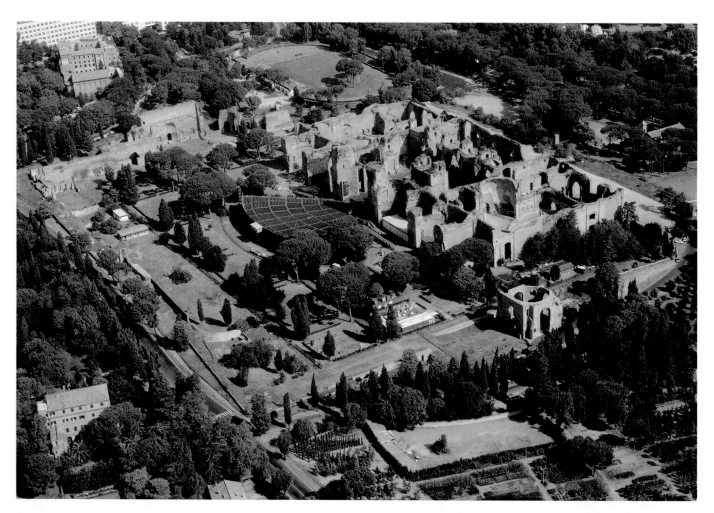

16-20 **Aerial view of the Baths of Caracalla, Rome, dedicated 216.**

BATHS OF CARACALLA The Severan emperors also made sure to meet the Romans' enormous appetite for ever more magnificent public bathing complexes. Early on, Septimius Severus built a new bathing complex on the Aventine Hill, the Thermae Septimianae, and he also began construction of the huge complex on the outskirts of the city that Caracalla completed. The Baths of Caracalla (**Fig. 16-20**), or the Thermae Antoninianae as they were officially called (in line with the new name Caracalla acquired after his father's self-adoption into the Antonine family), dwarfed the earlier Severan baths in size and outshone them for lavish appointments. In the fifth century, the Thermae Antoninianae were ranked among the Seven Wonders of the ancient city. Today, the Baths of Caracalla have been reduced to scattered concrete walls and fragments of fallen vaults, but they still impress visitors by their scale and extent. Originally, the vaults sprang from thick concrete walls up to 140 feet high. The circular caldarium (**Fig. 16-21,** no. 5) was capped by a dome almost as large as the Pantheon's, and the concrete drum that supported it was much taller. Until recently, the remains of the caldarium's concrete walls formed part of the support for the modern seats visible in the aerial view, Fig. 16-20. Those seats accommodated hun-

dreds of spectators at open-air summer performances of Italian operas and help give an idea of the size of the caldarium and the bathing complex as a whole.

The plan (Fig. 16-21) of Caracalla's thermae was similar to those of the Baths of Titus and Trajan (Fig. 11-18): bilaterally symmetrical, with the natatio, frigidarium, tepidarium, and caldarium on the central axis, and twin palaestras to the left and right. The central bathing bloc, however, was only part of the complex. There were also landscaped gardens, libraries, meeting and lecture halls, and similar amenities spread over 50 acres within the gigantic precinct walls—in short, all the leisure attractions that drew thousands, rich and poor, to the public baths daily (see "An Afternoon at the Baths," Chapter 2, page 24).

The magnificence of the Baths of Caracalla is evidenced by a reconstruction drawing (**Fig. 16-22**) of the frigidarium (Fig. 16-21, no. 3), the central hall of the bathing bloc at the intersection of the two main axes of the building—the longer one running from palaestra to palaestra (Fig. 16-21, no. 6) and the shorter one from natatio to caldarium (Fig. 16-21, nos. 1 and 5). The frigidarium had three huge stuccoed groin vaults that were visually supported by colossal columns with Com-

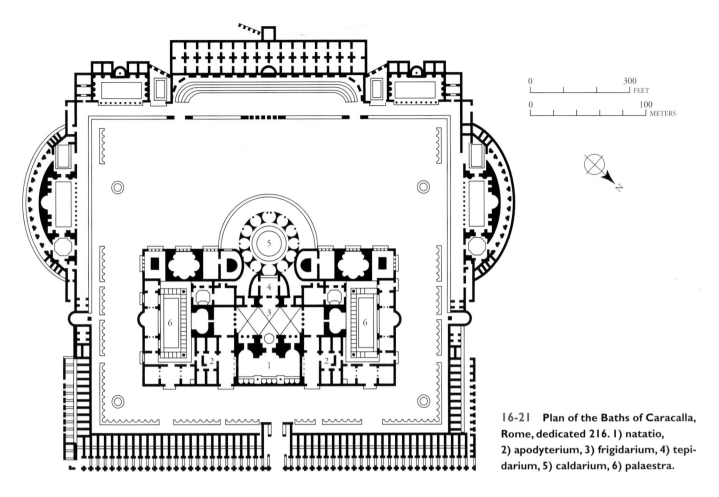

16-21 Plan of the Baths of Caracalla, Rome, dedicated 216. 1) natatio, 2) apodyterium, 3) frigidarium, 4) tepidarium, 5) caldarium, 6) palaestra.

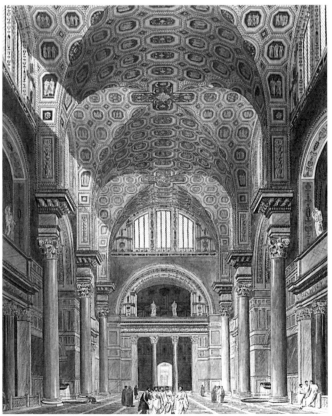

16-22 Restored view of the frigidarium, Baths of Caracalla, Rome, dedicated 216.

posite capitals but were actually held up by the concrete walls (compare Fig. 19-12). Those walls as well as the floor were revetted with marble slabs of different colors from a variety of quarries on three continents. Statues, many of superhuman size (10 are preserved), completed the decorative program.

Some of the rooms had mosaic floors, either polychrome or in the black-and-white style so popular in second- and third-century Ostia (Figs. 14-5 to 14-7). The most ambitious mosaics filled the semicircular exedras of the palaestras and represented athletes and their trainers (**Fig. 16-23**). The nude athletes—some full-length, some bust-length—all conform to an ideal of physical perfection very different from that of the Greek works that inspired earlier Roman statues such as the Republican Pseudo-Athlete (Fig. 4-10), the Corinthian portrait of Gaius Caesar (Fig. 5-14), the marble statues of Antinous (Fig. 12-6), or even the Cypriot bronze portrait of Septimius Severus (Fig. 16-5). The Severan athletes in the Baths of Caracalla have barrel chests and thick necks and thighs. In contrast to the lean, perfectly proportioned bodies of Greek Olympic athletes, these Roman athletes have the bodies of ancient gladiators and modern wrestlers and football players. They are exemplars of brute strength, not grace. It should come as no surprise, then, that the most muscle-bound statue known of Hercules, the so-called Farnese Hercules (named for the pope who plundered

16-23 Athletes, detail of floor mosaic, exedra of the palaestra, Baths of Caracalla, Rome, dedicated 216. Musei Vaticani, Rome.

RELIGION AND MYTHOLOGY

Oriental Gods in Severan Rome

Septimius Severus hailed from Lepcis Magna (see Chapter 17) in North Africa, and his wife Julia Domna from Syria. Their Eastern backgrounds exposed them to deities and cult practices that were foreign to Rome, and they and the Severan emperors who succeeded them imported some of these cults to the capital.

The most significant of these—and the most foreign—was the worship of the Syrian sun god Ba'al. Julia Domna and her sister Julia Maesa were the daughters of the high priest of Ba'al at Emesa, a position that Elagabalus inherited while still a teenager. When he became emperor in 218, he resolved to bring the cult with him to Rome. Elagabalus arrived in the capital in July 219 with the sacred *aniconic* (portrayed symbolically rather than represented) image of Ba'al in his possession and immediately began planning to build two temples to the sun god in Rome, one in the suburbs and a more important and larger one on the site of a

temple to Jupiter on the slope of the Palatine Hill facing the Temple of Venus and Roma. After the temples were completed, the emperor instituted a twice-yearly procession of Ba'al's cult image between the two shrines. He also divorced his wife in order to marry a Vestal Virgin, a union that symbolized for him the sacred marriage between heaven and earthly fire.

The Romans were revolted by the orgiastic aspects of the Ba'al cult, which involved circumcision and human sacrifice, but they were most offended by Elagabalus's decision to make Sol Invictus (the Invincible Sun, Ba'al's Latin name) the supreme god of the state, usurping Jupiter, who had held that position for nearly a millennium. Roman opposition to the Oriental god led to Elagabalus's murder, the banishment of Ba'al from the capital, and the rededication of the temple on the Palatine to Jupiter Ultor (the Avenger)—a fitting epithet under the circumstances. ▪

16-24 Glykon of Athens, early-third-century copy (Farnese Hercules) of Weary Herakles by Lysippos, ca. 320 BCE, from the Baths of Caracalla, Rome. Marble, approx. 10′ 5″ high. Museo Archeologico Nazionale, Naples.

the Baths of Caracalla for his private collection), was found in this complex. The statue (**Fig. 16-24**), more than 10 feet tall, is signed by Glykon of Athens and is a copy of a late-fourth-century BCE statue by the Greek master Lysippos. Mosaics and statues alike presented a new model of male perfection to the Romans who frequented the Thermae Antoninianae—a look consistent with the brute power and emotional intensity on display in the emperor's own portraits (Figs. 16-9 and 16-10).

SEVERAN TEMPLES The Severans were not great temple builders, but some of the shrines they restored or erected are significant for the history of Roman religion if not of Roman architecture. Septimius Severus constructed a new temple for the worship of Hercules and Bacchus, the Roman equivalents of the two patron deities of his native Lepcis Magna, Melqarth and Shadrap. Caracalla erected a gigantic new temple to Serapis on the Quirinal Hill, the only known temple with a facade of 12 columns. Elagabalus built two temples to the Syrian sun god Ba'al (see "Oriental Gods in Severan Rome," page 244). Severus Alexander renovated the Sanctuary of Isis in the Campus Martius. All these dedications can be explained by the African and Syrian roots of the imperial family, but the new temples also reflected the increasing popularity of Oriental religions in Italy. This Orientalizing trend would reach a crescendo when Constantine embraced Christianity and constructed the first churches in Rome in the early fourth century, setting in motion the rapid decline of the traditional Greco-Roman gods and the eventual triumph of Christian monotheism (see Chapter 20).

SUMMARY

When Septimius Severus defeated his last rival in 194 in the civil war following Commodus's assassination, he immediately set out to establish what he hoped would be a new long-lasting dynasty. Having adopted himself as the son of Marcus Aurelius, the African-born emperor used coins and portraits in the round to present himself, his wife, and their two sons as the rightful heirs of the Antonines and the initiators of a great new era for Rome. A victory over the Parthians allowed Septimius Severus to celebrate a triumph and build a huge triple-passageway arch in the Forum Romanum in sight of Augustus's own two-century-old Parthian arch. The relief panels of the Severan arch, in which the sculptors abandoned the traditional compositions of imperial reliefs in favor of the narrative format of the Columns of Trajan and Marcus Aurelius, are important documents of the accelerating dissatisfaction with the Classical style.

When Severus died, his dream of his sons' succession as co-emperors came true, but Caracalla soon had Geta murdered and became a hated ruler who was himself assassinated six years later. Caracalla's portraits are noteworthy for their psychological characterization of the ruthless emperor, setting the tone for most of the imperial portraits of the next half century (see Chapter 18).

The most significant Severan architectural project in the capital was Caracalla's huge and lavishly decorated Thermae Antoninianae, but the Severans were also active builders elsewhere, especially in their hometown of Lepcis Magna in North Africa (see Chapter 17).

Lepcis Magna and the Eastern Provinces

Lepcis Magna, some 75 miles east of Tripoli on the Mediterranean coast of present-day Libya, was the birthplace of Septimius Severus and his powerful praetorian prefect Plautianus (see Chapter 16). The origins of Lepcis are not recorded, but the site seems to have been settled by the end of the sixth century BCE. During the Roman Republic, Lepcis was a Punic city allied with or an outpost of Carthage, Rome's great African enemy. After the Roman defeat of the Carthaginians, Lepcis came under Roman control, but the city remained a modest settlement, albeit one with a natural harbor that linked its residents with other ports all over the Mediterranean.

Under Augustus, Lepcis Magna enjoyed its first period of prosperity, and some of its citizens were able to amass sufficient wealth to sponsor the erection of major new civic buildings, most notably a theater and *macellum* (public market), both constructed of gray limestone from nearby stone quarries. The theater's dedicatory inscription—characteristically bilingual (Latin and Punic)—gives its date as 1 or 2 CE and names Annobal Rufus as its patron.

Other public monuments were erected under Tiberius, Nero, Vespasian, and Trajan, but the next great period of building activity at Lepcis Magna did not occur until the principate of Hadrian. During his rule, a great public bath complex was constructed, one of the largest outside Rome. Inaugurated in 126, the Hadrianic baths had a symmetrical plan modeled on the imperial thermae in the capital and were richly decorated. The floors were paved with marble, and many of the vaults were covered with mosaics. Copies of famous Greek statues were on display there, as was at least one portrait of Antinous.

SEVERAN LEPCIS MAGNA

Not surprisingly, Lepcis Magna experienced its greatest prestige and prosperity under the Severans. Septimius Severus expanded and improved the city's harbor and aqueducts, began construction of a new forum, and erected a triumphal arch as well as a monumental nymphaeum and other structures. The boom period was short-lived, however. Lepcis's fortunes declined rapidly during the turbulent third century, and the site was abandoned after the Vandal invasion of 455. The city had a brief revival under the Byzantine emperor

17-1 Detail of the facade of the Khazneh (Fig. 17-16), Petra, Jordan, second century.

Justinian in 533, but the Arab conquest of 643 ended the life of Lepcis permanently. In time, the city was buried beneath the desert sands, lost to history until Italian archaeologists began to explore the site in the 1920s. Today, extensive restoration work is under way to make Lepcis Magna a tourist-friendly destination.

SEVERAN FORUM The major Severan architectural project in Lepcis Magna was a new forum (**Figs. 17-2** and **17-3**) located near the refurbished harbor. No dedicatory inscription has been found, but the base of a portrait statue of a local dignitary mentions the "new Severan forum," as it must have

been called in the third century to distinguish this complex from the city's older civic center. Although a new building project, the Severan forum was located in an old section of the town that had an irregular plan with bending streets. This accounts for the asymmetrical contour of the forum and explains why the basilica (Fig. 17-2, no. 3) is at an angle to the forum proper (Fig. 17-2, no. 2). The architect, however, managed to disguise these irregularities by placing a wedge-shaped row of tabernae all along the south side of the forum and a second set of shops and an exedra at the east end between the forum colonnade and the basilica. Thus, anyone standing inside the forum would see only a perfectly rectangular portico on three

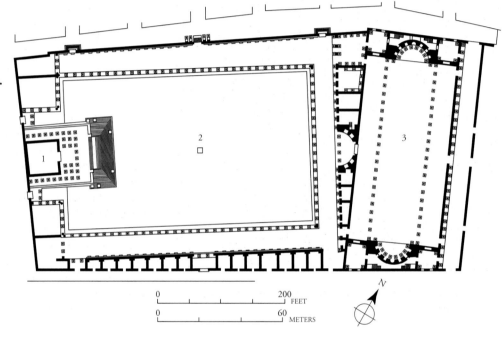

17-2 Plan of the Severan forum, Lepcis Magna, Libya, dedicated 216. 1) Temple of the Severi, 2) forum, 3) basilica.

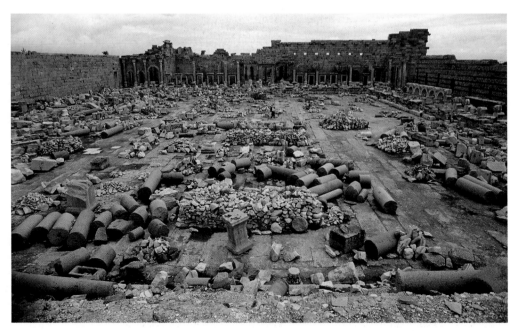

17-3 Severan forum (looking toward the basilica), Lepcis Magna, Libya, dedicated 216.

17-4 Portico arcade of the Severan forum, Lepcis Magna, Libya, dedicated 216.

sides framing the temple (Fig. 17-2, no. 1) at the west end. The exedra at the east end served a double purpose: It formed an impressive columnar entrance to the basilica from the forum and also masked the change of axis.

The forum proper was an open area roughly 200 × 300 feet. The portico columns were more than 19 feet tall and supported arcuated lintels to form an *arcade* (**Fig. 17-4**) in place of the traditional colonnade (compare Fig. 12-14). As in other forums, the colonnades provided a frame for the temple at one short end of the enclosure. The temple was dedicated to the worship of the imperial family, as was standard practice in the East (see "The Imperial Cult," Chapter 7, page 97). The plan was of the alae type with freestanding pink Egyptian granite columns with white Pentelic (Athenian) marble Corinthian capitals and bases on the sides of the cella as well as in the porch. The back of the cella, as usual, was flush against the precinct wall, and the stairway was only at the front of the building. The temple's podium was so tall that 27 steps were required to reach the cella from the ground level of the forum.

BASILICA Septimius Severus also began construction of the basilica (**Fig. 17-5**) at the east end of the forum, but Caracalla completed the project and dedicated the new building in 216, according to the long inscription on the lower frieze of the nave's two-story pink Egyptian granite colonnade. The Corinthian columns separated the wooden-roofed nave from the aisles. At each end of the nave was an apse (made of concrete, well suited for the curvilinear shape, instead of cut stone). The northern apse housed the basilica's tribunal, where the presiding magistrate appeared against the backdrop of two gigantic freestanding Corinthian columns framed on each side by two stories of Ionic columns with a bracketed entablature, a device used long before in Domitian's Forum Transitorium

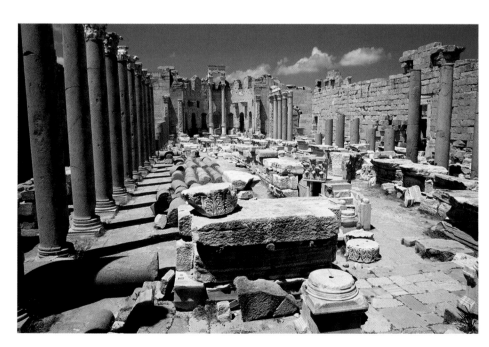

17-5 Interior of the basilica (looking north), Severan forum, Lepcis Magna, Libya, dedicated 216.

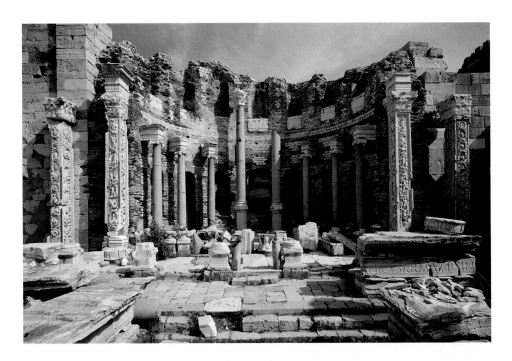

17-6 **South apse of the basilica, Severan forum, Lepcis Magna, Libya, dedicated 216.**

(Fig. 9-21). At the entrance to each apse were two richly carved white marble pilasters decorated with reliefs of Bacchus and his followers and the labors of Hercules amid acanthus leaves (**Fig. 17-6**). Bacchus and Hercules were the Roman equivalents of Shadrap and Melqarth, the patron deities of Lepcis Magna. Septimius Severus had built a temple in honor of the same pair of deities in Rome (see Chapter 16). It was fitting that he would honor them at Lepcis as well.

ARCH OF SEPTIMIUS SEVERUS Both the old and the new forums of Lepcis Magna were located near the city's harbor, reflecting the crucial importance of seaborne commerce for the local economy. The siting of the forums therefore violated a basic rule of Roman urban planning, which called for the forum to be situated at the junction of the city's cardo and decumanus, as at Trajanic Timgad (Fig. 2-3) in Algeria. Septimius Severus's agents at Lepcis instead chose that all-important focal point of the city for a very different kind of monument, a *quadrifrons* arch (**Fig. 17-7**) erected in 203 to celebrate the emperor's visit to his native city. The arch also commemorated Severus's recent Parthian victory and his dynastic ambitions, two themes he had repeatedly emphasized in the capital and on the coinage that reached an Empire-wide audience (see Chapter 16).

The Severan arch was in ruins when first excavated, but it has since been almost completely restored using the original architectural fragments and casts of the relief sculptures. (The latter are on exhibit in the Castle Museum in Tripoli.) The builders used local limestone for the core of the arch but imported marble for the facing. Although many quadrifrons arches were constructed throughout the Empire, the Lepcis arch is unique in form. Each side has a large arcuated bay spanning either the decumanus or the cardo. To the left and right of the passageway are freestanding Corinthian columns on projecting pedestals. They support not a standard entabla-

ture, pediment, or any other traditional architectural configuration, but rather tall and narrow broken pediments. This kind of architectural fantasy in which fragments of buildings are arranged in a purely decorative, distinctly nonfunctional manner was characteristic of Fourth Style mural painting (Figs. 10-1 and 10-16) and had become increasingly common

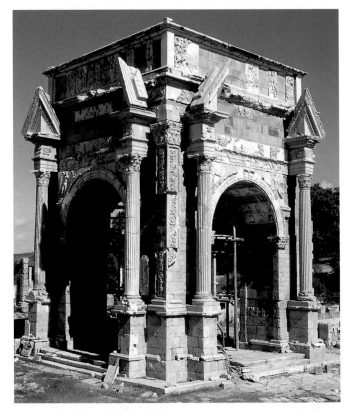

17-7 **Arch of Septimius Severus, Lepcis Magna, Libya, 203.**

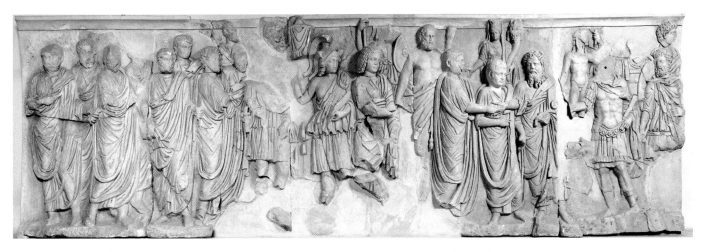

17-8 Concordia Augustorum, attic relief, Arch of Septimius Severus, Lepcis Magna, Libya, 203. Marble, approx. 5′ 6″ high. Castle Museum, Tripoli.

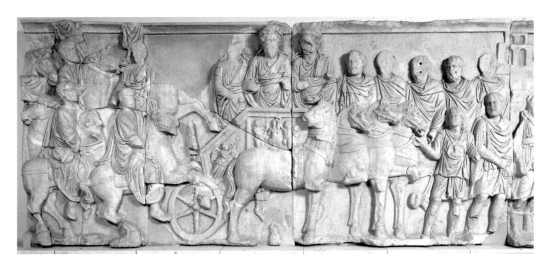

17-9 Chariot procession, attic relief, Arch of Septimius Severus, Lepcis Magna, Libya, 203. Marble, approx. 5′ 6″ high. Castle Museum, Tripoli.

in actual buildings of the second and third centuries, especially in Rome's Eastern provinces (discussed later in this chapter).

Every available surface of Severus's Lepcis arch was covered with relief sculpture: Victories in the spandrels, trophies with bound Parthian captives between the columns and the corner pilasters, vertical panel reliefs on the eight inner sides of the four piers flanking the four passageways, and figural friezes on the four sides of the attic where the dedicatory inscription would normally be placed. Some of the panels on the piers represented siege scenes similar in character to the reliefs (Fig. 16-16) of the Arch of Septimius Severus in the Forum Romanum. The Victories, however, are fully in the Classical tradition—monumental in conception, finely proportioned, and expertly foreshortened.

Of the four attic friezes, three are preserved in large part. One depicts the imperial family sacrificing. Septimius Severus, Julia Domna, Caracalla, and Geta are all present. Virtus places a wreath on the emperor's head. The fact that Geta's features were never erased is difficult to explain except as an expression of hometown affection for the boy in the face

of Caracalla's damnation edict. The imperial family appears again in the Concordia Augustorum frieze (**Fig. 17-8**), where Julia Domna, Virtus, Hercules, Fortuna, and other divinities look on as Septimius Severus and Caracalla clasp hands in front of Geta in a show of imperial harmony (concordia). At the time the Lepcis arch was erected, Caracalla had been co-Augustus for five years. In 202 he was co-consul for the first time with his father, and the sharing of that honor is probably what is commemorated here. Geta had the title of Caesar in 203. The triad composition with a central frontal figure, well documented in Antonine and Severan Rome (Figs. 13-26, 16-3, 16-18, and 16-19), was employed for the Lepcis frieze as well. It is one of the key features of what art historians have come to call the Late Antique style.

This new Late Antique style, more formal and abstract than Classical naturalism, can be seen especially well in the chariot procession (**Fig. 17-9**) on the Lepcis arch. Often erroneously called a triumphal procession (triumphs took place only in Rome), this procession probably depicts the homecoming of the Severan family in April 203. Three figures ride

in the chariot—the emperor and his two sons—while other figures walk in front of the quadriga and horsemen ride behind it. The representation can effectively be compared with earlier depictions of triumphal processions on the Boscoreale silver cup (Fig. 8-4), the Arch of Titus (Fig. 9-16), and the Arch of Marcus Aurelius (Fig. 13-21). The Severan relief gives no sense of forward motion. Rather, it has a stately stillness. The chariot and the horsemen behind it are moving to the right, but the imperial triad is detached from the procession and all three face the viewer. Also different is the way the figures in the second row (and those in the Concordia Augustorum relief) have no connection with the ground and are elevated above the heads of those in the first row so that they can be seen more clearly. Both the frontality and the floating figures (compare Figs. 13-18 and 13-24) were new to official Roman art in Antonine and Severan times, but both appeared long before in the private art of freed slaves (Figs. 6-8 to 6-10). Once embraced by sculptors in the emperor's employ, these non-Classical Late Antique elements had a long afterlife, not only in Roman art but for the next millennium in the art of the Middle Ages.

ASIA MINOR AND NORTH AFRICA

Scholars have often described the architecture of the Roman provinces in the East (**Map 17-1**) during the High and Late Empire as *baroque,* borrowing the term first applied to the buildings, especially churches, of 17th-century Italy. Both in antiquity and later, baroque architects delighted in breaking the rules of Classical design while still employing the vocabulary of Classical architecture. For example, baroque buildings incorporated columns, pediments, and other traditional Greek features, but the elements of the Classical orders were juxtaposed in eccentric ways. Columns—originally used exclusively as supports for a horizontal entablature—became decorative motifs to be attached to facades according to the designer's fancy, often supporting nothing at all. Pediments, which in Classical Greek architecture were the logical result of placing a gabled roof over a columnar facade, were employed as independent shapes to be applied to walls, often not in their canonical triangular form but broken in half or curved. Early examples of the baroque mentality in Italy are the pediments of the hemicycle facade of the Markets of Trajan (Fig. 11-14) in Rome and the colonnade of

Map 17-1 **The Eastern provinces during the second and third centuries.**

17-10 **Library of Celsus, Ephesus, Turkey, ca. 117–120.**

the Canopus (Fig. 12-14) of Hadrian's Villa at Tivoli, but both of these are modest departures from the Classical norm. Paintings of more characteristically baroque buildings appeared even earlier on the walls of Roman houses, but such flights of fancy did not become commonplace in real buildings until the second century and then mostly in the Greek-speaking East.

LIBRARY OF CELSUS, EPHESUS One of the earliest preserved examples (recently reconstructed) of Roman baroque architecture is the facade of the Library of Celsus (**Fig. 17-10**) at Ephesus. Ephesus was an ancient Greek city in Ionia in western Asia Minor that boasted one of the Seven Wonders of the World, the gigantic Temple of Artemis, built originally in the sixth century BCE and rebuilt in the fourth century BCE and decorated with sculpture by some of the most renowned artists of the day. The city retained its prestige under Roman rule, when many civic and religious structures were newly constructed or significantly renovated, including the large theater, capable of seating 24,000 spectators, where the Ephesians famously hailed their Artemis/Diana in the face of the apostle Paul.

The Library of Celsus was erected during the first years of Hadrian's principate by Gaius Iulius Aquila, consul in 110, in honor of his father, Tiberius Iulius Celsus Polemaeanus, consul in 92, whose sarcophagus was placed in a tomb chamber beneath the apse of the library's reading room. Celsus's portrait statue probably stood in the apse. The library is thus a rare case of burial within the limits of a Roman city, an honor accorded only exceptional individuals, such as Trajan (Fig. 11-9). The library facade has two stories of pairs of columns grouped to form niches with alternating triangular and curved pediments in the upper story. The upper niches are directly above the spaces between the lower ones, creating a dynamic visual effect similar to that of a theatrical scaenae

frons (compare Figs. 4-14, 5-20, 7-12, 7-14, and 17-14). In fact, the adjective often used to describe baroque facades like that of the Celsus library is "scaenographic." Between each pair of columns on the library's facade is a doorway or window or a niche for a female statue personifying one of Celsus's virtues: goodness, thought, knowledge, and wisdom.

TEMPLE OF HADRIAN, EPHESUS Much more modest in size despite its lofty purpose was the temple (**Fig. 17-11**) erected at Ephesus for the worship of the emperor Hadrian during his lifetime. A small structure, little more than a

17-11 **Temple of Hadrian, Ephesus, Turkey, 130–138.**

17-12 **Model of the nymphaeum, Miletus, Turkey, early second century. Museo della Civiltà Romana, Rome.**

streetside shrine, this privately funded building is nonetheless of interest as another relatively early example of baroque design. In this case, the *tetrastyle* (four-column) facade is not truly columnar. Piers replaced traditional columns at the corners. Moreover, the lintel above the two columns was arched up into the pediment to form what many architectural historians call a Syrian arch because the motif is especially common in that province. Hadrian used a similar device (without pediments) at the same date for his Canopus (Fig. 12-14) at Tivoli. Arched pediments, however, appeared much earlier on the sides of the Tiberian arch at Orange (not visible in Fig. 7-7), and the Syrian arch was a popular motif in Pompeian mural painting of the mid-first century BCE (Fig. 3-21). The number of known examples multiplied rapidly beginning in the second century.

NYMPHAEUM, MILETUS The baroque approach to architectural design was especially well suited to buildings that were, in essence, facades rather than structures for human activity, for example, monumental fountains. One of the earliest examples of a baroque nymphaeum (**Fig. 17-12**) was built at Miletus in honor of Trajan's father. Miletus was another Ionian city with a proud heritage. Destroyed by the Persians in 494 BCE, Miletus was reconstructed after the Greek victory of 479 BCE employing a strict grid plan devised by Hippodamos of Miletus, whom the Greeks considered to be the father of city planning.

Miletus enjoyed the fruits of Roman patronage first under Trajan. The Trajanic nymphaeum was a much more elaborate version of the facade of Celsus's library at Ephesus, with three stories of columnar niches that again alternated from story to story so that the niches of the upper two stories always were aligned above an unroofed niche below. Most of the pediments were triangular, but some took the form of paired scrolls. There

was a statue in every niche. The similarity between a facade such as this one and the reliefs on Asiatic columnar sarcophagi (Figs. 15-9 and 15-10) is noteworthy and not coincidental. Both reflect the same regional preference for baroque designs.

SOUTH MARKET GATE, MILETUS Faustina the Younger visited Miletus in 164 and donated funds for the construction of the public baths that bore her name and perhaps also for a new theater. Contemporary in date is the gateway (**Fig. 17-13**) to Miletus's south *agora* (marketplace), the largest civic square in the Greek world. The gate has been reconstructed in Berlin. Although it has three arcuated bays on the lower level, only one served as a passageway, and even it was only for pedestrians because of its narrow width and especially because of the flight of stairs in front of it. A far more modest portal could have served to restrict access to the agora. The Miletus gate thus is an exercise in pure baroque design, a facade that has no purpose other than to impress those who passed through it. Once again, columns support nothing but other columns or fragments of pediments. As in the Temple of Hadrian at Ephesus, the architectural ornament is especially rich. Elaborate, deeply cut moldings and pilasters are a common feature of baroque buildings in the Eastern provinces. One statue from the upper story is preserved—a headless cuirassed emperor with a kneeling Parthian at his feet. It must have portrayed Lucius Verus, who battled the Parthians in the years 162–165.

THEATER, SABRATHA Given the scaenographic quality of the Miletus gate and nymphaeum as well as the facade of the Library of Celsus at Ephesus, it is not surprising that many real stages of baroque character were constructed during the second and third centuries. The best example today is the almost completely restored scaenae frons (**Fig. 17-14**) of the theater at

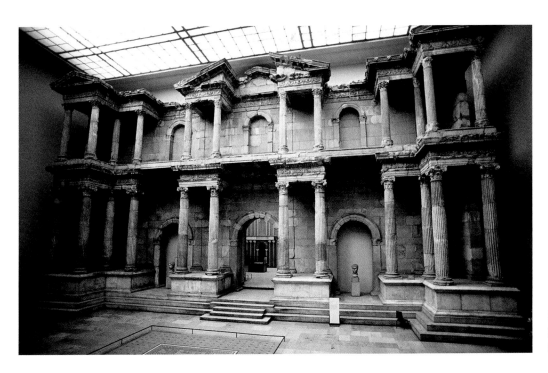

17-13 Agora gate, Miletus, Turkey, ca. 165. Reconstructed in Staatliche Museen, Berlin.

Sabratha on the coast of Libya west of Lepcis Magna. Like Lepcis, Sabratha was an old Punic town that came under Roman control after the defeat of Carthage. The theater was built under Commodus or Septimius Severus, at the time shipping agents from Sabratha had an office (Fig. 14-6) in the Piazzale delle Corporazioni at Ostia. Unlike the Miletus nymphaeum and Ephesus library, the Sabratha stage has three stories of columns perfectly aligned one above the other. The architect made this simple design more interesting and complex by setting some of the sections farther back than others and by alternating curved and flat wall surfaces. In the bright light of the North African desert, the columns also cast strong shadows and enliven the facade, which the designer doubtless took into consideration when planning the placement of the columns.

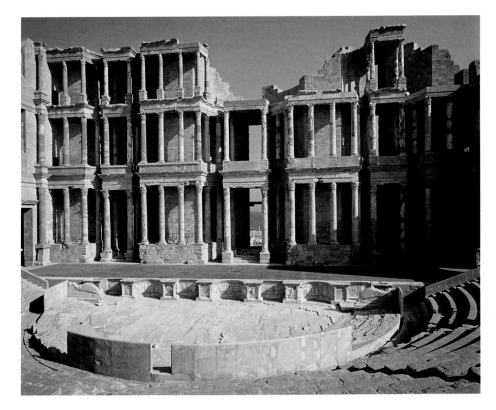

17-14 Interior of the theater, Sabratha, Libya, late second century.

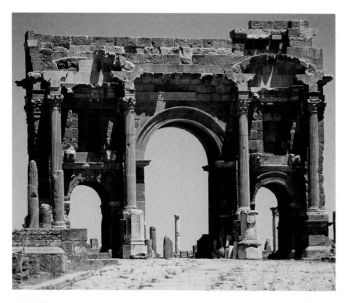

17-15 "Arch of Trajan," Timgad, Algeria, late second century.

houses into churches and synagogues. Only a brief survey of selected building projects in present-day Jordan, Lebanon, and Syria is possible here, but the monuments chosen for discussion highlight the extraordinary diversity of Roman architecture in the Near East during the High and Late Empire.

KHAZNEH, PETRA About 200 miles south of Amman, Jordan, is Petra, the capital of the kingdom of Nabataea until Trajan conquered it in 106. The site is a secluded oasis on a major caravan route, protected by rose-colored granite cliffs all around and accessible only through a narrow mountain pass called the Siq. Petra is justly famous for its tombs cut directly into the cliffs, with usually modest burial chambers carved into the mountain and often spectacular facades on the cliff face. Most of the tombs, including the so-called Khazneh, or "Treasury" (**Fig. 17-16**), are impossible to date precisely. Some scholars think the Khazneh is a Nabataean tomb, perhaps the mausoleum of King Aretas IV, who died in 40 CE, or even of one of his predecessors, but most architectural histori-

"ARCH OF TRAJAN," TIMGAD By the time of Septimius Severus, the Trajanic colony at Timgad (Fig. 2-3) had burst through its original perimeter wall, and a new, haphazard network of streets had been laid out to serve the rapidly growing population. Probably under Severus, most of the original wall circuit was torn down, and a new freestanding arch (**Fig. 17-15**) was erected in place of the old southern gate. Known erroneously as the "Arch of Trajan," the late-second-century gate is another example of a scaenographic facade—in this case, two facades. Pairs of two-story-tall freestanding Corinthian columns on high pedestals frame the lateral passageways of the arch and columnar niches for the display of honorific statuary. Curved pediments crown those niches. The juxtaposition of projecting columns and recessed statues is documented long before in Rome on the Arch of Nero (Fig. 8-22) and in the entrance gateway (Fig. 11-7) to the Forum of Trajan, but such designs enjoyed much greater popularity in the Eastern provinces from the late second century on.

THE NEAR EAST

The conquest of what had been Alexander the Great's empire in the Near East brought the Romans into contact with many foreign cultures, far different in character from the Greek cities of Asia Minor and even the formerly Punic cities of North Africa. In time, Rome itself would embrace one of the religions that originated in its Eastern provinces as the official state religion, bringing about the radical transformation of the pagan ancient world into the Christian Middle Ages. In the second and third centuries, however, most Roman architects in the Near East were still building temples to the Olympian gods and majestic tombs celebrating individual wealth and achievement. Others, in contrast, were busy converting private

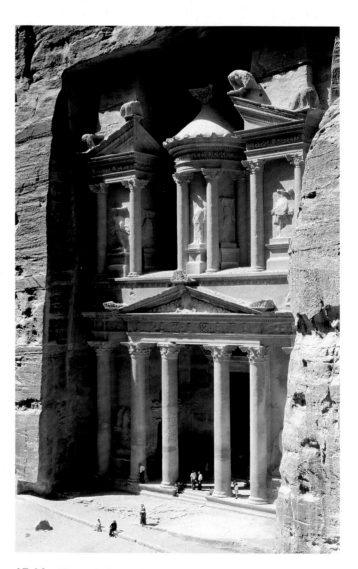

17-16 Khazneh, Petra, Jordan, second century.

ans now date the tomb to the High Empire. A date sometime in the second century CE is most likely.

Whatever its date, the Khazneh is one of the most striking examples of the baroque mentality in which Classical architectural elements were used in a purely ornamental fashion and with a studied disregard for Classical rules. The facade is more than 130 feet high and consists of two stories. The lower story resembles a traditional *hexastyle* (six-column) Corinthian temple facade, but the columns are unevenly spaced, and the pediment is only wide enough to cover the four central columns. On the upper level (**Fig. 17-1**), a temple-within-a-temple is set atop the lower temple. Here a gable-roofed tetrastyle temple is split in half to make room for a central tholoslike cylinder, which contrasts sharply with the rectangles and triangles of the rest of the composition. On both levels, the rhythmic alternation of high projection and deep indentation creates dynamic patterns of light and shade, a characteristic feature of the most successful baroque designs. The resemblance of the Khazneh facade to Second Style murals at Pompeii and Boscoreale (Figs. 3-1, 3-13, and 3-21) depicting tholoi seen through columns is striking and deserves further investigation, but it does not in itself support an early date for the Petra tomb.

SANCTUARY OF JUPITER, BAALBEK Probably the most spectacular building project in the Near East during the Roman period was the construction of the Sanctuary of Jupiter at Baalbek (**Fig. 17-17**) in Lebanon, an undertaking so ambitious that it required two centuries to complete. Baalbek, the Roman colony

of Heliopolis founded in 16 BCE, was, as its modern name suggests, sacred to Ba'al, who in Hellenistic times had already been equated with Zeus. The first part of the project, which began perhaps as early as Augustus, was a grandiose temple to Jupiter (Fig. 17-17, *top right*); an inscription suggests it was completed by 60 CE. The Jupiter temple is a typical example of the compromise between Greek and Roman temple design so common in the Eastern provinces. It had a peripteral colonnade of 65-foot-tall gray limestone columns but access stairs were only at the front. The temple is remarkable chiefly for its size. The facade was decastyle, a rare feature not seen in Rome until Hadrian's Temple of Venus and Roma (Fig. 12-16), and there were 19 columns on the sides. The podium was 44 feet tall, and the peak of the gabled roof towered 130 feet above ground level.

About a century later, possibly under Antoninus Pius, the Heliopolitans constructed an enormous precinct in front of the temple consisting of three columnar porticos enclosing a plaza 320 feet long and 280 feet wide. At the same time, a temple dedicated to Bacchus (Fig. 17-17, *top center*) was erected to the south of the Jupiter temple. Although small in comparison to its earlier neighbor, the Temple of Bacchus is still quite large—and much better preserved than the Temple of Jupiter. It too was peripteral with a frontal staircase. The rich carving of the entablature impresses all who visit the temple.

Finally, in the third century, Caracalla and then Philip the Arabian (r. 244–249; see Chapter 18) added an unusual hexagonal forecourt and a monumental *propylon* (entrance gateway; Fig. 17-17, *lower left*). The center of the propylon

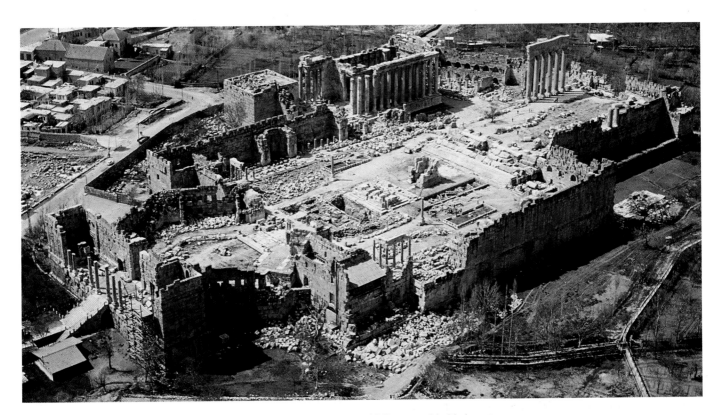

17-17 **Aerial view of the Sanctuary of Jupiter, Baalbek, Lebanon, mid-first to mid-third century.**

had a pediment with an arcuated lintel, as in the Temple of Hadrian at Ephesus (Fig. 17-11). This facade and the six-sided forecourt are the only baroque elements in an otherwise traditional design.

TEMPLE OF VENUS, BAALBEK "Traditional" is a word that cannot, however, be applied to the last temple to be erected at Baalbek, the small mid-third-century shrine dedicated to Venus (**Figs. 17-18** and **17-19**), which epitomizes the baroque style of ancient Roman architecture. The unknown architect of this temple ignored almost every rule of Classical design. With its circular domed cella set behind a gabled columnar facade, the Venus temple emulates the novel layout of the Pantheon (Figs. 12-18 and 12-19a), which by the mid-third century had already achieved the status of a classic. But the Baalbek temple is no imitation of the Hadrianic building; rather, it should be considered a critique of it. As is characteristic of baroque architecture in general, many of the Venus temple's features intentionally depart from the norm. The platform, for example, is scalloped all around the cella. The columns—the only known instance of *five*-sided Corinthian capitals with corresponding pentagonal bases—support a matching scalloped entablature (which serves to buttress the shallow stone dome). These concave forms and

those of the niches in the cella walls play off against the cella's convex shape. Even the "traditional" facade of the Baalbek temple is a baroque variation on the Pantheon's facade with a Syrian arch in the pediment. The Temple of Venus at Baalbek is baroque architecture in its most novel form.

CHRISTIAN COMMUNITY HOUSE, DURA Several Eastern religions had already enjoyed official imperial patronage in third-century Rome (see "Oriental Gods in Severan Rome," Chapter 16, page 244), even if some were repudiated as soon as the sponsoring emperor was dead, whereas the monotheistic religions of Judaism and Christianity had to remain underground. But in the Near East, where they originated, Jews and Christians were generally free to construct public places

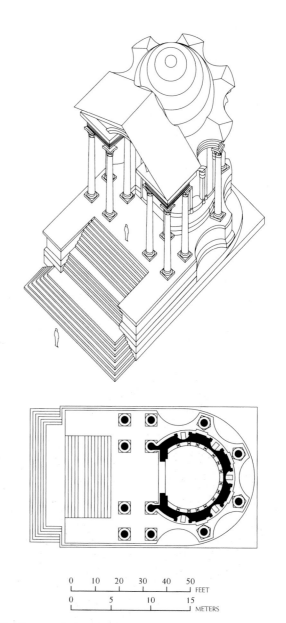

17-18 **Rear view of the Temple of Venus, Baalbek, Lebanon, mid-third century.**

17-19 **Restored view (*top*) and plan (*bottom*) of the Temple of Venus, Baalbek, Lebanon, mid-third century.**

Polytheism and Monotheism at Dura-Europos

Dura, in present-day Syria, was probably founded by Seleucus I, one of Alexander the Great's successors, around 300 BCE. The Hellenistic city, which the Greeks called Europos, was strategically situated on a promontory overlooking a bend in the Euphrates River northwest of Damascus between Ctesiphon and Palmyra. Its location made Dura an important crossroads between Syria and Parthia and the Mediterranean world. From the beginning it was a heavily fortified settlement. In fact, the first significant discoveries at the site occurred accidentally in 1920 when a British army detachment took refuge behind the ruins of the ancient walls.

Around 113 BCE, the Seleucids had to yield Dura to the Parthians, who made the city one of the westernmost outposts of their expanding empire. Dura fell in turn to the Romans in 115 CE, when Trajan pushed far into Mesopotamia, but the Parthians regained control two years later and held the town for another half century. Lucius Verus won back Dura for Rome in 165 and stationed a permanent garrison there. Within a century, however, a powerful new force had arisen in the East, the Sasanians. These heirs to the Parthian empire laid siege to Dura and captured the city in 256. Unlike their predecessors, the Sasanians did not occupy the town. Rather they evacuated the population and left Dura to be buried gradually by the desert sands.

Given its history and location, it is no surprise that archaeologists have uncovered more than a dozen shrines of different religions at this "Pompeii of the desert," as some have called Dura. Often, the deities worshiped were composites of Classical and Eastern gods—for example, Zeus/Jupiter and Syrian Ba'al, and Artemis/Diana and the Semitic Anath. Purely Eastern gods also were worshiped at Dura, including Mithras, whose followers had made important inroads also in the West, even in Rome and Ostia.

Alongside these polytheistic religions, Judaism and Christianity took root at Dura during the second and third centuries. The small Jewish community converted a private house into a synagogue (Fig. 17-21) sometime between 165 and 200, and the Christians established a baptistery and prayer hall in another house (Fig. 17-20) around 240. Dura, although merely a modest garrison town in the desert, has proved to be a treasure trove of information about the diverse religious currents sweeping across the Roman world between the Severan age and the accession of Constantine. ■

of worship or, as was often the case, to convert earlier buildings for use as centers of collective prayer. The latter was the case at the fascinating Syrian site of Dura-Europos, which was a microcosm of the religious diversity of late antiquity (see "Polytheism and Monotheism at Dura-Europos," above).

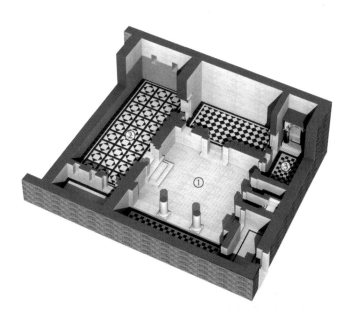

17-20 Restored cutaway view of the Christian community house, Dura-Europos, Syria, ca. 240–256 (John Burge). 1) Courtyard of private house converted into Christian community house, 2) meeting hall, 3) baptistery.

The Christian community house (**Fig. 17-20**) at Dura-Europos was a remodeled private residence with a central courtyard. Its meeting hall (created by breaking down the partition between two rooms on the court's south side) could accommodate no more than about 70 people at a time. It had a raised platform at one end where the congregation leader sat or stood. Another room, on the opposite side of the courtyard, had a canopy-covered font for *baptism* rites, the all-important bathing ceremony initiating a new convert into the Christian community. Upstairs a communal dining room may have existed for the celebration of the *Eucharist,* when the faithful partook of the bread and wine symbolic of the body and blood of Christ (see Chapter 20). Even compared to the pagan shrines at Dura, let alone the great stone temples of Baalbek, the place where the Christians of Dura-Europos gathered to worship was modest in the extreme, a reflection of the fact that before Constantine, Christian communities were small in number and often attracted the most impoverished classes of society. Especially appealing to them was the promise of an afterlife where rich and poor were judged on equal terms.

260

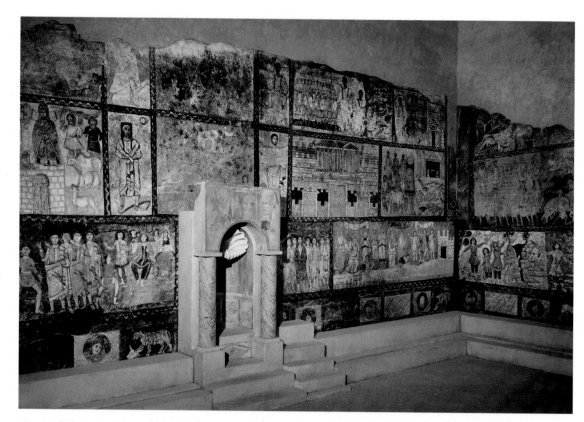

17-21 Interior of the synagogue, Dura-Europos, Syria, with mural paintings of Old Testament themes, ca. 245–256. Tempera on plaster. Replica in Museum of the Diaspora, Tel Aviv.

17-22 Samuel anointing David, mural painting in the synagogue, Dura-Europos, Syria, ca. 245–256. Tempera on plaster. Replica in Museum of the Diaspora, Tel Aviv.

SYNAGOGUE, DURA The synagogue (**Fig. 17-21**) at Dura-Europos is remarkable not only for its very existence in a Roman garrison town but also for its extensive cycle of mural paintings depicting biblical themes. The building, also originally a private house with a central courtyard, was converted into a synagogue during the latter part of the second century. The paintings surprised scholars when they were first reported, because they seem to defy the Bible's Second Commandment prohibiting the making of graven images. It is now apparent that although the Jews of the Roman Empire did not worship idols as did their pagan contemporaries, biblical stories appeared on the painted walls of synagogues and probably also in painted manuscripts, although no illustrated Bible of this period survives. God (Yahweh in the Old Testament), however, never appears in the Dura paintings, except as a hand emerging from the top of the framed panels.

The Dura murals are mostly devoid of action, even when the subject is a narrative theme. The artists told the stories through stylized gestures, and the figures, which have expressionless features and lack both volume and shadow, tend to stand in frontal rows. The Dura painting of Samuel anointing David (**Fig. 17-22**) is a characteristic example. The episode is depicted just to the right of the niche that housed the sacred Jewish *Torah* (the scroll containing the *Pentateuch,* the first five books of the Hebrew Scriptures). The prophet anoints the future king of Israel as David's six older brothers look on. The painter drew attention to Samuel by depicting him larger than all the rest. David and his brothers are emotionless and almost disembodied spiritual presences. Their bodies do not even have enough feet! David, however, is further distinguished from his brothers by the purple toga he wears. Purple was the color associated with the Roman emperor. The Dura artist borrowed the imperial toga to signify David's royalty.

The style of the Dura synagogue paintings is thus consistent with the new artistic trend that was rapidly displacing the Classical style even in Rome and that would soon become the formal basis for much of the art of the Middle Ages.

SUMMARY

In 203, a decade after he became emperor, Septimius Severus returned to his birthplace of Lepcis Magna. Rome's first African emperor had already allotted funds for the embellishment of his hometown, and by 216 he and his son Caracalla had built a magnificent new forum for the city that included a temple for the worship of the Severan family. The Severan monuments of Lepcis Magna also include a quadrifrons arch celebrating Septimius Severus's Parthian victory and the new dynasty he had founded. The reliefs on that arch are among the most important surviving examples of the non-Classical Late Antique style that was gaining increasing favor throughout the Empire.

The buildings the Severans erected at Lepcis Magna also exemplify the baroque style of Roman architecture that was especially popular in the Eastern provinces during the second and third centuries. At Lepcis and Sabratha in Libya, at Ephesus and Miletus in Turkey, at Timgad in Algeria, and at Petra and Baalbek in Jordan and Lebanon respectively, Roman architects, in a burst of creative energy, ignored the rules of Classical design and bent lintels into arches, broke pediments in half, delighted in the interplay of concave and convex forms, and even invented five-sided Corinthian capitals.

The Eastern provinces are also where archaeologists have discovered some of the earliest meeting places of the monotheistic religions of Judaism and Christianity. The mural paintings in the synagogue at Dura-Europos reveal how easily artists were able to adapt the Late Antique style of pagan monuments to biblical subject matter, foreshadowing the Early Christian art of the era of Constantine (see Chapter 20).

The Soldier Emperors

The half century from the downfall of the Severan dynasty to the rise of Diocletian was a bleak period for the Roman Empire, an era of almost continuous civil warfare when emperors came and went sometimes more frequently than the seasons changed (see "The Soldier Emperors," page 264).

The insecurity and brutality of the age are perhaps best exemplified by the horrific events of 238, which brought death to five emperors within a few months. Maximinus Thrax ("the Thracian") was in the third year of his rule when Gordian I, the elderly governor of Africa, was hailed emperor in opposition to him and took his son Gordian II as his co-Augustus. The Senate, which also opposed Maximinus, quickly ratified the selection, but the governor of Numidia led his army against the new emperors and killed the younger Gordian. Gordian I committed suicide. The Senate then appointed two co-emperors to defend Rome against Maximinus, placing Balbinus in charge of civil affairs and installing Pupienus as head of the army. Both men had enjoyed long senatorial careers but lacked the crucial support of the praetorian guard. The praetorians murdered both emperors barely three months after their appointment.

Julius Capitolinus vividly recounted some gruesome details of the civil strife of 238 in his biographies of Maximinus, Pupienus, and Balbinus:

> [The soldiers] slew Maximinus and his son as they lay in their tent, and putting their heads on poles, showed them to the citizens of Aquileia. And thereupon . . . the statues and portraits of Maximinus were immediately thrown down . . . One can scarcely describe how great the joy was when the head of Maximinus was carried through Italy to Rome. From all sides folk came running as to a public holiday . . . [The Senate passed a formal resolution, reading in part,] "We decree temples for the Deified Gordians [and the damnation of Maximinus's memory]. Let the head of the public foe be cast into running water. Let no man bury his body."[1]

To the great joy of the senate and Roman people, Balbinus and Maximus [Pupienus] began governing the city, doing so with great moderation. They showed great respect for the senate; they instituted excellent laws, . . . they planned the military policy of the state with great wisdom . . . [but the praetorians] were seeking an opportunity of killing the Emperors . . . The soldiers came upon them and stripping them both of their royal robes and loading them with insults, they dragged

18-1 Detail of the sarcophagus (Fig. 18-14) of a consul(?), from Acilia, mid-third century. Museo Nazionale Romano–Palazzo Massimo alle Terme, Rome.

[1]Julius Capitolinus, *The Two Maximini,* 23.6–7, 24.4, 26.2–3. Translated by David Magie, *The Scriptores Historiae Augustae,* vol. 2 (Cambridge, Mass.: Harvard University Press, 1924), 359–363.

WHO'S WHO IN THE ROMAN WORLD

The Soldier Emperors

Maximinus Thrax (Gaius Iulius Verus Maximinus, r. 235–238) was hailed emperor at Mainz by the German troops who opposed Severus Alexander. The same troops murdered Maximinus three years later.

Gordian I (Marcus Antonius Gordianus Sempronianus, r. 238) was elevated to emperor by his African troops in opposition to Maximinus, but he was quickly defeated by the governor of Numidia and committed suicide.

Balbinus (Decius Caelius Calvinus Balbinus, r. 238) was the Senate's choice as co-emperor with Pupienus to defend Rome against Maximinus. Balbinus was given charge of the civil administration, and Pupienus command of the army.

Pupienus (Marcus Clodius Pupienus Maximus, r. 238) was co-emperor with Balbinus for only three months in 238. They enjoyed senatorial backing, but the praetorians mutinied and killed both men.

Gordian III (Marcus Antonius Gordianus, r. 238–244) was the grandson of Gordian I. The praetorians saluted the 13-year-old Gordian III emperor after they murdered Balbinus and Pupienus. Gordian died of wounds incurred in Parthia.

Philip the Arabian (Marcus Iulius Philippus, r. 244–249) was Gordian III's praetorian prefect and succeeded him as emperor. Philip was killed in the civil war against Decius.

Trajan Decius (Gaius Messius Quintus Decius, r. 249–251) was proclaimed emperor by his troops in opposition to Philip the Arabian, whom he defeated at Verona, Italy. He died fighting against the Goths.

Trebonianus Gallus (Gaius Vibius Trebonianus Gallus, r. 251–253) was hailed emperor by the army after Decius's death. Within two years, Gallus's troops revolted and murdered him.

Valerian (Publius Licinius Valerianus, r. 253–260) was saluted emperor by his troops after the murder of Trebonianus Gallus. He was captured by the Sasanian king Sapor I and died while imprisoned in the East.

Gallienus (Publius Licinius Egnatius Gallienus, r. 253–268) was the son and successor of Valerian. He spent his unusually long tenure as emperor fighting barbarians on several fronts. Eventually his officers mutinied and murdered him.

Claudius Gothicus (Marcus Aurelius Claudius Gothicus, r. 268–270) served under Gallienus but probably helped organize the plot to overthrow him. Claudius's short reign ended when he died of the plague.

Aurelian (Lucius Domitius Aurelianus, r. 270–275) was also a party to the assassination of Gallienus and was a key commander under Claudius Gothicus. Aurelian's troops murdered him in the fifth year of his reign.

Tacitus (Marcus Claudius Tacitus, r. 275–276) was an elderly senator who was chosen as Aurelian's successor. He defeated the Goths but was killed by his own soldiers.

Probus (Marcus Aurelius Probus, r. 276–282) had to defeat a rival general to succeed Tacitus. Probus had several military successes in the North and East but was murdered by troops loyal to Carus.

Carus (Marcus Aurelius Carus, r. 282–283) overthrew Probus and was the first emperor not to seek senatorial approval to rule. He was killed in battle after capturing Ctesiphon.

Numerian (Marcus Aurelius Numerianus, r. 283–284) was the younger son of Carus and succeeded his father as emperor. He died a year later. The soldiers chose Diocletian (see Chapter 19) to succeed him. ■

them from the Palace. Thence, after handling them very roughly . . . they slew them both and left them in the middle of the street.[2]

The year 238, though an extreme case, was typical of this period in Rome's history, with the Senate powerless in the face of the praetorian guard and the provincial armies, and the emperors themselves fearing for their lives from the moment their troops elevated them to supreme command. In such an atmosphere, the "soldier emperors," as they have come to be called, lacked the luxury of long-range planning or the security to initiate major new building projects in the capital or elsewhere,

although impressive new civic buildings in the provinces continued to be erected, especially in the East (see Chapter 17).

PORTRAITURE

If architects went hungry in third-century Rome, sculptors and engravers had much to do. Great quantities of coins (in debased metal) were produced so that the troops could be paid with money stamped with the current emperor's portrait and not with that of his predecessor or rival. Each new ruler set up portrait statues and busts everywhere to assert his authority. The sculptured portraits of the third century are among the most moving ever produced. Following the lead of the sculptors of the likenesses of Marcus Aurelius (Fig. 13-22)

[2]Julius Capitolinus, *Maximus and Balbinus*, 13.4–5, 14.5–7. Translated by Magie, 473–477.

18-3 Togate bust of Pupienus, 238. Marble, 2′ 10¼″ high. Musei Vaticani, Rome.

18-2 Togate bust of Maximinus Thrax, 235–238. Marble, 2′ 1½″ high (without base). Museo Capitolino, Rome.

and Caracalla (Figs. 16-9 and 16-10), artists fashioned portraits of the soldier emperors that are as notable for their emotional content as they are for their technical virtuosity.

MAXIMINUS THRAX Maximinus Thrax was a huge man whose enormous physical strength and great height propelled him through the ranks to become emperor after the death of Severus Alexander (see "The Heroic Ideal in the Third Century," page 268). A portrait (**Fig. 18-2**) in the Capitoline Museum can confidently be identified as of the Thracian emperor because of its similarity to his numismatic likenesses. In fact, the coins are almost the sole evidence art historians have for naming the hundreds of third-century portraits in museums throughout the world. The Capitoline portrait of Maximinus captures the intensity of his personality. The head (the togate bust is ancient but may have been made for a different head) is one of several replicas of the emperor's official portrait type in which, following the pattern Caracalla set, Maximinus turns his head to one side, so that the emperor does not make eye contact with the viewer. He appears to be lost in thought, disengaged from his physical environment. The hair is closely cropped and follows the shape of the skull. The individual locks are incised into the marble rather than carved in relief; the same is true of the beard. The pupils of the eyes

are drilled, and there are sharp lines in Maximinus's forehead, under his eyes, and around his mouth.

PUPIENUS It is remarkable that portraits of Pupienus survive from his mere three-month tenure before the praetorian guard dragged him in humiliation from the imperial palace and murdered him and his co-emperor Balbinus before dumping their bodies in the streets of Rome. The existence today of portraits of both rulers testifies to the importance of each new Roman emperor distributing his image as rapidly and as widely as possible in order to advertise that the Roman state was "under new management."

The finest of Pupienus's portraits is a bust (**Fig. 18-3**) in the Vatican in which he wears a toga with contabulatio. The choice of costume is interesting in itself, because Pupienus was placed in charge of military matters, whereas it was Balbinus to whom the Senate had awarded responsibility for civilian affairs. Probably both emperors were portrayed in both roles in matching portraits designed to underscore the concordia of their shared power.

Pupienus's likenesses uniquely combine features of contemporaneous portrait style, for example, the close-cropped military hairstyle rendered by scratching into the marble, and of Antonine portraiture, most notably the full beard with its prominent drillwork but also the half-closed eyes (see Chapter 13). The deep lines in the forehead and the sideways glance—despite the frontality of the head—are unmistakable characteristics of the insecure times in which Pupienus lived.

18-4 **Balbinus in the guise of Jupiter, from Piraeus, Greece, 238. Marble, 6′ 7½″ high. Archaeological Museum, Piraeus.**

18-5 **Cuirassed bust of Gordian III, from Gabii, ca. 243. Marble, 2′ 5½″ high. Louvre, Paris.**

BALBINUS Although third-century portraits differ sharply from all pre-Marcus Aurelius portraits in their psychological intensity, the traditional types were maintained, including depictions of the emperors in the guise of divinities. A statue (**Fig. 18-4**) of Balbinus from Piraeus, the harbor of Athens, represents the short-reigning emperor as Jupiter with an eagle by his side, carrying on the imagery of the Early and High Empire (for example, Fig. 8-10). Balbinus's body type, however, differs from that of earlier eras. He has a broad torso and thick neck, and his feet are planted firmly on the ground.

Gone are the Greek contrapposto and trimmer proportions that still characterized the nude statues of Septimius Severus (Fig. 16-5). Sheer physical power is now valued more than grace. This new look first appeared under Caracalla and became the norm in the portraiture of the soldier emperors (see "The Heroic Ideal in the Third Century," page 268).

GORDIAN III Gordian, the grandson of a highly respected governor and short-lived emperor, had been named Caesar under Balbinus and Pupienus in deference to the people's wishes. After their assassination, his succession was uncontested. Barely in his teens, however, Gordian yielded real power to his mother and the praetorian prefect. He died while still a teenager, fighting against the Parthians. A number of portraits of Gordian are extant, including togate and cuirassed busts. The most impressive of these is an over-life-size military portrait (**Fig. 18-5**) of unusual format. It is, in fact, more likely the upper half of a full-length statue of the boy-emperor dressed in cuirass and paludamentum and carrying a sword sheath in his left hand. The portrait head is typical of the era except for the absence of a beard, which highlights the emperor's youth. Indeed, at his accession Gordian was too young to serve in the Roman army, let alone

head, knotted brow, scowling expression, and avoidance of the viewer's gaze.

TRAJAN DECIUS Decius is remembered primarily for persecution of Christians. He viewed the growing popularity of that monotheistic religion, which rejected the official Roman gods, as a threat to the stability of the state itself. His best portrait (**Fig. 18-7**) depicts him as an old man with bags under his eyes and a sad expression. In his eyes, which glance away nervously, is the anxiety of a man who knows he can do little to restore order to an out-of-control world. The master sculptor modeled the marble as if it were pliant clay, compressing the sides of the head at the level of the eyes, etching the hair and beard into the stone, and chiseling deep lines in the forehead and around the mouth. Like other portraits of the soldier emperors, Decius's image reveals the anguished soul of the man and the instability of the era.

18-6 Togate bust of **Philip the Arabian**, from Porcigliano, 244–249. Marble, 2′ 4″ high. Musei Vaticani, Rome.

command it. As in contemporaneous portraits, the hair is short, and the locks are incised into the stone. Gordian also turns his head sharply to the right. Despite his impressive armor, he seems unable or unwilling to look at the viewer.

PHILIP THE ARABIAN When Gordian died of the wounds he suffered in his Eastern campaign, his praetorian prefect, Philip the Arabian, took his place in the imperial palace. He ruled for five years, but his portraits are exceedingly rare. Fortunately, one bust (**Fig. 18-6**) of very high quality survives. It shows Philip playing the role of first citizen, dressed in a toga. Although no third-century emperor could hold onto power without the soldiers' backing, it was still important for each ruler to project an image as the head of state and source of all governmental largesse. Philip had the good fortune to be emperor when Rome celebrated its 1,000th birthday, and he staged lavish entertainments to delight the populace. Nonetheless, the insecurity of the age is reflected in his furrowed fore-

18-7 Head of **Trajan Decius**, 249–251. Marble, 1′ 2″ high (without modern bust). Museo Capitolino, Rome.

The Heroic Ideal in the Third Century

By the third century, the tradition of portraying Roman men in heroic nudity was hundreds of years old. From the Late Republic on, public figures and private citizens alike often commissioned portraits in which they likened themselves to Greek gods and athletes with strong and perfectly proportioned bodies (Figs. 4-10, 4-11, 5-14, 8-10, 12-6, 14-19, and 16-5). The models for these Roman statues were usually famous works by Greek masters of the fifth and fourth centuries BCE. The prestige of the Greek models provided an additional reason for the Roman patrons to be portrayed nude.

Although Classical Greek art never went completely out of fashion in ancient Rome, in the early third century a new ideal of heroic nudity began to emerge. In the Baths of Caracalla, for example, the models set before Romans exercising in the palaestra were not trim javelin throwers or the youthful Apollo but heavyset wrestlers and gladiators (Fig. 16-23). One of the vaulted halls featured a colossal statue of Hercules (Fig. 16-24) with exaggerated musculature.

In the era of the soldier emperors, this new kind of ideal body type began to be used in place of the Classical Greek type for imperial portraits, for example, the colossal bronze statue (Fig. 18-8) now in New York of Trebonianus Gallus. This was, after all, an age in which a barbarian of low birth like Maximinus Thrax could become emperor almost solely on the basis of his physical size and strength.

Julius Capitolinus described the reason for the Thracian's rapid rise to power:

[When Maximinus first came to the attention of the emperor Septimius Severus, he was a] youth, half barbarian and scarcely yet master of the Latin tongue, speaking almost pure Thracian . . . Severus [was] struck with his bodily size . . . and immediately ordered the tribune to take him in hand and school him in Roman discipline . . . [After Maximinus bested everyone in a series of contests, Severus ordered him] to take a permanent post in the palace with the bodyguard. In this fashion, then, he was made prominent and became famous among the soldiers . . . In height and size and proportions, in his great eyes, and in whiteness of skin he was preeminent among all . . . He was the bravest man of his time—whom some called Hercules, others Achilles, and others Ajax . . . He was of such size . . . that men said he was six inches over eight feet in height, and his thumb was so huge that he used his wife's bracelet for a ring . . . And never was there a more savage animal on earth than this man who staked everything on his own strength, as though he could not be killed. Eventually, indeed, . . . he almost believed himself immortal because of his great size and courage.* ∎

*Julius Capitolinus, *The Two Maximini*, 2.5–6, 3.1, 3.5–6, 4.9, 9.2–3. Translated by David Magie, *The Scriptores Historiae Augustae*, vol. 2 (Cambridge, Mass.: Harvard University Press, 1924), 317–323, 331.

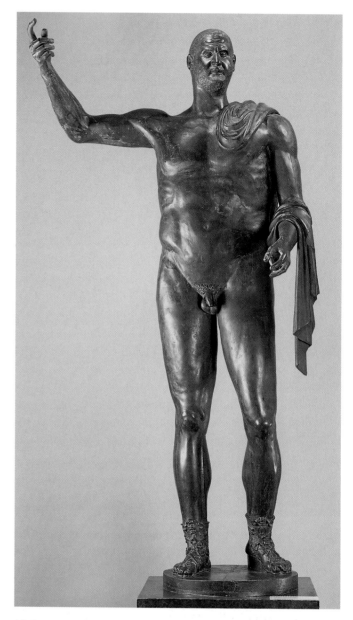

18-8 Heroic statue of Trebonianus Gallus, from Rome, 251–253. Bronze, 7′ 11″ high. Metropolitan Museum of Art, New York.

TREBONIANUS GALLUS Decius's successor was Trebonianus Gallus, whose larger-than-life-size bronze portrait statue (**Fig. 18-8**) has fortuitously been preserved. Gallus appears fully nude save for his military boots and a cloak thrown over his left shoulder and arm. His physique, like Balbinus's (Fig. 18-4), is that of a wrestler with a swollen chest and massive legs (see "The Heroic Ideal in the Third Century," left). The heavyset body dwarfs his head (**Fig. 18-9**) with its nervous expression. In this portrait, the Greek ideal of the keen mind in the harmoniously proportioned body has given way to a paradoxical image that at once projects immense physical strength and a troubled psyche. The head is also of interest

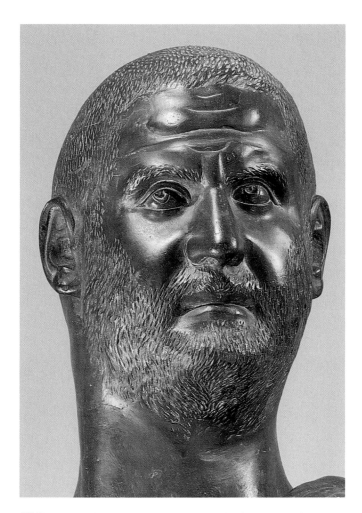

18-9 Head of Trebonianus Gallus, detail of the statue in Fig. 18-8.

18-10 Head of Probus, 276–282. Marble, 1′ 6⅛″ high. Museo Capitolino, Rome.

for its technique. The bronze-caster, following the lead of contemporary marble sculptors, did not mold the hair of the emperor's head, eyebrows, or beard. The details were scratched into the bronze after it had hardened and been removed from the mold.

PROBUS The history of Probus's rise and fall reads very much like that of the other soldier emperors. After his predecessor was killed by his own soldiers, Probus had to defeat another army commander who aspired to become emperor in order to grab power for himself. Within six years, despite victories in Gaul, the Danube, and Egypt, Probus lost the support of an army faction to his praetorian prefect, who overthrew him. Yet in the realm of art, Probus's portraits break significantly from those of the earlier third century.

A head (**Fig. 18-10**) in the Capitoline Museum is the best surviving portrait of the emperor. As in the marble likenesses of other soldier emperors, the hair is very short and rendered mostly by incision, but the beard is raised slightly in relief. More significant, the head has a cubical shape, with simplified

masses, and the large, rather sad eyes stare out directly at the viewer. These features will characterize the much more abstract portraits of the tetrarchs (see Chapter 19), whose stylistic roots can be traced to the artists who were in Probus's employ.

PORTRAITS OF WOMEN During the Flavian era (see Chapter 9), there was a pronounced dichotomy between the rugged verism of men's portraits and the ideal beauty of women's portraits. More typically, Roman male and female portraits from the Republic through the High Empire exhibit similar stylistic and ideological traits, and that was the case in the third century as well. The pattern had already been set at the end of the Severan dynasty. The portraits of Julia Mamaea, Severus Alexander's mother and one of the most powerful women of the era, were important trendsetters. A bust

18-11 Bust of Julia Mamaea, ca. 220–230. Marble, 1′ 5½″ high. Museo Capitolino, Rome.

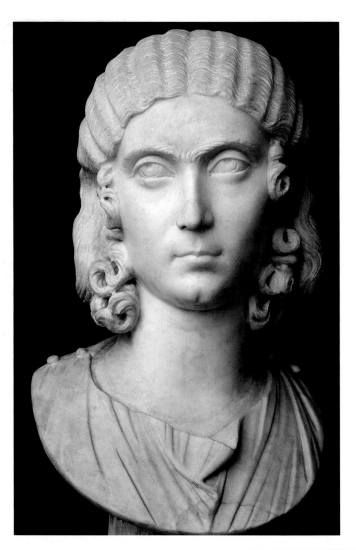

18-12 Bust of a woman, ca. 220–230. Marble, 1′ 1″ high. Museo Capitolino, Rome.

(**Fig. 18-11**) in the Capitoline Museum depicts Julia as a mature woman wearing her characteristic coiffure, which is a simpler, natural version of Julia Domna's wig (Fig. 16-7). The hair is parted in the center and falls in waves to each side of the head, where it is combed behind the ears and then flows down over the shoulders ending in an upward curl. At the back of the head the hair is gathered in a bun. But unlike Julia Domna, Julia Mamaea looks away from the viewer. The insecurity of the age shows in her face even more than in her young son's (Fig. 16-12).

The female portraits of the second and third quarters of the third century depict women of all ages. One of the finest is a bust (**Fig. 18-12**) of a young woman in the Capitoline Museum that is roughly contemporary to the portrait of Julia Mamaea. The woman sports a much more elaborate coiffure, however, with cascading curls framing the cheeks and tumbling down almost onto the shoulders. As in the portraits of Pupienus (Fig. 18-3), the sculptor of this bust used the chisel

to pick out the hairs of the eyebrows and the individual strands of the wavy coiffure but employed a drill to render other parts of the head, especially the corkscrew curls near the eyes and below the ears. This anonymous young beauty with perfect features has the same nervous glance as her older counterparts. Neither young nor old, emperor nor commoner, was immune to the psychological stress of this troubled era.

SARCOPHAGI

The age of the soldier emperors was a time of continuous warfare, both civil and foreign, and the workshops that produced coffins had a strong market for their goods. The accelerating popularity of richly sculpted sarcophagi was also a boon for artists, because the traditional jobs for relief sculptors—panels for triumphal arches, friezes for temples and altars, and the like—had almost completely dried up after

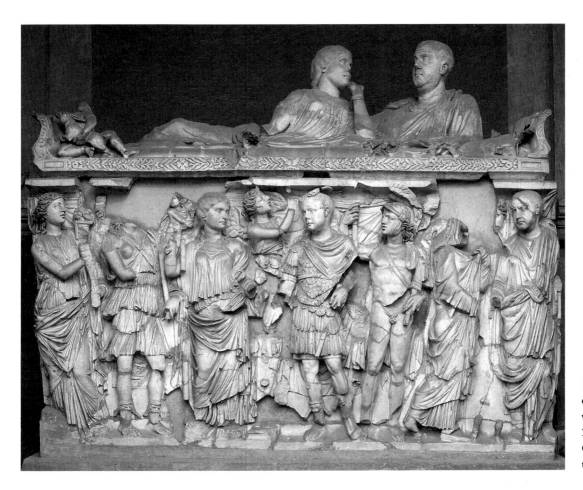

18-13 Sarcophagus of Balbinus and/or his wife, from Rome, ca. 238. Marble, 6′ 7″ high. Catacomb of Praetextatus, Rome.

the demise of the Severans. Sarcophagi are therefore of singular importance for the history of sculpture in the third century, including the history of portraiture.

BALBINUS SARCOPHAGUS No one knows which emperor was the first to be buried in a sarcophagus instead of having his body burned on a funerary pyre (see "Imperial Funerals," Chapter 13, page 195), but the change in practice postdates Septimius Severus and his family. The earliest securely identifiable sarcophagus of a member of the imperial family is the so-called Balbinus sarcophagus (**Fig. 18-13**). The coffin has a lid in the form of a kline with reclining portraits of the emperor and his wife (her name is unknown) and may have contained both of their bodies or perhaps hers alone. Husband and wife have nearly equal prominence in the pictorial decoration.

The lid portrait of the togate emperor is similar to the head of the statue (Fig. 18-4) of Balbinus from Piraeus. Balbinus has a round face and thick neck. His short hair and beard are incised. He turns his head to the right and his eyes look even farther to the right—not meeting the gaze of his wife, who props her chin on her left hand and looks respectfully at her husband, thus making him the focus of the viewer's attention as well. She, like her husband, has a full face and heavy

chin. She is older than either Julia Mamaea or the anonymous young woman in the Capitoline Museum (Figs. 18-11 and 18-12) and wears her hair in a simple coiffure, parted at the center and combed in waves over the ears. The hairstyle is closer to Julia Domna's than to styles popular in 238, but it is consistent with her age. Older people, both male and female, today as then, often maintained the hairstyles popular in their youth long after they went out of fashion.

The front of the sarcophagus is a variation of the compositions on Antonine biographical sarcophagi (Fig. 15-14). At the center is the imperial couple. Fortuna, holding a cornucopia, and Virtus stand beside the empress (whose features are younger and more idealized than on the lid). Mars is to the right of the emperor. Victory flies in to place a wreath on Balbinus's head. At the right, the emperor and empress join hands on the occasion of their marriage. The right short end of the sarcophagus has a relief depicting dancing figures. On the left end are the Three Graces, the goddesses of beauty, grace, and happiness. These are virtues associated with women, not men. Balbinus probably commissioned this sarcophagus for his wife. He may have intended to be laid to rest in it as well, but his murderers dumped his tortured body in the streets, and he may never have received a proper burial.

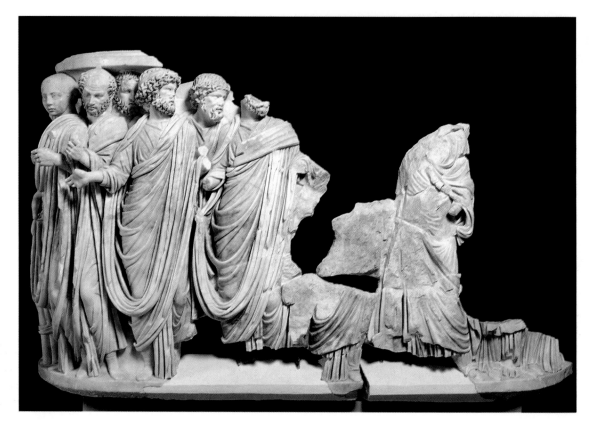

18-14 Sarcophagus of a consul(?), from Acilia, mid-third century. Marble, 4′ 10½″ high. Museo Nazionale Romano–Palazzo Massimo alle Terme, Rome.

ACILIA SARCOPHAGUS One of the finest—and most controversial—works of third-century relief sculpture is the fragmentary sarcophagus (**Fig. 18-14**) found at Acilia, near Rome. It is an example of a later form of Roman coffin that art historians call the *lenos* (bathtub) sarcophagus type because of its rounded corners. The decoration of the body of the sarcophagus (fragments of the lid are also preserved) places it in the biographical category, and many scholars believe the coffin was made for a member of the imperial family.

Dominating the front of the Acilia sarcophagus are a man and a woman accompanied by other men and women. The central couple does not clasp hands, however, and this is not a marriage scene but a procession of the type long part of the Roman sculptural repertory, for example, on the Ara Pacis Augustae (Fig. 5-18). The event depicted seems to be a *processus consularis,* the procession honoring the appointment of a new consul in which he marched with his senatorial colleagues and members of his family. The identification of the consul in the absence of his portrait depends on the identification of the youthful togatus (**Fig. 18-1**) on the left side of the sarcophagus. His head stands out sharply from those of the bearded senators around him, who are portrayed with outdated Antonine coiffures and beards carved in large part with a drill. The style of the boy's portrait and his distinctive features have led many to identify him as Gordian III (compare Fig. 18-5). If the identification is correct, the consul on the Acilia sarcophagus would be Gordian's father, Julius Balbus, and the woman beside him would be Maecia Faustina, Gordian's mother and the daughter of Gordian I.

This attractive theory is not without problems. Most important is the fact that "Gordian III" has the large hands with prominent veins of an older man. The boy's head must have been recut from a larger head of another bearded senator. Since an imperial commission would certainly have called for a custom-made sarcophagus, not a stock piece recut at the time of purchase, this was probably a private sarcophagus, purchased for a Roman whose son bore an uncanny resemblance to the boy-emperor. Whether the deceased was ever a consul is debatable, given the role-playing rampant on Roman sarcophagi and in Roman art in general.

LUDOVISI BATTLE SARCOPHAGUS Battle scenes were also popular choices for sarcophagi in the third century—for the obvious reason that warfare then was almost continuous. An unusually large sarcophagus (**Fig. 18-15**), discovered in Rome in 1621 and purchased by Cardinal Ludovisi, is decorated on the front with a chaotic scene of battle between Romans and one of their northern foes, probably the Goths. The sculptor spread the writhing and highly emotive figures evenly across the entire relief, with no illusion of space behind them. This massing of figures is an even more extreme rejection of Classical perspective than was the use of floating ground lines on the pedestal of the Column of Antoninus Pius (Fig. 13-18) or the elevation of background figures on the Column of Marcus Aurelius (Figs. 13-24 to 13-27) and the Arch of Septimius Severus at Lepcis Magna (Figs. 17-8 and 17-9). This figural composition underscores the increasing dissatisfaction Late Imperial artists felt with the Classical style.

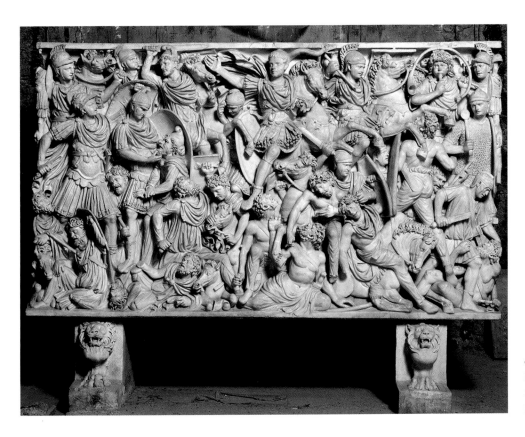

18-15 Sarcophagus with battle of Romans and barbarians, from Rome, ca. 250–260. Marble, 5′ high. Museo Nazionale Romano–Palazzo Altemps, Rome.

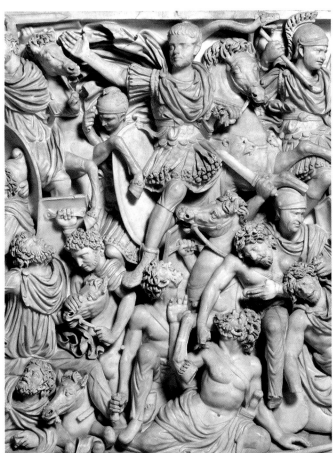

18-16 Detail of the battle sarcophagus in Fig. 18-15.

Within the dense mass of intertwined bodies on the Ludovisi battle sarcophagus, the central horseman (**Fig. 18-16**) stands out vividly. He is bareheaded and thrusts out his open right hand to demonstrate that he holds no weapon. Several scholars have identified him as one of the sons of Trajan Decius, and this superbly carved coffin may have been an imperial commission. In an age when the Roman army was far from invincible and Roman emperors were constantly felled by other Romans, the young general, whether an emperor's son or a private citizen, is boasting that he is a fearless commander assured of victory. His self-assurance may stem from his having embraced one of the increasingly popular Oriental mystery religions. On the youth's forehead is carved the cross-shaped emblem of Mithras, the Persian god of light, truth, and victory over death. Many shrines to Mithras dating to this period have been found at Rome and Ostia.

The lid of the Ludovisi sarcophagus is in Mainz, Germany, today. It has a central plaque, uninscribed but probably once bearing painted letters stating the deceased's name. To the left is a scene of the same general granting clemency to a barbarian family, reprising a theme often used on Antonine sarcophagi (Figs. 15-13 and 15-15, *lid*). To the right is a bust-length portrait of a woman, who must be the wife or the mother of the heroic young general.

LION HUNT SARCOPHAGUS A long tradition in the ancient world dating to early Egypt and Mesopotamia equated prowess in the royal sport of hunting with prowess on the battlefield, so it is not surprising to find Roman sarcophagi

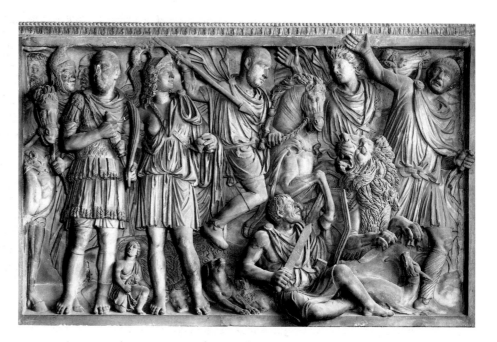

18-17 **Sarcophagus with lion hunt, ca. 250. Marble, 4′ 4⅜″ × 7′ 4½″. Palazzo Mattei, Rome.**

that incorporate both themes and invite the viewer to draw the parallel. A sarcophagus (**Fig. 18-17**) in the Palazzo Mattei in Rome shows a cuirassed Roman general at the left with Virtus by his side and a kneeling barbarian at his feet. At the right, the same man, now wearing a hunter's tunic and mounted on a horse, charges a lion that he will kill with the spear he holds in his right hand.

The deceased's success in the hunt here, however, is more than merely a demonstration of his fighting ability. His victory over the king of beasts is also an allegory for his victory over death itself, namely the achievement of a happy afterlife free from the woes of the turbulent times of the mid-third century. Other contemporary lion-hunt sarcophagi are also preserved. They can be considered biographical versions of earlier sarcophagi representing heroic mythological hunters

such as Meleager (Figs. 15-7 and 15-8). The style of the portrait suggests a date around the middle of the third century for the Mattei sarcophagus, roughly contemporary with the Ludovisi battle sarcophagus.

PHILOSOPHER SARCOPHAGI The insecurity of the times led many Romans to seek solace in philosophy. On many third-century sarcophagi, the deceased assumed the role of the learned intellectual. One especially large, if fragmentary, example (**Fig. 18-18**) depicts a seated Roman philosopher holding a scroll. Two standing women (also with portrait features) gaze at him from left and right, confirming his importance. In the background are other philosophers, either students or colleagues of the central deceased teacher. Some scholars once thought the deceased was Plotinus, the leading philosopher of

18-18 **Sarcophagus with philosophers and muses, ca. 270–280. Marble, 4′ 11″ × 7′ 10½″. Musei Vaticani, Rome.**

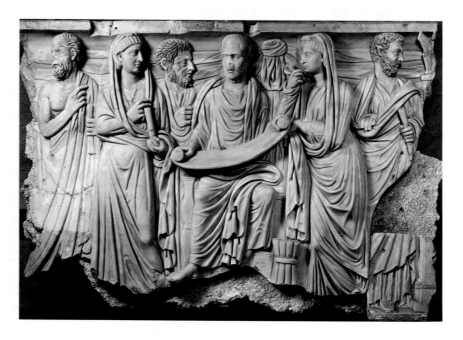

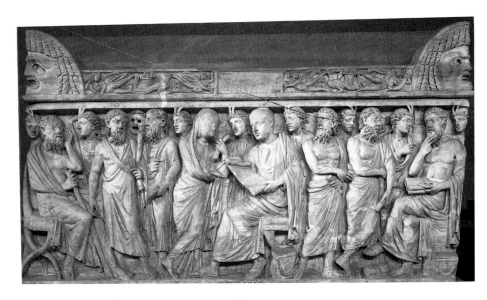

18-19 **Sarcophagus of Lucius Pullius Peregrinus, ca. 250–260. Marble, 4′ 4$\frac{3}{8}$″ × 7′ 3$\frac{3}{8}$″. Museo Torlonia, Rome.**

the era of the soldier emperors, but the identification is no longer accepted. The two women may be the deceased's wife and daughter, two sisters, or some other combination of family members. All the figures are based on Greek representations of philosophers and muses, but the composition is distinctly Roman and specifically Late Antique with a frontal central figure and two subordinate flanking figures.

Philosopher sarcophagi were so popular during the mid-to-late third century that workshops both in the West and the East produced large numbers of stock pieces, confident that there would be many customers for them. The portrait features might be custom additions, left unfinished until a specific individual purchased the sarcophagus, but the coffins were otherwise ready for use. This was clearly the situation when the family of Lucius Pullius Peregrinus chose his sarcophagus (**Fig. 18-19**), today in the Museo Torlonia in Rome. The workshop that manufactured the coffin had left the heads of the seated philosopher and his muse blank in anticipation of carving portraits of a husband and wife when the piece was sold. Peregrinus's portrait is similar to those of other young Romans

of the mid-third century. He may, however, have been a bachelor at the time of his death. The head intended to be his wife's is featureless. A similar unfinished head—of the deceased himself—on the Portonaccio battle sarcophagus (Fig. 15-1) has already been discussed. These two Antonine and third-century sarcophagi should caution scholars not to assume that those buried in battle sarcophagi were generals or those buried in philosopher sarcophagi were learned men. Patrons chose from among several stock types that a workshop had to offer, selecting the image they wished to present to posterity, even if the deceased never assumed that role in life.

MARS AND RHEA SILVIA As in Antonine times, third-century customers also had a wide variety of mythological heroes and heroines with which to associate the deceased if they preferred a nonbiographical sarcophagus. Greek myths continued to be the most popular choices, but some sarcophagi portray the exploits of famous figures from Roman mythology. A sarcophagus (**Fig. 18-20**) in the Palazzo Mattei depicts the foundation myth of Rome. Mars (whose head has

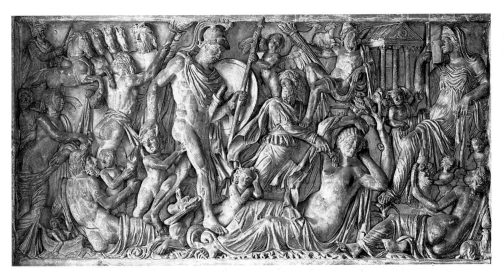

18-20 **Sarcophagus with Mars and Rhea Silvia, ca. 200. Marble, 4′ 2$\frac{3}{8}$″ × 7′ 9″. Palazzo Mattei, Rome.**

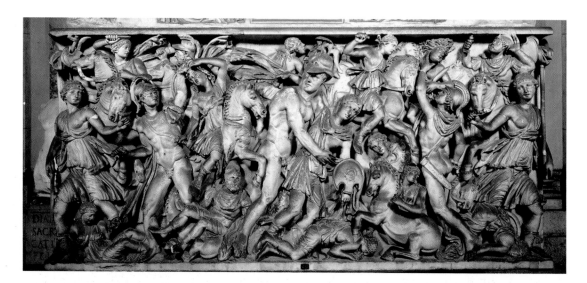

18-21 Sarcophagus with Achilles and Penthesilea, ca. 225–250. Marble, 3′ 10″ high. Musei Vaticani, Rome.

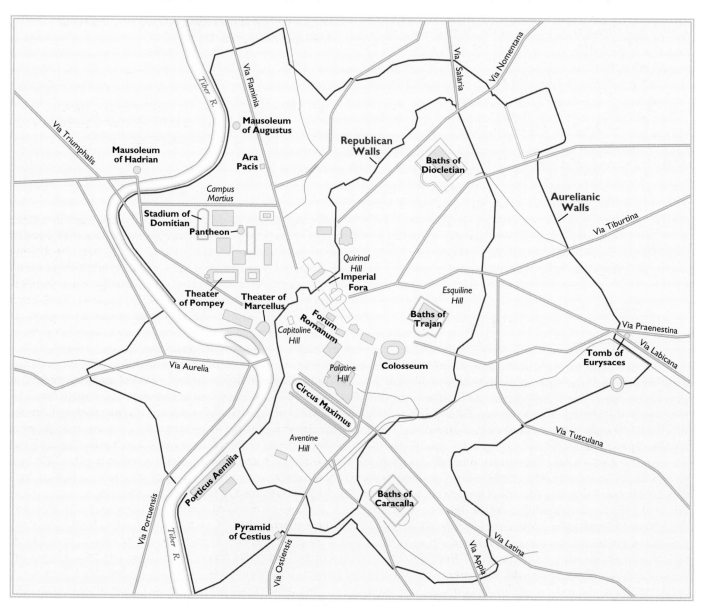

18-22 Plan of Rome at the end of the third century.

the portrait features of a third-century man) strides in from the left to seduce the Vestal Virgin Rhea Silvia, a role played by a contemporary Roman woman whose coiffure emulates Julia Domna's (Figs. 16-3, 16-4, and 16-7). The woman, no doubt the wife of the man portrayed as Mars, does not, however, dress like a Vestal Virgin. She is seminude and reclines langorously with Cupid at her feet. The assimilation to Venus is underscored by the goddess's presence in the composition. Venus is the seated goddess next to the temple at the upper right. In the lower corners are, at the left, Oceanus and a sea dragon and, at the right, Tellus with a cornucopia. The right end of the sarcophagus depicts two shepherds discovering the she-wolf nursing Romulus and Remus. This Roman couple indulged in self-flattery by playing the roles of the mother and father of the founders of Rome.

ACHILLES AND PENTHESILEA A work that illustrates both the appeal of Greek mythology in the third century and the insecurity and alienation of the age is the Achilles and Penthesilea sarcophagus (**Fig. 18-21**), now in the Vatican and datable to the second quarter of the century. It recounts the tragic tale of how the Greek hero Achilles killed the Amazon queen Penthesilea during the Trojan War (see "Greek Myths on Roman Sarcophagi," Chapter 15, page 221) and how the two foes gazed into each other's eyes and fell in love—too late. The myth was a popular one in Greek art, and artists typically chose to depict the moment the two fell in love. But on this third-century sarcophagus, the lovers (both heads are portraits) do not look at each other at all. Penthesilea is already dead. Achilles props up her limp body but turns his head over his right shoulder. Just as freestanding portraits of the era of the soldier emperors almost never meet the viewer's gaze, these famous lovers cannot look in each other's eyes either—even though that visual exchange is the essence of the myth.

ARCHITECTURE

Although during the half century between the Severans and the tetrarchs, cities throughout the Empire were busy constructing new buildings, often in the then-fashionable baroque style (see Chapter 17), the only significant building activity in Rome occurred under Aurelian between 270 and 275. He constructed the Temple of the Sun and a new fortified wall circuit for the capital, which enclosed the greatly expanded urban center of the third century, about three times the area within the old Republican walls (**Fig. 18-22**). The Aurelianic Walls (**Fig. 18-23**), more than a dozen miles long, were designed to defend the city from external threats that did not exist during the Early or High Empire. Roman soldiers could patrol the city's perimeter along a continuous protected walkway at the top of the walls. Square towers projected from the walls at regular intervals. The gates in the walls were built of stone, but the walls themselves were brick-faced concrete incorporating almost exclusively reused bricks because of the economic difficulties of the age and the enormous cost of the project.

18-23 Section of the Aurelianic Walls near the Porta Ardeatina, Rome, 271–275.

Although a strain on the imperial treasury, the Aurelianic Walls were a military necessity in 270 and a poignant commentary on the decay of Roman power.

SUMMARY

The only parallel for the turbulent times of the era of the soldier emperors was the period following Nero's suicide in 68, but that earlier civil war lasted only a single year (see Chapter 9). During the almost ceaseless strife of the mid-third century, the only major architectural project in Rome was, tellingly, a new fortification wall designed to defend the capital against attack from without. It could not, however, protect the emperors against attack from within, and many third-century rulers were killed at the hands of the praetorian guard.

In contrast to the dearth of new buildings in Rome during the era of the soldier emperors, works of sculpture survive in considerable numbers and are of enduring importance. The portraits of the men and women of the mid-third century are among the most moving ever made. They not only preserve the likenesses of emperors, empresses, and private citizens but also record their psyches. Reflecting the insecurity of the age, those portrayed, whether old or young, male or female, typically look away nervously from the viewer.

Sculptors also fashioned an impressive series of marble sarcophagi, which were in high demand—even, for the first time, among members of the imperial family. The reliefs on third-century sarcophagi reprise many of the same themes popular under the Antonines (see Chapter 15), but new subjects also gained prominence, including portrayals of the deceased hunting lions, marching in a consular procession, and seated as a philosopher among his muses.

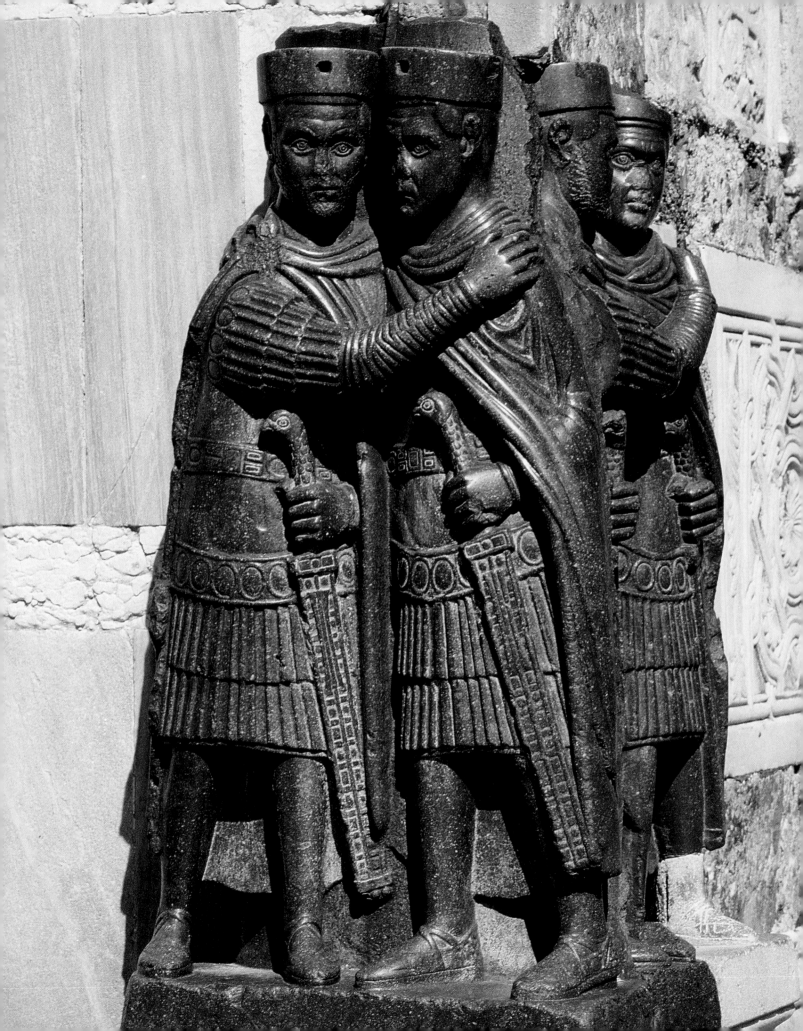

CHAPTER NINETEEN

The Tetrarchy

Diocletian was born in Dalmatia (roughly corresponding to the former Yugoslavia). On November 20, 284, when he was about 40 years old, the army hailed him emperor at Nicomedia after Aper, the praetorian prefect, killed Numerian. Diocletian had to defeat Carinus, Numerian's brother, as well as another rival before he established himself as sole emperor, naming Maximian, a loyal general also born in Dalmatia, as his Caesar. In 286, Diocletian promoted Maximian to co-Augustus. But even this division of power did not provide the desired stability for the Empire. Threats from without continued all along the northern and eastern frontiers. The new emperors also had to live with the constant fear of challenges from within the Roman army. In 293, Diocletian created the *tetrarchy* (rule by four) and adopted the title Augustus of the East. Maximian became the Augustus of the West (see "The Tetrarchy," page 280). Each adopted an epithet suggestive of their divine right to rule. Diocletian took Iovius (Jupiter), and Maximian Herculius (Hercules). Diocletian also named two Caesars: Galerius, Caesar of the East, and Constantius Chlorus ("the Pale"), Caesar of the West. To cement the allegiance of the Caesars to the Augusti, new marriages were arranged. Galerius divorced his wife to marry Diocletian's daughter Valeria, and Constantius divorced Helena (mother of Constantine; see Chapter 20) to marry Maximian's stepdaughter Theodora. Together, the four emperors ruled without strife until Diocletian retired in 305. Without his leadership, the tetrarchic form of government collapsed, and civil war resumed. Diocletian's division of the Roman Empire into Eastern and Western spheres survived, however, and persisted throughout the Middle Ages, setting the Latin West apart from the Byzantine East.

PORTRAITURE

Under the tetrarchy, the Roman Empire was more stable than it had been for a half century, but it was also more divided than it had ever been in its thousand-year history. Four emperors ruled from different centers (see Map 11-1, page 156)—and none was Rome. Diocletian's capital was at Nicomedia (Turkey), Maximian's at Milan (Italy), Galerius's at Thessaloniki (Greece), and Constantius's at Trier (Germany). The most pressing need, therefore, was to project an image to the world of imperial concordia, that is, the harmony of the four emperors. Coins and statuary groups—and, no doubt, paintings also, but all are lost—met that need admirably.

19-1 Columnar portraits of four tetrarchs, from Constantinople (Istanbul), Turkey, ca. 300. Porphyry, approx. 4′ 3″ high. San Marco, Venice.

NUMISMATIC PORTRAITURE A gold medallion in the American Numismatic Society in New York, struck in the year Diocletian established the tetrarchy, bears portraits of the four emperors, two on each side. The obverse (**Fig. 19-2**) has bust-length facing portraits of the Eastern emperors, Diocletian

WHO'S WHO IN THE ROMAN WORLD

The Tetrarchy

Diocletian (Gaius Aurelius Valerius Diocletianus, r. 284–305) became emperor after the murder of Numerian, but in 286 he decided to share power with Maximian, and in 293 he established the tetrarchy. Diocletian was Augustus of the East from 293 until his retirement in 305.

Maximian (Marcus Aurelius Valerius Maximianus, r. 285–308) became co-emperor with Diocletian in 286 and was the tetrarchic Augustus of the West from 293 to 305, when he abdicated with Diocletian.

Galerius (Gaius Galerius Valerius Maximianus, r. 293–311) was Diocletian's praetorian prefect. He was named Caesar of the East in 293 and Augustus of the East in 305. He died of an illness in 311.

Constantius Chlorus (Flavius Valerius Constantius, r. 293–306) was Caesar of the West from 293 to 305, when he became Augustus of the West. He died at York in 306, where his son Constantine was hailed Augustus in his place. ■

AVG[ustus] and Maximian (that is, Galerius) *C*[aesar]. On the reverse (**Fig. 19-3**) are the Augustus of the West, Maximian, and his Caesar, Constantius Chlorus. Only the accompanying (much abbreviated) titles distinguish the Augusti and the Caesars by rank. All four are similarly dressed in cuirass and paludamentum and have wreaths in their hair. Even their "likenesses" are similar. The coiffures and beards are as identical as are the costumes, and each emperor has a square-shaped head. Only small differences in the nose profile or the pattern of lines in the face distinguish one portrait from another, and these may be the result of incidental variations in

engraving rather than intentional markers to set one man apart from the others. The artist's primary purpose was to present the four men as tetrarchs, not as individuals. The ensemble is a portrait of the new form of government, not of the four men who were the four rulers.

ATHRIBIS BUST For a portrait of a tetrarch displayed singly, identification is impossible unless an inscription is preserved, and none is. Scholars have identified a portrait bust (**Fig. 19-4**) from Athribis, Egypt, as Galerius largely on the basis of its findspot within the Eastern Empire that he ruled. The portrait

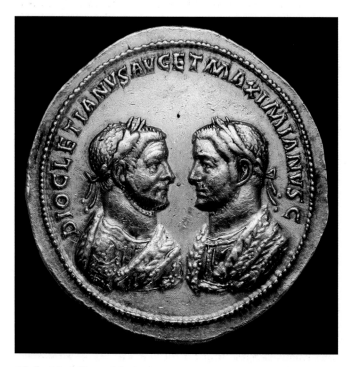

19-2 Medallion with obverse portraits of Diocletian (*left*) and Galerius (*right*), 293. Gold, 1⅝″ diameter. American Numismatic Society, New York.

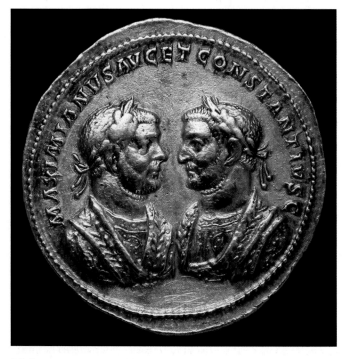

19-3 Medallion with reverse portraits of Maximian (*left*) and Constantius Chlorus (*right*), 293. Gold, 1⅝″ diameter. American Numismatic Society, New York.

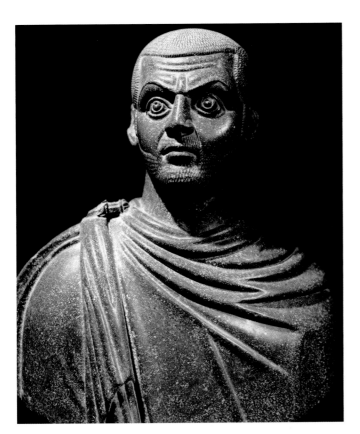

19-4 **Bust of Galerius(?), from Athribis, Egypt, ca. 300. Porphyry, 2′ 5½″ high. Egyptian Museum, Cairo.**

19-5 **Detail of the heads of two of the tetrarchs in Fig. 19-1.**

is carved out of porphyry, the hard purple stone quarried in Egypt and favored by the tetrarchs because of its color. Purple, the color of high office in Rome for centuries, connoted rulership and royalty in late antiquity. Galerius (if it is he) has a cubic head, a stylistic legacy of the portraiture of Probus (Fig. 18-10), but the abstraction is greater in the tetrarchic head. As in the portraits of the soldier emperors, the sculptor negatively carved the hair on the top of the head and the beard, but the irregular incisions of earlier portraits have become neat lines of chisel marks. Abstract patterning is also seen in the parallel lines of the furrows in the forehead, the matching arched eyebrows, and the round, staring eyes that resemble a bull's-eye target. The abstraction gives the bust an impersonal, iconic look. The artist drained all individuality from the face—and all sense of nervous insecurity as well, in contrast to the portraiture of the soldier emperors (see Chapter 18). The Athribis bust is a portrait of the notion of "emperor," not a likeness of Galerius or one of his colleagues.

COLUMNAR PORTRAITS Two sets of porphyry portrait groups of all four tetrarchs are today in Venice and in the Vatican. Both groups are of similar unusual format. The tetrarchs appear in two pairs, one pair in high relief projecting on brackets midway up the shaft of each of two columns. The Venetian group (**Figs. 19-1** and **19-5**) is more fragmentary, and because only a small curved section of each column

shaft survives, few of the thousands of visitors daily to San Marco, where the fragments are embedded in the church's southwestern corner, realize that the portraits once adorned two freestanding columns. The discovery of one tetrarch's missing foot in the later imperial palace at Constantinople (modern Istanbul, Turkey) proves that Venice was not the original location of the columns, but when the portraits were imported to Italy is unknown.

The bodies of the Venetian figures (Fig. 19-1) are of stocky proportions—suitable complements to the cubical heads. No trace remains of the grace or contrapposto of the Early and High Empire. Instead, Late Antique abstraction characterizes every aspect of the full-length portraits. The drapery is schematic, and the bodies are shapeless. The faces (Fig. 19-5) are emotionless masks, differentiated only by the beard on two of the rulers, probably the older Augusti to distinguish them from the younger Caesars. This means that the tetrarchs were paired as on the medallion (Figs. 19-2 and 19-3) of 293, with the Western rulers on one column and the Eastern tetrarchs on the second. Otherwise, the groups are as alike as freehand carving can achieve. As on the medallion, all the tetrarchs are identically clad in cuirass and long paludamentum. Each wears the simple stiff round cap that Diocletian introduced to the imperial wardrobe. The caps once had a stone of a different color pegged into the front to approximate the appearance of the jewels that were the sole ornamentation of

19-6 **Columnar portraits of two tetrarchs, from Rome, ca. 300. Porphyry, figures 1′ 10″ high. Biblioteca Apostolica Vaticana, Rome.**

these caps. Each tetrarch grasps a sheathed sword in his left hand. With their right hands they embrace one another in an overt display of imperial concord. As in other tetrarchic portraits, the emperors have lost their individuality. All has been subsumed into the larger entity of the tetrarchy itself.

The Vatican columns (**Fig. 19-6**), found in Rome, are better preserved. The style of these portraits is even more abstract than that of their Venetian counterparts. The figures are very squat. The width of each pair at the bottom of the cloaks is approximately the same as the height of the portraits. The bodies, therefore, are as cubical as the heads, which have the same kind of powerful staring eyes as the Athribis bust (Fig. 19-4). In the Vatican group, all four tetrarchs wear beards, but one figure in each pair has a relatively unlined face. This must be the sculptor's way of differentiating the Caesars from their fathers-in-law, the Augusti. The central message is still that of the harmony of shared power, symbolized once again by the tetrarchs' embracing one another. But the Vatican group differs from the Venice group in other ways. These tetrarchs wear jeweled laurel wreaths and hold orbs in their left hands, the symbol of world power. Each, however, rules over only a portion of the Empire, but together the tetrarchs exercise hegemony over the entire world.

ARCHITECTURE AND RELIEF SCULPTURE

Toward the end of 303, Diocletian arrived in Rome with Maximian to commemorate the *decennalia* (10th anniversary) of the tetrarchy and his own *vicennalia* (20th anniversary) as emperor. It is symptomatic both of Rome's continued symbolic significance as the center of the Empire and the sharp decline in the city's actual importance that Diocletian chose to celebrate his double anniversary there—and never visited Rome before or after. His short sojourn in the old capital did result, however, in the erection of an honorific monument in the Forum Romanum. Earlier his builders had begun construction of an immense new public bathing complex that was still unfinished in 303. But the emperor was able to see the new Curia (Senate house; Fig. 5-5, no. 9) in the old Republican forum (Fig. 1-1) that he rebuilt after a fire in 283, faithfully reproducing the form of the Curia when Caesar and Augustus first erected it three centuries before.

DECENNIAL FIVE-COLUMN MONUMENT In 303, Diocletian set up near the Curia, behind the Rostra, five statue-topped rose-colored granite columns to mark the tetrarchy's 10th anniversary. By then, he had been emperor longer than anyone in the third century, and no co-rulers in Rome's long history had ever shared decade-long power. The decennial monument, as it is usually called, paid tribute, and justly so, to the longevity of the tetrarchy and the stability Diocletian had brought to the Roman world after the chaotic era of the soldier emperors.

The decennial monument is pictured in the frieze of the later Arch of Constantine, in which Constantine is shown addressing the Roman people from the Rostra (Fig. 20-10). Behind the speaker's platform are five columns. The central column is the tallest and supports a statue of Jupiter, Diocletian's patron god. The other four bear porphyry portraits of the four tetrarchs, or, more precisely, statues of each emperor's *genius,* the imperial alter ego carrying a cornucopia and patera. The statues of the *genii* of the Augusti are somewhat larger than those of the Caesars. Almost all that survives of this five-column monument is a white marble pedestal, roughly the size of a sarcophagus front on each side, with relief sculptures on all four sides. It honored one of the two Caesars.

The front (**Fig. 19-7**) of the pedestal depicts two Victories displaying a shield that one of the Victories has inscribed with the words *Caesarum decennalia feliciter* (the happy 10th anniversary of the Caesars). Trophies are to the left and right, and two captive barbarians are beneath the shield, underscoring the success of the tetrarchs in protecting the Empire from foreign foes as well as in maintaining internal peace. A now-lost inscription hailing the 20th anniversary of the Augusti (*Augustorum vicennalia feliciter*) must have come from either Diocletian's or Maximian's column, even though the latter was still a few years short of his 20th anniversary in 303. Most significant was the presentation of the two Augusti as equals with matching columns. The carving is very shallow, and the figures on each side of the pedestal are usually outlined with grooves to set them off more sharply from the backgrounds.

19-7 Victories inscribing a shield, pedestal of a column from the tetrarchic decennial monument, Forum Romanum, Rome, 303. Marble, 5′ 10″ wide.

Some details, for example the trophies in the Victory relief, are composed entirely of sunken lines.

On the left side (**Fig. 19-8**) is a procession of toga-clad men. The four most prominent figures in the procession carry scrolls and wear togas with contabulatio. Their faces are obliterated, but it is likely that these togati are the tetrarchs themselves, perhaps with Diocletian in the lead, although given the artistic preference of this age for frontal groups with the most important figure(s) in the center, the two conversing togati in second and third place in the procession may be Diocletian and Maximian. If so, the flanking figures would be the two Caesars. In the background, other figures carry military standards capped with imperial devices including Jupiter's eagle and a Victory.

19-8 Procession, pedestal of a column from the tetrarchic decennial monument, Forum Romanum, Rome, 303. Marble, 5′ 10″ wide.

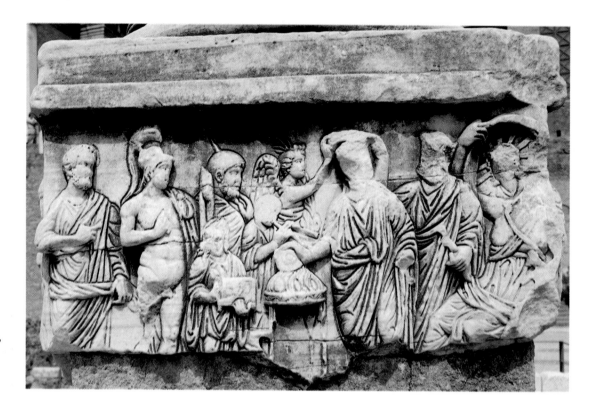

19-9 Sacrifice, pedestal of a column from the tetrarchic decennial monument, Forum Romanum, Rome, 303. Marble, 5′ 10″ wide.

The right side represents attendants leading in the pig, sheep, and bull of the suovetaurilia, and the back (**Fig. 19-9**) of the pedestal depicts the sacrifice itself. The relief here is also very shallow, and the sculptor relied more on incised lines than raised relief to depict the participants. One of the emperors, presumably the Caesar whose *genius* statue topped the column, pours a libation from a patera as Victory places a wreath on his head. Aiding her in the crowning ceremony is the personified Senate—pictorial affirmation of senatorial support for the tetrarchs. The onlookers include, at the left, the war god Mars, nude save for his helmet and cloak, and, at the right, Roma seated and behind her the radiate sun god.

BATHS OF DIOCLETIAN Diocletian left a permanent mark on the capital he had shunned by constructing an immense new bathing complex (**Fig. 19-10**) on the outskirts of the city but within the Aurelianic Walls, in the area adjacent to what is now Rome's main railroad station, the Stazione Termini.

19-10 Aerial view of the Baths of Diocletian, Rome, ca. 298–306.

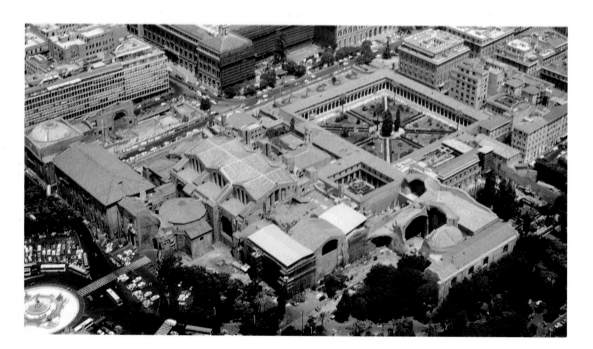

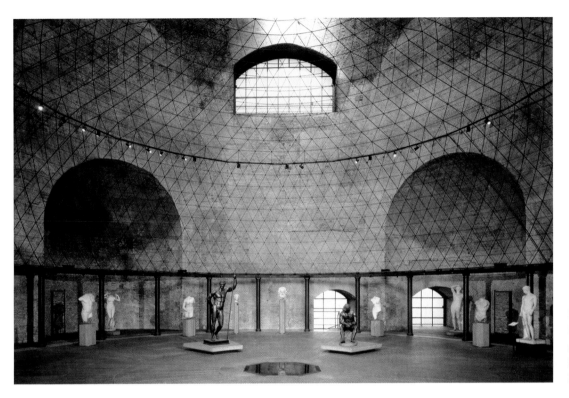

19-11 **Octagonal hall, Baths of Diocletian, Rome, ca. 298–306 (remodeled as an exhibition hall in the Museo Nazionale Romano).**

The central block alone, which contained the cold-, warm-, and hot-water bathing facilities, the swimming pool, and two palaestras, was 785 × 475 feet. The organization of the rooms followed very closely the pattern established in the 80-year-old Baths of Caracalla (Fig. 16-21), but the Diocletianic plan was simplified, especially with regard to the arrangement of the rooms around the perimeter of the complex. The tetrarchic designer also substituted a rectangular three-bay groin-vaulted caldarium for the dome-capped cylindrical caldarium of Caracalla's baths, repeating the plan of the Diocletianic frigidarium but varying it by the addition of semicircular apses at the center of each side. The alternation of curved and rectilinear recesses also characterizes the layout of the rooms around the perimeter.

Diocletian's baths have had a colorful afterlife in later times. Today, for example, they house a branch of one of the city's most important archaeological museums, the Museo Nazionale Romano. The museum's most impressive exhibition space (**Fig. 19-11**) is an early-fourth-century domed octagonal hall (Fig. 19-10, *far left*) that served from 1928 to 1987 as a planetarium. The ancient bathing complex also incorporates two churches: Sant'Isidoro in Thermis (Saint Isidore at the Baths) and Santa Maria degli Angeli (Saint Mary of the Angels, Fig. 19-10, *left center*). The huge groin-vaulted frigidarium of Diocletian's baths formed the core of the latter, which Michelangelo redesigned in the 16th century as the church's nave (**Fig. 19-12**). Luigi Vanvitelli remodeled the church in the 18th century but was faithful to Michelangelo's vision. The Renaissance/Baroque interior has many new elements not part of the original frigidarium, including a painted altarpiece, and the ancient mosaics and marble revetment are long gone, but

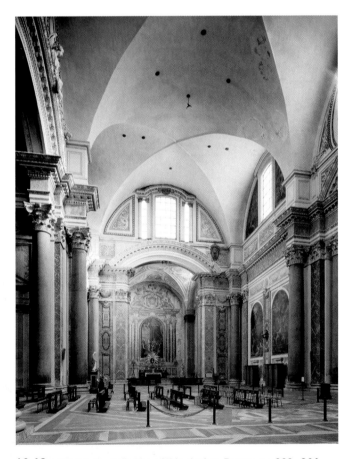

19-12 **Frigidarium, Baths of Diocletian, Rome, ca. 298–306 (remodeled by Michelangelo as the nave of Santa Maria degli Angeli, 1563).**

the present-day interior with its rich wall treatment, colossal columns with Composite capitals, immense groin vaults, and clerestory lighting gives a better sense of the character of one of Rome's imperial thermae than does any other building in the world. In Santa Maria degli Angeli, as in the Pantheon (Fig. 12-1), visitors can appreciate how magnificent the interiors of Roman concrete buildings once were. It takes a powerful imagination to visualize the original structures from the crumbling ruins of brick-faced walls and concrete vaults at ancient Roman sites today, but Santa Maria degli Angeli makes the task much easier.

ARCH OF GALERIUS In 293, Diocletian erected a triumphal arch on the Via Flaminia in Rome to commemorate his personal achievements on the battlefield and the establishment of the tetrarchy. Only fragments of the relief decoration of the monument, the Arcus Novus ("New Arch"), are preserved. Reconstruction of the arch is problematic, but it seems certain that much of the decoration consisted of recycled reliefs from earlier monuments, although two relief-clad column pedestals from the arch, now in the Boboli Gardens in Florence, appear to be Diocletianic in date. Much better preserved, although but a shadow of its former self, is the Arch of Galerius (**Fig. 19-13**) at Thessaloniki, the capital of the Caesar of the East, where Galerius also constructed his palace and his mausoleum. The latter, a dome-covered rotunda, became the Byzantine church of Saint George in the fifth century.

Galerius's arch took the exceedingly rare form of an *octopylon,* an arch with eight piers. It stood at the intersection of two colonnaded streets, and its core was a quadrifrons, like the Severan arch (Fig. 17-7) at Lepcis Magna, but lateral bays were added to two sides so that two of the four sides had three bays. Only part of one of the three-bayed facades (Fig. 19-13) still stands. The arch was begun in 298 and completed in 303. It commemorated Galerius's victory over King Narses of Persia, a difficult campaign in which the emperor was initially defeated but, with the aid of reinforcements, launched a new attack that brought a resounding victory. The arch, like Diocletian's Arcus Novus in Rome, therefore celebrated Galerius's personal triumph, but the other tetrarchs were also honored. Two niches on each triple-bay facade housed portrait statues of the four emperors. Most likely Diocletian and Galerius were portrayed on the southeastern side, and Maximian and Constantius Chlorus on the northwestern side, facing their respective domains.

The four piers of the quadrifrons were decorated with marble reliefs in the form of stacked friezes. **Fig. 19-14** reproduces the top three friezes of the outer face of the southwestern pier ("pier B"). Like the reliefs (Figs. 19-7 to 19-9) on the pedestal of the decennial monument in the Forum Romanum, the friezes of Galerius's arch are sarcophagus-like in format. During the era of the soldier emperors, sarcophagi were the only major commissions available to relief sculptors, and it is not surprising that when the tetrarchs revived the

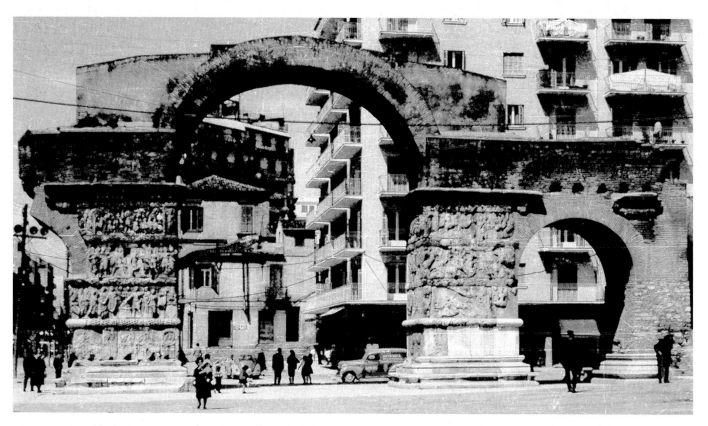

19-13 Arch of Galerius, Thessaloniki, Greece, ca. 298–303.

practice of erecting commemorative monuments in Rome and the provinces, sculptors decorated them with reliefs of the size and shape with which they were most familiar.

Scholars continue to debate which specific events during Galerius's Eastern campaigns are depicted on the remaining piers, but most of the friezes are generic in character, and their compositions draw upon the long tradition of Roman historical relief sculpture. In their general character, the piers resemble the relief-clad Columns of Trajan (Fig. 11-1) and Marcus Aurelius (Fig. 13-24), but with self-contained stacked episodes instead of a continuously unfolding narrative in a spiral frieze. The Galerian arch also mixes battle scenes and ceremonial scenes. It is unclear whether the friezes are to be read in chronological order from top to bottom or, as on the columns, from bottom to top, or even if a specific chronological narrative is intended at all. What is certain is that some of the scenes relate episodes from Galerius's war against Narses, and others on the same pier are generic scenes celebrating all four tetrarchs.

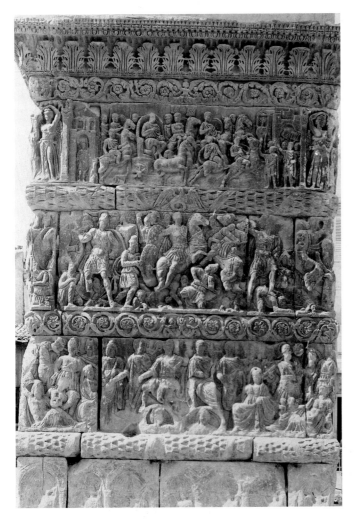

19-14 Three friezes of the southwest pillar (pier B), Arch of Galerius, Thessaloniki, Greece, ca. 298–303.

The uppermost frieze of the northeastern side of pier B (Fig. 19-14, *top*) represents the adventus of Galerius, perhaps his entry into Thessaloniki itself, although a conquered city is also a possibility. The emperor rides in a *biga* (a two-horse chariot) with a protective cavalry escort. As in other Late Antique reliefs, the two files of horsemen are represented in staggered tiers (compare, for example, the chariot procession on the Severan arch at Lepcis Magna, Fig. 17-9). The horses in the foreground have their legs firmly planted on the ground at the lower border of the relief, but those in the background float in space. At the right end of the frieze is the city gate, where the people have gathered to greet the approaching emperor. They are smaller in size than the horsemen, who are in turn smaller than Galerius. Such hierarchy of scale was not new to Roman imperial art, but there are few earlier instances. Exaggerating the size of the emperor was the easiest way for sculptors to denote his higher status.

Below the adventus scene is a representation of Galerius on horseback battling the Persians (Fig. 19-14, *center*). The emperor's horse is trampling a kneeling Persian while Galerius thrusts his spear into the chest of an enemy usually identified as Narses himself. The composition is a traditional one, closely paralleled, for example, on the Great Trajanic Frieze (Fig. 11-23), which drew in turn on battle scenes in Classical and Hellenistic Greek art (for example, the painting of Alexander the Great in battle against King Darius of Persia, Fig. 3-10), but the piling up of figures to fill every inch of the relief surface is a distinctly Late Antique phenomenon (compare the Ludovisi battle sarcophagus, Fig. 18-15). As on the mid-third-century sarcophagus, where the protagonist is depicted in an unrealistic manner (unarmed), the scene on Galerius's arch is also fictional. Galerius and Narses never faced each other on the battlefield.

The third frieze (Fig. 19-14, *bottom*) depicts the four tetrarchs, posed frontally, with the two Augusti enthroned at the center and the two Caesars standing to their left and right. Male and female personifications of uncertain identity with billowing cloaks appear below the Augusti. The bearded male figure is most likely the sky god Caelus. His presence signifies that the Augusti rule the cosmos. Victories fly in to crown all four emperors. Two conquered nations or provinces kneel at their feet. At left and right are several Roman divinities, including Jupiter, Mars, Honos, Virtus, Oceanus, and Tellus. Hierarchical representations such as this one, centered on frontally posed enthroned figures, had an important afterlife in the art of the Middle Ages, in which Christ or the Virgin Mary took the place of the Roman emperors, and angels and saints substituted for the standing and kneeling divinities and personifications.

PALACE OF DIOCLETIAN After visiting Rome in 303 to celebrate the decennalia of the tetrarchy, Diocletian returned to the East, where he remained for the rest of his life. In poor health, he decided in 305 to retire—something no Roman emperor before him had ever opted to do. On May 1 he abdicated along with his co-Augustus of the West and went into seclusion in the palace he had built for himself at Split in

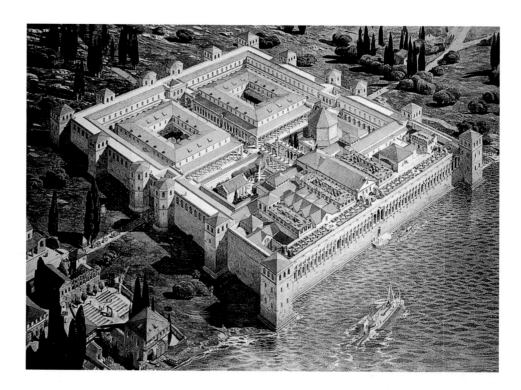

19-15 **Restored view of the Palace of Diocletian, Split, Croatia, ca. 298–306.**

Croatia near ancient Salona on the Dalmatian coast of the Adriatic (see Map 17-1, page 252). Just as Aurelian had felt it necessary to girdle Rome with fortress walls (Fig. 18-23), Diocletian instructed his architects to provide him with a well-fortified palace (**Fig. 19-15**). The complex, which is almost rectangular in plan and covers about 10 acres, was laid out like a Roman castrum, complete with octagonal watchtowers flanking the gates. The south side, where the former emperor's residential quarters were situated, had a 600-foot facade overlooking the sea. The only entrances were the gates in the east, west, and north walls.

The north gate, the Porta Aurea (Golden Gate; **Fig. 19-16**), is a simplified version of the baroque facades of second- and third-century Asia Minor and Africa (see Chapter 17) with columns on brackets and arcuated niches forming a decorative screen in front of the wall. At Split, however, the columnar screen is confined to the area above the portal, and the heavy walls of the gate itself and the flanking towers are fully visible. The Diocletianic gate, in which the columns appear to be hung onto a preexisting wall, almost as a decorative afterthought, stands in sharp contrast, for example, to the second-century gate (Fig. 17-13) to the south agora at Miletus.

Within the high walls of Diocletian's palace, two avenues, comparable to the cardo and decumanus of a canonically planned Roman city such as Timgad (Fig. 2-3), intersected at a colonnaded courtyard (**Fig. 19-17**) where a city's forum would have been situated. The arcaded porticos led to the templelike entrance to the residential wing. The facade, with an arch inside the pediment as in the Temple of Hadrian at Ephesus (Fig. 17-11) and in the Temple of Venus at Baalbek (Fig. 17-19), is another baroque feature of the palace's design. The arch over the central columns also served to frame

Diocletian whenever he emerged from his private quarters to appear before those who gathered in the courtyard to pay homage to him. Consistent with the intrinsic eclecticism of Roman architecture, behind the columnar facade was a concrete dome with an oculus, which formed the vestibule to the residential wing.

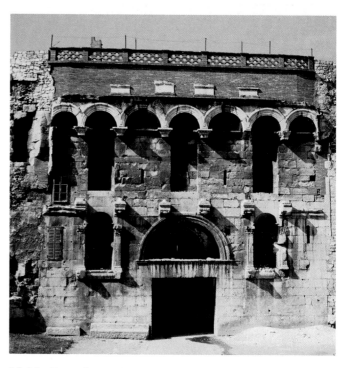

19-16 **Porta Aurea, Palace of Diocletian, Split, Croatia, ca. 298–306.**

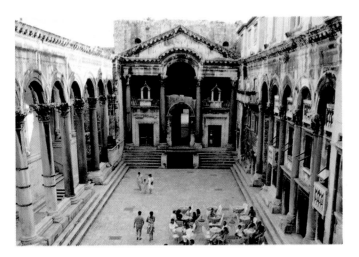

19-17 Courtyard and entrance to the residential wing, Palace of Diocletian, Split, Croatia, ca. 298–306.

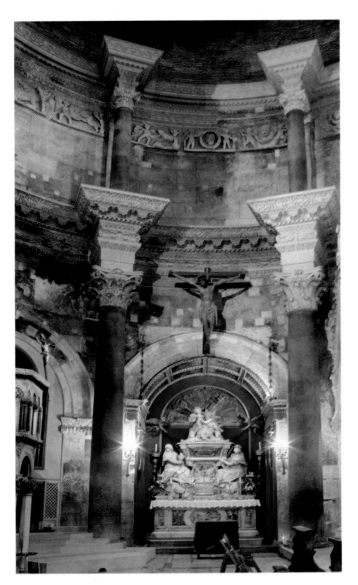

19-18 Interior of the mausoleum, Palace of Diocletian, Split, Croatia, ca. 298–306.

On one side of the court was a small stone barrel-vaulted temple of Jupiter, Diocletian's patron god, and facing it was the emperor's mausoleum (Fig. 19-15, *right center*), which towered above all the other structures in the complex. The mausoleum was a domed octagon, similar in general form to Galerius's domed rotunda at Thessaloniki. It too was later converted into a church. Outside, on the steps leading up to the doorway, were Egyptian statues of sphinxes, a reference to the great tombs of the ancient pharaohs. Inside (**Fig. 19-18**), two tiers of columns, also imported from Egypt, adorned the walls. Those of the lower level are of red granite. The shorter columns of the second level are alternately gray granite and porphyry. One unusual feature of this baroque design is the misplacement of the sculptured frieze of the upper level behind the Corinthian capitals instead of above the columns. Appropriately, many of the motifs of the frieze, for example, erotes carrying garlands or tondi containing portraits of Diocletian and his wife Prisca, have close parallels on tetrarchic sarcophagi.

When Diocletian retired to his Dalmatian palace in 305, Constantius Chlorus and Galerius became Augusti, and two new Caesars were appointed. Such an orderly succession could have established a long-lasting model extending the tetrarchic form of government for generations, but civil war quickly ensued instead. The eventual victor was Constantius's son Constantine, who would soon transform Roman society in ways still felt today (see Chapter 20).

SUMMARY

Diocletian established the tetrarchy in 293 in order to bring stability to the Roman Empire after a half century of constant civil war. The new form of government gave rise to a new kind of imperial portrait in which artists strove to represent each of the four co-rulers as identical components of the larger entity that was the tetrarchy itself. Abstract, iconic imagery replaced the introspective portrayal of individuals that was the norm under the soldier emperors.

The return of order to the Roman world also fostered the resumption of major architectural projects. In Rome, Diocletian built a gigantic new bathing complex to rival the century-old Baths of Caracalla, and he erected a five-column monument in the Forum Romanum to commemorate his 20th anniversary as emperor and the 10th anniversary of the tetrarchy. At Split in his native Dalmatia, Diocletian erected a fortress-palace as his retirement home, complete with a temple to Jupiter and a mausoleum for the emperor and his wife. At his capital of Thessaloniki in Greece, Galerius built a palace complex that also included a mausoleum as well as an imposing triumphal arch in the form of an octapylon, whose piers were covered with reliefs recounting his victorious campaign in Persia. Characteristically, it incorporated portraits of all four tetrarchs, thus honoring the tetrarchy as an institution as well as one of its individual rulers.

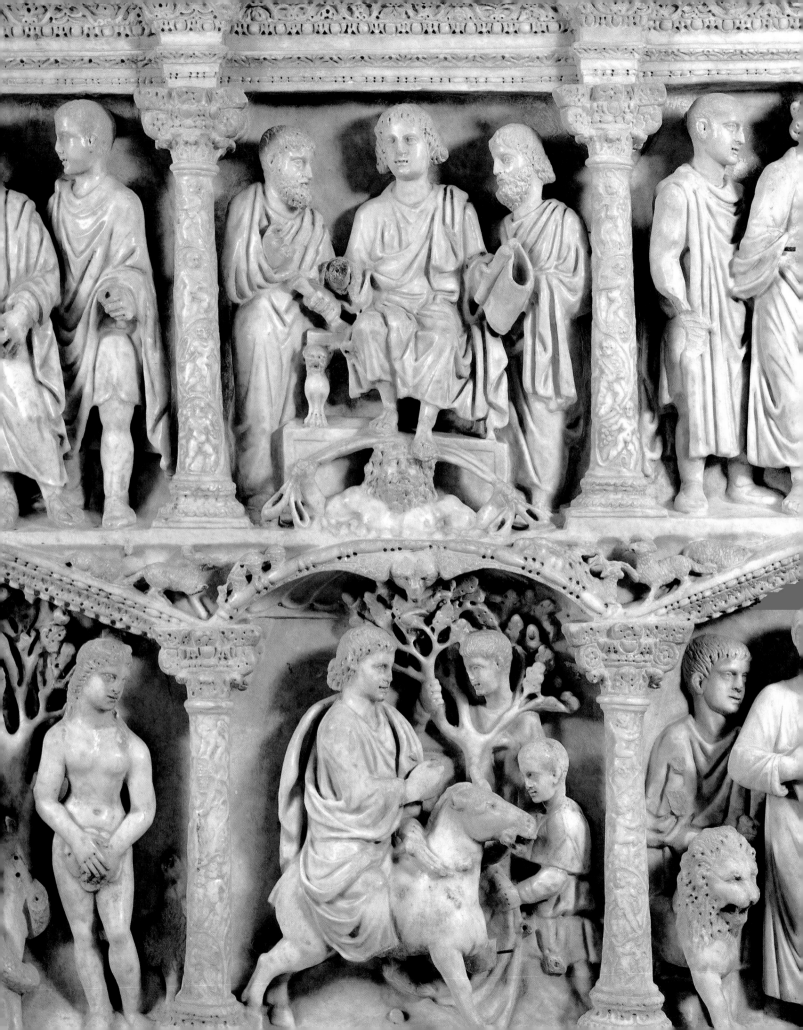

Constantine, Emperor and Christian Patron

The short-lived concord among the tetrarchs that ended with Diocletian's abdication was followed by an all-too-familiar period of conflict. This latest civil war among rival Roman armies lasted two decades. The eventual victor was Constantine I ("the Great"), son of Constantius Chlorus, the former Caesar and new Augustus of the West. After Constantius's death in Britain in 306, the troops loyal to him hailed his son emperor (see "The Age of Constantine," page 292). Constantine ruled the northwestern provinces from his father's base in Germany, while Maximian's son Maxentius took control of Rome. Constantine invaded Italy in 312, engaging and defeating Maxentius's forces at Verona in the north, before marching south to Rome. The showdown with Maxentius came at the Mulvian Bridge, the northern gateway to the city, where Constantine routed his foe's forces and Maxentius drowned. Constantine attributed his decisive victory to the aid of the Christian god. The next year, he and his ally Licinius, Augustus of the East, issued the Edict of Milan, which established Christianity as a legal religion with equal or superior standing to the traditional Roman cults. The Milanese edict marked the beginning of the ascendancy of monotheism in the Roman world.

In time, Constantine and Licinius became foes, and in 324 Constantine defeated and executed Licinius near Byzantium (modern Istanbul, Turkey). Constantine was now the unchallenged ruler of the entire Roman Empire. He died of natural causes near Diocletian's old capital of Nicomedia in 337 and passed power on to his sons, reviving the dream of hereditary succession that had eluded his predecessors for more than a hundred years.

20-1 Christ between Saints Peter and Paul, and Christ entering Jerusalem, detail of the sarcophagus of Junius Bassus (Fig. 20-20), from the Vatican cemetery, Rome, 359. Museo Storico del Tesoro della Basilica di San Pietro, Rome.

PORTRAITURE

The Constantinian era opened politically as a continuation of the tetrarchy but with competing rather than united Augusti and Caesars. Early-fourth-century imperial portraiture also followed tetrarchic models initially, but just as Constantine eventually transformed the Roman world politically and religiously, so too did his artists radically alter the way the emperor was presented to his subjects

The Age of Constantine

Constantine (Flavius Valerius Constantinus, r. 306–337) was the son of Constantius Chlorus. Declared Augustus of the West by his troops on his father's death, he invaded Italy in 312 and wrested control of Rome from Maxentius.

Maxentius (Marcus Aurelius Valerius Maxentius, r. 306–312) was Maximian's son and married Galerius's daughter. When Constantius died, the praetorian guard hailed him emperor. He died fighting against Constantine.

Licinius (Valerius Licinianus Licinius, r. 308–324) married Constantine's half-sister Constantia and served as his co-emperor. They later became enemies, and Constantine defeated him in 324 and executed him in 325.

Helena, the first wife of Constantius Chlorus and mother of Constantine, converted to Christianity after her son became emperor. At the end of her life, she traveled to Judaea and founded churches in Jerusalem and Bethlehem.

Pope Sylvester was the 34th bishop of Rome and the first pope (r. 314–335) to head the Christian Church after the Edict of Milan of 313, which granted legal status to Christianity. ■

MAXENTIUS The portraits of Maxentius epitomize the continuing dominance of tetrarchic style after the retirement of Diocletian. An aureus (**Fig. 20-2**) struck in 308, naming Maxentius as Augustus in opposition to Constantine's claim to the same title, bears his frontal portrait on the obverse. As noted in the discussion of Julia Domna's unusual portrait on a Severan aureus (Fig. 16-3), frontal heads are extremely rare on ancient coins because the facial features were gradually obliterated as the coins passed from hand to hand. The choice of a frontal portrayal for Maxentius, however, was consistent with the preference of Late Antique artists for depicting the emperor(s) looking directly at the viewer. Maxentius's portrait is otherwise indistinguishable from the numismatic representations of the other emperors of the late third and early fourth centuries. The face has generic features, the standard tetrarchic hair and beard, andx large staring eyes.

CONSTANTINE ON COINS The early portraits of Constantine are also fully in the tetrarchic mold, as seen on a *nummus* (**Fig. 20-3**), a Late Roman denomination issued in debased metal, struck shortly after the death of his father. Constantine was then in his early 20s, and his position was still insecure. On this coin, in contrast to many of his predecessors, he appears considerably older than his true age, because the tetrarchic "look" had become synonymous with the notion of "emperor." Indeed, were it not for the accompanying label identifying this Caesar as Constantine, it would be impossible to know who was portrayed.

Eight years later, after the defeat of Maxentius and the issuance of the Edict of Milan, Constantine's portrait appeared on a silver medallion (**Fig. 20-4**) in a radically altered form. Clean-shaven and looking his actual 30 years of age, the unchallenged Augustus of the West rejected the mature tetrarchic mask in favor of youth. Eternal youthfulness henceforth characterized all the emperor's portraits until his death more than two decades later, reviving the conceit that Augustus had introduced more than three centuries before. These two coins highlight the often fictive nature of imperial portraiture and the ability of Roman emperors to choose any official image that suited their needs. In Roman art, a "portrait" is rarely a "likeness."

The medallion is also eloquent testimony to the dual nature of Constantinian rule. The emperor appears in his traditional role as imperator, dressed in armor, wearing an ornate helmet, and carrying a shield bearing the enduring emblem of

20-2 **Aureus with obverse portrait of Maxentius, 308. Gold, approx. $\frac{4''}{5}$ diameter. Private collection.**

20-3 Nummus with obverse portrait of Constantine, 307. Billon, approx. 1″ diameter. American Numismatic Society, New York.

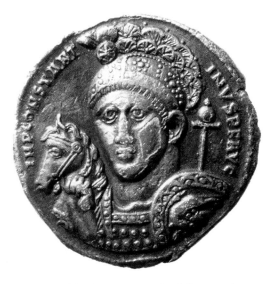

20-4 Medallion with obverse portrait of Constantine, ca. 315. Silver, approx. 1″ diameter. Staatliche Münzsammlung, Munich.

the Roman state—the she-wolf nursing Romulus and Remus (compare Fig. 1-8 and Roma's shield in Fig. 13-17). On the reverse, Constantine is shown addressing his troops. Although commander in chief, he does not carry Jupiter's eagle-tipped scepter, a sword, or a spear. Rather, he holds a cross crowned by an orb. Moreover, at the crest of his helmet, at the front, just below the grand plume, is a disk containing the *Christogram,* the monogram made up of *chi* (X), *rho* (P), and *iota* (I), the initial letters of Christ's name in Greek. Constantine is here portrayed both as Roman emperor and as a soldier in the army of Christ, in tribute to the god who gave him his victory over Maxentius a few years before.

COLOSSUS OF CONSTANTINE The most impressive by far of Constantine's preserved portraits in the round is an eight-and-one-half-foot tall head (**Fig. 20-5**), one of several marble fragments (**Fig. 20-6**) of a colossal enthroned statue of the emperor that was composed of a brick core, a wooden torso covered with bronze, and a head and limbs of marble. Constantine's artist modeled the seminude seated portrait on Roman images of Jupiter. The emperor held an orb, the symbol of global power, in his extended left hand. As in tetrarchic portraiture, the nervous glance of the soldier emperors is absent, replaced by a frontal mask with enormous eyes set into the broad and simple planes of the head, but otherwise the imagery of the tetrarchy has been rejected. If the youthful face reminded the ancient viewer of Augustus (Figs. 5-10 to 5-12), the coiffure recalled images of Trajan (Figs. 11-2 and 11-3). These visual connections with Rome's two most revered rulers and happier times were certainly intentional. Constantine's youthful portraits were designed to dissociate him from the tetrarchy and associate him with the great monarchical rulers of the Early and High Empire.

20-5 Head of Constantine, from the Basilica Nova, Rome, ca. 315–330. Marble, approx. 8′ 6″ high. Palazzo dei Conservatori, Rome.

20-6 **Fragments of a colossal seated statue of Constantine, from the Basilica Nova, Rome, ca. 315–330. Palazzo dei Conservatori, Rome.**

ARCHITECTURE AND RELIEF SCULPTURE

Constantine's emulation of Augustus and Trajan extended also to architecture. During his three-decade reign, he erected buildings throughout the Empire, notably a palace complex in Trier; a basilica, arch, and baths in Rome; and churches in Rome and the Holy Land. At the end of his life, Constantine even founded a new capital in the East, called Constantinople ("City of Constantine," modern-day Istanbul).

ARCH OF CONSTANTINE, ROME After his decisive victory at the Mulvian Bridge, Constantine erected a great triple-passageway arch (Figs. 1-2, no. 21, and **20-7**) in the shadow of the Colosseum to commemorate his defeat of Maxentius. The arch is remarkable in many ways, not least because it was the first openly to commemorate a victory over another Roman instead of the defeat of a foreign foe. In the dedicatory inscription, repeated on both sides of the attic, Constantine refers to Maxentius only as "the tyrant." He also thanks an unnamed "divinity" for granting him that victory. The divinity in question can only be that of the Christians, because Constantine would not have hesitated to name Jupiter, Mars, or another god of the ancient Roman pantheon. The deliberately vague reference to the Christian god was a recognition that the population of Rome was still

20-7 **South facade of the Arch of Constantine, Rome, 312–315.**

overwhelmingly pagan. Constantine wanted to avoid offending the powerful elite traditionalists in the capital but still pay homage to the god that brought him success against Maxentius.

The Arch of Constantine was the largest erected in Rome since the end of the Severan dynasty nearly a century before, but recent investigations have shown that the columns and every block of the arch were reused from earlier buildings. (*Spolia*—reused material—had earlier been employed for Diocletian's Arcus Novus; see Chapter 19, page 286.) Although the figures on many of the stone blocks were newly carved for this arch, much of the sculptural decoration was taken from monuments of Trajan, Hadrian, and Marcus Aurelius. Sculptors refashioned the second-century reliefs to honor Constantine by recutting the heads of the earlier emperors with the features of the new ruler. Hadrian hunting a boar, for example, became Constantine on horseback (Fig. 12-11). Trajan battling the Dacians became Constantine at war but with new labels celebrating his defeat of Maxentius: Liberator Urbis (liberator of the city; Fig. 11-22) and Fundator Quietus (bringer of peace; Fig. 11-23). The heads of Marcus Aurelius in the panel reliefs that formerly decorated one of his triumphal arches became heads of Constantine in scenes ranging from sacrifice and the distribution of largesse to the granting of clemency to enemies on the northern frontier and riding in triumphal procession in Rome. The Aurelian panels were placed on the attic of the arch between statues of captured Dacians (**Fig. 20-8,** *top*) taken from the Forum of Trajan. The Hadrianic tondi were placed over the lateral bays of the arch (Fig. 20-8, *bottom*), and the Great Trajanic Frieze was divided between the central passageway and the short ends of the attic. Constantinian in date are the Victories and Seasons in the central spandrels and the river gods in the lateral spandrels, the reliefs on the column pedestals, tondi representing the Sun and Moon in their chariots on the east and west sides of the arch (**Fig. 20-9**), and six sections of a frieze recounting Constantine's campaign against Maxentius (his departure from Milan, siege of Verona, and battle of the Mulvian Bridge) and subsequent

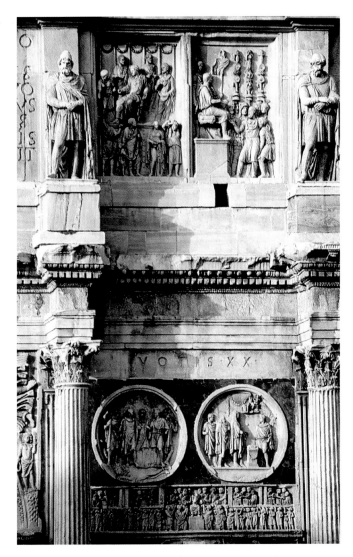

20-8 Detail of the north facade of the **Arch of Constantine,** Rome, 312–315.

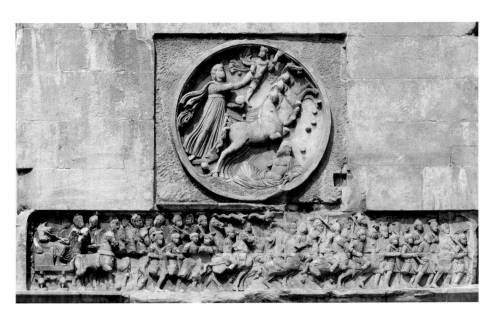

20-9 Sol (tondo) and entry into Rome (frieze), east side of the **Arch of Constantine,** Rome, 312–315.

20-10 **Address to the people, detail of frieze, north facade of the Arch of Constantine, Rome, 312–315.**

20-11 **Distribution of largesse, detail of frieze, north facade of the Arch of Constantine, Rome, 312–315.**

ceremonial scenes in Rome (adventus, address to the people, distribution of largesse) after his victory (Figs. 20-8, *bottom*, **20-10**, and **20-11**).

The recycling of statues and reliefs on the Arch of Constantine has often been cited as evidence of a decline in creativity and technical skill during economically trying times. Although that judgment is in large part deserved, it ignores the fact, as many scholars have pointed out, that the reused sculptures were carefully selected to associate Constantine with the "good emperors" of the second century. On the other hand, that message was probably lost on most viewers, because the heads of those earlier emperors were removed and replaced with Constantine's portrait. Very few Romans at that time would have had the sophistication of an art connoisseur necessary to recognize Trajanic, Hadrianic, or Antonine style, especially when the reliefs were seen at a distance. Nonetheless, the monumental size of the second-century reliefs, so different from the sarcophagus-like friezes of Constantinian date, signaled that they belonged to an earlier era.

The argument as to whether the Constantinian audience would have recognized that the emperor was reusing the older reliefs in order to present himself as a ruler on a par with his revered predecessors becomes less important, however, because Constantine's artists made that connection explicit in one of the new friezes on the arch. On the north facade, Constantine appears on the speaker's platform in the Forum Romanum (with the tetrarchic decennial monument as a backdrop), flanked by seated statues of none other than Hadrian and Marcus Aurelius (Fig. 20-10), two of the emperors whose reliefs appear directly above the Constantinian frieze (Fig. 20-8).

In another Constantinian relief (Fig. 20-11), the emperor is shown distributing largesse to grateful citizens who approach him from right and left. Constantine is a frontal and majestic presence, elevated on a throne above the recipients of his munificence. The ceremonial scene is stylistically similar in many ways to the frieze of the four enthroned tetrarchs (Fig. 19-14, *bottom*) on the Arch of Galerius at Thessaloniki, and the Constantinian figures are squat in proportion, as in tetrarchic sculpture in general. They do not move according to any Classical

principle of naturalistic movement but rather have the mechanical and repeated stances and gestures of puppets. The relief is very shallow. The sculptor did not fully model the figures, relying instead on incised details. The heads are not distinguished from one another. The artist depicted a crowd, not a group of individuals. (Constantine's head was carved separately, as in the Rostra scene, and set into the relief; in both cases the head is unfortunately lost.) The frieze is less a narrative of action than a picture of actors frozen in time so that the viewer can distinguish instantly the all-important imperial donor (at the center on a throne) from his attendants (to the left and right above) and the recipients of the largesse (below and of smaller stature).

This approach to pictorial narrative was once characterized as a "decline of form," and when judged by the standards of Classical art, it was. But the composition's rigid formality, determined by the rank of those portrayed, was consistent with a new set of values. It soon became the preferred mode, supplanting the Classical notion that a picture is a window onto a world of anecdotal action. The Arch of Constantine is the quintessential monument of its era, exhibiting a respect for the Classical past in its reuse of second-century sculptures while rejecting the norms of Classical design in its new frieze, paving the way for the iconic art of the Middle Ages.

BASILICA NOVA, ROME Constantine's reference to Maxentius in the dedicatory inscription of his arch as an unnamed tyrant was consistent with his policy of erasing his rival's name from public memory. Before he died, Maxentius had begun construction of a new basilica (Figs. 1-2, no. 18, **20-12**, and **20-13**) on the Via Sacra near the Temple of Venus and Roma. Constantine completed the project, dedicated it in his own name, and installed his own portrait (Figs. 20-5 and 20-6) in the western apse where Maxentius had intended to place his own statue.

The Basilica Nova ("New Basilica") ruins never fail to impress tourists with their size and mass, and the building surely

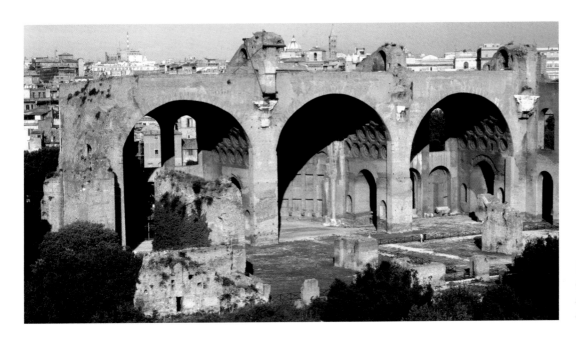

20-12 **Basilica Nova (Basilica of Maxentius and Constantine), Rome, ca. 306–312.**

would have awed Constantine's contemporaries as well. With the exception of the Baths of Diocletian (Figs. 19-10 to 19-12), no building of this size had been erected in the capital in a century, and the Basilica Nova was the first basilica to be constructed in the city center since Trajan. The Constantinian basilica was 300 feet long and 215 feet wide. Brick-faced con- crete walls 20 feet thick supported coffered barrel vaults in the aisles. These vaults also buttressed the groin vaults of the nave, which was 115 feet high. The walls and floors were richly marbled and stuccoed, and all who entered the basilica could readily admire them, because the groin vaults permitted ample light to enter the nave directly. The reconstruction in Fig. 20-13

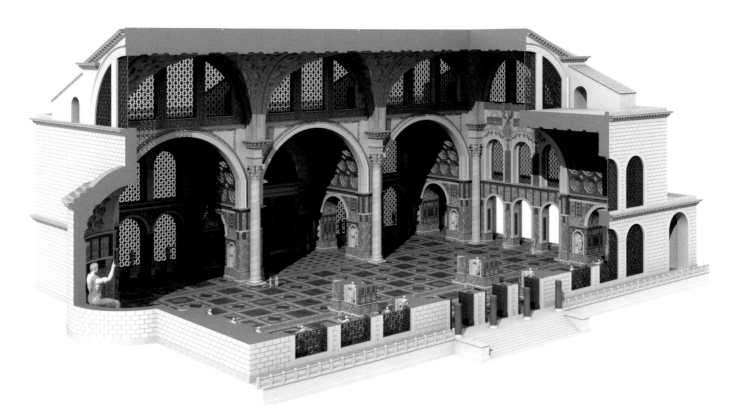

20-13 **Restored cutaway view of the Basilica Nova (Basilica of Maxentius and Constantine), Rome, ca. 306–312 (John Burge).**

effectively suggests the immensity of the interior, where the great vaults dwarf even the emperor's colossal enthroned portrait. The drawing also clearly reveals the fenestration of the groin vaults, a lighting system akin to the clerestory of a traditional stone-and-timber basilica, as well as the external buttressing of the nave vaults. The lessons learned in the design and construction of buildings such as Trajan's great market hall (Figs. 11-16 and 11-17) and the Baths of Caracalla (Fig. 16-22) and Diocletian (Fig. 19-12) were applied here to the Roman basilica.

Although the Basilica Nova arguably was the ideal solution to the problem of basilica design with its spacious, well-lit interior and economical, fire-resistant concrete frame, the use of concrete for basilicas became the exception rather than the rule. In ancient Rome, innovation was not always a goal of either the patron or the architect, and adherence to traditional forms usually lent prestige to new buildings. The marble-colonnaded and timber-roofed basilica design exemplified by Trajan's Basilica Ulpia in Rome (Fig. 11-8) remained the norm for centuries.

AULA PALATINA, TRIER At Trier (ancient Augusta Treverorum), an old Gallo-Roman town on the Moselle River in Germany that was the imperial seat of Constantius Chlorus first as Caesar and later as Augustus of the West, Constantine built a new palace complex. It included a basilica-like audience hall, or Aula Palatina (**Fig. 20-14**), of traditional form and materials. The Trier basilica measures about 190 feet long and 95 feet wide. The architect alleviated the austerity of its brick exterior with boldly projecting vertical buttresses, which created a dramatic pattern of alternating voids and solids. As seen today, the pronounced verticality of the design is deceiving, however. The Aula Palatina originally had two stories of tim-

ber galleries, which permitted servicing the windows and underscored the horizontality of the building. The brick wall was stuccoed in grayish white. The growing taste for large windows was due to the increasing use of lead-framed panes of window glass. These enabled Late Imperial builders to give life and movement to blank exterior surfaces.

Inside (**Fig. 20-15**), the audience hall is also very simple. Its flat, wooden, coffered ceiling is some 95 feet above the floor. The interior has no aisles, only a wide space with two stories of large windows that provide ample light. At the narrow north end, the main hall is divided from the semicircular apse (which also has a flat ceiling) by a so-called *chancel arch*. The arch provided a suitably pompous setting for the emperor when he received foreign dignitaries and Roman citizens who came to seek an audience. The Aula Palatina's interior is much more severe today than it was in Constantine's time. The windows had colored marble frames, and the arch and apse originally were covered with marble veneer and mosaics to provide a magnificent environment for the enthroned emperor. A reduction in the size of the windows in the apse made the arch framing the emperor seem even larger to those approaching him for an audience. At Trier, the living emperor occupied the apse; in the Basilica Nova in Rome, his statue presided over the interior (Fig. 19-13) in his absence, dominating the nave in much the same way enthroned statues of Greco-Roman divinities loomed over awestruck mortals who entered the cellas of pagan temples.

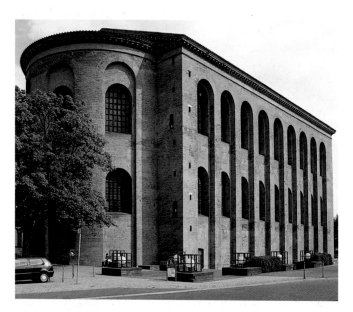

20-14 **Aula Palatina, Palace of Constantine, Trier, Germany,** ca. 310.

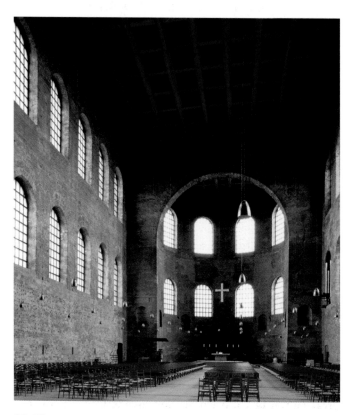

20-15 **Interior of the Aula Palatina, Palace of Constantine,** Trier, Germany, ca. 310.

Constantine and Old Saint Peter's

Constantine was the first emperor to sponsor the construction of churches in Rome. His generosity, however, reached well beyond providing land and erecting edifices. It extended to outfitting the interiors with costly altars, chandeliers, candlesticks, pitchers, goblets, and plates fashioned of gold and silver and sometimes embellished with jewels and pearls. The *Liber Pontificalis,* or *Book of the Pontiffs (Popes),* compiled by an anonymous sixth-century author, provides a vivid picture of the emperor's involvement with the building of Old Saint Peter's (Fig. 20-16) and of his gifts to the new basilica, as well as a list of the income from imperial properties in cities around the Empire that was donated as an endowment for the new church. No Christian building before—and few after—was so magnificently endowed or so lavishly adorned.

The description of Old Saint Peter's is contained in the life of Pope Sylvester.

The emperor Constantine built a basilica to St. Peter the Apostle . . . where he buried the tomb with St. Peter's body. . . . He sealed [the tomb] on all sides with copper. . . . Above he decorated it with porphyry and other vine-scroll columns which he brought from Greece. He also built the basilica's apse-vault of shining gold-foil; and over St. Peter's body . . . he provided a cross of finest gold weighing 150 lb. . . . He also provided 4 brass candelabra, 10 ft in size, finished in silver. . . , each weighing 300 lb; 3 gold chalices with . . . jewels . . . ; 20 silver chalices . . . ; a gold paten . . . adorned with . . . jewels and with pearls, 215 in number . . . ; 5 silver patens; . . . a gold crown . . . , which is a chandelier, with 50 dolphins . . . ; 32 silver lights in the centre of the basilica, with dolphins . . . ; on the right of the basilica, 30 silver lights . . . ; the altar itself, of silver chased with gold, weighing 350 lb, decorated on all sides with . . . jewels and pearls, the jewels 400 in number; [and] a censer of finest gold, decorated on all sides with jewels, 60 in number.* ∎

* Translated by Raymond Davis, *The Book of Pontiffs* (Liverpool: Liverpool University Press, 1989), 18–19.

EARLY CHRISTIAN ART AND ARCHITECTURE

Constantinian art is a mirror of the transition from the Classical to the medieval world, and there were two sides to the emperor's patronage. In Rome and Trier, Constantine was a builder of basilicas, baths, a palace, and a triumphal arch, but he was also the benefactor responsible for Rome's first churches, in which Christians could openly celebrate their faith as they never could before.

Very little is known about the art of the first Christians. When art historians speak of "Early Christian art and architecture," they mean the earliest preserved works with Christian subject matter and the earliest known buildings for Christian worship, not the art and architecture of Christians at the time of Jesus. The first Christian services probably were held in private community houses of the type found at Dura-Europos (Fig. 17-20), and similar meeting halls must have remained the norm until the Edict of Milan in 313. Then, suddenly, an urgent need arose to construct churches. The new buildings had to meet the requirements of Christian liturgy, provide a suitably dignified setting for the celebration of the newly approved religion, and accommodate the rapidly growing number of worshipers.

OLD SAINT PETER'S Although Constantine was the first great patron of Christian art and architecture, he was also obliged to safeguard the ancient Roman religion, especially in the capital where pagan traditions were strongest. The major Constantinian churches in Rome were built on sites associated with the graves of Christian martyrs, which, like all Roman burial grounds, were located on the city's outskirts. The decision to erect churches at those sites also permitted Constantine to keep the new Christian shrines out of the city center and to avoid any confrontation between Rome's Christian and pagan populations.

The greatest of Constantine's Roman churches was Old Saint Peter's (see "Constantine and Old Saint Peter's," above), which was probably begun as early as 319. The present-day church, one of the masterpieces of Italian Renaissance and Baroque architecture, was a replacement for the Constantinian structure. Old Saint Peter's stood on the western side of the Tiber River on the spot Constantine and Pope Sylvester believed was the burial site of Peter, the first apostle and founder of the Christian community in Rome. Excavations in the Roman cemetery beneath the church have in fact revealed a second-century memorial erected in honor of the Christian martyr at his reputed grave. The great Constantinian church, capable of housing 3,000 to 4,000 worshipers, was raised, at immense cost, upon a terrace over the ancient cemetery on the irregular slope of the Vatican Hill. It enshrined one of the most hallowed sites in Christendom, second only to the Holy Sepulchre in Jerusalem, the site of Christ's Resurrection. The project also fulfilled the figurative words of Christ himself, when he said, "Thou art Peter, and upon this rock I will build my church" (Matt. 16:18). Peter, whose name means "rock" (in Greek, *petra*), was Rome's first bishop and the head of the long line of popes that extends to the present.

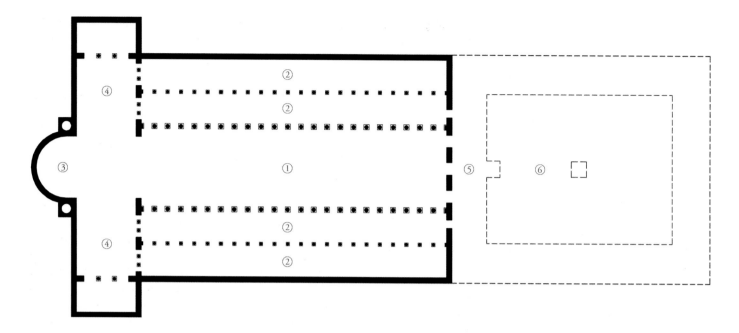

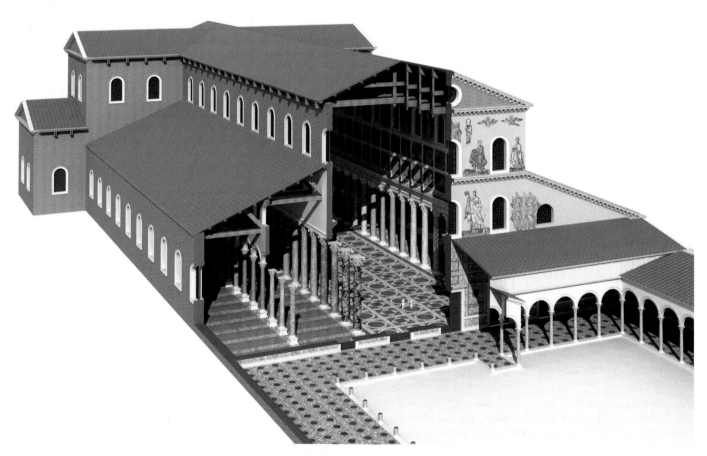

20-16 Plan (*top*) and restored cutaway view (*bottom*) of Old Saint Peter's, Rome, begun ca. 320 (John Burge). 1) nave, 2) aisle, 3) apse, 4) transept, 5) narthex, 6) atrium. (The restoration of the forecourt is conjectural.)

The plan and elevation of Old Saint Peter's (**Fig. 20-16**) resemble those of Roman basilicas and audience halls, such as the basilica at Pompeii (Figs. 2-9 and 2-10), the Basilica Ulpia in the Forum of Trajan (Figs. 11-6 and 11-8), and the Aula Palatina at Trier (Figs. 20-14 and 20-15), rather than the design of any Greco-Roman temple. The Christians, understandably, did not want their houses of worship to mimic the form of pagan shrines, but practical considerations also contributed to their shunning the pagan temple type. The Greco-Roman temple housed only the cult statue of the deity. All rituals took place outside at open-air altars. The Classical temple, therefore, could have been adapted only with great difficulty as a building that accommodated large numbers of people within it. The Roman basilica, in contrast, was ideally suited as a place for congregation, and Early Christian architects eagerly embraced it.

Like the Basilica Ulpia, Old Saint Peter's had a wide nave and four aisles, but it had an apse at only one end, because like the Pompeian basilica, the church was entered from the end of the 300-foot-long nave instead of on the side, through the aisles. The apse replaced the tribunal in basilicas of the Pompeian type. In front of Old Saint Peter's was an open colonnaded courtyard, very much like the forum proper in the Forum of Trajan but called an *atrium,* like the central room in a private house. Worshipers entered the basilica through a *narthex,* or vestibule. When they emerged in the nave, they had an unobstructed view of the altar in the apse, framed by a chancel arch, as in Constantine's Aula Palatina (Fig. 20-15) at Trier, but in Old Saint Peter's the arch divided the nave from the transept. The *transept,* or transverse aisle, an area perpendicular to the nave between the nave and apse, was a special feature of the Constantinian church. It housed the relics of Saint Peter that attracted hordes of pilgrims. (*Relics* are the body parts, clothing, or any object associated with a saint or Christ himself.) The transept became a standard element of church design only much later, when it also took on, with the nave and apse, the symbolism of the Christian cross.

Unlike pagan temples, Old Saint Peter's was not adorned with lavish exterior sculptures. Its brick walls were as austere as those of Trier's Aula Palatina (Fig. 20-14). Inside, however, were frescoes and mosaics, marble columns (spolia taken from pagan buildings, as was customary at the time), grandiose chandeliers, and gold and silver vessels on jeweled altar cloths for use in the Mass, all illuminated by the light coming through the nave's clerestory windows. A huge marble *baldacchino* (domical canopy over an altar), supported by four spiral columns, marked the spot of Saint Peter's tomb.

The placement of virtually all ornamentation, including all of the figural decoration, inside the Early Christian church was a reversal of the pattern in Greco-Roman religious architecture, but the motivation was the same. The audience for visual narratives in pagan society was outside the temple, and the sculptures in the pediments and friezes faced outward so that the worshipers could read their pictorial messages. The audience for Early Christian figural art was inside the building, in the nave and facing the apse, and that is where the decorators of churches situated their mosaics and frescoes.

THE CATACOMBS Most Early Christian art in Rome was not church art, however, but funerary art found in the *catacombs*—vast subterranean networks of *galleries* (passageways) and chambers designed as cemeteries for burying the Christian dead, many of them sainted martyrs. To a much lesser extent, the catacombs also housed the graves of Jews and others. The builders tunneled the catacombs out of the tufa bedrock, much as the Etruscans created the underground tomb chambers in the necropolis at Cerveteri (Figs. 3-3 and 6-3). The catacombs are less elaborate than the Etruscan tombs but much more extensive. The name derives from the Latin *ad catacumbas,* which means "in the hollows." The catacombs in Rome (others exist elsewhere) comprise galleries estimated to run for 60 to 90 miles—and additional catacombs may be discovered yet. From the second through the fourth centuries, these catacombs were in constant use, housing as many as four million bodies.

In accordance with Roman custom, Christians had to be buried outside a city's walls on private property, usually purchased by a *confraternity,* or association, of Christian families pooling funds. Each of the catacombs was initially of modest extent. First, the builders dug a gallery three to four feet wide around the perimeter of the burial ground at a convenient level below the surface. In the walls of these galleries, they cut openings to receive the bodies of the dead. These openings, called *loculi,* were placed one above another, like shelves. Often, the Christians carved small rooms out of the rock, called *cubicula* (as in Roman houses of the living), to serve as mortuary chapels. Once the original perimeter galleries were full of loculi and cubicula, workers cut other galleries at right angles to them. This process continued as long as lateral space permitted. They then dug lower levels connected by staircases. Some catacomb systems extended as deep as five levels. When adjacent burial areas belonged to members of the same Christian confraternity, or by gift or purchase fell into the same hands, the owners opened passageways between the respective cemeteries. The galleries thus spread laterally and gradually formed a vast network. After Christianity received official approval, churches rose on the land above the catacombs so that the pious could worship openly at the grave sites of some of the earliest Christian martyrs.

CATACOMB OF PETER AND MARCELLINUS The frescoes that decorated the Early Christian catacombs were Roman in style but Christian in subject. The ceiling (**Fig. 20-17**) of a cubiculum in the Catacomb of Saints Peter and Marcellinus in Rome, for example, is similar to the century-earlier frescoed vault (Fig. 14-11) in room 4 of the Insula of the Painted Vaults at Ostia, with a central medallion and four lunettes around the circumference. The lunettes contain the key

20-17 **Christ as Good Shepherd, story of Jonah, and orants, painted ceiling of a cubiculum in the Catacomb of Saints Peter and Marcellinus, Rome, early fourth century.**

episodes from the Old Testament story of Jonah. The sailors throw him from his ship on the left (**Fig. 20-18**). He emerges on the right from the "whale" (the Greek word is *ketos,* or sea dragon, and that is how the artist represented the monstrous

20-18 **Jonah thrown from the ship, detail of the painted ceiling of a cubiculum in the Catacomb of Saints Peter and Marcellinus, Rome, early fourth century.**

marine creature that swallowed Jonah; compare Figs. 5-17, *right,* and 18-20, *between the legs of Mars*). Safe on land at the bottom, Jonah contemplates the miracle of his salvation and the mercy of God. Jonah was a popular figure in Early Christian painting and sculpture, especially in funerary contexts. The Christians honored him as a *prefiguration* (prophetic forerunner) of Christ, who rose from death as Jonah had been delivered from the belly of the ketos, also after three days. (Old Testament miracles prefiguring Christ's Resurrection abound in the catacombs and in Early Christian art in general; see "The Subjects of Early Christian Art," page 303.)

A man, a woman, and at least one child occupy the compartments between the Jonah lunettes. They are *orants* (praying figures), raising their arms in the ancient attitude of prayer. Together they make up a cross-section of the Christian family seeking a heavenly afterlife. The cross's central medallion shows Christ as the Good Shepherd, whose powers of salvation are underscored by his juxtaposition with Jonah's story. The motif can be traced to sixth-century BCE Greek art, but there the bearded calf bearer offered his sheep in sacrifice to Athena. In Early Christian art, Christ is the youthful and loyal protector of the Christian flock. In the Christian motif, the sheep on Christ's shoulders is one of the lost sheep he has

The Subjects of Early Christian Art

The subjects that Early Christian artists represented in paintings and sculptures were chosen almost exclusively from biblical events recounted in both the Old and New Testaments.

Old Testament

From the beginning, the Old Testament played an important role in Christian life and Christian art, in part because Jesus was a Jew and so many of the first Christians were converted Jews, but also because Christians came to view many of the persons and events of the Old Testament as prefigurations of New Testament persons and events. Christ himself established the pattern for this kind of biblical interpretation when he compared Jonah's spending three days in the belly of the sea monster (usually translated as "whale" in English) to the comparable time he would be entombed in the earth before his Resurrection (Matt. 12:40). In the fourth century, Saint Augustine (354–430) confirmed the validity of this approach to the Old Testament when he stated that "the New Testament is hidden in the Old; the Old is clarified by the New."*

Some of the most popular Old Testament stories depicted in Early Christian art are the following:

Adam and Eve Eve, the first woman, ate the forbidden fruit of the tree of knowledge at the urging of a serpent. She also fed the apple to Adam, the first man. As punishment, God expelled Adam and Eve from Paradise. This "Original Sin" ultimately led to Christ's sacrifice on the cross so that all humankind could be saved.

Sacrifice of Isaac God instructed Abraham, the father of the Hebrew nation, to sacrifice Isaac, his only son, as proof of his faith. When it became clear Abraham would obey, the Lord sent an angel to restrain him and provided a ram for sacrifice in Isaac's place. The episode was considered a prefiguration of the sacrifice of God's only son, Jesus.

Jonah Jonah was an Old Testament prophet who had disobeyed God's command. In his wrath, the Lord caused a storm while Jonah was at sea. Jonah asked the sailors to throw him overboard, and the storm subsided. A sea dragon then swallowed Jonah, but God answered his prayers, and the monster spat out Jonah after three days and nights, foretelling Christ's Resurrection.

Daniel Daniel was a Hebrew prophet who violated a Persian decree against prayer. The Persians threw him into a den of lions, expecting that Daniel would be killed. But God sent an angel to shut the lions' mouths, and Daniel emerged unharmed. Like Jonah's story, this is an Old Testament salvation tale, a precursor of Christ's triumph over death.

New Testament

Christians believe that Jesus of Nazareth was the son of God, the *Messiah* (Savior, *Christ*) of the Jews prophesied in the Old Testament. His life—from his miraculous birth from the womb of a virgin mother through his execution by the Romans and subsequent ascent to Heaven—has been the subject of countless artworks from Roman times through the present day. Only some episodes, however, were popular in Early Christian art:

Good Shepherd In John 10:11, Christ says to his disciples: "I am the good shepherd; the good shepherd gives his life for the sheep." Christ appears frequently in Early Christian art as a youthful shepherd carrying a sheep on his shoulders.

Baptism A key event in the life of Jesus was his baptism at age 30 by John the Baptist in the Jordan River, when God's voice was first heard proclaiming Jesus as his son.

Entry into Jerusalem The final events leading to Jesus' death began on Palm Sunday when he rode triumphantly into Jerusalem on a donkey, accompanied by disciples. Crowds of people enthusiastically greeted Jesus and placed palm fronds in his path.

Jesus before Pilate After being betrayed by Judas, Jesus was brought before the Roman governor of Judaea, Pontius Pilate, on the charge of treason, because he had proclaimed himself King of the Jews. Pilate asked the crowd to choose between freeing Jesus or Barabbas, a murderer. The people chose Barabbas. The judge condemned Jesus to death and washed his hands, symbolically relieving himself of responsibility for the mob's decision. ■

* Augustine, *City of God*, 16.26.

retrieved, symbolizing a sinner who has strayed and been rescued. Early Christian artists almost invariably represented Jesus as a young man. Only much later did artists begin to depict him with the beard of a mature adult, which has been the standard representation of Christ ever since.

SANTA MARIA ANTIQUA SARCOPHAGUS Most Christians rejected cremation, and the wealthiest Christian faithful, like their pagan contemporaries, favored impressive marble sarcophagi. Many of these coffins have survived in the catacombs and elsewhere. Predictably, the most common themes painted

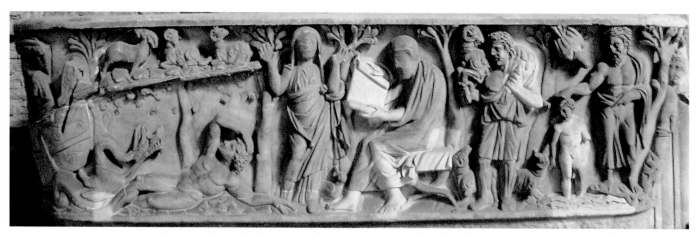

20-19 **Sarcophagus with philosopher, orant, and Old and New Testament scenes, ca. 270. Marble, 1′ 11¼″ × 7′ 2″. Santa Maria Antiqua, Rome.**

on the walls and vaults of the Roman subterranean cemeteries were also the subjects that appeared on Early Christian sarcophagi. Often, the decoration of the marble coffins was a collection of significant Christian themes, just as on the painted ceiling in the Catacomb of Saints Peter and Marcellinus. But the format of the sarcophagi matched those of contemporaneous pagan coffins, and some artists may have worked on both. Even if there were distinct workshops for Christian patrons, the artists received similar training, and many motifs and compositional patterns appear on both pagan and Early Christian coffins.

On the front of a lenos sarcophagus (**Fig. 20-19**) in Santa Maria Antiqua in Rome, the story of Jonah takes up the left third. The sculptor represented the last episode of the biblical story. Jonah's ship is at the far left, but he has already been saved. The ketos has spit him out and, as in the corresponding lunette (Fig. 20-17, *bottom*) in the Catacomb of Saints Peter and Marcellinus, he reclines under a protective canopy, safe on land. He does not look like a prophet, because the Early Christian artists' models for the Jonah figure, taken from pagan sarcophagi, were resting or sleeping nude mythological heroes.

At the center of the Santa Maria Antiqua sarcophagus is an orant and a seated philosopher, the latter a motif also borrowed directly from contemporaneous pagan sarcophagi, for example, the sarcophagus (Fig. 18-19) of Pullius Peregrinus. The portrait of Peregrinus's muse/wife was never carved. Similarly, on the Santa Maria Antiqua sarcophagus, the heads of both the praying woman and the seated man reading from a scroll are unfinished. This is thus another instance of a Roman workshop producing a coffin before knowing who would purchase it. The fact that the sculptors of Early Christian sarcophagi followed the same practice underscores the universal appeal of the biblical themes chosen and the attraction of being portrayed as a learned man or praying woman.

At the right on the sarcophagus are two different, yet linked, representations of Jesus—as the Good Shepherd and as a child receiving baptism in the Jordan River, though he really was baptized at age 30 (see "The Subjects of Early Christian Art," page 303). The sculptor suggested the future role of the baptized Jesus as the savior of the faithful by turning the child's head toward the Good Shepherd and by placing his right hand on one of the sheep. In the early centuries of Christianity, baptism was usually delayed almost to the moment of death because it cleansed the Christian of all sin. One deathbed baptism was of the emperor Constantine. The representation of the baptism of Jesus on the final resting place of a Christian therefore comes as no surprise.

JUNIUS BASSUS SARCOPHAGUS Another pagan convert to Christianity was the city prefect of Rome, Junius Bassus, who, according to the inscription on his sarcophagus (**Fig. 20-20**), was baptized just before he died in 359. The sarcophagus, decorated on only three sides in the Western Roman manner, is, however, divided on the front into two registers of five compartments, each framed by columns in the tradition of Asiatic sarcophagi (see "Roman Regional Sarcophagus Production," Chapter 15, page 218). In contrast to the Santa Maria Antiqua sarcophagus, the deceased does not appear on the body of the coffin. Instead, stories from the Old and New Testaments fill the 10 niches. Christ has pride of place and appears in the central compartment of each register: as a teacher enthroned between his chief apostles, Saints Peter and Paul (Fig. 20-1, *top*), and triumphantly entering Jerusalem on a donkey (Fig. 20-1, *bottom*). Appropriately, the scene of Christ's heavenly triumph is situated above that of his earthly triumph. Both compositions owe a great deal to official Roman art. In the upper zone, Christ, like an enthroned Roman emperor, sits above a personification of the sky god holding a billowing mantle over his head, indicating that Christ is ruler of the universe. The same conceit and composition were used for the enthroned tetrarchs in one frieze (Fig. 19-14, *bottom*) of the Arch of Galerius at Thessaloniki. The bottom scene in Fig. 20-1 is modeled on portrayals of Roman emperors entering cities on horseback or granting clemency to foreign foes, as in one panel (Fig. 13-19) from a lost arch of Marcus Aurelius in Rome. But on the Early Christian sarcophagus, Christ's steed is a much more modest animal, in conformity with the biblical text.

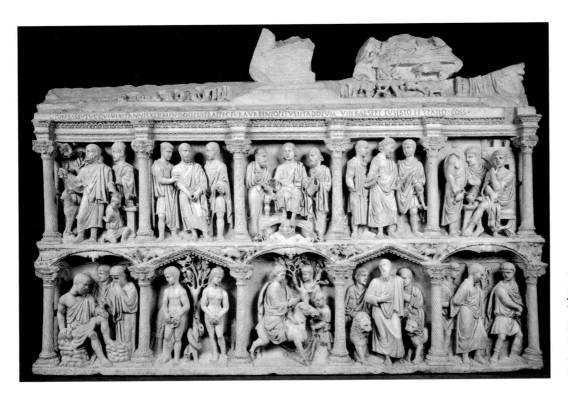

20-20 Sarcophagus of Junius Bassus, from the Vatican cemetery, Rome, 359. Marble, $3' 10\frac{1}{2}'' \times 8'$. Museo Storico del Tesoro della Basilica di San Pietro, Rome.

The Old Testament scenes on the Junius Bassus sarcophagus were chosen for their significance in Early Christian theology (see "The Subjects of Early Christian Art," page 303). Adam and Eve (**Fig. 20-21**), for example, are in the second niche from the

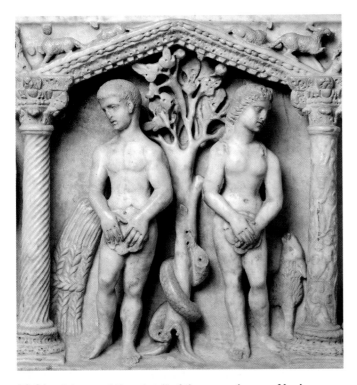

20-21 Adam and Eve, detail of the sarcophagus of Junius Bassus, from the Vatican cemetery, Rome, 359. Museo Storico del Tesoro della Basilica di San Pietro, Rome.

left on the lower level. Their Original Sin of eating the apple in the Garden of Eden ultimately necessitated Christ's sacrifice for the salvation of humankind. They are shown embarrassed by their nudity—a striking contrast to the prestige of nudity in Classical art. To the right of the entry into Jerusalem is Daniel, unscathed by flanking lions, saved by his faith. At the upper left, Abraham is about to sacrifice Isaac; this Old Testament story was a parable for God's sacrifice of his own son, Jesus.

Christ's Crucifixion, however, does not appear on the Junius Bassus sarcophagus. Indeed, the subject was very rare in Early Christian art and unknown prior to the fifth century. Artists emphasized Christ's divinity and exemplary life as teacher and miracle worker, not his suffering and death as a common criminal at the hands of the Romans. This sculptor, however, alluded to the Crucifixion in the scenes in the two compartments at the upper right depicting Jesus being led before Pontius Pilate for judgment. Pilate condemned Jesus to death (and then washed his hands of responsibility for the execution, hence the inclusion of the water ewer in the composition), but Christ rose again after three days, triumphing over death itself. Junius Bassus and other Christians, whether they were converts from paganism or from Judaism, hoped for a similar salvation.

STATUETTE OF CHRIST Apart from the reliefs on privately commissioned sarcophagi, large-scale sculpture became increasingly uncommon in the fourth century. Portrait statues of Roman emperors and other officials continued to be erected, and statues of pagan gods and mythological figures were still made, but their numbers decreased sharply. In his *Apologia,* Justin Martyr, a second-century philosopher who converted to Christianity and was mindful of the Second Commandment's admonition to

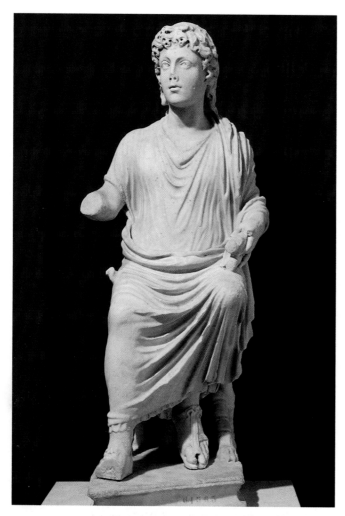

20-22 **Christ seated, from Civita Latina, ca. 350–375. Marble, approx. 2′ 4½″ high. Museo Nazionale Romano–Palazzo Massimo alle Terme, Rome.**

shun graven images, accused the pagans of worshiping statues as gods. Christians tended to suspect the freestanding statue, linking it with the false gods of the pagans, so Early Christian houses of worship had no "cult statues." Nor, as noted previously, did the first churches have any equivalent of the pedimental statues and relief friezes of Greco-Roman temples.

The Greco-Roman experience, however, was still a living part of the Mediterranean mentality, and many Christians like Junius Bassus were recent converts from paganism who retained some of their Classical values. This may account for those rare instances of freestanding Early Christian sculpture, such as the marble statuette (**Fig. 20-22**) of the seated Christ from Civita Latina. Less than three feet tall, the sculpture is contemporaneous with or somewhat later than—and a freestanding version of—the Christ between Saints Peter and Paul on the Junius Bassus sarcophagus (Fig. 20-1, *top*). As on the relief, Christ's head is that of a long-haired Apollo-like youth, but the statuary type was one usually employed for bearded Roman philosophers of advanced age. Like those learned men, Christ

wears the Roman tunic, toga, and sandals and holds an unopened scroll in his left hand. The piece is unique and, unfortunately, was not found in its original context, so art historians can only speculate about its function. Several third- and fourth-century marble statuettes of Christ as the Good Shepherd and of Jonah also survive, but they too are exceptional.

CONSTANTINOPLE Shortly after the death of Licinius, Constantine made the momentous decision to transfer the capital of the Empire from Rome to the East. He founded a "New Rome" on the site of Byzantium, which bridged the continents of Europe and Asia, and named it Constantinople after himself. A year later, in 325, at the Council of Nicaea, Christianity became de facto the official religion of the Roman world. From this point on, paganism declined rapidly—and so did Rome, which was finally besieged and sacked in 410, unable to defend itself behind the Aurelianic Walls (Fig. 18-23). Constantinople was dedicated on May 11, 330, "by the commandment of God." For many scholars, Constantine's transfer of the seat of power from Rome to Constantinople and recognition of Christianity mark the end of Classical antiquity and the beginning of the Middle Ages.

SUMMARY

The Constantinian age is the pivotal point when the pagan world of Classical antiquity became the Christian world of the Middle Ages. Constantinian art straddles those two worlds as well. The emperor's portraits grow out of the three-century tradition of imperial image-making, and Constantine realized perhaps more keenly than any emperor since Augustus that his official likenesses could take any form he preferred. After initially presenting himself to the public as a bearded tetrarch, Constantine adopted the clean-shaven visage and eternal youthfulness of Augustan portraiture. The triumphal arch Constantine erected to celebrate his victory over Maxentius is also firmly in the imperial tradition and, in fact, incorporates reliefs from monuments of Trajan, Hadrian, and Marcus Aurelius in an effort to associate the new emperor with those great rulers of the second century. The style of the Constantinian reliefs on the arch, however, breaks sharply with the Classical tradition in favor of the more abstract Late Antique manner that became the formal basis of medieval art.

Constantine was charged with protecting the ancient shrines of Rome, but he was also the first imperial patron of Christianity. In building the first churches in Rome, his architects adapted the traditional basilica form to a new religious function. During the early fourth century, Roman painters and sculptors also employed Classical compositions for a new repertory of biblical stories, both from the Old and the New Testaments. Just as Old Saint Peter's and Constantine's other basilican churches stand at the head of a long line of shrines of similar plan extending to the present day, so too did Early Christian artists establish much of the iconography of the life of Jesus in Western art for the next two thousand years.

Glossary

abacus – The uppermost portion of the *capital* of a *column*.

adlocutio – An address or a speech; a representation of a Roman emperor addressing his troops.

adventus – The ceremonial entry of an emperor into a city.

Aeternitas – Eternity.

agora – A Greek marketplace.

aisle – The area of a *basilica* to either side of the *nave* and separated from it by a row of *columns*.

ala (pl. **alae**) – The area between the *columns* and the *cella* walls on the sides of a temple. Also, the pair of rectangular recesses at the back of the *atrium* of a Roman house.

amphitheater – A "double theater" with an elliptical *cavea* around a central *arena* for the staging of *gladiatorial* combats and other spectacles.

aniconic – Portrayed symbolically rather than represented.

annular – Ring shaped.

apodyterium – The changing room in a Roman bathing facility.

apotheosis – The ascent to Heaven of a new god.

apse – A semicircular wall recess, often found at one or both ends of a *basilica* or at the end of a church *nave*.

arcade – A series of *arches* supported by *columns*.

arch – A curved structural member that spans an opening, composed of trapezoidal *voussoirs*.

Archaistic – Reviving the style of the Archaic Greek period of the sixth century BCE.

architrave – The *lintel* or lowest division of the *entablature*.

arcosolium (pl. **arcosolia**) – An *arcuated* floor-level recess in the burial chamber of a tomb designed to house a *sarcophagus*.

arcuated – *Arch* shaped.

arena – The central sandy area in an *amphitheater*.

argentarius (pl. **argentarii**) – Banker.

atmospheric perspective – See *perspective*.

atrium (pl. **atria**) – The central reception area of a Roman *domus,* partly open to the sky. In a Tuscan atrium, there are no *columns* supporting the roof. In a tetrastyle atrium, one column at each of the four corners of the *impluvium* supports the *compluvium*.

attic – The uppermost story of a building; the top of a *triumphal arch* with the dedicatory inscription.

augustalis – An official of the imperial cult, usually a wealthy freedman.

aula regia – Audience hall.

aureus (pl. **aurei**) – The standard Roman gold coin, which under Augustus weighed 1/40 of a pound.

baldacchino – The domical canopy over an altar in a church.

balnea – A small public or private bathing facility.

baptism – A Christian bathing ceremony for a newborn child or a new convert to the religion.

baroque – A term coined to describe the non-Classical art and architecture of 17th-century Italy (the Baroque period). The adjective "baroque" is also used to describe the architectural style of many Roman buildings of the second and third centuries CE, especially in the Eastern provinces.

barrel vault – A semicylindrical ceiling over parallel walls. Also called a tunnel *vault*.

base – The molded bottom of a *column*.

basilica – In Roman architecture, a building for legal and other civic proceedings. In Early Christian architecture, a church resembling a Roman basilica in plan and elevation.

bay – The *arcuated* passageway of a *triumphal arch* or city gate.

belvedere – A pavilion with a view of the countryside or the sea.

biga – A two-horse chariot.

broken pediment—See *pediment*.

bulla—A circular pendant worn on a cord around the neck; the emblem of a freeborn boy.

buttress—An exterior *masonry* structure that opposes the lateral *thrust* of an *arch* or a *vault*. Also a verb.

caduceus—The serpent-entwined herald's rod carried by the Roman god Mercury.

caldarium—The hot-water room in a Roman bathing facility.

cameo—A relief carved from a stone having layers of different colors.

capital—The ornamental top ("head") of a *column*.

Capitolium—The Temple of Jupiter Optimus Maximus on the Capitoline Hill in Rome. Also, any Roman temple dedicated to the gods Jupiter, Juno, and Minerva.

cardo—The main north-south street in a Roman city.

caryatid—A female figure used in place of a *column* in the *Ionic order*.

castrum—A Roman military encampment.

catacombs—Subterranean networks of rock-cut *galleries* and chambers that served as cemeteries for the burial of the dead.

cavea—The seating area in a theater or *amphitheater*.

cella (pl. **cellae**)—The inner chamber of a temple in which the deity's *cult statue* was displayed.

cenaculum (pl. **cenacula**)—An apartment in a multifamily *insula*.

cenotaph—A funerary monument without a burial chamber.

cestrum—A small spatula used in *encaustic* painting.

chalcidicum—The entrance vestibule of a *basilica*.

chancel arch—The *arch* separating the chancel (*apse*) or the *transept* from the *nave* of a church.

Charun—An Etruscan death demon.

Christogram—The three initial letters (*chi-rho-iota*) of Christ's name in Greek, which came to serve as a monogram (XPI) for Christ.

Classicizing—Imitating the Greek Classical style.

clementia— Clemency.

clerestory—The *fenestrated* part of a building that rises above the roofs of the other parts. In a *basilica* or Egyptian *oecus*, the clerestory is the second-story set of windows in the *nave* below the roof.

cliens—A client in a patron-client relationship in Roman society.

codex (pl. **codices**)—A book composed of separate *folios* of *vellum* or *parchment* bound together at one side.

coffer—A sunken panel in a ceiling.

colonnade—A series or row of *columns*, usually spanned by *lintels* but sometimes by *arches; see arcade*.

colonnette—A thin, attenuated *column*.

colossus—A gigantic statue.

column—A vertical, cylindrical weight-bearing architectural member, consisting of a *capital, shaft,* and *base*.

compluvium—The opening in the roof of the *atrium* of a Roman *domus*.

Composite capital—A *capital* combining *Ionic volutes* and *Corinthian* acanthus leaves.

concordia—Concord or harmony, as between husband and wife or between co-rulers.

concrete—A building material composed of lime mortar, volcanic sand, water, and small stones.

confraternity—An association of Christian families that pooled funds to purchase property for burial.

consul—One of two chief magistrates, elected by the Roman *Senate*.

contabulatio—The wide, flat band across the chest in late Roman *togas*.

continuous narration—The depiction of the same figure in the same setting at different moments in an unfolding story.

contrapposto—The disposition of the human figure in which one part is turned in opposition to another (usually hips and legs one way, shoulders and chest another), creating a counterpositioning of the body about its central axis. Often called "weight shift" because the weight of the body tends to be thrown to one foot, creating tension on one side and relaxation on the other. Characteristic of Classical Greek statuary.

corbeling—Courses of stone or brick in which each *course* projects beyond the one beneath it. Two such walls, meeting at the topmost course, create a corbelled *arch* or corbelled *vault*. When the courses are laid in a circle, a corbelled *dome* is formed.

Corinthian capital—An ornate Greek *capital* consisting of a double row of acanthus leaves, from which tendrils and flowers emerge, wrapped around a bell-shaped *echinus*. Although this capital form is often cited as the distinguishing feature of the Corinthian *order,* there is, strictly speaking, no Corinthian order, but only this kind of capital used in the *Ionic* order.

Corinthian oecus—See *oecus*.

cornice—The projecting, crowning member of the *entablature* framing the *pediment* of a Greco-Roman temple.

cornucopia—Horn of plenty.

corona civica—The civic crown of oak leaves awarded to a Roman who had saved the life of another Roman in battle.

course—A horizontal row of stone blocks or of bricks.

cremation—The burning of the bodies of the dead.

cross vault—See *groin vault*.

cubicula diurna—Sitting rooms in a Roman *domus,* usually with views of the countryside or the sea.

cubiculum (pl. **cubicula**)—A small bedroom in a Roman *domus,* usually opening onto the *atrium*. Also, a chamber in an Early Christian *catacomb* that served as a mortuary chapel.

cuirass—Leather breastplate; body armor.

cult statue—The (usually over-life-size) statue placed in the *cella,* representing the deity to whom the temple is dedicated.

Dacicus—An honorary title, meaning victor over the Dacians.

damnatio memoriae—The senatorial decree damning a person's memory. Those who suffered damnatio memoriae had their portraits destroyed or defaced and their names erased from public monuments.

decastyle—Having 10 *columns.* A decastyle temple has 10 columns on its facade.

decennalia—A 10th anniversary.

decumanus—The main east-west street in a Roman city.

decursio—The ritual circling of a funerary pyre.

denarius (pl. denarii)—The standard Roman silver coin, worth 1/25 of an *aureus.*

deus—A god.

dextrarum iunctio—Joining of right hands. The handclasp between a Roman man and woman signifies that they are married. The handclasp between two men indicates that they are allies or co-rulers.

dictator perpetuo—Dictator for life.

divi filius—Son of a *divus.*

divus—A deified mortal; god.

dome—A hemispherical *vault;* theoretically, an *arch* rotated on its vertical axis.

dominus—A lord.

domus—A Roman single-family house.

domus italica—The early form of Roman house, based on Etruscan precedents.

Doric—One of the two systems, or *orders,* of Greek architecture. The Doric order is characterized by, among other features, *capitals* with funnel-shaped *echinuses, columns* without *bases,* and a *frieze* of *triglyphs* and *metopes.*

dressed masonry—Stone blocks shaped to the exact dimensions required, with smooth faces for a perfect fit.

drum—One of the stacked cylindrical stones that form the *shaft* of a *column.* Also, the cylindrical wall that supports a *dome.*

echinus—The convex element of a *capital* directly below the *abacus.*

Egyptian oecus—See *oecus.*

encaustic—A painting technique in which pigment is mixed with wax and applied to the surface while hot.

engaged column—A half-round *column* attached to a wall.

entablature—The part of a building above the *columns* and below the roof. The entablature of a Greco-Roman temple has three parts: *architrave, frieze,* and *pediment.*

eros (pl. erotes)—A small cupid.

Etruria—The territory in central and northern Italy occupied by the Etruscans.

Eucharist—In Christianity, the partaking of the bread and wine, which believers hold to be either Christ himself or symbolic of him.

exedra—A recessed area, often semicircular in plan.

exempla virtutis—Models of virtue and valor.

fasces—The bundle of rods carried by a *lictor.*

fauces—The "jaws," that is, the foyer, of a Roman *domus.*

Fecunditas—Fertility.

fenestrated—Having windows. Fenestration is the arrangement of the windows of a building.

filius—Son.

findspot—Place where an artifact was found, or provenance.

First Style—The earliest style of Roman mural painting. Also called the Masonry Style, because the aim of the artist was to imitate, using painted stucco relief, the appearance of costly marble panels.

flute—A vertical concave channel on a *column shaft.*

folio—A page of a manuscript or book.

foreshortening—The representation in art of the apparent visual contraction of an object that extends back in space at an angle to the perpendicular plane of sight.

forum (pl. fora)—The public square of a Roman city, often situated at the intersection of the *cardo* and the *decumanus.*

Fourth Style—In Roman mural painting, the style that marks a return to architectural illusionism, but, unlike in the *Second Style,* the architectural vistas of the Fourth Style are irrational fantasies.

fresco—A mural painting technique in which the colors are applied to the wall while the plaster is still wet.

frieze—The part of the *entablature* between the *architrave* and the roof. In the *Doric order,* the frieze is subdivided into *triglyphs* and *metopes.* In the *Ionic order,* the frieze is left open to provide a continuous field for relief sculpture. Also, any sculptured or painted band in a building.

frigidarium—The cold-water room in a Roman bathing facility.

gallery—A rock-cut subterranean passageway in a *catacomb.*

genius (pl. genii)—The alter ego or guardian spirit of a person.

giornata di lavoro—A "work day," that is, the area of plaster that a *fresco* painter can complete in a single session.

gladiator—A professional fighter, usually a slave who had been purchased to train as a hand-to-hand combatant for public entertainment in an *amphitheater.*

groin vault—A *vault* formed by the intersection at right angles of two *barrel vaults.* Also called a cross vault.

Hellenistic—The term given to the culture that developed after the death of Alexander the Great in 323 BCE and lasted almost three centuries, until the Roman conquest of Egypt in 31 BCE.

herm—A bust on a quadrangular pillar.

hexastyle—Having six *columns*. A hexastyle temple has six columns on its facade.

hierarchy of scale—An artistic convention in which greater size equals greater importance.

Hippodamian plan—See *orthogonal plan*.

Honos—A seminude youth holding a *cornucopia;* the personification of honor.

horrea—Warehouse for the storage of grain and other commodities like oil and wine.

hortus—A garden; in a Roman *domus,* the hortus was at the back of the house.

hubris—Arrogant pride.

hypocaust—A floor raised on brick stilts so that hot air from a furnace can flow into and heat the room.

iconography—"Writing of images," the pictorial content or subject matter of a work of art; also, the study of meaning and symbolism of images.

imago (pl. **imagines**)—A wax portrait or mask of an ancestor, stored in a cupboard in the *atrium* of a Roman *domus,* and displayed or worn at funerals.

imperator—Commander in chief of the Roman army; root of the word "emperor."

impluvium—The catch basin in the center of the *atrium* of a Roman *domus* for the collection of rainwater admitted through the *compluvium*.

inhumation—The burial of the bodies of the dead.

insula (pl. **insulae**)—A city block. Also, a multistory apartment house.

Ionic—One of the two systems, or *orders,* of Greek architecture. The Ionic order is characterized by, among other features, *volute capitals, columns* with *bases,* and an uninterrupted *frieze*.

ketos—A sea dragon.

kline (pl. **klinai**)—A banqueting couch. Also, the lid of a *sarcophagus* in the form of a banqueting couch.

laconicum—The sweating room in a Roman bathing facility.

lararium—A shrine to the *lares*.

lares—Roman household gods.

lenos sarcophagus—A bathtub-shaped *sarcophagus* with rounded corners.

libertus, fem. **liberta**—A freedman/freedwoman.

lictor—A member of the imperial bodyguard. Lictors carry *fasces* as their identifying attribute.

linear perspective—See *perspective*.

lintel—A beam used to span an opening.

loculus (pl. **loculi**)—An opening or shelf in the wall of a *gallery* in a *catacomb* to receive a corpse.

lunette—A painting or relief with a semicircular or crescent-shaped frame.

luxuria—Luxury; wasteful spending on useless ostentation.

macellum—A public market.

Magna Graecia—The Greek cities of southern Italy and Sicily.

manumission—The granting of freedom to a slave.

masonry—Cut-stone construction. See *dressed masonry*.

Masonry Style—See *First Style*.

mausoleum—A grandiose tomb, named for Mausolos of Halikarnassos, whose fourth-century BCE tomb was ranked as one of the Seven Wonders of the ancient world.

menorah—The ancient Jewish seven-branched candlestick.

metope—The square panel between two *triglyphs* in a *Doric frieze*.

minotaur—A Greek mythological creature that was half man and half bull.

monochromatic—Having only one color.

mosaic—Patterns or pictures made by embedding *tesserae* of stone or glass in cement on surfaces such as floors and walls. The earliest mosaics, however, were pebble mosaics, made using naturally shaped stones instead of cut tesserae.

narthex—The vestibule of an Early Christian *basilica*.

natatio—The swimming pool in a Roman bathing facility.

nave—The central space of a *basilica,* demarcated from the flanking *aisles* by a row of *columns* on each side.

necropolis—A cemetery or "city of the dead."

nereid—A female sea creature.

nodus—The roll of hair over the forehead in a popular Augustan female coiffure.

novus homo—A new senator from a family that had never been represented in the *Senate*.

nummus—A late Roman coin made of debased metal.

nymph—A goddess of springs, caves, and woods.

nymphaeum—A monumental fountain.

octastyle—Having eight *columns*. An octastyle temple has eight columns on its facade.

octopylon—An *arch* with eight piers.

oculus—The round central opening, or "eye," at the apex of a *dome*.

odeum—A roofed theater (theatrum tectum) usually used for concerts.

oecus—A banquet hall in a Roman *domus*. A tetrastyle oecus has one *column* at each of its four corners. A Corinthian oecus has a continuous row of columns running around the walls of the room. An Egyptian oecus is a banquet hall in the form of a miniature *basilica,* with a *nave, aisles,* and *clerestory* windows.

Oikoumene—The personification of the civilized world.

optimus princeps—The best *princeps;* the title conferred on the emperor Trajan.

opus incertum—An early type of Roman *concrete,* characterized by a facing of irregularly shaped stones.

orant – Praying figure.

order – In Classical architecture, a system that determined the form and organization of the various parts of a columnar building.

orthogonal plan – The imposition of a strict grid plan on a site, regardless of the terrain, so that all the streets meet at right angles. Also called a Hippodamian plan after the fifth-century BCE Greek city planner Hippodamos of Miletus.

palaestra – An exercise courtyard framed by *porticos*.

paludamentum – A military cloak.

panegyric – A speech of thanks and praise.

papyrus – A plant native to Egypt used to make paperlike writing material.

parchment – Lambskin prepared as a surface for writing or painting.

Parthicus – An honorary title, meaning victor over the Parthians.

pater – Father.

patera – An offering plate for pouring a libation at a Roman sacrifice.

paterfamilias – The male head of a Roman household.

patrician – A freeborn landowner, usually from an old and influential Roman family.

patronus – The patron in a patron-client relationship in Roman society.

Pax – Peace.

pebble mosaic – See *mosaic*.

pediment – The triangular space at the end of a building, formed by the ends of the sloping roof above the *colonnade*. Also, an ornamental feature having this shape. A segmental pediment is a rounded pediment. A broken pediment is a half-pediment.

pelta – The scalloped shield used by Amazons.

Pentateuch – The first five books of the Hebrew Scriptures.

peripteral – Having *columns* on all sides.

peristyle – A *peripteral colonnade*. Also, a colonnaded courtyard framing a garden in a Roman *domus*.

perspective – A method of presenting an illusion of the three-dimensional world on a two-dimensional surface. In linear perspective, all parallel lines converge on a single vanishing point at the center of the composition, and objects are rendered smaller the farther from the viewer they are intended to seem. Atmospheric perspective creates the illusion of distance by blurring objects that are intended to seem farther away from the viewer.

pietas – Piety toward the gods, Rome, and family.

pilaster – A flat, rectangular, vertical member projecting from a wall of which it forms a part. It usually has a *capital* and a *base* and takes the form of a flat *engaged column*.

pistor – Baker.

plebeian – A member of the Roman social class that included small farmers, merchants, and freed slaves.

pointing machine – A device for copying sculpture consisting of a framework of metal arms used to measure and transfer a series of points on a plaster model to a block of stone in order to ensure that the copy is of the exact dimensions as the model.

pontifex maximus – The chief priest of the Roman state religion.

Populus Romanus – Roman People; in art, the personification of the people of Rome, a seminude youth carrying a *cornucopia*.

porta – A gateway to a city, sanctuary, or urban complex.

portico – A roofed *colonnade*.

post-and-lintel system – A system of construction in which two upright blocks support a horizontal *lintel*.

praetorian guard – The imperial police force in the city of Rome.

praetorian prefect – The commander of the *praetorian guard*.

prefiguration – An Old Testament forerunner of a New Testament person or event.

princeps – The "first citizen," the title Augustus adopted as Rome's first emperor.

principate – The system of rule by a *princeps;* the reign of an emperor.

processus consularis – The procession honoring the appointment of a new *consul*.

profectio – The departure of an emperor from Rome in order to wage war.

propylon – Entrance gateway.

pseudoperipteral – Having *engaged columns* on the sides and back of a building instead of a complete freestanding *peripteral colonnade*.

putto (pl. putti) – A cherubic young boy.

quadrifrons – A freestanding *arch* with four sides of equal width and an *arcuated* opening on each side; a four-sided *triumphal arch*.

quadriga – A four-horse chariot.

raking cornice – The *cornice* on the sloping sides of a *pediment*.

redemptor – Contractor.

relic – A body part or any object associated with Christ or a Christian saint.

revetment – An architectural facing, often in the form of marble slabs.

Romanitas – Roman culture; the distinctive quality of being a Roman.

Rostra – The speaker's platform in the Forum Romanum.

rotulus – A scroll.

roundel – See *tondo*.

rustication – Intentionally unfinished *masonry* with rough surfaces, producing a rustic appearance.

sacro-idyllic landscape—A painting of a rustic sanctuary.

salutatio—The morning visit by a *cliens* to greet a *patronus* in his *domus*.

sarcophagus (pl. **sarcophagi**)—A coffin, usually of stone.

scaenae frons—The stage front of a Roman theater.

scyphus—A two-handled drinking cup.

Second Style—The style of Roman mural painting in which the aim was to dissolve the confining walls of a room and replace them with the illusion of a three-dimensional world constructed in the artist's imagination.

segmental pediment—See *pediment*.

Senate—The legislative body of the Roman state.

Serapeum—A temple dedicated to the Egyptian god Serapis.

sestertius (pl. **sestertii**)—The standard Roman bronze coin, worth 1/4 of a *denarius* and 1/100 of an *aureus*.

sevir—A local magistrate charged with overseeing the cult of Roma and *Divus* Augustus.

shaft—The cylindrical main section of a *column* between the *capital* and the *base*.

skenographia—"Scene painting," the Greek term for *perspective* painting.

soter—Greek, "savior."

spandrel—The roughly triangular area enclosed by the curve of an *arch* and the framing *columns* and *architrave*.

spolia—Architectural elements and sculptures reused from earlier buildings and monuments.

stadium—A racetrack with one curved end.

stater—A Greek gold coin.

statio (pl. **stationes**)—A one-room business office.

still life—A picture of inanimate objects artfully arranged.

stylobate—The uppermost *course* of the platform of a Greco-Roman temple.

summi viri—Great men.

suovetaurilia—The Roman triple-sacrifice of a pig (*sus*), a sheep (*ovis*), and a bull (*taurus*).

taberna (pl. **tabernae**)—A single-room, usually *barrel-vaulted,* shop.

tablinum—The office or study at the back of the *atrium* of a Roman *domus*.

tempera—A painting medium employing pigments in egg yolk.

tepidarium—The warm-water room in a Roman bathing facility.

terracotta—Baked clay.

tessera (pl. **tesserae**)—Cube; a *mosaic* piece.

tetrarchy—Rule by four; the system of government that Diocletian established in 293.

tetrastyle—Having four *columns*. A tetrastyle temple has four columns on its facade.

tetrastyle atrium—See *atrium*.

tetrastyle oecus—See *oecus*.

thatched—Roofed with straw or a similar plant material.

theatrum tectum—See *odeum*.

thermae—A large imperial bathing complex open to the public.

thermopolium—A hot-food stand.

Third Style—In Roman mural painting, the style in which delicate linear features were sketched on predominantly *monochromatic* backgrounds.

tholos (pl. **tholoi**)—A temple with a circular plan.

thrust—The outward force exerted by an *arch* or a *vault* that must be counterbalanced by a *buttress*.

toga—The long formal garment worn by Roman male citizens.

togatus (pl. **togati**)—A man dressed in a Roman toga.

tondo (pl. **tondi**)—A relief or painting with a circular frame. Also called a roundel.

Torah—The sacred Jewish scroll containing the *Pentateuch*.

transept—The transverse *aisle* of a church that crosses the *nave* at a right angle in front of the *apse*.

tribunal—The elevated platform at the end of the *nave* of a *basilica* on which judges and other magistrates presided over official business.

triclinium (pl. **triclinia**)—The dining room of a Roman *domus*.

trident—A three-pronged pitchfork; the attribute of Neptune, the Roman god of the sea.

triglyph—A triple projecting, grooved member of a *Doric frieze* that alternates with *metopes*.

triton—A male sea creature.

triumph—The celebratory procession through Rome that the *Senate* awarded to victorious generals.

triumphal arch—A freestanding *arch* or gateway erected to commemorate an event or to honor a person or a family, often but not always on the occasion of a military victory.

trophy—A tree trunk adorned with the enemy's captured arms and armor.

tumulus (pl. **tumuli**)—A burial mound.

tunnel vault—See *barrel vault*.

Tuscan atrium—See *atrium*.

Tusci—The Latin name for the Etruscans. The region of central Italy called Tuscany today takes its name from the Etruscans.

ustrinum—A funerary pyre.

uxor—Wife.

vanishing point—See *perspective*.

vault—A stone or *concrete* ceiling constructed on the *arch* principle.

velarium—A cloth awning over the *cavea* of a theater or *amphitheater*.

vellum—Calfskin prepared as a surface for writing or painting.

venationes—Wild animal hunts staged in *amphitheaters*.

verism, veristic – True to natural appearance; super-realistic.

Vestal Virgin – A priestess of the goddess Vesta in Rome.

vicennalia – A 20th anniversary.

victimarius (pl. victimarii) – An attendant at a Roman sacrifice.

villa – A private home outside a city. Villae suburbanae are villas with expansive grounds in the immediate vicinity of a city or town.

villa suburbana – See *villa*.

Virtus – An Amazon-like woman; the personification of manly valor.

volute – The scroll-like spiral part of an *Ionic capital*.

voussoir – A wedge-shaped block used in the construction of an *arch*.

Bibliography

The bibliography on Roman art and architecture is vast and in many languages. This is a selection of English books for further reading; no journal articles are listed.

General Studies

Andreae, Bernard. *The Art of Rome.* New York: Abrams, 1977.

Bianchi Bandinelli, Ranuccio. *Rome: The Center of Power— Roman Art to A.D. 200.* New York: Braziller, 1970.

Brendel, Otto J. *Prolegomena to the Study of Roman Art.* New Haven, Conn.: Yale University Press, 1979.

Brilliant, Richard. *Visual Narratives: Storytelling in Etruscan and Roman Art.* Ithaca, N.Y.: Cornell University Press, 1984.

Clarke, John R. *Art in the Lives of Ordinary Romans: Visual Representation and Non-Elite Viewers in Italy, 100 B.C.—A.D. 315.* Berkeley: University of California Press, 2003.

Cornell, Tim, and John Matthews. *Atlas of the Roman World.* New York: Facts on File, 1982.

D'Ambra, Eve. *Roman Art.* New York: Cambridge University Press, 1998.

————, ed. *Roman Art in Context.* Englewood Cliffs, N.J.: Prentice Hall, 1994.

Elsner, Jaś, ed. *Art and Text in Roman Culture.* New York: Cambridge University Press, 1996.

Ferris, I. M. *Enemies of Rome: Barbarians through Roman Eyes.* Stroud, Gloucestershire, U.K.: Sutton, 2000.

Gazda, Elaine K., ed. *Roman Art in the Private Sphere.* Ann Arbor: University of Michigan Press, 1991.

Hannestad, Niels. *Roman Art and Imperial Policy.* Aarhus, Denmark: Aarhus University Press, 1986.

Henig, Martin, ed. *A Handbook of Roman Art.* Ithaca, N.Y.: Cornell University Press, 1983.

Holliday, Peter James. *Narrative and Event in Ancient Art.* New York: Cambridge University Press, 1993.

Hölscher, Tonio. *The Language of Images in Roman Art.* New York: Cambridge University Press, 2004.

Kleiner, Diana E. E., and Susan B. Matheson, eds. *I Claudia: Women in Ancient Rome.* New Haven, Conn.: Yale University Art Gallery, 1996.

————. *I Claudia II: Women in Roman Art and Society.* Austin: University of Texas Press, 2000.

Pollitt, Jerome J. *The Art of Rome, 753 B.C.—A.D. 337: Sources and Documents.* Rev. ed. New York: Cambridge University Press, 1983.

Ramage, Nancy H., and Andrew Ramage. *Roman Art: Romulus to Constantine.* 4th ed. Upper Saddle River, N.J.: Prentice Hall, 2005.

Ryberg, Inez Scott. *Rites of the State Religion in Roman Art.* Rome: American Academy in Rome, 1955.

Scarre, Chris. *The Penguin Historical Atlas of Ancient Rome.* New York: Viking, 1995.

Sebesta, Judith Lynn, and Larissa Bonfante. *The World of Roman Costume.* Madison: University of Wisconsin Press, 1994.

Stewart, Peter. *Roman Art.* New York: Oxford University Press, 2004.

Strong, Donald, and Roger Ling. *Roman Art.* 2d ed. New Haven, Conn.: Yale University Press, 1988.

Toynbee, Jocelyn M. C. *Death and Burial in the Roman World.* London: Thames & Hudson, 1971.

Architecture

Adam, Jean-Pierre. *Roman Building: Materials and Techniques.* Bloomington: Indiana University Press, 1994.

Aicher, Peter J. *Guide to the Aqueducts of Ancient Rome.* Wauconda, Ill.: Bolchazy-Carducci, 1995.

Anderson, James C., Jr. *The Historical Topography of the Imperial Fora.* Brussels: Latomus, 1984.

Anderson, James C., Jr. *Roman Architecture and Society.* Baltimore, Md.: Johns Hopkins University Press, 1997.

Boëthius, Axel. *Etruscan and Early Roman Architecture.* New Haven, Conn.: Yale University Press, 1978.

Bomgardner, David Lee. *The Story of the Roman Amphitheatre.* New York: Routledge, 2000.

Clarke, John R. *The Houses of Roman Italy, 100 B.C.–A.D. 250.* Berkeley: University of California Press, 1991.

Davies, Penelope J. E. *Death and the Emperor: Roman Imperial Funerary Monuments from Augustus to Marcus Aurelius.* New York: Cambridge University Press, 2000.

Ellis, Simon P. *Roman Housing.* London: Duckworth, 2000.

Evans, Harry B. *Water Distribution in Ancient Rome: The Evidence of Frontinus.* Ann Arbor: University of Michigan Press, 1994.

Hales, Shelley. *The Roman House and Social Identity.* New York: Cambridge University Press, 2003.

Hodge, Trevor A. *Roman Aqueducts and Water Supply.* London: Duckworth, 1991.

Lyttleton, Margaret. *Baroque Architecture in Classical Antiquity.* London: Thames & Hudson, 1974.

MacDonald, William L. *The Architecture of the Roman Empire I: An Introductory Study.* Rev. ed. New Haven, Conn.: Yale University Press, 1982.

————. *The Architecture of the Roman Empire II: An Urban Appraisal.* New Haven, Conn.: Yale University Press, 1986.

McKay, Alexander G. *Houses, Villas, and Palaces in the Roman World.* Ithaca, N.Y.: Cornell University Press, 1975.

Rowland, Ingrid D., and Thomas Noble Howe. *Vitruvius: Ten Books on Architecture.* New York: Cambridge University Press, 1999.

Sear, Frank. *Roman Architecture.* Rev. ed. Ithaca, N.Y.: Cornell University Press, 1989.

Stambaugh, John E. *The Ancient Roman City.* Baltimore, Md.: Johns Hopkins University Press, 1988.

Stamper, John W. *The Architecture of Roman Temples: The Republic to the Middle Empire.* New York: Cambridge University Press, 2005.

Taylor, Rabun. *Roman Builders: A Study in Architectural Process.* New York: Cambridge University Press, 2003.

Wallace-Hadrill, Andrew. *Houses and Society in Pompeii and Herculaneum.* Princeton, N.J.: Princeton University Press, 1994.

Ward-Perkins, John B. *Roman Architecture.* New York: Electa/Rizzoli, 1988.

————. *Roman Imperial Architecture.* 2d ed. New Haven, Conn.: Yale University Press, 1981.

Welch, Katherine. *The Roman Amphitheatre: From Its Origins to the Colosseum.* New York: Cambridge University Press, 2005.

White, L. Michael. *Building God's House in the Roman World: Architectural Adaptation among Pagans, Jews, and Christians.* Baltimore, Md.: Johns Hopkins University Press, 1990.

Wilson-Jones, Mark. *Principles of Roman Architecture.* New Haven, Conn.: Yale University Press, 2000.

Yegül, Fikret. *Baths and Bathing in Classical Antiquity.* Cambridge, Mass.: MIT Press, 1992.

Sculpture

Hallett, Christopher H. *The Roman Nude: Heroic Portrait Statuary 200 BC–AD 300.* New York: Oxford University Press, 2005.

Holliday, Peter James. *The Origins of Roman Historical Commemoration in the Visual Arts.* New York: Cambridge University Press, 2002.

Kleiner, Diana E. E. *Roman Sculpture.* New Haven, Conn.: Yale University Press, 1992.

Koortbojian, Michael. *Myth, Meaning, and Memory on Roman Sarcophagi.* Berkeley: University of California Press, 1995.

Rockwell, Peter. *The Art of Stoneworking.* New York: Cambridge University Press, 1993.

Stewart, Peter. *Statues in Roman Society.* New York: Oxford University Press, 2003.

Torelli, Mario. *Typology and Structure of Roman Historical Reliefs.* Ann Arbor: University of Michigan Press, 1982.

Varner, Eric R. *Mutilation and Transformation:* Damnatio Memoriae *and Roman Imperial Portraiture.* Leiden: Brill, 2004.

————, ed. *From Caligula to Constantine: Tyranny and Transformation in Roman Portraiture.* Atlanta, Ga.: Michael C. Carlos Museum, 2000.

Painting and Mosaic

Dunbabin, Katherine M. D. *Mosaics of the Greek and Roman World.* New York: Cambridge University Press, 1999.

Guillaud, Jacqueline, and Maurice Guillaud. *Frescoes in the Time of Pompeii.* New York: Potter, 1990.

Joyce, Hetty. *The Decoration of Walls, Ceilings, and Floors in Italy in the Second and Third Centuries A.D.* Rome: Giorgio Bretschneider, 1981.

Leach, Eleanor Winsor. *The Rhetoric of Space: Literary and Artistic Representations of Landscape in Republican and Augustan Rome.* Princeton, N.J.: Princeton University Press, 1988.

————. *The Social Life of Painting in Ancient Rome and on the Bay of Naples.* New York: Cambridge University Press, 2004.

Ling, Roger. *Ancient Mosaics.* Princeton, N.J.: Princeton University Press, 1998.

————. *Roman Painting.* New York: Cambridge University Press, 1991.

Mazzoleni, Donatella. *Domus: Wall Painting in the Roman House.* Los Angeles: J. Paul Getty Museum, 2004.

Walker, Susan, ed. *Ancient Faces: Mummy Portraits from Roman Egypt.* New York: Metropolitan Museum of Art, 2000.

Coins

Breglia, Laura. *Roman Imperial Coins: Their Art and Technique.* New York: Praeger, 1968.

Burnett, Andrew. *Coinage in the Roman World.* London: Seaby, 1987.

Carson, R. A. G. *Coins of the Roman Empire.* New York: Routledge, 1990.

Foss, Clive. *Roman Historical Coins.* London: Seaby, 1990.

Hill, Philip V. *The Monuments of Ancient Rome as Coin Types.* London: Seaby, 1989.

Kent, John P. C., and Max Hirmer. *Roman Coins.* New York: Abrams, 1978.

Sutherland, C. H. V. *Roman Coins.* London: Barrie & Jenkins, 1974.

Period Studies

The Etruscans

Barker, Graeme, and Tom Rasmussen. *The Etruscans.* Oxford: Blackwell, 1998.

Bonfante, Larissa, ed. *Etruscan Life and Afterlife: A Handbook of Etruscan Studies.* Detroit, Mich.: Wayne State University Press, 1986.

Brendel, Otto J. *Etruscan Art.* 2d ed. New Haven, Conn.: Yale University Press, 1995.

Haynes, Sybille. *Etruscan Civilization: A Cultural History.* Los Angeles: J. Paul Getty Museum, 2000.

Leighton, Robert. *Tarquinia: An Etruscan City.* London: Duckworth, 2004.

Spivey, Nigel. *Etruscan Art.* New York: Thames & Hudson, 1997.

Spivey, Nigel, and Simon Stoddart. *Etruscan Italy: An Archaeological History.* London: Batsford, 1990.

Sprenger, Maja, Gilda Bartoloni, and Max Hirmer. *The Etruscans: Their History, Art, and Architecture.* New York: Abrams, 1983.

Torelli, Mario, ed. *The Etruscans.* New York: Rizzoli, 2001.

Monarchy and Republic

Evans, Jane DeRose. *The Art of Persuasion: Political Propaganda from Aeneas to Brutus.* Ann Arbor: University of Michigan Press, 1992.

Flower, Harriet I. *Ancestor Masks and Aristocratic Power in Roman Culture.* Oxford: Clarendon Press, 1996.

Gazda, Elaine K., ed. *The Villa of the Mysteries in Pompeii.* Ann Arbor, Mich.: Kelsey Museum of Archaeology, 2000.

Gruen, Erich S. *Culture and National Identity in Republican Rome.* Ithaca, N.Y.: Cornell University Press, 1992.

Laidlaw, Ann. *The First Style in Pompeii: Painting and Architecture.* Rome: Giorgio Bretschneider, 1985.

Lehmann, Phyllis Williams. *Roman Wall Paintings from Boscoreale in the Metropolitan Museum of Art.* Cambridge, Mass.: Archaeological Institute of America, 1953.

Early Empire

Ball, Larry F. *The Domus Aurea and the Roman Architectural Revolution.* New York: Cambridge University Press, 2003.

Bartman, Elizabeth. *Portraits of Livia: Imaging the Imperial Woman in Augustan Rome.* New York: Cambridge University Press, 1999.

Blanckenhagen, Peter H. von, and Christine Alexander. *The Augustan Villa at Boscotrecase.* Mainz, Germany: von Zabern, 1990.

Boëthius, Axel. *The Golden House of Nero.* Ann Arbor: University of Michigan Press, 1960.

Castriota, David. *The Ara Pacis Augustae and the Imagery of Abundance in Later Greek and Early Roman Imperial Art.* Princeton, N.J.: Princeton University Press, 1995.

Conlin, Diana Atnally. *The Artists of the Ara Pacis.* Chapel Hill: University of North Carolina Press, 1997.

D'Ambra, Eve. *Private Lives, Imperial Virtues: The Frieze of the Forum Transitorium in Rome.* Princeton, N.J.: Princeton University Press, 1993.

Darwall-Smith, Robin. *Emperors and Architecture: A Study of Flavian Rome.* Brussels: Latomus, 1996.

Favro, Diane. *The Urban Image of Augustan Rome.* New York: Cambridge University Press, 1996.

Galinsky, G. Karl. *Aeneas, Sicily, and Rome.* Princeton, N.J.: Princeton University Press, 1969.

———. *Augustan Culture.* Princeton, N.J.: Princeton University Press, 1996.

Kleiner, Diana E. E. *Roman Group Portraiture: The Funerary Reliefs of the Late Republic and Early Empire.* New York: Garland, 1977.

Kleiner, Fred S. *The Arch of Nero in Rome: A Study of the Roman Honorary Arch before and under Nero.* Rome: Giorgio Bretschneider, 1985.

Kuttner, Ann L. *Dynasty and Empire in the Age of Augustus: The Case of the Boscoreale Cups.* Berkeley: University of California Press, 1995.

La Rocca, Eugenio, ed. *The Places of Imperial Consensus: The Forum of Augustus, the Forum of Trajan.* Rome: Progetti Museali, 1995.

Mattusch, Carol A. *The Villa dei Papiri at Herculaneum: Life and Afterlife of a Sculptural Collection.* Los Angeles: J. Paul Getty Museum, 2005.

Parslow, Christopher Charles. *Rediscovering Antiquity: Karl Weber and the Excavation of Herculaneum, Pompeii, and Stabiae.* New York: Cambridge University Press, 1995.

Pollini, John. *The Portraiture of Gaius and Lucius Caesar.* New York: Fordham University Press, 1987.

Rose, Charles Brian. *Dynastic Commemoration and Imperial Portraiture in the Julio-Claudian Period.* New York: Cambridge University Press, 1997.

Simon, Erika. *Ara Pacis Augustae.* Greenwich, Conn.: New York Graphic Society, 1967.

Toynbee, Jocelyn M. C. *The Flavian Reliefs from the Palazzo della Cancelleria in Rome.* New York: Oxford University Press, 1957.

Winkes, Rolf, ed. *The Age of Augustus*. Providence, R.I.: Brown University, 1986.

Wood, Susan E. *Imperial Women: A Study in Public Images, 40 BC – AD 68*. Leiden: Brill, 1999.

Zanker, Paul. *The Power of Images in the Age of Augustus*. Ann Arbor: University of Michigan Press, 1988.

High Empire

Boatwright, Mary Taliaferro. *Hadrian and the City of Rome*. Princeton, N.J.: Princeton University Press, 1987.

De Fine Licht, K. *The Rotunda in Rome: A Study of Hadrian's Pantheon*. Copenhagen: Gyldendal, 1968.

Kampen, Natalie. *Image and Status: Roman Working Women in Ostia*. Berlin: Mann, 1981.

Leander Touati, A. M. *The Great Trajanic Frieze*. Stockholm: Svenska Institutet i Rom, 1987.

Lepper, Frank A., and Sheppard Frere. *Trajan's Column*. Wolfboro, N.H.: Alan Sutton, 1988.

MacDonald, William L. *The Pantheon: Design, Meaning, and Progeny*. Cambridge, Mass.: Harvard University Press, 1976.

MacDonald, William L., and John A. Pinto. *Hadrian's Villa and Its Legacy*. New Haven, Conn.: Yale University Press, 1995.

Packer, James E. *The Forum of Trajan in Rome: A Study of the Monuments*. Berkeley: University of California Press, 1997.

———. *The Forum of Trajan in Rome: A Study of the Monuments in Brief*. Berkeley: University of California Press, 2001.

Rossi, Lino. *Trajan's Column and the Dacian Wars*. London: Thames & Hudson, 1971.

Ryberg, Inez Scott. *Panel Reliefs of Marcus Aurelius*. New York: Archaeological Institute of America, 1967.

Toynbee, Jocelyn M. C. *The Hadrianic School*. Cambridge: Cambridge University Press, 1934.

Vogel, Lise. *The Column of Antoninus Pius*. Cambridge, Mass.: Harvard University Press, 1973.

Late Empire

Bianchi Bandinelli, Ranuccio. *Rome: The Late Empire — Roman Art A.D. 200 – 400*. New York: Braziller, 1971.

Bowersock, G. W., Peter Brown, and Oleg Grabar, eds. *Late Antiquity: A Guide to the Postclassical World*. Cambridge, Mass.: Harvard University Press, 1998.

Brilliant, Richard. *The Arch of Septimius Severus in the Roman Forum*. Rome: American Academy in Rome, 1967.

DeLaine, Janet. *The Baths of Caracalla*. Portsmouth, R.I.: Journal of Roman Archaeology, 1997.

Elsner, Jaś. *Art and the Roman Viewer: The Transformation of Art from the Pagan World to Christianity*. New York: Cambridge University Press, 1995.

———. *Imperial Rome and Christian Triumph*. New York: Oxford University Press, 1998.

Finney, Paul Corby. *The Invisible God: The Earliest Christians on Art*. New York: Oxford University Press, 1994.

Haynes, D. E. L., and P. E. D. Hirst. *Porta Argentariorum*. London: Macmillan, 1939.

Holloway, R. Ross. *Constantine and Rome*. New Haven, Conn.: Yale University Press, 2004.

Jensen, Robin Margaret. *Understanding Early Christian Art*. New York: Routledge, 2000.

L'Orange, Hans Peter. *The Roman Empire: Art Forms and Civic Life*. New York: Rizzoli, 1985.

Lowden, John. *Early Christian and Byzantine Art*. London: Phaidon, 1997.

MacCormack, Sabine G. *Art and Ceremony in Late Antiquity*. Berkeley: University of California Press, 1981.

Mathews, Thomas P. *The Clash of Gods: A Reinterpretation of Early Christian Art*. Rev. ed. Princeton, N.J.: Princeton University Press, 1999.

McCann, Anna Marguerite. *The Portraits of Septimius Severus*. Rome: American Academy in Rome, 1968.

Pergola, Philippe, Francesca Severini, and Palmira Barbini. *Early Christian Rome: Catacombs and Basilicas*. Rome: Vision, 2000.

Richmond, Ian A. *The City Wall of Imperial Rome*. London: Oxford University Press, 1930.

Wilkes, J. J. *Diocletian's Palace, Split*. Oxford: Oxbow, 1993.

Wood, Susan. *Roman Portrait Sculpture A.D. 217 – 260*. Leiden: Brill, 1986.

Area and Site Studies
Rome

Claridge, Amanda. *Rome: An Oxford Archaeological Guide*. New York: Oxford University Press, 1998.

Dudley, Donald R. *Urbs Roma: A Source Book of Classical Texts on the City and Its Monuments*. London: Phaidon, 1967.

Nash, Ernest. *Pictorial Dictionary of Ancient Rome*. 2 vols. 2d ed. New York: Praeger, 1962.

Richardson, Lawrence, jr. *A New Topographical Dictionary of Ancient Rome*. Baltimore, Md.: Johns Hopkins University Press, 1992.

Italy

Allison, Penelope M. *Pompeian Households: An Analysis of the Material Culture*. Los Angeles: Cotsen Institute of Archaeology, University of California – Los Angeles, 2004.

Coarelli, Filippo, ed. *Pompeii*. New York: Riverside, 2002.

Cornell, Tim, and Kathryn Lomas, eds. *Urban Society in Roman Italy*. New York: St. Martin's, 1995.

D'Arms, John H. *Romans on the Bay of Naples*. Cambridge, Mass.: Harvard University Press, 1970.

Deiss, Joseph Jay. *Herculaneum: Italy's Buried Treasure*. Rev. ed. Malibu, Calif.: J. Paul Getty Museum, 1989.

Grant, Michael. *Cities of Vesuvius: Pompeii and Herculaneum*. London: Phoenix Press, 2001.

Hermansen, Gustav. *Ostia: Aspects of Roman City Life*. Edmonton: University of Alberta Press, 1981.

Kraus, Theodor. *Pompeii and Herculaneum: The Living Cities of the Dead*. New York: Abrams, 1975.

Meiggs, Russell. *Roman Ostia.* 2d ed. Oxford: Clarendon Press, 1973.

Potter, Timothy. *Roman Italy.* Berkeley: University of California Press, 1987.

Richardson, Lawrence, jr. *Pompeii: An Architectural History.* Baltimore, Md.: Johns Hopkins University Press, 1988.

Zanker, Paul. *Pompeii: Public and Private Life.* Cambridge, Mass.: Harvard University Press, 1998.

Western Provinces

Bromwich, James. *The Roman Remains of Southern France.* New York: Routledge, 1993.

Cleere, Henry. *Southern France: An Oxford Archaeological Guide.* New York: Oxford University Press, 2001.

Wightman, Edith Mary. *Roman Trier and the Treveri.* New York: Praeger, 1971.

Eastern Provinces

Bianchi Bandinelli, Ranuccio, Ernesto Vergara Caffarelli, and Giacomo Caputo. *The Buried City: Excavations at Leptis Magna.* New York: Praeger, 1966.

Boatwright, Mary Taliaferro. *Hadrian and the Cities of the Roman Empire.* Princeton, N.J.: Princeton University Press, 2000.

Perkins, Ann Louise. *The Art of Dura-Europos.* Oxford: Clarendon, 1973.

Taylor, Jane. *Petra and the Lost Kingdom of the Nabataeans.* Cambridge, Mass.: Harvard University Press, 2002.

Vermeule, Cornelius C. *Roman Imperial Art in Greece and Asia Minor.* Cambridge, Mass.: Harvard University Press, 1968.

Credits

The Metropolitan Museum of Art.; **16.11:** © Araldo de Luca/CORBIS; **16.12:** © Archivo Iconografico, S.A./CORBIS; **16.13:** © Alinari/Art Resource, NY; **16.14:** © Scala/Art Resource, NY; **16.15:** © Scala/Art Resource, NY; **16.16:** © Rene Seindal; **16.17:** German Archaeological Institute, Rome; **16.18:** © Alinari/Art Resource, NY; **16.19:** German Archaeological Institute, Rome; **16.20:** © Alinari Archives/CORBIS; **16.22:** Fototeca Unione, AAR; **16.23:** © Scala/Art Resource, NY; **16.24:** © Scala/Art Resource, NY

Chapter 17—**17.1:** © Dave Bartruff/CORBIS; **17.3:** © James Sparshatt/CORBIS; **17.4:** © Araldo de Luca; **17.5:** © Peter Wilson/CORBIS; **17.6:** © Araldo de Luca; **17.7:** © HIP/The Image Works; **17.8:** © Araldo de Luca; **17.9:** © Araldo de Luca; **17.10:** © Vanni Archive/CORBIS; **17.11:** © Scala/Art Resource, NY; **17.12:** © Alinari/Art Resource, NY; **17.13:** © Ruggero Vanni/CORBIS; **17.14:** © Roger Wood/CORBIS; **17.15:** © Roger Wood/CORBIS; **17.16:** © Jose Fuste Raga/CORBIS; **17.17:** © Roger Wood/CORBIS; **17.18:** © Foto Marburg/Art Resource, NY; **17.21:** © Erich Lessing/Art Resource, NY; **17.22:** © Art Resource, NY

Chapter 18—**18.1:** © Araldo de Luca; **18.2:** © Araldo de Luca/CORBIS; **18.3:** Photo Vatican Museums; **18.4:** German Archaeological Institute, Athens; **18.5:** The Art Archive/Musée du Louvre, Paris/Dagli Orti ; **18.6:** © Scala/Art Resource, NY; **18.7:** © Araldo de Luca; **18.8:** The Metropolitan Museum of Art, New York, Rogers Fund, 1905. (05.30) Photograph © 1983 The Metropolitan Museum of Art.; **18.9:** The Metropolitan Museum of Art, New York, Rogers Fund, 1905. (05.30) Photograph © 1983 The Metropolitan Museum of Art.; **18.10:** © Araldo de Luca/CORBIS; **18.11:** German Archaeological Institute, Rome; **18.12:** © Araldo de Luca/CORBIS; **18.13:** German Archaeological Institute, Rome; **18.14:** © Araldo de Luca/CORBIS; **18.15:** © Araldo de Luca/CORBIS; **18.16:** © Araldo de Luca/CORBIS; **18.17:** German Archaeological Institute, Rome; **18.18:** © Scala/Art Resource, NY; **18.19:** German Archaeological Institute, Rome; **18.20:** German Archaeological Institute, Rome;

18.21: © Scala/Art Resource, NY; **18.23:** © Werner Forman/Art Resource, NY

Chapter 19—**19.1:** Canali Photobank, Italy; **19.2:** The American Numismatic Society, NY; **19.3:** The American Numismatic Society, NY; **19.4:** © Archivo Iconografico, S.A./CORBIS; **19.5:** Canali Photobank, Italy; **19.6:** © Scala/Art Resource, NY; **19.7:** © Scala/Art Resource, NY; **19.8:** © Scala/Art Resource, NY; **19.9:** © Scala/Art Resource, NY; **19.10:** Pubbli Aer Foto; **19.11:** © Scala/Art Resource, NY; **19.12:** © Scala/Art Resource, NY; **19.13:** German Archaeological Institute, Rome; **19.14:** German Archaeological Institute, Rome; **19.15:** Courtesy of the author; **19.16:** © Bettmann/CORBIS; **19.17:** © Jonathan Blair/CORBIS; **19.18:** © Zlatko Sunko, Croatia

Chapter 20—**20.1:** © Scala/Art Resource, NY; **20.2:** Hirmer Fotoarchiv; **20.3:** The American Numismatic Society, New York; **20.4:** Staatliche Münzsammlung, Munich; **20.5:** © Scala/Art Resource, NY; **20.6:** © CORBIS; **20.7:** © Index/Artphoto; **20.8:** © Hubert Stadler/CORBIS; **20.9:** © Araldo de Luca/CORBIS; **20.10:** © Alinari/Art Resource, NY; **20.11:** Istituto Centrale per il Catalogo e la Documentazione, (ICCD); **20.12:** © Scala/Art Resource, NY; **20.14:** Courtesy Saskia Ltd., © Dr. Ron Wiedenhoeft; **20.15:** Courtesy Saskia Ltd., © Dr. Ron Wiedenhoeft; **20.17:** Pontificia Commissione per l'Archeologia Sacra; **20.18:** © Scala/Art Resource, NY; **20.19:** Photo by Darius Arya; **20.20:** Foto Archivio di San Pietro in Vaticano; **20.21:** © Scala/Art Resource, NY; **20.22:** Courtesy Saskia Ltd., © Dr. Ron Wiedenhoeft

ILLUSTRATIONS

1-4, p. 5: From *Etruscan and Early Roman Architecture* by Axel Boethius, p. 46, 34. © 1978 Yale University Press. Reprinted with permission; **1-11,** p. 9: From *Etruscan and Early Roman Architecture* by Axel Boethius, p. 130, 126. © 1978 Yale University Press. Reprinted with permission; **1-15,** p. 11: John Burge, based on *Etruscan and Early Roman Architecture* by Axel Boethius, p. 129, 125. © 1978 Yale University Press; **2-2,** p. 18: From *Scavi di Ostia, I: Topografia generale*, p. 58–59, 19. © 1953

Libreria dello Stato. Reprinted with permission; **2-10,** p. 23: From *Guida archeologica di Pompei* by Eugenio La Rocca, et al., p. 110. © 1976 Arnoldo Mondadori. Reprinted with permission; **2-11,** p. 25: From *Cities of Vesuvius* by Michael Grant, p. 81. © 1976 Penguin; **3-2,** p. 32: John Burge, based on *Guida archeologica di Pompei* by Eugenio La Rocca, et al., p. 37. © 1976 Arnoldo Mondadori; **3-8,** p. 35: From *Cities of Vesuvius* by Michael Grant, p. 112. © 1976 Penguin; **3-14,** p. 38: From *Guida archeologica di Pompei* by Eugenio La Rocca, et al., p. 32. © 1976 Arnoldo Mondadori. Reprinted with permission; **4-14,** p. 57: James E. Packer, John Burge, Richard Beacham, and King's Visualization Lab, King's College London; **4-18,** p. 59: From *L'architecture romaine* by Pierre Gros, p. 212, 284d. © 1996 Editions A. & J. Picard; **5-5,** p. 64: From *Forum Romanum. Die Neugestaltung durch Augustus* by Paul Zanker, plate V. © 1972 Ernst Wasmuth; **5-8,** p. 65: From *Hadrien et l'architecture romaine* by Henri Stierlin, p. 97. © 1984 Office du livre de Fribourg; Poem, p. 89: From *The Aeneid by Virgil,* translated by Robert Fitzgerald, copyright © 1980, 1982, 1983 by Robert Fitzgerald. Used by permission of Random House, Inc.; **9-17,** p. 132: John Burge, after *Roman Imperial Architecture* by John B. Ward-Perkins, p. 81, 37. © 1981 Penguin. Used by permission of Yale University Press; **10-3,** p. 141: From *Herculaneum* by Giorgio Giubelli, p. 51. © 1951 Vincenzo Carcavallo; **10-9,** p. 143: John Burge, after *Houses, Villas and Palaces in the Roman World* by A. G. McKay, p. 45, 15. © 1973 Thames & Hudson Ltd., London. Used by permission; **10-11,** p. 144: From *Cities of Vesuvius* by Michael Grant, p. 137. © 1976 Penguin; **11-5,** p. 157: From *Roman Imperial Architecture* by John B. Ward-Perkins, p. 30, 6. © 1981 Penguin. Used by permission of Yale University Press; **14-2,** p. 204: From *Roman Ostia,* Second Edition, by Russell Meiggs, © 1973 Clarendon Press; **16-21,** p. 243: From *Römische Kunst* by Bernard Andreae, © 1973 Verlag Herder GmbH; **17-2,** p. 248: From *Das römische Weltreich* by Theodor Kraus, p. 160, 2. © 1967 Propyläen Verlag; **18-22,** p. 276: Adapted, from *Lexicon Topographicum Urbis Romae,* Vol. 3, 190, p. 484. © 1996 Quasar, with permission from Edizion Quasar di Severino Tognon s.r.l.

Index
